THE LURE OF THE LOCAL

O T H E R B O O K S B Y L U C Y R L I P P A R D

The Graphic Work of Philip Evergood

Pop Art

Surrealists on Art (editor)

Dadas on Art (editor)

Changing: Essays in Art Criticism

Six Years: The Dematerialization of the Art Object . . .

From the Center: Feminist Essays on Women's Art

Eva Hesse

Tony Smith

I See/You Mean (novel)

Overlay: Contemporary Art and the Art of Prehistory

Ad Reinhardt

Get the Message? A Decade of Art for Social Change

A Different War: Vietnam in Art

Mixed Blessings: New Art in a Multicultural America

Partial Recall: Photographs of Native North Americans (editor)

The Pink Glass Swan: Selected Feminist Essays on Art

The Lure of the Local

Senses of Place in a Multicentered Society

LUCY R. LIPPARD

THE NEW PRESS, NEW YORK

LIBRARY OF CONGRESS
CATALOGUING-IN-PUBLICATION

Lippard, Lucy R.
The lure of the local: senses of place in a
multicentered society / Lucy R. Lippard.
p. cm.
ISBN 1-56584-248-0

1. Human geography—United States. 2. Geographical
perception—United States. 3. Multiculturalism—United States.
4. United States—Social life and customs. I. Title.

GF503.L56 1997
304.2'3—dc20 96-23879
CIP

Published in the United States by THE NEW PRESS, NEW YORK

Distributed by W.W. NORTON & COMPANY, INC., NEW YORK

*Established in 1990 as a major alternative to the large commercial
publishing houses, The New Press is a nonprofit American
book publisher. The Press is operated editorially in the public interest,
rather than for private gain; it is committed to publishing,
in innovative ways, works of educational, cultural, and community
value that, despite their intellectual merits, might not normally
be commercially viable. The New Press's editorial offices are located
at the City University of New York.*

Book design by BAD

Printed in the United States of America

9 8 7 6 5 4 3 2

To Peter, for being the Maine part of this book in so many ways.

The Veins of Maine on Salter's Island, 1996 (photo: Peter Woodruff).

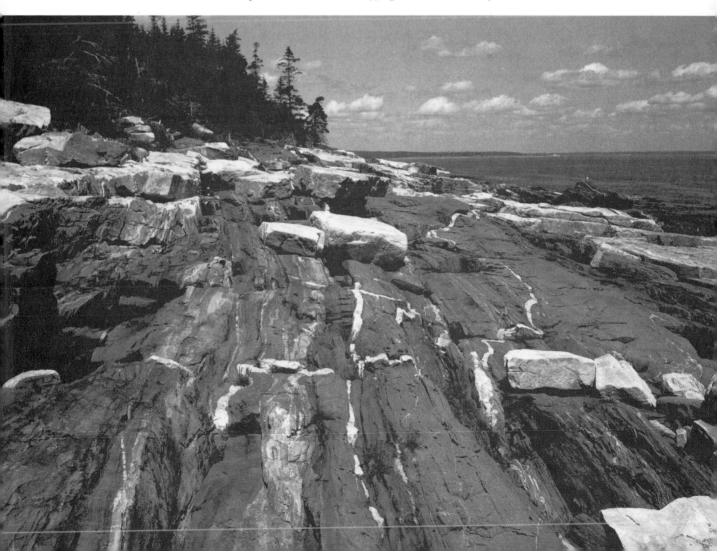

ACKNOWLEDGMENTS

I learned as much from living in New York City, Georgetown, Maine, Galisteo, New Mexico, and Boulder, Colorado, as I did from all my research—so first of all, I'm grateful to my communities there.

In 1993, when I was teaching my own seminar on land, history, culture, and place, and beginning this book, I sat in on Don Mitchell's seminar in cultural geography at the University of Colorado at Boulder; it was an eye-opener, and bits of his insights (filtered through my own idiosyncrasies) appear throughout.

Many thanks to André Schiffrin of The New Press for his longstanding support; to Grace Farrell, for persevering, and for living up to her name as the tactful in-house editor; to Gary Weston DeWalt, who lent me more books on the subject than I could digest and read the manuscript twice, which was particularly helpful with the Western sections; to Hall Smyth for his elegant design and patience with my stodgier tastes; to Ted Byfield, who was the appropriately critical copy-editor; and to Bill Metcalf, without whose support when my computer died, this book would *never* have been finished.

Photographer-friends Susan Crocker, Caroline Hinkley, Judith Coyle Bush, and Andrea Robbins filled in last-minute pictorial gaps, and Richard Hooker of the New Mexico Arts Division was also a big help. Peter Woodruff braved the elements for two years to picture Maine up until the eleventh hour; his professors in the New England Studies Program at the University of Southern Maine have also been unwitting accomplices.

Thanks to the University of Colorado's Art Department for letting me teach an "all over the place" seminar for three years even though it didn't seem to have much to do with art; to Caroline Hinkley, for introducing me to J. B. Jackson's work years ago; to Peter's Exclusive Clipping Service in Bath, Maine; to those in Tierra Amarilla, New Mexico, who resisted the erosion of community land rights in the late 1980s; to Billie Todd, editor extraordinaire of *The Georgetown Tide* for all the information I've found there; to the memory of Jim Oliver, and to Francis Oliver, Bud Brown, and Emerson (Tad) Baker for sharing their local knowledge; to all the other friends around the country who turned me on to ideas, writings, and images; and especially to the artists who provided the visual material that brings this to life.

Finally, retrospective thanks to my grandmother—Florence Isham Cross—whose local history on Kennebec Point was an inspiration for this book.

PERMISSIONS

Modified excerpts from *The Lure of the Local* have appeared in *Mapping the Terrain* (Suzanne Lacy, ed.), *Z Magazine* (some of my "Sniper's Nest" columns), *The Dissident* (no. 5, Nov., 1995), *Whitewalls* (no. 37, 1996), *Prison Sentences* (Courtney and Gilens, eds.), SITE Sante Fe's *Longing and Belonging*, and *FATE* in *Review* (Honolulu).

THE LURE OF THE LOCAL

All Over the Place

Most educated people say where is it written? Our people say where is it lived?
— STEVE GONZALEZ

We are in the epoch of simultaneity; we are in the epoch of juxtaposition,
the epoch of the near and far, of the side-by-side, of the dispersed.
— MICHEL FOUCAULT

PLACE FOR ME IS THE LOCUS OF DESIRE. Places have influenced my life as much as, perhaps more than, people. I fall for (or into) places faster and less conditionally than I do for people. I can drive through a landscape and vividly picture myself in that disintegrating mining cabin, that saltwater farm, that little porched house in the barrio. (My taste runs to humble dwellings nestled in cozy spaces or vulnerable in vast spaces.) I can walk through a neighborhood and picture interiors, unseen back yards. I can feel kinesthetically how it would be to hike for hours through a vast "empty" landscape that I'm dashing through in a car—the underfoot textures, the rising dust, the way muscles tighten on a hill, the rhythms of walking, the feeling of sun or mist on the back of my neck. In the late seventies, I lived on an idyllic farm in England for a year. While there, I wrote a weird short story about a woman who fell erotically in love with the place and was literally absorbed by it. I missed Ashwell Farm terribly when I returned to New York,

then I found I could continue to take my daily walks in a kind of out-of-body form—step by step, weather, texture, views, seasons, flowers, wildlife encounters.

Since childhood I've done the same with the shoreline of a little peninsula on Georgetown Island jutting into the Atlantic Ocean at the mouth of the Kennebec River in Maine, which remains the bedrock place in my life. I first arrived there in 1937, at the age of three months, as a basket case on the boat from Boston. I've returned every summer for sixty years. Although I will always be perceived as "from away," Kennebec Point is for me, as for many of my contemporaries there, my soul's home. When I realized that a book about the local couldn't be approached only with general ideas, Georgetown was the logical point of departure. The "vein of Maine" that runs through this book like a vein of granite or quartz through schist is offered as an antidote to all the tentative concepts surrounding it, an anchor line for my driftings. I have trolled for years in many disciplines and adhere to no particular theory.

4

We drive over the Piscataqua from Portsmouth, New Hampshire, and we're in Maine! Already it smells different. The air is fresh with salt and anticipation. An hour and a half later we pass Portland, a first whiff of real sea, sharper if the tide is out and the mudflats are breathing. For years, when the papermills upstream felt free to indundate the river with waste, there was a foul smell of rotting cabbages as we crossed the Presumpscot.

Through Brunswick, home of Bowdoin College, and its grove of towering old growth pines, and then—on Witch Spring Hill just outside of Bath—the first glimpse of the green towers of the Carlton Bridge. (As a kid I got a penny if I saw it first.) We cross the broad Kennebec, opening the windows to receive its blessing, passing the huge crane

However out of fashion romanticism and nostalgia may be, I can't write about places without occasionally sinking into their seductive embrace. As I follow the labyrinthine diversity of personal geography, lived experience grounded in nature, culture and history, forming landscape and place, I have to dream a little, as well as listen for the political wake-up calls.

> Everything written in the "objective style" of 1950s social sciences or "New Criticism," and everything written in the opaque style of post-structural discourses, now risks being read as a kind of political cover-up, hidden complicity, and intrigue on either the right or left. Interestingly, the one path that still leads in the direction of scholarly objectivity, detachment, and neutrality is exactly the one originally thought to lead away from these classic virtues: that is, an openly autobiographical style in which the subjective position of the author, especially on political matters, is presented in a clear and straightforward fashion. At least this enables the reader to review his or her own position to make the adjustments necessary for dialogue.
> — DEAN MACCANNELL

I have chosen to weave myself and my own experiences into this book from time to time because lived experience is central to my writing and to the subject of place. While the North American continent is my hazy focus here, my notions of place are inextricable from all the places I've lived and been, and from accounts of other localities that have moved me. I know I have been lured to the subject of the local by its absence or rather by the absence of value attached to specific place in contemporary cultural life, in the "art world," and in postmodern paradoxes and paradigms. Other threads in this textual fabric are information gathered from decades of scholarship on the subject and the contributions of contemporary artists.

I've spent a lot of my life looking, as a writer on visual arts, but less of it looking around, or around *here*. I was drawn to this particular intersection of land, history, and culture—at once rotary and crossroad—from separate paths and directions, through my previous books on prehistory (*Overlay*), the cross-cultural process (*Mixed Blessings*), and the historical representation of Native North Americans (*Partial Recall*). I've spent my adult life not as an art historian but as a witness to the absolutely contemporary—what's happening or should happen in progressive, mostly North American art right *now*. But in the last few years I've found myself mired in history: history of native/white contact in this hemisphere through national organizing to counter the dominant versions of 1492/1992; history of family since the deaths of my parents; and the local histories of places, especially those of Georgetown and a rural *Hispano* village in northern New Mexico I first saw eleven years ago. Combined with a long-standing commitment to grassroots politics and to an art that is part of lived experience, as well as to a feminist fascination with the processes of everyday life, the lure of the local has been a visceral pull for many years now.

Yet this book is also a personal irony characteristic of late twentieth-century life. When I began to write about the lure of the local, I was living in four different states, each of which had its own deep visual and emotional attraction. Although I've now narrowed it down to two, I will continue to be an emotional nomad and a radical (the root of which means "root"), playing the relatively conservative values of permanence and rootedness off against restlessness and a constructed "multicenteredness."

The notion of multicenteredness is an extension of the often-abused notion of multiculturalism. Most of us move around a lot, but when we move we often come into contact with those who haven't moved around, or have come from different places. This should give us a better understanding of difference (though it will always be impossible to understand

of the Bath Iron Works and the lurking gray destroyers in various stages of construction lined up along the shore. In Woolwich for only a minute or so, we take an abrupt right at the Dairy Queen and cross the Sasanoa on another high bridge, heading south. Past the old Arrowsic Town Hall, Sewall Pond, the front-yard cannon… getting closer. Finally the car roars over the "buzzy bridge" between Arrowsic and Georgetown. Almost home.

Past Gene and Claire Reynolds' antler-bedecked garage and gravel pits, past the road to Robinhood, past what was once Allan and Agnes Wells's "Seguin Post" store (later a small pottery, now for sale), past the old Heald (or Heal) roadside cemetery belonging to painter Jason Schoener and his ecologically outspoken wife Virginia, past

6

everything about difference). Each time we enter a new place, we become one of the ingredients of an existing hybridity, which is really what all "local places" consist of. By entering that hybrid, we change it; and in each situation we may play a different role. A white middle-class art type without much money will have a different affect and effect on a mostly Latino community with less money than on a mostly white upper-class suburb with more money. S/he remains the same person, and may remain an outsider in both cases, but reciprocal identity is inevitably altered by the place, by the relationship to the place itself and the people who are already there. Sometimes the place, or "nature," will provide nourishment that social life cannot.

Another personal paradox is the fact that despite my passion for the hybrid, my own family is terrifyingly monocultural, at least as far as I know. (I once did a performance that began, "I'm 100 per cent WASP and no longer ashamed of it.") My roots are in England, Ireland, Canada, and New England. Some of my ancestors were in Ohio and New York state. Two pairs of my great grandparents went west, but they spent only two generations wandering there, then kept wandering elsewhere. One pair of my grandparents immigrated from London's East End and Nova Scotia in the late nineteenth century. Nevertheless, my own *culture*—the habits, ethics, memories that form me—is decidedly New England on both sides. This despite the fact that I was born in New York City, raised in New York, New Orleans, and Charlottesville, Virginia, studied in Massachusetts, France, and New York, lived part-time in Boulder, Colorado, and sojourned in Mexico, Spain, Italy, and England. As a nomad with a serially monogamous passion for place, I often wonder if this inconsistency constitutes hopeless fragmentation or hopeful integration.

How will we know it's us without our past?
— JOHN STEINBECK

There is a huge literature on "place"—far more than I had suspected when I embarked on a seminar on the subject in 1992. But I am always struck by the neglect and miscomprehension of contributions made by artists, who read, think, and see from angles not often found by scholars. As an afterthought to his important "Axioms for Reading the Landscape," geographer Pierce Lewis revealingly, and almost surreptitiously, adds that to teach oneself how to see, it helps to *draw* —not "arty impressionistic sketches," but "literal primitive drawings…to force one to notice details that might otherwise go unseen." As a child, I was a Sunday

Christina and Florence Isham, Colorado, 1892 (photographer unknown). Christina, my great aunt who died in her early thirties, and Florence Emily Isham Cross, my grandmother, were the eldest of the five Isham girls who were raised in Dakota Territory, Wyoming, and Colorado. In my favorite picture (too blurry to reproduce here) of the two, they are younger, and sit proudly sidesaddle on their ponies, Stockings and Ribbon. During the 1890s, when the family lived in Colorado Springs, they gave up their house every summer and "camped" in Northern Colorado, returning after vacation to move into a new house.

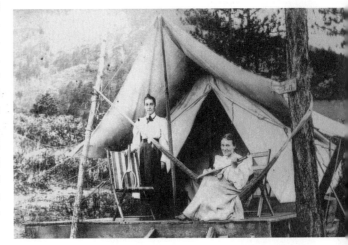

the Heald farm and the tall gray Higgins house, plain for years, now refurbished with a red door and barn, and grazing horses. Past the newer cemetery, sprawling Georgetown Pottery, the Georgetown Country Store, the volunteer firehouse, the big yellow house on the corner with Noreen Peterson's beautiful garden.

Excitement mounts as we take a right on the Bay Point Road, past the Central School, the spare white Baptist Church and the old cemetery, past the late Jack Lee's neat little white house, perhaps the oldest in Georgetown, past Middledyke Farm and its barn marked 1884 (now wooden bearings are manufactured there), past the Olivers' "Three Bears House," past the old stone schoolhouse that now houses the

painter along the Maine coast with my family of amateur watercolorists. Our enthusiastic regard for the substance of the landscape laid the groundwork for *The Lure of the Local*. Like all my recent books, it is a weave of ideas and information, an attempt to integrate visual art and my own experience into the broader debates, into all I have learned from those who are the "real experts" (on cultural geography, in this case).

This book is concerned not with the history *of* nature and the landscape but with the historical narrative as it is written *in* the landscape or place by the people who live or lived there. The intersections of nature, culture, history, and ideology form the ground on which we stand—our land, our place, the local. The lure of the local is the pull of place that operates on each of us, exposing our politics and our spiritual legacies. It is the geographical component of the psychological need to belong somewhere, one antidote to a prevailing alienation. The lure of the local is that undertone to modern life that connects it to the past we know so little and the future we are aimlessly concocting. It is not universal (nothing is) and its character and affect differ greatly over time from person to person and from community to community. For some people the lure of the local is neither felt nor acknowledged; for some it is an unattainable dream; for others it is a bittersweet reality, at once comforting and constricting; for others it is only partial reality, partial dream. These days the notion of the local is attractive to many who have never really experienced it, who may or may not be willing to take the responsibility and study the local knowledge that distinguishes every place from every other place.

Inherent in the local is the concept of place—a portion of land/town/cityscape seen from the inside, the resonance of a specific location that is known and familiar. Most often place applies to our own "local"—

entwined with personal memory, known or unknown histories, marks made in the land that provoke and evoke. Place is latitudinal and longitudinal within the map of a person's life. It is temporal and spatial, personal and political. A layered location replete with human histories and memories, place has width as well as depth. It is about connections, what surrounds it, what formed it, what happened there, what will happen there.

British geographer Denis Cosgrove defines landscape as "the external world mediated through human subjective experience." I'd define place that way. A lived-in landscape becomes a place, which implies

PHOTOGRAPHER UNKNOWN, 1950S(?) An "innocently" gendered picture: man stands back and admires culture's control of nature—Hoover (Boulder) Dam in the Colorado River, built in 1936 to form the largest human-made lake in the world— while woman as artist represents what Alexander Wilson called "the culture of nature."

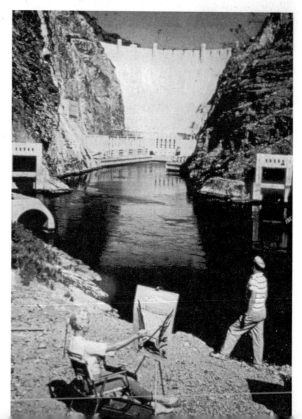

Georgetown Historical Society, past the Sagadahoc Bay road and bear left onto Kennebec Point. Our driveway scales the hill. Beyond the house's rather ugly facade (it was the first "flat roofed" house on our part of the coast), lies the bay—shrouded in fog or changing grays or glistening blue, placidly calm, or ruffled by wind and white-caps, promising all the delights and adventures of summer. Out of the car, shoes off, and down the steep path to the beach, as yet unclipped bushes scratching my legs, mosquitoes rising from the high grass in the meadow, through the bed of a now dry stream that used to run full time, into stiffer beach grass to the sugary white sand. If the tide's out, mud squooshes between my toes and then hard sand,

8

intimacy; a once-lived-in landscape can be a place, if explored, or remain a landscape, if simply observed. Sometimes a spontaneous attraction to place is really an emotional response to the landscape, which is place at a distance, visual rather than sensual, seen rather than felt in all its affective power. Even in places we've never been before, human lives can eerily bubble up from beneath the ground and haunt us. When I arrived in Boulder, Colorado, in 1986, I planned to stay only the four months a temporary job required. I wasn't initially moved by the forested foothills rising from the vast (and now crowded) plains. About a month later, as I was hiking, what can only be called a "vision" of the entire history of the place rose from the ground at me—not in pictures or in narrative form, but in an indescribable whole, a burst of land, history, culture that *was* the place. I recalled that my grandparents and great grandparents had lived in Colorado. I lived there off and on for nine years.

> I suspect no landscape, vernacular or otherwise, can be comprehended unless we perceive it as an organization of space; unless we ask ourselves who owns or uses the spaces, how they were created and how they change.
> — JOHN BRINCKERHOFF JACKSON

The word landscape originated in the German fifteenth-century term *landschaft*—a shaped land, a cluster of temporary dwellings and more permanent houses, the antithesis of the wilderness surrounding it, according to John Stilgoe; and in the Dutch seventeenth-century word *landschap* or *landskip*—a painting of such a place, perceived as a scope, or expanse. Today the word is commonly conflated with place, nature, view, scenery, and has radiated out into any number of meanings from the popular pretty rural scene to a complex social construction or produced space.

On the most basic level, landscape is everything you see when you go outdoors—if you're looking. It's what you see from a single (static or mobile) point of view—a set of surfaces, the pictorial or the picturesque, "as far as the eye can see" (without aid of microscope or telescope). Unlike place (which I defined above as seen from the inside), landscape can only be seen from outside, as a backdrop for the experience of viewing. The scene is the seen. The word landscape is used interchangeably for a scene framed *through* viewing (a place) and a scene framed *for* viewing (a picture).

Alexander Wilson has suggested that landscape is a kind of "activity"—"a way of seeing the world and imagining our relationship to nature," while landscape writer J. B. Jackson says a landscape is "a space deliberately created to speed up or slow down the process of nature." If labor is the mediator between nature and culture (as Marx says in *Kapital*), landscape as the product of labor is a synthesis, resting somewhere between the two (as "countryside" forms the buffer zone between "civilization" and "wilderness"). I'm particularly intrigued by the vernacular element, as pioneered by Jackson—finding connections between land and people and what people *do* there. Places bear the records of hybrid culture, hybrid histories that must be woven into a new mainstream. They are our "background" in every sense.

The American landscape (at least in the East and Midwest) was formed by a conservative working class in the image of European "Old Countries," as John Stilgoe observes, describing landscape within these conventions as "essentially rural, the product of traditional agriculture interrupted here and there by traditional artifice." He also sees it as something of the past: "Contemporary Americans recall landscape with vague delight and understanding, remembering it as space objectifying a traditional social order. What keeps alive the half-imagined memory?"

clamshells crunching harmlessly underfoot as I wade in the channel, tiny creatures tickling my ankles. If the tide's in, over the rocks to Far Beach with its Indian shell midden and the smooth old pothole we called "the aquarium," then to Far Far (or "Fa'thest Fa'") Beach with its white granite point, looking out to Seguin, the big humped lighthouse island three miles out to sea. The texture of sand and rock and seaweed under bare feet is the surest sign that I'm home.

Later, down the Point and over the hill for the first head-on view of the open sea, Pond Island Light, the mouth of the Kennebec River—a sight called "Why-Go-To-Heaven?" by Ida Carlisle at the turn of the century. Past the oldest house on

Pierce Lewis extends Mae Thielgaard Watts's idea that the landscape reveals clues to a culture and can be read like a book: "Our human landscape is our unwitting autobiography…the culture of any nation is unintentionally reflected in its ordinary vernacular landscape." Both landscape and place can be broken down into their social components, the vortices where people and environment work on each other. But place is where we stand to look around at landscape or look out to the (less familiar) "view." The word *place* has psychological echoes as well as social ramifications. "Someplace" is what we are looking for. "No place" is where these elements are unknown or invisible, but in fact every place has them, although some are being buried beneath the asphalt of the monoculture, the "geography of nowhere." "Placelessness," then, may simply be place ignored, unseen, or unknown.

Few of us in contemporary North American society know our place. When I asked twenty university students to name a place where they felt they belonged, most could not. The exceptions were two Navajo women, raised more or less traditionally, and a man whose family had been on a southern Illinois farm for generations. For many, displacement is the factor that defines a colonized or expropriated place. And even if we can locate ourselves, we haven't necessarily examined our place in, or our actual relationship to, that place. Yet our personal relationships to history and place form us, as individuals and groups, and in reciprocal ways we form them. Land, history, and culture meet in a multicentered society that values place but cannot be limited to one view.

Space defines landscape, where space combined with memory defines place. The spatial experience of a landscape can be impressive because it evokes a known place or, on the other hand, because it is so totally unfamiliar. Space itself is defined in my 1958 Webster's dictionary as "distance extending without limit in all directions" or "distance, interval or area between or within things." In contemporary criticism, the word "space" represents the desentimentalized (some would say dehumanized) postmodern version of place. It is used as a neutral sociological and economic synonym for the more literary, aesthetic, cultural, sentimental, and sometimes ecological word "nature." At times it even implies "devoid of nature" —to the point where Margaret Fitzsimmons exhorts progressive geographers to work toward "a new integrated geography of Nature and Space" in both city and countryside. This would correspond to what Neil Smith calls "deep space…[a] quintessentially social

TOM GASKINS, *Beauty Humor Nature Knowledge*, c. 1995 (Photo: copyright Mika Fowler). The sculpture/road sign created out of cypress branches is one of many that stood along U.S. 27 near Lake Okeechobee for some 47 years, promoting Tom Gaskins's World Famous Cypress Knee Museum in Palmdale, Florida. (His father had perfected a method of forcing cypress to grow in determined shapes, such as "Bona Lisa— the brother of Mona Lisa.") The signs have recently been moved from the highway to the museum grounds at the request of the rancher on whose land they stood. Gaskins is also concerned with the ecological deterioration of the cypresses, and he told writer Connie Fowler (a native Floridian who visited the museum as a child) that the swamp is "real Florida. It's not some plastic mouse show."

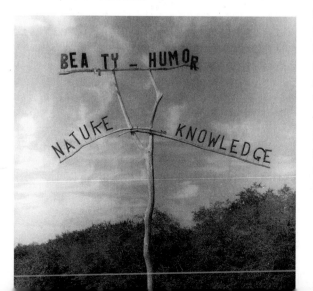

Kennebec Point (c. 1783), past the community tennis court that we built during World War II, past Overlook—a turn-of-the-century turreted shingled pile, where my grandparents first visited Kennebec Point in 1915, guests of the formidable Mrs. Mattie

Brown Rich Bowen (now her great grandson lives there year-round) and the original house on that property where four generations of Browns have lived. Past "Holtville" —the old Oliver farmhouse, converted barn and woodshed, now occupied by several

rapidly expanding generations of a family who were classmates of my grandparents at Colorado College in the late 1800s.

Past "The Anchorage," another turn-of-the-century mansion, and down the rocks next door to the more modest "High Tide,"

10

space." I use space here as a physical, sometimes experiential, component. If space is where culture is lived, then place is the result of their union.

A "sense of place" is often used as though it were only applicable to small towns or to "nature," but urban and industrial environments are also places (and nature) formed differently, more likely to spawn the multiple selves that ease (and are often the result of) cross-cultural communications. As a multicentered society searches for lost centers, the growing intercultural contributions of the last decade have opened up fresh ways of understanding the enormously complex politics of nature. Those of us living in any big city today are confronted by a vast mirror whenever we step outdoors. It reflects us and those who, like us, live on this common ground; we may look and live differently, but we can't look into the mirror without seeing each other. When we know *where* we are, we're in a far better position to understand what other cultural groups are experiencing within a time and place we all share.

The locale itself may change so often as to defy what anthropologist Clifford Geertz has called a "thick description." Between restlessness and continuity lie a lot of contradictions. Marshall McLuhan wrote that we turn to the past when the future is frightening. That would be a good enough excuse these days: we are poised at a retrospective moment in history, nearing the end of a millennium and just past the five-hundredth anniversary of the most heralded point of colonialism —Columbus's "discovery" (as it is called on the right), or "encounter" (as it is called in the center), or "invasion" (as it is called on the left, where I stand). These "landmarks" have offered our lethally shortsighted culture the impetus to look back for solid ground from which to leap forward into a shifting future. As multicenteredness is changing our images of place, it may also help us take our places more seriously.

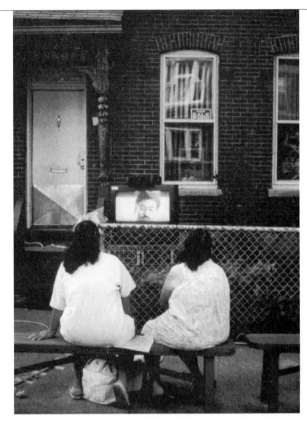

IÑIGO MANGLANO-OVALLE, *Tele-Vecindario; A Street-Level Video Block Party*, 1993. One of fifteen video installations in a 75-channel public video installation commissioned by Sculpture Chicago's "Culture in Action" project, curated by Mary Jane Jacob. Raised in Spain, Colombia, and Chicago, community arts activist Manglano-Ovalle has developed the concept of the "video map," in which local youth describe their neighborhoods. *Tele-Vecindario* was a way of creating a sense of home and place in gang-buffeted communities. In a process described as "productive collision rather than conflict resolution," tapes were shown outdoors— in yards, vacant lots or streets—rooted, but nomadic within the neighborhood. The working group later became Street-Level Video (SLV), a larger and more structured youth media project still going strong in the community. SLV's Second Annual Block Party in 1994, for instance, functioned as a negotiation zone between rival gangs after a drive-by shooting and turned "an embattled local street into a multimedia neutral zone"—a "live jam" of video, music, a spray-painting brigade, and break-dancers.

the little "shooting box" my grandparents bought in the early 1920s. It sits almost on the rocks facing a small beach, its porch (where an Indian canoe whirligig used to spin), looking out to sea. I spent much of my childhood here and it remains almost closer to my heart than my own house. "Grannie's house" has the tiny one-room *cabine*—site of my first memory, of gulls crying and foghorns honking mournfully, muffled in mist. (The *cabinet,* or two-holer outhouse, was also pretentiously Fran-cophile.) Close to the road is the old well, filled in and grown over; when I was a child we hauled up the cold fresh water in a tin bucket and drank it from a long gourd dipper in the kitchen. The wooden cisterns for rainwater at the side of the house are

SYLVIE READMAN, *Manèges,* 1991, (detail of triptych from *"Les traversées du paysage"* series) original photographs in color (Photo: courtesy of Samuel Lallouz Gallery, Montreal). *Manèges* means manoeuvre, play, trick, or intrigue. Readman comments on the "truths" of photography by quoting the Beaux-Arts tradition to which much landscape photography is indebted and, as Danielle Léger writes, "by taking her pursuit of the picturesque to its limit and rendering any sense of place or time incidental." In this triptych, Readman superimposes her own landscape photography of a local village on nineteenth-century paintings, creating a synthesis while simultaneously maintaining tension between the two mediums and between the paradise pictured by the nineteenth-century painters and a late twentieth-century view of post-modern "nature."

Culture is usually understood to be what defines place and its meaning to people. But place equally defines culture. A family that moves from New York to New Orleans, or California to Connecticut, will undergo a certain culture shock and find its way of life changing despite the ubiquitous TV, Walmarts, and condo-towns. In addition, our concepts of place affect how we identify the living process within them. The degree to which the places where individuals and groups interact are culturally and naturally constructed is one of the foremost debates at the end of the twentieth century. Cultural geographer Don Mitchell suggests that we tend to say "culture" when we're not sure what

we're talking about, because any consensus on social relations is always contested and always changing. Since the eighties, culture has become a euphemism for race and ethnic background, a key word in the identity politics that has crossed the tracks into acade-mic parts of town. (The danger here is of fencing people in with cultural preconceptions, using the term to explain away things we don't understand—"it's just our/their culture...")

I will try to avoid cultural determinacy and its twin, environmental determinacy, which lead all too smoothly to eugenics, sociobiology, and "scientific racism." In their simplistic forms, these approaches come up with idiotic overgeneralizations like "cold climates produce great civilizations because people have to work harder and hot climates produce lazy inferior cultures." The ideological notion that "you can't escape your culture" leads to conservative programs that emphasize reforming the individual rather than larger social change. If innate "nature" exclusively forms cultures, then cultures are unlikely to be reformed; whereas if variable cultures exclu-sively form nature, then nature must be under control —which it clearly is not. Obviously the desired balance lies somewhere in between.

No matter how far culture will go to destroy its connections to nature, humankind and all of our technology, good and bad, are inextricable parts of Nature—the original determinant, the mother and matrix of everything, that all-pervasive structure that lies beneath scenery, landscape, place, and human history. On a popular level, "nature" has been diminished to mean everything outside the city, including farmland and countryside. Sometimes it is used to connote wilderness, which in Europe once meant the lair of wild animals. When Chris-tian monarchic rationality confronted the forces of

also long gone, as is the woodstove of my childhood. The big dock where my often dour clergyman grandfather spent his happiest moments fishing, his canvas hat down over his eyes and pipe clenched in his teeth, was washed away by storms in the 1950s.

The road winds through tall dark woods and I try to remember the names of the flowers that have fled to the ditches' light. Although both my grandmother and my mother were knowledgeable botanists, they never had gardens here (I do); they special-

ized in the wild. Grannie led nature walks for local children and mother published a useful little book on Georgetown's wildflowers when she was in her seventies. In places, the pine woods where my grandmother made us chew wintergreen, smell

12

heathen "bewilderment," wilderness came to mean any relatively uncontrolled nature.

We cannot conceive of a world without "nature" even as we deny its power and try to curtail its effects with our rising and falling cultures. The notion that natural order is expressed by instability and flux rather than by respectably predictable systems has been challenged on the grounds that it might unleash more immoral human behavior, not to mention the psychologically discomfiting notion that nothing is certain. Others argue that acknowledgment of constant transformation will increase human respect for nature's complexity, that unpredictable change is not necessarily arbitrary. All of us wonder which concept might prove most beneficent in the world's environmental crises, since all of us resist some aspects of our cultures and consent to others. The moral aspect of this discussion is made clear by Wendell Berry, one of the most consistently inspiring writers on the specificity of American place, who nails us as accomplices in everything that happens around us, perceiving "the ecological crisis as a crisis of character—that is, of culture.…Our culture and our place are images of each other and inseparable from each other, and so neither can be better than the other."

The idea that "nature is a place where we are not" has ruled for centuries; at least since Newton, nature, like woman, has been seen as powerful, uncontrollable and threatening, on one hand, and inferior and subordinate (though necessary and convenient) to human culture, on the other. As Neil Smith puts it, "Placing nature on a pedestal as ultimately uncontrollable merely renders 'her' a worthy opponent: romancing nature as foreplay for rape. By being so aggressive, by threatening to control, nature is asking for it. Simultaneously woman and other, she is M/Other Nature.…The Big Guy directs while

M/Other Nature does the work.…" In the last twenty years or so, the word "environment" has replaced and demythologized a great part of what was once considered Mother Nature, but it allows us to maintain the separation: humans are the center, *surrounded* by everything else, reflecting the way Western culture has been built in opposition to nature. In April 1994, President Clinton, speaking in his role as Great White Father to the leaders of some five hundred American Indian nations, told them that for hundreds of years, "You have held nature in awe." He has it all wrong; it is Europeans who fear nature and hold her captive "in awe." Divergent indigenous cultures see nature as *natural*, as a living web of respected and interconnected parts rather than any-

PETER DE LORY, *A Western Landscape,* triptych, 1989. De Lory's characteristic triptych form is a vehicle for subtle narratives about our heroic and predictable images of the West. The "natural" but extraordinarily dramatic view brackets the "unnatural" motel-room decor, which parodies and domesticates that landscape in a velvet painting. De Lory contrasts adventure and comfort, firsthand and mediated experience.

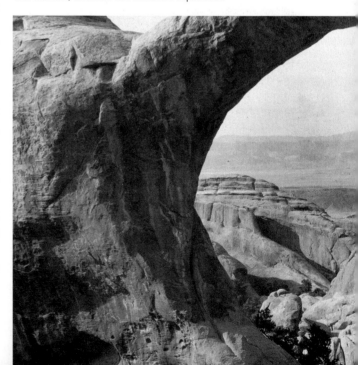

the skunk cabbage, and wonder at the Indian pipes are beginning to give way to hardwoods. The blossoming roadsides, where my mother collected samples in a basket that also held a ubiquitous pack of cigarettes, are viciously mowed down twice

a summer and only the hardiest survive.

On down the point, past the imposing "Red Gables," to the fork in the road. Take the left to Read's Beach (named after an earlier inhabitant and not to be confused with nearby Reid State Park or the Reed/

Stewart/Dalrymple/Woodruff clan at the end of the Point) and Little Harbor Head, which opens to the islands and the two lighthouses. As a child, every other day I took one of these forks, armed with a sandwich, bathing suit and towel, long pants and

thing so hierarchically "awesome" as the Judeo-Christian God.

History with a capital H has often been described as a fiction written by the conquerors, yet there are other histories, often hidden, sometimes literally buried. "History is the essence of the idea of place," writes folklorist Henry Glassie. "In place, the person is part of the history." We study history as great waves that pass over the land and change how we use and think of it, but apart from an element of nostalgia, or longing, it tends to pass us by. It rarely seems to be our story. We forget that it goes right up to yesterday. The practical and grassroots process of living is the way most of us experience history and time. The concept of bioregionalism, which opposes the imposition of artificial states or geopolitical borders and proposes remapping the world according to biological distinctions, is most pertinent to this book because it is based in local autonomy, albeit in terms unfamiliar and perhaps threatening to most "locals."

Yet the history of most places remains elusive, dependent upon cultural concepts of time. In this society, history tends to mean what we (or more likely some powerful group) have chosen to remember—usually not the mean, greedy, unjust, unfair, or ecologically disastrous aspects of our collective past. Americans willingly forget our pasts in favor of our futures which, without the past, are houses built on sand. And if only the history of Euro-America is studied, or if everyone's history is only studied by Euro-Americans, the American place remains hidden. The resurgence of mainstream interest in (and exploitation of) Native American culture is a case in point. Partly due to Indians' grassroots strength and pride at having survived against the odds, partly bolstered by rage at what survival has meant for Native culture, health and land, it is also a product of growing recognition of continuity between immigrations, which cannot be artificially marked off into "prehistory" (them) and "history" (us).

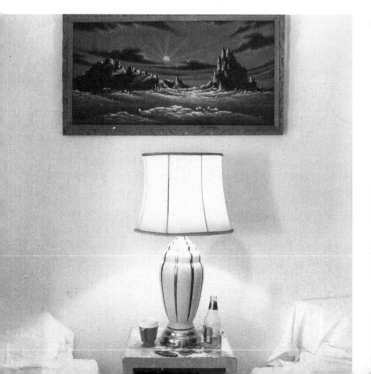

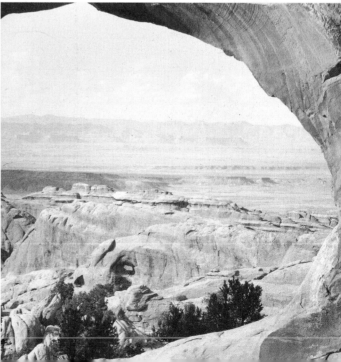

shoes for emergencies, to visit Frannie Wren, my best friend, who came to me on the alternate days, equally fortified. Both roads led to her house, the Point road a bit darker, lonelier, scarier as it wends through an uninhabited patch of woods. At the end of the Point are three old houses where the river pilots used to live, racing out in their dories when a ship appeared on the horizon. Standing at the very end, we look over the Gut to the long neck of Stage Island, across the river's mouth to the great and busy curve of Popham Beach, anchored by the granite crescent of Fort Popham, built during the Civil War.

At each leg of this walk I could pause, point out communal and personal landmarks, tell you stories about history or fami-

To American Indians who believe that the past is to a people as dreams are to a person, stories are the communal snaggings of generations, the nets that keep people from free-falling toward pointlessness.... Indians widely believe that the past belongs to everyone, but only the proper storyteller can open it, and archaeologists know that in any dig some shards remain mute, isolated, and disconnected, waiting for other hands to come along and discover their pattern and reassemble them.
—WILLIAM LEAST HEAT-MOON

Landscape's most crucial condition is considered to be space, but its deepest theme is time.
—REBECCA SOLNIT

The Lure of the Local is embedded in land, history, and culture and the possibilities they hold for place-specific, place-responsible "public art" and photography that share the goals of a "humanistic geography": "to recover the geographical imagination...and to introduce moral discourse..." Living in the West for the last decade, I have become increasingly conscious of "land" as a distinct spatial and spiritual element as well as the raw material for habitation and "use." Land is neither place nor landscape nor property. We talk about physical land (to some a neutral term measurable in acres), metaphorical land (often abused in imitation-indigenous practices, but too strong a notion to be weakened by its burdens), and ideological land (loaded, as in "mother/fatherland" or "this land is my land, this land is your land...").

For non-landbased people, land is an idea. For land-based people (those fortunate enough to maintain their places or unfortunate enough not to be able to leave them), it is the concrete epitome of experienced reality and often worth dying for: *"Tierra o Muerte."* Land is an amalgam of history, culture, agriculture, community, and religion, incorporating microcosm and macrocosm—the surroundings further than the eye can see, and the living force of each rock, blade of grass, small animal, or weather change. On the model of many indigenous belief systems, stated and unconscious, all of these parts (human being's merely one of them) are linked within the whole. This appealing and increasingly common, but not yet internalized, model of interconnection is making inroads on the dominant Euro-culture.

To trace the history of a river, or a raindrop, as John Muir would have done, is also to trace the history of the soul, the history of the mind descending and arising in the body. In both, we constantly seek and stumble on divinity, which, like the cornice feeding the lake and the spring becoming a waterfall, feeds, spills, falls, and feeds itself over and over again.
—GRETEL EHRLICH

J. B. Jackson has observed that landscapes are symbolic, expressing "a persistent desire to make the earth over in the image of some heaven." (In other cases, it may be the image of some hell that has been decided upon by those who own but do not work the land.) Different cosmologies and belief systems shape the ways land is seen. But the spiritual component, situated for many people between nature and culture, and rarely acknowledged by scholars as a factor in contemporary life, is doubly difficult to incorporate into the current debates. It is still more difficult to define the way the word "spiritual" is used today as an amalgam of institutional or syncretic religions, individual soul-searching, and an array of less socially accepted parareligious activities ranging from astrology, tarot, channeling, UFO watching, dialogues with guardian angels, and "mind–body" healing techniques, to a vague pantheism that probably best defines my own inclination. I understand the spiritual as a way of living the ordinary while sensing the extraordinary. Frederick Turner suggests that "the spiritual history of the world

lies or things that happened to me here and there, about people and pets and boats that have come and gone, legendary storms, animals sighted, the old sleigh rotting in the woods, the cellarhole opposite the Mill Pond, about lying on prickly pine needles in the island woods with my teenage boyfriend, unseen by the lobster boats plying their trade nearby....

When my grandparents, Florence and Judson Cross—both from New England families, but raised in Colorado—were intro-duced to Kennebec Point in 1915 as guests of a parishioner of my grandfather's Congrega-tional church in Fitchburg, Massachusetts, they came by boat from Boston to Popham, took a "launch" across the river to Bay Point, then a smaller boat to a long-gone pier at the

is not over, and revelations as great or greater than those given to us in the past may yet be in store. One symptom of the coming changes is the vigorous reli-gious syncretism now taking place in many parts of the world."

Feng Shui ("wind water"), the ancient Chinese art of geomancy, for instance, has enjoyed a revival in the United States over the last decade, and in the process has been co-opted for large consulting fees. Applying the I Ching's principles of yin/yang permutations to place, it illuminates "the invisible world," locating the flow of natural energy in houses or landscapes, and how it will affect the activities of those who live there. Feng Shui is "environmental psychology," offering a "spiritual approach" to design and architecture, and a way for Americans to open themselves to spatial expe-riences unfamiliar to this culture. One of its tech-niques is the use of mirrors to deflect bad energy, reminiscent of African American yards with mirrors or shiny objects on the porch to protect the house and attract good energy. The use of water, sunshine, and air to permeate living spaces charges everyday life with metaphysical meanings.

The spiritual landscape is part of the one we live in and also lies beyond it. According to Elaine Jahner, the Lakota teach that "the physical world is spirit seen from without and that the spiritual world is the physi-cal viewed from another dimension." Symbolic and "real" landscapes can be the same. ("The physical aspect of existence is only representative of what's real," said Lame Deer.) The vision quest is a journey through the outer landscape to find the inner land-scape, which in turn reveals the path to take when returning to the outer landscape. Thus the Lakota succeed "not only in feeling at home but also in learn-ing to see in it a set of symbols for a personal and cultural self-understanding that makes them genu-inely present to the environment." A description of aboriginal Australians' total identification with the landscape parallels many Native Americans' similarly "poetic approaches" which are infinitely appealing to a disoriented culture: "there is no contrast of the natural and the spiritual, and there is no geography without

REBECCA BELMORE (Ojibway), *Ayum-ee-aawach Oomama-mowan*, 1991, a gathering with thirteen Native speakers addressing the land through a two-metre-wide megaphone, executed for the exhibition *Between Views* at the Banff Centre for the Arts (Photo: Don Lee, courtesy of Walter Phillips Gallery, Banff). The title is Ojibway for "speaking to their mother." For an exhibition about nature and tourism, Belmore organized an eclectic gathering of Native Canadians—leaders, writers, poets, social workers and activists—who spoke to their mother earth from an alpine meadow in the Rockies. The huge megaphone symbolized public address, carrying amplified Native voices far and wide. Self-determination and land rights were primary themes, but they were couched in the empowering language of celebration: "Protest often falls upon deaf government ears," said Belmore, "but the land has listened to the sound of our voices for thousands of years." Mohawk Elizabeth (Toby) Burning said through the megaphone: "You are our reason for continuing our resistance against development, and standing up for our language and for our past, because we are you." Belmore's work is a way of healing assimilation, her forced estrangement from her own culture. A place in a culture is a place to speak from.

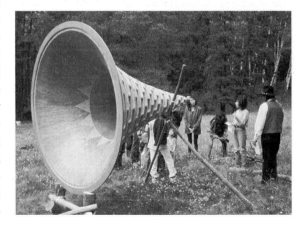

end of Kennebec Point. The last half mile of dirt track they traveled in a wagon, arriving at sunrise (how often I've heard this described) at Mrs. Bowen's elegant "cottage."

After that, my grandparents came back with their three children for subsequent summers to rent one of Kennebec Point's empty old houses, finally buying the Ranney place on its one shore acre over a small beach. It had been built in 1888 for a young man who died soon after. They brought friends, who brought friends, many with Congregational missionary and church backgrounds, and between them they resettled four more houses on

history and meaning. The land is already a narrative—an artefact of intelligence—before people represent it.... There is no wilderness." Acoma poet Simon Ortiz, on the other hand, contends that there is a wilderness: it is modern cities.

Most people today, at least those not attached to any religious institution, are hard put to explain what they believe in; however, many would assert that they have been closer to "it" in "nature" than not. Those of us raised in city and suburb (and many in the country-side as well) feel that humans have lost contact with the world of earth, sky, sea. We do not seem to be able to regain consciousness or even healing except by imitation or summoning up primal images that recall our lost connections. Most "spirituality" is androcen-tric, looking less to "nature" itself than to ancient human responses to it which offer some guidelines, or lifelines, to the lost unbeliever. Even as ecofemi-nists and "deep ecologists" call for the resurrection of Gaia, the concept of a great living and nourishing force that is Mother Earth, I am wary of myths of an external autonomous nature of any gender. Nature is capable of the sublime; humankind is capable of the ridiculous. Whatever truth there is lies somewhere in between, as the Pueblo ritual clowns know.

Concepts of reciprocity—between cultural belief systems and between people and "nature"—inform most spiritual views of the land. Yet too much is made of "the interconnectedness of all things," which I believe in wholeheartedly, despite my disgust at some of the ways in which the idea has been commercially and ideologically exploited by "plastic shamans," who may be indigenous or wannabes. It is one thing to enjoy the idea of interconnectedness and another to understand what it means in contemporary American society and daily life. Many adherents are more anxious to connect with land and its most attractive creatures than to forge a collective human connection and take responsibility for the ways their own lifestyles affect entire ecosystems. "Natural history" (which can sound like an oxymoron) is a national hobby, caught between the nineteenth-century methodologies on which the popular museums are based and "Granola TV" (two bugs making love to Mozart, as someone described it). Despite the Endangered Species Act, Western thought still tends to perceive plants, animals and non-western civilizations as existing outside of time and outside of history.

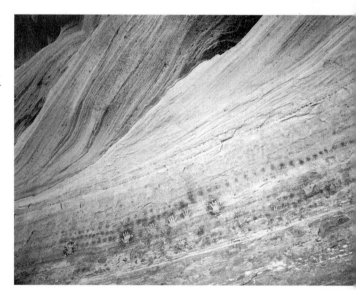

LINDA CONNOR, *Dots and Hands, Fourteen-Window Ruin, Bluff, Utah,* 1987. These Anasazi pictographs are probably 800 to 1,000 years old. Hands dipped in clay and/or stenciled with light clay are considered community-based because there are often many on one wall, on domestic sites. The dots may be some kind of record of time, while the hands can be seen as reassurances of presence ("I am here") and as connection with the very substance of place and home, as well as with the spirits that are guarding it. These themes, internationally reflected, have also dominated Connor's photographic work for many years.

the Point. Other families have been there for seven or eight generations.

The two-bedroom High Tide couldn't hold the next generation (luckily my aunt opted for her husband's Vermont farm) and my parents boldly bought some land on Sagadahoc Bay and built a small "modern" house in 1939.(The mortgage was $16 a month and it nearly broke them.) Then the war came and my father volunteered; we saw him off at the long-gone railroad station in Bath. My mother and I, along with my Uncle Jud and Aunt Eloise and eventually my cousin Anne, often lived at "Grannie's and Grampa's,"

I like to think of landscape not as a fixed place but as a path that is unwinding before my eyes, under my feet.
— GRETEL EHRLICH

Walking alone cross-country is a form of meditation, particularly compelling for those of us with nervous energy to spare. It offers an unparalleled way to open oneself to the "spirit of place" and to its subterranean history. Motion allows a certain mental freedom that translates a place to a person kinesthetically. "Walking is the only way to measure the rhythm of the body against the rhythm of the land," writes Rebecca Solnit. When I was walking among the Stone Age and Bronze Age megaliths of Britain that I would write about later in *Overlay*, I was "avoiding art by seeking sensuous and esthetic pleasure in the natural environment [only to be] seduced back into art by artifacts that had almost returned to nature....I began to perceive places as spatial metaphors for temporal distance." It also came as a surprise to me at the time that as an atheist I was forced to think about religion. (The word "spiritual"

was not yet in vogue and meant little to me.) In retrospect, I recognize not so much the need to avoid as to expand the sensuous intellect, whether it is called art or religion. "Nature lovers," including some artists, are just that: the erotic communication of body and place combines the elements of desire and risk with those of time and space. Women, when alone with nature, are subject to a particularly contradictory experience, liberating on one hand, threatening on the other. For us, there is another predator out there: exhilarating sensual identification with landforms and processes is countered by social fear and oppression.

Even for those of us who do not feel strong spiritual attachments to any specific deity, who prefer to think in terms of interconnections, or "All That Is," are overcome from time to time by a need to give thanks. To whom or what, I couldn't say. Sometimes it seems easier to communicate (or identify) with people long dead who were once stewards of a particular landscape than with today's property owner, even when the land is "our own." Their distance and unfamiliarity lend themselves to transports not encouraged by our culture. The real challenge, however, is to reinstate a spiritual relationship with that which is close and familiar. As religious studies scholar Sam Gill has observed, throughout history "religion has celebrated the tasks of a working day, the seasonal unfolding of the year, and the plateaus of personal development. When it marks these day-to-day experiences, religion pervades life and gives it meaning, but when the

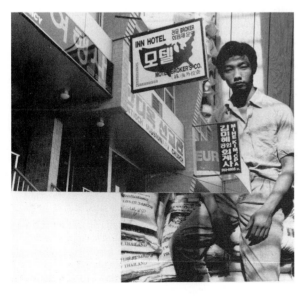

NINA KUO, *Product of Flushing*, 1990, original photograph in color (copyright Nina Kuo). Countering the local image most New Yorkers hold of Flushing, Queens, this "international" photograph, with apparent references to Europe, China, Korea, and Thailand, to money and religion, is one of Kuo's "Casting Identities" series in which she explored the power of Asian American identity for her residency at the Museum of Chinese in the Americas.

the seat of most of my early memories of Maine. I remember my grandfather making ice cream by hand, my grandmother frying fresh fish for breakfast, charades at night, roasting peanuts in the fire, hiding under Grannie's shawl when it was bedtime, the wind howling and the waves crashing in storms. In the woods behind the Hills's boathouse, on the edge of our property, was the Grouch House, a tiny green shack just big enough for one person to go there and sulk.

We learned to row in my grandfather's small "captain's dory," and to swim in "the bathtub"—a shallow part of the beach. At

mundane events of human existence are no longer celebrated through regular and formal ritual, much of the power of religion is lost."

The notion of the "sacred place" or "place of power" has come down to us from indigenous cultures but for us it is usually somewhere distant. For land-based people such as the Navajo, on the other hand, sacred places are interwoven with daily life, land use, ceremonialism, and stories. One place cannot be isolated from its network of other places and meanings. Sacred places are important because "they are where people have performed the activities that keep Navajo life going." The sacred space, "the right place," is also home. As The Crow chief Arapooish said:

> The Crow country is a good country. The Great Spirit has put it exactly in the right place; when you are in it you fare well; whenever you go out of it, whichever way you travel, you fare worse....The Crow country is in exactly the right place. It has snowy mountains and sunny plains, all kinds of climates, and good things for every season....The Crow country is exactly in the right place. Everything good is to be found there. There is no country like the Crow country.

Visionary artists of all kinds, from tribal Americans to Shakers to the avant garde, depend on some connection with the spiritual side of "nature," but specific places play minor roles in vision quests, transcended by the experiences produced there. The words *spirit* and *spiritual* are thrown around a lot in contemporary culture, but contemporary visual evocations of the divine in nature have rarely been successful. One simply has to take the artists' word for their experiences, difficult as they are to transmit. A great deal of art (and performances based in uprooted rituals) is intended to sensitize the viewer to nature, to natural phenomena, and to the unseen powers that appear to determine them. Too often it is painfully self-conscious rather than open to larger meanings (or it becomes vacuous

by opening itself to meanings larger than the artist can handle). For those who have literally "seen the light," no painting or photograph comes close to the power of the experience itself. The same might be said for a nonreligious epiphany in the desert or any other place.

The challenge for the artist is to search for the good and make it matter, to map the terrain of the outside world through confrontation with the inner territory of the soul—the earth that, in fact, we are.
— ESTELLA CONWILL MAJOZO

Although "art" is only one of the subjects of this book, human creativity is an integral part of the web formed by land, history, culture, and place. Artists are looking around, more and more, to record what they see or would like to see in their own environments. In addition, they are broadening their horizons by reading in the fields of cultural geography and cultural studies, sociology, folklore, and literature. Some have gone

FRED WILSON, *Insight: In Site: In Sight: Incite: Memory,* installation in St. Philip's Church, Winston-Salem, North Carolina, 1994 (Photo: courtesy Southeastern Center for Contemporary Art). Wilson is best known for "mining" museum collections, rearranging and recontextualizing objects in order to reveal buried messages and histories, especially those of African Americans and "so-called exotic others." For SECCA's Artist and the Community program, he delved into local history and architecture in a Winston-Salem neighborhood (first called Liberia and then Happy Hill) allotted to black people by the founding Moravians. The 1861 church is part of the restoration project of Old Salem and was built over the "Strangers' Graveyard." Wilson unearthed the gravestones beneath the floorboards, connecting them to his "object portraits" of these people at another location. Among the ten buildings he replicated in the church sanctuary were a mud press used by an African American brick maker, a ballroom that hosted well-known performers, a slave cabin, a shotgun house, and a footbridge. Wilson's series of works in Winston-Salem (where he has family connections) added another layer to the town's history: "While I had designed this work to be pro-active," he said, "I was truly surprised by the breadth of its impact... revealing surprises for people who don't expect to find surprises in history..."

low tide we found sea-smoothed pottery and old bottles. Sometimes we took (very wet) trips up the river, crowded into the little catboat, and after the war my parents and I went off on painting trips with water colors in a metal box, water in an old whiskey bottle, and paper thumbtacked to breadboards. My parents had taken life drawing classes at Cooper Union and my father had taught himself to paint in the South Pacific. Among my prized possessions are two watercolors they did, sitting side by side at New Harbor. One looks like Maine, the other like New Guinea.

For several years we invented and hosted

beyond the reflective function of conventional art forms and beyond the reactive function of much activist art. The potential of an activist art practice that raises consciousness about land, history, culture, and place and is a catalyst for social change cannot be underestimated, even though this promise has yet to be fulfilled. Artists can make the connections visible. They can guide us through sensuous kinesthetic responses to topography, lead us from archaeology and landbased social history into alternative relationships to place. They can expose the social agendas that have formed the land, bring out multiple readings of places that mean different things to different people at different times rather than merely reflecting some of their beauty back into the marketplace or the living room. As envisionaries, artists should be able to provide a way to work against the dominant culture's rapacious view of nature, reinstate the mythical and cultural dimensions of "public" experience, and at the same time become conscious of the ideological relationships and historical constructions of place. The dialectic between place and change can provide the kind of no-one's-land where artists thrive.

I shall not discuss the long history of landscape painting with its sometimes impeccable attention to the local, although, as Cosgrove remarks, subjectivity is usually denied those who live in or work the landscape. (In the eyes of some Marxist critics, historical landscape painting only celebrates property and the status quo, failing to engage in the social dynamics that produced the landscape.) I personally get a lot of pleasure from looking at landscape paintings, though not as much as from landscapes themselves; a painting, no matter how wonderful, is an object in itself, separate from the place it depicts. It frames and distances through the eyes of the artist, which is what it's

19

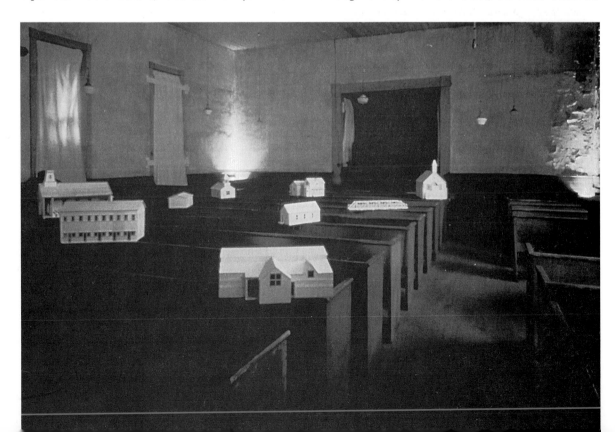

the annual Kennebec Point Art Show in our house (the interior plywood walls, divided neatly into rectangles by the studs, were perfect for pictures). Prizes were given and much Kool Aid punch was drunk by all. There were a surprising number of skillful, if hardly daring, amateur artists on the Point and we all painted the same scenes—what we saw out our windows.

supposed to do. Like tourism, painting formalizes place into landscape.

The same, of course, can be said of photographs, which lie and expose lies. But because they are printable, reproduceable, and can be mass-distributed, photographs can often transcend their recently awarded status as art. Although still an indoor, two-dimensional, portable, exhibitable, collectable, and endlessly manipulable medium, photography has another life. Its modest background has allowed it to outpace "high art," to embrace scientific evidence, journalistic witness, hobby, performance and the interactive arts. Photographs are about memory—or perhaps about the absence of memory, providing pictures to fill voids, illustrating our collective memory. So they are an excellent means with which to trigger concern and soothe anxieties about history and place, even when the means they employ resemble conventional landscape art. In fact, landscape photography could have it both ways—at once subject to personal vision and attributed the objectivity of scientific precision.

An art that is in place, or on site, can create a different (not necessarily better) relationship between the viewer and the place. It too frames, but in collaboration with the place itself, and with the looker, both of which are always changing. My models, then (more fully examined in Part Five) are those artists who strengthen the bonds between art, audience, and context. They tend to be interested in the narrative landscape, understanding place and history to include people, forming the grass roots of much interactive or so-called "new genre" public art.

Yet a place-specific art is still in its infancy. Of all the art that purports to be *about* place, very little can be said to be truly *of* place. I say this even though there was no shortage of provocative and evocative works with which

ALLAN SEKULA, *Staten Island Ferry*, February 1990, from *Fish Story*, 1990-1995 (105 large-format color photographs with texts and slide projections). Sekula grew up on a harbor where, he says, "the concrete movement of goods" and "a crude materialism underwritten by disaster" are the central concerns. The role of the sea, cargo ships, and industrial ports in the global economy is the subject of this five-year project continuing the artist's scrutiny of "the imaginary and material geographies of the advanced capitalist world." Striking workers, fishmongers, detailed views of tools and technology, shutdown shipyards, and industrial seascapes constitute the maritime epic. "Most sea stories are allegories of authority," writes Sekula as he questions the veracity of the photograph, the history, and the system. This image, paired with one of a boy on the ferry looking away from the telescope (titled *Boy Looking at His Mother*) are the opening images of *Fish Story*.

to illustrate this book and my scope could have been aesthetically still broader had I been writing an "art book." I am concerned here only with that which is directly tied to place—with examining the ways art can help us focus on existing places, how their topography and every detail reflects and generates memory and a certain kind of knowledge about nature and culture.

We are living today on a threshhold between a history of alienated displacement from and longing for home and the possibility of a multicentered society that understands the reciprocal relationship between the two. What historian Lawrence Grossberg calls "the very cornerstones of historical research" could also be called the very cornerstones of a new kind of responsible perception of place and the art that emerges from it: "Appreciation of difference; understanding of context; and ability to make critical comparative judgements on the basis of empathy and evidence." And in the case of a restless, multitraditional people, even as the power of place is diminished and often lost, it continues—as an absence—to define culture and identity. It also continues—as a presence—to change the way we live.

AROUND HERE

*Whenever we enter the land, sooner or later we pick up
the scent of our own histories.*
—WILLIAM LEAST HEAT-MOON

*All our prayers in the morning, in the evening,
start with the word "Here."*
—EDMUND LADD

*The population on this continent
will become grounded, will find their place, by a slight
change of mind that says "I'm here."*
—GARY SNYDER

Sweet Home

A concentration of large rocks has tumbled into the deeply eroded creek bed beside my house. New Englander that I am, I think about building a wall. I'm told I should check first with an archaeologist. In a nearby dump I've found dark gray sherds of Pueblo pottery, but these rocks look too big and square to be the remains of an Indian dwelling. An archaeologist friend says they are probably from an old settler's outbuilding that fell into the creek as the banks crumbled. A Hispano neighbor, whose ancestors were here long before the Anglos came, says it was probably part of an irrigation structure. I am intrigued by these temporal reminders, whatever they are. Once the creek (it's called a river on some maps, a wash on others) ran gently between shallow banks. There was an orchard on my side. Since then the stream has cut deep into the landscape, an ever-widening wound holding an ever-smaller channel choked with silt, because about a century ago the ridges were deforested to make railroad ties, the climate changed thanks to the 1883 eruption of Krakatoa, and ranchers mercilessly overgrazed their ranges, resulting in today's ragged gullied landscape.

Remedios Chavez, an elderly woman who was born and raised here, tells me (in so many words), "We worried at first when they came, but if they love this place and mind their own business, it's all right." They is me. I'm part of the Anglo exploding invasion of Northern New Mexico over the last twenty years (it started in the 1820s). And I don't really mind my own business—I spend a lot of time wandering the vast rangeland, sandstone outcrops, and volcanic dikes, looking at traces of the paleolithic, the Tewa, the Tano, Keres, Apache, Comanche, Hispano and Anglo pasts.

Kennebec Point is on Georgetown Island, at the mouth of the Kennebec River, in Sagadahoc County—the name given to the lower part of the river by the Kennebec Indians. This is the area that is "local" to me—the mouth and the east bank of the Kennebec, where three peninsulas jut into the sea between the Kennebec and the broad estuary of the Sheepscot River. There the island slants "down east" (so-called because the prevailing wind is southwest and a run up the coast under sail was downwind). The nearest city is Bath, upriver on the west side.

From the sea, the mouth of the Kennebec is just another niche in the ragged line that is Maine's 3600-mile coast line. Small Point (in Phippsburg) divides it from Casco Bay to the South, with its many islands, centered

"AROUND HERE," WHERE WE LIVE, IS A CIRcular notion, embracing and radiating from the specific *place* where generalizations about land, landscape, and nature come home to roost. "Out there" is a line of sight, the view, a metaphor for linear time. The relationship of the center to the peripheries is crucial, a crossroads, but the center doesn't hold forever, and neither do the margins. Home changes. Illusions change. People change. Time moves on. A place can be peopled by ghosts more real than living inhabitants.

The lure of the local is not always about home as an expressive place, a place of origin and return. Sometimes it is about the illusion of home, as a memory. If place is defined by memory, but no one who remembers is left to bring these memories to the surface, does a place become noplace, or only a landscape? What if there are people with memories but no-one to transmit them to? Are their memories invalidated by being unspoken? Are they still valuable to others with a less personal connection? Sometimes when people move to a place they've never been before, with any hope or illusion of staying there, they get interested in their predecessors. Having lost or been displaced from their own history, they are ready to adopt those of others, or at the very least are receptive to their stories.

Is "around here" just about individuals who see themselves as centers trying to create peripheries wherever they go? (Geographer Yi-fu Tuan says Americans have a sense of space rather than a sense of place.) Or does even serial familiarity with places satisfy deeper longings for roots and continuity as we come to terms with a way of life that disregards them? One can be "homesick" for places one has never been; one can even be "homesick" without moving away. When place-oriented sculptor Mary Ann Bonjorni says, "Place is what you have left," I'm not sure whether she means "all that remains" or "that which is left behind." William deBuys has pointed out that traditional cultures should be conserved because of "the fresh new questions they pose about the relation of people to each other and to the land." As we examine our own cultural origins and mixtures, and their effects on our own places, we learn a people's history of the United States, to use Howard Zinn's phrase. History can be illuminated by looking back at one's own family's story, generation by generation—moves, job changes or losses, houses, illness, social expectations, class and religious fluctuations, the role of women, and so on…all the things that connect us to each other and to a community, which can be a place or a feeling. It proves not only that the personal is the political, as the feminist movement established long ago, but that the political is personal. However, the degree to which the past is key to the present is debatable; too much made of the past fosters a determinism that limits the future.

Whatever the future may have in store, one thing is certain; unless local communal life can be restored, the public cannnot adequately solve its most urgent problems—to find and identify itself.
—JOHN DEWEY, 1927

Community is as elusive a concept as home in this millennial culture. The word community is often used as a euphemism for poor neighborhoods and small towns, the false assumption being that people are huddled together there with nobody to depend upon but each other, and that they all get along more or less fine. Yet community can also be denied those deemed too poor, ignorant, or criminal to support each other —hardworking families living in the South Bronx, for

AVENIDA VIEJA, Galisteo, New Mexico, 1996 (Photo: copyright Susan Crocker). The adobe ruin in the foreground is said to be an old stage stop. Within recent memory there was a large adobe "hacienda" next to it, which was moved brick by brick and rebuilt at San Sebastian. The Galisteo Creek and its *bosque* are at the right, and the author's house is barely visible in center background.

on Portland, the largest port and largest city in the state. Upstream, the Kennebec meets the Androscoggin River at Merrymeeting Bay and proceeds to its source far north in Moosehead Lake.

Kennebec Point, between busy Bay Point to the west across Heal's Eddy and larger Indian Point to the east across Sagadahoc Bay, is the quietest and least known of the three peninsulas that make up my home ground. Each one has a different ambience, a different character, depending on topography, background,

recent history, and current inhabitants.

Bay Point is still a working fishing village and year-round community, although much diminished since its heyday as Georgetown's major boat landing in the 19th century. It still surveys a swirl of activity pouring out of the

24

instance. In fact, community can be created, and denied, anywhere. The struggle for survival can set communities at each others' throats; neighborhoods can cover the absence of "community" by creating its facade though social conventions. The Boy Scouts, PTA, Rotary Club, Masons, Elks, golf and bridge clubs may simulate communal elements even as members prefer to stay out of their neighbors' business (the Kitty Genovese syndrome) and to have the world's business stay out of their neighborhoods (the NIMBY or "Not In My Backyard" syndrome).

I often find myself conflating place and community. Although they are not the same thing, they coexist. A peopled place is not always a community, but regardless of the bonds formed with it, or not, a common history is being lived out. Like the places they inhabit, communities are bumpily layered and mixed, exposing hybrid stories that cannot be seen in a linear fashion, aside from those "preserved" examples which usually stereotype and oversimplify the past. As community artists can testify, it takes a while to get people to discard their rose-colored glasses and the fictional veneer of received "truths." Community doesn't mean understanding everything about everybody and resolving all the differences; it means knowing how to work within differences as they change and evolve.

"Good neighbors" remains an American ideal, but it has been pointed out that subdivisions and anonymous bedroom communities are often devoid of gathering places where neighbors can plan strategies and discover mutual strengths. Bars, cafés, and other commercial meeting grounds have been zoned out of many areas. The lack of common history and the habit of transience means that even well-meaning efforts at community can lack substance, while an excess of shared history can lead to feuds and cultural confinement. As assimilation and cultural intermarriage accel-

erate, community responses vary, with some feeling threatened and others enriched. Peter Marris, using the term "tribalism" in the general sociological sense, identifies it as a perverted, embattled form of community, the result of a confusion of identities: "Wherever people are expected to treat each other as equal members of the society, yet do not share the same symbolic code, the anxieties of misinterpretation create pervasive defensiveness." A healthy community in a mixed society can take these risks because it is permeable; it includes all ages, races, preferences, like and unlike, and derives its richness from explicit disagreement as much as from implicit agreement.

Most of us are separated from organic geographical communities; even fewer can rely on blood ties. We can only hope to find created communities—people who come together because they are alike on some

CELIA ALVAREZ MUÑOZ, *Herencia: Now What?*, 1996, photographs, objects, installation at Roswell Museum and Art Center, Roswell, New Mexico (Photo: William Ebie.) In this collaborative project between a Texas artist and the Hispano community of Roswell, viewers first see a curved bank of old doors representing both antiquity and obstacles; the walls on both sides of the gallery are lined with portrait photos (by local photographer José Rivera) and excerpts from interview texts, with a superscript of graceful green grasses and a frieze of words in Spanish and English ("Dream, Caprice, Compromise, Neglect, *Olvido, Fuerza, Costumbre, Poesia*..."). On the back wall are some 100 shining

river into the ocean: sailboats, lobster boats, futuristic yachts, windjammers and tall ships, destroyers and their tugs from BIW, the occasional daring kayaker (one was drowned there recently in a storm), the despised jet-skis, and, rarely, a rowboat or two. There have been summer houses on Bay Point for a century, some planned as a workers' vacation resort.

When I was a kid it was a treat to walk over to Bay Point to get a soda at Millie Spinney's little store. As a teenager I went to rousing and sometimes rowdy Saturday night dances at the "Casino," a barnlike structure with a wide porch. There was a thriving fishing business with two lobster wharves. Today the docks are ruins, the store is a private home, and the site where the Casino stood is only bushes.

level—or communities that are accidentally formed through place, workplace, and other more artificial means. Sometimes created places, based in dissimilarity, can be more vital and less isolating than unchosen ones. But most of us live such fragmented lives and have so many minicommunities that no one knows us as a whole. The incomplete self longs for the fragments to be brought together. This can't be done without a context, a place.

A starting point, for artists or for anyone else, might be simply learning to look around where you live now. What Native peoples first inhabited this place? When was your house built? What's the history of the land use around it? How does it fit into the history of the area? Who lived there before? What changes have been made or have you made? If you've always lived there, what is different now from when you were young? If you haven't, what's different from where you were raised and from when you moved there? What is your house's relation to others near it and the people who live in them? How does its interior relate to the exterior? Does the style and decoration of either reflect your family's cultural background, the places from which your people came? If not, why not? Is there a garage? (the automobile, "the machine in the garden" as Leo Marx put it, has drastically changed the American landscape). Is there a lawn? a garden? Have you cut down trees or planted them? Is the vegetation local or imported? Is there water to sustain it? Do any animals live there? Have they always been there? Are there more or less of them? What do you see from your favorite window? What does the view mean to you? How does it change with seasons and time? And so on and on.

Questions like these provide ways to understand how human occupants are part of the environment and where we fit in personally. Research into social desire can set off a chain of personal reminiscences and ramifications, including lines and circles of thought about the interlinking of histories, unacknowledged class systems, racial, gender, and cultural divisions, and common grounds (not to mention the possibility of past lives)—all of which define our relationships to places and help to explain the lure of the local. Such investigations constitute an archaeological rather than a historical process, moving from the present down through layers of culture and history, back to the sources, rather than beginning in the chronological mists and working up to present smog. It makes clear how memory fades as it recedes, how legend then myth creep in and take over. Yet myths and legends also come full circle to affect the way we live the daily present. Some African American artists call up the traditional African *griot*, a communal figure who represents historian, shaman, and the old relative, telling

sport trophies, borrowed from local clubs and schools; they are set on a high shelf—almost but not quite "out of reach"—below a brief poetic text by the artist. *Herencia* is the result of a month-long residency and a much longer study period during which Muñoz worked cross-generationally with Roswell residents, mirroring the adults with still photographs and the youth through a videotape. It documents a moment in an ongoing internal dialogue about time and space, place, home, history, community and the difficulty of understanding them in a disorienting and disenfranchised society. The show was extraordinarily popular and evocative for an audience that rarely feels welcome in museums.

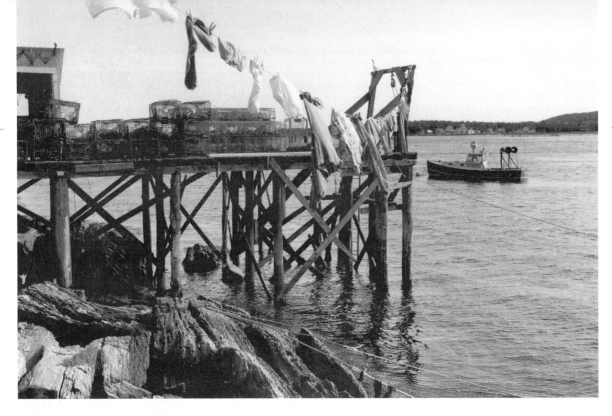

stories that are, as filmmaker Julie Dash put it, "not linear, but always coming back around," a notion manifested in her evocative film *Daughters of the Dust*. Going backward, the artifacts get mixed up, the path meanders, allowing more lateral exploration. T. S. Eliot wrote in "Four Quartets" that home "is where one starts from....We shall not cease from exploration/ and the end of all our exploring / Will be to arrive where we started / And know the place for the first time." On the other hand, Georg Lukacs characterized Western society as one of "transcendental homelessness." Both were right. These are the two strands of our multicentered experience.

Well ahead of us, treeless hills begin to emerge from the haze, hills steaming constantly as though Hell has sprung a leak; hot vapors are pumped underground here to melt the thick petroleum. At the foot of those hills hides a town. A few dark hints of trees betray its location but we know it well: Oildale, a community now contiguous with North Bakersfield. We discern a distant building, then two, then the silvery tangle of a refinery. I turn to my wife and smile. "Almost home," I say. She smiles back: "Almost home."
— GERALD HASLAM

The first thing we think we see when we look "around here" is home, or dwelling place; they are not necessarily synonymous. A dwelling is at least "a roof over your head"—a room, usually an apartment or house. Sometimes this place is a home, assumed to be the focus of one's own landscape, which is what one sees out the windows. The English word *home*, reflecting a "domicentric" view, can uniquely "refer with equal ease to house, land, village, city, district, country, or, indeed, the world," writes David Sopher. "It transmits the sentimental associations of one scale to all the others..." Even if the word *home* has taken on a more temporary, transitory, meaning, and even if many have come to believe with Thomas Wolfe that "you can't go home again," there's no place like it. Home is at once more intimate and more isolated than place.

It may be possible to live with the doors slammed shut, to call a room or a house "home" without consid-

Brenton and Susan Wren Perow's dock on Bay Point, 1995 (Photo: Peter Woodruff). Perow's lobster boat—the West Side—is moored off the dock where the couple was married. He is a second-generation lobsterman from Bath, and she is a former Kennebec Point summer person, who is also a jeweler, arts administrator, and landscaper.

Indian Point is larger, less sheltered on the ocean side than Kennebec Point, and more dramatically "scenic" (Marsden Hartley once painted crashing surf here). It too was farmed and grazed and then summer cottaged like Kennebec Point, but until the 1950s it was sparsely settled. Then the whole point was subdivided and sold off, becoming a summer community of artists, school teachers and professionals, an

ering where it is located, where it stands, and where we stand. Yet eventually the peripheries enter, and any "house" expands into place, which may be the highway that goes past and the view beyond it, the city street outside with unconnected human and motor traffic. For some, home is the street itself, slabs of cardboard on a particular heating grate or hallway floor. But in every case, the surroundings seep into lived experience, permeating even the heaviest armors of alienation.

The search for homeplace is the mythical search for the *axis mundi,* for a center, for some place to stand, for something to hang on to. For indigenous people, home is often a much broader and shared concept, "an extension of their soul and spirit," as Pueblo writer Rina Swentzell has put it. Seneca artist Peter Jemison has said that it is not the American flag but the pole and the eagle on top that mean something to his people: they connect earth and sky, body and spirit. The British, although famous for their imperial arrogance in importing a monolithic version of home to the "jungle"

(a euphemism for others' unfamiliar homes), are not the only ones who have seen themselves as the center of the world. Most tribal peoples call themselves simply "the people," and their terrain is "the center," the place of emergence or creation or the goal of ancestral journeys. Lakota shaman Black Elk wisely pointed out that "anyplace can be the center of the world."

The dominant cultural clichés about home are all idealized: "home sweet home," "a house is not a home," "be it ever so humble, there's no place like home," "home is where the heart is," and, of course, a

DAVID IRELAND, *Interior site,* the artist's house at 500 Capp Street, San Francisco, 1975 to the present (Photo: copyright 1988, M. Lee Fatherree). Ireland, an architect, designer, artist who blurs the boundaries between these activities, has made an ongoing artwork of his own 19th-century house in the Mission District (a former boarding house and accordian factory built by a retired sea captain). A curious bridge between past, present and posterity, the house is both an artwork and a receptacle for artworks and/or the paraphernalia of daily life. Old tools or household objects (a bouquet of used brooms in room at right) lean against the walls, amputated furniture hangs from the ceiling, and collected bits (rubber bands, toilet paper tubes) fill glass jars or are stacked on shelves, suggesting the ritualization of domestic labor. When stripping down the interior, Ireland chose to maintain its layered history by adding coats of Verathane; the cracked and mottled walls glow with internal light and their shabbiness becomes an unexpected elegance. Time is exposed in its use and its elusiveness. Ireland's Capp Street house, wrote Rebecca Solnit, "became a museum of its own past," but, as a home, it escaped the conventional state of suspended animation to "evolve, adapt and function as a stage for private life."

increasing number of whom are living there year round. Over one hundred houses now stand on Indian Point, the smaller ones on the Bay side, facing us, and the larger ones fronting on Sea Beach, Little River, Reid State Park, and the open sea.

When I was a child "old man Webster" held sway over the Indian Point road, blocking access to Sea Beach and its striking array of white rocks, tidal pools and "Devil's Chasm"—the best storm-watching spot in the area. We would trespass by walking across the flats and bushwhacking or drive down the road with my grandmother, who would get out to beard the irrascible Mr. Webster in his den: "I'll visit with Mr. Webster a while, you children go on down to the beach." When I was an

28

more telling pair—"a woman's place is in the home," and "a man's home is his castle." It was not until the seventeenth century—in Europe—that the comfort and privacy we assume as part of the notion of home was even an issue. It came with the increased isolation of family units, led by the bourgeoisie, as communal living waned. In his evocative book on domestic interiors—*Home: The Short History of an Idea*—Witold Rybczynski traces the human dwelling place from campsites to bare rooms to the complex spaces we inhabit today, drawing parallels with the development of self-consciousness, "the house as a setting for an emerging interior life."

Comfort and privacy or intimacy are by no means the cultural or economic norm in many parts of the world; nor is there any agreement as to what they mean. Domesticity was, from the beginning, "a feminine achievement," as was the success of a newly scientific approach to housekeeping called "domestic engineering" in the nineteenth century, and, from the other side of the door, the later need for "a room of her own." Gender affects our experience of the four walls we return to as well as our experiences of the "outside world," defined by mobility or lack thereof, as well as by boundaries—which originally meant places bound together rather than lines of separation. Gender often merges with class as a key to reading domestic places. (Poor women, for instance, know rich neighborhoods because they are domestics there, while rich women remain ignorant of the places where their servants live.)

The notion of a gendered landscape is still new to many Americans, although we are generally aware that house, home, street, neighborhood are experienced as prison and refuge, confining and protecting, different —especially for women—in daylight and dark. On the domestic level, "a woman's touch" has long been valued (even as a woman's work has been devalued and de-skilled), though seen as the superstructure rather than the infrastructure of American history. Yet these same women often stepped out of conventional divisions of labor to do much of the work involved in cutting a home out of the wilderness, fighting off its previous inhabitants, and cultivating the land.

This was not what the Victorians meant when they said women and children were "closer to nature," an idea that survived through the fifties. Suburbs, perceived as refuges, were considered more "natural" than cities and were therefore where women and children belonged. Lewis Mumford's support for the "garden city," says Elizabeth Wilson, was based on the belief that it would restore women to their proper maternal role (whether they liked it or not). The signs of culture—lawns and barbecues—as male, and horticulture—gardens and daily maintenance—as female, are reflected in suburban yards. At the same time, women have constantly struggled to bridge the gaps between private and public domains, partly to break out of our own gender captivity and partly to change the way difference is perceived. The suburbs may have been a good place to come home to, but they were not a good place to be stuck in. In the three years that Herbert Gans was studying Levittown, there were fourteen suicide attempts, thirteen of them by women.

SUZANNE LACY, *Auto: On the Edge of Time*, 1994. Lewiston, New York (Photo: Suzanne Lacy). Part of a larger national multi-site project sponsored by New York's Public Art Fund, in which the artist worked with battered women and children, women in prison, and various support groups. These battered cars, parked in a neighborhood filling station, were "decorated" by those who know domestic violence firsthand. The place-specific installation brings the terrible stories out from behind closed doors and into a community space, turning private experience inside out for public view. In a related installation for Pittsburgh's Three Rivers Festival, Lacy drew a metaphorical parallel between the domestic violence support network and the underground railroad.

adult, an overzealous constable became my arch adversary as I refused to give up Indian Point, which I saw as part of my "traditional" turf.

In May 1995, the liberal weekly *Maine Times* reported that the governor was buying a summer house on "exclusive Indian Point," where he "would join a de facto millionaires' club." This came as news to most residents, although one of them is a co-founder of the *Maine Times*. The governor himself insisted his house was modest, proving it by saying that his next door neighbor was a retired schoolteacher. Georgetown is no Rockefeller hangout, although one movie star does summer inconspicuously in Robinhood.

Real estate agents ignore the adage "a house is not a home" and persistently advertise "lovely homes" as though a home could be found ready-made. For many, the domestic landscape is formed not by family activities or by the trees or buildings visible from the window but by familiar cartoon shows or MTV or the Internet or the "local" shopping mall, which has taken the place of mysterious small-town vacant lots or creeks and woods to explore. After only a few centuries, if that, domesticity has become as specialized and alienated as the rest of modern life, fragmented along cultural and class lines.

According to Gwendolyn Wright, zoning (first implemented in Los Angeles in 1909) "was designed to remove the class of people who would have worked in larger stores and to ensure that most suburban women were protected in their homes, affording them little opportunity for employment." Homework was also banned in many suburbs, leaving in the lurch the growing number of single mothers who commuted to urban jobs but were unable to afford childcare, and fueling the feminization of poverty. Although working mothers prefer apartment living, landlords are conventionally unwelcoming to pets and families; in 1979, 70 percent of Los Angeles apartment buildings did not allow children. The cooperative aspects of suburban living, such as they are, seem mostly available to women who don't work out of the home; friendship, baby sitting exchanges, coffee klatches, phone calls, help in emergencies, a certain security. Here too, however, there are rules. A cousin of mine was a suburban "househusband" in a New England town for a few years in the seventies while his wife worked. He found himself excluded from kitchen social life and child-oriented neighborhood intimacies because other husbands were threatened by his presence around their wives while they were away at work.

Very little has changed on Kennebec Point in my sixty years; all but two of the summer families who were there when I was born have remained, and some houses are bursting at the seams with grandparents, parents, and children's children.

In 1997, for the first time in some thirty years, a new family has bought a house on the Point, having rented it previously. (The "old" family, which has summered there since the late 1930s, is still in residence elsewhere on the Point.

There are now 23 houses on Kennebec Point, three built since the 1930s, and two more are in the works. The three

30

The content of the American homeplace is often conformity disguised as self-expression, the creation of a transparent nest that reflects a family's self-image and social aspirations, or literally exposes their lives, through a street-facing picture window. Zoning often prohibits non-traditional families and "unrelated" people living together in group homes. Peter Jackson has mapped the "ecology" and "micro-geography" of prostitution in California, and analyzed the ways in which gay and lesbian politics "are simultaneously social and spatial" as they shift the boundaries between private and public domains. Gay men have often played a gentrifying role much as artists have, revitalizing parts of the inner city by superimposing their own cultural values, while displacing the inhabitants. They have developed their own urban "ghettos" (Christopher Street in New York, the Castro in San Francisco, South Beach in Miami, among others), which serve as protective bastions but can also expose its occupants to harassment. Lesbians, however, have been reluctant to form "identifiable residential clusters"—no doubt due to the added vulnerability all women feel in this society; they are also more likely to be living with children and need to consider school districts, to blend more harmoniously into "ordinary" life.

Such blending is not always possible. A "good address" may be merely a facade, like house styles. A 1988 Ohio State University survey solicited responses to pictures of six different house styles—Farm, Contemporary, Colonial, Mediterranean, Saltbox, and Tudor. Respondents were told the houses were the same size, layout, and location; the landscapes were identical and entirely neutral. Then they were asked to choose which one would be most comfortable to approach if you needed help, the house of a leader, and your dream house. The farmhouse was considered friendliest (it was the most horizontal, and the porch spanning the whole facade was more welcoming). The columned Colonial was seen as the leader's (it was taller, suggesting a literally colonial hierarchy, and the entryway was also tall and directive). The Tudor was the dream house (it combined the imposing and the homey, its central entrance section resembling a smaller house). Class played a much larger role than region in these choices: respondents from Los Angeles and Columbus, Ohio, came up with very similar answers.

However, sometimes our design preferences are reactions *against* class or social conditioning. You can build a pseudo-adobe house in a New England colonial town, or a two-story clapboard house on the high desert, but you can't make them part of the bigger picture. Cultural suppression can be communal rather than imposed from the outside. In an essay on internal constraints on Appalachian folk art, Charles Martin tells a sad story of conformity: a man who returned home after living outside of eastern Kentucky for years built a house and painted it an odd (unidentified) color; instead of facing the road, as was customary, his house faced the back hillside. He was laughed at, criticized, and then virtually ostracized for challenging local ways and, in doing so, damaging his family's reputation. He eventually gave in and remodeled, but he is still known as "the fellow with the house."

The cultural significance of plan or layout (more than facade or decoration) in vernacular architecture resembles the significance of paths beaten by custom through a landscape. John Vlach's study of the southern shotgun house, for instance, establishes its origins in the compounds of West Africa, then traces its creolization in French Haiti and New Orleans and its spread through the American South in the nineteenth century; painter John Biggers has seen the shotgun's line of rooms as railroad cars, "buildings on the

oldest date to 1783, 1823, and "before 1830." Another five were built between 1830 and 1845. The next building boom on Kennebec Point, and everyplace like it along the southern Maine coast, began around 1889, as the influx of people from Massachusetts and New York worked their way up through New England looking for quaint and healthy summer refuges. One of the several large turn-of-the-century summer homes was built by a descendent of the Olivers, who date back to a David Oliver who lived on Parker's Island in the 1600s and fled to Sagadahoc Rock during Indian raids.

move, on the track, led by an unseen locomotive, of freedom and spirit." Robert Farris Thompson contends that the American porch reflects another African influence, brought by slaves from Kongo and Angola. Today, according to Labelle Prussin, when black people move into a white neighborhood, they often add on front porches, turning the street "into a wholly different cultural situation, with dialogues crossing streets, porch to porch."

If the history of vernacular architecture can be written in warm but vulnerable wood and "permanent" prestigious stone, now metal too must be added. Sometimes the home is a "mobile home"—a phrase that expresses the contradictions at the heart of American life. Perhaps the real American dream is to "sleep in one's own bed" and at the same time "be on the move." The trailer camps and RV (recreation vehicle) parks that make up "moburbia" can offer the best of both worlds —belonging and escape, community and independence. "Just knowing that underneath the floor is a set of wheels makes you feel free," said one afficionado.

Writing about "wheel estate," Michael Aaron Rockland describes passing a caravan of Winnebagos on the road. The rear vehicle had a neon sign that said

Waterbed Truck in Des Moines, Iowa, early 1970s (Photo: Lucy R. Lippard). Inside out, a bed on wheels, a kind of boat, American commercial folk art.

HOWDY and the lead vehicle flashed COME AGAIN, like a friendly small town. Trailers and mobile homes (officially called "manufactured homes," since many of them travel only once, in halves, from factory to home-site) are in fact a response to the shortage of affordable houses in the United States. Energy-efficient, relatively tax-free, and half the price of on-site construction, mobile homes and motor homes allow retirees a new start as well as a new double-gendered toy—a truck to play house in. And they are democratic, too, heirs to the mail-order (later "prefab") house that began with balloon-frame construction in the mid-nineteenth century. When post-World War II builders seemed to have abandoned the blue-collar homeowner, the mobile home industry came to the rescue: "Although there are a lot of steakeaters, the basic diet is still hamburger," says Art Decio, the self-made owner of Skyline, one of the nation's largest manufacturers. "The story of America is really a chronicle of man's [sic] unending quest for homeownership."

RVs head south and west. Like everybody else selling anything in the USA, their advertisers tout "new frontiers." Homes on wheels have, from their inception, been seen as heirs to the covered wagon and the gypsy or sheepherder's caravan; they recall the nineteenth-century homesteader's shed, which could be taken apart in a day, loaded on a wagon, and moved on to claim new land. It is no less "natural" for humankind to move than to stay rooted, but the traditionally rootless (gypsies, or "travelers," and hobos) remain suspect in this society, despite the fact that they are really the prototypical Americans. "A century ago, when, just as today, one American in five changed residences within a year," writes David Sopher, "one of the most widely treasured household icons was a plaque or sampler carrying the words Home Sweet Home." Today there is a plaque that reads "God Bless our Immobile Home."

Being in Place

The land is important to me, but even more important is the idea that it becomes a "place" because someone has been there.
— MARLENE CREATES

In Maine, where you come from is always an issue. "Though I've spent a good portion of every year since birth in this house, in this town, I was born in Miami," writes Joseph Barth of Alna. "This automatically calls into question my credentials as a native. Somehow a zygote starting its division here is not blessed with the same innate potential as a flesh-and-blood baby inhaling a first lungful of Maine air. But despite the accident of my subtropical birth, I've always felt that here is where I belong, so I try to do my part and participate."

There are several tiers of status; to take them from the bottom up: Tourist/out of stater, summer person or someone "from away," local, and native. Native, however, does not mean indigenous people. Over

EVERY LANDSCAPE IS A HERMETIC NARRAtive: "Finding a fitting place for oneself in the world is finding a place for oneself in a story." The story is composed of mythologies, histories, ideologies—the stuff of identity and representation. Jo Carson, a professional storyteller from Johnson City, Tennessee, knows her sight lines. She learned in college that when she talked Appalachian, people were "either rude or enchanted." Gradually she realized she was exotic because "I am of, and from, a single place, and most people don't have the privilege." As a "placed person," to use Wendell Berry's phrase, she says she is "involuntarily rooted....Unless I can see these old mountains, some piece of heart is missing in me....Perhaps in my last life I was a tree. I am from here, I was raised here." When Carson talks about place, she means not only landforms, but "the flavor of a society, the beliefs and activities of people who make up a given place." Her stories start with "basic central place functions— grocery store, gas station, auto mechanic, restaurant, movie house (read video rental, these days) and decent bookstore. Most geographers do not consider a bookstore a basic central place function, but I do."

MAGGIE LEE SAYRE, *River Life*, n.d. (Photo: Courtesy Center for Study of Southern Culture). Sayre lived most of her life on a houseboat with her family, fishing rivers through Kentucky and Tennessee. Born deaf, she began taking pictures as a child around 1936 with a box camera. She signed her work "Deaf Maggie Lee Sayre." Her pictorial autobiography, a chosen means of communication with a world she couldn't hear, combines local knowledge and respect for memory with an itinerant's curiosity, detailing the activity and paraphernalia of fishing life—the nets, the floods, the friends, the fish caught (giant carp, catfish and spoonbills). In regard to Sayre's life, Tom Rankin quotes Eudora Welty: "A sheltered life can be a very daring life. For all serious daring starts from within." About this picture, Sayre told Rankin: "This is Pearl Dotson....That's my father on the porch....I was standing on land when I snapped this shot, looking at the boat there. I think it's a good picture."

Much has been written in the last twenty years or so about "the sense of place," which is symbiotically related to a sense of displacement. I am ambivalent about this phrase even as I am touched by it. "A sense of place" has become not just a cliché but a kind of intellectual property, a way for nonbelongers to belong, momentarily. At the same time, senses of place, a serial sensitivity to place, are invaluable social and cultural tools, providing much-needed connections to what we call "nature" and, sometimes, to cultures not our own. Such motives should be neither discouraged nor disparaged.

All places exist somewhere between the inside and the outside views of them, the ways in which they compare to, and contrast with, other places. A sense of place is a virtual immersion that depends on lived experience and a topographical intimacy that is rare today both in ordinary life and in traditional educational fields. From the writer's viewpoint, it demands extensive visual and historical research, a great deal of walking "in the field," contact with oral tradition, and an intensive knowledge of both local multiculturalism and the broader context of multicenteredness. On one hand, there is "the ability to know a new place quickly and well, and to adapt to its circumstance," a source of mapping in indigenous societies. This is still a survival technique, a kind of scanning known to citydwellers as well as to woodsmen. On the other hand, memory is stratified. If we have seen a place through many years, each view, no matter how banal, is a palimpsest. Yi-fu Tuan says that the terrain of late childhood seems to penetrate our lives and memories most intensely. In Georgetown, driving on an almost-two-lane tarred road, I can call up its predecessors: the one-lane hardtop, the gravel, the dirt with the tall grasses growing up between the ruts, stained with oil from under the cars, the straightened curve now lying forgotten over there

heard in an Indian crafts store near Wiscasset: A Native American woman (from the West, I suspect) asks the white woman behind the cash register whether the objects are all made by Native people. "Oh yes," she replies cheerfully, unaware that the question is culturally loaded, "all native Mainers."

The legal definition of a "resident" of Georgetown is someone who lives here a minimum of six continuous weeks each year. A mere resident, however, is not a local and certainly not a native. A historical

34

in the puckerbrush. I can imagine even further back. The old road seen in photographs, described in recollections, is now woods, its ruts the faintest trace. Even as a newcomer, in New Mexico, once I know that *Avenida Vieja* (the old road) ran northeast-southwest before the highways came in and the adobe ruin next door might have been a stage stop, I can call it up along with the noisy carts and carriages that bumped over it. Memory is part first-person, part collective.

The sense of place, as the phrase suggests, does indeed emerge from the senses. The land, and even the spirit of the place, can be experienced kinetically, or kinesthetically, as well as visually. If one has been raised in a place, its textures and sensations, its smells and sounds, are recalled as they felt to a child's, adolescent's, adult's body. Even if one's history there is short, a place can still be felt as an extension of the body, especially the walking body, passing through and becoming part of the landscape. Michael Martone is eloquent about his sensuous identification with the Midwest:

> The Midwest is too big to be seen [as the Heartland]....I think of it more as a web of tissue, a membrane, a skin. And the way I feel about the Midwest is the way my skin feels and the way I feel about my own skin....the Midwest is hide, an organ of sense and not power, delicate and coarse at the same time....

Kent Ryden isolates the sense of place as a specific genre of regional folklore, offering four "layers of meaning" familiar to local residents but invisible to visitors, cartographers, and even scholars: local and material lore including local names for flora, fauna, and topography; handed-down history, much of it intimate, some of it apocryphal; group identity and place-based individual identity; and the emotions or affective bonds attached to place, which Yi-fu Tuan calls "topophilia."

Place is most often examined from the subjective viewpoint of individual or community, while "region" has traditionally been more of an objective geographic term, later kidnapped by folklorists. In the fifties, a region was academically defined as a geographic center surrounded by "an area where nature acts in a roughly uniform manner." Today a region is generally understood not as a politically or geographically delimited space but one determined by stories, loyalties, group identity, common experiences and histories (often unrecorded), a state of mind rather than a place on a map. Perhaps the most accurate definition of a region, although the loosest, is Michael Steiner's; "the largest unit of territory about which a person can grasp 'the concrete realities of the land,' or which can be contained in a person's genuine sense of place."

"Regionalism"—named and practiced as either a generalized, idealized "all-Americanism" or a progressive social realism—was most popular in the thirties when, thanks to hard times, Americans moved voluntarily around the country less than they had in the twenties or would in the fifties. During the Great Depression, the faces and voices of "ordinary people" became visible and audible, through art, photographs, and journalism, and had a profound effect on New Deal government policy. John Dewey and other scholars recognized that local life became all the more intense as the nation's identity became more confusingly

notion of "nativism" colors the way people see their places. "It is part of Maine folklore that those from 'away' may be street-smart and book-smart, but they lack the knowl-edge the true Mainer has of how to survive, physically and mentally, in a harsh climate," says Douglas Rooks. "Mainers tend to develop a get-along mentality, doing what-ever's necessary in order to survive and stay in Maine," writes Edgar Allen Beem, but with this comes "a sense of limited horizons."

diverse and harder to grasp. (Allen Tate called America "that all-destroying abstraction.") The preoccupation with regionalism was a "search for the primal spatial structure of the country....[for] the true underlying fault lines of American culture."

Bioregionalism seems to me the most sensible, if least attainable, way of looking at the world. Rejecting the artificial boundaries that complicate lives and divide ecosystems, it combines changing human populations and distinct physical territories deter-mined by land and life forms. But most significantly, a region, like a community, is subjectively defined, delineated by those who live there, not by those who study it, as in Wendell Berry's description of regional-ism as "local life aware of itself."

In April, 1996, the town of Fairfield, California, for instance, inspired by a coalition of local public artists and administrators, asked itself, "Where is Fairfield?" A local high school designed chairs as symbols of places in the community; grade schoolers designed postcards; t-shirts, supermarket bags, banners, local media, and oral history projects all asked the ques-tion. A year later, responses are still coming in as the formerly agricultural, now-urban, town continues the process of struggling to identify itself and its disparate parts.

In the art world, the conservative fifties saw region-alism denigrated and dismissed, in part because of its political associations with the radical thirties, in part because its narrative optimism, didactic oversimpli-fication and populist accessibility was incompatible with the Cold War and out of sync with the sophisti-cated, individualist Abstract Expressionist movement,

35

PEDRO ROMERO, *El Torreon de El Torreon*, 1993, flagstone and ceramic tile, 14' high, Santa Fe (stonework by Phillip Romero). The stone tower built at the edge of a playground was inspired by early Spanish watchtowers in the Southwest, one of which gave this Santa Fe barrio its name. Romero found the watchtower first mentioned in records from 1703, when two sisters, Juana and Maria Griego, were upholding their right to live in it. The ceramic tile mural that circles the tower relates the history (beginning with a Native American) of this once agricultural area along the Santa Fe River. Today the *torreon* watches over the barrio children and reminds them of their ancestors.

Mainiac Cap (Photo: Lucy R. Lippard). Mainers are proud of being called Mainiacs. This cap is worn by a Kienholzian figure that is part of an anonymous roadside sculpture near Skowhegan made of found objects and an abandoned car.

36

just then being discovered as the tool with which to wrench modern art away from Parisian dominance. Today the term *regionalism*, most often applied to conventional mediums such as painting and printmaking, continues to be used pejoratively, to mean corny backwater art flowing from the tributaries that might eventually reach the mainstream but is currently stagnating out there in the boondocks.

In fact, though, all art is regional, including that made in our "art capital," New York City. In itself extremely provincial, New York's artworld is rarely considered "regional" because it directly receives and transmits international influences. The difference between New York and "local" art scenes is that other places know what New York is up to but New York remains divinely oblivious to what's happening off the market and reviewing map. Yet, paradoxically, when the most sophisticated visitors from the coasts come to "the sticks," they often prefer local folk art and "naive" artists to warmed-over syntheses of current big-time styles. (Ad Reinhardt, the ultimate avant-gardist, "last painter" of apparently solid black canvases, once gave a jury prize to an elderly woman's leaf collages, infuriating his local imitators, who thought they had the inside track.)

Instead of getting angry, defensive, or discouraged, it might be a good idea for local artists to scrutinize their situation. Why *does* this very local art often speak so much more directly to those who look at a lot of art all over the place? What many of us find interesting and energetic in the "regions" is a certain "foreignness" (a variation on the Exotic Other) that, on further scrutiny, may really be an unexpected familiarity, emerging from half-forgotten sources in our own local popular cultures. Perhaps it is condescending to say that a regional art is often at its best when it is not reacting to current marketplace trends but simply acting on its own instincts; the word "innocent" is often used. But it can also be a matter of self-determination. Artists are stronger when they control their own destinies and respond to what they know best—which is not necessarily related to place. Sometimes significant work is done by those who have never (or rarely) budged from their place, who are satisfied with their lives, and work out from there, looking around with added intensity and depth because they are already familiar with the surface. These artists may seem marginal even to their local artworld, but not to their own audiences and communities.

It has been argued that there is no such thing as regionalism in our homogenized, peripatetic, electronic culture, where all citizens have theoretically equal access to the public library's copy of *Art in America* if not to the Museum of Modern Art (which costs as much as a movie). On another level altogether, middle-class museum-goers living out of the centers do become placeless as they try to improve and appreciate, and in the process learn to distrust their own locally aquired tastes. They are usually unaware that mainstream art in fact borrows incessantly from locally rooted imagery as well as from the much-maligned mass cultures—from Navajo blankets to Roman Catholic icons to Elvis to Disney.

Everybody comes from someplace, and the places we come from—cherished or rejected—inevitably affect our work. Most artists today come from a lot of places. Some are confused by this situation and turn to the international styles that claim to transcend it; others make the most of their multicenteredness. Some of the best regional art is made by transients who bring fresh eyes to the place where they have landed. They may be only in temporary exile from the

"How can you argue with a Mainer whose roots are 11 generations deep?" begins a local book review. Although my grandson is the fifth generation in my family to love this place, we're summer people "from away" and always will be. (In parts of the West the term is "from off.") It's partly a class thing. You can be a newcomer, but if you've worked at the Bath Iron Works for a couple of years, you're a local (but not a native); you can come here summers all your life and you're still "from away."

Over the last thirty years, ownership of a "second home" has become more common among the middle class, and homes vary in scale from a full-sized winterized house on the shore to our summer-only house made of one layer of plywood, to a trailer on a

centers (usually through a teaching job), but they tend not to waste their time bewailing their present location or getting away whenever possible. They are challenged by new surroundings and new cultures and bring new material into their art. As Ellen Dissanayake has observed, the function of art is to "make special"; as such, it can raise the "special" qualities of place embedded in everyday life, restoring them to those who created them. Yet modernist and some postmodernist art, skeptical of "authenticity," prides itself on departing from the original voices. The sources of landbased art and aesthetics remain opaque to those who only study them.

An American Brass Plant in Waterbury, once the tube mill of Benedict and Burnham, being torn down in 1961. From *Brass Valley* (Photo: Tom Kabelka, *Waterbury Republican-American*). Valley people, says worker Frieda Ewen, "are always on the edge....The factory can get up and go and people know that....You're totally dependent on that building." By 1980, there were fewer than 5,000 workers in Naugatuck Valley brass plants, where once there had been 50,000. The decline of the brass industry has been attributed to outdated machinery, high labor costs, runaway shops to Asia, South America, the Middle East, and to the replacement of brass by plastic and aluminum. According to longtime worker and union organizer Bill Moriarty, "one thing that went sour was that these were all once locally owned plants. Then Kennecott came in and took over Chase; Anaconda took over American Brass. The only semi-local plant was Scovill's; it also had tentacles out all over the country. These conglomerates came in, and they just ran these plants into the ground." Union man Tony Gerace adds, "We didn't realize that the bigger corporations could unload a particular plant without any feelings..."

In all discussions of place, it is a question of abstraction and specifics. If art is defined as "universal," and form is routinely favored over content, then artists are encouraged to transcend their immediate locales. But if content is considered the prime component of art, and lived experience is seen as a prime material, then regionalism is not a limitation but an advantage, a welcome base that need not exclude outside influences but sifts them through a local filter. Good regional art has both roots and reach.

A model for this kind of project, though not well-known among artists, was the Brass Valley Workers History Project, initiated in 1979 by Jeremy Brecher, Jerry Lombardi, and Jan Stackhouse in the Naugatuck Valley near Waterbury, Connecticut. It embraced community organizing, union education, an illustrated book on the local history, and an exhibition; in still another ripple outward, it inspired a larger process that included music festivals and teaching resources. The project did not enshrine the past in a palatable cocoon but functioned as a social catalyst. It was received by families living in the valley as "a kind of collective family album in a community where almost everyone has a relative who worked in the brass industry."

As early as 1947, geographer John K. Wright stated the importance of including in his field the way people saw the world as well as its physical attributes, of mapping the desirability and undesirability of places and the reasons people feel the way they do about them. This relationship of peripheral places to central places has also informed more recent studies. Psychologist Tony Hiss asks us to measure our closeness to neighbors and community and suggests ways to develop an "experiential watchfulness" over our regional "sweet spots," or favorite places. Seeing how they change at different times of day, week, and year can stimulate local activism:

patch of wooded inland. But when I was a child in the 1940s and 1950s there was a huge social gap between summer people and those called "the natives." It was cultural, not just economic, and rural versus urban. (Georgetown year-rounders were just beginning to go to beaches for pleasure; many who spent their lives on the water never learned to swim.) Such differences were exacerbated by snobbery in some quarters. Within the summer colony itself, there were those who carefully distinguished renters from owners, prep school students from those who went to public high schools. Such attitudes have diminished greatly, but they have left scars.

Other than parks, what landscapes do you know and care about that you would nominate to a list of Outstanding National Landscapes? How secure are these places at this point? Who's in charge of them? What kind of changes to what you see, hear, smell, or touch would damage your sense of connectedness to these landscapes?

"Regional" photographers and conceptual artists have paralleled these ideas in the visual arts. Dan Higgins has been deeply rooted in the local for over twenty years. His works on Winooski, Vermont, are shown at local bars, stores, and other municipal sites. They include *The Forgotten Trash Can Photos* (1975), selected from a group of discarded photos from the fifties and sixties found behind a pharmacy. As Nathan Lyons has written, "the accidents of millions of amateurs devoid of a picture vocabulary—which produced an outpouring of multiple exposures, distortions, unusual perspectives, foreshortening of planes, imbalance— has contributed greatly to the visual vocabulary of all graphic media since the development of photography."

Higgins's *The Incredible Onion Portraits* (1978)— posed portraits of groups of Winooski people who shared a workplace, a school class, a club, or a neighborhood, each holding an onion—constitute not only a portrait of a place, but a commemoration of its history and a protest against its destruction, gentrification and homogenization by the bulldozers of urban renewal: "The Onion Portraits speak of specificity," wrote Higgins in his introduction. "They deal with fabrics and textures that exist rather than with planners' preconceptions....The Onion is prop, appropriate not only because the town's name is the Abenaki word for wild onions growing along its river, but because the Onion is strong and reeks of a flavor unsettling to bourgeois taste....To hold the Onion is to participate in local lore; its embrace is an affirmation of locality."

DAN HIGGINS, 12 *Scenic Views of Winooski, Vermont*, 1973, foldout postcard. The first in an ongoing series of communal, collaborative love notes to his hometown, Higgins made this with eighth graders at the John F. Kennedy Junior High School in Winooski as part of a Vermont Council on the Arts artist-in-the-schools program. Students took pictures of their favorite places which were offset printed, folded by hand, and distributed. This project epitomizes the lure of the local, its apparently innocuous sites—decidedly places rather than landscapes—offering a classic "geography of childhood." The imaginative viewer will be able to crawl under the bush, kick the dirt beneath the overpass, or hang out at the railroad tracks, sensing the secrecy that dramatizes ordinary crannies. The project works both as "art" and as an educational strategy by which students take their own realm seriously.

On the Move

*We are part of a societal ebb and flow,
people washing in and out of suburbs and cities. Like hunter-gatherers,
we must go where we will be fed, where the jobs are listed....
Whether we like it nor not, we are bound together
by that which may be the cheapest and ugliest in our culture—
[brand names and Golden Arches and celebrity recognition].
These symbols and heroes may annoy us, or comfort us....
at the very least they give us context.*
— LOUISE ERDRICH

Distances in coastal Maine still vary depending on the mode of transportation: Popham by car takes an hour to reach; by boat it is very close, but once there, we have to worry about tides and moorings. Roads rather than water became the main coastal routes in the 19th century. During the same period, the soil was becoming exhausted, and by the turn of the century, many of the old saltwater farms were abandoned for houses closer to town and industrial jobs.

Since the 1940s, mobile homes and trailers have sprung up next to handsome old houses, crumbling because they were too expensive to heat and maintain. Some vanished, others were rescued by an influx of summer people, a few of whom were in fact returning to ancestral turf. One young

NORTH AMERICANS ARE FAMOUS FOR WANTing to know what lies over the next hill. From the spiritual journey or mythic quest to the more mundane search for land, job, or peace and quiet, mobility has been more American than stability. Wendell Berry says, "wherever we have been, we have never really intended to be. The continent is said to have been discovered by an Italian who was on his way to India." At the same time, he has also observed another national tendency—"to stay put, to say 'No farther. This is the place.'" Given our national history, such a declaration sounds like wishful thinking, although Berry's heartfelt and practical paeans to rootedness in the Kentucky hills pluck chords of longing in many of us. Today Americans move on an average of every four years and American adults are usually older than the houses they live in. (Even as I write this, comes the news, in September 1995, that Americans are moving less, down from 20 percent to 16 percent, and the majority now move within their own county or state.) The kind of content that depends on memory and continuity is unavailable to those who move so often. Our migratory preference, writes Wallace Stegner, has deprived us of bonds to place and community: "It has robbed us of the gods who make places holy."

The first cross-country lure was land—or real estate. That impetus came to a forced halt at the Pacific. According to historian Frederick Jackson Turner in 1893, the "frontier"—marking the boundary between savagery and civilization, wilderness

Previous page: MARK KLETT, *Checking the Road Map: crossing into Arizona, Monument Valley, 6/22/82.* In her preface to Klett's book *Revealing Territory,* Patricia Limerick remarks that "U-Hauls can carry as substantial a cargo of hope and ambition as anyone ever packed into a covered wagon," but despite the promise of "Adventure in Moving," a West that can be traveled seventy miles an hour instead of fifteen miles a day has diminished in both size and legend.

and cultivation—disappeared around 1890. While Turner's thesis has been dismissed by revisionists, it was in itself a watershed: when there was no more frontier to look forward to, our national movements became more frenetically random—here and there, back and forth between coasts, following elusive fortune and driven by economic necessity, inventing new frontiers to replace the vanished ones. Alaska is even today called "the last frontier"; the land battles taking place there are eerily reminiscent of earlier frontier histories. Wave after wave of exiles and immigrants are still coming through the United States, and we have made internal exiles of those who are its natives. Whatever our ethnicity, we share a disturbed and disturbing common ground.

It was once believed that identity could be submerged into a harmonious relationship between people and place, that "Americans" were created by immersion in the American landscape which in turn had been created to reflect the American ethos. This kind of one-way environmental determinism riding on rugged individualism has since given way to more complex readings of the relation of place to identity and society, varying widely among cultures and generations. J. B. Jackson has pointed out that the scorned and flimsy architecture of poverty (from the Middle Ages until the present) protects people from being tied involuntarily to their environments, from remaining in untenable and tyrannical circumstances, which is the flip side of a romanticized rootedness. Nathaniel Hawthorne presented a character in *House of Seven Gables* saying similarly: "We shall live to see the day, I trust, when no man shall build his house for posterity....It were better that they should crumble to ruin, once in every twenty years, or thereabouts, as a hint to the people to examine into and reform the institutions which they symbolize." The notion that a house might not be home forever,

family on Kennebec Point was condemned for bringing in a mobile home in the 1960s, even though their parents owned one of the grandest turn-of-the-century mansions on the Point. They soon built the shell of a "regular house" around the mobile home and now no one would suspect the hidden core.

Maine summers are warmer in the day and cool at night. June and July can be wet and foggy, August is bluer, and after Labor Day come stronger winds and crisp weather. End-of-summer melancholy affects everyone, but for natives Labor Day marks the moment when they reclaim their state.

Maine's "summer complaint" can be traced back to the late 18th century. But the infrastructure for a tourist economy catering

that it should be built impersonally, with eventual sale in mind, was new in the 19th century.

The term "Americans" (used for U.S. citizens to the exclusion of those with whom we share the hemisphere) masks and maintains deep social and cultural divisions that determine place and displacement like nothing else. There is a dialectic between center and movement, home and restlessness, that every American understands—even if s/he has never budged, has only watched road movies, read the novels of restlessness, listened to the plaintive ballads of loss. In fact, the resurgent popularity today of country music (even as it loses its roots in questionable fusions with homogenized pop) expresses the melancholy of those forced to move constantly in search of a decent living.

> *I'm not from here, I just live here. I grew up somewhere far away…I'm not from here, I just live here. Came here thinking I'd never stay…on my way to somewhere else. People tell me it's not like it used to be, I shoulda got here before it got ruined by folks like me…Can't say that it matters much….Nobody's from here. We just live here….Locals long since moved away….*
> — JAMES MCMURTRY

These words from a contemporary song echo bitter frontier experience expressed earlier by a disillusioned second generation of Western sodbusters: "We do not live, we only stay / we are too poor to get away."

When one is ready or forced to move is the time when fantasies rise to battle with experience. Pictures form in our minds and we go in search of them; they don't always jibe with reality. Americans going from West to East or East to West, North to South and South to North, for instance, are surprised by the spatial differences. Some Westerners are claustrophobic in the East, while others find it charming and cozy; some Easterners are agoraphobic in the West, while others find it liberating. Trying for months to make up my mind about whether to build my little house in the West next to the trees along the creek or in a bare pasture with a splendid view of sheer space in all directions, I realized the tension lay between my "Eastern" and "Western" personae: the former was drawn to the water and trees, the latter to the 360-degree view and vast space. (I chose the creek.) As I look back at my family history, I see a tension between West and East that continues in my own life—not a conflict so much as a visceral pull from one to the other, the same pull that keeps me moving from ocean to plains, from woods to mountains. Perhaps this dialectic between rest and restlessness is peculiarly North American and should simply be accepted as the source of our multicenteredness.

Those Americans who have not yet found their place, their bit of land, are dissatisfied with it, are not allowed to keep it, or simply need to move on, are joined by those exiled from other nations. We are all "the immigrant population" in the U.S., and most of us lack a center, an orientation. As the national resources shrink and jobs disappear with them, change for working people is less and less voluntary. Among the villains are corporations, "whose very survival is predicated on destroying local economies and thus local communities," writes James Howard Kunstler, although he concludes rather vindictively: "So it is somehow just that their hirelings should live in places of no character, no history, and no community."

> *If you would find yourself, look to the land you came from and to which you go.*
> — HENRY DAVID THOREAU

We tend to presume our ancestors had a place, but in my own family, once they were uprooted from the old world, people moved around constantly; from the seventeenth century on, it was rare for two or three

to the wealthy was not in place until the 1840s, when speculators began to imagine, construct and sell "summer retreats" along the New England coast to the New York and Boston elites. After the Civil War the tourist industry took off as Americans became "increasingly bewildered by the effects of industrialization, urbanization and immigration." The image of Maine as "vacationland" was born then, with writers and artists as the vanguard. Writer William Dean Howells seems to have coined the all-too appropriate term "summer colonists." According to a 1910 newspaper account, "Cove and cape, the coast is pretty well monopolized by non-

generations to stay in the same town. Each generation, even each member, of a single family may be looking for a different kind of center based on their own class and cultural experiences. Before leaving the parental home, my father lived in one house; my mother lived in five; I lived in ten; my son has lived in three, one of them for most of his life, and he is still there with his own child. These are stories of preference—of upward and downward mobility, of loss and privilege—that would be very hard to read from the outside.

The relationship of multicenteredness to identity is less acknowledged than that of either rootedness or placelessness. We come to a sense of belonging in a place by any number of different roads; in fact, mere time spent is often not enough. Although tradition has it that the longer a family has occupied a place, the deeper their roots, psychological ties can be as strong as historical ones, and they can be formed by "rootless" individuals if their longing for roots is strong enough. To be *of* rather than *in* a place certainly does not demand that one be born and raised there. Yet the pulse of contrast remains. William Kittredge writes of returning to rural Oregon, where he was raised, and meeting a man whom he might have become: "That man is home, where I could have been. I was born to it, but I left. As a consequence I carry a little hollow spot inside me." Yet in the same book, Kittredge also writes: "People ask me if I don't wish I was back on the ranch. The answer is no, and always will be. I have a new life, which is mine, I invented it. That other life belonged to somebody else, to somebody's son or grandson."

There is an ironic cast to some adopted homes, as when Danish-born Isak Dinesen wrote rather smugly of Africa: "Here I am, where I ought to be." People from privileged classes tend to confuse place with property (and even "nature"), because they have the means and leisure time to be strangers in others' lands, to indulge their wanderlust, to travel to sites of beauty, difference, curiosity, to have "second homes" on shores, in mountains, on abandoned farms. Like Maine, like New Mexico, much of the world is a local battleground between those who would like to stay and those who want to move in. The question of who "belongs" is a matter of overlapping degrees, ranging from the indigenous people who may have been in an area for thousands of years, to the "natives" whose ancestors may have come from one hundred to four hundred years ago, to the "locals" who've been there a while or just live in a place now, to those "from away" who may own land but only live in a place part time, to the visitor, the tourist, the stranger.

The "stranger" unites "here" and "there." If s/he stays, s/he may come to belong and reciprocate, or may remain detached and disinterested. Some places

residents; 'no-trespass' signs are so thickly set they form a blazed trail. The man from the city resents intrusion...." Summer people probably dislike tourists as much as local people do, but for different reasons; they disturb our peace, invade places where we are already the privileged invaders. We are traditionally lumped with them.

The psycho-sociology of a small summer community provides complex microcosms of society at large. The families on Kennebec Point are interwoven and have known each other for generations. Incomes, politics, vocations, and home bases vary widely although most came first from

hold strict and apparently irrational criteria for belonging. Class is often the unspoken qualifier. In midcoast Maine, for instance, you can spend eighty summers in a place and you are still from "away." But you can come from away, from Texas or Massachusetts (in which case you are genially called a "Masshole"), to work at the Bath Iron Works, Maine's major employer, for only a few years and you become a "local" (though not a "native") with the attendant privileges of complaining about those from away. Each area has its own fine distinctions. Writer George Ella Lyon says you can be from the town of Harlan in Harlan County, Kentucky, but "if your daddy owned a dry cleaners instead of working in a coal mine, your credentials are questionable."

The cliché "strangers in their own land" is relative, more applicable, in a sense, to those who have displaced the indigenous people (to whom the phrase is most often applied) but remain alienated from the land. E. V. Walter cites a need "to experience the world in a radically old way"; is he calling us back or calling the old ways forward? Those sensitive to the dangers of both gentrification and nostalgia (its root is the Greek word for "return") are not necessarily effective or unselfish when it comes to balancing the old and the new in ways that will comfort and satisfy old and new

inhabitants. One way to understand where we have landed is to identify the economic and historical forces that brought us there—alone or accompanied.

The changing landscape is created by the replacement of some people, the displacement of others, and the disappearance of ways of life paradoxically envied by those who have come to emulate them but, by their very arrival, actually destroy them. All of us who have adopted rural places are guilty to some degree of the "drawbridge syndrome"—wanting to be the last of our kind to enter the kingdom of heaven. If no one else like us could move in, we could live suspended in time, simple spectators to the way life has been there without us.

"Having increased our individual mobility in both the physical and social sense—the speed and ease with which we can travel from place to place as well as the power to choose our hometowns—we find ourselves less and less sure of where it is we have finally arrived," writes Robert Finch, who calls his adopted home on Cape Cod "the place where I should have been born." The journey defines the destination.

Most people do not have the time or inclination to ponder the meaning of place, especially if they have always been there. A multicentered population is more often forced to consider places than a monocentered

CHRISTIAN BOLTANSKI (with Leslie Camhi), *What They Remember*, from *Lost: A Project in New York*, 1995, A Citywide Project of the Public Art Fund, New York. (Photo: N. Folberg, courtesy of Eldridge Street Synagogue) One of four pieces that make up the project *Lost, What They Remember* was located in the 1887 Eldridge Street Synagogue on New York's Lower East Side, now a historic landmark where services are still held; the main sanctuary is a heritage center. Boltanski, who is French, thought his violinist uncle, who had emigrated and disappeared, might have worshipped here. At nine stations throughout the synagogue, three- to five-minute tape loops of children from different ethnic backgrounds could be heard telling their own versions of their histories. (They were asked how their families came to New York and about their memories of the countries and cultures they came from.) *What They Remember* was tied into the project's three other pieces: *Dispersions* at another historical landmark—the Church of the Intercession in Harlem—where piles of clothes were arranged along the nave, and bagfuls marked with the artist's name and title of the work were sold for two dollars; *Lost Property* at Grand Central Terminal, where 5,000 personal belongings from the Lost and Found were arranged on long metal shelves; and *Inventory* at the New-York Historical Society, where Boltanski made a pseudo-ethnographic show of ordinary items.

Massachusetts. ("Massturbation" is suggested as a parallel to western "Californication."). One family became year-rounders early on. The summer patterns of my childhood—when mothers and children came for two months and fathers appeared on weekends or on their month's vacation—have changed drastically; now people come and go more often, usually for shorter periods. It's harder to keep up with the children's children. "Who's that?" we older ones whisper to each other at communal gatherings.

one: choice alone, the forks in the road, demands it. Newcomers must find their own place in the place they have chosen. Deborah Tall sees the process as an encounter with the land itself: "Because I've stayed, the land feels attentive, full of reciprocal energy. The Iroquois call that energy *orenda*—a power inhabiting all living things sometimes described as a kind of voltage or static electricity that can be accumulated through ritual and then used."

However, the benefits of multicenteredness are not available to those who move geographically without ever really changing places—those so weighed down with baggage that they are never able to open themselves to local difference and change. Many of these are members of the "migratory elite" (yuppies, and the international "restless cosmopolitans" of business and the arts). Unlike deep identification with place or the need to keep moving is the kind of placelessness engendered by sheer indifference, which has reached such a point in this country that there are teenagers whose daily routes run from home to school to mall to television. They have never climbed the hill immediately behind their town, and there are children who have never gone the few miles from their homes to the sea.

In a Word

*One could almost say that when an old man or an old woman dies in the Hispanic world,
a whole library dies with that person.*
— CARLOS FUENTES

The Whiteman's names are no good. They don't give pictures to your mind.
— ANONYMOUS APACHE

CHRISTOS DIKEAKOS, *Deadman's Island*, from "Sites and Place Names (*Boîte Valise*)" 1991-94, color photograph beneath etched glass. (Collection of the Art Gallery of North York, Toronto.) At the age of eleven, soon after immigrating to Canada from Greece, Dikeakos first became interested in the Indian grave-yard on Deadman's Island (*skwatsa* in Squamish) in Vancouver Harbor, having heard about it from a storyteller at the public library. Early accounts described the dead lying in carved coffins and canoes, or in tree burials; by 1911, the island had been logged to desolation, "shivering in its nakedness, a monument to materialism, vandalism and stupidity, cleverness and illegality," according to the local paper. In Dikeakos's "Sites and Place Names" series, the panoramic images seem to stretch between times, between Native and non-Native memories. Sometimes the result is poetic, as in a picture of a wooded landscape in Sasketoon called Wanaskewinihk, or "forgotten place"; sometimes the layered complexity of inhabitation is more ironic, as in an image of a suburban Vancouver road overwritten with its archaeological contents: "ground slate points, trout, salmon..."

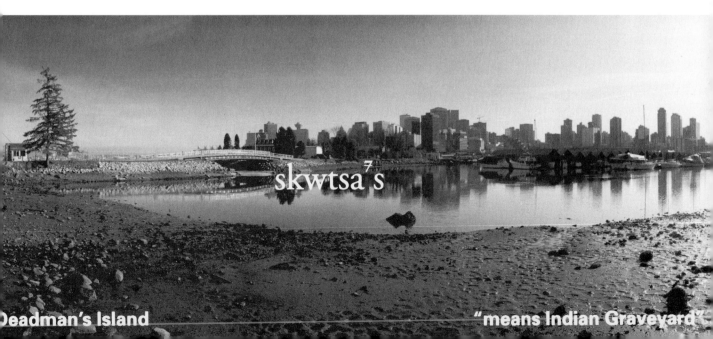

skwtsaʔs

Deadman's Island "means Indian Graveyard"

Beneath the familiar name of any one hill, town, cemetery or even family, there are layers of nomenclature, some of which remain mysterious, or illogical, like the names of our three peninsulas: Bay Point is on the Kennebec River, not a bay. Kennebec Point lies between two bays. No one seems to know exactly when they were named. Indian Point (the tip of the peninsula now given that name as a whole) appears on maps from the 18th century, as does Sagadahoc Bay, which was Rodgers (or Rogers) Bay until the mid 19th century, when the Rogers had disappeared and someone realized that the indigenous and historic name for the

EVERY PLACE NAME IS A STORY, AN OUTCROPping of the shared tales that form the bedrock of community. Untold land is unknown land. The places most valued by Americans in the early nineteenth century were those evoking myth or legend, and most of the newly American landscape, supposedly bereft of human history, was perceived as inferior to that of Europe, where every hillock told someone a story. Sarah Josepha Hale, writing in 1835, bemoaned "the barrenness, the vacancy, painfully felt by the traveller of taste and sentiment, [arising] from the want of intellectual and poetic associations with the scenery he beholds. Genius has not consecrated our mountains, making them high places from which the mind may see the horizon…they are nothing but high piles of earth and rocks, covered with blighted firs and ferns; the song has not named our streams." The landscape, in other words, was not yet acculturated to Euro-Americans, who were blind to the storied Native landmarks already in place. As Jan Zita Grover puts it, the *unstoried* was as yet unassimilable. Naming is, with mapping and photography, the way we image (and imagine) communal history and identity. Yet surprisingly little detailed attention has been paid to the local origins of American place names and what they have to say about specific histories of place.

Vancouver artist Christos Dikeakos is the only visual artist I know who has studied place names in depth. In his series "Sites and Place Names," the original indigenous names are etched on glass over photographs of modern sites, continuing an interrogation of home and community begun in 1968, when Dikeakos began to decipher and demystify changing urban reality with unassuming black-and-white photographs. Informed by conversations with Plains Cree scholar Stan Cuthand and Native Salish elders, Dikeakos brings back the so-called "pre"-history of western Canada,

"piecing together" Native and non-Native histories while critiquing the dominant Canadian art genre of landscape painting. He believes that "historical imaginings" can help us locate ourselves in the present and notes the authority of naming, as well as the lack of public monuments celebrating the relationship of Native people to the land. Patricia Berringer says that Dikeakos "asks us to look at Vancouver in a new way, seeking what was in what is or appears to be…the past is represented by the word, the present by the image." This linguistic relationship does not easily cross cultural borders. Native people cautioned Dikeakos that "the world is not mutually translatable," that unbridgeable abysses were created not by their "unwillingness to communicate," but by cultural autonomy.

Indigenous names tended to locate resources for common good—pointing out the place where a healing herb grows or the water is bad—or to say what happened there. There are parallels with the aboriginal people of Australia who sing their places into being as they pass through them. For us, names on maps play a similar role— a lazier, more detached way of reading the land in sequence. Euro-American names tend to be less about what *is* there than what it *looks like* or who *was* there. They are used as grassroots affirmations, as bids for posterity, and as proof of ownership, a means of control from the top. "The name lays claim to the

WANDA HAMMERBECK, *Name Reflecting Attitude: The Bisti Badlands*, 1994, original photograph in color. Hammerbeck, who lives in rural California and is a member of Water in the West, has since 1975 worked with notions of site and boundaries, of "resting and rising, that is, issues of being on the earth and under the sky—the basic place of humankind." Investigating the ways a site "makes meaning," she looked at how the imposed names of such "exotic" landscapes reflect social attitudes and can lead to exploitation—"in this case, extensive mining." Hammerbeck includes text to escape the slick image of landscape photography and to make the viewer deal with the meaning as well as the look of the land.

whole river's mouth had been lost locally. Bedroom Bay, also modern, is a mystery. Kennebec Point's rocky southern headland was first called Great Head and the adjacent harbor Little Harbor Head, named in a time when travel was by water. The spit of land between my house and the rest of the Point was called Oliver's Neck—for the family farming there in the 18th and 19th centuries and still living a few miles inland.

Georgetown (after King George or Fort St. George) was called by Natives Erascohegan, "a watching place or lookout"—probably a specific high place, like the southern end of Kennebec Point, with a view of the

view," Alan Trachtenberg remarks. The ability to name or rename oneself and one's place is an aspect of ownership. Conquerors have always taken advantage of it. (The rechristening of landmarks after invasion suggests the way married women lose one or both birth names—Florence Emily Isham becomes Florence Cross or Mrs. Judson Cross.)

Imperialism favors names that remind people of power and property, but the need to familiarize a harsh and unknown landscape must also have played a part in the days of early European exploration and settlement of this continent. Naming (or renaming) landmarks could be a matter of life and death, as well as a way of providing a sense of power and psychological security. The new names were sometimes whimsical and, in retrospect, disrespectful of indigenous people's culturally significant events. For all the romantic paeans to wilderness and the moral heights attributed to unconquered nature, "Americans" did not respect a landscape until it had been tamed—at least by romance or narrative. An intimidating peak in the distance or a strange geological formation becomes more familiar once it is dubbed "Pike's Peak" or "Shiprock."

NAME REFLECTING ATTITUDE
THE BISTI BADLANDS

river's mouth and out to sea. Arrowsic may be based on the word for rapids. Other local Abenaki names: Kennebec (long quiet water), Sagadahoc (to pour forth, river's mouth), Seguin (hump), Hockomock (hell, as in the two present "hellgates" of rough water), and Sasanoa (for chief Sasanou, an "a" added after death).

The European habit of naming places after families is confusing as generations change names, places are sold, or people move. There were some two dozen John Parkers in Georgetown in the 17th and 18th centuries. The Heals or Healds were Huguenots named Delano. The Poors changed

48

Places to name must have seemed as infinite as the land and its resources for those colonizing North America in the seventeenth through nineteenth centuries. Wives, children, nieces, patrons, drunken fantasies, jokes, literary references, rude puns, and pure whimsy as well as deadpan descriptions enliven the maps of the West, whereas the East, in the beginning, was more soberly named for its old world predecessors or given the Native names already indelibly attached to some new places. Cultural groups always carry old names into new places, where eventually they lose their meanings and acquire new pronunciations (as in "Callus"—Calais, Vermont; "Demoyne"—Des Moines, Iowa; or "Beeyuna Vista"—Buena Vista, Colorado). Many names are time-worn, having weathered phonetically from an Indian or "foreign" name to English words that resemble them and mean something entirely different. (The Ku-kwil tribe, for instance, became "Coquille" for the French trappers.) The western river Owyhee might sound Native North American but was named for Hawaiian Natives who were among the early explorers. The name Guadalupe, ubiquitous in the Southwest in homage to the indigenous Mexican virgin, is not Nahuatl as often assumed but stems from the Arabic word for a river hidden in a ravine, via Moorish-Spanish immigrants.

European newcomers were often baffled by unfamiliar scale and land forms, creating new names or borrowing them from other languages: bluff, bottom, knob, crossing, notch, gap, creek, run, wash, pass, prairie, plains, mesa, fork, peak, butte, park, and desert (which originally meant a place no one lived, then came to be a place no one lived because there was no water). Nomads tend to name only the major landmarks, while agrarian people may have names for every corner of their lands. An intricate boundary system on the Hawaiian Islands resulted in hundreds of thousands of place names, opaque to outsiders with their plethora of vowels and baffling similarities. The continental United States is parsimonious, by contrast, with about one name per square mile.

In the mid-nineteenth century, when the Western territories were annexed and then became states, the arbitrary official naming process hit its stride. According to George Stewart's monumental *Names on the Land*, Congressional orators liked "long and rolling polysyllables" (Maine is the only monosyllabic state in the union). Colorado was almost named Idaho and Idaho was almost named Montana, and the word Oregon is thought to have emerged from a long history of misspellings of a midwestern river. Arizona and Indiana were both named after commercial enterprises; Oklahoma—"Indian Territory"—was named by a Choctaw chief, Reverend Allen Wright, who made it up from the Choctaw words for "red" and "people." Wyoming was a perversion of Meche-weami-ing, a massacre site in Pennsylvania made fashionable by an 1809 poem, which congressmen found euphonious and preferred to the Native names despite its "rootless artificiality." A certain Mr. H. R. Williams, vice president of the Milwaukee Railroad in the late nineteenth century, named thirty-two stations in Washington state from a wildly diverse set of sources, including several Massachusetts towns, foreign countries, battle sites, a health food, a malted milk, a poet, a Shakespearean play, a college, a stockholder, and some "chance selections."

Name changes then ensued. In the late nineteenth and twentieth centuries, towns were constantly switching names to honor some newly important person or event, just as Cape Canaveral, a name going back to the early sixteenth century, was changed to Cape Kennedy. Alternatively, the original names, some of which referred to specific landmarks and

their name to Powers; Birch Island was Poor's Island, but got changed on some irrevocable official map. Fishermen and farmers named places after specific local harvests and markers incomprehensible and

unlocatable today. Pond Islands, Ragged Islands, Fox Islands, Long Islands, and Wood Islands abound along the coast. Before roads, when each community was relatively self-contained, only fishermen and traders

ventured far enough afield to be bothered by the question "which Ragged Island?"

Read's Beach on Kennebec Point is named for Annie Lauriat Read, but is confused with the Reeds now on the Point and

histories, were felt to be too crude: places that had acquired "a bad name" could opt for a clean slate. Some of the changes were made by local wits, as when Mountain was made out of Mole Hill, West Virginia. Some changes have been successfully resisted; New Yorkers have simply ignored the gratuitous change of Sixth Avenue to the pretentious Avenue of the Americas. External nicknames for urban ethnic communities are usually insulting or infantilizing: Spaghetti Hill, Beantown, Japtown, Little Dixie, Little Italy, Little Tokyo. Not so little, these enclaves often contain populations larger than major cities in the homeland; there are supposedly more Italians in New Haven, Connecticut than in Naples, and the same is true for many American cities and their counterparts abroad. With increasing local consciousness, long-time residents today are monitoring officials to ensure that the commonly used names of places are on signposts and maps instead of being named anew or inappropriately.

It seems logical that street names would be more local than those of larger areas, but a failure of imagination appears to have struck many towns (and most commercial developments). Certain streets appear monotonously cross-country, though I suppose there's a chance that the generic Pine and Walnut streets once boasted their eponymous vegetation; New York's Spring and Canal streets are named after real, now buried, features. Regional clichés were born, so that every Colorado town has its Colfax, Euclid, Arapaho streets; coastal New England towns have their Fore, Front, Middle, Winter, Summer, Commercial, and Mechanic streets. Names can trace odysseys and occupancies. The Huguenots who named streets in New Rochelle, New York, moved on to North Carolina, where the same series of names is to be found. In Manhattan, the Bowery (following an

Indian trail known as the old Beaver Path) kept its Dutch name for part of its journey, its northern end breaking into English with Broadway. Nonchalantly winding across the orderly checkerboards of the planner's city, it subverts control by recalling earlier, more organic courses.

In the sixteenth and seventeenth centuries, Indian names were adopted casually, because they were there, because that was the dominant culture. With the settlers' ascendency, Indian names were reviled as harsh and uncouth and were replaced by "civilized" names from the Old countries. Later still, when indigenous people were no longer a threat and a mellower romantic movement pervaded American culture, Indian names—often distorted and/or poeticized— became popular again, so that many American Indian names were collaged back into the culture long after the fact. Stewart says that Seekonk, in 1812, was the first Massachusetts town to deliberately choose an Indian name. Most Americans were ignorant of tribal distinctions and languages, using "Indian" names randomly or inaccurately. Ridiculous translations were paralleled by disregard for geographic specificity. (The name Osceola, the great Seminole chief who resisted colonizers for years, has been affixed to seventeen places, most outside his territory.) The names the Europeans replaced are for the most part lost, echoing or whispering through myth and oral history to be recaptured here and there by attentive anthropologists or special tribal maps.

Lafayette Bunnell's account of the Mariposa Battalion's "discovery" of Yosemite in 1851 includes a poignant scene at a mountain lake. The Yosemite chief Tenaya and his people had been captured and were about to be marched off to a reservation in the San Joaquin Valley. Bunnell informed the chief that the lake and river were now named after him: "At first he

49

50

seemed unable to comprehend our purpose, and pointing to the group of glistening peaks, near the head of the lake, said 'it already has a name; we call it Py-we-ack.' Upon my telling him that we had named it Ten-ie-ya, because it was upon the shores of the lake that we had found his people, who would never return to it to live, his countenance fell and he at once left our group and joined his family circle." As Rebecca Solnit interprets this exchange: "Bunnell says, in effect, that there is no room for these people in the present, but they will become a decorative past for someone else's future....Pyweak means shining rocks; like most of Yosemite's original place names, it describes what is present rather than monumentalizing a passing human figure....Bunnell claims to Tenaya that the new name will give the man a kind of immortality, but what he is really doing is obliterating Tenaya's culture from the place and beginning its history over again."

> A place is a story happening many times
> ...Over there? We say blind women steaming clover roots become ducks.
> We will tell that story for you at place of meeting one another in winter.
> But now is our time for travel.
> We will name those stories as we pass them by.
> — KWAKIUTL, QUOTED BY FRANZ BOAS

As we move in and out of each other's homes, we can at least nest more comfortably if the memories begin to register, even those which are not ours. How did that stain get on the bathroom wall? Who chose the ugly linoleum or carved the handsome woodwork? Why did they plant trees that darken the living room or block the views of the mountain? Who were they? Where did that path in the garden go? Clues are offered by layers of wallpaper and linoleum, or the newspaper with which a fireplace has been blocked, or

old foundations in the back yard, or artifacts that turn up while you're gardening. Abandoned houses are especially poignant. Their shattered, gaping, or boarded windows offer opaque apertures onto an unknown past that is not, but might be, our own. They are receptacles for shared fantasies. The natural response is to ask, "What happened here?"

The answer is a story. Narratives articulate relationships between teller and told, here and there, past and present. In the absence of shared past experience in a multicentered society, storytelling and old photographs take on a heightened intensity. The place is "the heart of storytelling...the imaginative act of bringing together self and earth, culture and nature, as if these were remembering one another as members of one family, binding life to life," write Susan Scarberry and Reyes Roberto Garcia in regard to the work of Navajo artist Bill Russ Lee.

Where once the stories detailed shared experiences, today it may be mostly the stories themselves that offer common ground. Once you start hearing the stories, you are becoming a member of the community. You are becoming "related," because the story is, as Terry Tempest Williams says, "the umbilical chord between past, present, and future." When governments and educational institutions can't be trusted, historical authority shifts to grandmothers. The most valuable local cultural resources may be elderly relatives (or younger ones with good memories, who took notes, or tape recorded, or identified the old pictures), or the old guy in the cabin on the outskirts of town who is eager to remember his youth in a very different place (which is now where you live), or the elderly woman who can be persuaded to tell her grandmother's tales. "The sense of place can outlast place itself." Whatever may have happened here in the past, it is altered by your very presence, even if it is temporary.

he was a pest; as they rowed away, they yelled mockingly, "Spud Walks!" and he had to wait for low tide to get home across the flats.

Turn-of-the-century summer colonists brought the habit of giving their "cottages" pretentious names, which soon filtered down from the wealthy to many a modest abode. A cottage at Sagadahoc Bay is called "The Wreck," after a shipwreck that provided its porch decoration. My grandmother changed the name of her house from Shore Acres to High Tide. Others on Kennebec Point are called "The Ledges," "The Anchorage," "Red Gables," "Overlook," "Lighthouse Ledges," "The Crow's Nest," and a recent, much

51

Just as stories can make the outsider feel more at home, they can also expand a small world. With their stories, write Jane Staw and Mary Swander, "the people of south-central Minnesota live in a fluid time and place, which allows them to see through boarded-up buildings to their future city park....It allows their worlds to be peopled not only by their husbands and wives, children and grandchildren, but also by the hired hand who lived on the farm twenty years earlier, or by an elementary school friend who went off to live in the Twin Cities. And it allows their space to expand, almost indefinitely, to encompass their daughter's farm, three miles away, where their granddaughter is riding her bike up and down the gravel drive, to encompass even Japan, home of the exchange student who lived with their son the past year and graduated from Winnebago High School that spring."

Since revisionist history took hold in the sixties, an increased interest in oral history has given us access to local life, and insights into our own lives, illuminating places better than idealized or objectified histories can. Oral histories offer poignant additions to our own personal experience and provoke more optimism than pessimism about the contradictory human enterprise. Local knowledge and awareness contextualize historical information or images that might otherwise become detached as "high art." In cities and large towns, the need to know others' histories as well as one's own is particularly urgent and particularly difficult because the geography encourages alienation. Although more conventional physical bonds—like sharing schools, streets, stores, churches—are multiplied to the point where they are invisible and perceived as missing, cities are not free of narrative bonds to place, of folklore. Elders Share the Arts, for instance, a fifteen-year-old New York City group, specializes in lively theatrical presentations of "living history" by residents of senior centers, nursing homes, and hospitals in neighborhoods where pride and dignity are hard won.

However, any suggestion of nostalgic quaintness is well hidden in contemporary "urban legends." They often cluster around subway stations, dark streets,

JACK BAKER, *The Museum of Neighborhood Phenomena*, Seattle, 1977. Baker's exhibitions/artworks in his Seattle storefront studio (a former grocery store) were based on local stories and sights—everything from traffic patterns to found objects— sparked by the artist hanging out and noticing the "little fragments you see on the street and wonder about." Along the back wall of the museum were a group of images serving as memory triggers for those who had grown up there. Baker taped stories people told and photographed the places where they had happened, as well as documenting current events himself, taping sounds and commentary. The tales ranged from "Passing Pentecostal" and "Hare Krishna" to "Glen's Crow Story," "Howard Giske's Heavy Cruiser," and one called "Loading Corn Syrup." "Bullshit is always interesting anyway," says Baker. "You realize the depth that this neighborhood has, or the depth that any situation has for that matter." Seeking to make unpretentious and accessible art, Baker was also interested in mapping his neighborhood so as to understand where its various systems overlapped. Twenty years later, he still lives in the same neighborhood, which has been gradually gentrified, with a few rusting cars and old timers hanging on.

giggled-about addition—"Heronwater."

Stories and local humor inform Maine places from various cultures. • Penobscot Mike Sockalexis didn't know the petroglyphs up the Kennebec at Emden until he was taken there in 1995 by Rosalind Strong of NEARA; he recognized the rock drawings as mnemonic devices for telling Penobscot creation stories. • A woman named Looke living on Kennebec Point in the 19th century became famous because a shipwrecked sailor appeared at her side at the moment he was drowning. • When called just plain Mark, Georgetown resident *Captain* Mark Marr remonstrated, "I have a handle to my

elevators, and suburban shopping malls. New Yorkers, according to folklorist Eleanor Wachs, reveal New York as "a world of chaos and unexplainable violence," although my own forty-six years of experience there (some of it spent in poor neighborhoods) would focus more on the extraordinary sights and encounters, on the city's vitality and variety, its curious fusions of dark and light, the humorous and the horrifying—its constant surprises. I remember returning to New York once after several months in Colorado: it was a drenching hot night in a dirty subway station and nothing was functioning properly. Just as my exasperation with urban life reached a peak, the train came, and I entered a car with such a vividly diverse and sad and funny and dynamic population (and, yes, a feeling of community among strangers) that I was overcome by love for this homeplace that offered so much unfamiliarity in such a familiar way.

We New Yorkers (I was born there) tell our stories of violence with such relish because they make us heroes (or at least survivors); we think they make our place more exciting than most, and us more interesting. I've often told about being burglarized in the early sixties, when we were living in a drug-infested building on Avenue D. One time, the would-be thieves discovered

that we had nothing (I hid my life-supporting typewriter in the bathtub under a counter of dirty dishes whenever we went out) and, having gone to a lot of trouble to break down a heavily bolted door, were so enraged that they threw my jewelry, consisting entirely of plastic "pop-it pearls," all over the apartment; we found them underfoot for weeks. I was too young and trustful to worry much, even though I realized that the little boy on the staircase who whistled when anyone came up was a lookout, and even though the sounds of warfare echoed through the streets at night. At the same time, there was a warmth I hadn't known before,

JOHN PLOOF AND CHICK LOEHR, *Mr. Loehr President of Little City*, 1994. Ploof is an artist/teacher, and Loehr a developmentally handicapped man at the Little City Foundation in a Chicago suburb. Both, from different angles, are preoccupied with power and powerlessness—Loehr confronting lack of respect and space for the disabled; Ploof wondering how he can offer choice to those he works with when "power relationships are inherently unequal." Conventional art interested Loehr very little, but he had messages he wanted to communicate to the world ("Change Before It's Too Late" and "Workshops Are Good Ideas at Little City But Community Jobs Are Better"). Their collaboration led to a series of publicly exhibited signs resembling political campaign placards that expressed Loehr's frustration and desire to control more of his life and surroundings.

name." The reply was, "My mother's old pisspot had one too, but it broke off." · And from a recent newspaper story: a man complained that he was no longer allowed to ride up Morse Mountain."I rode my bike

here all my life," he said. "Not yet you haven't," replied the Phippsburg policeman.

Some stories were not told. In the 1940s, my doctor father was consulting at Oak Ridge when it was still top secret. When we

arrived in Georgetown, storekeeper Will Todd took my mother aside into the privacy of the frozen food locker and said, "Margaret, the FBI came around asking about Vernon...I didn't tell 'em a thing."

on hot summer evenings, when men were playing dominoes and drinking beer from quart bottles on the sidewalks and women and children were hanging out and Latin music was wafting in the windows. I made up stories about them, and in doing so, vaguely identified with these lives so different from my own. Even though I was only in that building for a year or so and knew few people by name, I moved to others like it, and it was the first time I was emotionally aware of a community outside of my own experience.

Urban attitudes and narratives are also colored with a certain fatalism and exaggeration, as are tales from other places where danger is one of the landmarks, like mining and factory towns, logging camps, fishing villages, or cattle ranches; tales of muggings and burglaries in Cleveland and uprisings in Los Angeles belong with tales of twisters in Kansas ("the storm center of the nation"), "No'theasters" in Maine, flash floods in Colorado, avalanches in Idaho, hurricanes in Florida, and other "acts of God" met and matched by legendary acts of humankind. Acts that are too large to comprehend—such as the earth pulverized in the

Nevada nuclear test site or the monster dams that have killed our rivers—are disregarded in favor of smaller acts that can be inflated.

Tall tales, "whoppers," or "blanket stretchers," and the images that accompany them, from montaged postcards to roadside sculptures, throw local conditions into proud relief, lest they be taken for granted. Local heroes play a similar role. Edward Ives says of George Magoon, the survivor folk hero of Down East Maine who does battle with the harsh environment and triumphs over nature: "To tell about George is—for that fleeting moment it takes the breath to pass—to assume his strength along with his spirit of denial. There is sustenance in that for ordinary men." Such tales stem from local pride. They make the place look better and the people along with it. When local stories are unanchored, when the hearers cannot visualize where they take place, then they become what folklorists call the "migrating story," which "floats into a place and becomes temporarily localized, anchored on known and named features in the local landscape."

53

In an Image

The invention of photography has forever changed human consciousness,
shortening the distances between families and cultures,
while also widening the ruptures in history.
— HUNG LIU

The art in photography is literary art before it is anything else:
its triumphs and monuments are historical, anecdotal, reportorial, observational
before they are purely pictorial....
The photograph has to tell a story if it is to work as art.
— CLEMENT GREENBERG

WHERE GREENBERG CAME FROM (A FORMAL-ist stronghold he defended brilliantly for decades), this was a disparaging comment on photography; he found literary elements incompatible with "quality" visual art. Where I come from (decidedly outside the stronghold), this is a list of photography's virtues, valuable precisely because they deny art for art's sake. The image-makers I admire are indeed trying to transform landscape photography into something closer to a photojournalism of place (and even propaganda, in the good sense, for ecological organizing) by acknowledging a new and weighty responsibility to "tell it like is is out there." Of course, we're all aware that photographs lie, especially since computers arrived on the scene with their unlimited capacity for visual mendacity; but combined with language—the other source of all our misconceptions—they are what we have to work with.

Beginning in the sixties, Conceptual artists have created a curious genre that reflects a totally neutralized stance toward place, balancing between fondness and scorn, ideology and ignorance. In works like Ed Ruscha's deadpan artist's books from Los Angeles, like the classic *Twenty-six Gasoline Stations* (1962) and *Every Building on Sunset Strip* (1966), vernacular naivete becomes stylelessness becomes an artworld style. Local sites are catalogued in an antisentimental, antinostalgic manner, as in Dan Graham's modular images of suburban New Jersey. New Jersey, in fact, is the epitomous state of this state of mind. The opening quotation for "A Tour of the Monuments of Passaic, New Jersey," (1967), Robert Smithson's classic artwork/essay demythologizing the nostalgic and remythologizing the industrial landscape, is from Vladimir Nabokov: "...today our unsophisticated cameras record in their own way our hastily assembled and painted world."

Documentary photographs of Maine were taken primarily by "interested insiders" or "interested outsiders" who cared enough about the everyday activities of their communities to document them, or to whom such activities were strange and therefore worthy of commemoration. Thanks to the tourist industry, most Maine photography until recently has fallen under the latter category, although the former is the more difficult task. The ordinary is oceanic, hard to separate from ourselves, hard to prioritize. When I was a kid buying ice cream from Will Todd, the much respected proprietor of the old Georgetown Store, it would never have occurred to me to see him as an artist. Yet I recently heard about a large collection of glass negatives taken by

ROBERT SMITHSON, *Negative Map Showing Region of the Monuments Along the Passaic River*, and *The Fountain Monument*, from "A Tour of the Monuments of Passaic, New Jersey." (Photos: Robert Smithson, courtesy of Nancy Holt). Smithson could be called a cantankerous proto-postmodern regionalist; his 1967 trip to his home turf of Passaic resulted in a series of twenty-four photographs and a now-classic account published in *Artforum*. Simultaneously involved in the place and self-consciously removed from it, he reflected a sense of suburban unreality, writing with typical ambivalence of "photographing a photograph," of walking on a bridge as though he were "walking on an enormous photograph," with the water beneath it "an enormous movie film that showed nothing but a continuous blank." At another Passaic site he remarked on a landscape that was "no landscape but...a kind of self-destroying postcard world of failed immortality and oppressive grandeur."

Photoeditor Ellen Manchester emphasizes the importance of helping writers, historians, and specialists in various fields "learn how to read photographs and to reconsider photography's importance in understanding and defining historical and contemporary attitudes toward the land." Such skills are crucial. How can "experts" be expected to read landscapes if they cannot read pictures? Perhaps the only lay people who are really able to interpret social landscapes are locals— those who can recognize subtleties of change within a place over time, who know what the lumps and bumps once were and what has replaced them. But even local people need help in reading images, need education about what to look for outside of their immediate experience. "Between an exposed photographic plate and the contingent acts whereby people read that inscription and find sense in it lies the work of culture."

"Do I believe in this photo?," asks Chicana artist Amalia Mesa Bains of a beautiful 1913 photograph of her grandmother and family in Mexico. "I have to. It holds for me, like a transitional object, my own security, ancestry and legacy, my own 'Mexicanidad.'...This image is 'true' for me because its open permeable quality has become a historical site where, as the years go by, I accrue and imbue meanings deep in archival memory, fantasy and curiosity."

Photography has been so central to African Americans...more than any other artistic practice, it has been the most accessible, the most present in our lives....[Snapshots] enable us to trace and reconstruct a cultural genealogy through the image.
— BELL HOOKS

The snapshot is the personal photographic equivalent (or support) of the local narrative. In lieu of ancestral homes, over the river and through the woods, we have recorded oral histories and old photographs to visit. They permit us to go back along a path and notice

Will Todd in the early 1900s. Transcending the common family portrait, they show Georgetown life with flare and detail. Nationally known professionals F. Holland Day and Clarence White also worked in Georgetown.

When part-time Georgetown resident Vance Muse found an album of turn-of-the-century photographs in an antique store, his interest was piqued by images of same-sex couples and the history of "passionate friendships" in those days. He traced the album back to a wealthy Philadelphia family who summered on Bailey Island in Casco Bay. After intensive research, Muse has written a book on the photographs and organized an exhibition (shown at Brunswick's Pejepscot Historical Society in 1996).

things we missed when or if we were "there." Photographs are seen both as "facts" and as ghosts or shadows. They are the imperfect means by which we fill the voids of memory in modern culture, to preserve the remnants of a world that has disappeared. Often we don't even know who the people in the photographs are, or where they were taken.

Most old family photographs are simultaneously tantalizing and unsatisfying. I can spend hours perusing mine, extricating the fragments of narrative, knowledge, and empathy that are left to me. Yet I'm struck by their unbridgeable distance, their consistent failure to represent what I really want to see and know about the past. It seems as if "the wrong pictures" always got taken. What appears is a peripheral view dictated by convention, by a lack of connection between known familiar reality and the social formalities of picture-taking that maintain relationships established in the nineteenth century. However, these images are what we have left, the deeds to our pasts.

Family histories are transparent or opaque layers over maps of places we've never seen. Many of us come in touch with our family history only sporadically, through parents' and grandparents' stories. Home movies are now being studied as indicators of local history: the Center for the Study of Southern Culture in Oxford, Mississippi, runs an outreach program to alert people to the way local family films can counter the images made by outsiders and give insiders a forum within which to clarify and expand their own places. Even funeral homes advertise "tribute programs," memorial videos made from family photos and footage.

A family still in place is a direct tie to our own history. Barbara Allen writes poignantly of "the genealogical landscape" in south central Kentucky as revealed in years of conversations and driving local routes with her mother-in-law. ("Which way did you come?") The local landscapes are small and detailed, changing within a few miles. Every place is identified with a family; whether or not they still live there, it remains so-and-so's "homeplace." "That generational memory produces an emotionally powerful sense of place that almost defies articulation....this sense of interconnectedness of people and land [constructed in conversations], thus seems to be at the heart of the southern sense of place." "If I could see a *name*," says her mother-in-law of a house with no marked mailbox, "I'd know *where* I'm at." Impermanent, landless tenants, on the other hand, are not on the map. A family displaced and divorced from place is already distant. Returning to the homeplace when it has been swallowed up by a development, a strip, or a barren wasteland, when familiar names have vanished from the neighborhood, is like visiting a grave.

MARY LOUISE INGSBY-WALLACE-THOMPSON (with digital collaborator Rashda Arjmand), *Piano...Paid*, c. 1993. This is a portrait of Rosa Lee Ingsby-Wallace, described by her daughter Mary as "a very determined young black motherreaching and working for her dreams." In 1928, with the money she earned as an expert seamstress (she made the suit she wears in the picture), she bought this piano—"the only one in the neighborhood." Remembering her mother, who died when she was in kindergarten, Mary Thompson says "the piano has been a part of my life for twenty-five years and I still have the beautiful scarf and flower vase that used to adorn it." This piece and the short essay accompanying it is part of "Extended Family: Reclaiming History," a project directed by Esther Parada with the Afro-American Genealogical and Historical Society of Chicago, projected to become a book and a website.

Francis Oliver, the last surviving Georgetown male named Oliver in a line that goes back to the 1600s, with the house where he was born, 1996 (Photo: Peter Woodruff). A cantankerous local wit and world traveler, Oliver walks the roads, sticking cans and bottles on branches to chastise the litterers, creating a kind of public art in the process.

Mythic pasts meet and mix in archival photographs of places as well as in family albums. Stories, photographs, and memories often contradict each other. Sometimes our memories are so strong we can't believe our eyes when confronted by our own pictured pasts: the big house on the hill looks modest in the picture and the beautiful aunt who died young seems kind of plain. Sometimes we see through our lives to those of our forebears and their sites. Sometimes we know them firsthand, the places where those stories "took place," although these days we are more likely to visit elderly relatives in nursing or retirement "homes" than to spend holidays at the family homestead.

Images can survive but lose their places. Once I was going through family pictures with an elderly cousin when we came across an unlabeled snapshot of a small white clapboard house. She had no idea what it was and wanted to throw the picture out. I insisted on keeping it. But why? The house had been disconnected, come unglued from any historic or personal context. Its meaning lies buried forever. Yet it holds its place in family history, independently. It belongs in the album, unlabeled. Photographs root other places in one time, one moment. I recall my grandparents' house in Marlborough, Massachusetts, as a small clapboard house on the edge of a factory town, with a big yard, a small orchard, a vegetable garden (I can still smell the equally sweet scents of blossoms and decay), and a farm across the street where my father had worked as a boy. The tiny gas station my grandfather leased after retirement from the shoe factory, within walking distance, was heaven for a visiting city

child; I could treat my friends to Necco Wafers from the glass case inside and soda pop from the ice-filled Coke cooler outside. It was always early or late summer when we visited; in all my recollections, in all the pictures, the sun is shining; my white-haired grandmother with the soft Canadian-accented voice and flowered housedresses even baked cookies. The last time we drove by this "homestead," long after my grandparents' deaths, the town had engulfed it and the house had become a Chinese restaurant.

In recent years, there has been a flurry of "rephotography" projects in which memory (an earlier photograph) is juxtaposed with present experience (a contemporary shot of the same place, from the same angle). Sometimes the contrast reveals "lost wilderness," and sometimes just the opposite—when the site of a thriving mining town, for instance, has "gone back to nature." (Sometimes strange matches are made, as though one image has been laid over another in a double exposure.) Jan Zita Grover contends that the stories told by vernacular photographs of altered landscapes have been misrepresented by contemporary interpretations: they were not about "what we have destroyed" but about "what we have built....people were proud of their interventions in nature....It is a perversion of their historical presence to ignore them for a mere testimony to a past that never was."

Local newspapers have taken up this "Then and Now" idea. The captions are usually perceptual and ahistorical, along the lines of the cartoon: "What has changed in this picture?" The road was dirt, the screen porch has been added, there were no power lines. This is a strictly visual presentation, offered less for edification than for entertainment. At the same time, such comparisons cannot help but trigger curiosity and memories for those alive in, say, 1909, when the road *was* dirt, the power lines *were* inconceivable.

There are frequent letters to the editor about inaccuracies. People care about the landscapes of their childhoods. At the Hopi Cultural Center in Arizona, old (and often demeaning) photographs by Anglos of the mesa villages are perused for relatives or remaining views and structures with equal enthusiasm. The process of familiarity overwhelms, at least temporarily, the grating colonial memories.

Family connections and memory draw us into the photographed spaces rather than leaving us gawking at the window. We "read into" those spaces with vocabularies based in our own lives. The late British photographer/theorist Jo Spence developed with Rosy Martin a "reenactment phototherapy," based on old family pictures, paralleling landscape rephotography. Concerning the porous nature of the combined image and interpretation, she wrote, "we should use photos to ask questions rather than to show facts." Many contemporary photographers have made substantial photo-text series about their own families as a way to explore culture and place, in which they have tried to avoid both convention and idealization. Karen Ellen Johnson, for example, uses family papers and old as well as new photographs in several bodies of work about her Midwestern family. She explores not only poverty, alcoholism, infidelity, and the strength of maternal bonds but also their context—the unfulfilled expectations of rural families that have left the farm. Her work centers on "the interplay of memory and artifact…the boundary between cultural icon and personal relics." Such boundaries and tensions define place, as well as private and public spaces.

Women's reciprocal approach to looking into places, reflecting a different set of lived experiences of land and place, might be called "vernacular." In a 1994 essay on women's landscape photography and the ways it has been subordinated to men's visions and domination of the land, I argued that perhaps the "feminist landscape" is an "acculturated landscape" incorporating a critique of landscape altogether by being more attuned to the local/personal/political than to the godlike Big Picture. (I should note that many feminists consider this viewpoint complicit with dread "essentialism.") I suggested the reason that there have been no women photographers to play Eve to two generations of Adams (Ansel and Robert) is that women's frequently calmer and more intimate approach to landscape is not exciting enough to appeal to a public taste formed by the dramatic (and possessive) spectacles of the BLM (Boys' Landscape Movement). Photographer Linda Connor, along the same lines, suggests a

KAREN ELLEN JOHNSON, *Approaching Mom*, 1949/1995, silver print with ink. Johnson grew up in a working-poor family in the Midwest. The first generation to leave the farm, her parents were influenced by rural family expectations but, torn by poverty, alcoholism, and infidelity, their marriage dissolved. The handwritten text here reads in part: "With a 'pride of possession' gaze, Grandma presents me to the camera…Mom watches from backstage. I stare yet again at this image, trying to decipher the layers of meaning presented there…." About her exhibition (at the 494 Gallery, New York, 1995) also titled "Approaching Mom," Johnson wrote that she was probing "the economic, cultural and psychological terrain which influenced my experience of being mothered" and dealing with "the dialectic between private memory and public history" as it is exposed in artifacts like family pictures. Highlighted by an artist, casual snapshots can tell volumes about people and place.

The George and Abigail Todd House c. 1890 (photographer unknown), and in 1996 (Photo: Peter Woodruff) looking North down Kennebec Point across the neck between Heal's Eddy and Sagadahoc Bay.

Few women photographed in Maine. The best known is Chansonetta Stanley Emmons of Kingfield. But Emma D. Sewall, who lived in Bath, made images of rural, coastal working life and women's work between 1884 and 1899. In the 1930s, the

FSA sent Jack Delano to shoot "the trailer life and boarding houses scene" of the Bath Iron Works. His "evocative photographs of lonely men in smoky bars" have yet to be reprinted. Berenice Abbott documented Route 1 up the coast in the early 1950s and

connection between a male dog's territorial pissing and the "Bob Loves Ginny" she saw carved into a thousand-year-old pictograph. (Would Ginny choose to commemorate her own affection on one of the hundreds of adjacent *blank* rocks?)

If men find the unknown irresistible, as Susan Griffin has suggested, many women feel the same way about the known. With some irony, Connor puts it this way: "we are nature, so why venture very far?" Christine Battersby, scrutinizing the ways both the sublime and the picturesque in the nineteenth century were equated with women's bodies and sexuality (regular and beautiful, irregular and ruined) has called for a "cross-eyed" feminist gaze that disturbs "the directness of the male gaze by looking in (more than) two directions at once," raising the difficult question of "how a photographer who is seeking to develop a specifically female viewpoint on the landscape of patriarchy can prevent herself being read as simply merging back into that landscape."

Carrie Mae Weems achieves this kind of visceral identification in her work on the Sea Islands off the Georgia/Carolina coast. Years earlier, disoriented in her graduate study of photography that seemed to be going nowhere, she found her way when she read Zora Neale Hurston's *Their Eyes Are Watching God*. It led her to a degree in folklore and the development of a unique body of photo-text work concentrating on language, culture, family, and place. In 1992, the Sea Islands project emerged when she *Went Looking for Africa* (the installation's title) in the Gullah culture, where some of the African American inhabitants can trace their ancestry and their religion back to the Temme tribe of West Africa, as well as to the Seminole

59

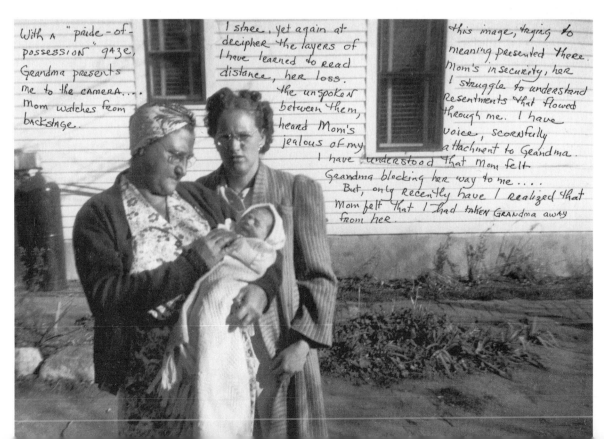

With a "pride-of-possession" gaze, Grandma presents me to the camera.... Mom watches from backstage.

I stare, yet again at decipher the layers of I have learned to read distance, her loss. The unspoken between them, heard Mom's jealous of my I have understood that Mom felt Grandma blocking her way to me.... But, only recently have I realized that Mom felt that I had taken Grandma away from her.

this image, trying to meaning presented there. Mom's insecurity, her I struggle to understand resentments that flowed through me. I have voice, scornfully attachment to Grandma.

published *A Portrait of Maine* in 1968. John McKee caught Maine's seamier side. "His image of a traditional street scene of Old Orchard Beach," writes C. Stewart Doty, "complete with 'no parking' signs, placed tourism in a new light," as did "the 'no trespassing' signs that deny Maine people's access to the shore, and open sewer pipes into the ocean." In 1978 the documentary task was taken on by the Salt Center for Documentary Field Studies in Portland. Oddly, the coastal images included in its most recent anthology are the least interesting group, as though the coast had been "done" to such an extent that even the best photographers were wearied by the weight of its past.

Indians. "I'm really only interested in spiraling deeper and deeper and deeper into this cultural place that I happen to occupy," says Weems. She wants her work, under the right circumstances, to be "a catalyst to memory, a catalyst to some sort of action, a part of a force, a movement for something bigger." And she is adamant about her art's distance from the first person, describing it in terms of resonance—"a communal voice, a voice of a group, a voice of a class."

Weems's straightforward photographs are usually unpeopled, although the inhabitants are always present in their created landscape, even in their absence. The images show homes, stores, churches, graveyards, extended by texts drawn from local lore. She uses installation techniques to endow her photographic series with a rhythm, a substance beyond photography or art itself which is the product of her folklife studies and her lived experience. Images are accompanied by suggestively formatted texts from proverbs and legends: next to the picture of an old brick slave quarters is a house-shaped block of text that begins, "when you move into a new house, remove old spirits by washing around the windows and doors with vinegar water," and ends, "never build an addition to your house. A home can never be extended." Elsewhere, history is traced in one line: "Gola/Angola/Gulla/Gullah/Geechee," leading from an African nation to a patronizing diminutive for its cultural descendants. In one photograph, leaning hub caps are set carefully on end. These are what Robert Farris Thompson has called "flashes of the spirit," charged objects that function as spiritiual magnets and deflectors, legacies of African religions. But Weems makes clear that her references are not just about ethnography as entertainment and "not just vernacular culture—it's class." In this as in many of Weems's images, the culture *is* the landscape.

CARRIE MAE WEEMS, *Untitled*, silver print, from the 1992 installation (of photographs, texts, and ceramic commemorative plates) *Untitled (Sea Islands Series)* (Photo: courtesy PPOW, New York). A lacy mattress spring hanging from a branch is almost invisibly integrated into the land, at once barrier, ornament, and sign. bell hooks interprets this image as revealing "the place of technology in agrarian black life...the mattress spring that becomes the backdrop in a natural, pastoral world, where it appears in union with nature." While other images in this series are more overtly anecdotal, the mattress suggests more stories than it tells, hovering, as does much of Weems's work, between formalism and folklore.

Out of Place

I only love my country when I am far and away. Elsewhere—that's where I belong:
the vast diaspora. Nowhere and everywhere.
— ILAN STAVANS

The man who finds his homeland sweet is still a tender beginner;
he to whom every soil is his native one is already strong;
but he is perfect to whom the entire world is as a foreign land.
— HUGH ST. VICTOR

A wandering Jew is at home only in time.
— STEPHEN KERN

Remembering is never a quiet act of introspection.
It is a painful re-membering, a putting together of the disembered past
to make sense of the trauma of the present.
— HOMI BHABHA

IF LANDSCAPE IS A WAY OF SEEING, THERE are potentially as many landscapes as individual ways of seeing, or at least as many as cultural ways of seeing —although some people seem threatened by this degree of multiplicity. Otherness and familiarity are reinforced by impressions of landscape. Backgrounds inevitably affect foregrounds. Part of the yearning for a homeland left behind is a sense of space and place that differs from the hybrid one that has come to be seen as generically "American." Given a choice, people often immigrate to geographies that remind them of home.

Studies of place and identity overlap in many ways. While the U.S. continues to think of itself as a "young" nation, an American national identity actually preceded those of Italy, France, and other countries that were just knitting together various states and cultures into nations; "It was Americans who became Ohioans and Iowans and Oklahomans and Oregonians, not the other way around as in Europe." Everybody in the United States is in diaspora—diffusion.

Maine is the second whitest state in the Union, surpassed only by Vermont. Aside from Jamaican, Mexican, and Central American migratory workers who pick apples and blueberries, and the African Americans posted at the Brunswick Naval Air Station, among other military bases, multiculturalism in Maine is mostly a matter of Anglo/Franco relations. The Protestant Scotch/English settler population (augmented by Irish Catholics in the early 19th century) has long been leavened by French Canadians from Acadia.

One of the best-known local 19th-century paintings, by John Hillings, shows the burning of Old South Church in Bath in 1854, one of a series of attacks on Catholics and new Irish immigrants by the "Know-Noth-

62

The more recent the move, the rawer the wounds of people wrenched involuntarily or unhappily from their homelands, and the more hope battles with hostility. We North Americans don't see ourselves as refugees, as victims of wars and natural disasters, but our frenetic mobility is externally driven and a culture is changed whenever it is joined by new groups. People like me, whose ancestors (on one side) have been here for centuries, are being swept into a new culture just as surely as newcomers are. An increasing number of our towns are border towns, wherever they are located; they are a great undigested diversity, currently described as a "salad," a "mosaic," a "stew," or a "patchwork quilt," rather than as a "melting (down) pot." This vivid ethnic mix changes everything, from the look of our neighborhoods to the food we eat. But one of its ingredients is a powerful urge toward assimilation and homogeneity, accompanied by a need to focus on the present which allows only a few selected Americans to recall and value their past. Cultural interpretations of space may vary from place to place even as recent immigrants insist they are "Americans" first and foremost.

> The second generation here are not interested in their ancestors [because] we have never told them of the realities of life [in Ireland], and would not encourage any of them to visit....When we left there, we left the old world behind, we are all American citizens and proud of it.
> —ANONYMOUS IRISH IMMIGRANT

A major cultural factor within any group is the period, means, and reasons for immigration. Those Native people who were here when Europeans first came, those English who came for religious freedom and/or civil freedom, those Africans who were shipped here involuntarily for labor, those Asians who came under restrictions disallowing family members, those Irish and Italians who arrived under duress of famine and poverty, those Russians who were escaping pogroms and war, and those Mexican, Central American, Caribbean, and Asian people who take tremendous risks to come without permission, hiking over fortified borders or rafting rough seas—each group comes with a different set of needs and expectations.

Immigrants are often involuntary exiles. The Irish word for immigration actually means "exile," which in turn implied death; when famine forced the Irish to migrate in the late nineteenth and early twentieth centuries, wakes were often held for those who were leaving the homeland and would probably never return. In past centuries, first generation immigrants were called not "Americans" but Swedes, polacks, limeys, canucks, hunkys, hopping frogs and other less flattering epithets. Hyphenation came later. Today, many Americans "live on the hyphen," or as Coco Fusco has put it, in a hybrid space that can be seen as "a shelter between cultures." They are identified by two words, balanced between where they come from and where they have gone—Native people who return periodically to the reservation, Puerto Ricans and West Indians who go back and forth between North America and the islands, for example. Yet many people who are said to "live between two cultures" do not; they live as alienated outsiders within one culture. Deculturation and deracination hits every individual life in different ways, so some remain attached to their origins while others find new homelands; still others remain suspended forever over the abyss, in what Amalia Mesa Bains has called "a landscape of longing."

A hybrid culture can be fertile ground for multicenteredness, while assimilation can be a weapon against history, burying multiple pasts under a single marker. Richard Rodriguez, a gay Chicano writer and commentator whose resistance to "multiculturalism" has made him an outcast in many progressive Latino

ings." In 1875, James Healy of Maine, a former slave, was consecrated as America's first black Catholic bishop. The Irish perceived him as having "indelicate blood" (though he was part Irish) and religious bigots burned down the Catholic Church of St. Joseph in East Machias in protest.

In 1995 a nine-year-old girl from Greenville, Maine, won the national prize offered by a dinnerware manufacturer for a plate design "honoring America's multicultural character."

When Arthur Davis opened a Bonsai nursery in rural Woolwich, his friends asked him what a black man would do "in that all-white, frigid, godforsaken place?" He likes it, and the business is a success, since the Maine climate is especially favorable for Bonsai cultivation.

circles, enters the fray with a complex argument that assimilation can be a subtly aggressive act against the dominant culture. When asked if he felt more Mexican or more "American," Rodriguez replied perversely that he felt more Chinese, since he lives in San Francisco, which is strongly colored by that culture. He also reverses the history of the conquest of the Americas, wondering who has assimilated who. As a *mestizo* (mixed blood) he writes:

> I represent someone who has swallowed English, and now I claim it as my language, your books as my books, your religion as my religion—maybe this is the most subversive element of the colonial adventure. That I may be truest to my Indian identity by wanting to become American is really quite extraordinary.

Coming from the other side of the political spectrum, Mexican-born-and-raised performance artist Guillermo Gomez-Peña also advocates mixture as a weapon against conformity and repression. He contends that he no longer has a one-word identity because he is geographically defined as Mexican, Chicano, and Latin American; he is *Latino, chilango* or *mexiquillo, pocho* or *norteño* or *sudaca*:

> We witness the borderization of the world, byproduct of the "deterritorialization" of vast human sectors. The borders either expand or are shot full of holes. Cultures and languages mutually invade one another. The South rises and melts, while the North descends dangerously with its economic and military pincers. The East moves west and vice-versa. Europe and North America daily receive uncontainable migrations of human beings, a majority of whom are being displaced involuntarily.…the weary travelers, the dislocated, those of us who left because we didn't fit any more, those of us who still haven't arrived because we don't know where to arrive at, or because we can't go back anymore.

Despite the fragmented configuration of all our centers, common ground among ethnicities can be offered by geography; a long string of communities along a river's banks may have more in common with each other than with inland towns closer by. And

LUIS JIMENEZ, *Plaza de las Lagartos*, fiberglass and misting fountain, installed June 1995, San Jacinto Plaza, El Paso, Texas, 9' 1/2" x 9' 1/2" x 10' (Photo: Frank Ribelin). When Jimenez was a child in El Paso there were live alligators (*lagartos*) in a pool in the central plaza; they had been there since the 1890s, but were removed to a zoo in the mid-'60s because people abused them. The plaza continued to be called, unofficially, *La Plaza de los Lagartos*. Years later, now a nationally known sculptor commissioned to make an artwork for the plaza, Jimenez brought back the alligators, which form an emotional link with many residents' childhoods: "It was the best part of going to Downtown," recalls Irma Salazar. "We would just sit there and look at them. They didn't do much, but it was a real thrill to see them." Rearing up, jaws agape, Jimenez's creations are more spirited than the lethargic originals. A fine mist is supposed to keep them wet and lifelike, but after the sculpture's dedication—a major event, prompting news stories and personal reminiscences—it was turned off because it made the pavement slippery.

A conductor of the New York Philharmonic (a patient of Dr. Robert Read, husband of the influential matriarch Anne Lauriat Read) built a house in 1905 but stayed only a few summers on Kennebec Point, because he was Jewish and did not feel welcome in such a WASP's nest. These attitudes have been slow to disappear, although younger generations have begun to culturally "marry out" of WASPdom in various directions. Until very recently Jewish families (and homosexuals) have not been made to feel comfortable by some residents. A Jewish friend of mine, who insisted on stalking around L.L. Bean country in shorts, heavy city shoes, and knee high black socks, swore never to return; another couple of close friends rented on Kennebec Point for years, but

within each town there are the class-based boundaries: "the other side of the tracks" is a geographical distinction, like " the folks on the hill," "east side, and west side." Commonality can also be imposed—by fear of the Ku Klux Klan, by the impermanence of migratory workers' camps, and by the architectural homogeneity of company towns, where ethnic tastes and decoration are suppressed.

Subtle cultural markers that hint at the history of towns and areas can be caught by a good eye and ear. John Coggeshall writes about ethnic geography in the town of Herrin in the "Egypt" region of southern Illinois (where towns are named Cairo, Karnak, or Thebes, and coal mines attracted Polish, Slovak, and Italian immigrants). The Polish communities gathered around Catholic churches in which old customs were nourished and place names from the old country

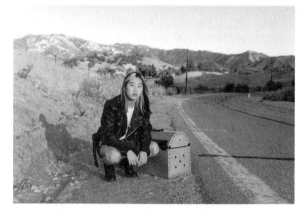

STILL FROM MAMA BLUES, 1993, a 30-minute color film by Jae Soh, written with Nina Blake, starring Debbie Ha, Adam Thompson, Eric Dickey, Stacy Chun and Bok-Nam Cha. The film follows Christina, a hip young Korean American woman, as she hitchhikes from Alaska to Los Angeles's Koreatown in search of her mother, whom she finds just as two young African Americans rob her liquor store. In an attempt to find a home and an identity, Christina confronts racial and generational obstacles. Jae Soh shot the film two months after the riots in his hometown of Los Angeles, but had written the script some time before the rebellion.

maintained. Slovak homes were identified by the fences around them. The Italians, late arrivals, weren't able to name streets or cities after their original homes, but they established a conspicuously Italian business center and residential neighborhoods in which everyone had a grape arbor and a vegetable garden.

Our life depended not on the time clock, as in America, but on the seasons. This is much more exciting and interesting than working in the city, where every day you go to work at the same time and do the same boring tasks. Our agricultural schedule was flexible, diverse, closer to nature, and enjoyable.
— ANONYMOUS VIETNAMESE IMMIGRANT

Asian immigrants have their own singular memories and bonds to homelands, which they share indirectly with Asian Americans. Like indigenous people generations before them, the Chinese in pioneer California saw latent fertile soil and uses for wetlands and other marginal areas, in "weeds" that were underestimated by Americans. This "ability to see the potential in the most mundane things may be the greatest contribution of the Chinese immigrants," says Sandy Lyon. Today we hear similar strains from the accounts and oral histories we are just beginning to receive from the recent wave of Southeast Asian immigrants. (In spring, next to a hiking trail I frequented in Colorado, there were often Vietnamese women collecting plants I didn't recognize on the trailside.) For many Vietnamese displaced during the "American war," leaving their native villages, homes of their ancestors, was almost as wrenching as migration to another country. The importance of place and nature in Vietnamese art has crossed the ocean with immigrants, and it figures prominently in Vietnamese reminiscences and art.

Given the deep ties of first-generation immigrants, and the agrarian heritage of many who have come here, there is surprisingly little written or visual material on

settled on Indian Point where the population was more diverse and they were not scornfully called "renters."

Maine's small African American community dates to the 17th century; by 1764 the census listed 322 free black people and slaves, two of whom supposedly lived on Kennebec Point in the late 18th or early 19th century. (One, called "Old Black Joe," may have lived in my meadow.) Thanks to "revisionism," the black history of New England is finally being explored. Tiny Malaga (Abenaki for Cedar) Island, nearby at the mouth of the New Meadows River, was unique in Maine—home to a small group of black, Indian, mixed race people and other outcasts for about a century until they were evicted en masse by state officials

place and specific experiences of place in Asian American experience, although there is a good deal of powerful art on the impact of displacement on identity. Patricia Limerick has written eloquently about the obstacles to writing an evenhanded multicultural history of landscape without firsthand sources other than those of high-handed white men. In her search for Asian American responses, as part of a project to understand the American landscape as discovered from West to East, she has gone to the literature, beginning with the poetry scratched on the walls of Angel Island in San Francisco, the vantage point from which most Chinese immigrants "discovered" Gold Mountain, as they called America. (There are also Chinese poems scratched into the walls of Ellis Island.) Limerick attributes the paucity of information about Asian immigrants' responses to the landscape to the "failure of records and not a failure of response," noting that there were few land-owning literati among them to do the recording. It is almost always the relatively leisured middle class that does our looking for us and provides our memories.

This is a challenge that was taken up by Korean American artist and activist Young Soon Min in her complex 1994 installation *DMZ XING*, commissioned by Real Art Ways, in Hartford, Connecticut, and displayed at the Hartford Civic Center Mall, among other venues. Suggesting that crossing into a metaphorical demilitarized zone is the core of immigrant experience, Min constructed an open circular room of glass and mirror panels, illuminated by flashing red lights, to tell the stories of refugees to Connecticut from Cambodia, Laos, Korea, and Vietnam, based on interviews conducted over a six-month residency. They are interwoven with the artist's own immigration experience, which ends with these words overlaid on a

DOROTHY IMAGIRE, *Madbury Community Calendar*, 1992, Durham, New Hampshire. Related to New England-based photographer Imagire's "alien-nation" series, concerned as is most of her work with the mixed-blood's confused sense of divided community, this is a plant calendar based on the Community Club's "multicultural" garden, cultivated by the artist and others. It includes plants that are Japanese American, Italian American, South African American, Russian American, and so forth. Imagire (whose background is Japanese and Iranian) came across a book on the origins of plants and was surprised to find so many of those common to Madbury were "from away." The botanical language made her "rethink words like colonizers, invaders, natives, immigrants, and aliens," she wrote. "I hope the origins of the plants inside this calendar surprise and please you too."

because they "offended the propriety of everyone nearby." (They also threatened a burgeoning tourist industry, although turn-of-the-century postcards suggest they were a curiosity in themselves; Holman Day, among others, photographed them.)

Malaga was founded by a former slave and fisherman who squatted there with his white wife and children. Economic recession forced the community into joblessness and in 1903 aid was requested from Phippsburg, which was disinclined to add to its welfare

rolls and argued that Malaga belonged to Harpswell. It was called a "no man's land," where poverty and intermarriage combined with lack of good Yankee planning ahead made "March Hill" an annual obstacle. But one writer noted that the Malaga residents

66

self portrait: "For those of us whose histories have been marginalized, or who have been colonized or displaced, or have lost a 'heartland,' memories are all we have…we must re-member and re-invent and create new contexts for our histories and ourselves."

JOAN MYERS, *Garden, Gila River, Arizona*, 1985. Platinum-palladium print. At every camp, the internees built ponds, public and private gardens, planted fruit trees and vegetables. Kango Takamura recalls that in the first year at Manzenar, the place was shadeless and miserable, but eventually, with the addition of water, "the green grows up. And mentally everyone is better." Jeanne Wakatsuki Houston mused over the garden ghosts on her return to the camp: "It was so characteristically Japanese, the way lives were made more tolerable by gathering loose desert stones and forming with them something enduringly human. Each stone was a mouth, speaking for a family, for some man who had beautified his doorstep."

"Fundamentally," writes Vishakha N. Desai, bicultural Asian Americans "no longer have the choice of belonging to one place, one culture, or one country. Their sense of 'home' is no longer equated with an unqualified sense of belonging.…" When artworks by Asian Americans do deal with place, they tend to do so through global politics or through tourism—the most alienating experience of place. (Best known is the work of the late Tseng Kwong Chi, who appointed himself "unofficial abassador of China" as he saw and photographed the sights of North America wearing a "visitor" badge.) The sense of an unfinished journey pervades much Asian American art. "It's a journey back that I am always taking," writes Filipina American poet Jessica Hagedorn.

were "not vicious...and they extend the rude hospitality of their island with touching warmth and sincerity."

In 1912, however, the state took control of Malaga, evicting 56 residents, paying only one family for its land. The buildings were torn down and even the graveyards were exhumed; no trace was left on their native ground. Some built rafts and drifted downstream to seek new lives, but most were transported to Pineland, then a school for the "feebleminded," where many lived out their lives. One resident reported their fate in a 1912 *Bath Independent*: "Eliza Griffin has moved over to the main, but she visits the old home every day so not to be homesick nor to give up her rights....The others of us are having hard times to find homes anywhere."

The generational sense of loss felt by a "floating population" of exiles applies with particular intensity to the first-generation Japanese-American farmers (*issei*) who were instrumental in "taming" and irrigating the west; and to 110,000 of their second and third-generation descendants (*nisei* and *sansei*), most of them American citizens, who were unconstitutionally interned in desert concentration camps during World War II by the infamous and unconstitutional Executive Order 9066. This "mistake of terrifically horrible pro-portions," as John Hersey called it, was not just the result of war hysteria but of a long history of anti-Asian sentiment on the West Coast, where prewar analogies were made between a "Japanized" California and a "Negroized" South. Over half the first American-born generation of Japanese Americans had worked in agriculture, teasing far more from the soil (when they were legally allowed to own land) than the average Caucasian farmer. When they were forced to abandon their lands and crops in 1942, one strawberry grower asked for a few days deferral so he could harvest; it was denied, and in anger he plowed the berries under, an act of justified bitterness for which he was arrested by the FBI as a saboteur.

By the time the absurdity of the internment finally became apparent in 1944-45, many West Coast Japanese Americans had lost their land, houses, and possesions to the government, tenants, or vandals. This second internal exile was often more painful than the first. For the *issei*, the American landscape was a foreign land with potentially fertile soil on which they worked, and worked wonders; for the *nisei* their birthplace was suddenly rendered sterile and futureless, symbolized by the barren, desolate places to which they were banished in the western deserts in 1941.

The poetry and memoirs of Japanese Americans torn from their urban farming lives and thrown into dry, windy, dusty desert concentration camps are poignant testimony to the deracination other Americans have suffered less noticeably. "All residential blocks looked alike, people were lost all the time," recalled artist Miné Okubo. Toku Shimomura wrote from the camp in Minidoka, Idaho: "What a view! I have never seen such a dust storm. We were sent to such a harsh place." "City of Dust" in "surroundings as bleak as a bleached bone" is how Yoshiko Uchida described the Topaz camp ("Jewel of the Desert") in Delta, Utah. "The floor is carpeted with dust, wind-borne / dry alkali, patterned by insect feet. / What peace can such a place as this impart?" wrote Toyo Suyemoto Kawakami.

NOBUHO NAGASAWA, *Toyo Miyatake's Camera*,1993, bronze, 18" x 18" x 20 1/2". Little Tokyo Historic District, Los Angeles (photos: copyright Gary Hulton and Leslie Aboud). This oversized replica of the camera Miyatake used surreptitiously in Manzenar is one of Nagasawa's proposed series of thirteen small sculptures for Little Tokyo, spanning Japanese American history from 1843 to 1942. Miyatake's camera, as Michael Several observes, has become "a symbol of defiance and resistance" to internment. It stands on a corner where the photographer had played as a child and had his professional studio before and after the war, still operated by his son and grandson. At night, slides from Manzenar are projected from the camera onto a window in the new Japanese American National Museum.

One of the saddest tales of bigotry on Kennebec Point is recorded in a biography of Molly Spotted Elk, an extraordinary Penobscot modern dancer. It took place in 1923 at Camp Overlook, run by Mrs. Brown Rich Bowen, where Molly, aged 20, was hired to teach then-popular "Indian lore." (It was a coup to have a "real Indian" in residence.) Although she won a poetry contest and was well-liked, she was dismissed for stealing some jewelry and maybe even a canoe. "We didn't believe Molly took those things," recalls fellow-camper Dorothy Crocker Reed. "It was almost like a frame-up." (Camp Overlook was briefly succeeded by Camp Shelta-Sea for boys. Long after both camps' demises, we had Wednesday night community square dances in its main hall until the

Yet when landscape photographer Ansel Adams arrived to document Manzanar, in the water-deprived Owens Valley of California in 1943, he was first taken by the "grandeur of space.…I believe that the arid splendor of the desert, ringed with towering mountains, has strengthened the spirit of the people of Manzanar." He saw the camp as a "suitable haven" for "war-dislocated minorities." As Jan Zita Grover has pointed out, Adams focused on the distance—panoramas of the "sublime" landscape, and close-ups—portraits of the internees nobly sacrificing their lives to a patriotic whim, avoiding the contextual reality of bleak, treeless lines of barracks. He shot the cramped interiors with a wide-angle lens that made them look far more commodious and few of his images begin to suggest the freezing winters and burning summers, sandstorms, lack of privacy (and, of course, freedom). Adams was given much more leeway than other, more critical and political photographers like Dorothea Lange, but he too was ordered to decontextualize Manzanar, to document this "city in the desert" without showing guard towers, guards, or barbed wire. Photographs by the internees might have revealed these disjunctions between the outsider's and insider's views, but photographs were either censored in camp newspapers or internees were forbidden cameras. Toyo Miyatake smuggled one into Manzanar and his images were exhibited with Adams's many years later.

It was not the fearful landscape, but Japanese Americans' culture that lent them strength. They brought their farming genius with them to the barren land, cultivating thousands of acres to make the camps self-sufficient. Sometimes they were able to combat the devastating lack of water and greenery by creating an alternative landscape, or recreating their memory landscapes in miniature, making small ponds, gardens, parks, vistas and dioramas in the arid wastes. At Manzanar they built a Japanese-style "pleasure park" with pool, stone paths, wooden bridge and shelter; it must have been a surrealist vision of elsewhere in that landscape, and an unmistakably ironic symbol of hope and cultural resistance.

I was only an American Negro—who loved the surface of Africa and the rhythms of Africa—but I was not Africa. I was Chicago and Kansas City and Broadway and Harlem.
— LANGSTON HUGHES

African Americans, "first in legal bondage and later in economic peonage, constituted a kind of peasantry in the South." Their historical relationship to the land they lived on has been unique, still diverging hugely from that of other immigrants long after slavery was ended. The black families of white landowners, for instance, were given no part of their heritage. After the Civil War, former slaves found their forty acres and a mule insufficient to avoid becoming tenant farmers, or sharecroppers, and with every new Jim Crow humiliation and every lynching, more black people left for the North. The Great Migration, so movingly documented by the painter Jacob Lawrence, was bittersweet. Though "glad to escape from oppression, nostalgia for the more pleasant associations of the homeland assailed the exiles," writes Arna Bontemps, whose family went from Louisiana to California. They were "homesick for familiar speech, faces, and scenes," banding together in social and fraternal clubs named for their homeplaces —the Alabama Club, Mississippi Club, Vicksburg Club.

"Back then, no matter where you lived, *home* was where you came from, and it was just natural to go home to do something as important as having your child," says a character in Marita Golden's *Long Distance Life*. Later, when she urges her father to come North too, he tells her: "That farm, little as it is, is all I

floor began to give way. Today the camp provides summer cabins for the Brown/ Moore families.)

For at least 11,000 years, the Kennebec has been inhabited by Native groups. Historians are divided as to the precise identity of those living in coastal Sagadahoc but they appear to have been western Etchemin, ancestors of the contemporary Penobscots, with the Abenakis—"People of the Dawn"—living inland up the Kennebec and inhabiting the coast later. They were part of a larger group called Wobanakiak, which, according to Tomas Obamsawin, "better describes the region that we inhabit...'Aki' means land or earth, and the 'ak' on the end of the word signifies plural or 'all' of the land where the sun rises."

know.... Sides, they can't run us all out. That land's got more of our blood in it than theirs. Not all us s'posed to leave. Some of us got to stay, so y'all have a place to come back to."

Some of those who stayed behind, tied to, but not necessarily attached to, land that was usually not theirs, nevertheless held hopes for it, as in Robert Hayden's poem:

And if we keep/Our love for this American earth, black fathers,/O black mothers, believing that its fields/Will bear for us at length a harvesting/Of sun, it is because your spirits walk/Beside us as we plough; it is because/This land has grown from your great, deathless hearts.

Still others held a sense of historical loss expressed in the old spiritual "This World Is Not My Home" or in Jacqueline Joan Johnson's contemporary statement: "No matter where I lived, geography could not save me." It couldn't save her, but she acknowledges that three years as a child "in the land of my ancestors" marked her for life: "Charleston, my new home, was a place of okra gumbo, she-crab soup, shrimp and grits, day-old cheese-rolls and little jars of flowered sachets, red, red stockings that never matched anyone's complexion and lace hankies knotted in the corner with my money in it...."

Despite the extreme deracination of the African American communities, culture kept them going, and it moved with them. In some areas (like the Sea Islands, off Georgia and the Carolinas), true communities with deep roots remain to this day, founded when African Americans held on to title to islands in white territory or actual islands where their ancestors had landed. Fighting off both state and private developers who are buying up local residents' land and destroying longstanding customs and ways of life in order to accomodate a growing tourist industry, those on Sapelo Island, for instance, have already suffered the destruction of oyster and crab harvests on which they have traditionally depended. Sulaiman Mahdi, of the Center for Environment Commerce and Energy in Atlanta, who has worked with Sapelo Islanders, says "the issues of black-owned land and reparations cannot be dealt with in isolation from issues of ecological and economic justice. How we treat the land is reflected in how we treat the people who live on it: the protection and preservation of one demands the protection and preservation of the other."

Underlying any discussion of African Americans and the land is the harsh question as to whether the South is a "racist landscape," unloved by or unloveable to those who have suffered in it. A reply is provided by Carol Stack's book *Call to Home*, in which she documents an unprecedented return to the South by the children of the Great Migration to the North. "Speak of the South as you will," she says, "but you still have to speak of it; there is no forgetting a southern upbringing." The returnees go back not to urban strongholds where change has settled in but to tiny rural communities where life will be harder than anything they have known in the North. They are looking for something else, something that is both inexplicable and undeniable. Stack quotes Earl Henry: "When you return to your homeplace, you go back to your proving ground, the place where you had that first cry, gave that first punch you had to throw in order to survive."

Melvin Dixon has explored "the dilemma black American writers have faced in resolving their sense of homelessness or in exploring the often puzzling relation between land and family." In their search for a home in this world they have created alternative American landscapes in art and literature that narrate journeys, havens, refuges, and freedom. Dixon identifies these as wilderness, underground, and

Today the Penobscot reservation consists of some 200 islands in the Penobscot River between Old Town and Medway, about 4,800 acres, plus 55,000 acres of trust land "protected" by the US government and about 89,000 acres that are "unprotected." Indian Island is the largest settlement, with 600 people, and about 1200 Penobscots live off the reservation.

"One of my friends lives in the suburbs of Nashville," says a Passamaquoddy man, "and it is just like being in a container, which is subdivided into a hundred square blocks and everybody is in their own little block. My friends didn't seem to know too many neigh-

70

mountaintop—"broad geographical metaphors for the search, discovery, and achievement of self." Wilderness was the spiritual harbor where enslaved Africans held their religious and political ceremonies, hidden deep in woods or swamps, where they ran to escape as well. (In the twentieth century, "brush dances" were still held in the remains of western Kentucky "wilderness.") Underground was also hidden, as in the underground railroad, getting down to move up and out. And the mountaintop, in the work of Toni Morrison and the famous speech of Martin Luther King, Jr., is the reward for "riding out" oppression.

Ruby Lerner has remarked sadly how chauvinism and self-loathing in the black and white South have led to devaluation of the local, a loss of self sufficiency and self esteem which becomes a self-fulfilling prophecy. However, black and white people in the south do share a sense of the landing, and of cultures embattled but interwoven. At rare moments the complexity of race and racism is transcended by consciousness of a common (if injust and unequal) history.

After the Civil War, many African Americans moved west with great optimism. The town of Nicodemus, Kansas, was founded in 1877 by black homesteaders lured to a promised land promoted by the railroads; as the birthplace of abolitionist John Brown, Kansas had a certain mythical appeal. Called the "exodusters," the settlers thought they were headed for freedom, but whites, alarmed by the influx of some forty thousand African Americans, met them with biased laws and racist violence. Eventually two thirds left the state that had been anticipated as "the land that gives birth to freedom" and the black farming communities slowly disappeared. Writer Ian Frazier, touring the Great Plains a decade ago, saw a display in the Fick Fossil Museum in Oakley, Kansas that said, "Today, the once-prosperous town of Nicodemus is

BEVERLY BUCHANAN, *Mary Lou Furcon House—No Lady*, 1990, original photograph in color. For years Buchanan, raised in the Carolinas and now living in Georgia, has concentrated her sculpture, pastels, and photographs on rural Southern shacks, endowing them with color, life, and stories that would be unavailable to outsiders, often naming her works in honor of the people whose homes inspired them. Her professor father had written his thesis on African American tenant farmers and her parents had taken documentary photographs in the late '20s. As a child Buchanan had visited and slept over in such shacks, which "are not just about black people," she says. "They are based on people I knew growing up who were black. Once I grew up I saw other people living in similar conditions." Buchanan's photographs are portraits of places, like her sculptural shacks, their narrative doors closed to viewers until opened by the artist. The inhabitant's presence, or absence, is tangible; here the coat hanging on the porch is particularly eloquent. Furcon was elderly by the time Buchanan met her—fiercely independent, proud of her gardens and of the home she had built herself from logs, sticks, twigs, and found materials.

no more." Fond of ruins, he went there, and found a living town in the midst of its annual Founders Day Weekend. While watching the six Robinson sisters dance to Prince's "When Doves Cry" with an attentive black and white audience, wheatfields under vast sky hovering in the background, Frasier had a place-induced epiphany:

bors around them. That's not the case here. But if we continue heading that way without that sense of community and tribalism, I'm sure we'll end up that way....And we have a much greater price to pay; it's more painful for us. When we see the language disappearing, for example...When we see some good customs dying—and for these customs, it wasn't just a matter of doing a particular activity, it's the reason for doing it and how we did it—those are the things that are really important."

A Penobscot man who lived alone, self sufficient, for 26 years in the woods, says he did so because "You should know

Suddenly I felt a joy so strong it almost knocked me down....And I thought, It could have worked! This democracy, this land of freedom and equality and the pursuit of happiness....Nicodemus, a town with reasons enough to hold a grudge, a town with plenty of reasons not to exist at all, celebrated its Founder's Day with a show of hats and a dance revue....To me, and maybe to some others in the room, the sight of so many black people here on the blue-eyed Great Plains was like a cold drink of water....I was no longer a consumer, a rate payer, a tenant, a card holder, a motorist. I was home. The world looked as I wanted it to....Did people use to feel like this all the time? Was this what those old timers were looking for, and finding, on the Great Plains?

In the late eighties the words "bridges," "boundaries" and "borders" became popular as titles for exhibitions and conferences in the field of cultural studies. As Jeff Kelley has put it, "stereotypes loom largest at the border, beyond which awaits *the other*, threatening to cross." The gist of most progressive analyses in these forums was the blurring of boundaries, the porousness of national, racial, ethnic identities, the unstable, shifting ground on which any of these are constructed, and the creation of a hybrid state. As Gloria Anzaldua has written of all working-class people of color (and it could be extended to the rest of us), "our psyches resemble the bordertowns and are populated by the same people." I don't recall anyone mentioning Robert Frost's "good fences make good neighbors," especially in view of the U.S. government's apparently contradictory plans to erect a huge metal barrier on the U.S.-Mexico border to defeat undocumented workers and simultaneously to install the North American Trade Agreement, which condones runaway shops and the use of cheap international labor. Fences mean you have something to hide or protect.

Fenced into reservations, most American Indian nations epitomize displacement. They cannot *return* to a mythologized "homeland" because it has been here all along and they are still here. Laguna Pueblo writer Paula Gunn Allen says that "a tribal member's estrangement from the web of tribal being and the conflict that arises are the central preoccupations of much of contemporary American Indian literature." The past, distorted by loss, tragedy, outmarriage, and reinvention, is only accessible by a flawed route through the reservation, which sets dire poverty as well as natural connection in relief against the dominant culture's wealth and disregard for "nature." Like immigrants from elsewhere, Native Americans often live in or between two worlds—city and reservation—moving back and forth between the two, living in both lines and circles.

This is not to say that the reservation is frozen in the past, but that the present time and space are, from some reports, perceived differently there, in rhythms with the land or in dissonances formed by dissimilarity. Despite casinos and tax havens, the reservation stands for an indigenous nation's historical landscape, whether or not it is the actual geographical site. It is a symbol of all the land previously occupied or seasonally traveled. Similarly, the bitter controversies taking place today over indigenous sacred sites are argued on ground that shifts between two cultural understandings of place; and, predictably, they endow the dominant culture with the right to decide what is and is not authentic for any other culture. U. S. law demands archaeological proofs of settlement and use where only philosophical or symbolic proof may be forthcoming.

New respect for indigenous ways parallels the growing nostalgia for small-town America. Pueblo peoples in the Southwest, who live in towns and have been in place for longer than anyone else on the continent, now epitomize belonging. This is because of their gift for constructing the places where they landed,

more about your surroundings where you live....We depended on nature for our livelihood. For everything, we always lived with sharing—that's the only way we could live."

"In my traditions, back where I lived, I lived in style," he says. "The woods was my source of materials." "It was my drug-store, where I got all my medicines. It was my lumber yard, where I got all my materials

[for carving], and also my meat market. Rabbits come in the fall, partridges come in the fall, deer.

"Then I'd go on a summer diet, organic foods, such as greens, dandelions. I planted

72

making them a "homeland since the beginning of time" despite their own long migatory histories. Yet they too know displacement. According to Paul Gonzales, an arts adminstrator from San Ildefonso Pueblo, Native people returning from the cities to which they were banished by relocation policies in the fifties, "feel they have lost an entire lifetime...so *everybody's* looking for a place to belong."

Yet here too, looking for firsthand responses to land and landscape from land-based Native cultures is a frustrating task. Native Americans have had good historical reason to keep their most important feel-

JAMES LUNA (Diegueño-Luiseño), detail from a ten-page magazine piece, "I've Always Wanted to Be an American Indian," 1992. The title is quoted from a white man to whom Luna responded with a visual verbal description of his homeplace, the La Jolla Indian Reservation in Southern California. Along with photos of handsome children, a neat church, and bucolic landscape, Luna lists, deadpan, the disproportionate rates of unemployment, murder, and death on the reservation, and the number of tribal members jailed, on welfare, mentally ill, or suffering from diabetes and cancer. He says that despite the painful statistics, "I would live no place else because this is my home, this is where my people have come. I also know that this place, like other places, is the reality that we Indians live; this is it. This isn't the feathers, the beads of many colors, or the mystical, spiritual glory that people who are culturally hungry want. Hey, do you still want to be an Indian?"

ings and knowledge to themselves, to maintain a kind of emotional sovereignty. Indian views of nature have been so overstated, misunderstood, and abused in the last three centuries that it is difficult to sift out any perceptions about landscape or place from the little we have actually been told. One story that rings true and exposes another way of seeing place is told by anthropologist Dorothy Eggan: A Hopi asks an Anglo woman to close her eyes and tell him what she sees from Hopi House at the Grand Canyon: "She describes the landscape she has seen—the brilliantly colored walls of the canyon, the trail that winds over the edge of it reappearing and crossing a lower mesa—and the Hopi responds, 'I know what you mean...but your words are wrong.' For him the trail does not cross; it does not disappear: it is only that part of the mesa that has been changed by human feet. He says, 'the trail is still there even when you do not see it, because I can see all of it. My feet have walked on the trail all the way down.'" In other words, "one envisions the whole in order to understand the trail; or, by envisioning the trail, one understands the whole."

Modernist art by contemporary Indian artists offers access to Native perceptions through a cultural language that has been forged between the two views of art. Yet it also differs from Euro-abstraction, which it can

a small garden there, cucumbers and a few things.

"Right around the last of October when things began to get frost, then I begin to build up on bone foods, more bacon, muscle foods

you eat, like joints, that's like gelatin, you eat that. Then in the winter, you ice fish.

"Certain seasons of the year, I plant. They first start in May...June you have another one, July you have another one, August you

have another one....September's the last thing you get, because everything's gone to seed then, it begins to lose its strength. It begins to go the other way....

"I don't only gather for myself. I gather for

formally resemble. Land is not localized but symbolized in ways that include local detail, deeply embedded in any larger view. Art commenting on land use—especially treaty-protected land, water, timber, range, hunting and fishing rights—is also inseparable from land symbolism, since such rights are tribally considered religious and moral as well as economic issues.

> In the language of the Yuchi people, there are no words for lines of demarcation, boundaries, borders, or landscapes that are measured, surveyed, designated, and set aside as the sole possession of one. In the Yuchi language, the word for land, SAAH-CHEE, is ephemeral and evolving....Our relationship with the land is that we are more and no more than the space we occupy at once....it is the land herself that has true possession of us as a people, and this is reflected within the Yuchi tongue, as we bend and learn to conform to the language of the land.
> —JOE DALE TATE NEVAQUAYA

There is little "landscape" as it is generally understood in Native American painting or photography. There is no such word in indigenous languages and no such retrospective, passive concept of the land. Nor is there

any "earth art" by Indian artists, despite the overwhelming influence of indigenous cosmologies and architectures on mainstream earthworks. American Indian land imagery is often based in a ritual understanding of what is sensed and seen, a far cry from European pictorialization. When Salish painter Jaune Quick-To-See-Smith curated a 1991 exhibition of Indian art about land, she called it *Our Land/Ourselves*, implying a dismissal of conventional boundaries between self and place, nature, and culture. The title reflects the complex and problematic relationship of Native people not only to "their" land—the fragments they have been forced to "own"—but to their "Land." It embodies a sense of place that transcends the use-oriented notions of the dominant culture as well as the domestic specificity, the "coziness," that appeals to Euro-Americans. Similarly, Russell Means has pointed out that the popular image of the earth as a goddess means "you would have to see it as an extension of human beings, which is a distinctly Christian sort of view. We Lakotas look at it in the exact opposite way, that humans are an extension of the earth's life-giving nature." According to the Santa Clara Pueblos, the breath of the land is

73

PATRICIA DEADMAN (*Canadian Tuscarora*), *Conserve, Self-serve,* Duratran prints from the "Serve Series" 1994. The five large prints, or five words, of the "Serve Series," question the meaning of "service" related to modern Indian life. Deadman encourages viewers to recombine the words, to create our own social and ecological interpretations of: *preserve* (mountain goats in captivity), *reserve* (a painted tipi), *deserve* (an object being passed between two shadow figures), *conserve* and *self-serve*. In the landscape, Deadman comments on notions of "wilderness," and in the self-portrait on self-sufficiency and sovereignty, taking responsibility, "doing things for yourself because no one will do it for you." She asks via the t-shirt ("Indian Genuine Parts and Service"), "What does it mean to be Native today?"

all the people. It's not only the material things I help them with. It's also the spiritual things.

All the things they want to find out, the Passammaquoddy, Micmacs, Penobscot, Maliseets, they come here...."

And a Passamaquoddy man says: "In the Passamaquoddy world, we are as much of a victim to the Madison Avenue version of living as anybody else...And I really think that's a sad sign because when you lose that sense of community, you have two choices: either chaos, or the other one, you start compartmentalizing your life as you would in suburbia..."

gathered from the air, bringing with it authority and power; and according to the Navajo, human breath is garnered from the wind.

> [White westerners] think of time as linear, flowing from past, to present, to future, like a river, whereas Nompenekit [a local Native man] thinks of it as a lake or pool in which all events are contained.
> — JOHN HANSON MITCHELL

Time being part of space, and the Native understanding of time as sacred being crucial to ceremony and ritual, the loss of land was a disaster, says Vine Deloria, but the related destruction of ceremonial life was even worse. He argues that forced adaptation to secular, mathematically measured time has produced a fundamental sense of alienation, making "Indians strangers in a land that was becoming increasingly strange—as whites changed it to suit themselves—and that old ceremonies might have provided an emotional bulwark against this alienation, but their prohibition only increased the feeling of exile among people of the tribe." Contemporary Hopi photographer Victor Masayesva says that photography can be seen "as ceremony, as ritual, something that sustains, enriches, and adds to our spiritual well being." His film *Hopiit* is what Westerners might call a "portrait of a place"— Hopiland seen for once through Hopi eyes, in the Hopi language, casually as well as profoundly, from the inside, as a place, not as a sight or a site. The film's pace is leisurely but not really "harmonious" in the Western sense; watched from an Anglo vantage point, it is slightly disturbing, a curious combination of distance and intimacy, which is the way so many of us experience place. In fact, there is something that can seem vaguely unsatisfactory to the mainstream eye about what little Native American landscape photography we do see. This is due not to aesthetic failings but to the way it is less self-conscious than what we are used to, than conventional training leads us to expect —as though the land is being allowed to speak for itself, with a certain de-emphasis on the frame.

When filmmaker Sol Worth and anthropologist John Adair were teaching film on the Navajo reservation, they noticed reflections of the Navajo respect for movement and balance in a preference for the circular pan as a camera technique. Of Mike Anderson's film, *Old Antelope Lake*, for instance, they wrote: "not only must the sequence be in a sunwise direction around the lake, but also certain shots must be followed by the appropriate animal and direction of action. The time element isn't very important in this film....What was important to Mike was that we first saw the source and then moved all around the lake showing the unity between the natural things and the human beings in the environment." Of Al Clah's *Intrepid Shadows*— the film "least understood by the Navajo and most appreciated by 'avant-garde' filmmakers"—they remarked that a variety of landscapes are shown in static shots; movement is introduced by a young Navajo poking at a spider web, a rolling metal hoop, a Yeibichai mask wandering through the landscape, moving faster and faster in complex circular, spiral and chaotic patterns, and the shadow of the camera man getting longer and longer.

On and Off the Map

It is not on any map; true places never are.
— HERMAN MELVILLE

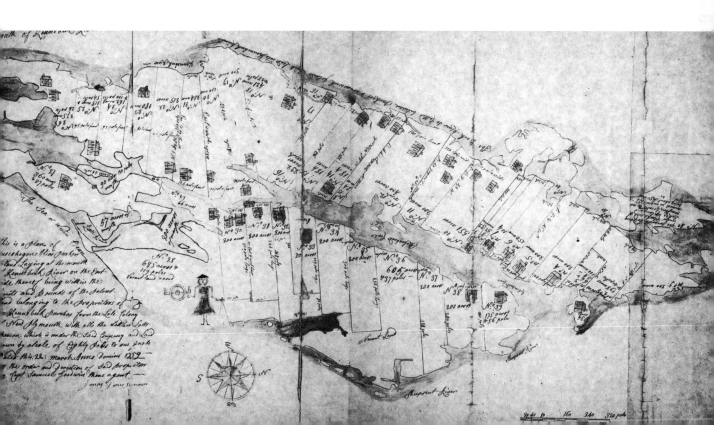

76

WHEN I WENT A FEW YEARS AGO TO PAY MY New Mexico taxes at the local courthouse, a clerk and I pored over the county's huge crumpled, dog-eared property map. It overflowed her desk and fell in awkward pleats to the floor, sticking up like cowlicks in the many places where it was patched by penciled notes taped over each other. The information too was vintage. There was no record of the last two owners of "my" land, nor of its subdivision. For a panicked moment I felt my place did not exist.

Place history is most often recorded in maps. People from oral traditions carry detailed maps in their heads over years; the rest of us depend on outside sources. In the seventies, anthropologist Hugh Brody solicited "map biographies" from British Columbian Native people whose culture was threatened by an oil pipeline. Within this cross-cultural collaboration, memories and stories of land use and lives were overlaid upon official spaces; subjective visual layers together form a multivocal history approaching an "objectivity" that could not have been written in words alone. The same people also possessed a large old "dream map," covered with marks and trails revealed to them in dreams, which constituted another form of understanding of life as well as land.

The gap between image and lived experience is the space in which both dreams and ideas are created, as reflected by the Gitskan and Wet'suwet'en in British Columbia, who worked with a professional cartographer to create an atlas, "a beautifully crafted set of images" describing "how people immigrated to their present territories, the meaning of ancient place names, where berries grow, and where to catch salmon." The Inuits make relief maps that have been called "environmental mimicry." An Inuk elder told an anthropologist that he had drawn intricate maps of an area from memory but then had thrown them away, because it was the act of making them that was important. The extraordinarily accurate Pacific Islanders' stick and shell navigation charts may date back forty thousand years. There are maps scratched into the earth and, in Kenya, detailed maps of rainfall are made with seeds on the ground. Inspired by indigenous cultures' inventive mapping procedures, Doug Aberley has written about local empowerment through homemade maps based on honest descriptions of what people actually know about where they live. In the process of "re-inhabiting" places, he predicts, "maps will also be sung, chanted, stitched and woven, told in stories, and danced across the fire-lit skies."

As a young man, writer William Least Heat-Moon was guided around Lafayette/Yoknapatawpha County for a day by William Faulkner's stepson: "Until those hours with him," he wrote, "I had never really known what it is to travel *into* a country, to go bodily into a topographic dreamtime." Kent Ryden calls Faulkner a "literary cartographer," fusing exterior and interior maps, nonfiction and fiction, to map the visible and the "invisible landscape." He points out that Faulkner's famous map of Yoknapatawpha County, Mississippi, complete with references to events in his novels, "demonstrates a keen awareness of the way in which history piles up on the land, of the way terrain absorbs and recalls history, of the way narrative is an unstated component of any map and thus of any landscape." Faulkner's county map has no external boundaries. It is all center, which can be read as a metaphor for its lack of borders, its extension of the local into the global on one hand, or the local focus inward, on the other. I'm reminded of Blaise Pascal's definition of nature as "an infinite sphere whose center is everywhere and whose circumference is nowhere." In an almost feudal assertion of author(itarian) or artistic license, Faulkner inscribes himself as "sole owner and

The island's 80-mile coastline had provided harbors and temporary homes for European fishermen for over a century before English settlement began (encouraged by Massachusetts Governor Shute, who offered 100 acres, free transport, a paid schoolteacher and a minister, to tempt colonists and rid the area of Indians). The original 17th-century grantees in the area were Oliver, Parker and Rodgers.

A wonderful series of names describes the lower Kennebec to the mouth: The Chops, Long Reach, Doubling Point, Fiddler's Reach, Bluff Head, Squirrel Point (named not for the creature but for the ship that carried a governor to parley with the Indians on Lee Island), Parker's Head, Cox's Head, Gilbert Head, Popham, and Hunnewell Beach.

proprietor" of the 2,400 square mile county, with its population of "6,298 whites" and "9,313 negroes."

For most of us the map is a tantalizing symbol of time and space. Even at their most abstract, maps (especially topographical maps) are catalysts, as much titillating foretastes of future physical experience as they are records of others' (or our own) past experiences. For the map-lover, maps are about visualizing the places you've never been and recalling the ones you have been to. A map can be memory or anticipation in graphic code. While there are probably some armchair map-lovers for whom connoisseurship is paramount, most are lured by the local, imagining places as they peruse the spaces delineated. We are field trippers, hikers, explorers, would-be travelers, or just daydreamers. We can follow with a finger the channel between islands, imagining a smooth sail on a crisp clear day, or recalling the terrifying sound of nearby surf breaking on a reef unseen in the fog. We can spend cold winter nights poring over contour lines and wondering if there will be an open gate on unmarked ranchroads, trying to reconcile old, vague maps of desired places with new detailed ones that look like totally different locations, anticipating the moment when the backpack is cinched and the first steps are taken up that concentrically lined incline. The thin blue line of a stream can summon up a remote canyon leading to a long-forgotten ruin, the heat of the day, the talus rumbling underfoot, the prick of cactus on a bare leg.

Local places remain stubbornly hidden from the systems of control and ownership. John K. Wright notes, "the interior of my place in Maine, no less than the interior of Antarctica, is a *terra incognita*, even though a tiny one. Indeed, if we look closely enough ….the entire earth appears as an immense patchwork of miniature *terrae incognitae*." This might be a description of Least Heat-Moon's intriguing book *PrairyErth*, a place portrait structured by the twelve quadrangles of Chase County, Kansas, over which the author walked and talked to assemble their stories. This "deep map" was an extended quest for the whole revealed by all the parts: "The least I hoped for was a topographic map of words that would open inch by inch to show its long miles."

Maps are "embedded in a history they help construct," according to designer Denis Wood. Where some aboriginal maps depend on inherited knowledge and mean nothing to the uninitiated, our own modern maps work in the opposite way—they make public that which we cannot see, and we are supposed to trust their accuracy and authority. Wood deconstructs the official North Carolina state highway map, its choices and legends, then concludes: "It is not that the map is right or wrong…*but that it takes a stand while pretending to be neutral on an issue over which people are divided.*"

Official boundaries can also be internalized; county, state, and national borders have become identity makers. "Speaking of the new computerized "cartographic regime," John Hitt writes, "the whole earth is catalogued. Including, perhaps, your own home." Mapping in the Western world developed from the depiction of particular places, the warmth of narrative delineation (with pictorial cartouches and fanciful guesswork filling in the gaps of the unknown), giving way to the chilly climes of abstract documentation of neutralized spaces. As literate people began to describe and document further and further afield, the juxtaposition of local knowledge and foreign fantasy gave way to a mechanistic and "scientific" process that has become increasingly detached from place. Today, construction of a map may not even demand the cartographer's presence on the land. The narrative

The only extant maps of the long Native history of Sagadahoc are those made by archaeologists, marking the sites of shell middens and camp sites. They also make microscopic maps of specific excavations, test pit by test pit, stratum by stratum, artifact by artifact. Sometimes these investigations reveal lost topographies—streams that have dried up or moved, forests that were cleared, fields that were plowed. We have considered mapping small areas in different periods, perhaps as a kind of artwork.

In the early '90s the Kennebec Point Associates commissioned a map made of the Point on which everyone's private names for places were to be recorded. Not much was new to any of us; our history is as communal as it is personal.

78

that leads from the concentric circles rippling out from "around here," to the rectilinear lines of official surveys, to photographs taken by machines from high above the earth is a story that begins here at "home" and ends out there in "space."

The need for a map to go to or imagine a place for purposes of religion or survival differs from the more cerebral or political need to fill in the blanks, to own vicariously by recording. J. B. Harley has demonstrated the map's "double function in colonialism of both opening and later closing a territory....In this view the world is full of empty spaces ready for taking by Englishmen." Sixteenth- and seventeenth-century maps of North America omitted Native peoples and "took on the appearance of a window through which the world was seen"—the European view, or overview.

JOYCE KOZLOFF, *Eugene*, detail from *Around the World on the 44th Parallel*, 1995, ceramic tile mural in the Library of Mankato State University in Minnesota (tiles produced at the Tile Guild, Los Angeles). Since the 1970s, Kozloff has been making public art based in local information conveyed through regional decorative patterns. Eugene, Oregon is one of the twelve cities represented in this series of colorful, idiosyncratic maps that combine culture and topography to characterize a city. Eugene and the dense, misty forests of the Willamette Valley are represented by primordial foliage and Salish Indian motifs. The other North American cities included are Toronto (icy Lake Ontario and symbols of English heraldry), Burlington, Vermont (Lake Champlain and the tie-dyes of the Counter-Culture), and Mankato (fertile farmland, boys fishing, and Woodland beadwork patterns).

The "naturalization" of maps—the myth that maps show the world the way it really is —veils the fact that maps are cultural and even individual creations that embody points of view. They map only what the authors or their employers want to show; resistance is difficult. They are "powerful precisely to the extent that the author disappears." Artists trying to combat and expose hegemony, on the other hand, put their names on their work and are vulnerable in their individualism; they lack the social power of the nameless mapmakers who, like the image-makers of the mass media, determine how we see and are not called upon to take personal responsibility.

"The map is not the terrain....What your map does not show," the skinny black man told her, *"is that the floods in December washed away a part of the road. I see the floods didn't affect your map."*
— DONALD WESTLAKE

Two versions of a place can both be cartographically correct, but as John Hitt puts it, "each will reveal a completely different view of the landscape." Cartographer Mark Monmonier has written a book called *How to Lie with Maps*, and the introduction to *Goode's World Atlas* warns, "because a well-drawn map creates an aura of truth and exactness, the cartographer should caution the reader against interpreting the generalized data too literally." As "map feuds" develop, everyone is going to have to become far more map literate so as not to be fooled by exploitative agendas as we learn to look around.

If maps exist to order and record the world, the world fights back. Even the most seasoned map reader does not know what to expect until s/he gets "there" (chamber of commerce brochures notwithstanding). Not only do most maps omit vegetation, landmarks, and built structures, to say nothing of current history

Georgetown Island (about the size of Manhattan) is almost split in two by Robinhood Cove, which runs from the back of Sagadahoc Bay up past Robinhood village and into Hockomock Bay. A few miles upriver Georgetown overlaps on the west side with Arrowsic. These two big islands are connected to each other by a bridge and to the towns of Woolwich and Bath by two more bridges, all built in the 1920s and 30s.

The USGS maps traditionally measure the coastline at 3,600 statute miles, but a new study on GIS doubles it to 7,040 miles. If the tiny coastal islands are included, the Maine coast is another 2,471 miles longer (not counting some 1,000 ledges), all dependent on disagreements as to tidelines and where the seacoast stops and riverbanks begin.

and economics, but most are out of date, and the scale is beyond untrained imaginations. The topography changes slowly, but the landscape is constantly transforming itself. (So are we; the depth of individual emotion engendered by place is also unpredictable.) An apparently isolated stream has been polluted, a bridge has washed out, a back road has been paved, a forested area clear cut or slashed by a power line, a village abandoned. What looks like a secluded beach is noisy with jet skis. A picturesque local retreat is now a shoddy development or a gated hideaway ringed by *No Trespassing* signs. Much is revealed about how maps relate to places as we move back and forth between the two. All over the country, alternative mapping projects are being used as catalysts for bioregional community organizing, augmented by conferences, newsletters, local history booklets, murals, and celebrations.

Geomatics, the new digital information technology that analyzes and manipulates geographical images, is beginning to be used by environmental activists and indigenous people to reclaim their lands, to monitor and protect their land bases—a better defense than guns, says Bernard Neitschmann. They are making syncretic maps that reflect traditional knowledge and occupancy history through memory. In Canada the Assembly of First Nations has involved sixty-one communities in remapping the Great Lakes Basin from an indigenous perspective; the Nunavik Inuit are gathering information on ecology and land use; others use geographic information systems (GIS) to map fishing resources. Miskito Indians in Central America have produced a map of their ocean reefs (in their own language), working with small boats, scuba divers, and satellite images.

Yet some things remain the same. Tools for the analyses which would unveil the interests behind most maps are not widely available. (What we can't see won't hurt us?) Satellite imaging is hugely expensive and used primarily for spying and other governmental agendas. Neither system nor images are made available to "locals," although there are any number of local uses for such technology. Access to new technology is always out of reach of the grass roots until someone resists through invention. For instance, John Broadhead, an environmentalist working with the Haida in the Queen Charlotte Islands, found the general public there baffled and put off by dense specialized data on the dangers of excessive logging; on a desktop computer with widely available software, he created a simple visual map of logging on the islands, which clarified damage to the ecosystems and proved to be a highly effective organizing tool.

The mapmaking process can also bring together disparate elements in a community. In the sixties, geographer William Bunge proposed a "Society for Human Exploration" that would map from different human viewpoints, including children's. (If only we could read animals' mental maps.) Local people would lead expeditions to create "oughtness maps," whose goals were to change rather than merely map the world. In the early seventies, the New Thing Art and Architecture Center in Washington, D.C., proposed a map of the Adams-Morgan community "drawn for the people who live there...to give our community a picture of itself—to define our territory." Architect John Wiebenson drew the map and "found all sorts of neat things that only the children know about"—like some park steps that make "great grandstand seats to watch the subway construction."

Mapping change is one challenge. Mapping desire for change is another, which has long appealed to visual artists. The Surrealists' 1929 map of the world parodied the hegemonic motives of mapmakers by

We read nautical charts more often than topo maps. The small islands immediately offshore from Kennebec Point are intimate elements of the local geography: the light-houses, now automated, on Seguin and Pond, the wooded strongholds of Salter's and Stage hiding their Indian and colonial histories, the two rock Sugarloaves, and Wood, with its sandbar to Popham. Long Island, with its Spinney homesteads, should also be counted in, as it lies just across "the creek" (Long Island Narrows) from Bay Point and boasts the grandest old house around, on Gilbert Head. (Elizabeth Etnier, married at the time to artist Stephen Etnier, wrote a romantic book in the thirties about fixing the place up, which entranced me as a child.)

eliminating the United States altogether, enlarging Russia, China and Alaska, and promoting Easter Island to the size of South America. In the eighties, several artists (notably "border *brujo*" Guillermo Gomez-Peña) mocked the West's successful imposition of "top and bottom" on a spherical globe—a view that has become so internalized that we have trouble even recognizing North America when the directional hier-archy is reversed and South America is given "top" position. Other artists, notably Peter Fend, have worked with the Petersen projection of the world—a correction of the four-hundred-year-old Mercator projection's scale distortions—which has a similarly disorienting (and imperializing) effect. At the time of the G7 Summit in Halifax, Canadian artist Peter Dykhuis made an exhibition of "world views"—world maps published by each of the G7 countries: "Seeing them all side by side, the differences between maps are striking. Aspects of their design and choice of colour seem to embody national stereotypes—the Japanese map looking understated, with light, cool colors, while the Italian map is bold and funky, with wildly curva-ceous lettering. Each of these superpowers locates itself towards the centre of the world, and relegates the rest of the world more or less to the margins."

Equally selective from a subjective viewpoint, indi-vidual environmental memories have been developed into the concept of "cognitive" or "mental" mapping, which has been useful for a number of different disci-plines, and is particularly appealing to artists. Mental mapping often reveals class lines, as in the centrality of a bowling alley or an upscale coffeeshop in people's lives. Bridging psychology and geography, for example, Florence Ladd asked a group of urban African Ameri-can youths in California to draw maps of their neigh-borhood and received widely diverse interpretations of a single area which helped her to understand "where they were coming from." Cognitive mapping can also be linked to the renarrativization of art by Conceptual artists and feminists in the sixties and seventies. In 1961, the Surinamese-Dutch Conceptual artist Stanley ("this way") Brouwn exhibited scribbled pencil maps made by people in Amsterdam from whom he asked directions to a well-known landmark. Unintentionally subverting objective space with subjective perceptions, these maps became compelling vortices of eye, mind, and body. A few years later, the Japanese expatriate artist On Kawara mapped out his daily life with date paintings, serial lists, maps, and newspaper clippings; the series were titled "I Got Up," "I Went," "I Met."

Some other artists who have employed the visual power of maps range from Smithson's "non-sites" (p.55) to the British "walking sculptors" Richard Long and Hamish Fulton, whose quite dissimilar arts consist primarily of documenting long walks through various international landscapes, to those like David Wojna-rowicz, who have used maps as lifelines to connect body and travel; the routes on his collaged maps suggest bloodstream and nervous system. Douglas Huebler's early conceptual works (some titled *Location Piece*, others *Duration Piece*) transferred the sculptor's obsession with space and scale onto maps, freeing him from the physical object and permitting works that followed the forty-second parallel cross country through the U.S. mail, mapped the country state by state from an airplane, and were exhibited simultane-ously in several places.

In 1972, Roger Welch made his "generation pieces" exploring the gestural vocabulary, subconscious asso-ciations, and conscious memories of his own family, often using old photographs to trigger dissimilar memories from those pictured there; in *Front Porch* (1972), he and his father and brother wrote captions to a photo taken of the three when the artist was an

Salter's is often thought to be so named because fish were salted on it, but it was owned in the 1600s by Thomas Salter, a grandson of John Parker. Now it belongs to the Blisses of Kennebec Point and is a favorite traditional picnic spot. Seguin is the high- est and second oldest of Maine's 62 light- houses. The wooden structure, first (miser- ably) occupied by one Count Polereczky de Polereca from 1796 to 1802, was replaced by stone in 1820 and by today's 40-foot granite tower in 1857. Seguin has its stories—of pirate's treasure and a piano-playing ghost, another ghost who plays with a bouncing ball, and another who cries on the rocks for her drowned children. It is the foggiest light- house in the country, and its doleful double honk, not quite syncopated with Pond's one

ROGER WELCH, *The Laura Connor–Marshville, North Carolina Memory Map*, 1973. Work in progress: interview at John Gibson Gallery, New York. (Resulting diptych of ink, photographs, phototext, and wood blocks collaged on plywood, 48" x 170" x 4").Welch wanted to break with the traditional artist/model relationship and turn the gallery into a studio. He sought out the oldest people he could find, from various backgrounds, who had lived as children in small towns here and in Europe, and invited them to the gallery to describe their homeplaces before an audience, while he created a simple relief map. The four all-day "performances" were recorded and taped for inclusion in the final works. Welch recalls that "it absorbed some seasoned gallery visitors more than they had expected," and many returned week after week. In 81-year-old Laura Connor's interview about Marshville in "the horse and buggy days," she chides Welch when he asks her if something was on the "other side of the street": "You will say streets! We didn't have any streets...just dirt roads."

infant. While videotaping his father's recollections of his childhood home in New Jersey, Welch realized the artistic potential of the memory map. His 1973 New York exhibition consisted of a series of "performed" interviews with elderly New Yorkers which resulted in memory maps of their hometowns. He wanted to make work about "the importance of place not as a grand earthwork carved in the desert but as a personal, spiritual, mental form we each carry inside us, a sculp- ture carved by memory and exposed by simple conver- sation." Welch differs from most Conceptual artists in his sincere interest in people and egalitarian collabora- tion with them, which is more often characteristic of feminist artists; and he differs from sociologists and documentary photographers in the inventive and often visually striking presentation of his data, arrived at, he says, by "chipping away at the real place and leaving exposed that memory place." In 1974, In Milwaukee, he interviewed Kitty Ewens, who was 100 years old, and the completed artwork inspired a six-generation family reunion. He has also worked with the future. In 1990–91 he asked children to draw over old photo- graphs and describe the future of their town (Austin, Texas) as well as to project their personal futures. The next step would be to make the process and the results more accessible to a community that might emulate them, not as art but as a means of knowing themselves.

Artists are harking back to the premodern, subjec- tive map that "concentrated on geographical mean- ings" and offered "as full an impression as possible of the lived texture of the local landscape." In the process, artist and viewers become acutely aware of migrations and colonization. Houston Conwill's ongoing series of public works are based on maps that overlay American physical geography with the events and inherited meanings of African American history. They document a complex spiritual pilgrimage through spatialized time. In contrast to Conwill's macrocosmic journeys, Aminah Robinson concocts from brilliantly colored fabrics layered microcosmic maps of her local neigh- borhood in Columbus, Ohio.

Even as artists and art writers have begun to read geographers, and geographers have begun to acknowl- edge the fact that theirs is a visual science, the theories may meet, but the ways of seeing remain distinct: "the geographer's work entails map interpretation as well as direct observation, and he makes no distinction between foreground and background," wrote Marwyn

higher note, was the mesmerizing background music of my childhood, sorely missed since automation made both boringly regular. In 1995 the present owners—Georgetown's Friends of Seguin—celebrated

its 200th anniversary with much fanfare.

On a map the islands' forms are static, but from a boat they change shape and apparent size depending on the angle, and in a fog they loom with ominous unfamiliarity. We once

rowed to all of them for excursions; now motor boats make everything easier, although sailing in a small boat without a motor at the mouth of the Kennebec, with its colossal tides and currents, can still be an adventure.

82

Mikesell. Despite the centrality of maps, says Cosgrove, the field of geography has persistently ignored the graphic image. In the early seventies there was a call for the development of an "image geography," which would include ambience, meaning, and the likes and dislikes of people living in a place.

Since the late seventies, Canadian artist Marlene Creates has been making works that deal with human perception and occupation of places. Working in remote areas, she likes to overlay "a fragile moment on an enormous natural and historical past." Creates became interested in cognitive mapping when she noticed the differences between directions on the tundra given by Euro-Canadians and Inuits: the former focused descriptively on landmarks whereas the latter depended more experientially on contour. *The Distance Between Two Places Is Measured in Memories* (begun in 1988) initiated a series of works combining hand-

drawn memory maps of places in Labrador and her native Newfoundland where elderly people had lived long ago, with their portraits, photographs of the places now, and a small pile of stones, sand, sticks gathered there, suggested by the narrative. Thus document, personal recollection, and sensuous evidence form a multilayered portrait of the place recalled. Included, however implicitly, is the artist's journey and experience there, and the prevailing image of Labrador, in particular, as an empty, unexperienced place, and finally, its desecration by the military.

The beauty of maps, and the reason they aesthetically approach, even surpass, many intentional works of art is their unintentional subjectivity. This is why they have been so important to the cultural construction of landscape. A map is a composite of places, and like a place, it hides as much as it reveals. It is also a composite of times, blandly laying out on a single surface the results of billions of years of activity by nature and humanity.

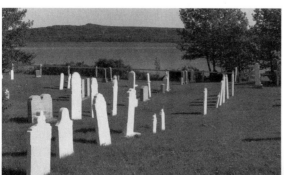

MARLENE CREATES, detail of *where my grandmother was born*, from the series *Places of Presence: Newfoundland kin and ancestral land, Newfoundland 1989-91*. (Installation of this section is 20' long, consisting of fourteen photographs on a wooden shelf under six memory map drawings and seven text panels; also "natural souvenirs": a framed group of aspen leaves and a single large beach stone.) The "Places of Presence" series, which reveals patterns of rural land use from generation to generation, centered on "three precise bits of 'landscape'" where Creates's grandmother, grandfather, and great grandmother were born. In the hand-drawn memory maps and spoken texts, her Newfoundland relatives recall their lives and the land on which they were born. Some have remained there, others have moved. She sees this work, which she executed "with my heart pounding in my chest," as "a net that was set at one point in the flow of people, events, and natural changes that make up the history of these three places."

Manipulating Memory

*Who controls the past
controls the future;
who controls the present controls the past.*
— GEORGE ORWELL

*With so many pasts and futures making claims on us,
it's hard to know which way to turn.*
— ALEXANDER WILSON

In Mothballs

I was nine years old when we—a New England/New York family—moved to New Orleans in 1946. It was sheer culture shock, a place totally unlike any place my parents or I had ever been. I was already indoctrinated as a history buff. As New Englanders, we had visited Paul Revere's home, Longfellow's house, Louisa May Alcott's house, Plymouth Rock, Walden Pond, and so on. New Orleans was different. Its history seemed foreign to us, and alive. When we first arrived, we lived briefly within history itself, staying with friends in a deteriorating old mansion in the Garden District. We ate out a lot (the food was new too) and drove up River Road, visiting the old plantation houses. Already a fiction addict, I surrendered to a paroxysm of antebellum romanticism, fed by historical novels written for people much older than I and by

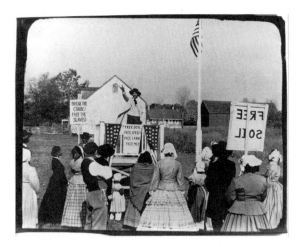 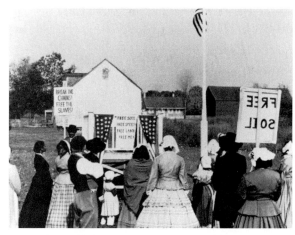

WARREN NEIDICH, *Free Soil Part I/II*, Albumen and RC prints, 1989. Neidich's newly created "historical" photographs are presented as diptychs. The left-hand image has a hyperreal "historical" look; it recontextualizes African-Americans in the photo archives of 19th-century life in which they are conspicuously under-represented, placing them in the confident and comfortable circumstances associated with period photographs of whites, rather than the predictable slavery and poverty associated with blacks. On the right hand, these relatively straightforward images (in a harder, more "modern" print) are then cropped, reframed, or otherwise dismantled to reveal the cracks in this invented reality, and to expose "photo-racism." In the *Free Soil* diptych, the apparent documentary on the left is subjected to a kind of "what's wrong with this picture?" analysis that has resulted, on the right, in the disappearance of the Black "agitator," whose public presence would never have been so democratically tolerated in the ante-bellum era. Neidich shot this series at Old Bethpage Village Restoration in New York. One of his several subtexts is the futility of "reproducing the past" in such sterile environments.

My partner and I—both life-long summer residents of Kennebec Point, though he is also a 17-year "local"—are the Point's co-historians, an unofficial position held by both of our grandmothers in the past. Our relaxed field work involves mapping and measuring old cellarholes, weirs, shell middens, and other sites hidden in the puckerbrush amid the raging mosquito population for which Georgetown is infamous. We have found artifacts eroded out of sand dunes, desecrated cemeteries, mysterious mounds and rock piles.

We gave a talk in the Georgetown Baptist church basement for the Historical Society and encouraged the large audience to join us in our search for the past, but got little response. Dona Brown writes that

the melancholy beauty of the places themselves. The alleys of live oaks dripping Spanish moss, overgrown gardens, peeling paint on regal columns all evoked the stories buried in deserted shacks and unkempt graveyards. Later I got even closer to them, visiting a friend's grandmother and great aunts in an old plantation house upstate, complete with isolated "slave cabins" (still occupied), sandy creeks, vast fields and scrub pine forests. With another close friend I spent time on Bayou Barataria, where we rode bareback through the fields and swamps of Cajun country (long before the franchised good times began to roll), confronted large snakes, swam in the murky sweetsmelling bayou, went deer hunting, watched movies from backless wooden benches, and went to church along a boardwalk through the wetlands. Here the history was less grand, less fictional.

THE PAST IS NOT AS SEPARATE FROM THE present as its manipulators would like us to think. It is constantly being broken down and reintegrated into the present, reinterpreted by historians, curators, anthropologists, popular novelists, and filmmakers. Nostalgia is a way of denying the present as well as keeping some people and places in the past, where we can visit them when we feel like taking a leave of absence from modernity. It can also be seen as an apology for the betrayal of forgetfulness, a halfhearted bow to the significance of histories we are too lazy to learn. A generalized nostalgia lurks in every old house, but history itself is highly selective.

One reason to know our own histories is so that we are not defined by others, so that we can resist other people's images of our pasts, and consequently, our futures. Beyond the "George Washington (or Al Capone) slept here" gesture, it is not only a matter of saving old things but of selecting those that mean something and cultivating responses to them. A provocative community exercise would be to ask people what local existing sites, buildings, or artifacts they would like to see saved for posterity, and how; what

remaining parts of the past they would like to see preserved, and how; what disappeared histories they would like to see resurrected, and why. (Klara Kelley and Harris Francis have done this in an exemplary fashion, regarding places sacred to the Navajo Nation.) For, as Raymond Williams has remarked, "a culture cannot be reduced to an artifact as long as it is being lived."

History known is a good thing, but history shared is far more satisfying and far reaching. The layered history of words and places is barely visible to the outsider, and less and less visible even to the insider. Towns can wither on the vine as the obsolete is preserved out of stubbornness or impotence. Or town histories can inform their residents' current lives. Past places and events can be used to support what is happening in the present, or they can be separated from the present in a hyped-up, idealized no-place or pseudo-utopia. We need more fluid ways of perceiving the layers that are everywhere, and new ways of calling attention to the passages between old and new, of weaving the old place into the new place.

In a 1972 book inventively titled *What Time Is This Place?* (which presciently laid out many "postmodern" arguments about history and authenticity), Kevin Lynch observed that the preservation of a certain kind of past channels us into a certain kind of future. He asks the core question: "Why save things and what should be saved?" Then comes a drumroll of provocative queries which, if considered in depth. would change our individual ways of thinking about our local surroundings:

Are we looking for evidence of the climactic moments or for any manifestation of tradition we can find, or are we judging and evaluating the past, choosing the more significant over the less, retaining what we think of as best? Should things be saved because…they are unique or nearly so or…because they were most typical of their time? Because of their importance as a

early summer people's search for a "usable past" made them unconscionably proprietary about the areas they colonized. They were after history, but "it had to be a history they could live with— at least for the summer."

Except for those whose families have been around for generations, the pursuit of history in Maine is all a kind of tourism. Ian McKay might be talking about coastal Maine when he writes of Nova Scotia: "In

the special case of a dependent and under-developed region where, for six decades, culture has been commodified in the interests of tourism, a myth of a prelapsarian Golden Age—for which we might (follow-

group symbol? Because of their intrinsic qualities in the present? Because of their special usefulness as sources of intellectual information about the past? Or should we (as we most often do) let chance select for us and preserve for a second century everything that has happened to survive the first?

Lynch traces the concept of preservation in Europe back to 1500, when sham ruins were first constructed. General affection or respect for the antique, and its fashionable appeal, became more widespread in the upper classes during the eighteenth century, trickling down to the middle class as an idealization of any old "old" in the nineteenth century. In the United States, the antique was at first relatively hard to come by, since American "history" was so close as to be remembered by the living. There was a certain collective inferiority complex about the newness of the "new world." Even the landscape seemed a blank slate to the newcomers, although of course it was rich with memory for those

who already lived there for millennia. Tradition, as such, was evaporating, but nouveau riche was still not as prestigious as old money. The museological notion that the antique object maintains importance even if we no longer understand its meaning (and the older it is, the better) pervades site preservation as well.

As soon as places in the Northeast got "old," they engendered a certain respect, contradicting but not overruling the deeper American cultural preference for the new. Today this paradox rules in the panoply of neocolonial homes and businesses (and their off-spring, condo-postmodernism) that sprawl over traditional landscapes. In the Southwest, on the other hand, where the older European settlements had been more deeply affected by the indigenous, Anglos, arriving from the 1820s on, rejected traditions that were not their own until they found them useful. Today in Santa Fe, paradox rules: only those building styles borrowed from such unfamiliar cultures are fashionable. As their giant offspring loom over crumbling adobes and battered tin roofs, they erase the very history they claim to admire.

All histories perceived in the landscape are to some extent subjective, as are the social and cultural biases

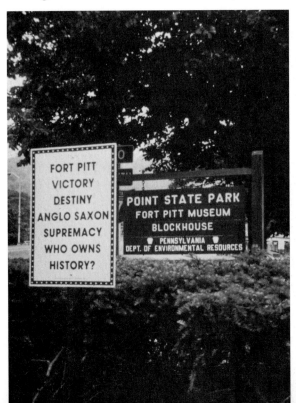

HACHIVI EDGAR HEAP OF BIRDS (Cheyenne), *Who Owns History?* 1992, Three Rivers Arts Festival, Pittsburgh. The question has been behind a decade of Heap of Birds' historical awareness signworks. Here he zeroes in on a 1930 bronze plaque commemorating Fort Pitt's establishment in 1758 by General Forbes. It reads in part: "His victory determined the destiny of the great west and established Anglo-Saxon supremacy in the United States." In previous works, Heap of Birds has placed signs reminding passersby who their "hosts" are (Native peoples who originally occupied the area); *Building Minnesota*, another laconic and powerful work, is a series of signs along the Mississippi to honor forty Dakotas who were hung in Minnesota in 1862 and 1865 by order of Presidents Abraham Lincoln and Andrew Johnson. Heap of Birds has recently collaborated with Aboriginal artists in Australia, where land and cultural rights are also paramount.

ing Barthes) coin a word, 'Maritimicity,' a peculiar petit-bourgeois rhetoric of lobster pots, grizzled fishermen, wharves and schooners—is both a material and a moral force, both a resource to be appropriated and a powerful idiom shaping local interpretations of Maritime history and landscape.... One does not come to Nova Scotia to escape the postmodern sense of unreality, but to feel its sharp, cutting edge...."

Everywhere in Maine locals are grappling with the dilemma of biting the hand that feeds them while avoiding the overcrowding that mars Maine's roads and beaches. Many subscribe to the bumpersticker, "Welcome to

that color them. For example, the nineteenth-century revivalist preacher Lyman Beecher saw the history of the town of East Hampton, New York, as a theater for religious morality, whereas the same town records that Beecher studied suggested to the contemporary historian T. H. Breen "a story of competitive economic behavior." Breen's fascinating book *Imagining the Past* details his work as a "resident humanist" brought in from the outside to document the ways in which perceptions of East Hampton's history affect its views for the future. As he traces (very critically) the positions

of each major chronicler over three hundred years, he describes in detail his interactions with the locals and creates a virtual detective story from his futile search for the remains of the seventeenth-century Mulford warehouse. But he reveals little of his own cultural background, his life before East Hampton, the associations he himself brings to the table.

The authors of the "public history texts" that Breen peruses in East Hampton can be traced from the "Daughters, Dames, Sons and other commemorative genealogical societies" (the filial nomenclature implies

MEREDITH MONK AND VOCAL ENSEMBLE, *American Archaeology #1: Roosevelt Island*, New York City, 1994; performers: Jan Brenner, Dina Emerson, Victoria Boomsma (Photo: Tom Brazil). In Monk's "dream landscapes," archaeology and history are material counterparts of archetypal memory. This two-part performance/musical piece, a "journey" through history beginning with the Leni-Lenape, was performed on Roosevelt Island (previously Minnahannock, Blackwell's Island, Hog Island, Manningham Island, Perkins Island, and Welfare Island, renamed in 1973

for Roosevelt's social programs). The first part took place in Lighthouse Park on the northern end of the island near the remains of a 19th-century insane asylum, and the second (illustrated here) on the southern end amid ruined buildings and the remains of a smallpox hospital. Monk's performers, dressed in 19th-century period costumes, were accompanied by a horse. She intended to perform simultaneously in two times, bringing the dirt road and old buildings to life without denying their present identities.

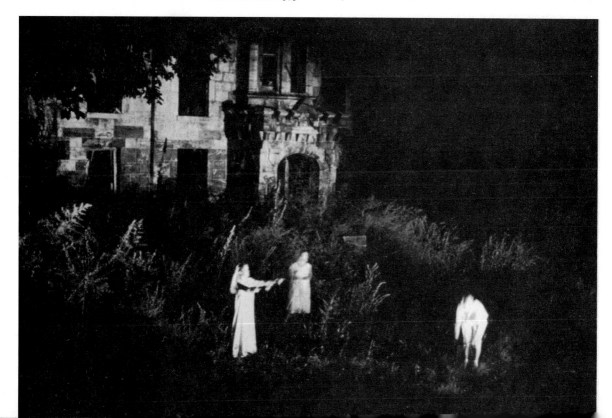

Maine. Now Go Home." In 1994, the Maine office of tourism spent $27,000 to plead with citizens to be kinder to tourists, stressing the connection between their paychecks and the $2.7 billion annually generated by tourism. Responses included opinions of tourists as

"living proof that pond scum can be trained to approximate human form," and people who "think all Mainers are hillbillies."

The Georgetown Historical Society is housed in the "Old Stone Schoolhouse," the

best-known of the three one-room stone schoolhouses on the island. This one was built in 1820 by three Irishmen living on Long Island at the behest of General Joseph Berry (1797-1872), the Georgetown ship-builder who found buried pirate treasure

88

"family values" and prosperous propagation) spawned in the late nineteenth century by the perceived threat of ethnic influxes. As Michael Wallace has put it, "the bourgeoisie buckled History around themselves like moral armor." From there, Martha Norkunas observes, the armor was assumed by the corporate executives of the twenties (Henry Ford's Greenfield Village and John D. Rockefeller's Williamsburg). Rockefeller restored colonial Williamsburg to be a "living landscape" of the past, but he was hampered by his own class background and its preference for controlling the view: the lack of realism kept Williamsburg pretty but fairly moribund. Recently, the tidy concoction was messed

up a bit with the grime of early industry, manure in the streets as evidence of a horse-drawn economy, a grim bedlam, and a larger slave quarters.

In the thirties, the New Deal's populist focus on social history brought regional and local history to the surface of the American consciousness with projects such as the Farm Security Administration's photography project (which raised rural poverty issues in urban contexts), the Federal Writers Project (which produced state-by-state guidebooks based on extensive local research), and the WPA Mural Project (which pictured regionalism in post offices and government buildings across the country). They offered a mirror to a disillu-

BARBARA JO REVELLE, *A People's History of Colorado*, 1989-1991, photo-based, computer-generated ceramic tile mural, 20' x two city blocks, Convention Center, Denver. Four-foot-square faces of 84 men on one side and 84 women on the other in black and white flank two central color panels of children of all races with a backdrop of the Flatirons, a local landmark. Interspersed are a few historical group or action pictures—a Ute war party crossing the Los Piños River, a gang of Chicana workers on a World War II locomotive, a black woman shearing sheep, a woman farmer, a turn-of-the-century football team, a horseman holding a banner of the Virgin of Guadalupe. At a distance, the faces are clear and poignant; as you approach, they begin to dissolve into their digital fabric, an abstract sea of black, white and gray spread over 300,000 tiles. The scale and intensity communalize a corporate space, summoning up a hard past on which Denver's tourist

industry still capitalizes. Revelle chose the mural's final cast of characters, an intentionally revisionist history, from research, archives, suggestions from local people and historians, and occasionally from her own imagination.

It is an extraordinary list, ranging from outlaws to beauty queens, immigrants to suffragists, naturalists, artists, pilots, tycoons, nurses, and two residents of the "Silver Triangle" community that was displaced by construction of the Convention Center. She had to fight for inclusion in several cases, including that of an AIDS activist, a Black Power leader and Chicano rights leaders Corky Gonzales and Neva Romero. A biographical key to the mural's faces was in the original plans; it is only now being put into place from Revelle's notes, but out of her direct control. Without their often controversial biographies, the faces remain captive on the facade they adorn.

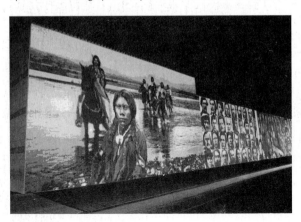
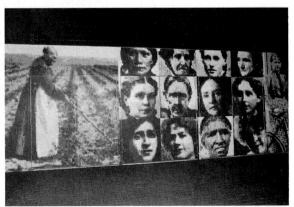

while digging the foundation for the lighthouse on Pond Island. The schoolhouse resembles the stone cottages on the west coast of Ireland.(No window was placed on the road side for fear of distracting the children.) It served for a while simultaneously as a church. Children walked long distances to get to it, those on Indian Point fording the marshes on suspended bridges made of chicken wire. There are a number of photographs and reminiscences of years at the school, and some former students are still living. After the school closed, a poor family lived there for a while, adding a room by pulling an old car up next to its wall. Refurbished as the Historical Society in the seventies, it contains the seeds of an important archive of local objects and documentation.

sioned but stubbornly patriotic country; often their imagery was framed by a left that shared some ideological ground with conservatism. The hope for change vied with a shaken status quo. In both scenarios, the faces of the "common people" victimized by capitalism's big mistakes rose to haunt the nation's image of itself, even as they were often manipulated for political and legislative agendas.

A postwar return to a capitalist presentation (epitomized by Boeing's 1952 Museum of History and Industry in Seattle) was challenged in turn in the sixties by revisionists beginning to redefine history in terms of power, turning their backs on the mansions and gardens to look at the mills, the slave quarters, the warehouses, the tenements, the prisons. One resulting insight is that historical preservation may have been better served by a lack of money than by a myopic philanthropy. Jonathan Daniels says that "poverty is a wonderful preservative of the past. It may let restoration wait as it ought not to wait, but it will keep old things as they are…the living occupy the past."

Prime among the choices that must be made by preservationists is which era of a place's long life should be privileged, which sacrificed to growth? The distant past threatens the present less than the recent past, which may heat up smoldering emnities. (For instance, the president of South Korea has recently begun demolishing in the name of patriotism all those buildings erected during the thirty-year Japanese occupation that ended in 1945, whatever their distinction or usefulness.) And when, for that matter, does history "start" or "stop"? As fishing in the Northeast falls victim to centuries of overkill, two Long Island fishermen, permitting a photographer to document their work, told him, "You've come to the right place. This is all going to be history real soon." And, as this happens, even those who were previously irritated by the sights and smells of the dying industry become its champions, naming their yachts after hitherto-despised people and places, contributing money for the preservation of dilapidated wharves. The probable fate of the Bonackers of East Hampton is comparable to that of

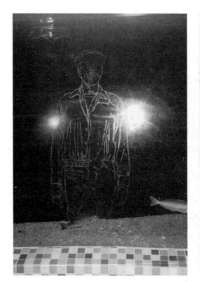

MAY SUN (with Paul Diez and Richard Wyatt), *City of Dreams, River of History*, 1995, c. 8,300 square feet area, Union Station Gateway Transit Center, Los Angeles, sponsored by the Metropolitan Transit Authority. This complex installation includes a mural, a 30'-long "aquarium bench" (with ghostly ethnic/historical figures etched on the glass, housing native coastal fish), and across from it a "river bench" and a "river" of bronze inlays referring to the Los Angeles River and the communities that once lived along its banks. The Chinese, for example, were displaced in the 1920s by the railroad their ancestors helped to build. Subway excavations in the 1980s turned up an abundance of Chinese and other artifacts, with which Sun has lined her waterway and covered her rock mountain. Born in Shanghai, she has made other performance pieces and installations on Los Angeles Chinese history and myth, connecting them to self and social transformation. This work was successfully planned as a place to sit, hang out, and maybe learn too. The process, however, was often painful; for example, although the concept of the aquarium bench was to suggest the river flowing into the ocean with native Pacific fish, the artists had to fight not to have them replaced by tropical fish, which were "prettier."

Interior of Georgetown Historical Society (Photo: Peter Woodruff). In the foreground, George Horn researches his family. His mother, Edith Berry Horn, was a schoolteacher in this building and he is a descendent of Joseph Berry, who built it.

the Montauk Natives whom their ancestors displaced. In fact, Breen reports the Ghost Dance-like dreams of a fisherman's wife: an immense hurricane blew in from the Atlantic and cleaned the beaches and fields of summer cottages.

Another pertinent question raised by Kevin Lynch is how distant the past must be to become valuable. He argues that sites should not have to conform to past values but should be used as they best enhance the present, stressing the importance of preserving "the near and middle past, the past with which we have real ties." Too often, the choices have been made for us. Certain periods in the United States are regionally favored over others, just as certain ethnic groups have been idealized or ignored. In New England it is the Colonial and Revolutionary periods and the "pilgrims/ puritans" syndrome. In the Midwest, pioneer taming of the land and its previous inhabitants, plus industry, is primary; in the Rockies and Plains, nineteenth-century Anglo mining and ranching (their Native and Mexican roots are rarely mentioned); in the Southwest, despite 150 years of Anglo control, the spotlight is shared by outlaws, the Conquistadors, and the "disappeared" Anasazi Indians; in California, the "Mission" years and the Gold Rush take precedence over Mexican-American and Asian contributions; in the South, it's the antebellum period and the Civil War—with slavery's role downplayed.

Without the aid of original records and authentic documents, history will be nothing more than a well-combined series of ingenious conjectures and amusing fables. The cause of truth is interesting to all...and those who possess the means...of preventing error, or of elucidating obscure facts, will confer a benefit by

communicating them to the world. —1805 STATEMENT BY THE FOUNDERS OF THE NEW YORK HISTORICAL SOCIETY, now the home of some six million objects, including a swatch of George Washington's hair and Gouverneur Morris's wooden leg

Historical societies tend to be places where any old paraphernalia is given equal time but little structure is provided that might help us understand its meaning. While there are ironic parallels with an arty or even formalist approach (the decontextualized object is paramount), historical societies are primarily intended to be unintimidating and, therefore, popular. At the same time, the visitor is not asked to think about what this hodgepodge means; s/he is simply asked to enjoy how pretty or time-consuming or inventive or weird or different-from-now or just-like-now everything is.

Especially in small towns, historical societies represent the way people know or see their places— in fragments, through stories and unidentified photographs rather than within any historical framework. With luck there may be some documentary labels, tapes, or transcripts of interviews with the area's oldest residents, a timeline that offers some hooks on which to hang the randomly acquired artifacts, and an ongoing newsletter or column in a local paper that unearths genealogies, stories, and facts. The "collection" is the result of people cleaning out their attics as much as sharing their knowledge of the past. The resulting fetishization has little to do with common history.

Typically, historical societies are run by the local history buffs, a motley and dedicated crew in most communities, and apt to be of a certain age and/or income bracket, leisure time being a prerequisite for volunteer work. Women have been the backbones of these volunteer-dependent organizations, and as

The Historical Society opens the school-house on weekends in July and August, sponsors talks and tours, and cares for its motley collections, which range from "Indian artifacts" that may or may not be local, to old dresses, postcards, toys, clippings and maps. Billie Todd, the indefatigable editor of the monthly *Georgetown Tide*, whose married name is one of the town's old ones, writes up history and genealogy with verve and an inexhaustible store of local knowledge. The *Tide* began in 1975 with $500 federal seed money to celebrate the Bicentennial. Some wanted to spend it on a float for the Bath parade, but Sandra Garson, the original editor, insisted that it go to a newsletter, making a major contribution to the community.

keepers of the family stories in most cultures, genealogy is the backbone of their work. Preoccupation with and celebration of the "first families" has been perceived as snobbish, but in many areas their descendants are among the community's poorest, and it is not they who are celebrating their ancestors.

Genealogy, for all its interfamilial fascination and archival value, cannot be substituted for history. When library work precludes field work, the role of the place itself is often lost; ideally, the two should be combined. What *is* that pile of stones down in the field? Who built the barn that's falling down? Whose broken whiskey bottles keep turning up in the garden, and what are those mysterious bits of iron? What was the stone foundation in the woods? What crops were planted here, what animals hunted? Unfortunately, few historical societies or their changing volunteer staffs are equipped to answer such questions. Knowledge tends to die with its holder rather than being transferred to a map or an archive that continues to build cumulatively rather than being reinvented by each hardworking newcomer.

The arbitrary relationship of historical societies to history and place is important because they may represent the only local history most residents ever learn. Their insidious charm lies in their clutter and naiveté, even as the real connections with the place they claim to reflect is usually lost in the mess. Yet it would be a pity to totally "modernize" or museumize such intimate collections into cute, clean, didactic schoolrooms. For all their shortcomings, local historical societies are apt to be a better reflection of the ordinary lives lived around them than the small museums bearing the names and protecting the collections of wealthy philanthropists. The more elegant the installations and objects, the more voyeurism and economic envy overwhelms common roots. If the museum is merely a repository, local historical societies fill the bill; if the intention is aesthetic enlightenment or an educational tool, they are often sadly lacking, especially in terms of the place itself, as it exists today.

Historical societies reflect (for the most part unconsciously) inherent ideologies as much as large museums do. They too are part of the "consciousness industry," and the consciousness they evoke is very close to home. Decoding the way a place is presented in one's local historical society or museum is a rewarding way of understanding where one lives. Specialization has taken its toll on history as it has on every other part of modern life. Cultural and natural history meet only in natural history museums and in the visitor centers and museums of parks across the country, where culture (usually indigenous) is conflated with nature rather than integrated into Euro American history. Social and ecological histories—causes and effects—are usually unstated in favor of depoliticized technological solutions. "Thinking about natural history and human history," Rebecca Solnit writes, "is like looking at one of those trick drawings…a wineglass that becomes a pair of kissing profiles—it's hard to see them both at the same time. One doesn't usually write, 'Washington crossed the Delaware, a south-flowing river whose animal populations include….'"

Martha Norkunas has explored the cultural production of history geared to tourists in Monterey, and the extent to which it is a collaboration with the people who made the history and/or live in the place. If history tends to be inscribed by the upper and upper middle classes, everyone else participates in their own stereotyping, voluntarily (those dressed in period costumes who inhabit replicated landscapes) or involuntarily (those who go about their daily business framed by some exterior notion of "quaintness" or "authenticity"), unless they actively rebel against the process.

When is a Fort More than a Fort?...

"Welcome! To tour Old Fort Western is to travel through time, between 1754 and 1810 as the Fort changed from military post to community store and family residence. We encourage you to look for and talk with our costumed staff..." (from brochure). The fort, located on the Kennebec River across from downtown Augusta, has been managed by the city since 1958, and run on a low budget. There have been proposals to rename downtown Augusta the Old Fort District, tying in the fort more closely with other town museums.

The ethnographic presentation of our own forebears offers insights into the way other people are represented. In many or most historical societies, Native people who inhabited the place longer than anyone else are ignored. A dusty collection of undated, unidentified arrowheads, stone tools, or pottery sherds that may or may not have been found in the area may be jumbled together in a bowl or a case. The objects are not sequentially integrated into the general history through contact with the present, and the participation of Native people still living in the area is rarely solicited. Norkunas points out that in the sole general history museum in Monterey, of all the ethnic groups, only Native Americans are treated to ethnographic display, and the Native exhibit is "set apart from the main body of the historical artifacts in a dimly lit, unheated area."

In museums, the past is usually roped off, under glass, literally or figuratively. Period rooms are collected under one roof—a dizzying or even dazzling array of times and places juxtaposed. Neighborhoods offer similarly unexpected transitions and conjunctions: historic buildings that have survived urban development are decontextualized, divorced from place, isolated as objects, perceived and even labeled as "artifacts" in the "collection" of the state or municipality. Time has destroyed their contexts and provided new ones. Old roads lead past handsome old buildings devalued by their proximity to a mall, a development, an industry, or the road itself. Islands of calm, green, fenced squares ringed by brick town houses, relics of a supposedly pleasanter past (like pretty little Gramercy Square Park in New York, from which all but "qualified" neighbors are locked out) remain crouched in urban seas of tall buildings, traffic, and poorer people. Single structures may be left stranded in an incompatible and unfriendly context (like Trinity Church in downtown Manhattan, the old church in Jamaica, New York, or the occasional little clapboard dwelling trapped in canyons of skyscrapers). A Boston reactionary once bemoaned his city's failure to "trade on its great and glorious past" because its oldest buildings were now "hidden away" in ethnic quarters that lay beyond the pale.

According to current fashion, the ravages of time can be removed for effect, maintained for effect, even counterfeited for effect. Greek marble temples, associated with glistening whiteness (which isn't easily maintained in industrial climes, so sometimes the marble has had to be painted white) were originally gaudily polychromed. The elegantly faded pastels of "the Santa Fe look" would not be so chic in their originally "garish" Mexican brilliance. New England's brightly colored houses of the past were whitewashed in the mid-nineteenth-century in memory of an imagined puritanism. Recent interior paint analysis of a seventeenth-century house in East Hampton revealed "gaudy" blues and oranges that cast doubt on our stereotypes of colorless Calvinists. Exterior color has staged a comeback in the United States. In the fifties, when we passed a bright blue house on the road in Maine, someone who probably lived in a brown, gray, cream, or white house would say condescendingly that "Canucks" must live there. Today such colors are common even in upper-class areas of New England, and exaggeratedly playful Victorian trim has become a

Maine houses that were originally buff, cream, or off-white were "restored" to a glaring "pure" white—a color unpopular in 18th-century New England but perceived in the 19th century as a recreation of pre-immigration New England and the "bright white Anglo Summer." Babe Gunnell recalls a "rainbow house" in Georgetown Center in the early years of the century, painted all different colors. (Was it striped? Who was the proto-hippie occupant?)

The old houses on Kennebec Point are uniformly white, brown or gray, painted or shingled (with one huge bright red exception) and now an incursion of vinyl siding—because who wants to spend their entire vacation painting the sea-battered house, as my father did, on top of clearing brush and

regional style in cities like San Francisco and Denver as well as in refurbished mining towns, where polychromatic houses resemble toys in the landscape.

Over time, houses become pastiches. They gain and lose stories, change roof angles, wings, shutters, chimneys, and architectural detail, resulting in what Thomas Schlereth has called a "time collage": "one will often find, lined up along a single streetscape or clustered about a civic space, a series of artifacts from different chronological eras of a community's history," or individual buildings that incorporate several eras at once. In designated historical districts, exteriors are religiously maintained; not a detail can be changed without permission, despite the fact that the "originals" were frequently altered prior to preservation. Interiors, on the other hand, are sacred in another sense—as private property; they can be altered at will so long as false fronts are maintained for public viewing and illusion—an attitude that says a great deal about our society. Kevin Lynch asks "To what degree does contemporary utility, however discreetly provided, rupture the sense of historical integrity?...And what is to be done where inside and outside are hard to separate, as in a large public building or in a landscape?"

As buildings are stripped of their immediate environments they are also stripped of their reasons for being and their function in local history, although sometimes they are skillfully recontextualized to the extent that the visitor is romantically transported, as in a novel or film. Because of our social ease with simulacra, we are more drawn to a created image of what we think a place "was like then" than to any accurate rendition of other times, with their bad smells and rough sights. Real time travel would be hard on the middle-class twentieth-century adventurer.

Arrowhead Fountain, 1930, Old Fort, North Carolina (Photo: Judith Coyle Bush). Built in 1776, Old Fort was once the westernmost outpost of "civilization." One face of the Arrowhead monument bears crossed tomahawks, crossed muzzle-loading rifles, and a powder horn; the other shows a profile of Cherokee Chief Sequoia. Legend has it that if you drink water from this fountain, you will always return to Old Fort. For all this display of Native images, the handsome historical society in this small town omits Cherokee history; as a remedy, a local Cherokee man opened a storefront showplace of his own near the arrowhead monument, in which nature (local flora and fauna, stuffed and dried) and culture (Native artifacts) are enthusiastically intermingled.

cutting firewood. They have been suburban-
ized to some extent, but as modest summer
homes they are not overly modernized; most
have been altered by the addition of porches,
decks, larger windows and other "apertures"
that transform the small dim rooms. Barns,
sheds and boathouses have been moved
and/or converted into houses. Parking—not
a traditional concern—is at a premium.

Old sites are regularly pillaged for build-
ing materials. For centuries, cellarholes in
Georgetown have been dismantled to build
new houses, walls, or gardens. A Kennebec
Point neighbor carted off a 17th or 18th-
century granite doorstep from the site of a
colonial community on land he had bought
to develop. My parents broke it to me late
that our porch was rotting because to save

Some old structures are considered valuable enough in
themselves to be moved to a neutral or contrived new
site for private or public use. This passion for moving
historic buildings from their original sites is like tear-
ing the picture in half. They seldom maintain their
power, although there are exceptions, like the grim
cattle car at the Holocaust Museum in Washington.
Perhaps the barrack from the Heart Mountain intern-
ment camp in Wyoming, now at the new Japanese
American National Museum in Los Angeles, holds its
own without the desolate landscape that originally
defined it, but the specific sense of surrounding space
would seem to be as important in this case as knowl-
edge of global context.

The relationship of rural gentrification to historical
preservation is two-sided. Many grand old New
England farmhouses went through bad times when
farmers lost out to larger-scale Midwestern enter-
prises and were abandoned by the late nineteenth and
early twentieth centuries. Later, families moved to
trailers and mobile homes that are easier to heat and
less expensive to maintain, while the expensive old
roof slowly collapsed next door. Sometimes the old
houses are "rescued" by summer people who can
afford to maintain them as second homes; many
buildings that do survive end up on the Historic Land-
marks Register. This is a decidedly mixed blessing for
those who have been displaced from their ancestral
lands, and are offered less access to the larger "place"
—treasured woods, beaches, and trails.

When old houses are demolished, their parts go to
the winds, transplanted into other buildings for miles
around. There are villages in New Mexico made from
the stones of abandoned pre-Conquest pueblos.
Houses from ghost mining and railroad towns were
commonly moved to new sites, and in fact, all over the
country, houses and even huge brick and stone build-

MEL CHIN, *Ghost*, 1990, chalk on nylon mesh, urban rubble
in steel caging, 30' x 35' x 10', Hartford, Connecticut, sponsored by
Real Art Ways (Photo: Mel Chin). In an ephemeral, temporary
installation, the past rises to criticize the present in a form that
Chin has called "a floating blueprint"—a chalk-on-black-scrim
recreation of the facade of the Talcott Street Congregational
Church, Connecticut's oldest free black church. The original 18th-
century meeting house was the cornerstone of a thriving commu-
nity. Chin chose it as a resurrective symbol of Hartford's past after
extensive research and work with Talcott Street's heirs—members
of Hartford's Faith Congregational Church. A commemorative
service was held around the piece. Placed as it was in a looming
corporate facade, *Ghost* questioned whether human architectural
constructions or social, philosophical and religious structures can
prevent the erosion of our culture and communities. Functioning
as a haunting presence that critiqued the unfulfilled promises of
urban renewal, it was intended as a catalyst for continuing critical
discussion and developing action in response to those unfulfilled
promises. Chin's point was "that if we ignore the concept of
community, it will come back to haunt us."

ings were regularly moved to new sites. The reuse of
old buildings is thrifty and eco-historically correct on
one level, despite the often ludicrous and sometimes
subversive changes in identity that result. Grand old
houses become dentists' offices; sweat shops become
artists' studios; churches become restaurants; farms
become bed and breakfasts; working ranches become

money in the '30s they had used wood from an old fallen-down house.

Some local examples of house re-use: in Bath, a BIW union is headquartered in a former church, a coke machine visible in the foyer. A perfectly ordinary older house is the town's only chic restaurant. In Boothbay, the tugboat Maine (built around 1900 for the Moran fleet) was transformed into a cocktail lounge in 1973.

John and Judy Kennedy have built, by hand, their own replica of a mid-17th-century house in Hallowell, with blown-glass casement windows, diamond-shaped leaded panes, no windows on the back of the house, and no cupboards and closets. Each room has a fireplace (augmented by radiant heat). A modern wing separates 20th-century

dude ranches. Mansions and estates are broken up into low-income apartments, while formerly poor neighborhoods are gentrified. Most preserved environments have been through several cycles from rich to poor to rich again. Such changing functions for buildings are particularly interesting indicators of the evolution and devolution of places.

A restoration is really the production of a new object which stands in dialectical relation to the original.
— DEAN MACCANNELL

When "the real thing" is too far gone but nevertheless stands for something that someone feels should be preserved, the commodification of history is aided by replicas, which range in quality from the plastic tipis of an "Indian Village" along the highway, to Williamsburg's relatively more faithful primness. Sometimes the replacement is just too good to be true, like glossy reproductions of art "masterpieces" which are shinier, prettier, cleaner, and more intense than the originals. When re-creation is carried to extremes, as in the "first-person" interpretation at Plimoth Plantation, "visitors experience the thrill of the hyperreal and at the same time the fragility of the membrane that has been constructed to separate the present place and time from that which has been reconstructed." The height of flesh-and-blood artificial history is the reenactment, usually of Revolutionary and Civil War battles, which offers a vicariously "three-dimensional" experience and might be classified as participatory performance art. During the 125th anniversary of Gettysburg, some eight thousand "soldiers" volunteered, but nobody was killed. Flourishing souvenir markets—"Civil War shopping malls"—accompany such events.

Historical preservation is usually related more to property than to any expansive sense of place, and it can be hotly contested on an ideological level. The

BLAISE TOBIA, *Highland Park Bank/Porn Theatre* from "Pillars of the Community" series, 1982, original photograph in color (copyright Blaise Tobia). Other images in this series, taken in Detroit, show banks converted to a church and a pizza parlor, but this is a classic example of a building's changing roles: A neo-classical edifice transformed from bank to adult movie house, from protecting financial illusions to promoting sexual illusions.

triumphant, usually elite, point of view will represent a place, perhaps one-sidedly, for "posterity" (or until it is replaced by a more multifaceted view of the past). Ancient non-European cultures, for instance, tend to be perceived either as golden eras or as absurd and dirty underdevelopment. I once heard a ranger at the Anasazi ruin of Betatakin on the Navajo Nation tell his audience rather scornfully that those *primitives* in the twelfth and thirteenth centuries just threw their garbage over the edge of the rock alcove where they

conveniences from 17th-century style.

A whole row of houses in Bath were moved to the other side of town when the Bath Iron Works needed their waterfront sites for expansion. In 1994 a handsome old Federal house was offered free to anyone who could pay to move it, but people were more interested in buying its parts than saving its whole. "We need to maintain the integrity of the city to attract tourists and those houses are our gems," said a member of the Sagadahoc County Preservation Society.

A classic conflict between social needs and historic preservation took place in 1996 when the directors of the Bath Children's Home announced their plan to place a residence for some six teenagers in a "historic neighborhood." The opposition, which won,

had built their multistoried dwellings; I couldn't resist asking him what he thought urban Europeans of the same period were doing with their garbage—emptying their chamber pots out windows into the streets, among other "primitive" customs.

Yet even armed with such awareness, we can succumb to the harmonious and calming spell of a neighborhood that is more or less historically homogeneous. It makes a better environment for idealized imaginings about the past and provides an escape from the often harsh realities of our own lives. The historic district of Charleston, South Carolina, for instance, remains one of the most undeniably charming old wealthy neighborhoods in the country; it was zoned in 1931, the first preservation ordinance in the United States, New Orleans followed in 1935, to protect the Vieux Carré, then San Antonio in 1946 to protect La Villita. Today there are almost two thousand such ordinances nationwide.

Whiffs of the Civil War and class wars mix with the perfumes of honeysuckle and magnolia in Charleston. Yet for all their beauty and "authenticity," these lovely old houses have modern lives as well as antique memories. Passing by, one knows more or less who lives there. There is no decay, despite the fact that there is a law in Charleston that buildings older than seventy-five years (or younger ones rated high on the city's architectural inventory) cannot be torn down without approval by the Board of Architectural Review; they must be restored or allowed to deteriorate organically, presumably offering a picturesque counterpoint to their luckier neighbors. Slightly different criteria reign

in three districts of the city, with their socioeconomic variations, the strictest applying to the "old and historic district." (Historic mansions are notoriously costly to maintain and insure, but a few years after Hurricane Hugo, which battered but did not beat them, Charleston's prides are a pristine form.)

The federal Historic Sites Act of 1935 gave the green light to preservation of places where, primarily, important people lived or the architecture is deemed formally important. In 1966 the National Historic Preservation Act was passed, "a formal statement that at last historic resources were recognized to be 'woven into the fabric of our daily lives and not separate from it.'" The U.S. National Register of Historic Places listed twelve hundred sites in 1968 and thirty-seven thousand in 1985—the year that Charleston expanded its curatorial domain past the traditionally "historic" areas of the city. More recently, however, the battles have heated up between advocates of property rights and lucrative "progress" on the one hand, and advocates of historic preservation on the other. The existing laws are increasingly threatened by a political climate that favors the former, but they are paradoxically upheld by some members of the wealthiest old guards for whom "heritage" is a crucial component of identity.

MICHELE VAN PARYS, *Charleston Courthouse*, 1996. This building, located in the historic district at a spot called locally "the four corners of law," is undergoing restoration. Two versions of the building-to-be have been superimposed on its surface—a torn vinyl version at the left and a painting on wooden panel on the fence below.

used history to support their NIMBYism. In Freeport, the state was not allowed to put vinyl shingles on an historic house that is home to mentally retarded adults because it would not qualify for the National Register. There is no money for restoration.

Reliving the western frontier in the east, Maine has a "Buckskinner's Club" called The Ancient Ones, inspired by the apparition of a suspiciously authentic Revolutionary soldier. They concentrate their reenactments on the age of exploration, until 1840. "The legend is

that when someone is recreating the past and they are trying their best to duplicate what happened at the time, the Ancient Ones—the people who have passed before—will come down from heaven and meet with these people," says founder Terry Barlow.

The contents of these preserved buildings—art and furnishings—often overshadow anything that can really be called "history"; the owners have become "historical figures" by virtue of their acquisitive prowess. Guides' and docents' spiels are clues to how a place is being represented, usually without the input or consent of the people who live in the place. Sometimes the class nature of history is unintentionally communicated: in Hilo, Hawaii, I was guided through a nineteenth-century Congregational missionary's house by an apparently *haole* (white) woman, dressed in a mumu. The gist of the tour was typically narrow and focused on decor, but the guide's prim demeanor and speech was just as I would have imagined a nineteenth-century Christian-ized Hawaiian woman. The sanitized surroundings did not catch my imagination at all, but she did.

There are of course exceptions to the unspoken emphasis on upper-class history. I like to think of installations from the New York Chinatown History Project (now the Museum of Chinese in the Americas) and the Lowell National Historical Park as "artworks" because they diverge from the conventional museum and historical society. They have a more open-minded social analysis, accompanied by an experimental approach to didactic display. The Chinatown History Project began when Jack Tchen and Charles Lai discovered in a garbage dumpster the lifetime effects of an old man of the "bachelor society" that developed because Chinese women and families were not allowed to immigrate; only men were considered useful, but when they died they often had no heirs. The project was conceived as "a community documentation endeavor designed to reconstruct the hundred-year legacy of what is now the largest Chinatown community in America....We seek to learn about the backbreaking toil of Chinese seamen who shoveled coal into the giant furnaces of ocean steamers; the songs composed by lonely wives living in

CHINATOWN HISTORY PROJECT, *Installation of "Eight Pound Livelihood,"* 1984 (Photo: Courtesy of the Museum of Chinese in the Americas, New York). This exhibit—named after the eight-pound flatirons used in Chinese hand laundries—was key to the fledgling Chinatown History Project and was the museum's first exhibition, weaving oral histories and visual documentation. It is based in the material contents of a Bronx laundry that went out of business when its owner was murdered, and as the family packed up, each item provoked another story, another fragment of a fragile cultural legacy. "From a labor or social history perspec-tive," says founder Jack Tchen, "the evaluation of laundries is abso-lutely critical to Chinese-American history." Since the 1850s, laun-dries were the economic mainstay of many Chinese immigrants (today older men still work in Chinatown shirt presses), although when they visited China, the workers developed a folk myth that they owned clothing stores rather than washed the dirty clothes of strangers. The displayed information also bridges a generation gap, helping children understand the historical context rather than being ashamed of what their families did or do for a living.

Toisham bemoaning their sojourning husbands; the ghost stories about the tormented spirits of dead laun-dry men; the thriving street life on lower Mott, Pell, and Doyers streets; and the high-pressured piecework labor of garment factory workers…"

The project's first exhibition of historical photo-graphs, in 1978 at the Chatham Square public library, inspired respect for visual communication. "We'd see seniors climbing three flights of stairs just to look at the exhibit," recalled Tchen, a sociologist. "Some of

The Portland Woman's History Trail, created by Eileen Eagan, Polly Kauffman, and Patricia Finn, offers guided walks to 75 sites, including information on Native and working women whose names have not survived but whose places in history were nevertheless important. Among the named are teachers, suffragists, abolitionists, journalists, lawyers, a tavernkeeper, and an architect. Similar work is being done in Brunswick, where the honorees range from a former slave who ran a laundry business, textile workers at the mill now known as Fort Andros, and the town's first policewoman, who was less interested in crime than in helping the poor.

98

them brought little flashlights to look more closely for pictures of mothers or sisters or friends. They'd stand there talking for hours. It started to generate a lot of excitement, and that's when I realized we could use exhibits as an organizing tool to get more history....Many people think of history as a luxury; I think of it as a necessity."

When it comes to memorializing the working classes, and especially those who rebelled against their lot, the museum establishment seems baffled and unable to scratch the surface. At Lowell, the echoing halls give no sense of the vast crowds of women, men, and children that filled them daily from before dawn to after dark. The artifacts, interactive displays, and photo-text panels don't fill the gap. The loom rooms aren't hazy with choking lint; only a few of the machines are working, but they still produce such a deafening roar that visitors are given earplugs. At least the machines still produce something—plain, sturdy dish towels, which are sold at the museum shop. In most such places, "collectables" have replaced useful goods. Even at Lowell, sugar-coating can induce a bellyache. A boarding house installation conflates the troublemak-

ing mill girls, who were often labor organizers ("Radicals of the Worst Sort," to borrow an epithet of the era from Ardis Cameron's book on the subject), with homesick sorority sisters living in cozy (if crowded) intimacy and writing letters home to the farm.

Martha Norkunas has recorded a particularly opportunistic case of preservation in the transformation of John Steinbeck's literary output, his rebellious glorification of classes and groups erased from the image of the past, into "humorous caricatures of their former selves." Steinbeck himself recalled that when he wrote *Tortilla Flat*, the Monterey Chamber of Commerce issued a statement saying that "it was a damned lie and no such place or people existed. Later they began running buses to the place where they thought it might be." In 1958, fact merged with fiction when Ocean View Avenue was renamed Cannery Row. But rather than canonizing "rubbish," street people and class struggle, developers gutted Steinbeck's narrative of the sardine industry and are hyping an elegant nineteenth-century face.

LOWELL NATIONAL HISTORICAL PARK, Lowell, Massachusetts, 1978 to the present (Photo: James Higgins). National Park Service weavers operate and maintain the historical machinery in the 1920s-era Weave Room. Lowell, site of a dynamic and often tragic labor history, was the first planned industrial city in New England, and today the 1873 Boott Cotton Mills complex is the first national industrial park in the country. Boott first opened in the late 1830s and each weaver was responsible for two looms; as technology improved, each weaver was assigned twenty looms. The first workers were Yankee "mill girls" who were later joined by immigrants from many different countries. There are also museum exhibits, guided walking and boat tours, a turn-of-the-century tram to travel the 5.6 acres of canals, mills, and a reconstructed boarding house for mill girls. Artists David Ireland and Suzanne Hellmuth/Jock Reynolds are in the process of renovating two other sites in the complex, demonstrating, as Paul Marion has remarked, "how far the thinking about public art has advanced in a decade."

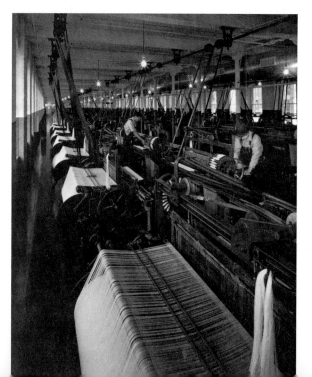

The excellent exhibition program of Portland's Maine Historical Society employs artifacts as catalysts for stories. A 19th-century can of corn tells the history of child labor; a Ku Klux Klan robe, a Black Panther poster, and an iron slave collar filed off an escaping slave by a Maine soldier in the Civil War explain racism and racial pride.

It is prohibitively expensive to salvage old records—primary sources for historians, genealogists, and even environmentalists. With little state support for the "professionals," local historians have a role to play. We knock on people's doors to see what they've got on their mantelpieces, what they've found on their properties. We ask them to xerox old pictures, letters, maps and records, to let us know when they find stone or bone

No matter how "historical" a site may be, it is always vulnerable to destruction for profit. Norkunas also documents the abandonment of the remnants of the tarpaper shacks that were worker housing on Cannery Row, once rented for between five and eight dollars per month; by 1987, the land beneath them was zoned for commercial use and was worth six figures. The president of the Cannery Row Foundation, which might have been expected to protect the site, was personally selling a lot next door for $350,000. Not surprisingly, he did not consider the workers' housing worthy of preservation.

The reasons why surviving industrial buildings are ruins (or have been transformed into shopping malls) are not overtly presented in most history museums; interconnections with contemporary site and social context are usually invisible. While the rise of industrial archaeology has brought with it an interest in old machines, technology rather than history is the crowd pleaser, with polished gears more attractive than glimpses of hard lives. In all such places, there is the danger Dean MacCannell has warned about: "work displays" in which backbreaking labor is made picturesque. Straightforward or twisted, these memorials to de-industrialization are too close for comfort to current problems. Descent into a soft bed of nostalgia is not the answer to the crisis dimensions of contemporary job loss, "downsizing," union "give-backs," and plant closings, although obviously related to the increase in enforced leisure time. It is understandable that a generation or two of local people may want to turn their backs on a closed mill or shipyard, until the pain subsides; but when the site is recognized as "family history," strategies for its use should be locally debated in depth, past initially superficial nostalgia or resentment to the real stories that need to be handed down.

SUZANNE HELLMUTH AND JOCK REYNOLDS, *Table of Contents*, 1990, Three Rivers Festival, Pittsburgh. Installed outdoors in a rusty steel box/room, this installation refers to the city's past through old photographs (high school yearbooks, nineteenth-century landscapes, and pictures of workers building the city's landmarks) and the materials from which its industrial triumphs were built. The interior consisted of rusty steel tables and bookshelves, with steel debris and framed photographs strewn about as though found in an abandoned library. The piece was in fact dedicated to the restoration of the local Braddock Carnegie Library, which celebrated its centennial in 1989. The artists researched the history of steel and Andrew Carnegie's role in the industry, creating a piece that was a library and was also about libraries, pointing out that knowledge of local history must "calculate and thereby guide subsequent perception and action," rather than merely informing for information's sake.

Suppression of popular struggles (as well as the sanitization of "heroic workers") in the past fends off resistance in the present. A classic example is the recreation in 1977 of Johnstown, Pennsylvania (a steeltown known as "the city of adversity"), after the last of three devastating floods. Don Mitchell has analyzed the way the new city has been accompanied by a new representational history—"in essence a mythology that valorizes certain parts of the environmental and social history of Johnstown while minimizing others." Plans

tools or clay pipe fragments or dated fire-places, ceramics or metals, old nails and trade beads, so we can photograph or record them.

We urge people to keep an eye out for clamshell fragments escaping from eroded banks along shore, lines or piles of stones under water that are old wharves, or remains of weirs, roads, and salt marsh fences. We suggest they keep a notebook about changes in their family, house, land, boats, or environment. We're not just interested in "the past," since the present gets there pretty quickly. Recollections even from recent child-hoods about things that are no longer here are important to jot down while memories are fresh.

And we interview the elders, as my grand-mother did in the 1930s and 1940s, when

underway for "discovery trails," a "Heritage Park," and a "National Cultural Park" stressing industrial history on a now postindustrial site will make the entire city a history museum—and a fascinating display of the way myths, clichés, and partial history will foster a moral landscape that erases a real history of struggle.

To remedy this situation, in 1984 an exemplary art project was conceived for Los Angeles by designers Dolores Hayden and Sheila de Bretteville. They founded a nonprofit organization called The Power of Place, intended to celebrate multicultural and women's history in the urban landscape through collaborative projects by artists, historians, and designers. Hayden has since published a book by the same name, which is crammed with insights about urban place and the ways "cultural citizenship" can be constructed from collec-tive memory and public information/art. De Bret-teville's *Biddy Mason: Time and Space* wall and her Little Tokyo project are the project's only permanent public art pieces executed so far. Contrasting inner-city neighborhoods "shaped by distinct ethnic cultures" with the homogeneity of contemporary city planning, Hayden observes that taxpayers' dollars are usually spent "to muffle history, pave geography, standardize social relationships." She advocates the politics of identity as conceptual frameworks of urban design, rather than merely as decorative shorthand to assuage this or that ethnic community—the Pagoda banks and phone booths of Chinatowns, tulips and windmills to evoke new Hollands (p. 240). There is no more sig-nificant model for artists concerned with these issues than this ongoing project—"a politically conscious interpretation of urban landscape history."

Artists' roles in connecting the dots between past and present in place are just beginning to be explored, with the currently burgeoning interest in representing the historic in avant-garde forms—as pioneered by

SHEILA LEVRANT DE BRETTEVILLE, *Biddy Mason: Time and Place*, 1990, 8' x 82' x 6", downtown Los Angeles (Photo: Annette del Zoppo). Biddy Mason was a remarkable woman, a midwife and eventual landowner who came to California as a slave and resisted returning to Texas with her "master." She and others courageously took their cases to court in the free state of California and were spared a return to slavery. Mason was a prominent citizen of Los Angeles's new black community. Shapes referring to her life (midwife's tools, the deed to her land —a monumental achievement for a recently freed slave) are embedded in the concrete of this memorial wall, like fossils of the place's past life. The letter X, Biddy's signature, marks the place and becomes a symbol of the African diaspora. De Bret-teville says that whenever she goes back to see this work, she overhears "people of various ages and backgrounds tell each other Biddy Mason's and Los Angeles' story, putting the empha-sis on what interests them. This is what I intended—to catch their attention, to surprise them, to make it possible to enjoy a place history in this concrete way."

Houston Conwill, Sheila de Bretteville, and Jane Greengold, among others. Since the seventies, *trompe l'oeil* muralist Richard Haas has recreated historical facades and details on contemporary buildings. In 1979 Rosemary Mayer made a series of portrait snow sculptures in the garden of the Lenox, Massachusetts public library, commemorating local women of the eighteenth and nineteenth centuries. Fred Wilson's

the oldest people could remember the Civil War, and they in turn had talked to those who remembered the Revolutionary War. But either she didn't keep her notes or they got thrown out at her death. A similar fate seems to have met the notes of Roy New-

man, who was also a student of Georgetown history. Along with many other avid amateur historians, we are reinventing the wheel even as the information leaks away.

There is one family graveyard on Kennebec Point, home to Olivers and Todds, nestled

below a steep bluff, its marked stones dating to 1823. The summer family who owns it has buried three of their own there and added a white picket fence, leaving the unmarked fieldstones to the west outside the pale, banished to obscurity on the overgrown

oblique view of museum collections to bring out the histories of race and racism has proved particularly appealing to broad audiences.

New York sculptor Gail Rothschild has made art on small pox as biological warfare (*Hot Spot*, 1990), on the history and poultry industry of Arkansas, the Triangle Shirtwaist fire, Margaret Fuller and women in the nineteenth century. Her 1994 *Muted Belles* in Memphis pays homage to eight Southern women across cultures with a witty columned and corniced play on the shapes of bells and hoop skirts. Rothschild just completed a postmodern monument for Daniel Chester French's garden in Stockbridge, Massachusetts, in which a classical base ironically supports a prehistoric Indian cairn, or stone pile. (She quotes French as saying "the important thing is not to find a site for a statue, but a statue for a site.")

Melissa Gould, inspired by research into her Jewish heritage, began a series of temporary memorials to places by outlining the floor plans of destroyed European synagogues in fluorescent light. Her *Titanic Project* would recreate in lights the full length of the tragic ship at Manhattan's Pier 54, the Titanic's 1912 destination. Ann Hamilton also "brings the past to light" in ways not available to static objects in her on-site, labor-intensive performance activities (such as folding and piling 14,000 pounds of denim work shirts and pants in Charleston in 1991). Brece V. Honeycutt executed *Health and Hearth*, a multi-media installation with night performance at the Clara Barton National Historic Site in Maryland, in 1995. She used glowing heated bricks, mica candle lanterns, an opaque canvas screen, and taped texts to commemorate for a general public the Civil War nurse who worked in "the open field between the bullet and the hospital"; the piece was so successful that the Park Service asked for a replay the next year.

The most ambitious project yet along these lines was the 1995 "Prison Sentences; The Prison as Site/The Prison as Subject," organized by Julie Courtney and Todd Gilens, consisting of fourteen installations in Philadelphia's empty nineteenth-century Eastern State Penitentiary, commissioned from local and international artists. The historical presence of the building itself, its light and darkness, threatened on one hand to overwhelm the works it contained (none of which dealt specifically with the prison's history and people), and on the other hand heightened their emotional and political content.

In 1994-95, the Bronx Council on the Arts initiated "Biography Memorials," a temporary exhibition in another evocative site, the Woodlawn Cemetery. Participating artists were asked to consider individual and symbolic issues on a site rich in history and sculptural invention. At the same time, in New York's Central Park, Judith Shea "shadowed" Augustus Saint-Gauden's turn-of-the-century Central Park sculpture of William Tecumseh Sherman with a black wooden cutout of a watchful (probably Native American) figure on a standing horse that mocks the overblown classical image of his counterpart; it echoed in public an earlier indoor installation work by David Hammons in which he deconstructed Manifest Destiny through the re-representation of a Teddy Roosevelt equestrian statue, flanked by Native and African people (on foot). Such pictorial activism marks the moment when, as Guillermo Gomez-Peña has put it, "we all began to remember/instead of being remembered."

Predicting the Power of Place project, Kevin Lynch suggested a "public attic"—a place where old machines, clothes, papers could be rummaged through and literally played with, extending the notion that "the city itself can be a historical teaching device." Such displays could include "old fashioned clothes in a

margins. (One of them mysteriously bears the initials T.L.) Legend identifies this as an Indian graveyard, but unmarked stones were common among the English settlers. There are a number of so-called "Indian graves" on Georgetown Island, most of which are prob- ably not, although in a cemetery on the Phipps Point Road in Woolwich there is plaque inscribed:"Here Lie Buried Several American Indians," no comment on the circumstances. Deep in the woods just off Kennebec Point there is a very old pile of quartz stones that has never been excavated. It might prove to be a legitimate Indian burial and is therefore best left unmolested.

We found a similar pile of displaced quartz rocks on a Kennebec Point Beach, near two small middens and a possibly

clothing store, former work methods in a factory, previous illustrations of a site on the site itself...." Artists could make hay with this sort of guideline, instead of being parachuted into the provinces from the art capitals for purportedly "site-specific" exercises that rarely involve or even interest the local communities. One group that has made locally grounded work their focus is the New York-based REPOhistory collective of artists, writers, historians, and activists (pp. 111, 194). When they were discussing the possibility of a project with the Museum of the City of New York in the mid-1990s, one of the suggestions that emerged was to use the building's exterior to relate to the East Harlem community so as to bring the neighborhood into the project. Another proposal was to look at the ethnic shifts in New York City in relation to the dates at which objects were acquired by the museum.

At some point, distinctions must be made between history and memory. Personal memory of course is less manageable and less factually reliable than recorded history, but history as collective memory can be manipulated from the outside—by the state, by teachers, by religious institutions. Within each person's life, histories vie with stories, teachers with elders, received information with lived experience. Memory replaces official history especially when a group of people is displaced geographically or culturally. Much Chicano art, for instance, is rooted in this sort of alternative historical memory, with an emphasis on intimacy and the religious-spiritual roots of family history. And if history is associated with text, memory is associated with image, with a full panoply of the senses.

The Alamo, in San Antonio, Texas, is a case in point, illuminated by Kathy Vargas's photo series *My Alamo*, a photographic memoir of an *Hispano* family's long-term ambivalent relationship to an ambiguous monument. In 1836, 189 Texans held the fort against thousands of Mexicans led by the unpopular general Santa Anna. The Texans' motives, according to the Daughters of the American Revolution (DAR), which has managed the site since 1905, were purely patriotic. Recent research suggests otherwise. Today the Alamo is under siege again. *Hispano* residents and politicians accuse the ladies of perpetuating white supremacist myths, which are countered by lesser-known research: Davy Crockett tried to surrender; Sam Houston was an opium addict; the fort's commander was crazed from drinking mercury to treat venereal disease; Jim Bowie had murdered some Apaches, stolen their hoard of silver and gold, and buried it on the premises, which contributed to his desire to hang in and win.

For many in the Mexican-American city of San Antonio, the Alamo and its troops of idolatrous tourists are bitter reminders of a history of exploitation and racism against their ancestors, including the Native populations. "Here's a mission that existed for 120 years and the only people you hear about had been in Texas for two months," said a local reporter. Yet Santa Anna is no hero either. To "Remember the Alamo" is not a pleasant process for either side, but revisionist historians can take some of the credit for a raised consciousness about challenging orthodoxies on historic sites. According to the Inter-Tribal Council of American Indians, the Alamo occupies the site of an eighteenth-century graveyard containing 920 Indians, thirty nine Spaniards, four mulattoes, and one Canary Islander— "the real founders of the San Antonio." At a 1994 Saint Patrick's Day ceremony, the DAR characterized the Alamo defenders (who included Irish, Mexicans, and an African American) as "the first Rainbow Coalition." Anglo artists in town are drawn to the kitsch value of the Alamo without considering its full history.

Ruins are the *vanitas* of the contemporary landscape, especially when their melancholy is enhanced by

human-made berm behind the beach. At the end of another beach is a curious mound of sand that has no ready geological or cultural explanation. In the 1970s, I was convinced it was a "burial mound," and almost sacrificed my eight-year-old to it by digging a side tunnel and sending him in. He saw only sand before I got scared and yanked him out. Given changes in sea level, erosion, and plowing, it would be impossible without major excavation to determine whether these were Native monuments or the results of natural events.

A seventy-two-year-old man said it made him sad to see graves overgrown: "These people should not be forgotten. They're the ones who cleared the land and opened the fields. They earned a meager

nature's encroachment (as opposed to manicured lawns). Vernacular ruins of farmhouses, barns, and windmills, for example, augur the demise of the family farm. Sometimes ruins are cautionary monuments against war and other mindless destruction (the bombed-out cathedral in central Berlin), but usually they function as generalized and disembodied mnemonic devices that urge us to remember what we never experienced and cannot know. As artist Will Insley has remarked, what is "absent from the ruin is often less marvelous than we imagine it to have been. The abstract power of suggestion (the fragment) is greater than the literal power of the initial fact. Myth elevates."

Of course, there are ruins and there are ruins. Factories and tenements are considered more expendable than bridges and churches. On the more commercial and the more organic sites, chronologies are blithely mixed. The social criteria with which we have defined the "picturesque" over the ages is a story in itself. Responses are culturally conditioned, as when large-scale ruins, like the huge city of mounds at Cahokia, Illinois, are considered too ambitious to have indigenous origins—despite the fact that Indian sites, place names, and false myths have filled the historical vacuums in the American landscape, competing with European ruins.

Cemeteries are symbolic ruins, those most commonly inspiring introspection. Neil Herring, writing about different trends in the urban and rural South, suggests that the wooden markers and uninscribed gravestones of the frontier days paralleled "the phantom history of farmsteads, villages, even whole towns which were built, and presumably thrived, only to be abandoned in the constant movement westward, onto new ground, freshly stolen from the natives." The formation of rural cemeteries, says David Charles Sloane, "coincided with a national movement to reestablish the American past.... The cemetery, by definition a

KATHY VARGAS, *My Alamo*, 1995. From a series of altered photographs with handwritten texts concerning a Chicano child's ambivalent relationship to the Alamo: "Once I refused to wear the coonskin hat for the photo because on TV Davy Crockett fought Indians in his coonskin hat. My father said that we were part Indian. Was Davy fighting us? I didn't want his hat. Another part of me was Mexican, but the Mexicans were the bad guys at the Alamo. It was very confusing. Was I the bad guy?" Vargas's great grandfather, a Tejano since 1830, was at the Battle of the Alamo on the Mexican side, but he wasn't given a gun because he was an *indigeno*. The artist identifies with this role, feeling like a witness to the gunplay over Texas, much like a human camera." The caption to this piece discusses the *raspa* vendors selling ices in front of the Alamo, obscuring the view, "commercializing it for pennies. The Daughters tried in vain to have them expelled. They would have been welcome if only they'd brought in bigger bucks."

living from sunup to sundown. And it's not right that they be abandoned and abused."

Georgetown's Oak Cemetery is a literary treat, containing many uncommon first names, among them: Zephalanta, Eliphalet, Ina, Zina, Bina, Aravesta, Philena, Eusebus, Thirza, Pelatiah, Flavilla, Adaliza, Abishu, Azubath, Balbena, Christania, Lalla, and Farolyn. The Georgetown 5th and 6th grades have made a survey of the cemetery with Billie Todd, a project to be extended to all the town cemeteries.

104

place of memories, became a location for the memory of the community."

Graveyards symbolize both loss and celebration of individual lives, and they are most poignant in calm, natural spaces conducive to pleasant recall or when they are come upon unexpectedly in some forgotten corner. Their intimate scale pulls visitors into memory more powerfully than most overblown colossi. They gain their emotional impact from that which they monumentalize rather than from its physical representation. Michel Foucault sees cemeteries as classic "heterotopias," representing several places at once. These landscapes of death in memory of life are attempts to carry life's social hierarchies of gender, class, and race into the next world. In many places, those buried by charity are in mass graves or segregated in a special section, while the rich and important are rarely modest in their demands to be remembered for conspicuous consumption.

With great regional variation, churchyards that often included several bodies in one grave gave way to tiny family burial grounds and then to more impersonal commercial or community cemeteries where space is sold, or reserved in every sense. James Deetz traces through the images of New England gravestones the theological development toward an emphasis on the individual, from unlabeled fieldstones to elaborate urn-and-willow monuments that abstract presence into commemoration.

Cemeteries imply immortality, promising "perpetual care" which may in fact be shortlived. My father died only thirteen years ago, but when I visited the cemetery, both his and my grandfather's modest flat-to-the-ground stones were almost covered with earth and grass (evidence of the uncaring passage of power mowers). The lawns are mowed, the parklike atmosphere—though now in the middle of a deteriorated neighborhood—is carefully maintained, but the language and the individuals it recalls are disappearing into the earth. The cemetery is now a social monument for defusing death rather than a collective reminder of mortality.

In a deracinated society, cemeteries represent deracinated continuity, taking the places of disappeared family homesteads. Cemeteries change less rapidly

Right: *Georgetown's Oak Cemetery* (Photo: Peter Woodruff).

The Galisteo Cemetery, 1996 (Photo: copyright Susan Crocker). The sign reads "KEEP OUT No filming, no photographing by order of the Archbishop." This is a result of the influx of tourists in New Mexico who wander the byways and have angered residents with their lack of respect. It is also the result of photography classes and a nearby movie set; when Hollywood escapes its confines, the entire village becomes an involuntary stage.

Truck graves at a cemetery in Edgecomb, Maine (Photos: Peter Woodruff).

than other sites, and embody (so to speak) spatial, aesthetic, and social dimensions. Yi-Fu Tuan writes about Chinese "geopiety," expressed as the need to be buried in ancestral ground. This is what has been lost in the contemporary United States. Today's impersonal cemeteries reflect a crisis of belief. It is rare that a stone even refers to the interred's profession (women's professions are mentioned far less often than men's); Herring noted a stone sickle in a Tennessee farming community, a grim pun on the reaper and the heavenly harvest, as well as some rare sightings in Georgia —an etched shrimp boat and an unusual three-dimensional tractor trailer. Now and then someone will be buried in his or her car, or the vehicle will top the grave as a paralyzed memorial to mobility. A 1994 headline in a Maine newspaper: AFTERLIFE IN THE FAST LANE: CAR ENTHUSIAST WILL REST IN PEACE IN HIS BELOVED CORVETTE.

My mother never visited her parents' and my father's nearby graves because she didn't believe they were present there in any sense; as a place, the cemetery meant nothing to her. I tend to agree, yet I have asked that my ashes be scattered on land or water in the places that mean most to me, and I find that thought comforting — perhaps because, whatever one believes about the life of the spirit, the bonds between body and land are obvious. Visiting the graveyard in New Haven, Connecticut, where several generations of my family lie, I was surprised when my iconoclastic son wondered if we shouldn't at least have our names there, on a stone, because the plot constituted a family history. All most of us can ask of the future is "remember me as you pass by..."

Marking the Spot

*Past and present are linked by a contract, a covenant between the people
and their leaders, and this covenant is given visible form
in monuments and a temporal form in a series of scheduled holidays
and days of commemoration.*
—J. B. JACKSON

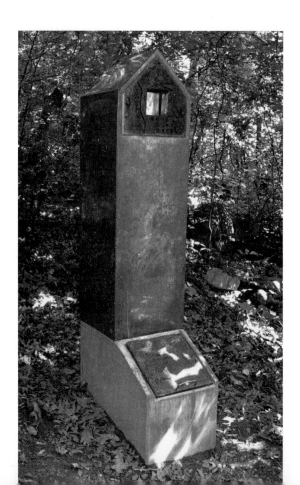

There are no conventional monuments outside the cemeteries in Georgetown, but there is a modest predilection for (recent) bronze plaques, publicly commemorating those (often summer) residents who have contributed to the town, or privately commemorating those who lived or died on site. On an island off Hunnewell Beach a Bates College student who drowned there is remembered. In the depths of the woods on Long Island are three plaques to the memories of former residents.

Our real monuments are of another order, still on the move. Boats are a big part of Maine's attraction. "Tall Ships" and "wind-jammers" (perceived as "clipper ships" though they are often old cargo coasters) ply the coast as mobile inns, or dock here

THE CELEBRATION OF THE PAST CAN EASILY be made to play politics, and monuments are linchpins of this process. Most monuments favor mythology and are even further from "reality" than historical preservation. Nationalist and conservative forces are particularly fond of manipulating meaningful regional forms and histories to bolster their chauvinistic agendas, often denigrating modern life and blaming its faults on recent immigrants and ethnic minorities. Loyalty to "homeland" and "the unity-in-diversity discourse" still serve to ease immigrants into assimilation. Sometimes buildings themselves are monuments, but for the most part a monument is a structure built on top of memory relating to it only superstructurally, or even beyond memory—creating compulsory recall. Usually a sorry substitute for any actual remains, it can serve several contradictory purposes—resurrecting history, laying it to rest, and attracting tourists.

While monuments are often sterile pronouncements of the obligation to honor a truly dead past that occupies only a static place in the ongoing present, they can also recall the dead in order to make the survivors responsible to the living. Commemorating a place can have the same effect, as it did with a 1967 event staged by the New York State Council on the Art's visual art director, Allon Schoener, to commemorate the sesquicentennial of the Erie Canal—931 miles of heroic engineering and endangered waterway. The cultural and

HOUSTON CONWILL, ESTELLA CONWILL MAJOZO, AND JOSEPH DE PACE, *Stations of the Underground Railway*, 1992-93, New York State, Niagara Region: Lewiston, Niagara Falls, Niagara-on-the-Lake, Ontario, Pekin, Parker, and Niagara University (Photo: Biff Henrich, courtesy Castellani Art Museum, Niagara University). Each site has a historical connection to the Underground Railroad —the escape route taken by enslaved African Americans to reach free territory in the North or in Canada. The installation of each shrine-like sculpture was accompanied by a "response poem" by Estella Majozo and a symbolic libation—the pouring of water.

economic role of the canal in the state's history was dramatized by the voyage of the Erie Maid, a twin-decked "exhibition boat' carrying a lively audiovisual show that stopped at thirty communities between Albany and Buffalo with much fanfare, costume pageantry, and a pseudo-historical newspaper handout called *The Canal Courier*.

Is it more important to preserve the sites of pleasure or of pain? Monuments to social tragedies should intervene in daily public space, lest responsibility be displaced, whereas celebratory monuments may blend more harmoniously. Monuments to victories are often less moving than those to losses, and monuments are not always in place; sometimes the event memorialized, like the Holocaust, happened far away. The gleaming black angle and fifty-eight thousand chronologically listed names rising from or descending into the earth of Maya Lin's Vietnam Memorial in Washington, D.C., is a rare monument that has become a place in itself rather than a reference to another place and time. It overwhelms the conventional bronzes nearby —Frederick Hart's heroic soldiers and Glenna Goodacre's noble nurses—demanded by conservatives who were outraged by the great black wall and its youthful Asian designer. Most literal representations are melodramatic and banal to an extreme, but abstracted monuments can seem to deny experience. Monumental architecture and sculpture rarely hold their own against space or time. The feeling of reverence sought by monument makers is not easy to come by in our irreverent society.

Where Lin's Vietnam Memorial and her smaller but equally impressive Civil Rights monument in Atlanta create places of memory and mourning, the squat volcanic rock obelisk marking ground zero at the Trinity site in southern New Mexico, where the atomic age began, cannot compete with the place itself. Dwarfed

and there for paying tours. The Maine Maritime Museum in Bath is homeport to the fishing schooner Harvey Gamage and there is talk of creating a "naval historic park" based on the first destroyer designed to carry missiles, built at the Bath Iron Works in 1959.

For as long as I can remember, the Wiscasset waterfront on the Sheepscot River has been centered on the ghostly hulks of two 80'-long, four-masted sailing ships. The Hesper and the Luther Little were built in 1917-18 and brought to Wiscasset in 1932 as

part of a lumber-hauling scheme that fell victim to a post-Depression economy. They were towed close to shore and abandoned, gradually becoming much-loved landmarks. Even listing in the mud, they provided one of the most romantic images in the area.

by the vast landscape of White Sands Missile Range, which is dotted with military bunkers and ominously unidentifiable structures, the Trinity monument makes no references to Hiroshima and Nagasaki—and no plaque has been added for Chernobyl. Evocation of the planetary consequences of the event of 1945 are left to the place, the space itself, the blue mountains in the distance, thunderclouds on the horizon, the dust devils rolling across the desert.

> Older jish [ceremonial bundles, or kits] belong in the community where they were originally acquired… Some of these have a history that goes back 200 years. A jish contains rare elements from all over Navajoland and beyond. In a way it is a miniature version of Navajoland that concentrates the power of its rare elements and species.
>
> — KLARA KELLEY AND HARRIS FRANCIS

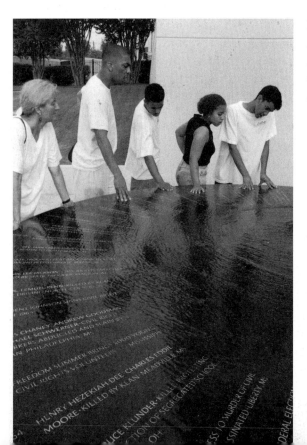

American Indian history, so integrally entangled with place, has been ill served by the ubiquitous brave-on-a-horse monuments (especially James Earle Fraser's dispirited *End of the Trail*, which began as a life-size bronze but has since become ubiquitous, reproduced in many scales and mediums). Gutzon Borglum's Mount Rushmore defiles rather than commemorates the sacred Paha Sapa, or Black Hills, by transforming them into a monument to American colonialism. It is rather ineffectively parried by the in-progress monument to Crazy Horse near Rapid City, South Dakota—a generic image since the great Lakota warrior refused ever to have his picture taken. For many Native American nations, the land itself provides the monuments, marked by innumerable sacred sites where mythical and historical events took place, known only to those who care.

Making the connections between the genocide of Native Americans, Jews, and the living death of African American slavery, James Young has suggested that we might all share "common spaces of memory, if not common memory itself. As a result, every group in America may eventually come to recall its past in light

MAYA YING LIN, *Civil Rights Memorial*, 1988-89, black granite and water, Southern Poverty Law Center, Montgomery, Alabama (Photo: Hubert Murray). Maya Lin's name has become synonymous with the "new monument," since her Vietnam Memorial was built in Washington D.C. in 1982. In this more intimate Civil Rights Monument, water is the theme and the content, as it runs down a wall behind the oval black table and bubbles up from the table itself—a form inviting dialogue and touch, on which the movement's open-ended history is documented. Incised on the wall are the words that inspired the work, Dr. Martin Luther King quoting the Bible: "We are not satisfied and we will not be satisfied '*until justice rolls down like water and righteousness like a mighty stream*.'" Water becomes a healing, purifying agent as it flows gently over the names of forty men, women and children slain during the struggle for civil rights, showing, as Lin says, "how individual people helped to change history." This picture shows visitors from Project Hip-Hop in Boston: Nancy Murray, Wyatt Jackson, Nick Andrade, Sandra Marcelino, and Ravi Dixit.

Year by year, however, saw increasing depradations. The masts and rigging went first, but even the rotting hulls had an imposing profile. Then they too began to disintegrate. Finally, in 1996, the town admitted that the old ships were more of a liability than an attraction. Their fate is still undecided. Some propose to salvage them, bring them on land, and start a waterfront museum. Local opinion ranges from get-rid-of-that-eyesore to nostalgic reluctance to see them go.

A recent arrival in Bath is a 17' section of the 35' bow of the Snow Squall—the last known clipper ship. Built in Cape Elizabeth in 1851, she sank near the Falklands in 1864. After months of controversy about her fate when the Spring Point Museum in South Portland was no longer able to maintain her

of another group's historical memory, each coming to know more about their compatriots' experience in the light of their own past." The Washington Mall will eventually provide a panoply of cultural contributions, with the addition of Smithsonian museums dedicated to American Indian and African American culture. Those who see multiculturalism as divisive rather than inclusive oppose this pan-humanism as "Balkanization of the Mall."

Only an avid military buff would be moved by the ubiquitous war memorials that dot the nation's small town squares and parks. In the late sixties, I suggested that all the equestrian statues in Central Park be brought together in a single field, like toy soldiers, strength in unity being the last hope for obsolete statuary. It was a time when a number of Minimalist, Conceptual, and Pop artists (Dan Graham, Robert Smithson, Carl Andre, and Claes Oldenberg, among others) had become interested in monuments, precisely because of their often absurd vacancy and loss of

CHARLES SMITH, *African-American Heritage Cultural Center*, Aurora, Illinois, 1986 to the present (Photos: Dave Kargl). Smith, who holds a BA in social sciences and is an ordained minister, is a Vietnam veteran. He began to make sculpture while struggling with post-traumatic stress disorder and now his ever-growing yard environment includes some 75 works commenting on history and current events. Despite a focus on activism and tragedy (slavery, Vietnam, Somalia, Rodney King), the museum is also a healing place, including among its many figures an arched gateway spelling "We Shall Overcome," and historical figures representing various virtues: "Grandma Hands" (Heritage and Remembrance), "Ms. Sassy" (Dignity), Gwendolyn Brooks (Character) and Louis Armstrong (Achievement). The Center is dedicated to "those of African ancestry that paid the price with their lives and their commitment to the struggle for liberation of African-Americans here and in Africa," says Smith. "I see this facility being the first African-American art institute in the United States that is free from all outsiders explaining, telling, and controlling it, because it is designed to tell the raw truth. Nor will we have anyone telling us these pieces are too graphic, that there is too much blood, or there's too much hatred. There is none of that. All of it is history." Smith welcomes groups, gives tours of his museum, and uses his sculptures as teaching aids for neighborhood youth. The environment continues indoors, where living space merges with work space and Smith shares his life with sculptural companions.

109

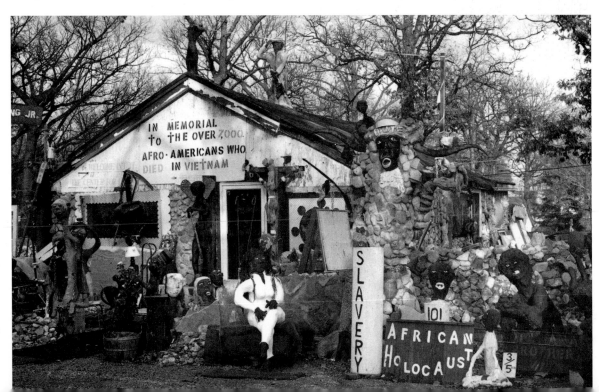

waterlogged timbers, and no museum would take this "big pile of wet wood" because of the expense of preservation, the Maine Maritime Museum offered the Snow Squall's remains a home.

One of my fondest memories is a boat funeral. My uncle Jud sailed for years a broad-beamed, gaff-rigged 14-foot catboat called the Anne L. ("the floating hotel"), inherited via several Dalrymple "boys" from its original owner, Anne Lauriat. The boat was built in the 1870s, and when time finally took its toll, Jud couldn't bear to have her end up as a rotting monument or beach toy (or worse still, a planter). So we gave her a Viking burial at the annual July 4th picnic on the Cross's beach in 1952. She burned for a long time. Everyone else went home. Four

meaning. For a municipal art project in New York City in 1967, Oldenburg had a hole dug by union gravediggers behind the Metropolitan Museum—negative spatial comment on the mausoleum role of the museum and monuments in general. Since then, some of the most impressive ideas for monuments have dealt directly with the fact that absence can be more powerfully evoked than presence. The jury for the Free Speech Movement monument at Berkeley (I was on it) recommended Mark A. Brest's project: a small circle of dirt marked by an inscription on marble: "This soil circle and the air space extending above it are not part of any nation and are not subject to any entity's jurisdiction." A decade later, a jury recommending public art for the Atlanta Olympics (I was there again) gave a prize to a similarly "artless" delineation of a space that nullified all zoning laws. These awards were not just nods to clever gestures of resistance but critiques of the lack of inventiveness in proposals presented for built monuments. Writing about several artists' spatially negative Holocaust monuments in Germany, Young has called this kind of work the "counter-monument," since it mocks "the traditional monument's certainty of history…Memory is thus sustained, not denied, by a sense of human temporality."

While monuments tend to be the results of complex social processes (including design competitions, political maneuvering, community approval, massive fund-raising, and endless compromises), the marker offers a small-scale, subtler, and potentially subversive way of recalling the history of a place. The brown wooden roadside historical markers, illegible from a speeding car (despite the addition of "warning' signs so that people will be able to slow down and stop) are sometimes inaccurate and do little to provoke those who already think "there is nothing to see." Here again, however, the place itself, changed or apparently unchanging, is the monument.

Bronze plaques on urban buildings can be seen as subtexts to the houses themselves, "a part of the system of inscriptions that institutions of power write about themselves." When we read them without entering the house, they take precedence over the primary artifact. Signage pushes interpretation in one direction or another and often quells associative ponderings. But a more imaginative use of signs could ask questions, connect the site to the place itself. Firsthand accounts are always the most riveting. For example, the signs at a restored adobe ruin of a seventeenth-century mission church at Quarai, New Mexico, range from the predictable to the informative. But only one captures the last decade of the mission's and the pueblo's existence—a first-hand account by Fray Bernal, who wrote back to Spain that for two years both Spaniards and Indians had eaten toasted hides and leather while they lived in constant fear of Apache attacks. What now is a beautiful, peaceful spot was the scene of slavery, battle, and starvation. In fact, every place is the site of both contentment and despair, and it is this complexity that historical preservation and signage should convey.

Contemporary morality tends to interfere with realistic impressions. Josie Bassett's little homestead ranch in Utah has been swallowed by Dinosaur National Park. Her boarded-up cabin still stands in its idyllic site with a Parks Department sign showing a photo of the grandmotherly type who settled and ran the place alone in the early years of the century. It takes a book in the visitor's center to fill out the picture: Josie had four husbands, may have murdered one of them, and might have engaged in cattle rustling with her mother and sister. In an area known for its outlaws (heroes of novels and movies who are well documented in local museums or roadside attractions), a woman's crimes apparently are not so marketable.

of us sat by her side until just at midnight, with the Popham bell ringing, the waves broke over her embers. We drank a toast to her long life heading jauntily into the wind. I still have some of her ashes, my cousin Anne has her transom as a coffee table, and my 12-foot broad-beamed, gaff-rigged Beetle Cat named Rosita looks and sails just like the Anne L.

John Bunker, an amateur historian from Palermo, Maine, collects living monuments—"antique apple trees" he plants on his property. "The apples are a link with the past," he says. "Each has a history. They are a living incarnation of amazing things that happened 100 or more years ago... Looking at an apple is almost like looking into a crystal ball and seeing who's there."

Far more informative and evocative of place than most signage are the "history trails" through cities that have appeared in the last decade. Designed to unearth the lost histories of women, minorities, or workers, they bring historical landscapes up into view from under the concrete, but without substantial architectural and landscape components, they tend to float. Markers may be inadequate on their own, but like unmarked walking tours of historical areas, they have one foot in the past and one in present reality. What one tours is the remains, sometimes almost invisible, but at least visualizable with a little help. Physical movement through streets and past buildings, even when they offer a mixed bag in terms of chronology and remodeling, brings the tourist closer to the past than history books can. Gail Lee Dubrow has proposed to introduce innovative, "nondidactic" interpretive panels in historic places for a Women's Heritage Trail in Boston, a city that already boasts a Black Heritage Trail (including little about black women) and other historical itineraries. Her proposals, supported by grassroots activities in the public school system, have been influenced by the Power of Place project and other public artists.

Appropriation of the signage styles of the bureaucracy is a popular strategy for artists to enter the picture. Edgar Heap of Birds's confrontational texts force passersby to acknowledge genocidal tragedies and the histories of stolen lands. REPOhistory (replaces the neutral markers of the bureaucracy with lively and opionated visual-verbal commentaries on historical events up to the present. Scott Parsons and David Greenlund confounded expectations by

offering a sign in the Lakota language, among others in their skeletal tipi project, which was pivotal in the cancellation of Denver's Columbus Day parade in 1992. Gloria Bornstein and Donald Fels provided critical "viewpoints" on the historic development of the Seattle waterfront. Ilona Granet, who makes her living as a sign painter, also makes signs as art that comment with wickedly straightforward humor on male behavior toward women in public places. Since these are not functions art is expected to fill, the artist's sign becomes an effective mediator between general expectations of public information and of art.

For all the talent and sophistication that goes into such artworks, none have achieved the public appeal of the Burma Shave signs, which began in Minnesota in 1926. Just as anonymous advertising artists have more cultural influence than the biggest names among fine artists, popular culture is way ahead of "public art" in representing the past to millions of North Americans. In her scholarly and entertaining book *The Colossus of Roads: Myth and Symbol Along*

REPOHISTORY (James Malone and Tom Klem), *Sarah Lena Echols Malone*, from the "Entering Buttermilk Bottom Project," 1995, Atlanta (Photo: copyright Frank Niemier). Signs marking well-known and anonymous lives, created in collaboration with local residents, were accompanied by an installation in Piedmont Park and a parking lot painted with the life-size outlines of houses and streets that had occupied that site before demolition, including house numbers and family names, based on a 1959 city directory. Klem was inspired at an early project meeting by James Malone pulling out a tattered snapshot of his mother sitting on a porch in Buttermilk Bottom, where he was raised. The text reads simply: "Mrs. Sarah Lena Echols Malone raised her family on 267 Pine Place, Apt. #3, in the early thirties."

Like the sumacs that grow thick in disturbed ground, gnarled apple trees are often our first clues to old cellar holes and wells buried in the woods.

Tourists now go to see the monuments of tourist history. Tourist cabins emerged with the advent of the Model A—the "tin can tourist" that ended Maine's exclusivity

as a summer playground for the wealthy. By 1930 there were about 150 motor courts in the state. Traffic-clogged Route One (known as America's Main Street), which

the American Highway, Karal Ann Marling celebrates the sculptural counterparts of the tall tales that fuel American folklore. Her talisman is a fifteen-foot tall statue of Paul Bunyan and Babe the Blue Ox on the shore of Lake Bemidji, Minnesota: built in 1937, it is the model for many others of its kind that define Midwestern space and assert local identity. Such behemoths are particularly well suited to the Great Plains, where they are visible for miles, breaking highway monotony and luring tourists to towns that may have little else to offer outsiders. They are counterparts of postcards advertising local produce: the giant potato on a railway flatcar, the pair of huge, breastlike navel oranges flanking a happy small boy, the ear of corn looming over a tractor, the barn-sized loaf of bread in a Kansas wheatfield, the huge fish or grasshoppers that may be caught nearby, and mythical animals like the "Jackalope" (the gigantic antlered jackrabbit

invented in Douglas, Wyoming, in 1934 and since immortalized in postcards, a band, and a Southwestern gift store). These artistic creations may have taken a cue from their found-object siblings, symbols of the past too large or too ordinary to fit in museums—the locomotives, cannons, cable cars, airplanes, and missiles that dot local public parks.

Roadside sights are created independently by local artists as well as by entrepreneurs and chambers of commerce. Some evoke distant sites (in Washington state, in the seventies, I saw a roadside miniature Egyptian desert, complete with camels and pyramids); some evoke the local past (in a New Mexican village a little painting of a church stands on a mound of rubble where an earlier church stood (pl. 2). Elaborate yard displays of bottles and crockery embedded in cement or fantastic found-object sculptures and gardens featuring stone or shell castles, religious

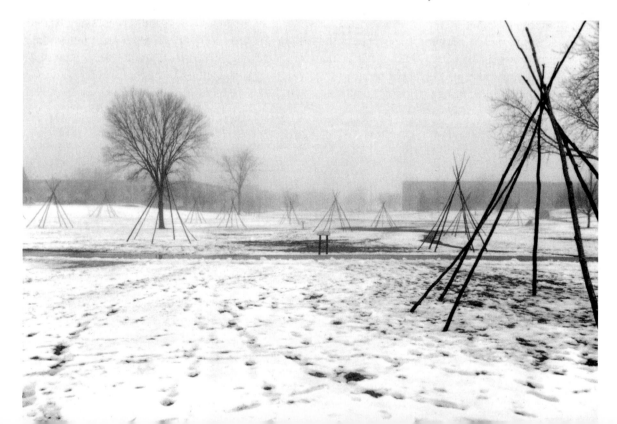

runs up the coast and then inland, from
Kittery to Fort Kent, is rich in road-
side rustic cabins, stylized motels, diners,
movie theaters, and 1950s-era gas sta-
tions. They are being surveyed for a State
Historic Preservation Commission listing
of vernacular roadside architecture and
possible inclusion in the National Register
of Historic Places. "Every generation rebels
against the taste of its parents and prefers
the taste of its grandparents," says com-
mission director Earle Shettleworth.

shrines set in upended bathtubs, whole hills painted
and transformed into paeans to Jesus—these loving
and obsessive works may lack the scale of the
commercial offerings but make up for it with a
marvelous degree of detail and subtlety, and far
more connection to local place than imposed com-
mercial monuments.

*All of Polynesia is represented on forty-two acres of
the Hawaiian island Oahu, at the Polynesian Cultural
Center, which claims that "more people come to
know and appreciate Polynesia while touring these
beautifully landscaped grounds than will ever visit
those fabled islands.*
— BARBARA KIRSHENBLATT-GIMBLETT

The president of Colonial Williamsburg once boasted
that the flourishing souvenir market was "proof that
history could be sold." There has been little doubt

SCOTT PARSONS AND DAVID GREENLUND, in cooperation with
members of the Oglala Lakota nation and Augustana College,
The Reconciliation Project, 1992, Sioux Falls, South Dakota. 29
charred skeletal tipi frames, 25' tall, were placed near the Nobel
Institute Peace Prize Forum, recalling the fact that Native Ameri-
cans had not been invited to attend. The lodgepoles (already
burned) came from the sacred Black Hills, recalling the
massacres that took place all over the west. They were accompa-
nied by nine simulated National Park Service Historical Markers
with text and image that included quotations from Native writers,
including Leslie Marmon Silko, Russell Means and Leonard
Peltier. Greenlund and Parsons recreated the tipis (90 of them
this time, plus 29 markers) in Civic Center Park in Denver at the
time of the 1992 Columbus Day Parade, providing a spiritual
center for Native American protests against the parade, which
was called off at the last minute and has not taken place since.
The ghostly monuments reached into the sky and cast long
shadows on the earth, combining visual poetry and harsh fact,
directly affecting the cultural memories of those who experienced
them, and overshadowing a bronze cowboy in the background.
The artists intended the piece as a counter-memorial, "not stuck
in the past, [but] a springboard to reconciliation for the next 500
years.... We wanted to imagine what apologies and historical
accountability looked like."

since then: from the reenactment of the gunfight at
OK Corral in Tombstone, Arizona, to antebellum
belles guiding visitors through plantation gardens on
Louisiana's River Road, to the Graceland phenome-
non, history is decidedly for sale in this country. Grady
Clay points out that no city is complete (or economi-
cally viable) without an "epitome district" character-
ized by a name ("Old Town"), a center, local history
explained in maps, pamphlets, signage, mythology,
and costumed celebrations.

The most spectacular challenge to this trend
involved the Walt Disney Corporation's projected
American history theme park near the Bull Run/
Manassas Battlefield in Prince William County,
Virginia. "Disney's America" (not a misplaced
possessive) raised questions of land use in the rural
(and bedroom community) borderlands around a
densely populated urban center. The corporation
secretly bought up three thousand acres before
announcing its plans to capitalize on the nineteen
million tourists who visit nearby Washington, D.C.
annually, some of whom might prefer an ersatz rural
version to the real thing located in an inner city. Iron-
ically, the history park would have endangered
a dozen battlefields and sixty-four National Register
sites from America's most popular war, not to
mention destroying a beautiful rural landscape
(which includes many wealthy fox-hunting estates),
and threatening some six thousand local farms on
its peripheries. The prospect of three thousand new
jobs was weighed against water, sewage, air pollu-
tion, and traffic congestion. District residents polled
early on were 52 percent undecided, with 32 percent
for and only 16 percent against. Governor George F.
Allen was all for Disney, though, and in the spring
of 1994 the state legislature agreed to financial incen-
tives for the corporation.

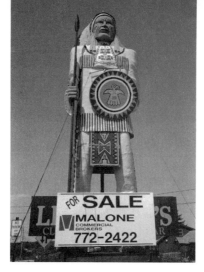

"The Big Indian," 40' high, Freeport (Photo: Peter Woodruff). Commissioned by the Casco Bay Trading Post and sculpted in Pennsylvania, it arrived on Route 1 in 1969 and has survived two owners since. The Indian is Plains generic, unrelated to Maine tribes.

But the real battle was over views of history. Despite claims to the contrary, Disney's track record suggested that the park would have constituted a counterrevolution against the gains made in broader and more critical views of history by trivializing and rescripting the events that have formed North America. The "Industrial Revolution" attraction was to be (literally) a roller coaster ride through a turn-of-the-century steel mill "culminating in a narrow escape from a fiery vat of molten steel," not plant closure; an Ellis Island recreation was to celebrate the "immigrant heritage." The "Native America" exhibit was to end in 1810, thereby omitting much of the bad news, and implying that indigenous people's histories came to an end almost two hundred years ago. All of which tends to confirm Jean Baudrillard's whimsical assertion that "Disneyland is there to conceal the fact that the 'real' country, all of 'real' America, is Disneyland. Disneyland is presented as imaginary to make us believe that the rest is real, when in fact all of Los Angeles and the America surrounding it are not any longer real but of the order of the hyper-real and of imagination."

In summer 1994, Disney Chairman Michael Eisner wrote a nationally published op-ed piece quoting Thomas Jefferson, appealing for Disney's right to "freedom of expression" and citing the popularity of their Lincoln talking doll exhibit at Disneyland: "At the Disney's America we will open in 1998," he boasted, "we will use all of our new technology, our creativity, our film and theater techniques and, yes, our entertainment skills to create a place that we hope will inspire renewed interest in American history and a renewed pride in American institutions." When the battle heated up, fueled by reports of Disney's avoidance of taxes and broken promises in Florida, the corporation surrendered and withdrew the project.

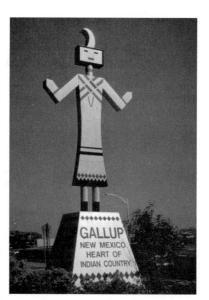

Yeibichai, painted aluminum with lights, 1990, 36' high, made by Hinkley Signs for the Gallup Visitors and Convention Center, New Mexico (Photo: Richard Hooker). Popularly known as "the yellow Yei," and inscribed "Gallup, New Mexico, Heart of Indian Country," this monumental figure of a Navajo deity is a near replica of an earlier figure on the outskirts of Gallup. Both were made with no Indian consent or input and there was opposition to yet another unauthorized representation of sacred imagery.

Under the Surface

*We're "here" oriented and future oriented, but not back oriented,
so when I ask my grandfather: "You know the white man says that your past
is valuable." He says, "How much do they want to give me for it?"
…the ancient ones own the past. We own the present and the future because
we can do something about those aspects.*
— EDMUND LADD

PETER WOODRUFF, *Mouth of the Kennebec, an Archaeological View*, 1996.

In the summer of 1993 I intended to start this book, but got lured by the local and spent three months in historical and archaeological delirium, wandering shores, wading marshes, bushwacking woods, and participating in my first archaeological dig. I became seriously addicted with the discovery of a perfect 1,500 year-old Jack's Reef arrowhead washed out of a midden on a Kennebec island, below the tide line, about to disappear into the mud.

Only in the last twenty years have modern archaeologists begun to decipher Maine's prehistoric past. Earlier archeologists "were little more than pot hunters who spread myths about the first residents of Maine," says Emerson Baker, and "many pieces of the puzzle are still missing....even the ethnic identities of the natives of Maine remains a

AROUND HERE IS BOTH NOW AND THEN, BUT the degrees to which the past is important to the meaning and future of a place vary widely. With increasing popularization and popular participation, archaeology has been an effective educational tool about place. The excitement of the isolated find dissipates as artifacts gather dust on local mantlepieces, but when these unprepossessing bits of stone tools, pottery, or rusty machinery are endowed with a whole context in time, familiar surroundings acquire an aura of unsuspected richness and mystery. Local inhabitants have a chance to get under a place's skin.

Archaeology is about change. It explores the nature of, and relationships between, cultural and environmental change, society and nature (which came first? the deforestation or the drought?). Although archaeology conjures up images of bejeweled burials and painted sherds, and is popularly associated with "the ancient" (which can range from a hundred years ago to millennia ago, depending on the length of memories, tradition, or documents), in fact historical and industrial and now even commercial archaeologists unearth and analyze machines and advertising signs that may still be found in our barns or attics.

The notion of the *local* may sound geographically specific, but how we understand space is affected by how we understand time. What *was* here is inseparable from what *is* here: it must all be considered together, without recourse to nostalgia or amnesia. Those cultures with ways to comprehend greater expanses of time also incorporate greater expanses of space. If North American indigenous people respect and continue tradition from the past, they have not been all that interested in its material residue, or in overturning the earth in order to retrieve the past. Euro-Americans tend in the opposite direction: we are obsessed by material culture, by buildings and artifacts from the past, but we pay less attention to the sites and events that produced the past (battlefields and cemeteries being the exceptions).

Archaeology is popularly seen more as the retrieval of "museum-quality" objects than as scrutiny of place and history, yet it is also another way of reading a place: it is all about layers and sifting through the strata of time, looking for evidence of social, cultural, and ecological change, and pondering its significance for present and future. Professionals now know that the real meaning of these artifacts is to be found in their relationship to each other and to the earth in which they are buried. Everything is important. Everything, no matter how humble or apparently insignificant, is carefully excavated, counted, washed, measured, recorded, labeled, and stashed in museum basements. (Unstratified remains, which have been washed or eroded or dug out of their graves, are considered less significant because they have lost their context, although they too bear messages, and can be traced back to their contexts.) A few objects may make it into a glass case for public consumption, but the layers of lives and land use to which the objects testify usually remain invisible to the public.

The word *archaeology* was coined in the seventeenth century. *Arché*, its ancient Greek root, meant both "beginning" and "power": the past was already being used to manipulate history and the places where it happened for ideological advantage. Archaeology was the beginning of a series of specializations, creating a discipline to study objects and monuments, distinguished from that of the "antiquarians," who concentrated on other sources of information about the past, such as legends, place names, topographies, and natural histories. In the Americas, it was the Spanish and English—those with the greatest investments here —who began to integrate colonial experience with

hotly debated issue." Maine's best-known Archaic culture was the so-called Red Paint people, of the Moorehead phase. (We found a Moorehead "clumsy plummet" on the tide line of an offshore island.) They were replaced by the Susquehanna, who lived along our shores before 3,500 BP. (We found a Susquehanna knife blade in a tree-throw on a river island.)

A major source of archaeological knowledge are the innumerable shell middens, or rubbish piles, along the coast. Slightly alkaline, they protect organic materials from the acid soil which gobbles up bone, pottery, and wood, leaving less evidence than is found in drier climates. There are several middens on our three points. A broad one on Sagadahoc Bay has surrendered only a tiny broken arrow

European experience and language, to frame unfamiliar cultures in familiar cultural terms. Trying to fit the new world into the old worldview has led to all kinds of distortions of American history, based on distinctions between civilization, barbarism, and savagery that lurk beneath our cultural surface to this day. Savages, the lowest on the pole, were seen as hardly distinguishable from the landscape or scenery. (This notion has not yet been exorcised: for example, the poster for a 1991 photography show called "Lens and Landscape" but featuring the portrait of a Navajo man.)

Most new "Americans" did not consider the Americas the source of their own heritages; instead, they focused their scholarly endeavors on biblical and Mediterranean cultures. Even when massive earthworks were found in the South, Midwest, and Southwest (they had been known since the sixteenth century but were re-"discovered" in the early nineteenth century), they were credited to the Lost Tribes of Israel and other distant relatives—some superior, disappeared race. Scholars (with the blessings of politicians and land barons) concluded that such major monuments could not have been made by ancestors of the contemporary "savages" and therefore, the land was conveniently "unowned."

According to such racist theories, acquisition and ownership of property was an essential component of a civilized society; communal property didn't count. Archaeology was used to support these ideas. The reported "absence" of antiquities (monumental ruins and earthworks) in Texas, Oregon, Washington, California, and even New Mexico was cited to prove that the land was up for grabs. Manifest Destiny, mounted on such premises of white (or Anglo Saxon) superiority, rode roughshod over human obstacles. Colonial

PAMELA BEVERLY-GAGNER, *Nothing Is Sacred*, 1994, digital photomontage, cactus print. The site pictured—on South Broadway in Boulder, Colorado—is the location of the Arapaho Medicine Wheel's remaining stones where a government building is going up. This proposal (made "real" by computer) depicts the landscape that would be directly behind the site, as though the billboard were transparent and the statement were captioning the entire landscape of dramatic scenery and increasing development.

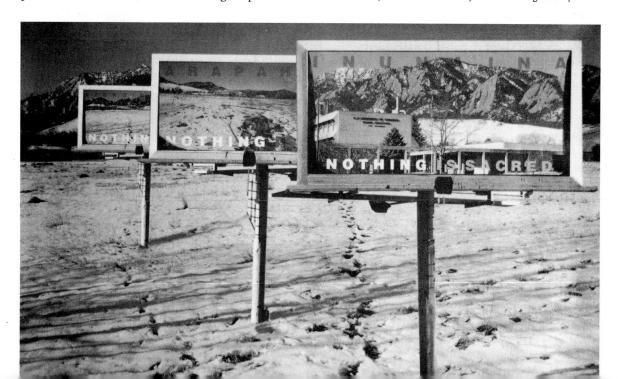

point—perhaps because the site has been mined by generations of afficionados. In 1994, we noticed clamshells bleeding into the path in my meadow; test pits revealed another midden, bits of pottery, a beaver incisor (used as a tool), and fish vertebrae, though the site was disturbed by plowing and held bits of crockery and metal from the 19th century. Colonial settlers dumped their clamshells as unceremoniously as the Indians; some of our local middens may date right up into the 20th century.

The most nationally significant archaeological site in the area is that of the 1607 Popham Colony, the first English settlement

118 and postcolonial excavations have backed up oral and written documents on the systematic exclusion of non-European groups from the mainstream of American life. This was exacerbated during the so-called Gilded Age—the 1870s and 1880s—when the Archaeological Institute of America was founded, and when "the ruling class attempted to construct and impose a genteel cultural tradition based on European standards and a greater appreciation of the European past." This tradition survives today in the institutions opposed to "multiculturalism" and defended by the various canons of the status quo.

Wherever different pasts and presents confront each other, innumerable questions are raised about social and religious values. How power is exercised—a question usually ignored in conventional archaeology—can be read through artifacts, which include local newspaper headlines and development maps, reflecting the forces that set social boundaries and maintain inequality of material and resources. "Archaeology provides access to the full theater of domination and resistance, and is beginning to develop the interpretive methods to understand the working of power at individual sites and in regional settlement patterns," write Robert Paynter and Randall McGuire in a recent book called *The Archaeology of Inequality*, which ranges from slave cultures in the South, to Colonial race relations in the North, to manipulation of the urban landscape reflecting power relations, to distinctions between men's and women's domains.

The politics of archaeology involve not only nature and place but questions about who determines what part of our past is dug up, interpreted, and displayed? Who does the digging, interpreting and displaying, and from what point of view? What are the roles of private landowners, volunteer labor, public institutions? Which sites are funded and which are ignored and abandoned to erosion, rising tides, or commercial development?

Archaeological scholarship is no more impartial than that of any other field. By the late fifties, ecological anthropologists and archaeologists were linking cultural development to the environmental systems in which they take place. Regional cultures and their economic destinies have also affected and been affected by archaeological practices. Since the seventies, "postprocessual archaeology" (with its British origins and emphasis on human agency and historical contingency, as opposed to the previously fashionable determinism) has embraced diverse camps, from materialist to idealist. Feminist archaeologists point out that all previous data is incomplete because it dealt primarily with male roles seen through the eyes of mostly white middle-class academic male scholars. This, then, is another field in which the past is an increasingly contested territory, its boundaries shifting as hierarchies and stereotypes are challenged and all races and cultures demand to be reintegrated into the category of "civilization," from which they were banished in the nineteenth century.

In the United States, archaeology's primary political issues concern relationships to living Native peoples, their artifacts, burials, and sacred sites. For example, the rare Plains Indian medicine wheels—large circular arrangements of stones usually on high ground—originally sites of ceremonies, vision quests, and perhaps astronomical prediction, have become arenas where scholarship and commerce, tourism and ritual, vie for primacy. A fence has been erected around the classic Big Horn, Wyoming, site, perhaps necessary for protection, but ruining the wheel's relationship with the surrounding land and curtailing sacred rituals there. Like so many other sacred sites, it is also threatened by development. In 1992, the possible remains of

attempt in New England, contemporary with Jamestown. Two ships of settlers arrived in August, led by George Popham, who died that winter. When his second-in-command, Raleigh Gilbert (commemorated in Gilbert Head, facing Popham from Long Island), had to return to England, everyone else gave up and went too, declaring the place a barren "desert," and "uninhabitable." They had suffered through a bad winter, exacerbated by the initially friendly Kennebec Indians, who turned hostile after being mistreated by the colonists. The British returned home with an additional ship, the Virginia, a small pinnace that had

an Arapaho medicine wheel were found within the city limits of Boulder, Colorado, on the site of a proposed federal building. Archaeologists working for the city found no evidence and dismissed the wheel's existence, even as the Colorado Native American community was already fighting off New Age rituals at the site and removing "offerings" that had been tied to the vegetation. After a movement began to save the site, local artist Pamela Beverly-Gagner spoke to Francis Brown, an Arapaho elder, about the possibility of reconstituting the wheel (now a few random and hardly recognizable piles of stones) for a historical site. He told her, in so many words, that there was no need to change what was physically present because the power was still there

GAIL RADOVICH, *Display at Visitor's Center, Etowah, Georgia*, c. 1992. The small museum at the site of an ancient Cherokee mound community bears this warning on its burial exhibit: "Out of respect for Native Americans this museum has no bone materials on display. All such materials have been replicated."

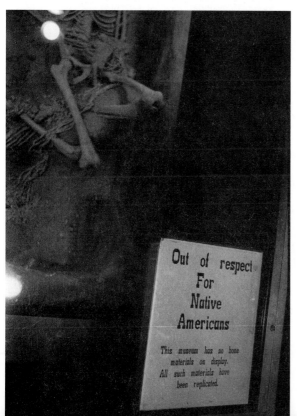

and the site needed no cosmetic improvements. What is taking place here is a classic conflict between value systems, between the Arapaho belief in the holistic sacredness of the land itself without separation of subject and object, and the Euro-American need to reconstitute or add sacred objects or monuments before the land means anything.

The Native American Graves Protection and Repatriation Act (NAGPRA) of 1990 has given pause to archaeologists who previously felt entitled to trespass anywhere in the name of scholarship. Real efforts are now being made to secure the support and cooperation of whatever Native nation is under scrutiny—never a comfortable place to be, even in the best of circumstances. Such attempts will not be successful until more indigenous archaeologists are trained as equal partners in such enterprises.

This kind of federal regulatory legislation (including the Historical Sites Act of 1966, the National Environmental Policy Act of 1969, and the Archaeological and Historical Conservation Act of 1974) has also changed the archaeological backdrop. While today our educational institutions pay lip service to the belief that the past holds lessons for the present, and that those who do not understand the past are doomed to repeat it, the shining image of progress—or seizing the immediate opportunity—is always more important. And more American. On the positive side, however, this pragmatic, present-focused approach to the past has spawned federal, state, and local laws requiring that before any area is destroyed for dams, highways, or developments, a (usually rapid) archaeological survey must be undertaken to see what might be lost. These laws in turn spawned a field called "contract" or "salvage" archaeology, a last-ditch remedy in which digs are funded by public or private developers before the site is destroyed, or, possibly, saved. Writing about

Although 17th-century artifacts had been found there previously (notably a lead baling seal), it was only in 1996 that solid architec-

120

"the changing face of archaeology" on some sixty-five thousand acres of the Navajo and Hopi reservations on Arizona's Black Mesa (mother landform of the three still-inhabited Hopi mesas), archaeologist George Gumerman has explored the contradictions embedded in contract archaeology—in the relationship between scientists, the land, the Anasazis who once inhabited it, their Hopi descendants who inhabit the area now, and the Peabody Coal Company, which with one hand stripmines Black Mesa and with the other hand supports archaeological work on it. As new technology becomes prohibitively expensive, a majority of the archaeology undertaken in the United States today falls into the salvage category, thanks to lack of broader support. If the site can be proved extremely important, there is a faint chance it might be saved—if people care enough to organize, protest and/or litigate. If not, at least some information has been gained and some archaeologists have been supported in a field where decently paying jobs are rare, projects are threatened by diminishing state funds, and the way is being paved for a return to dependence on the capricious support of private foundations and individuals.

Another source of support is field schools (where volunteers pay for the privilege of helping do the hard

PHIL YOUNG (Cherokee), *Burial at Canyon de Chelly*, 1993-95, installation on the rim of Canyon de Chelly, Arizona. A painter who has made work inspired by rock art and real archeological sites, Young has in the last few years made several installations that use burial and archaeology as double-edged metaphors and critical weapons. He has buried astroturf (now reclaimed by real grass) and a painting of his own. Several works, dealing with the burial of fake, stereotypical, or stolen Indian objects, parody and condemn the random use of Native images, or highway signs like "Rattlesnake Eggs and Indian Dolls Just Ahead" and "Make Your Own Mandella [sic] and Indian Legend Dream Catcher Today." Young says of ancient pottery shards he finds when walking in the West: "It's a little fragment, but it's speaking of something that's whole.... I'm trying to weave broken threads back together.... I am attempting to reconnect the cord, searching for 'home.'"

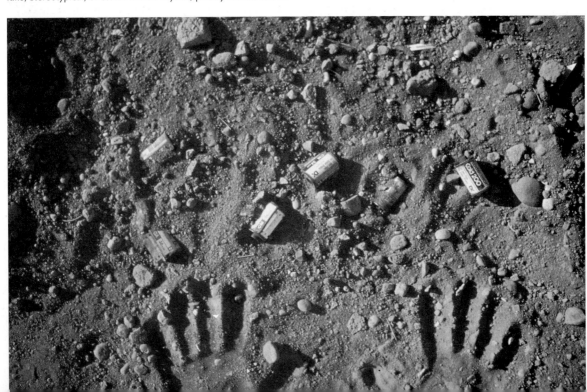

months with so few laborers—probably a ploy to scare off the Spanish.

Along with the Popham site, the most important local archaeological site is Sagadahoc Island (its old name) where, after the Halloween storm of 1991, a friend found hundreds of Indian and 17th-century artifacts about to vanish into the sea. The island holds traces of occupations from 17th-century fishing stations and garrison to 18th and 19th-century fishing and farming. Empty now, there were numerous houses there over 350 years. On Kennebec Point itself, exactly where local legend says a Todd once found a kettle of gold, we found traces of another 17th-century dwelling, and we have clues to another on Indian Point.

work of surveying, digging, troweling, screening, backfilling, washing and labeling). Like "archaeotourism" and state and municipal "archaeological parks," the schools raise public awareness about communal identity and the fragility of sites. As such activities become increasingly popular, and summer digs are written up in the local papers, archaeology becomes another source of general information about local place in time.

Groups such as the New England Antiquities Research Association (NEARA), local amateur archaeologists who peer at every stone pile and brambled trench, explore those murky speculative areas where professionals fear to tread; at best, their open minds and dedication to fieldwork compensate for lack of professional training. With no reputation to lose, they are able to follow up on hunches and clues discarded by professionals. The entire field of archaeoastronomy (or astroarchaeology), which deals with the extent to which ancient cultures understood and marked celestial movement, emerged on the fringes and has now been widely validated. Similarly, the American Rock Art Association (ARARA), begun in the seventies by afficionados, is now respected by the professionals who are grateful for the amateurs' perseverance in finding the sites of obscure petroglyphs and pictographs. Most professional archaeologists, however, are dead set against speculative archaeology of any kind—techniques like dowsing, the tracing of "ley lines" (in England) and magnetic energies, and even astronomical alignments, all of which is dismissed as "cult" or "lunatic fringe" along with a vastly popular global literature on "mysterious places"—sometimes conventional archaeological sites eccentrically interpreted, sometimes strangely disjunctive places that do not coincide with the way the dominant culture prefers to see them.

Nevertheless, as a reaction against, or perhaps an adjustment to, the specialization and "professionalization" that dominated mid-twentieth century scholarship, interdisciplinary cooperation has been on the rise in the last two decades. Archaeologists, for instance, now work closely with botanists, historians, climatologists, geologists, zoologists, and anthropologists (not to mention descendants), among others—a necessity if culture is to be considered in relation to places and their natural environments.

Contemporary avant-garde artists are learning to work the interdisciplinary peripheries. While a number of artists have made drawings of, or drawn inspiration from, the poetic aspects of archaeology, and every so often an installation that imitates a dig turns up, few have really gotten dirt under their nails, except metaphorically. Carrie Mae Weems says of her preoccupation with folklore and landscape, "I wanted to dig in my own back yard"; sculptor Michael Heizer, son of a well-known archaeologist, has made huge cement enlargements of artifacts as well as the immense earthworks, suggesting prehistoric architecture, for which he is best known, but seems uninterested in the communicative aspects of such imagery. In 1984, an exemplary exhibition, called "Art and Archaeology," curated by Kathleen Cadon Desmond in Newark, Ohio, combined the general and the specific to illuminate the local presence of hundreds of prehistoric mounds and earthworks. It provocatively mixed and compared maps, diagrams, documentary photography, and drawings by professional preservationists with the work of artists employing more conceptual, lyrical, and symbolic modes. This multifaceted view of a place and fusion of disciplines is a model for exhibitions about place.

Although archaeology is popularly imagined in isolated desert or jungle landscapes, the urban site

Emerson Baker III began work on Sagadahoc Island in 1983 as part of the Lower Kennebec Archaeological survey, made test excavations with Robert Bradley in 1984, and returned in 1993, 1994 and 1995, confirming that "Saga-dahoc Island is one of the richest seven-teenth-century sites in the state of Maine. It is also one of the most endangered by erosion"—and by "collecting"; despite No Trespassing signs and the owners' adamant attempts to protect it, too many neighbors have an artifact or two, gathered on surrepti-tious trips to the island, which is locally considered public domain.

presents an exceptionally complex picture. City residents are rarely aware of what lies beneath their beds, and thus far, artists and archaeologists have not collaborated to let them in on the buried secrets. More archaeology has been done in Philadelphia than any other major U.S. city—over 150 sites since World War II, documented with varied capsule histories of places by John L. Cotter, Daniel G. Roberts, and Michael Parrington in their book *The Buried Past*. Cotter sees archaeology as a way to "fill out pattern and add texture and color...to the historical tapestry." This metaphor is particularly apt for the excavation of a nineteenth-century tenement school begun in 1993 on Orchard Street, on New York's Lower East Side, where the original tenements still stand in the heart of a lively street market.

One of the most socially significant colonial sites to be discovered in recent years is in downtown New York City: part of a seventeenth-century commons, six acres of which were set aside in the eighteenth century for the African Burial Ground. It was rediscovered in 1991 when salvage archaeologists working one step ahead of excavation crews for a new federal office tower found the first of about four hundred graves under a municipal parking lot. When it was given national historic status, *The New York Times* pointed out that the African Burial Ground had become an honorary object, joining "the city's wealthiest neighborhoods, loveliest temples and mightiest skyscrapers."

Since then, Houston Conwill, Joseph De Pace and Estella Conwill Majozo have made *The New Ring Shout* (p. 200) on the floor of the new Federal Building, aligned with the northernmost boundary of the African Burial Ground. It incorporates a cosmogram, songlines, the names of the African nations probably represented in the graveyard and of fourteen related geographical sites in the city, bringing the buried rhythms of culture and nature to the surface.

More than other historical disciplines, archaeology is inseparable from the land. The document to be deciphered is landscape itself, which is why fieldwork is as important as research. In principle, archaeologists see *through* the land's lumps and furrows to what lies beneath the surface; in fact, if they are lucky, they carry with them both the direct experience of the land and its details as it is now, and the aerial-to-satellite overview, which can provide insights into broader patterns. (Is the ground best seen when *out* of *touch*?)

An archaeological site is an undeciphered place—flexible and resonant in ways a book can never be. It provides a direct experience, no matter how ill-informed one may be. Wind blows through it; its textures and smells, its bugs and prickers, merge our own memories with the mud, with evocations of a past we can't remember. But physical and ethnographic documentation—the stuff of which history is constructed—may be elusive. Even the earth can't always be believed. Plow zones mix everything up; erosion and flooding redistribute evidence. James Deetz writes about a New York City park that is "composed partly of fill from Bristol, England, which was hauled in ships as ballast during the Battle of Britain." The missing link here is the usually unacknowledged collaboration with those who truly know their places. Archaeologists have always been deeply dependent upon local knowledge and support.

Down to Earth: Land Use

*We have mixed our labor with the earth, our forces
with its forces too deeply to be able to draw back and separate either out.
Except that if we mentally draw back, if we go on
with the singular abstractions, we are spared
the efforts of looking, in any active way, at the whole complex
of social and natural relationships which is at once
our product and our activity.*
— RAYMOND WILLIAMS

Traces

Be fruitful, and multiply, and replenish the earth, and subdue it.
— GENESIS

When we see land as a community to which we belong,
we may begin to use it with love and respect.
— ALDO LEOPOLD

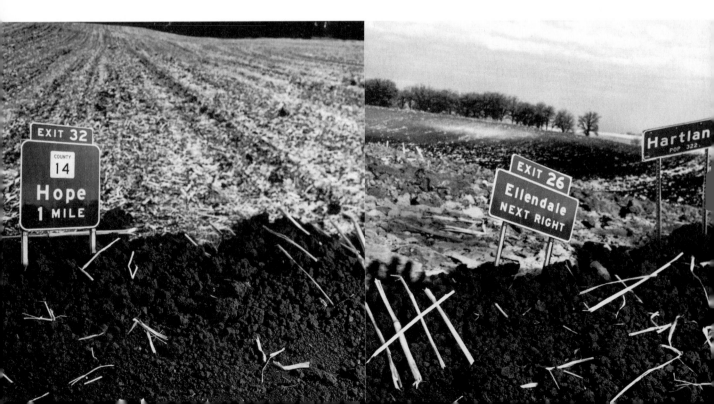

Looking East across Sagadahoc Bay with Indian Point on the other side, a gap in the trees reveals the open sea. Twice a day the tide goes out for almost a mile, leaving a glorious expanse of mud and sandflats creased by silvery channels, where we walk amid the teaming birdlife. Everywhere, big pines and oaks grow down the ledges and cling precariously to the rocks at water's edge, thriving in no perceptible soil until a strong wind uproots them into the water.

Land use in coastal Maine has changed drastically in this century. Once the site of hard subsistence work and a treasured independence, the seashore is increasingly

AS WE WALK OR DRIVE THROUGH ANY LANDscape, paying attention to its details and contours accentuated by light and shadow, we can fantasize (or hypothesize) about all the fences, lumps, bumps, furrows and tracks that cross it. They may be ancient traces or very recent ones, agricultural, industrial, or natural, accidental or intentional. "Ruins" are rapidly created in this society of planned obsolescence. Nature's reclamation of human neglect can be equally fast.

"You are here," insist the arrows on maps and guides. How many of us really are? One way to find ourselves is to walk the map, to think about how the land around us is being and has been used. Looking at land through nonexpert eyes, we can learn a lot about our own assumptions and about the places we live in and pass through. The connections between land and people and what people do in their particular domains, as well as what they are forced to do in and for others' domains, are an extension of the questions I've asked

125

JO BLATTI, LINDA GAMMELL, AND SANDRA MENEFEE TAYLOR, from *Landscape of Hope and Despair*, bookwork, 1989, edition of 350, sponsored by a Jerome/MCBA Book Arts fellowship (Photos: Linda Gammell). This uniquely structured fold-out book is based on oral histories about farm life, conducted with Ed Menefee, Gregg Menefee, and Sandra Menefee Taylor of Bath Township, Freeborn County, Minnesota. The artists quote Wendell Berry: "The good farmer, like an artist, performs within a pattern; he must do one thing while remembering many others...." Taylor and Gammell both "grew up rural," and now lead local workshops sponsored by the Minnesota Food

Association and the U.S. Department of Agriculture. In 1994 they were joined by sociologist Michal McCall, who is also concerned with women's lives and sustainable agriculture, to conduct workshops with rural women in which they were asked to bring an object that represented farm life to them and to photograph the landscape each thought most important. These conversations have led to performances, exhibitions, college classes, public lectures, and another beautiful little bookwork called *The One About the Farmer's Daughter: Stereotypes and Self-Portraits*. The overriding theme of all their work is "putting land and women back into the picture."

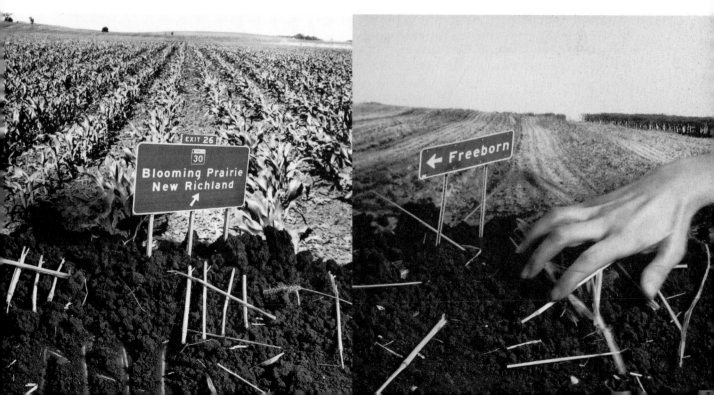

devoted to pleasure. Except for one state park, descendants of Georgetown's earliest Anglo and Irish settlers no longer have access to the shoreline, to the beaches and coves that document their past, although their displacement is, of course, nowhere near as complete as that of the indigenous inhabitants.

Fifty six 17th-century deeds from the Sagadahoc region have survived, among them the transfer by the sagamore Manawormet, called Robinhood, of Erascohegan/Georgetown Island to John Parker. Emerson Baker suggests we look at these deeds as ethnohistorical texts revealing the intricacies of the land transfers and relationships between Europeans and Native peoples, going beyond the rather patronizing general assumption that Indians did not know what they were signing.

about looking around, about attitudes toward houses and yards and neighborhoods.

Development of a land ethic, first defined in conservationist terms by Aldo Leopold, demands a much broader understanding of local land use than most of us have or ever had. In a rural landscape the best place to begin to think about land use and abuse might be where the gardens, plants, yards, gates, fields, corrals, windmills, ponds, outbuildings, and for-sale signs are located, and why. Our various cultures have most directly affected the look and lay of the land by using, or producing it. Farms, for instance, differ in appearance, arrangement, processes of production, and economic success in the black South and the white South; western ranching differs similarly among *Hispanos*, Indians, and Anglos. Absentee agribusiness obviously diverges drastically, in more than just scale, from family farming, and both in turn vary from Texas to Ohio to New Hampshire. There are landscapes of work and landscapes of pleasure, but the site of one person's deep pride in labor may be the site of another's miserable drudgery, and of still another's scenic drive. A much-quoted passage from William James cites the dissimilar responses of a sophisticated nineteenth-century traveler and a "responsible landowner" to a pioneer forest clearing in Appalachia. For the traveler, everything was visual, or "scenery"; for the owner, "the place was invested with personal and social meaning that had little to do with its visual form."

Similar examples of conflicting interests and dissimilar perceptions are easy to find today—the rancher and the backpacker complaining about cow pies; the farmer and the suburban commuter complaining about smells, the barrio dweller and the yuppie who likes local color but not the drug dealers and other spoils of poverty. There are landscapes in transition between labor, abandonment, and recreation, and landscapes that seem, at least from the outside, to be pure wasteland or wasted land, often poisoned within an inch of their lives by pesticides, industrial waste, or perhaps by strychnine laid out for wildlife "control." (Is wasted land a Euro-American concept implying that every inch should be financially productive? Or is it a Third World concept, where every inch of arable earth counts for someone's survival?) The acquisition, ownership, and use of lands in the U.S. and the way they are perceived and represented is a gigantic subject demanding historical and legal expertise beyond my scope. However, the general political outlines are crucial to the way "landscape" is produced and the ways we see the land around us.

Today we are still heirs to a collective sense of loss that had spread through North America by the end of the nineteenth century. Most of the Eastern forests had been destroyed and most of the workable land in the West had been grabbed by 1893—the frontier's official demise. With the end of the frontier came the end of what was perceived as America's unique character-building course. With no "others" to conquer nor lands to tame, so this story line goes, Americans didn't know what to do with themselves. Ever since, it's been downhill all the way, as we confront the ramifications of our spending spree.

The nostalgia and mythmaking that followed such losses lead many if not most people in the U.S. to cling to the old expansionist belief that our water, soil, fuels, and oxygen are infinitely renewable. Just as the first Europeans imported denial, seldom connecting the "old world's" exhausted resources, scarcity of wood and arable land, and decimation of wildlife to the "inexhaustible" resources of the "new world," this disease remained prevalent among their descendants. Despite the fact that the need for conservation was officially recognized in England as early as the mid-

Certainly the legal jargon went over the heads of most colonists as well. Some suggest that the Natives saw land transfers as gifts to the English, given in "friendship, admiration, or even pity," and were cheated in return. Others believe that they were giving only rights to use the land, having no concept of exclusive ownership on such a scale. This is supported by a 1670 deed signed by Robinhood when he sold all of Woolwich to James Smith for a hogshead of corn and 30 pumpkins, but also received "rent" of one peck of corn every Christmas.

Native people often remained for years on the land they had "sold," and continued to trap there; the English bought and sold furs but seldom trapped themselves, preferring farming and fishing. When they ran out of

sixteenth century, old habits were reasserted in the American westward and northward movements. America, it has been said, was Europe's second chance. Yet as Mexican scholar Edmundo O'Gorman put it, America "had to be invented because of its explorers' reluctance to discover it."

No primeval forest challenged the pilgrims, who acquired both farmlands and agricultural techniques from their predecessors, huge numbers of whom had died of imported diseases. The land was "widowed" not "virgin," as Henry Nash Smith put it—the product of centuries (at least) of village-building, cultivation, irrigation, and biannual clearing by fire. The primarily holistic, earth-centered but mobile and often nomadic indigenous peoples of this hemisphere changed the land over thousands of years, although their numbers were fewer and their methods usually more benign than those of their successors. In some areas they maintained an ecological equilibrium and in others they degraded the land or facilitated destructive change, as have all human groups everywhere.

Tzvetan Todorov, in his *Conquest of America*, says that what Europeans found in the Americas was "the totality of which they are a part, whereas hitherto they formed a part without a whole." This is where a lot of North Americans are today, existing as independent parts ignorant of the whole and therefore not whole. Cultural exchange was an important part of the process: "a distant world and its inhabitants gradually become part of another people's ecosystem," writes

BEVERLY NAIDUS, *"With light for worship..."* from *What Kinda Name Is That?* 1995, laser-printed computer generated bookwork, 8.5" x 11," 64 pages. Initially titled *But You Don't Look American*, this autobiographical artist's book on immigration and assimilation was eventually focused on Jewish identity. Naidus wanted it to "define a complex space for an outsider culture" within the dominant culture and to "look ironically at the pressures to assimilate" that come from a consumer society. In each double spread, the right page is drawn from mid-century advertisements and the left is the blurry face of an immigrant from an old group photograph.

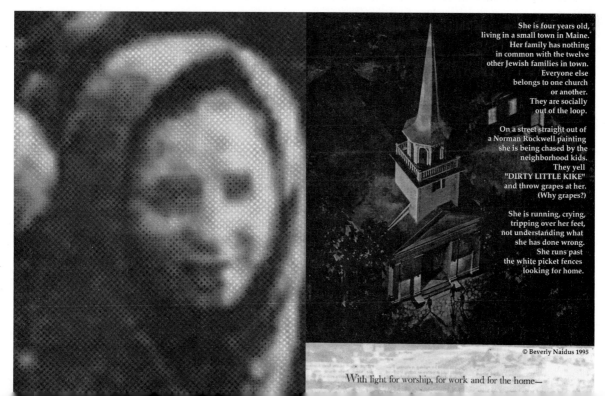

She is four years old, living in a small town in Maine. Her family has nothing in common with the twelve other Jewish families in town. Everyone else belongs to one church or another. They are socially out of the loop.

On a street straight out of a Norman Rockwell painting she is being chased by the neighborhood kids. They yell "DIRTY LITTLE KIKE" and throw grapes at her. (Why grapes?)

She is running, crying, tripping over her feet, not understanding what she has done wrong. She runs past the white picket fences looking for home.

© Beverly Naidus 1995

With light for worship, for work and for the home—

furs, Indians had only land to trade and they probably understood the trade as such. Thomas Gorges complained in 1642 that "the trade of beaver is utterly lost, the Indians understanding the value of things as well as the English."

In 1717, different views on land ownership characterized a treaty conference on Lee (Puddle-Stone) Island in the Kennebec at "Georgetown on Arrowsic," of which a first-hand account exists. The Abenaki representative Wiwurna said that his people would

embrace the English settlers "that come to settle on our lands," whereupon the Governor said sharply, "They must not call it their land, for the English have bought it of them and their ancestors." Wiwurna says they can discuss that later but that the Indians

128

William Cronon, "so that it is increasingly difficult to know which ecosystem is interacting with which culture. This erasure of boundaries may be the most important issue of all."

Across the continent, the European newcomers initially survived by modeling themselves on indigenous people, even while doing their best to wipe them out. Many of the colonists' problems in both East and West can be attributed to their lack of the very mobility and flexibility they despised in Indian life. Rather than moving with the ecological tides of scarcity and abundance, the colonists stayed in one place and exhausted whatever was there. From the beginning, some recognized what was at stake in the clash of cultural value systems playing out on the land, realizing that they were working harder and enjoying life less than the people they replaced. In 1616, Jesuit Father Pierre Biard wrote some very modern comments about the Iroquois: "They are never in a hurry. Quite different from us, who can never do anything without hurry and worry; worry, I say, because our desire tyrannizes over us and banishes peace from our actions." In 1632, Thomas Morton also suggested that the cultural exchange might be going the wrong way: "Now since it is but foode and rayment that men that live needeth (though not all alike), why should not the Natives of New England be sayd to live richly, having no want of either?" A significant number of early white captives who spent long enough with Indians to become acclimated were reluctant to return to their own often rigid society, though we rarely read these accounts today.

At the same time, Natives were becoming dependent on European goods. The fur trade, Cronon points out, "revolutionized Indian economies less by its new technology than by its new commercialism." Farming cultures did have territory and use boundaries, but the concept of individual land ownership was foreign. When the tide turned, those Indians who had survived decimation by disease, war, and starvation had to adapt to a new way of life, one that brought with it a class system and the commodification of and subsequent alienation from, land. As the concept of property changed, specialization of use, the introduction of foreign vegetation and animals, rapid deforestation and the draining of wetlands, with the resultant erosion and climate changes, brought down the levels of native diversity in flora and fauna. The complexity set into motion by any single alteration is mind-boggling. For example, Cronon notes: "The pig was not merely a pig but a creature bound among other things to the fence, the dandelion, and a very special definition of property. It is these kinds of relationships, the contradictions arising from them, and their changes in time, that will constitute an ecological approach to history." In the end, of course, European colonialists' intentions were weighed against historic occupancy and found superior in ways still being repeated today in appropriation and abuse of Indian lands. In the 1820s, Timothy Dwight shrewdly characterized the contact period: "A people who loved property little had been overwhelmed by a people who loved it much."

Still under the illusion that change will always mean progress (though it now demands blinders and earplugs), we pay scant attention to the ways rural and urban spaces are being restructured and how they affect our daily lives. While permanence is an unattractive ideal, so, often, is the change for changing's sake that continues to pervade our national psychology. But change being a fluid state, the question always remains, change from and to what? The paradox of boarded-up ghost malls and empty, cracking asphalt fields right next door to brand new malls with newly surfaced parking lots is making some impression on

"Desire there may be no more Settlements made. We shan't be able to hold them all in our Bosoms, and to take care to Shelter them." Shown a 1684 treaty with six saga-mores that handed over both sides of the Kennebec, Wiwurna insisted nothing on the East, or Georgetown, side of the Kennebec had been sold, and reminded the English of broken former treaties. In the midst of the meeting a letter was delivered from the Jesuit father Sebastian Rale, based with the Nor-ridgewocks further up the Kennebec (he was later murdered by the English). The letter was dismissed out of hand and the meeting only resumed the next day under the leadership of a more conciliatory Indian speaker. In the end the Penobscots were the only Maine tribe to maintain any landbase at all.

our national psyche. It is dawning on us that the phys-ical, spatial changes we have seen in our lifetimes—and things change so fast that a perceptive twelve-year-old is privy to these insights—do not always represent unquestioned good.

This eye-opening comes at an unfortunate moment—when the economy is closing down on the working population. The conflict between jobs and tomorrow's acquisition power on one hand, and ecological health and longevity on the other, has kept Americans addicted to short-term thinking. West and East, from fossil fuels to fish, resources are being exhausted. Extraction of oil, gas, uranium, and other products is often visible (the scars on the earth or removal of whole mountains are glaring), but incomprehensible, because we don't know how to look at it aside from a shudder or a shrug. Land and water rights are closer to the surface of all our lives, even as we disregard them. The poles lie in maintenance and waste, excess and deprivation. The goal is, or should be, balance.

Geologist Rick Bass ponders the experience of driving on "through those busy oil fields, as in a time machine, where the doomed present does not know its future…We are going to run out of oil very soon…and it will be very interesting to see how we handle it." While some experts now say we have enough fossil fuel for three hundred more years, all agree that it is not renewable. So, denial still being in fashion, the question isn't so much *how* we address this, but *if* we will do so. Look up "land use" in a university library computer and the paucity of refer-ences is alarming. "At present the issue of *use* is still in its beginning," says Wendell Berry. There is no coherent land use policy in the United States, and while local groups often know best, they too can be wrong. They can sell out to larger interests that care little about local tradition or subsistence, for example.

I wonder how many of us are aware that no place in the U.S. is farther than twenty-one miles from a road; or that "the largest untouched temperate wilderness remaining in the lower 48," the Greater Salmon-Selway Ecosystem in Idaho, is threatened by the loss (through a passionately contested timber sale) of Cove/Mallard, a critical wilderness corridor consisting of two roadless areas of seventy-six thousand acres in the Nez Perce National forest.

We did not think of the great open plains, the beautiful rolling hills, and winding streams with tangled growth as "wild." Only to the white man was nature a "wilderness" and only to him was the land "infested" with "wild" animals and "savage" people. To us it was tame…Not until the hairy man from the east came and with brutal frenzy heaped injustices upon us and the families we loved was it "wild" for us. When the very animals of the forest began fleeing from his approach, then it was for us the "Wild West" began.…But in the Indian the spirit of the land is still vested; it will be until other men are able to divine and meet its rhythm.

— LUTHER STANDING BEAR (LAKOTA)

The healing power of "wilderness" is a nineteenth-century idea that inspired the North American national park system. Going "out there" to nature is supposed to recharge our batteries. Recreation is re-creation, a way of transforming ourselves, of being reborn. In 1864, Abraham Lincoln declared Yosemite a California State Park, and in 1872, Yellowstone was created as the first national park. In the 1890s, European ideas of "socialized" forestry and land use inspired Ameri-cans to consider forming a "commons" out of public lands. In the 1920s, Aldo Leopold defined wilderness as an area great enough to accomodate a two-week pack trip. Howard Zahniser, in the Wilderness Act of 1964, defined it as "an area where the earth and its community of life are untrammeled by man, where

Today the coast is heavily developed, although fishing and shipbuilding—the local industries for over 300 years—remain the economic base beyond tourism. Environmentalists fear that inland the twin plagues of industrial forestry and overdevelopment will merge. It's already poised to happen in northern Maine. Although one remote subdivision has been turned back, the area is still vulnerable to smaller, piecemeal development over a longer period, which would damage its "wilderness" status just as effectively.

man himself is a visitor who does not remain." The difference between these two statements indicates the distance traveled in the interim, from direct experience of the land itself to theoretical stewardship.

John Muir, wilderness advocate extraordinaire, is still influencing generations of backpacking conservationists who share his biocentric pantheism and "demotion of Lord Man." Today's arguments for wilderness areas as strongholds for freedom and for the rights of wild, nonhuman communities come up against the rights to have and to hold property, as well as demands for more comfortable park experiences. In the last few years, battles have raged among farmers, ranchers, sportsmen, and advocates of managed nature over the introduction of gray wolves to Yellowstone, Mexican wolves to New Mexico, the mass killing of coyotes, rattlesnakes, and prairie dogs, and over permutations and desecrations of the Endangered Species Act. Arizona environmentalist Steve Johnson suggests that there are long-term lessons to be learned about place from our attitudes toward wildlife: "We see animals and their body forms and their adaptations, and we see time. The specialists of the animal world have lived so long in a place."

Each area has its own literally underlying land use and life story to tell. Because there is no way the whole story can be told in a book of this breadth, I will focus this section on a few cases from the American West, which, as historian Patricia Limerick has observed, exemplifies our national history of innocence, optimism, and violent imperialism like nowhere else. The mass of information we are all beginning to accumulate about land and resource management and the environment, and their effect on our lives, applies

LYNNE HULL, *Otter Haven*, one of several pieces for the Green River Greenbelt (including "butterfly hibernation sculptures" made with local schoolchildren), 1993, wood, 12' x 7' x 8', in conjunction with the Wyoming Game and Fish Division. Working out of Wyoming and Colorado, Hull has developed a unique "trans-species art"—habitats, roosting places, or water sources for creatures whose territory is decreasing thanks to human incursion. Her work also provides esthetic and educational experiences for a human audience. She has made raptor roosts on the Wyoming plains that are striking functional sculptures, and *The Uglies Lovely*, a habitat for frogs, toads, newts and bats in an abandoned swimming pool in Lexington, New York. She is working on *The Exiled Oxbow* in Salina, Kansas, a memorial to the loss of wetlands within an old oxbow cut off from the Smoky Hill River by a human-made dike. Hull proposes "EcoAtonement Parks," or community healing places, where we can restore devastated sites and come to terms with "the wounds left from our war against nature."

with an urgency and complexity in the arid West as nowhere else. I won't get into the arguments about its territorial boundaries (West of the Mississippi? West of the Rockies? beginning in the Dakotas, Nebraska, Kansas, Oklahoma?) or its geographical definitions (Aridity? What about the Pacific Northwest?) I'll use it in the unscholarly popular sense. We all know where The West is.

Looking West

From my window I see low mountains, miles away across a rolling, juniper-dotted rangeland. I also see four kinds of fences, each serving a different purpose and signaling a different use of the land they protect.

My "yard" (simply a continuation of the native grasses and range "weeds") is separated from the road by two strategically placed arcs of "coyote fence"—irregular barked pine saplings bound together vertically with wire. This fence is purely cosmetic; it contains nothing and serves only as a visual semi-barrier between me and passing traffic, which has mightily increased since I came here.

Cutting raggedly across my open seven acres are sagging barbed wire fences on crooked, haphazardly spaced wooden posts, the remnants of overgrazed pastures that once bordered the orchards of a hacienda belonging to a village patron. One half-standing fence marks the zoning boundary of the "traditional village."

Across the road is the intimidatingly efficient fencing of my "neighbor"—an absentee rancher who owns similarly huge spreads in several states. His fenceposts are metal and uniform, supporting a taut tier of five wire strands so closely spaced that a child would be hard put to squeeze between or under them. The creek runs through both our properties (he calls my house "that shack by the creek"). Where the road crosses it, we share a state-sponsored concrete bridge; its low steel wings to keep wayward cars from trespassing are the last of my barriers.

These four fences reflect land use in the West, serving domestic, pastoral/traditional, commercial, and governmental functions. They also affect my daily life on many levels.

"We're lucky here in Indian Township and Pleasant Point," says a Passamaquoddy man, "because we get to still express ownership of land from a communal sense.... We don't need a lawyer to understand [the rules]. Lately, for example, I've seen fences sprout up, but there have never been any legal challenges. People, if they feel strongly about a particular issue or a particular piece of land, will raise hell about it...Everybody has their own space; on the other hand it's our space as a family."

"The bluefin tuna fishery is the last buffalo hunt, and they're saying the same things the buffalo hunters said: 'They're out there, They've just moved. You can walk to Europe on their backs.'"

THE FENCE REMAINS THE MOST SALIENT symbol of the European notion of private property and control of domestic animals. Barbed wire—"the wire that won the West," invented in 1873 to replace "natural" fences of prickly Osage Orange—formed the range that we call "home," the West we think we know. "Don't Fence Me In" is only a nostalgic theme song since economic reality intruded. Unfenced land is now rare. In free range areas, non-ranching landowners must fence livestock *out* if they don't want their streams trampled and vegetation consumed.

Nowhere are the two faces of nature—benevolent and beautiful, malevolent and ugly—so baldly evident or so embedded in contradictory attitudes about the land as in the West. Environmental historian Donald Worster writes, "the universal modern predicament appears with a stark, uncluttered honesty not always found in other landscapes. Here we are able to see etched in sharpest detail the interplay between humans and nature and to track the social consequences it has produced—to discover the process by which, in the remaking of nature, we remake ourselves....The encounter of Americans with the western landscape has been formative and profoundly revealing." Wallace Stegner has noted: "We were in subtle ways subdued by what we conquered....[When you're] living dry, you have to get over the color green. You have to get used to an inhuman scale."

The West requires a different set of eyes than the East does. Patricia Limerick, driving for the first time from her native Southern California to New England, found the East "infested" by vegetation and "distressingly green." Easterners first seeing the West are often spooked by space, so much of it, and "nothing to look

In Maine—the "Wild East"—fish and trees are the endangered resources. Like independent ranchers, fishers in the trade for generations are being forced into atypical self-examination by the disappearance of their prey. Like corporate ranchers, the forest industry is beginning to be called accountable for its crimes against nature.

"Maine is a metaphor for what goes on in the world with resource depletion, multiple use conflicts and man's intervention for his own purposes. The forest is a resource that has its own requirements, and those requirements seldom, if ever, coincide with man's."—Richard Barringer.

at." They can't believe how far you can see, though this is changing rapidly as increased pollution blows into even the most isolated areas, killing vegetation, veiling the distance—a saddening metaphor for pervasive short-term thinking.

The broad outlines of Western land issues are familiar to millions. From dime novels to Hollywood movies to spaghetti westerns to consumer seduction and popular culture, the cartoon West continues to inform our national psyche, although, as Limerick remarks, "if Hollywood wanted to capture the emotional center of Western history, its movies would be about real estate. John Wayne would have been neither a gunfighter nor a sheriff, but a surveyor, speculator, or claims lawyer." In fact, from my study window I can see a western movie set on the cusp of the next hill, a perfect postmodern illustration, a vignette within the view. Myths are being woven there that could profoundly affect the future of the beautiful but devastated ranchland in which they are being created.

The myth of the frontier sustained many through the hardships of settlement and continues to sustain nostalgic patriots on the fantasy level. But the west is not a state of mind. It is a place that is changing, like every other place. "The westerner is less a person than a continuing adaptation," wrote Stegner. We are an urbanized society, and the American West, contrary to popular belief, is no exception. In fact, it has the most concentrated urban populations in the country: 80 percent of the people in Arizona, for instance, live in Tucson and Phoenix. Just as in the East, Western land was perceived as unowned, unused, and was rapidly appropriated by settlers.

Explorer Josiah Gregg, as an early traveler on the Santa Fe Trail, looked forward to the day when "flourishing white settlements dispel the gloom" presiding over "this uninhabited region." A century and a half later, another traveler, New York journalist Ian Frazier, hardly found the gloom dispelled. His tirade encapsulating "our two hundred years on the Great Plains," and the way cultural and ecological histories are intertwined, bears repeating:

We trap out the beaver, subtract the Mandan, infect the Blackfeet and the Hidatsa and the Assiniboin, overdose the Arikara; call the land a desert and hurry across it to get to California and Oregon; suck up the buffalo, bones and all; kill off nations of elk and wolves and cranes and prairie chickens and prairie dogs; dig up the gold and rebury it in vaults somewhere else; ruin the Sioux and Cheyenne and Arapaho and Crow and Kiowa and Comanche; kill Crazy Horse, kill Sitting Bull; harvest wave after wave of immigrants' dreams and send the wised-up dreamers on their way; plow the topsoil until it blows to the ocean; ship out the wheat, ship out the cattle, dig up the earth itself and burn it in power plants and send the power down the line; dismiss the small farmers, empty the little towns; drill the oil and natural gas and pipe it away; dry up the rivers and springs, deep-drill for irrigation water as the aquifer retreats. And in return we condense unimaginable amounts of treasure into weapons buried beneath the land which so much treasure came from—weapons for

MERIDEL RUBENSTEIN, *Untitled (Good Luck)*, palladium print, 1982. The text is a poem by Cecil Harlan, a rancher from Peña Blanca, New Mexico, who took his own life as he watched the end of the West he knew: "Good Luck. May your spurs always jingle. May your rope never break. May you always be happy. May your heart never ache. May your horse never stumble. May you never catch a fall. May you always work fat cattle in the spring and in the fall." Known for her extensive earlier work with the lowriders of Española, and on the land, culture and people of rural New Mexico, as well as for her more recent installations on the vortex of Native American and nuclear cultures around Los Alamos, Rubinstein is deeply committed to the place where she lives as the core of her photographic art.

While seacoast and lakes form the outside image of Maine, nearly 90% of its land is forested, the highest proportion of any state; 96% is privately owned, more than 8 million acres by industry—way ahead of second-place Oregon. Maine's "timber-lands" (as opposed to "wilderness"), provide 30,000 jobs. Hikers on the Appalachian Trail are horrified when they reach Maine, the only state where the vistas are often marred by "vast expanses with no trees at all, except for pockets on the steep slopes of hilltops that harvesting machines couldn't easily reach."

These pockets represent crumbs thrown to recreational sectors by the corporate "multiple use" dogma. Local concerns are simply irrelevant. "The corporations," writes

134

which our best hope might be that we will someday take them apart and throw them away, and for which our next-best hope certainly is that they remain humming away under the prairie, absorbing fear and maintenance, unused, forever.

Westerners may have gone from being the avant-garde of American nationalism to being a province plundered by eastern corporations to being an integral [part of global capitalism].
— DONALD WORSTER

When the Smithsonian named its controversial 1991 exhibition "The West as America," curator William Truettner pointed out that the American's sense of self is indebted to the expansionist impulse that has come to rest in the "Wild West." Historian Richard Slotkin cites the "bifurcated geography" that defined the West as wilderness and the East as metropolis. Even as the West was perceived as an infinitely renewable source of land and resources, the East was providing unheeded lessons about the results of such an attitude. Truettner demonstrates how nineteenth-century landscape and genre paintings reflected this dichotomy and lured settlers westward where farmers were pictured in vast fields as their Eastern counterparts went about their tasks in cramped farmyards.

Beginning in the nineteenth century and continuing to a certain extent even today, the West has been the home of photography and the East of painting. Landscape photography has long been effective propaganda: the magnificent photographic images of the West by William Henry Jackson, Timothy O'Sullivan, Carleton Watkins, and others, were originally intended as functional records—for geological and railroad surveys, court evidence, and mining claims, or to bring settlers West. Nineteenth-century stereoscopic views were also entertainment; one could visit Monument Valley or be exposed to some revved-up ethnography in the comfort of one's own home— forerunner of television. From the beginning, then, photography of Western places and events has been sensationalized for armchair adventurers and couch potatoes (the *National Geographic* syndrome).

Unbridled Capitalism in today's West is countered by bureaucracy—and bureaucracy is nobody's hero. The Bureau of Land Management (BLM) is the biggest landowner in the United States. More than 50 percent of the land in most Western states is publicly owned, in some states the figure is as high as 85 percent. These lands are used in three ways: for working stock, largescale agriculture, logging, and mining; for parkland, "wilderness," and recreation; and for military-industrial concerns. The first two functions overlap, causing much furious debate. The third function encompasses huge chunks of the West appropriated as nuclear test sites, missile ranges, the storage of officially generated hazardous waste, and facilities devoted to perpetrating more of the same.

Just as the government has subsidized American farmers since the Depression, on a much smaller scale it also subsidizes a number of Western ranchers, maintaining, however artificially, two ways of life that most of us would hate to see disappear. Apparently infinite acreage has made for irresponsible use. The current rate to graze a cow on public lands for a month is less than one quarter of what it would be on private land, leading to the epithet "welfare cowboys." Some put the figures even higher. R. E. Baird has compared the 1993 rate of $1.92 per head on public land, and notes that nearly half of the leased BLM acres are held by five hundred large corporations (such as the Aetna and John Hancock insurance companies, the Getty, Texaco, and Union oil companies, and Pacific Power and Light) while the five hundred smallest allotments cover only about thirteen thousand acres. Along with inexpensive

Bob Cummings, "are doing what corporations are supposed to do, protecting their profits regardless of what happens to Maine. They can afford to clearcut Maine because most own land in many states and many foreign countries. When Maine forests are gone, they need only move elsewhere."

The North Woods have been called "wild-lands" for centuries, although the respected forest activist Mitch Lansky, who since 1970 has lived and worked in the forests of Aroos-took County, says that "we should be grateful that any wildlife survives, that any forest is worth looking at...since these are not primary considerations" in industrial forestry.

While most of Maine's available seashore and lakeshore property has been bought up

grazing fees, additional subsidy comes from federally donated materials for improvements (such as fencing and water tanks) and emergency feed programs.

> *People stick to ranching because they love the feel of a quick little horse moving intently after cattle, or the smell of greasewood after summer rain; or new-cut alfalfa on a spring morning, or the stretch of damp rawhide as they work at braiding a riata, or the look of a mother cow as she trails her dusty way back to her calf after a long walk to water. People stick to it because they enjoy the feel and smell and sound of things, and because they share those mostly unspoken loves with other people they can trust as being somewhere near to decent.*
> —WILLIAM KITTREDGE

Despite pleas for the survival of "subsistence ranching," public land ranchers (leasing some 307 million acres in sixteen states) represent only roughly one fortieth of the nation's one million livestock producers, and they are mostly part-timers who like the life but can't make a living from it. For all their touting of "traditional rights," only 32 percent of today's beef cattle ranchers have been on their land for over fifty years.

Onandaga faithkeeper Oren Lyons has pointed out that the West was settled by those who did not understand its biodynamics and superimposed their own illusions on the land. The Endangered Species Act is under attack by "traditionalists" who don't get the connections between land health and some odd and "dispensable" little creature or plant. However, the predicted demise of Oregon timber communities in favor of the now-notorious spotted owl never happened. (In fact, as Timothy Egan reported in *The New York Times*, the region's economy is now thriving with smaller mills and new industry.) Jim Baca, former head of the BLM, points out that more people in his home state of New Mexico are employed by the computer industry than all the natural resource industries combined, "but we still give [ranching interests] everything they want, no questions asked."

About half the western range is badly depleted, although some land is slowly recovering, thanks to ecological consciousness raising. The most crucial parts of the ecosystems—the riparian areas, rivers and creekbeds—are particularly vulnerable. In the Southwest, for instance, it is estimated that about 90 percent of the desert streams are seriously damaged

135

HOLLY HUGHES, *Trails End*, 1994, Magdalena, New Mexico, a community project sponsored by the Art in Public Places program of the New Mexico Arts Division(Photo: Richard Hooker). The life-size standing bull is accompanied by a cow and a cowboy, dispersed around the entryway of the Magdalena Rodeo Grounds. The sculptures are made of recycled materials used in the cattle industry, supplied by local ranchers. An adobe wall (decorated with handprints by local schoolchildren) and an adobe figure of a pioneer woman by Pat Beck complete the installation. Hughes, a native of Kansas, lives in nearby Socorro and has for many years been working internationally with recycled materials as community rallying points for environmental responsibility. Her current project is a 38,000-square-foot globe being constructed from donated materials with a Kansas City elementary school.

by out-of-staters, the cheaper and more remote logged-over inland is still held by local people for hunting camps. "People from Massachusetts. They sell their homes for two hundred and fifty thousand bucks and come up here, they can buy a bunch of acres and a house for a hundred thousand and it seems like a great deal. Which to them I guess it is. But then the first thing they do after they buy, is they post it," says camp owner Leo Roberge who, like most north country Yankees, is also, just on prin-ciple, against federal agencies. "We've been going on this land all our lives, and we can't go there anymore. ...I mean, people, come up, enjoy the nature. But don't try to tell us what to do. This is not a park. This is our country. We're not going to stop doing

136

by livestock. Some environmentalists would like to see cattle totally banned. Environmental groups have tried to acquire grazing licenses to free the land from cattle. In November 1995, this strategy was stymied when the New Mexico State Land Office denied bids by the Forest Guardians and Southwest Environmental Center on sixteen parcels of degraded state trust land. All of the land was awarded to ranchers, despite the fact that the environmental bids were higher and the money received is earmarked for education in a very poor state. In the fall of 1996, however, Forest Guardians finally succeeded in outbidding a rancher. The slogan "Cattle Free by '93" has given way to "Cattle Free by 2003."

Given the delicate balance between different local traditions, the West's power struggles between races, classes, and genders are unlike anywhere else. Donald Worster compares the similar effects of ranch and plan-tation on the social landscapes of the West and the South: both have defined a regional identity and were "spawned by the capitalist revolution in agriculture," which is based in dispossession and a nonwhite work force. The notion of a "cowboy proletariat" never caught on because "the hired men were allowed to ride big horses and carry big guns across a big space." (The African slave, for obvious reasons, was never granted this privilege.)

Stegner identifies the cowboy as "an antisocial folk hero....The cowboy in practice was and is an over-worked, underpaid hireling, almost as homeless and dispossessed as a modern crop worker, and his fabled independence was and is chiefly the privilege of quit-ting his job in order to go looking for another just as bad." That underling cowboy (originally a Mexican *vaquero*) was joined by a number of "Buffalo soldiers" and black cowboys, as well as a few women. The image has now been assumed by big ranchers in an uneasy

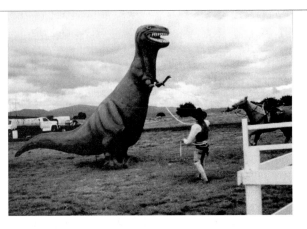

LARRY WILSON, *Adventures in Foam*, 1991, 14' high, polyurethane, Santa Fe, New Mexico (Photo: Anna Christine Hansen). Wilson, who owns a roofing and insulating business, loves his material: "There are plenty of foamers, but I'm the only one who has fun with it.... There are no limits to it but man's imagination." Over the last decade, he has also worked with artists, and developed a way of using foam on armature as a sculptural medium. When the dinosaur craze hit in the late '80s, his granddaughters asked if he could build a dinosaur, and he made a tyrannosaurus rex and a triceratops that dance in front of his house (the life-size cowboy came later). Visible from Interstate 25, they attract frequent visi-tors. Wilson sternly reminds people not to play on the sculptures because "this is not entertainment." He describes himself as a problem-solver. "I'm an amateur sculptor," he says. "I'm imper-fect and like to build ancient creatures, so if people say they're not right, I can say, well, they could have been."

merger of romantic poverty with corporate roles. Ranchers have gotten a free ride on the popularity of the cowboy as emblem of freedom, independence, and —ironically, since "real" cowboys rarely owned any-thing—private property. Like cowboys, ranchers bor-row their reputations from the quality of Western space itself and the ways it has been used, which stand in the national imagination for unrestricted freedom and the illusion of independence, or at least self-reliance.

Competing views of the New West have fueled lethal feuds, exacerbated by people like Alaska Repub-lican Congressman Don Young ("If I have my way, I'm

something just because you say so. Not when we've always done it."

"I tell people this isn't really a forestry issue at all," says Maine forester Mel Ames. "It's a political issue. It's about how we choose to live on the land. Once you understand that, you understand that it's the same for woodland and saltwater fisheries and rivers—anything we have the power to ruin."

"With millions of dollars provided by out-of-state multinational corporate owners of Maine timber lands, they have sought with slick ads to frighten Maine citizens into believing that the ban on clearcutting is a ban on forestry," wrote John Rensenbrink, the 1996 Green Party Senate candidate. At the same time, Boise Cascade advertised "a free tour of our Rumford

going to dissolve the Forest Service...They're not harvesting any trees, so why have them any more?"). Now that environmentalists have begun to challenge the hold of grazing on millions of Western BLM and Forest Service acres, and the media has begun to take notice, the ante has been raised. One sector of the ranching community has reacted with fear and denial. Violence has escalated. In 1993, Jim Baca received a threat from the "Tom Horn Society" in Nevada (named after a nineteenth-century hired gun for cattle barons). Ron Arnold, a "wise use" leader who once worked for Reverend Sun Moon's church, has vowed to "destroy the environmental movement for once and for all." Since 1988, the wise use and property rights movement as a whole (which includes anticonservation hunters, gun clubs, off-road vehicle buffs, Moonies, and some public land beneficiaries) has declared a "holy war against the new pagans who worship trees and sacrifice people." These groups are joined by those in the recent "county-supremacy movement," pioneered in Catron County, New Mexico, which has declared local authority over federal lands in its boundaries. Extremists have resorted to frequent death threats and scare tactics, and when those fail, to beatings, pet-killings, arson, rape, and perhaps even murder (as in the case of Navajo environmental activist Leroy Jackson) in order to evict environmentalists and forest rangers from public turf they consider their own rightful domain.

Property rights advocates, more often based in the East, oppose "takings" of private property for federal projects and join their western counterparts in opposing Clean Air and Water acts, the Endangered Species Act, and wetlands protection, among other things. Their Western agenda also calls for cheap or free access to federal land and water and for mining and drilling in national parks despite the fact that only

three in ten thousand Western jobs depend on mining on federal lands. These groups are joined by a Republican-dominated Congress that advocates the outright sale of many parks and national forests, harking back to the fifties, when Republican administrations transferred billions of dollars worth of federally controlled natural resources to state and private developers. Along with less virulent free-market environmentalists, wise use and property rights advocates have been fairly successful at organizing in rural areas and attracting media attention. Representing themselves as the "little guys," they are in fact supporting big rather than small herds, and agribusiness rather than small farmers.

Bill and Barbara Grannell, for example, directors of People for the West, began their work in the field in response to an invitation by "industry folks" to create an antienvironmentalist coalition. Their twenty-thousand-member organization packs a disproportionate wallop because it is heavily funded by mining and energy corporations intent on preserving an 1872 mining law that permits transnational corporations to claim public lands for a ridiculous $2.50 to $5.00 an acre. In September 1995, as funds for education, the arts, and medical care were slashed in a decidedly unbalanced attempt to "balance" the budget, we watched Interior Secretary Bruce Babbitt reluctantly sign over title to an estimated billion dollars worth of minerals to a Danish company for $275 (earlier he had been forced to give a Canadian firm ten billion dollars worth of gold for $10,000). "You might reasonably ask how can a public official give away a billion dollars without going to jail," he said at a news conference. "The fact is, I have no choice. This corporate welfare has been going on nonstop for 124 years and the U.S. Congress is the only place that can bring a halt to this." Congress demurs.

Mill or our working forests," illustrated by an idyllic scene of sparkling lake and tall pines and stating (in curiously tiny print) that "Boise Cascade is committed to managing forest resources for now and into the future." That future, however, may not be in Maine. New Hampshire is afraid that if the clearcutting ban ever won, Maine loggers would move into New Hampshire, which bars clearcutting only along roads and streams where "beauty strips" are maintained.

In 1996, Green Party leader Jonathan Carter challenged corporate control of Maine's woods with a Ban Clearcutting

138

Attempts to meet consensus have failed so far, but in some areas environmentalists and ranchers are realizing a common ground. Some ranchers are beginning to realize that they often do not understand the ecologies of their holdings, and that their own practices could be doing them out of a job. (Others still call up the glorious "tradition" of the West and the future be damned.) One Audubon Society employee says, "the environmental movement has come to realize that there are great opportunities for ranchers to make a positive contribution to the ecological restoration of range lands. We've moved beyond an issue of us versus them, of cows versus no cows, to a debate over the condition of the land."

Sharman Apt Russell's book *Kill the Cowboy*—which, despite the title, offers a committed but relatively balanced approach to these issues—quotes Connie Hatfield, an Oregon rancher who advocates the importance of women's voices in the debates:

"Five years ago, at a cattleman's association meeting, I was told to go away. They wanted me to join the Cowbelles and promote beef and give out recipes. But at our meetings now, when the men grunt and groan and can't say what they feel, the women are there to speak out and articulate their feelings. Women in general tend to be more right-brained and to understand the other person's viewpoint. We need more of that!" She recalls a meeting with an environmentalist who was talking about the necessity for both young and mature species—of fish, or willows—"and the ranchers are going, 'Oh, okay, why didn't you say so before? *We thought you just wanted to get rid of the cows.*' And everyone in that room was so surprised to learn that no one was really in opposition."

Even some conservative ranchers recognize that the

MICHELLE VAN PARYS, *God Bless America*, 1988. Van Parys, based in Charleston, has been photographing "the New West" for several years. This picture was taken in Nevada.

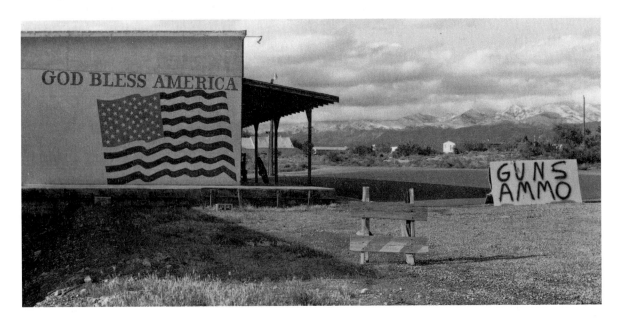

Referendum that attracted 58,000 signatures (the Greens have only 2,000 members). With Maine's governor Angus King, a former businessman who opposed the ban, the logging and paper industries engineered a complex and well-funded compromise "forest compact." Although it was criticized for muddling the issue and being much too complicated and inclusive, the compact won by a small margin on election day, imposing a 1997 runoff. Win or lose, the Ban Clearcutting Referendum focused crucial attention on the north. Local models for sustainable forestry have been emerging ever since the issue hit the headlines.

fiscal burden (some $200 million per year) of grazing on public lands should be on the shoulders of the rancher rather than the taxpayer. They see public land ranching as undermining the legitimate industry and coming dangerously close to "socialism." Low beef prices and drought are worse than ever in some areas, which makes it a bad time to try and enforce stricter environmental standards, even though an oversupply of beef would seem to offer an excellent reason for retiring percentages of herds on overgrazed lands.

The question behind these current debates is: Who is the best guardian of an intensively used land? Worster concludes that obviously "the private entrepreneur simply could not be trusted to look out for the long-term ecological health of the range resource"; government does it better, for all its faults. The battle has become increasingly complex, confused by a lot of partner-switching between a lot of strange bedfellows: ranchers, miners, and loggers; environmentalists/recreation interests (at times awkwardly allied with sports hunters, some of whom occasionally help track endangered species); and the BLM and the Forest Service, which, depending on the issues, are often at odds with both the ranchers and the environmentalists.

Each of the groupings has its own internal divisions, and the lack of effective coalitions makes it easier for developers, up against all of them, to win. The very complexity that clouds the future of the West will persist as long as most Americans are ignorant of its antecedents. A similar battle between ranchers and conservationists, states rights and federal regulation, took place under the Teddy Roosevelt administration in the early part of the century. (Conservationists thought they won, but look where we are now.) In the so-called Sagebrush Rebellion (1979-81), ranchers and entrepreneurs tried to reclaim federal lands

for stockmen and miners, but their image of underdog won't stick. The rich are more likely to get land for public use than the poor. "The Lakota lost the largest portion of their land not to the American public seeking a public use but to a group of very individualized white men and women who have made lots of individualized dollars with that land," says lawyer Charles Wilkinson, who warns that all law "is profoundly protective of established interests, and much of that protectionism is profoundly subtle."

Certainly, many of us living in the West would prefer the preservation of open space through enlightened ranching to even the most cosmetic development. Wallace Stegner, a native westerner who had high hopes for the region, reconsidered after the postwar boom: "The West is no more the Eden that I once thought it than the Garden of the World that the boosters and engineers tried to make it;...neither nostalgia nor boosterism can any longer make a case for it as the geography of hope." Nevertheless, he still believed that "somehow, against probability, some sort of indigenous recognizable culture has been growing on western ranches and in western towns and even in western cities," the product not of boomers and boosters but of those who love the life and the place and may be able to "resist and sometimes prevent the extractive frenzy that periodically attacks them."

Landbase: Mountains and Arroyos, Grandmothers and Uncles

Mountains and arroyos step in symbolically for grandmothers and uncles....
Losing the land is something the Western Apache can ill afford to do,
for geographical features have served the people
for centuries as indispensable mnemonic pegs on which to hang
the moral teachings of their history.
— KEITH BASSO

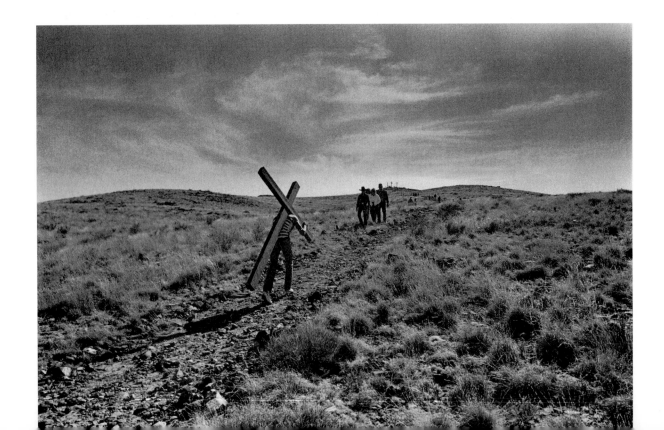

Coastal Maine's most important landbase is under water. Of the two traditional livelihoods, farming is scarce, but the sea still offers fish, lobster, shrimp, eels, clams, mussels, scallops, urchins, and worms to the enterprising local worker. At the mouth of the Kennebec, lobstering goes back at least to the Red Paint people; Europeans were quick to catch on. In 1605, James Rosier caught 30 large lobsters and mused on the potential profits. The 6,500 licensed Maine lobsterers (4,000 boats) catch half the U.S. harvest, landing over 39 million pounds in 1994, worth over $100 million. Despite growing concern over diminishing ocean resources, lobsters flourish, fed by baited traps. But 95 percent of those big enough to keep are harvested—a dangerous

LANDBASED PEOPLE, FRAMED AS A NOSTAL-GIC ideal within North American mythology, which specializes in vanishing races, are a minority in the U.S. today. But they are everywhere, and are often fighting, no holds barred, for their lives on and with the land. Up until World War II, land represented security for many Americans, although some complained of being slaves to their land or stuck in the country. But the Jeffersonian structure began to crack after World War I—there was some truth to "how ya gonna keep 'em down on the farm after they've seen Paree?" Landbased people are not often immediately concerned with "ecology." The feelings of farmers and farm workers, who directly experience the land, are rarely articulated from the inside, and they are "complicated by a profound sense of the earth as both friend and enemy," writes Michael Steiner. Many people who have recently moved to rural areas covet such deep connections that come only from a life bonded with or virtually tied to the land. Temporary and more obviously emotional, this may be as close as most of us can come to the landbased experience.

"If the landscape is in part a temporary 'consensus,'" writes Don Mitchell of the 1913 agricultural workers' strike in Wheatland, southern California, then conflict exposes its patterns and structures, "the workings of the everyday...the sedimented layers of spatial practices" that defined the land and the lives of migratory laborers. The landscape is "naturalized" when people stop fighting over it and take it for granted. Then comes either resistance or resignation —decisions to struggle or not against the way space has been ordered and privilege served.

As capitalism has eroded community and promoted "self-reliance" and alienation, the relationships between culture, land, and individual have changed. Visibility is an issue. Rural people rarely have a say in how they or their places are represented. Their relationships to place differ from those of the urbanites who usually represent them in images, or (in the case of some "earthworks") build or walk among them.

It is up to landbased people to name themselves. Those who come first to mind in the West are those Native people still living on some part of their ancestral territories (the Pueblos and Navajo, for instance) and the Mexican American *mestizos*. Writer Rudolfo Anaya speaks for "the Chicanos, Indians, and old Anglos, who worked the land" in the Southwest "and are now the labor force to serve the industries that the world economic and political system imposes on us. The time is disharmonious....It is no wonder that we feel we are being watched, our responses recorded. We are being used, and eventually we will be discarded." He describes what is being lost as a sense of "the earth as a creative force....The values of the old communities, the ceremonies of relationship, the dances and fiestas, the harmony in our way of life, and the mythic force we can tap to create beauty and peace." At the same time, this poetic view is not a cultural consensus among Latinos in the Southwest. Charles Bowden describes a wheeling, dealing friend in Arizona: "he is a hundred years deep into Tucson, his family roots twine back into *conquistadores*, and he spends his every waking moment selling the ground out from under his

MIGUEL GANDERT, *El Cerro, Tomé*, New Mexico, 1989. Gandert, well-known for years of striking documentation of his native turf and culture, says the reason there is little Chicano landscape photography is that the landscape is too private to expose to public scrutiny. This exception shows Tomé Hill, south of Albuquerque, a particularly significant and layered site: it is the location of the annual Holy Week processions pictured here, of Native American petroglyphs and an Anasazi ruin, and of a proposed public art work for the "Cultural Corridors Project" sponsored by Valencia County and the New Mexico Arts Division.

precedent, threatening the broodstock.

(An aside: I use lobsterers and fishers for lobstermen and fishermen, taking the lead from Lizzy Poole, of *The Fish Rapper Digest* in York, Maine, who accused a fellow journalist of "clinging to dead gender titles like a super-market hangs on to a red-eyed mackerel.")

Lobsterers like their freedom. There are no stop signs on the water, and no time clocks to punch, but it's hard and often dangerous work for the 5-6 month season. Even summers are fraught with problems: weather, bottom conditions, price and availability of bait, competition, ocean traffic, the mechanical fragility of both engine and the sophisticated equipment that is now de rigueur, all exacerbated by increasing regulations. Planning ahead is difficult and gambles

past, present, and future." Most Southwestern *Hispanos* are somewhere in between these two descriptions, proud of their long tenure and their intimacy with the land, of their Spanish (though less so, of their Mexican/Indian) heritages, resentful of the latest influx of newcomers, and trying to make do.

"To protect water and land," write Devon Peña and Joseph Gallegos, "is to protect the local culture." The San Luis Valley in southern Colorado shares strong familial and cultural ties with northern New Mexico, as well as a common history of land grants and lost communal lands. The region is a crucible of cultural land issues. A beautiful high desert plateau ringed by forested peaks, it is one of the last non-industrialized rural areas in the intermountain West. Here, as everywhere in the West, the ever-quickening shift from native to outside ownership and the resultant exodus of local populations is changing the landscape. The valley has been threatened by mining, corporate water-siphoning, low-level training flights from military bases in nearby Colorado Springs, and (on a more benign level) upscale development in Crestone, a small mountain ranch town that has become an ecumenical spiritual retreat.

San Luis de Culebra, in the valley's southeast, is the oldest agricultural-pastoral community in Colorado and the site of a number of "centennial farms" (owned for at least one hundred years by the same family); it is also entirely *Hispano*, as is most of the village population of the area. For some two centuries, since the early land grant days, the traditional *ejido* system made the slopes of the sierra accessible to hunting, fishing, and firewood gathering—a longstanding subsistence lifestyle in the *Hispano* communities. In 1960 the land was bought by Jack Taylor—a North Carolina lumber baron who, by fencing off the mountain tract, sparked decades of local resistance, often violent on both sides.

Prolonged litigation by the local Land Rights Council has involved a flammable mix of divided community activists, environmentalists, state agencies and private landowners. In 1990, this volatile mixture came to a boil with the development of a strip gold mine that leeches cyanide into the Rio Seco watershed—source of the San Luis People's Ditch, which provides irrigation to the state's oldest farms and ranches.

The Taylor Ranch, which went up for sale in the early nineties, is the center of intense internecine warfare between local *Hispanos* (many of whom are *herederos*, historical land grant heirs), big ranchers, politicans, environmentalists, sportsmen, and developers; in many cases, the groups overlap. The *Hispano* community—"the people up in the hills" who have most to lose—is a labyrinthine tangle of blood and marital bonds and feuds, with the two major organizations often at odds with each other and with the state, which is trying to buy the land for a park. A common fear of gentrification and amenity tourism was expressed by local rancher Gene Martinez: "I'm not keen on seeing a big bus over here with a bunch of tourists looking at me like I'm a monkey or something."

At issue are "historic use rights" and local *Hispano* tradition, which cover a multitude of virtues and sins, including, at times, overgrazing, overcutting, and the poaching that has been described as "a way of life." Ron Sandoval, an economic refugee raised in Costilla County but now working in Phoenix, says that the real issue is that the *herederos* are losing their "spiritual relationship" to the land and will need "training" before they are ready to use the mountain again. "The fact is, some local people have had access to that land, and they've abused it," he says, sometimes by selling endangered animals. "I don't think it can sustain people by itself, but it's there to help people survive, not for them to exploit or destroy it."

don't always pay off. Once a lobsterer has taken in a thousand traps only to find the predicted storm wasn't so bad or bypassed the area completely, s/he is likely to decide to leave them out for the next one, this time losing hundreds. Winters are spent on maintenance of boats, buoys, and traps. The wire traps are more expensive, but stronger and more durable than the wooden ones, though nowhere near as beautiful. The graceful bent arch is replaced by a pedestrian box. Buoys are no longer carved wood, but styrofoam, leaving color the lobsterer's last creative option.

In 1968 Maine Indians sued for the return of 12.5 million acres of land—about 60 percent of the state (later reduced to five million acres plus financial compensation).

Another struggle for socially and ecologically appropriate development is taking place in the nearby Chama Valley, over the New Mexico border. Outside the poverty-ridden and militant town of Tierra Amarilla, the site of two major land wars in 1967 and 1988, the village of Los Ojos witnessed a local success story that began in 1981 with the founding of Ganados del Valle (Valley Livestock). In this "vertically integrated business" which promotes careful grazing and local culture, Ganados members raise sheep, wash wool, spin it, weave it, and sell the handsome woven goods at Tierra Wools, run by Maria Varela, one of Ganados' founders, with her neighbor, teacher, and part-time rancher, Gumicindo Salazar. As Laura Pulido points out, the money stays in the area, where it is badly needed.

Ganados provides an alternative to New Mexico's promotion of tourism as the antidote to Rio Arriba County's grueling poverty. Tourism brings land prices up and only provides the local population with low-wage, often seasonal jobs, such as cleaning toilets and pumping gas; these are unpopular because their lack of dignity and meaning is culturally and ecologically corrosive. Sheep, which provide meat and wool, are, with the land and weaving, part of *Hispano* history and tradition. The weavers reaffirm their culture as well as catering to the popularity of "Southwest" design. "More importantly," writes Pulido, the whole organization—now several businesses—"is structured in keeping with local ways." Women are primary caretakers of children and the home. The weavers can work at home or take their children to Tierra Wools with them.

However, only limited grazing territory is available around Los Ojos, where much of the land is taken up by federal Wildlife Management Areas, and ranchland has been priced out of sight. In the summer of 1989, Ganados found themselves without sufficient pasture for their flocks. They decided on civil disobedience, and two thousand sheep briefly "occupied" public land. Although this got the attention of those who might have remedied the situation, once again it pitted local people trying to survive against environmentalists worried more about the long-term health of the land. "The people who ought to be allied are fighting," says Ganados leader Antonio Manzanares. "We're frontline environmentalists." Despite the two groups' similar goals, Ganados has come up against what Maria Varela calls a "Green Wall," despite her people's goal of "grazing livestock to protect habitat and culture." In defiance, she accepted an award from the vehemently anti-environmental People for the West. Ganados sued the Sierra Club Foundation, which had been given money to buy much-needed pastureland for Ganados, but spent it on other programs. (A judge ruled in their favor, and Ganados received one fifth of the acreage they need.) The conflict between preserving habitat for a "wilderness" ecology and for the people who have lived there for centuries remains an obstacle to real cooperation across the West.

Walking, I am listening to a deeper way. Suddenly all my ancestors are behind me. Be still, they say. Watch and listen. You are the results of the love of thousands.
— LINDA HOGAN (CHICKASAW)

Indigenous people personify landbased people in the Americas. "An Indian is a person whose roots are at least six feet into the earth." This bitter pun on life and death is seconded by Amos Owen in another *double entendre*, as he talked about gathering traditional medicinal plants in Minnesota: "A lot has been plowed under and what we have here is this nuclear plant, radiation spreads everywhere and if they say it's safe why do they tell us we can't eat the fish down here anymore....Man has become so advanced today that

The possibility of a real consolidated Indian nation based in a million or so acres in the north woods appealed to many, but was unacceptable to those "squatting" on the land. A court ruled for the Indians in 1975; in 1977 the U.S. government requested a nego- tiated settlement. In 1980, the Passamaquod- dies voted on the government's proposal by a show of hands; the Penobscots were given less than 6 days notice to approve it. The settlement was approved by the tribes des- pite the lack of community participation and the fact that many felt they had been ill informed and rushed through the process. A good many Maine Natives now regret the rapid approval of the bill, which virtually terminates Penobscot sovereignty. Indian lands and incomes are now subject to state

he forgets what Mother Nature has put upon this earth and like our people say, the Indian nation was sort of picked to take care of Mother Earth. We think that the Earth is forever going to be and yet we have to apologize for walking around killing the grass."

After contact with Europeans, indigenous people were bullied, starved, and displaced into totally alien ways of life. Even when living on "their own land," farmers with nomadic backgrounds were bound to regard the profession, and the land, differently from those who came from generations of agriculturalists. Like the "sacred," the "local" is likely to have a more expansive meaning for those whose ancestors had traveled within vast territories over thousands of years and yet maintain a sense of centeredness and the conviction that where they are is where they have always been. Santa Clara Pueblo writer and designer Rina Swentzell describes her people moving out of the underworld, being "born literally from the womb of the Mother. When we are asked to talk about the connection between land and the people, between people and the natural environment, how can we talk about it except to say that it is so intimate? Think of children…." Her brother, Tito Naranjo, describes the first time he ritually returned to the underworld in a kiva: "I realized, at that moment, that I was all Pueblo. This was absolutely and completely how it had been before the Spanish came. There was no other world but this world of being a Pueblo Indian."

Indifferent to the power of existing cultures, the new Americans insisted everyone fit in their mold. In one decade (circa 1823–1833) the U.S. Supreme Court demoted the Indian nations from the sovereign status guaranteed them in the Constitution to a perpetual "legal childhood" as dependent domestic wards of the federal government. With this they lost legal title to the lands held "in trust" for them by the government.

One betrayal set the stage for another through the nineteenth and twentieth centuries, prime among them the disastrous Dawes Act or "Allotment Act" of 1887. In an attempt to assimilate or destroy the tribes, individual ownership was forced upon them, immediately followed by "voluntary" sales to non-Indians. By the time this act was repudiated fifty years later during the New Deal, some ninety million acres of "surplus" or pre-allotment Indian lands had been lost, the majority of their most watered and arable acreage. "If it's an Indian private property right at issue, you can forget about it. But if the private property is in the hands of some settler or his descendant, then it's SACRED," says Anishinabe activist Winona LaDuke.

The 555 federally recognized Indian tribes scattered over the U.S. today occupy the poorest areas in a country where, as of 1995, 14.5 percent of the entire U.S. population and 24 percent of its children live below the official poverty level ($15,000 per annum for a family of four). Yet the reservation landbase provides crucial support of independence, sovereignty, and taxation as well as a strong sense of "home" among even uprooted Native people. "Where are you from?" is often the first question asked when Indian people meet. It may be two or more generations removed, but "going home" usually means a return to the rez, which is the domain of stories and memories, buried friends and ancestors, places and place names known only to those who live there. As termination, and relocation in the fifties, demonstrated all too well, destruction of the reservation system, flawed as it is, would be the final cultural blow to most Native Nations.

Even in the absence of direct experience, the landbase can become a symbolic homeland. Many Native people live in cities. "They're there, but they're dreaming reservation," says Lakota John Running Horse. "Being raised in this way serves as one's

jurisdiction and taxation. The regained land is held "in trust" by the U.S., which makes it subject to "eminent domain taking." The Secretary of the Interior has final say over how the lands are used. "The proposed settlement, which is being described in the press as a windfall to the Passamaquoddy and Penobscot Nations, is actually a disastrous setback to Native rights in general and practically wipes out aboriginal rights in Maine."

A Penobscot woman from Indian Island says,"Education opened my mind up to the outside world, and it's too bad that it wasn't the other way around too—that they could not open up to who I am instead of labeling me. They want to tie us into mainstream society, but people still have those attitudes. I don't know how to deal with it.

center," writes Navajo poet Luci Tapahonso, "and it serves as a foundation for life so that distance, where one travels, where one goes, is not really important. Renewal is possible whenever there is distance and wherever there is space and land." Compromise is the medium in which the hybrid life is lived. For instance, Navajo houses should face east to facilitate the sunrise prayer, but this is often not possible in cities. "You might get an apartment at a good rent and your door faces west," says Tapahonso. "What can you do? You have to work harder at it....In the end I am grateful for the situation I am in."

RONALD (R.J.) LEWIS JR. (HUALAPAI), *Satellite and Shack*, 1993 (Photo: Courtesy Shooting Back) The ten-year-old photographer on the Hualapai Reservation, Peach Springs, Arizona, was part of the "Shooting Back from the Reservation" project, in which Native American youth photographed their homeplaces. Lewis said, "When I pick up a camera, it feels like I'm going to a different dimension." Asked what dimension he went to, he replied, "the future." Harry Sahneyah, another ten-year-old participant, said of their home, "Our town has no fancy restaurants. Peach Springs is the nicest place on earth."

Some of the indigenous landbases, whittled down into the present pockets of undesirable lands, turned out to be ugly ducklings, rich in hidden resources. Soon all kinds of machinations were unleashed so that outsiders could own or control Native holdings. In 1903 the Supreme Court decided that treaties with Native nations (supposedly on a par with other international treaties) could be broken (as they had been all along). In the fifties, Republican administrations began to turn back the New Deal's relatively pro-Indian policies: one hundred and nine bands and tribes were involuntarily "terminated," their members losing all federal assistance and about 1.4 million acres of tribal land. In 1993, Indian water rights were severely affected by additional legal barriers. As Ward Churchill, who is Cherokee and Métis, points out in his book on indigenous resistance, *Struggle for the Land*, these processes have been not only genocidal, but "increasingly ecocidal in their implications."

There have been a few victories, notably the landmark land rights case in which the almost landless

They want us to go out, talk in other communities for better relations, and I don't know whether that works. I don't want to go out and reach all them. I want to stay here and bring up my children proud and strong to deal with that, because I can't change the whole world. I'm for Indian education and for Indian children, so you don't have to play into the stereotype, so you're not lost and fumbling around."

In the 1960s, Georgia Pacific hired French Canadians to harvest wood on Passamaquoddy land despite high unemployment on the reservation. "There was an awful uproar because there was no work," recalls

146 Passamaquoddy and Penobscot Nations claimed some twelve million acres of Maine, on the basis of a series of letters dating from the 1790s and signed by George Washington. No ratified treaty ceding these lands was ever found, and in 1980 the nations won some three hundred thousand acres and $27 million in compensatory damages. Dozens of such cases are still in the courts across the country. Despite a renewed surge of litigation since the seventies, and an occasional victory, the deprivation and degradation continue, sometimes abetted by corrupt or misled tribal councils. Obstacles to resistance are sometimes raised by the very conservationists who claim to be following the Native ecological lead.

Such struggles are also instructive for non-Indians trying to maintain local autonomy—though these groups and movements are hindered by the fact that they tend to disregard connections with other local struggles, isolating and weakening them all. How many local activists (not to mention states rights advocates) knew about or spoke up on the effect of the Alaska Highway Pipeline on Canadian Native peoples? On the other hand, as Hugh Brody writes, speaking on behalf of the Beaver Indians with whom he had lived; "What could be more indicative of the subordination of local interests to distant—and even foreign—interests than a pipeline that slices through British Columbia on its way from one part of the U.S. to another?...Does it really make sense to export limited and unprocessed resources to the most wasteful society there has even been?...And what better illustrates the utter disregard for the Indian interest than the haste and lack of concern over environmental effects with which the Alaska Highway Pipeline has been planned?"

Given this history of imposed stasis and involuntary "ownership," the tremendous ambivalence toward the land currently occupied by many Native

MELANIE ANDREW YAZZIE (NAVAJO), LAURA SHURLEY-OLIVAS (NAVAJO), KENN YAZZIE (NAVAJO), *Three Little Indians*, 1992, detail of installation, University of Colorado at Boulder (Photo: Three Little Indians, Inc.). Visible on the wall behind the stereotyped cut-outs were handsome acetate full-length photo portraits of the three artists overlaid on maps of their homes on the Navajo Nation, and surrounded by published stereotypes of Indians. The viewer had to look "through" or "past" the "cardboard" Indian (complete with BIA number) to see the real people, inseparable from their homeland. Small certificates of Indian Blood with temporary census numbers expiring in 24 hours were sold at the opening and people could pay two dollars to have their pictures taken in the cutouts. This kind of edgy humor is typical of the contemporary Native arts.

nations should come as no surprise. This history of cultural dispiritedness and dispossession is visible in landscapes today in the litter and apparent disregard for the land on some reservations. This can be a shocking sight, even when it is recognized as the product of despair and poverty, or perhaps as resistance to "disposable" foreign values. Sometimes old cultural values have been added to the mix: Tuscarora photographer Jolene Rickard's photographs of the rusting vehicles found on her New York state reservation convey the fact that the retired trucks and cars can be perceived not as eyesores but as the equivalents of aged farm animals put out to pasture, respected for the help they have provided.

a Passamaquoddy. "And the protest came when they saw all these wood houses coming in and there was no work for the Indians." When negotiations with the Canadians failed, the Indians went into the woods with painted faces wearing their traditional regalia, hid until the tractors came in and said, "Drop your equipment. You had your chance..." They confiscated chain saws and skidders. It took another round of confrontations, with the Indians charging the outside workers with trespassing, before Georgia Pacific agreed to train and hire the Passamaquoddy to work on their own land.

Although the loss of land must be seen as a political and economic disaster of the first magnitude, the real exile of the tribes occurred with the destruction of ceremonial life and the failure or inability of white society to offer a sensible and cohesive alternative to the traditions which Indians remembered. People became disoriented with respect to the world in which they lived.

—VINE DELORIA

The urgent need for long-term thinking about land use has been accompanied by a resurgence of mainstream interest in indigenous landbased culture, a politicized process that began in the sixties and extended to religious practices with the advent of the New Age. Partly due to Indians' grassroots strength and pride at having survived, partly bolstered by their rage at the toll it has taken on Native culture, health, and land, it is also a product of the growing recognition among Euro-Americans of the hitherto ignored cultural contribution of Native people to the entity (but not unity) called the United States. The Navajo tell a joke: Each time a group of white men arrived they were asked, "What are you looking for?" First it was land. Then it was oil; then it was vanadium and uranium. In the nineties, it's spirituality.

The separation of sacred and profane that has reigned for most of the twentieth century has become blurred again at the advent of the twenty-first century —and not just with demands for "voluntary" school prayer. Virtually all ancient spiritual models in every culture emerge from or exist in intimate relation to land or place. The spirit of place or the virtual spirits in a place have spoken to conservatives, reformists, and radicals alike; they are also at the heart of the environmental or conservation movements. Indirectly they probably affect current land ethics more than one would suspect. Today even a "First Nation" (the Canadian term for Native peoples) that is more or less "in place" may be culturally displaced if the land is being used in ways that are foreign to its value system or do not result from its own choices. For instance, the Anishinabe economic base and "cultural property" are threatened by conventionally farmed "wild" rice that has replaced the real thing, harvested by Indians on northern Midwestern lakes.

Given that Native strength and resistance is land-based, attacks on sacred lands are still more insidious. In 1988 the Supreme Court restricted indigenous religious rights with a decision that favored development over Native claims for the sanctity of certain lands, making it legal to bulldoze or build on sacred sites. The Havasupai and Walapai of the Grand Canyon were driven from the plateau to its depths and are now embattled again, since uranium mining has been approved on the sacred canyon floor. In 1990, at Woodruff Butte in Arizona, Hopi shrines were razed for gravel pits even after the owner was told to stop mining. In one incredibly complex case, the Black Hills, sacred to but also used by the Lakota, are approved for worship by Protestant churches and mining interests rather than for Indian use. The San Carlos Apache nation in Arizona is still fighting for their *Dzil nchaa si an* (Big Seated Mountain, now called Mount Graham), site of sacred springs, plants, ceremonies, and burials, a cherished feature of the original Apache original homeland (the Zunis also suspect that they have two shrines on the mountain); they opposed the University of Arizona's plan to build an observatory and thirteen telescopes there. Indigenous Hawaiians continue to protest the development of telescopes on Mauna Kea and geothermal energy plants which will affect their worship of the volcano goddess Pele.

These are only a few of the struggles against money and power, igorance and indifference, being waged by Native people in virtually every state of the union.

Town and Country and the Futures Man

Bob Griebel and sons Ken and Rich share-rented their 160 acres (now over 270 acres)
dairy farm from 1952 until 1962 and then bought it in 1963.
"The reason we got it was because my grandpa helped out this person
that owned our farm; helped his grandpa when he came over from the old country
and he gave him a home and he worked with him over winter
and let him stay there and helped him get started.
So once the landlord came over to my dad and said your grandpa gave my grandpa
a chance to start and now it's my turn to return the favor. So he said,
if one of your boys wants to farm on my place, he said he would sure like that…
We're not going to get rich but who wants to get rich?…
Like they say, there is a lot of difference between wanting and needing."
— FROM DAVID BUCKLAND

The apple orchard in my meadow once belonged to the Todd farm next door. Now almost dead, it still bravely produces wormy fruit. An old photo shows the shore below fully cleared, with a fence-line running over to Far Far Beach. The people living here were farmers, fishermen, and river pilots, who rowed out to sea when they saw a sail on the horizon. The only real industry to thrive on Kennebec Point was a mid 19th-century rope factory on Great Head; a long narrow mound, rich in summer yarrow, is all that remains of the ropewalk.

IF LAND IS BEST SEEN THROUGH THE EYES OF those actually living and working there, our long-standing lens—the small farm—has become clouded. Once the epitome of local, landbased, independent Americanism, the farm (and farmland) is in deep trouble across the country, in areas that few artists know and fewer care to address except when they come to live on former farmlands as agents of rural gentrification.

One of the exceptions, British photographer David Buckland's artist's book, *Agri-Economy*, is a concise and matter-of-factly poignant portrait of a Minnesota farm community, featuring the leading actors in any farm drama: farmers, cowboys, the agricultural economist, agricultural commissioner, a corporate vice president, grain co-op manager, bank manager, and the futures man. Perversely rendered in lurid color that makes them all look like advertisements or tableaux from the twilight zone, the posed portraits jostle against the down-to-earth interviews, a confrontation of two cultures. Nevertheless, the place emerges through the people—a locally centered community buffeted by global economics and national politics, struggling to straddle past and future. U.S. farm policy is explained from different angles; histories and attitudes to the land are casually buried in sparse facts. Buckland's book supports Wendell Berry's belief that "a healthy farm culture can be based only on familiarity, and can grow only among a people soundly established upon the land."

This is the Jeffersonian dream, which today verges on anachronism. The first New England colonists farmed collectively, and barely survived, but they did well under individual ownership; the American character was forming. Around 1785 the Midwest (then the frontier) was divided into 6 x 6-mile townships made up of square sections then divided in turn into quarter sections, or 160-acre family farms. The 1863 Homestead Act, also based on the magic number of 160 acres, introduced the heyday of American farming. Over five million farms were platted on public lands between 1800 and 1900. The boom lasted until 1935, when the number of family farms peaked at 6.8 million. Short-term thinking triumphed, topsoil thinned, and then came the piper, in the form of dust storms.

"When the black blizzards began to roll across the region in 1935," wrote Donald Worster, "33 million acres lay naked, ungrassed, and vulnerable to the winds....the work of a generation of aggressive entrepreneurs....There can be hardly any doubt now that the destruction by plow of the grass cover on vulnerable lands—semiaridlands where the soil is loose and the horizon flat and open to winds—has been the leading reason for the devastating scale of dust storms in the twentieth century." The specter of the Dustbowl rose again in the early eighties, when 6.4 million acres of grass in Montana and Colorado was ripped up to

ROSE MARASCO, *Grange Hall Exteriors/Shepherdess*, detail from the 60-image series "Ritual and Community: The Maine Grange," 1990-91; sponsored by Maine Humanities Council, University of Southern Maine, and the Farnsworth Museum, Rockland, Maine. This series grew from Marasco's "desire to address changes in the role of the individual and the ways in which we form communities." While photographing some 100 of the 300 still-standing Grange halls around the state, she listened to stories about the meaning of the Grange in people's lives, resulting in a state-wide traveling exhibition, a catalogue, and public programs, including two unique bean supper/art lecture events. The Grange, or Patrons of Husbandry, is an agriculturally-based secret society founded in 1867, open to both men and women, and once enjoying a national membership of over one million. The Grange hall was the center of the community, site of social, educational and cultural events as well as debates, public suppers and games, cooking, needlework and art contests. The society had its own musical style and song books. In 1887, Maine had the largest Grange membership nationwide; it peaked in the 1940s and today stands at 11,000, with some communities increasingly active.

A onetime saltwater farm on the Kennebec at West Georgetown (Photo: Peter Woodruff). No working farms are left on Georgetown Island.

150

plant wheat, and a reprise may be imminent in today's parched Southwest. Given the incredible rate of soil loss and dependency on fossil fuels, chemical fertilizers, and pesticides, some predict more and more dustbowls, while others, more optimistic, see the prairie grasslands reinstating themselves as people move away from the Great Plains. Plans for a national prairie park (originally suggested by painter George Catlin in 1832) rise and fall periodically, an idea whose time has not quite come. When it does, it may be too late. Precious little true prairie is left; most of it lies along railroad lines or in patches on the edges of town, where no one has bothered to kill it.

The Depression has been blamed for the erosion of self-reliance among American farmers and the shift to dependence on the government. Wendell Berry places the origins earlier, around the turn of the last century, when the market began to force household and farm apart, bringing a new "generalization of the relationship between people and land…made possible by the substitution of energy for knowledge, of methodology for care, of technology for morality." When short-term productivity is the only goal, and technological specialization forces formers to put all their eggs in one basket, consumer and producer become competitors instead of collaborators. The producer, says Berry, is no longer seen as an "intermediary between people and land—the people's representative on the land….We now have more people using the land (that is, living from it) and fewer thinking about it than ever before." In fact, as Wes Jackson of the Land Institute in Salina, Kansas, points out, the producers become consumers themselves, needing more and more capital and fossil fuels to continue "scientific" farming, as they balance on the edge of debtor's cliffs.

In 1860, six out of ten Americans lived by farming; now it's two out of one hundred—even though farming remains the nation's biggest business. Since the late '40s, "get big or get out" has been the message from Washington. Only six percent of the nation's farms make over $100,000 per year, yet they account for half of all farm earnings. The large farmer's mechanized, specialized, chemically intensive methods developed over the last fifty years have proven disastrous for the environment, and for the culture. Small farmers' land and lives may be physically incompatible with the giant equipment demanded for increased production. Today a backlash is developing. In some places, horses are even being brought back because motorized farm vehicles are so expensive to buy and maintain. Wes Jackson shows how the Amish farmer's mandate "to dress and keep the earth" resists this emphasis on productivity and mechanism in favor of homeostasis, or mutual maintenance. And "while modern farms are failing all over [New York state], the unmechanized farms of the Mennonites are flourishing."

We often don't understand the shortcomings of our ambitions until it is too late. Writer and former rancher William Kittredge recalls the postwar years when, following new fashions in farming, his father "modernized" their large spread in southeastern Oregon: "We were reinventing the land and the water flow patterns of the valley on a model copied from industry, and irrevocably altering the ecology of everything, including our own lives; moving into the monied technology which is agribusiness." In the late fifties, the changes, and financial success, continued: "The ranch was being turned into a machine for feeding livestock. We had leveled thousands of acres for alfalfa, and we kept leveling more; the swamps were drained, and the thronging flocks of thousands of

In the 18th and 19th centuries, Georgetown Island was both farmed and grazed by cattle and sheep. As New England farming—always (literally)a rocky proposition—lost ground to the Midwest in the 19th century, laboriously cleared fields grew back, second-growth scrub and then new forests took over. The laboriously constructed stone walls that wind through deep woods everywhere, even on the offshore islands, resulted from overworked farmlands; repeated plowing dredged up the stones.

The total number of Maine farms dropped from 39,000 in 1940 to less than 7,000 in 1969, while acreage was cut in half. In the late 1960s a minor resurgence began with newcomers starting up small-scale ventures.

waterbirds were diminishing year by year; the hunting was still fine if you had never seen anything else, but we knew better." And later: "The ecology of the valley was complex beyond our understanding, and it began to die as we went on manipulating it in ever more frantic ways. As it went dead and empty of the old life it became a place where no one wanted to live."

Like mechanization, expensive biotechnological solutions still on the drawing board will probably send most farmers further into debt. Many agree that only drastic alternatives can save the farm and the rural way of life, but, historian Gilbert Fite points out, "since America is a democracy, it pretty much rules out radical solutions." Leon Kohlmeier, a successful Missouri farmer who advocates a number of sustainable agriculture practices, including no-till plowing (which reduces the soil's vulnerability to erosion by not turning it over), says the government should reward farmers who are doing a good job "instead of people who are causing a problem." Others say that labor must be emphasized over capital: farming should get smaller and slower, and many more people should do it—at least part-time—so that there are less consumers and more producers. Others hold that the only hope for rural areas losing their farms is to turn to tourism or to extractive industries. In Sweden, it has been suggested that the government should pay farmers "rent" to maintain ecological, cultural, aesthetic, and recreational standards, which might help prevent the drain of farmlands to development and protect the "scenery" and wildlife habitats. Some suggest that rural America must be made more appealing to a new population through zoning and restrictions on the urban sprawl that destroys the bucolic ambience.

Just as the mechanization of farm life undermined self-sufficiency, rural life was changed forever by electrification and the automobile, as it had been earlier by the railroad. Small towns were decentralized and individual scopes were broadened as communities were weakened and dependence on corporate power structures increased. With access to larger towns farther away, businesses failed for lack of customers. Today the process continues. Wal-marts, regional malls, and other Main Street murderers are accomplices to their downfall. As self-employment falls, so does local stability; most farm work in California is done by wage laborers. And as fewer farmers own or work more land, there are fewer families to support communities. Farmers without livestock (which demands daily care and feeding) can winter in Arizona or Florida, further depleting the population of small towns.

"The towns that are most western," writes Worster, "have had to strike a balance between mobility and stability, and the law of sparseness has kept them from growing too big. They are the places where the stickers stuck, and perhaps were stuck..." Marfa, a county seat in west Texas, seemed to have been this kind of town: it was changed forever when Minimalist sculptor Donald Judd, a New Yorker raised in Missouri, bought an old U.S. Army fort on the outskirts of town. He set up an art foundation, bought and refurbished a number of central buildings in the town's center, set up an architecture-furniture design office, sculpture studios and exhibition spaces. Judd is credited by some with having "saved Marfa." The town has retained its original identity (only one gift shop that I noticed), and its main street store windows boast modest photo-text accounts of the history of each establishment, each in itself a history of the town as a whole. Marfa's very prosperity, however pleasant and modest, is incongruous at a time when such towns are on the downswing.

Some would, perhaps perversely, consider Judd's contribution a form of rural gentrification—a subject

"Suburbanization" has overtaken many summer colonies, which begin to appear as imitations of rather than alternatives to winter lives. There is a "Members Only" sign on our communally built and maintained tennis court that I hate almost as much as the "street" light near it that ruins the warm mysterious night walks I remember from teenage years. Electricity, plumbing, and telephones have long since replaced the kerosene lamps, privies, wells, and child-carried messages. (We found out about V-J Day, the end of World War II, by a yell from the beach; my father was in the South Pacific and I'll never forget the celebration that night, with row boats in the bay and flickering candle lanterns in pattern-punched tin cans reflecting like stars in the water.)

not often talked about that is just as much of an issue as urban gentrification. In the nineties more people have moved into rural counties than left them, reversing the trend of the eighties. As the millennium approaches and change seems imminent, the urge to live rurally, to have a local life, has been resurrected from the sixties countercultural "back to the land" movement, a result not just of inner-city decay but of spiritual imbalance and political escapism. But this time the impetus is yuppie rather than hippie. Rural suburbs are a contradiction in terms; rather than mediating between city and country, they deny both, perpetrating a fake rural life. People raised in conventional suburbs want to live in pastoral surroundings but have little interest in a rural life. Sentimentality about small-town living rapidly gives way to urban demands for convenience and comfort; urban escapees want solitude, authenticity, a good capuccino, and a nearby health club.

Alfalfa fields are becoming golf courses; terrain is designed by landscape gardeners, not farmers. In the East, fake charm is promoted through houses labeled with their ages, while developments are named "Forest Acres" in memory of the woods destroyed to create them, or "Sylvan Heights" to suggest upward mobility on the flatlands. Street signs are cultural indicators: in the "spiritual development" of Crestone, Colorado, many of the empty new streets are appropriately called "ways": Moonlight Way, Panorama Way, Beargrass Way (and, ahistorically, Camino Real). In rural areas, the general store is often transformed into

a self-conscious "country store"; the shoe repair or fruit and green grocer gives way to the boutique, gourmet food, or "gifte shoppe" on rural main streets. The rural star route is encroached upon by "lanes", "courts," "drives," "ways," and "circles," and it is no longer a mailing address, having been replaced by the impersonal "HC" (for highway contract); physical place has become a commercial exchange.

A local economy is a shared economy. But farms and ranches are often subdivided into lots so large and expensive that community is out of the question, and the result is simply more suburban sprawl. James Howard Kunstler, in his influential book *The Geography of Nowhere*, looks with a jaundiced eye on these new geographical desires: "People devised large-lot zoning thinking it was going to give them a country-like setting, but what it really gives them has none of

CLAES OLDENBURG AND COOSJE VAN BRUGGEN, *Monument to the Last Horse*, 1991, aluminum and polyurethane foam painted with polyurethane enamel, 19' 8" x 17' x 12' 4", The Chinati Foundation, Marfa, Texas (Photo: Todd Eberle). The base is inscribed "Animo et Fide." The cast-off shoe is elevated to a place of honor, becoming a medium between the history of the place and the artists who now inhabit it.

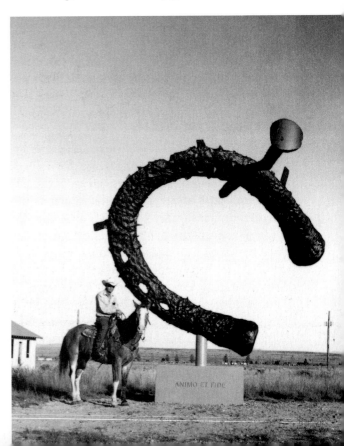

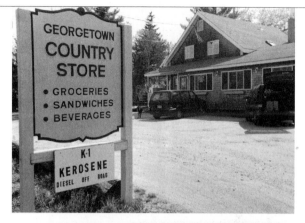

the benefits of town life and none of the characteristics of country life. All you get is a yard that's too big to mow and too small to plow and no sense of a neighborhood."

Although scattered expensive houses may be more visually attractive to some (in fact they ruin the landscape as much as anything does), tax breaks for developers of large lots are biased in favor of the rich, who do not always keep their "covenants" about subdividing, view-blocking, underground electric lines. All across the country, rural people are being priced and taxed out of their homes by wealth and speculation. In Santa Fe County, New Mexico, for example, there have been several desperate but failed attempts to spare long-established locals the rising taxes that most (though not all) of the newcomers can well afford.

Developments are thoughtlessly plunked down with no regard for what is already there, either land or community. Elsewhere, old facades are maintained, or imitated, but life within bears no resemblance to its original character. Although this trend is limited mostly to places suitable for retirement and recreational communities, many isolated populations are getting new blood, whether they like it or not—usually they don't. When farmland is sold off for development, a suburban aesthetic is overlaid on a totally dissimilar design. Urban expectations clash with rural reality. The smells and sights of a working farm don't jibe with the idyllic preconceptions promoted in the real estate ads any more than the diverse social mores of the new people jibe with the older residents. The loss of an "authentically old-fashioned" working landscape is also bad for tourism—a last resort, so to speak, for many nonindustrialized areas.

Rural Vermonters watch gentrification from "downcountry" with a jaundiced eye. David Budbill points out "some ugly, elitist, class-struggle type things operating." Trailers, for instance: "Well, a trailer is the only

La Tienda de Anaya, Galisteo, N.M. (Photo: copyright Susan Crocker). This little store on a secondary state highway is the only one in the village, owned and run by Andres and Josephine Anaya. The smaller sign reads: Anaya's Country Store Gift Shop Gasoline Indian Jewelry Gold—Silver—Brass." The store's specialty is home-made tamales.

living space a working man around here can afford. And if he, say, inherits three acres from a parent and wants to put a trailer on it, the eco-folks would like to say no, which is a dandy way to ghettoize the poor." He criticizes newcomers for letting their land stay "just the way it is" which often means neglecting and letting an idealized nature take over: "They treat the land like

Those who work on the sea, in the shipyard, or in service industries, generally agree that rural gentrification raises taxes, makes services expensive and housing unaffordable. Summer people were the flying wedge a century ago, though few seem aware of the effect we have had on the uses of what is now seen as *our* beloved landscape. When it was suggested years ago in a meeting of the Kennebec Point Associates that the private beaches be opened to Georgetown residents, the response was sheer disbelief and immediate dismissal. In early 1997, a battle appears to be in the making about a proposed trailer and RV Park at the base of Sagadahoc Bay; those living on the bay, most of whom are summer people, are horrified (me too) at the potential effect of added wastes on the

any other possession, object, they own, set it aside, watch it, passively....thinking it abhorrent to engage in a living relationship with it." Locals pick apples from absentees' trees because they think it's a sin to let them go to waste, and "Posted" signs violate "a strong local tradition of free trespass," purportedly to protect "nature," he says, but in fact to protect investments. The American Farmland Trust contends that water quality will also deteriorate if agricultural land is swallowed up by suburbia and parking lots; yet it is a sad fact that agricultural and ranching practices can be worse for the water in arid areas than the beneficent tree-planting that goes along with new houses and gardens. It's a race between the water that will be attracted by the growth of these trees and the water used to make them grow.

The tension between divergent ideas about what is ugly and beautiful informs the debate on the American landscape. It is often based in class, or class sympathy. Aesthetic preferences are created by tradition, necessity, academia, the mass media, and the real estate business. Different generations, cultures and classes consider different things eyesores. Middle and upper-class eyes are hypersensitive to ugliness they perceive as bad taste—like abandoned trucks and doublewide trailer homes—but are mellower about weathered barns and crumbling adobes. They can also shield themselves from it all with space and walls. But everything affects everyone, no matter how rich or sheltered. Geographer Pierce Lewis says we have to resign ourselves to the way things look now, as does J. B. Jackson, who told a horrified James Howard Kunstler in 1989, "I find myself reconciled to a great deal of ugliness, a great deal of commonness, and I don't object to it at all." (In ludicrous ignorance of New Mexico's 450-year Euro-history, Kunstler reported that Jackson lived in New Mexico "where, except for the Indian pueblos, the towns were all brand-new and uninfected by the viruses of history"!)

As a reluctant agent of rural gentrification, I am aware how selfish the process is. My own little house on the edge of a village, while hardly an eyesore, doesn't meld well into the landscape. (I thought I was paying homage to a traditional Northern New Mexican tin-roofed adobe, but I didn't pay enough attention to the proportions: it looks like the transplant it is.) At the same time, I would join Jackson in a tolerance for the "ugly" which Kunstler would find lax on the part of an esthetic arbiter. Romantically, no doubt, I like the village I live in precisely because it is both "beautiful" and "ugly"—or funky. I like the trailers and the crumbling adobes, the abandoned pink car, the saddle mounted high on the wooden gateway better than the adobe portals of spiffy new "Santa Fe style homes" in the attractive fifteen-year-old development on the other side of town.

In 1995, our village community association won a pyrrhic victory in a lawsuit with the millionaire rancher who is an absentee landlord of some 20,000 acres across the road. The lumps and pits in the land, the bunch grass, the consistency of the mud that trucks and cattle get stuck in, were discussed in court with the tender scrutiny of connoisseurship. The overt issue was an easement for a creek crossing. The covert issue is development. It is only a matter of time before the suburban sprawl daily creeping closer across the sold-out ranchlands from Santa Fe, meets this village and swallows it up in an entirely different context than the one it has known for some two hundred years. We shudder when we see the ominous green boxes of electrical transformers being installed in empty rangeland just up the road: they herald subdivision. I moved here to look out at the empty spaces for which the West is

clamflats and the horrendous jetskis and more speedboats on a peaceful rowing and sailing area. This issue too will sadly be seen as pitting natives against those from away.

Despite government subsidies, Maine's potato farms and dairy farms are slipping

away. One old farmer says that when he started, "you had to be one of three things: efficient, smart, or cheap. One was enough....today you've got to be all three of them." And you need to conform to changing esthetics. "I've been a farmer all

my life and if there is a little junk around, it just makes it look more like a farm," says Minot Holmes, a farmer in Limington, Maine, disputing the law's definition of "junk" in response to a violation notice to clean up his yard.

famous, but they are disappearing as I watch helplessly, knowing that I am part of the problem and wondering how I can also be part of the solution.

Most of us who are distressed by rural gentrification feel helpless to do anything about it, although bioregional community organizing is one effective alternative. Public interest confronts territoriality when more formal frameworks are proposed. The voluntary Comprehensive Land Use Plans, in which communities can plan for the future and agree on what they want to see their places become, are consistently rejected in rural areas, especially in the West, where ruggged individualism is prized. (Historian Samuel Bass Warner says that American land law is characterized by "its identification of land as a civil liberty instead of as a social resource.") Still, doing something about what we don't like about the way things are going is a significant way to uncover or construct our place as well as the potential community either evident or latent there. As Gary Snyder says, people who are alienated from national politics but committed to the place where they live often discover that "local scale politics accomplishes something....the Sierra Club is not going to come out and save your local marsh from a Safeway supermarket parking lot. You've got to do it yourself or nobody will." The heirs to Karen Silkwood at Kerr McGee, Lois Gibbs at Love Canal, the Southwest Organizing Project in Albuquerque, COPS in San Antonio, and many more anonymous role models are quietly working away all over the country.

The social conflicts characterized and generated by sites like the lone remaining farm holdout surrealistically crouched between condos and industrial parks, its fields bordered by parking lots, are summed up by Reverend David Bachman, a Methodist minister who served a brief sojourn in a small town in Iowa: "The old

group [of longstanding farm families] as they knew it is dying. You've got children leaving. You've got new people coming in who don't understand the rules. You've got farming as a profession changing. There's two ways to go; you can either adapt—which practically never happens—or you can build rigid defenses against change. A classic way is to retrench, to make the old rules even more rigid. And of course the sad thing, the pathological thing, is it makes it worse. Until it explodes....Traditions are only a way of dealing with your environment. If the environment changes, you are left with traditions that aren't useful anymore."

Every decade some twenty small towns in the United States disappear along with the farms, which are often torn down so as not to be taxed. At the same time, all over the country, young couples are looking for big old houses, the kind their parents' generation couldn't wait to replace with nice, compact, up-to-date suburban ranch houses. The surrounding trees and shelter belts, with nothing left to protect, remain in forlorn pockets surrounded by plowed fields—thus the title of Richard Critchfield's book, *Trees, Why Do You Wait?* in which he traces the health and cultural welfare of two pseudonymous rural towns where he lived as a child. "Prairie," North Dakota, is surviving primarily because it is a county seat, but a declining tax base also threatens its bureaucratic infrastructure; "Crow Creek," Iowa, is becoming a bedroom community for corporate workers in nearby cities. They are called "people like them" by the locals, who are historically neither ethnically diverse nor ethnically tolerant. (A Czech American woman, born and raised nearby, recalls being taunted as a "Boheemy" and having a brick thrown through her window.)

Those who have been on their rural land "from the beginning" (everybody's "beginning" is different) exist in every community, though they are rapidly

When the economy slumps, land is cheaper and more vulnerable to development. Maine cuts education subsidies when a town's property values go up, so development leads to crowded schools and less state money (although more from local taxes). A 1989 study found that commercial/industrial development required $.94 in services for every $1 paid in new taxes, while residential development required nearly $1.30 in services for every $1 in taxes. One alternative is land trusts, which reduce development, but also decrease the tax base.

People give to trusts to escape heavy taxes and to preserve for public use land they are emotionally attached to, which can be sold to trusts at well below appraised values. Obviously this is a less viable option

diminishing. In some areas where newcomers are treated warily, the "oldtimers" have only been in place for some twenty-five or fifty years. Their relation to the land they inhabit may be loving, but their memories are short—maybe just realistic. Novelist Bobby Ann Mason ponders her own departure from and occasional returns to her homeplace in the Jackson Purchase of western Kentucky: "What happened to me and my generation? What made us leave home and abandon the old ways? Why did we lose our knowledge of nature? Why wasn't it satisfying? Why would only rock and roll music do? What did we want?....My mother, who knows more about wind and weather and soil and raising chickens than I ever will, approves of 'progress,' even though she finds much of it scary and empty. The old ways were just too hard, she says

STEVE DAVIS, *The Story of Lori Smith (age 28)*, 1991. Davis believes that our attitudes toward landscape are formed by childhood memories. Although he was raised in the East, it was the recognition of the significance of open space and landscape in his own early years that inspired this project in Nevada. Davis collaborated with seventeen other local people ranging in age from twenty-eight to seventy-five and in profession from banker to artist, dentist to electrician. He accompanied them to sites that were important to their childhoods and photographed what had become of those places. (Most had gone from rural to suburban.) The story—"alive with life and water"—on this typical western scene, where an older trail and a little irrigation ditch edge a development, reads in part: "When I was in high school riding my horse was my life. I'd ride in winter when there was six inches of snow on the ground. Everything was white and I couldn't even see the trail...and the air was fresh, cold, and clear.... Mostly, though, I remember summer and the smell of sagebrush. I'd ride with my girlfriend up into the green meadows.... It's funny, but we'd ride with the smell of the meadow all around us and talk about how we knew that this place was going to be developed someday because it was just too pretty.... That land was my sanctuary. I'd go there to be alone...to think and to dream. And that's what that place meant to me."

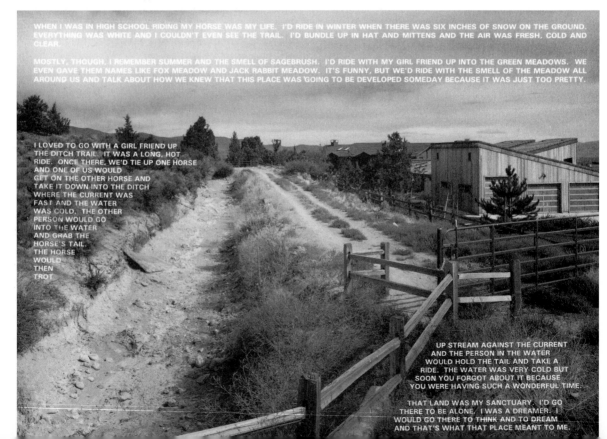

for lower income owners who are land rich through inheritance over the generations but can't pay the rising taxes now that others covet their places. A comprehensive "current use" assessment of land left in natural condition or managed for forestry or agricul-

ture spreads the tax burden more fairly.

The Lower Kennebec Regional Land Trust (LKRLT) was formed in 1989 to preserve wetlands, tidal rivers, deeryards, bird nesting sites and "open space." Founded and managed locally, it has easements on over

80 acres of land, including over two miles of shoreline. In Georgetown, the LKRLT focuses on the salt marshes of Back River; in 1996 it also acquired easements on Soldier Point (valued for its scenery) and along Robinhood Cove (valued for habitat

wearily. She and my father expected better lives for their children. They knew we'd leave."

Even the old farmers tend to go their separate ways. The old cooperative rural life is a thing of the past. A young couple who did not grow up on farms, came from another local town, rented quite a bit of land, and are making a go of it, cheerfully told Critchfield that they have no ties whatsoever to Crow Creek, that "all our friends live somewhere else." The farm they work is made up of five former farms, each of which once supported a family. Today they work hard, both of them full-time outdoors, to support one family: "How many people want to smell like we do and work in the soil and get dirty? A lot of Americans want an easier way of life."

Is a town still a town when there is no school, church, general store, bank? Churches and county fairs are no longer the meeting places; in Crow Creek it's the baseball diamond, which harbors a flourishing variety of Little League teams where kids learn competition early. But a real community life revives around births, deaths, and marriages, events that are no longer widely shared. The homes may be well tended, but Main Street—the real barometer of communal life—is dead. The town is empty in the daytime because people "don't really live there."

There is also ambivalence about the hard climate in most of the West, about the isolation, danger, loneliness, in which those who survive take pride. Poet Kathleen Norris calls these survivors "monks of the land, knowing that its loneliness is an honest reflection of the essential human loneliness." At the same time, she suggests that "it is the vast land surrounding us, brooding on the edge of our consciousness, that makes it necessary for us to call such attention to human activity." Small town people suffer from both inferiority and superiority com-

plexes, proud of—even righteous about—their stability and insularity and, at the same time, aware that not all is well in their alleged Eden. When their own children leave for college, they come back outsiders. Norris quotes someone saying suspiciously of newcomers: "If they were any good, they'd be working in a bigger place." There are both outsiders and insiders who concede that the constricted rural world can produce not only compassion and mutual concern, but an often mean-spirited narrowmindedness that forestalls any kind of necessary paradigm shift from short-term to long-term thinking, from concern with the parts to concern for the whole. A Catholic priest said of the vicious controversy, gossip, and slander in one small town, "Someone in that community has got to stand up and say 'Do you think we could be nice to each other this week?'"

North Dakota has always lost population. Some 80 percent of homesteaders left within the first twenty years of settlement (my own great grandparents among them). Today the only rapidly growing population is, ironically, the Native Americans. The state has only 90 small towns with a population of 500–2,500 people left, and roughly 250 with less than 500. The great majority of rural Dakotans still go to church on Sunday. Looking for "deep personal faith" in this country, Critchfield finds it not among white people but among Native Americans and those African Americans who retain ties with the rural South. Martha Nash, of the industrial city of Waterloo, Iowa, tells him that "blacks brought their abstraction of God from Africa....They kept that very personal relationship to God," and it fills a void, because "we haven't had much of your nice little happy family." Critchfield feels that Mexican migrants, mostly villagers "with strong agricultural, religious, and family ties," help to "reinforce the rural basis of American culture." He

as well as traditional use as a great winter sledding hill).

"Our land is not for sale. How much are you offering?" Right now, the backyard farms are keeping most open space open. "Farming isn't dead in New England. It's just reverting back to the way it was 150 years ago, where people grew their own and sold their surplus." But, says, a local owner, "Why should the farmer keep his land in agriculture so it's worth $50,000 when he could sell it for development for $500,000? Shouldn't the townspeople who like the looks of this open space be sharing in that? The farmer certainly doesn't want to bear all that loss."

158

praises the notable contributions of a newcomer to Crow Creek, Pedro Alvarez, who exuberantly charges in where angels fear to tread, from door-to-door visits to beer parties, becoming a controversial figure and probably changing the town for the better. His positive effect is attributed to the fact that as a Hispanic Catholic, he too has roots in the village tradition that is dying out in Crow Creek.

Local identity crises may sound petty to those concerned with global issues; yet the two are economically and often culturally inseparable. While community spirit still saves some days, generalized fear and inertia can destroy the vaunted spirit of enterprise in beleaguered small towns and lead to a deadening mediocrity. Kathleen Norris writes of western Dakota, "we live in tension between myth and truth. Are we cowboys or farmers? Are we fiercely independent frontier types or community builders? One myth that haunts us is that the small town is a stable place."

Ignorance or wilful disregard for local history plays its part in supporting the myths of small town independence, denying the proof of surrounding ghost towns and boarded-up stores. "Our cherished idol, local control, makes us more, not less vulnerable to outside interests," writes Norris, who calls the Dakotas an American colony. "I feel it every time I sell wheat for less than it costs to produce, or when I sell the grass-fed cattle of my grandparents' herd to be

ANDREW BAUGNET, *Schoolhouse, Kellogg, Minnesota*, 1995. Baugnet focuses on natural landscapes altered for human use, places structured by "access, domestication, livelihood, and relaxation... places worthy of celebration for their cultural representation." He has recently been commissioned by a Minneapolis bank to document the "community" in a newly developed suburb where "there is no main street or social center, nothing but strip-malls for the locals to meet at—the opposite of the school house in this photograph."

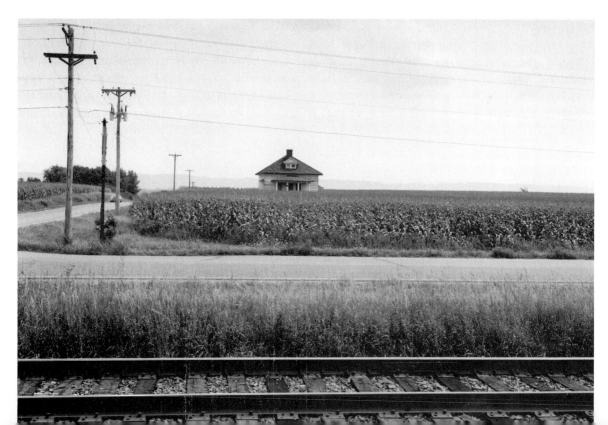

As a girl, my mother rowed across some of the worst currents on the coast to get a newspaper at Popham and thought nothing of a 6-mile roundtrip walk to Todd's store at the Center. By the time I was small, a trip to the Center was still a big deal (especially the Dixie Cups with blue movie star portraits on their lids, where you licked off the ice cream and Betty Hutton or Gabbie Hayes would emerge smiling), but we went by car. Bath, only 13 miles away over bad roads, was a bigger weekly excursion. Now we drive "uptown" casually in 20 minutes, too often, buying at the (necessarily more expensive) local store only in emergencies.

159

fattened and pumped full of chemicals in a feed-lot."

Perhaps the most important question of all those Wendell Berry asks in his impassioned defenses of the small, the local, the loved, is "How can I be responsible for what I know?" Responsibility and reciprocity are the keys to land care. People can love their land and still be lethally short-sighted about its use. Given litter-strewn roads and illegal dumping in both the rural places I live in, I know that disrespect is not incompatible with familiarity. In fact, like domestic violence, it can be spawned by long familiarity and a sense of ownership. Others may simply dislike the land because they have been forced onto it, dispossessed of the place they like. Land can be bought by those who see in it nothing but profit; land can be inhabited by disrespected people who love it but don't have the power to keep it or the money to use it well or even control its use. The good people of Maine and Vermont who love their places contracted to send their hazardous waste to the good people of Sierra Blanca, Texas, who are mostly *Hispano* and poor, and love their places too; after a national campaign, the compact bill was defeated in 1995, leaving the New England states as their own depositories, a large-scale equivalent of local littering. But the state of Texas still intends to use Sierra Blanca as a radioactive dump, despite the fact that it rests directly on a fault in an active earthquake zone. Small is powerless as long as it is isolated, but the national resistance has begun.

The breakdown of rural culture is the cause of some concern to almost anyone who thinks about it, since most of us came originally from rural backgrounds, however distant in time or space. If those in cities know and care little of what is happening to farms, those on farms are now in closer professional (though not social) touch with the rest of the world, through television, computers, and networks. Yet rural movies are still big box office even in these cynical times "because the countryside is where our deepest cultural feelings lie." Critchfield is convinced that the rural exodus, exacerbated in the eighties, has brought a breakdown of the agricultural moral code that is, or was, at the heart of American culture. Conflating farming, the work ethic, and family values, he states flatly that "what kind of urban culture we have in America is going to depend on how many Americans farm." Both Wendell Berry and Wes Jackson also see the "modernization" of agriculture as "a cultural crisis," though in somewhat less apocalyptic terms. Ours will be a very different society if rural culture disappears.

High Floods
and Low Waters

*All mythic waters feed a source that is located on the other side. The streams carry
the memories...Following dream waters upstream, the historian will learn to distinguish
the vast register of their voices....will recognize that the H20 which gurgles
through Dallas plumbing is not water, but a stuff which industrial society creates.
[The historian] will realize that the twentieth century has transmogrified water into a fluid
with which archetypal waters cannot be mixed.*
— IVAN ILLICH

WESTERN PLACES AND PEOPLE ARE MADE OR broken on the water wheel. Few non-residents driving through the arid West stop to wonder where the water comes from to nourish the obscenely green lawns spotting the desert in Phoenix, or the mushrooming subdivisions and attendant golf courses around Santa Fe and Albuquerque, where in a good year annual rainfall may reach a paltry fifteen inches. ("Now Santa Fe is famous for its turquoise, adobe...and greens," boasts an ad for a private "community" centered on a hundred-hole golf course.) Visitors have to ask: Why is the grass greener on the other side of the fence? Is it too green? Is it poisoned? Is it a golf course? They may look at the Navajo Nation as a desolate wasteland and admire the giant dams and artificial lakes made from flooded canyons without knowing that very few rivers in the West remain untampered with. "When a tourist looks into the flat water backing up behind a dam like Hoover," writes Worster, "he is in fact seeing his own life reflected. What has been done to the Colorado has been done to him as well; he too has, in a sense, been conquered and manipulated, made to run here and there, made to serve as an instrument of production."

In the decades since most American households acquired running water, our views of its sources have been dimmed, like the cliché about city kids who think milk comes from stores, not cows. Rebecca Solnit keeps a map of the Colorado watershed over her sink in San Francisco to remind her where the water that pours from her faucets comes from; perhaps this should be compulsory decoration, at least in schools.

Few of us seem conscious of how water shapes not only the way we live but the way we see. The oceans and the rushing streams and creeks of the East and South, the vast lakes of the northern Midwest, the hide-and-seek rivers of the high Western desert—each defines an ecological psyche.

Moving from one environment to another, we often unconsciously try to reproduce the conditions of our past. The early Euro-settlers did this without understanding the unique qualities of the different bioregions they moved in and out of. The anomalous absence of drought in the late nineteenth and early twentieth centuries deceived settlers into optimism. The year 1932 marked the beginning of a severe drought in the West which has yet to fully abate. Today, we have fewer excuses for building swimming pools, damming streams to create stockponds or rivers to create reservoirs, power sources, and recreational lakes; we re-create lawns and East Coast gardens in the desert at great cost to the indigenous plant life and water sources, and introduce the very allergenic plants that some came west to escape. Water is irreplaceable. A group devoted to population-environment balance cites a terrifying statistic: 3.2 billion gallons more water are permanently removed daily from our national aquifers than are replaced by natural processes.

I supply my own water from wells in the two places I now live. As a former Easterner and urbanite, I am very conscious of the health of "my" aquifer. I know that drought will affect me directly; there is no landlord or mayor to complain to, no reservoir or public system to back me up. It is as distressing to see friends pouring excessive amounts of water onto their yards and gardens for hours, even during droughts, as it is to see the beer cans and plastic bags thrown from cars over my fence. Living with an annual rainfall of twelve to

sixteen inches fosters empathy with the Pueblo peoples' land and water-based worldviews. I watch rainclouds hovering over nearby mountains and invite them in, but they only skirt my thirsty valley—the bed of a former sea. "The word water," says Santa Clara Tito Naranjo, "is not just a product that we use on a daily basis. Socially, in the Tewa story of creation, we emerged from water. We *are* the water. We are the *nature* of water...."

White settlers patted themselves on the backs for their temporary achievement of gardens blooming in the deserts. There is, however, a long and generally unknown history of effective irrigation in the Americas. By 800 A.D. the Native Hohokam people in the

STEPHEN CALLIS, *Golf Course, Hansen Dam Recreation Area*, from "*As Water Stories Go...*," gelatin silver print, 1995. This contradictory picture is relatively common throughout the west. "As water stories go," writes Callis, "the story of the L.A. River is a pretty dry one." It runs from the beautiful river flowing through a lush and spacious valley first seen by the Spanish to the cemented-over flood channel dominated by the Army Corps of Engineers despite many efforts to turn its banks into parks. Hansen Dam is one of three major flood control dams in the L.A. River watershed, which are kept empty until heavy rains. In the meantime, they provide open recreational space. Callis notes that flood control means more development and more development means worse floods, because paved land doesn't absorb water.

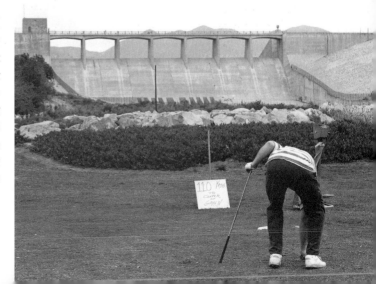

there are too many fishers and not enough fish. In 1994, a Newfoundland man warned Maine that fishing 365 days a year, giving the fish no recovery periods, boiled down to pure greed:"We've shown how to destroy a resource. We're the experts. What a legacy we leave to our children." At the same time, one local lobsterman (descendent of the "King of Malaga") declares: "You'll have to drag me screaming and hollering from the boat."

In 1995 the New England Fishery Management Council offered four dire solutions to the depletion of the resource, all of which involved the dreaded quotas to prevent over-harvesting, none of which was palatable to the fishermen: "We can't live with any of them. They all go too far." But in July, 1996, the still stronger Amendment 7 to the North-

162

Southwest had some two hundred miles of water-works, with canals up to eighteen feet wide and fifteen feet deep, but they collapsed by 1400 A.D., perhaps because of drought, perhaps, as Marc Reisner suggests, because "they irrigated too much and water-logged the land, leading to intractable problems with salt buildup in the soil, which would have poisoned the crops....they either had too little [water] or used too much." The Anasazi, also in the Southwest around the same time, supported urban populations of thousands in centralized pueblos until they outstripped their environmental capacity or were overcome by drought around 1200 A.D. American latecomers ignored this history at their peril and then reproduced it on a disastrously larger scale. Although irrigation, at its inception in the West, was originally considered a democratic process, powerful interests soon controlled the water market, eclipsing both indigenous and community rights. Truckee Canal, constructed in Nevada around 1905, marked the first federal diversion of a river to irrigate desert lands. Its offspring have since grown to unimaginable proportions.

Arid lands have their own identity. Living deserts are transformed into lifeless wastelands by human agency —a process known as "desertification." The center-pivot sprinklers that create the perfectly circular fields we see when flying over the western landscape are dependent on pumped water. In California's San Joaquin Valley, pumping exceeds replenishment by half a trillion gallons per year. The more water pumped, the closer water tables come to exhaustion. What rises to the surface is increasingly saline or alkaline. This in turn calls for escalation of the costly apparatus of tech-nological management, courtesy of the American taxpayer. "Even today," Wallace Stegner has written, "when municipal and industrial demands for water have greatly increased, 80 to 90 percent of the water used in the West is used, often wastefully, on fields, to produce crops generally in surplus elsewhere."

In Cadillac Desert, an engrossing horror story of the West's disappearing water, Marc Reisner tells one grim tale after another about how sensible alternatives and political decisions over the last century could have changed the downhill slide of the land use and water crises, and how these were inevitably derailed by politi-cal reality—corruption, greed, influence-peddling, porkbarrelling: "To a degree that is impossible for most people to fathom, water projects are the grease gun that lubricates the nation's legislative machinery. Congress without water projects would be like an engine without oil; it would simply seize up."

Worster describes a concrete lined irrigation canal in California (such things are all over the West): "a stream that is not a stream, where no willows are allowed to grow or herons or blackbirds nest. That intensely managed piece of nature tells us a great deal about contemporary rural life and land use." Managed nature, as it gets ever more complex, produces hierarchies and power elites, along with a huge work force to keep it going. Humans can work *with* nature as long as the scale remains small; we begin to work against it when profit rather than sustenance is the goal. Water becomes a commodity. Small farmers have to buy water from corporate controllers; local management gives way to absentee control. In a parallel situation, recent reports of increased pollution of municipal water systems have scared an increasing number of Americans into paying for bottled drinking water, an option not open to every-one. The Seneca prophet Handsome Lake predicted this situation in 1799: "There will come a time when the good water that we use to cook our food, cook our medicines, and clean our bodies will not be fit to drink...and the waters will turn oily and burn.... Our misuse of this water will turn against us and people will suffer and die."

east Multispecies Fisheries Management plan was implemented by the U.S. Commerce Department and despite bitter opposition, even stronger measures could be pending.

144 coastal communities and 25,000 jobs are dependent on fishing. Pat Percy from Popham Beach, married for 42 years into an old local fishing family and member of the board of directors of the Maine Fishing Industry Development Center, says "There really isn't much place for them to go. These are not transferable skills. Amendment 7 has put the very lives of small boat fishermen and their boats in peril. Their 300-year historic tradition has been regulated away; so has their safety, so have their marketplaces; so has their independence."

TERRY EVANS, *Irrigation in South Central Nebraska, August 23, 1990.* Evans, a member of Water in the West, has worked closely with farmer-geneticist-writer, Wes Jackson, and the Land Institute, documenting the changing landscape around her former home in western Kansas. She is currently working on an aerial study of different irrigation patterns and impacts along the U.S.-Canadian border.

In 1994 the Justice Dept joined the Penob-scots in opposing the proposed Basin Mills hydroelectric project on the Penobscot River because it would affect the Penobscot Nation's fishing for Atlantic salmon. In 1995 Micmacs trying to take over the former Loring Air Force Base's water source, dam, reservoir and treatment plant on their ancestral land were denied because it would jeopardize development. In Fall 1996, two of Bowater Inc.'s Great Northern Paper mills won an effort to reacquire 10-year licenses for dams that provide much of their electricity; they spent $11 million opposing environmentalists, outdoor groups and Indians. The Passamaquoddies are also involved in struggles with state and industry over water rights.

164

Nature cannot be controlled without the conquest of those people who cooperate with it. In U.S history, it has been an unequal competition. The primary land and water rights struggle in this country has been that of indigenous peoples and the partly indigenous *mestizo* population in the formerly Mexican states pitted against moneyed interests for whom water is a commodity. The lovely story about a garden springing up from the desert is replaced by a litany of technology, profit, and loss. The British writer Rayner Banham sensed "a way in which the American deserts and the protestant conscience go together." Some of the most crucial struggles of this long history will take place in the next decade, as recreation and tourism replace some of the West's heavier industries. Since World War II, the West, no longer economically dependent on the East coast, has grown and changed. Its urban population exploded as mining detritus clouded streams already polluted by agricultural runoff. Regional as well as cultural conflict of interest has characterized the whole story.

Native water rights in the West (now supposedly guaranteed by the Constitution) have been an especially complex case through the bumpy history of three hundred years of Euro-American rule. Charles Wilkinson, citing the old Western joke that "water runs uphill toward money," notes that there are "Indian reservations with superior water rights but no water." For instance, Native representatives were not invited to the divvying up of the West's most important resource during a 1922 compact for allocation of the Colorado River waters among the seven Colorado Basin states; litigation continues to this day. Another classic contemporary example is the treaty dispute between Peabody Coal Company and the Hopi Nation over the underground springs being drained for a coal-flushing pipeline. These waters are not only physically but spiritually and culturally sustaining—"our life…the blood of the Hopi," says Jerry Honawa. "If Peabody continues drawing the water from under us, the whole earth will dry up and we will not be able to do any farming, and in essence we will begin to dry up." A Peabody spokesman replied: "We are a business. We make economic decisions. The Hopi tribe is not a business. They don't make economic decisions. Their chairman indicates that this is a moral issue. I disagree with him."

Water rights function under an entirely different system in the West than in the humid East, where English common law of riparian (streamside) rights provided the model; those living along the streams can use or not use the water so long as neighbors on the stream are not harmed. In the arid West, the doctrine of prior appropriation holds sway: first come, first served. Specific amounts can be withdrawn by landowners and towns; in times of shortage, a hierarchy based on seniority comes into play. If you don't use it, you lose it, and only human use applies. Today, for all the concentrated urbanization and industrialization in the dry Western states, agriculture and livestock still consume more than eighty percent of the water. The wild plants and animal life that indirectly sustain human use have no rights whatsoever, although in the last decade federal agencies have tentatively begun to explore the need to leave some water in streams and rivers to protect the ecosystems.

A heartbreaking indicator that all is not well are the disappearing cottonwood groves that once flanked wild rivers flowing through western plains for thousands of miles, holding diverse ecosystems together. Today they are mere patches in urban and rural landscapes, brilliant green in the summer, shimmering, quaking gold in the fall, intricate branch patterns against the vast sky in the winter. Now the streambeds are infested with imports like Tamarisk and Russian Olive, which steal

The much-disputed regulations on the fishing industry aim to rebuild spawning stock biomass. The alternative to cutting the New England fishing fleet in half to halt the depletions is simply to wait until all the fish are gone and all the fishermen are out of work.

But no one wants to pick up the $100 million tab to limit the fleet. And fishers don't want to stop fishing, refusing to believe that their generations-long lifestyle is truly in crisis. Not many Mainers are jumping at the bait offered by boat buy-back and retraining programs.

My grandfather spent his vacations fishing from his Heal's Eddy dock for mackerel, cunners, flounder (the last two long gone). Through the '60s, my father caught flounder in Sagadahoc and Stage Island Bays; we stepped on them under the sand when

the stately old trees' water and smother their young. I watch with trepidation a bark-stripped branch of the big cottonwood that shields my house from the state highway and cross my fingers for the huge old trees in the *bosque* down the creek, where the village used to hold celebrations until a private landowner fenced it off. Streets and towns named for cottonwoods (Alamos, Alamosa) pervade the West. These groves are still communal meeting places. The city of Albuquerque has planted over five thousand trees to help preserve the largest cottonwood forest in North America, growing along the Rio Grande.

There is no more fascinating story of changes in the land and the cultural, communal role of water than that of the ditch system of the *manitos* (from *hermanitos*, the "little brothers" of the Penitentes, a local lay order of Catholicism), who live in dry, mountainous Northern New Mexico, an isolated area of the Spanish Southwest that until recently has resembled an island, a Fourth World nation. A limited amount of water flows seasonally and sporadically through the land via "rivers" that Easterners would call creeks at best, so irrigation was and remains necessary for pastures, orchards, and food crops. The first *acequias* (the word is very old Spanish, derived from the Arabic) were probably constructed over two hundred years ago when the Hispanic Southwest was first divided into land grants. The initial backbreaking work of digging the communal ditches that water often tiny patches of private land has been replaced by the equally hard work of maintaining and administering the system and keeping the *parciantes* or members satisfied with the amount of water that trickles into their fields per year. The *mayordomo* (elected ditchmaster) is responsible for this, answering both to the community and to the *comisión* (which deals with "foreign relations" — diplomacy with the neighboring ditch *comisiónes*).

The extraordinary social, cross-cultural, and physical intricacy of one small *acequia* system in northern New Mexico is lovingly detailed in Stanley Crawford's book *Mayordomo*, chronicling one year of the ditch on which he has worked in various capacities since 1970. One mile of an anonymous river is accessed by seven *acequias*, each serving from twelve to eighty *parciantes*. Muskrats, beavers, tumbleweeds, fallen trees and other vegetation, erosion, drought, recalci-

SHARON STEWART, *Mayordomo and Acequia Cleaning (Limpia), El Cerrito, New Mexico*, 1993, gelatin silver print. El Cerrito is an isolated village in Northern New Mexico and has been the subject of academic surveys since the late '30s. Stewart, who lives in the nearby village of Chacon, began her ongoing work in 1992 as part of the Water in the West project. It is a "village life portrait as illustrated by the interdependence on the community irrigation ditch." Since no one in the village remembers the establishment of the *acequia*, it may have been created by the Native Americans who settled the Pecos River Valley. In the early 1960s, when El Cerrito's population was at a nadir, every weekend in April was devoted to the annual *limpia*. Then the village was revived by the hippie migration to New Mexico (after someone convinced a villager to be the first to sell land outside the family). Now it is a residential amalgam of old family descendants, some of the original revivalists, and their friends; the ditch cleaning takes less than a day. Despite a resurgent feud between two old families, it is the one social gathering, aside from the rare wedding or funeral, in which everyone comes together, to ensure water for their fields.

165

playing in the channel. Thirty years ago, herring dories, nets and floats appeared annually in Little Harbor. I remember schools of pollock running up on our beaches at least once a summer. (They were once so plentiful that the name Passamaquoddy means "people of the place where pollock are taken"; no longer.) Salmon were partially restored to the Kennebec in the early seventies after having disappeared in the wake of upstream pollution. In 1972 we caught one trolling from a little plastic sailboat out to sea to the east of the river's mouth and didn't even know what kind of fish it was until we got ready to cook it at that night's campsite.

trant *piones* (workers), floods, highways, dams, trash, local "water hogs," longstanding family feuds, alcohol, drugs, poverty, government funding patterns, the whims of state water engineers, clashes between traditional and modern, *Hispano* and gringo, small and large—all of these are factors that a *mayordomo* must juggle to keep the water flowing, the fields fertile, and the community relatively harmonious. Collaboration with nature (independent nature and that produced by humankind, both constantly changing) make this humble narrative a classic. The central character is the pseudonymous "Acequia de la Jara," ruled by a whimsical tyrant of a river. The supporting cast is as cantankerous a group of nonfictional men (and one woman) as John Nichols could have invented.

This is deadly serious business as subsistence agriculture is threatened by the municipal-industrial demands of the ever-growing cities, and *Hispano* and Pueblo Indian communities are pitted against each other in competition for the diminishing resource. Under Spanish water law, water and land go together (which seems the only ecologically sane way to look at it), and ditches only transport water. Adjudication— the commodification of water rights by separating them from specific property and communities— replaces local, oral tradition based on negotiation with a new series of rules, regulations, and hierarchies. Water rights, once for sale, are wrenched from their beds in the land, in an ominous move from rural to urban methods. Crawford suggests that water may be even more important for its role in keeping communities together than for its agricultural use.

The ghosts of drowned rivers stir restlessly beneath the placid waters of reservoirs. In the eye-blink of a few thousand years, they will sweep away the concrete and earthen plugs that hamper their quest for the sea.
—DANIEL J. LENIHAN

Beneath the still waters of artificial lakes, created by dammed rivers across the West, rest indigenous ruins, thousands of petroglyphs, barbed wire fences, churches, old ranch houses, railroad tracks, even outmoded dams—and people's lives. These specters haunt the idolatry of temporary progress that rules our roots. Although only divers see them face to face, these waterworlds, mirrored on their surfaces, reflect the way the land is used.

Ralph Nader put it in no uncertain terms in 1971: "special interests, including government polluters, use [our water] as their private sewers. Toilet-training polluters will require the replacement of short-sighted, cowardly, or venal men and institutional abuses with a legal system that sees prevention as the cardinal ethic." Such warnings can be read literally. When Ella Filippone of the New Jersey Passaic River Coalition protested the flushing of a local sewer plant into the river, the manager of the sewage authority asked why she cared. "There's nothing there," he said. "The river looks terrible."

Charity begins at home. Grassroots local organizations and volunteer labor have led the way in demanding and creating cleaner waterways. Adopt-a-stream movements have followed the highway cleanup programs. The movement for sustainable communities is necessarily concerned with water, as each village or town is affected by everything that happens around it. The great flood of 1993 in the Upper Mississippi Basin constituted a national wake-up call for those concerned with the circular relationships between people, rivers, and wildlife, forcing local and federal organizations to rethink river management and to look at the history of the Mississippi's marvelously diverse ecosytems.

The flood had a tremendous impact on farms, wildlife habitat, and food chains. The Army Corps of Engineers has built twenty-eight dams and thousands

Maine Shrimp, Bay Point, 1994, (Photo: Peter Woodruff). Shrimping (confined to the midwinter months since 1973) provides off-season work for local lobsterers. Regulations have affected it too, but 1996 marked a record catch.

For years clams and mussels were a staple meal available virtually in our front yard. (One of the best known geodetic surveys on clams in the country took place in Sagadahoc Bay in 1959.) Now, with pollution, Red Tide,

of control structures between Minneapolis and St. Louis. Along the Missouri they eliminated 90 percent of wetland, 90 percent of sandbars, 75 percent of aquatic habitat and 66 percent of riverside woodland. Because only the river was considered, rather than its context and relationship to floodplain and watershed, the engineering failed when a big one came. "A lot of stuff that got really whacked in the flood was the river trying to recapture parts of its ancient habitat," says Bill Dieffenbach of the Missouri Department of Conservation. In a sense, the river succeeded: many riverbottom farmers sold out to state and private conservation organizations to establish wildlife refuges and protect the remaining wetlands. In southeast Iowa, an entire nine-mile square district is selling its land to the Iowa Natural Heritage Foundation to be converted back to natural floodplain. District chairman Robert Hawk says, "Nature always seems to come out on top. Man has squeezed it, and it has squeezed back."

Rivers are great metaphors for life, journeys, passion, and power. Because of this they are more locally embraced, and more graspable in their linear trajectories than the legal labyrinth of water rights and crimes. I often wonder if "my" small river would be in better shape if the people who lived along it knew its history. Every river should have a chronicler like Paul Horgan, whose *Great River: The Rio Grande In American History* is a classic. There is an organization called River Keepers which "listens to the river" with celebrations called "river soundings," taking an aesthetic approach to the issues and sometimes collaborating with the increasing number of artists who are making it their work to adopt, depict, or care for rivers. If, as Worster contends, "a new kind of creative imagination for the future" is what's needed to save the West, artists should be helpful. But few

have yet to scan this vast territory of national water issues, which is outside of most of their experiences.

There are, of course, exceptions, such as Billy Curmano's heroic and often hilarious swim down the entire Mississippi as a performance work and environmental statement, accompanied by a deluge of hokey fan club press releases ("As American as Apple Pie, But Better for You!"); at the beginning of the 1996 swimming season, he had swum 1,928 of the 2,500 miles from his home state of Minnesota to the Gulf of Mexico. Pat D'Andrea's bioregional study of the Rio Grande/Rio Bravo (declared in 1993 the most polluted river in the U.S.) is supported by Confluence, a group that has traveled the length of the river in a trailer painted to simulate an ear of corn, stopping in local communities along the way to gather signatures and exchange corn. In Boston, Christopher Frost, working with the Reclamation Artists group, made the *Miller's River Project* (1992) to commemorate the remains of a stream once bordered by the biggest collection of slaughterhouses east of Chicago—a stubbornly poetic sculpture of three boats made from local plant materials.

The "Water in the West" photography project is an exemplary artistic response to the Western water crisis begun in the early nineties by Robert Dawson and Ellen Manchester. With a team of eight colleagues, they soon expanded an individual project into a broader attempt to integrate art, history, public dialogue, and education around water issues, including an archive, an exhibition, a conference, and a book perversely titled *Arid Waters*. In an attempt to subvert the detached atmosphere surrounding art, the photographs were exhibited as work in progress, with one huge wall devoted to a "bulletin board" of selected documents, narrative sequences, combination prints, contact sheets and

and strict licensing, we eat them less and less. Georgetown's dedicated clam warden lurks at the edges of the bays to pounce on commercial clammers breaking the rules, or summer residents who think that because they're taking so few—just enough for a chowder—or have done it all their life, that they are exempt from the rules.

Five Islands is Georgetown's busiest harbor, home of the town wharf, local Fisherman's Co-op, and a no-frills, open-air restaurant serving lobster, clams, and corn in summer. It is also a hub for sport fishing—a big deal in Maine; in June and July the Kennebec is a hot spot for still plentiful striped bass. But the village lost its post office and Grover's general store, torn down in the '80s.

168

multiple images. During discussions about the group's direction, several of the photographers identified themselves as artists rather than lobbyists or politicians, and reiterated aspects of the longstanding debate about the role of aesthetics and imagery in social change. In their collective statement, they saw themselves as a clearinghouse for "a body of work which will contribute to the increasingly urgent dialogue about the future and quality of life on earth as sustained by increasingly limited natural resources," and for ideas about "how water use and perceived needs have shaped our natural and social landscape."

Many of these artists work collaboratively with each other and with others, expanding their effectiveness further into the public sphere in order to educate their audiences as they educate themselves. Their vision is shared by journalists and scientists nationwide. In a West that made sense, a West symbolized by bison, salmon, and antelope rather than cow, cowboy, and irrigation, writes Marc Reisner, "you might import a lot more meat and dairy products from states where they are raised on rain, rather than dream of importing those states' rain"; you might have cowboys driving bison that are more acclimated than cows to arid regions. You might even have a West "where a lot of people really don't give a damn how much money a river can produce."

ROBERT DAWSON, *Modesto Arch, Modesto, California*, from the Water in the West and the Great Central Valley projects, 1986 (copyright Robert Dawson). This sign, remarks Dawson, who is a major figure in the expansion of documentary photography into the realm of regional environmental activism, is a poignant reflection of nineteenth-century attitudes about water, land, and white settlement in the Great Central Valley of California.

Death by Geography

I associated environmentalists with hippies, wildflowers, and naturelovers,
and I felt that all this had nothing to do with my everyday living process.
— CHERYL JOHNSON, STAFF MEMBER
OF PEOPLE FOR COMMUNITY RECOVERY IN CHICAGO

JOLENE RICKARD (TUSCARORA), *Buffalo Smoke, Buffalo Road*, 1994, silvertone print. This image was inspired by the birth of a white buffalo calf (it has since turned brown) which attracted national attention among Indian people as a prophecy of change. "In the same way that a story has cultural meaning, so too does a photograph," says Rickard. When her cousin was herding buffalo on the Onondaga Nation, she helped him feed them and was impressed by their power—physical and spiritual. "Lakota friends taught me about the meaning of the buffalo's breath puffing out billows of white clouds in the early morning," she writes from the Tuscarora Nation near Buffalo, New York. "The only 'white smoke' that should be seen on this earth is the buffalo's breath." But the smoke she sees every day comes from a coal-based nuclear plant on Lake Ontario: "The buffalo is to spirit as power plant is to capital. Or is it that spirit is to power plant as buffalo is to capital? Or... capital is to spirit as power plant is to buffalo...."

"One by one, the symbols of Maine's outdoor heritage are being found to carry the insidious family of chemicals called dioxins." Since 1984, scientists have discovered them in fish, clams, and lobsters. Bald eagles along the Kennebec have already suffered.

The Penobscots' Indian Island, where inhabitants eat a lot of fish, is only 30 miles below the Lincoln Pulp and Paper Company which is "at least partially responsible" for poisoning the Penobscot's eagles. Much of Maine's tapwater is polluted with fecal bacteria, lead,

radiation or other contaminants.

Bath, once a major offender, got a 1996 EPA award for a new plant stemming the flow of sewage into the Kennebec. The Brunswick Naval Air Station will be cleaning up its waste sites and groundwater contam-

IN 1987 REVEREND BENJAMIN CHAVIS, THEN director of the Commission for Racial Justice of the United Church of Christ, oversaw a groundbreaking report about environmental racism, which found a consistent pattern of concentrating uncontrolled hazardous waste facilities in minority communities. Specifically, "three out of the nation's five biggest commercial hazardous waste landfills—holding 40 percent of the nation's estimated capacity—were located in predominantly black or Hispanic communities. The map on the cover of the report (regarding only black and Hispanic populations) shows large chunks of California, Arizona, and New Mexico affected, while only a small part of Nevada is *not* affected. Three out of five black and Hispanic Americans and approximately half of all Asian/Pacific Islanders and Native Americans live in such "wasted" communities.

Hazardous waste, defined by the EPA as "toxic, ignitable, corrosive, or dangerously reactive," was discarded until the late seventies with little consideration of the risks involved. By 1985, some twenty thousand sites had been inventoried, but many more remain unidentified. The Chavis report, which led to protest marches, media and official attention, made clear that it would be difficult to separate the environmental and health hazards from their social context of rising unemployment and poverty, poor housing, and declining educational quality. Arguments by industry that pollution brought jobs to poor communities were thoroughly rebutted.

That was a decade ago. Since then, the movement for environmental justice has taken grass roots in inner-city communities across the country, and rural communities have become the focus of most Western groups, especially those emerging from Native nations. In 1992 *The National Law Journal* demonstrated that minority communities were neglected by

Federal pollution cleanup programs: efforts were fewer, slower, and less thorough, and polluters were fined less and less often. It is difficult for communities to fight back in any case, but especially difficult for poor communities. Lois Gibbs, heroine of Love Canal and now director of the Citizens Clearinghouse for Hazardous Waste, says she suspects that over a third of people "protesting toxic waste sites and incinerators around the country have been intimidated." Companies prefer to pay court costs over cleanup costs and delay restitution forever, while people suffering health problems due to pollution are on their own. "Because there is so much resistance to doing the right thing from the top level down," says Cheryl Johnson, "we grassroots organizations and concerned citizens must reverse osmosis in order to be heard."

Since federal, state, county, and municipal agencies have rarely taken their responsibilities seriously, it has fallen to local people to protect local places. An astounding number of children are worried about their inheritance, among them the Toxic Avengers, from the primarily black and Latino section of Williamsburg in Brooklyn, New York. They got fired up in a class on environmentalism for high-school dropouts and waged a poster and leaflet campaign against the Radiac Research Corporation, which stores and transports toxic waste. Speaking out has been a process of empowerment: "I was very timid, very shy," said Rosa Rivera. "But since I've been a Toxic Avenger, I've sort of bloomed."

If most major environmental organizations are led by men, women tend to lead local groups. When hard-won homes are threatened, lead is discovered in children's bedrooms, or asbestos in schoolrooms, it is typically women who rise up. A majority of community organizations are founded, led, or supported by women who had no previous experience in politics or

ination for thirty years, costing at least $13 million. Two-stroke outboard motors on the 12 million pleasure boats in the U.S. release some 150 to 420 million gallons a year. (The Exxon Valdez spilled "only" 10 million gallons.) In September 1996 the largest oil

spill in Maine's history spewed 170,000 gallons into the Fore River at Portland.

Thirty-five years ago the Androscoggin was bereft of wildlife, littered with clots of colored foam from upstream paper industries. Now a rich fishing ground, and cele-

brated less than two years ago as "the transition from open sewer to a jewel of a waterway," in fall 1996, it was declared the worst toxic polluted river in the state (43rd in the country). The Kennebec is second in line with 698,418 pounds of industrial toxins

public action. And of course it was Rachel Carson, in her 1962 book *Silent Spring*, who jolted the entire world into consciousness of the pesticides that were poisoning people and wildlife.

"Pollution has no boundaries," says Johnson," and it doesn't settle in one place." In fact, more than half of the nation's population lives in communities with uncontrolled waste sites. One of the biggest villains is Waste Management, Inc., which operates the largest hazardous waste landfill in the U.S. in rural Sumner County, Alabama, where 65 percent of the residents are black and roughly 30 percent of the residents live below the poverty line. Although class issues cannot be ignored, race was found to be a far more significant factor than income and homeownership. When Robert Bullard, author of *Dumping in Dixie*, began to study the history of dumping in Houston, a clear pattern of discriminatory targeting emerged. He credits the white environmental movement with building an impressive political base for environmental reform but notes that it has paid "little or no attention to the implications of the NIMBY ('not in my backyard') phenomenon. If the waste generated by society's wealth was not going to end up in the backyards of those who benefited from it—namely, the white middle class—somebody else's backyard had to be used." In fact, the front yards of poor neighborhoods are the backyards of this society.

One of the sparks for the Environmental Justice movement was this widespread perception that the mostly white middle-class environmental movement did not care about minority communities. "We became a bargaining chip for the passage of the Clean Air Act," charges Jeanne Gauna of the Southwest Organizing Project in Albuquerque. "It allows lower standards in areas where most of us work and live." Moreover, "people of color organize differently," says

New Mexico activist Linda Velarde. "They are fighting for their lives economically and it's harder for them to find free time. You need to organize one-on-one and make personal contacts." A cartoon by Mark Gutierrez titled "We ask them to our meetings but they never come" will hit a nerve for liberal and progressive organizers. A white guy in a "Save the Whales" T-Shirt talks on the phone beneath a banner for "Green Earth": "Can you come to our meeting?" he asks. In the other frame, a guy of color in a "Housing for Our City" T-shirt stands before placards reading "Clean Air" and "Get the Lead Out." He replies, "No, we're real busy right now. Can you come to ours?"

The Chavis report noted that its figures on Native Americans (46 percent living in waste areas) "may not be a real indicator" because those communities are affected for the most part by radioactive wastes, which are regulated by the Nuclear Regulatory Commission and the Department of Energy—neither of which is famous for its openness or accountability. The Western Shoshone have battled for years for the return of their land in Nevada, now defiled by the nuclear test site where over eight hundred nuclear bombs have been set off since 1951. They have been offered payment (at 1872 prices) for their occupied land, which was never legally ceded to the United States in the Treaty of Ruby Valley (1863), but they are holding out for the return of the land itself. The struggle was renewed in the early seventies, and exacerbated in 1991 when the elderly Shoshone sisters Mary and Carrie Dann resisted the Bureau of Land Management's insistence that they needed to buy a grazing permit because they were "trespassing" on federal lands. "I told [the BLM agent] I wasn't," recalled Mary Dann. "I told him that the only time I'd consider myself trespassing is when I went over onto the Paiute land." I'm in our own territory, in our treaty. I told him about the

dumped from 1990 to 1994—data not issued in time for the 1996 fishing season.

"This Area CLOSED to All Digging..." say signs posted along our bays. Sewage pollution can close clamflats for 10 years, although they are "redeemable." Sometimes it is better economically to reduce pollution and reopen the flats, sometimes just to forget clamming. Digging for the bloodworms and irridescent sandworms used as sports fishing bait—hard labor and increasingly competitive—is another endangered coastal industry. "You used to be able to go anywhere and get worms," says one digger, "Now you can go two or three days without finding any."

The Maine Yankee nuclear plant in Wiscasset, up the Sheepscot from Georgetown, is owned by utility companies whose goal is

172

treaty and I showed him the map and he told me, 'Well, that's a big territory.' And I told him, Yes."

In the old days they gave us smallpox-infested blankets. Today they're giving us nuclear waste.
— GRACE THORPE (SAC AND FOX)

Land use is at the heart of the most controversial aspects of Native culture today. The establishment of gambling casinos on reservations across the country often seems to be the only way to fund the basic social services the U.S. government has been unable to provide. Toxic dumping is an even riskier alternative. Tribal councils nationwide are being seduced by the blandishments of waste management companies seeking to dump "ordinary" garbage (which is often quite hazardous) on Indian lands. In 1995, the Mescalero Apache voted first against and then, a month later, for the siting of a "Monitored Retrievable Storage" (MRS) site—a vast toxic waste dump—on their southern New Mexico reservation. Because indigenous sovereignty is a highly sensitive issue, few other Indian nations have publicly criticized this move by the longtime tribal chairman, Wendell Chino. A year later the agreement appears to have been rescinded, but the story may not be finished yet. Roughly 94 percent of the waste generated by the nation's 111 commercial nuclear reactors could end up "temporarily" on the reservation, which borders the White Sands Missile Base. The final destination of this waste—by no means a certain prospect —would be the controversial Yucca Mountain in Nevada; it is in earthquake-prone territory, and some members of the scientific team that selected it now oppose it, fearing that the dump's physical dynamics could produce a nuclear cataclysm. Even if the site were determined to be suitable, the earliest it could open would be 2010. The Waste Isolation Pilot Plant (WIPP) in Carlsbad, New Mexico, intended as a dump for defense-industry plutonium waste, is also stalled for the moment over protests, scientific uncertainty as to its safety, skyrocketing costs, and a New Mexico lawsuit over the Department of Energy's declining safety requirements. (The WIPP route runs through Santa Fe, and then passes within two miles of my house.)

Decisions like that made initially by the Mescalero perplex many white supporters of Native rights, disillusioning those who romanticize Native peoples' attitudes toward the land and are unwilling to admit that Indians are neither more nor less likely than anyone to escape poverty by whatever means necessary. Reservations have long since been transformed into "national sacrifice areas." The prospect of sovereign Native people producing their own landscapes is a source of pride for them and a threat to those beyond their borders. Our opinions are not sought, except when tourism is the object. But it is disturbing to think that Native people are beginning to think like Euro Americans in terms of a tradeoff between good earth and bad earth: save this, sacrifice that. To add insult to injury, "Mother Earth" becomes a rhetorical weapon for the "other" side: federal negotiators have told tribal officials that "leaders with vision" would participate because of their "reverence for the land." Tracey Bowers, a Paiute tribal council member, says, "They

DANA SHUERHOLZ, *Self-Portrait, Nevada Test Site*, 1992 (Photo: Dana Shuerholz, Impact Visuals). The artist defies the United States Department of Energy's "No Trespassing" edict by projecting her shadow, her spirit, her witness, onto the land of Newe Segobia (the test site's name in Shoshone). Schuerholz is a Seattle-based activist artist who is making a documentary study on the relationship between cancer and pollution. In part of a text panel that accompanies this picture, Shuerholz writes, "I don't know the best way to make change. I write politicians, I vote, I organize, I make art/educate, I protest, I get arrested, I go to court, I go to jail, I scream, I cry, I pray, I will never be silent because I believe in the deepest part of myself that no one is disposable and all life is valuable."

cheap power, not safety. Described by Mike McConnell as "a very large white elephant with a yellow 'Danger—Nuclear Radiation' sign around its neck," it has been warming the ocean waters for 24 years and generates about one quarter of the state's electricity.

Some see it as a LULU—Locally Unwanted Land Use—but three referendum drives in the eighties failed to shut it down, primarily because the short-term threat of lost jobs is scarier than the long-term threat of radiation or catastrophe.

Maine Yankee's license expires in 2008, but technical problems are longstanding. In 1991 there was a fire. In 1994 touring students got low doses of radiation. After several shutdowns for repairs, it was closed most of 1995 due to tube cracks, started up again in Janu-

fight us on our religious freedom, our hunting, fishing and water rights, yet they recognize our sovereignty when it comes to waste."

The beginning of this saga came long before the waste crisis was recognized. With the winds of war in the late thirties, the U.S. government and private industry began to mine uranium on Indian lands. A Navajo emergence story (perhaps updated) holds that when the Diné (Navajo) came out of the 'third world' into the present world, they were told to choose between two yellow powders—one a rock dust, the other corn pollen. When the Diné chose corn, the gods were pleased. They warned that the other yellow dust must be left in the ground: removing it would bring evil. Luke Yazzie, who found one of the most profitable uranium mines in the early 1940s, was warned by his father never to take those rocks to the white man: "If you do, you'll get nothing out of it."

These different warnings were not heeded, and the white man built nearly twelve hundred uranium mines on the Navajo Reservation. In his book *If You Poison Us: Uranium and Native Americans*, Peter H. Eichstaedt tells the appalling story of the results, which are still reverberating. Hundreds of Navajo miners worked unprotected, by hand, wheelbarrow, and bucket in primitive mines called "dog-holes," often receiving over a thousand times the acceptable levels of radon and other radioactive elements; innocently bringing their dust-laden clothes home to wives and children, they spread the carcinogens that would kill so many of them. The Atomic Energy Commission (AEC), state agencies, and mine operators were well aware of the hazards, already experienced by European miners, but it took them decades to inform the Navajo and to act on what they knew, pleading profits and national security.

173

ary 1996, and shut down again in July. Scrutiny was prompted by a whistle-blower. Early in 1997 the plant changed management.

Little foam rubber "atomic balls"—supposedly not radioactive—wash up on our beaches. A 1996 ad claiming "our plant, unlike some others, produces no air or water pollution" was pulled after an anti-nuke group filed a consumer fraud complaint. A booklet "preparing for a regional emergency" tells us unconvincingly that the amount of radioactive material released to air and water "is as low as reasonably achievable." Storage space will last one more decade, then high-level waste will be removed to Yucca Mountain around 2010; the journey begins on Route 1 through Bath and Brunswick to the Maine Turnpike.

174 Despite a number of studies and some dedicated Navajo and white health officials who understood by the late forties what needed to be done, it was twenty more years before the federal government mandated safety standards. By then, over two hundred miners had already died. It took the government thirty years to start cleaning up mill wastes, and forty years to begin the process of compensating the ill and the widowed. Just as the Navajo who had originally led prospectors to the lucrative sources were never given the rewards or royalties they were promised, the poisoned miners and many of their survivors have still not received their hundred-thousand-dollar "compassion payments"—despite the passage of the 1990 Radiation Exposure Compensation Act (RECA), which in any case covers only a small percentage of the victims.

The struggle continues for adequate testing and culturally sensitive standards. A number of Navajo have worked tirelessly for restitution and cleanup, among them Harry Tome, Harold Tso, Ray Tsingine and Perry Charley, who travels the reservation trying to explain what has happened to the inhabitants of contaminated areas. There are no words in the Navajo language for the radon and gamma radiation that threaten lives, sacred sites and medicinal plants: "I call it steam," he says, "but they associate that with the ceremonial steam baths, which are good." When occasional cleanups do take place, they are preceded by Navajo blessing ceremonies to encourage renewed harmony in the natural world.

Winona LaDuke calls the history of uranium mining, which has left hot tailings all over the West, "radioactive colonialism." In 1994, the White Mesa Utes organized a "peace march" to protest a proposed mill tailings truck haul in Monticello, Utah, complaining that Anasazi graves were dug up during the mill's construction. Acoma Pueblo, the oldest permanently occupied community in the U.S., along with neighboring Laguna Pueblo, is in close proximity to the Jackpile Mine, the largest openpit uranium mine in the world. At one point a mining company even asked residents of the Laguna village of Paguate if they would move because underneath it lay some of the richest uranium in the area. "The traditional elders refused," says Manual Pino, an Acoma activist. "This village is sacred land. You don't just move a village like that for economic incentives."

Beneath this history of human misery and death lies the wounded land. Piles of uranium tailings containing uncounted tons of radioactive waste are left lying within yards of homes and on grazing lands; they have poisoned waters, food, and livestock. Small rain-filled pits remain open, tempting children to swim and animals to drink. Many homes on the Navajo reservation are actually built of tailings and sand from the mines. At a site ironically named Naturita, the rocks are stained yellow a half mile from the plant. One of the few white heroes of this story, Duncan Holaday, has stated publicly that "these unfortunates were as surely victims of the Cold War as those who died in Korea."

This "death by geography," as photographer Carole Gallagher has called it, has not been limited to people

Georgetown is one of 16 towns in the "Emergency Planning Zone." Plans for an accident are laughable. The zone's summer population is about 62,000. We evacuate by the always jammed Route 1 and the often bottlenecked Bath Bridge. (If we chose to

flee by boat, we fantasize, how far would we get, before fuel, wind, or muscle gave out?)In a mock emergency preparedness drill in June 1996, there were various snafus: the team assigned to a dairy farm to test for contamination didn't know how to milk a

cow. Getting volunteers from communities for drills has been so difficult that Maine Yankee has actually paid towns simply to send people to sign a sheet.

Ray Shadis, an artist and anti-nuke activist from Edgecomb (in spitting distance of the

175

of color, although with other poor people, they bear the brunt of it. The infamous Hanford Nuclear Reservation in Washington state is a tragic example of how a community drugged by short-term prosperity can refuse to confront reality; since 1986, thanks to the Freedom of Information Act, its shocking history has seeped into public view. Located in sparsely populated farmlands along the Colombia River in eastern Washington, Hanford is now "arguably the most polluted place in the western world." Yet when one of Hanford's major reactors was closed down because of its similarity to Chernobyl's, citizens held a candlelight vigil for it, wearing caps boasting "Proud of Hanford." Such misguided chauvinism, now in the very veins of the community ("God help you if you're not on their team," said one worker) developed over years of total secrecy about what was happening to the place. When a company is the major supporter of a town or region, the identity of a community can become confused with that of the corporation and a threat to the company can seem to be a threat to the community.

In the last forty years, over a billion cubic feet of hazardous and radioactive waste have been identified

PATRICK NAGATANI, *Japanese Children's Day Carp Banners, Paguate Village, Jackpile Mine Uranium Tailings, Laguna Pueblo Reservation, New Mexico*, 1990, chromogenic color print. Nagatani, who lives in Albuquerque, spent time at the nearby Laguna Pueblo, researched the nuclear importance of the site and of Hiroshige's carp image—a celebration of life and youth which he then superimposed on hand-colored images of death, represented by the Pueblo tailings piles and graveyard. Other images in the series juxtapose Kachina dancers and animal symbols from Native cultures and pop culture against nuclear warheads, technology, and media. This enormously complex and detailed series is about myth (in ancient and contemporary cultures) and landscape. Nagatani felt he needed to "embrace," or understand, the hot nuclear and uranium tailings piles that seem ubiquitous in New Mexico. The book on this series—*Nuclear Enchantment*—is a powerful hybrid, relating art and personal experience in a form that is also highly informative about social issues.

by the Department of Energy; they are stored nationwide on 5,700 contaminated areas near schools, homes and public buildings. Nuclear fallout from open-air bomb testing has produced "atomic veterans" and "downwinders" whose stories are just as tragic as those of the uranium miners. In the early nineties, three major nuclear waste producing sites were closed. But the future is hardly cheerful. The cost of cleaning up these sites is astronomical and the difficulty of finding repositories elsewhere means that nuclear plants have become radioactive dumps by default, without public debate or input from surrounding communities.

An artist was in the vanguard of those breaking the story of this "secret nuclear war." Photographer Carole Gallagher dropped out of the New York art world in 1981 and went to live for most of eight years in small towns in Utah while she compiled *American Ground Zero*, her monumentally incriminating book about the deliberate contamination of the towns, farms and ranches of those downwind from the Nevada Test Site—"a damned good place to dump used razor blades," in the words of *Armed Forces Magazine* in the 1950s. It is now clear that the U.S. military knew there were serious health risks for people in surrounding areas when they started testing in Nevada in 1951, although a safer site was available. One top Los Alamos scientist, while denying that the fallout was dangerous, went to great lengths to remove his own family from harm's way. An air force colonel told Gallagher, "there isn't anyone in the United States who isn't a downwinder." Former Secretary of the Interior Stewart Udall, who was also instrumental in gaining some justice for the uranium miners, concludes that downwinders in Nevada and Utah were, like the miners, "unsuspecting participants in a medical experiment"—that is, guinea pigs.

plant) formed the monitoring group Friends of the Coast Opposing Nuclear Pollution in 1995 and is a member of the 25-year old New England Coalition on Nuclear Pollution, based in Vermont. (There is also Friends of Maine Yankee, a group that supports the plant because it is perceived as a mainstay of the state's economy.) Another artist, Fred Angier of nearby Alna, also wants the plant closed down, but he is coming from a conservative, cold warrior background and believes in nuclear power. Nevertheless, he says we are in deep trouble because "the public has become lazy, complacent and trusting with regard to the nuclear power industry...no nuclear power plant, to my knowledge, has reached the end of its life cycle....even a minor rupture will ruin Maine's

LISA LEWENZ, 1984, A View from Three Mile Island, 1983, calendar, pages 11" x 17". The calendar documents nuclear history, research, legal issues, and "events" (wars, accidents), making connections between the local and the global, as these photographs of the impersonal cooling towers are seen looming outside the intimate and personal space of homes on the nuclear plant's periphery. These images add new meaning to contrasts between interior and exterior.

Nowhere are the ties between the people and land made clearer than when they are wounded together. One by one, books based in impressive investigative reporting are beginning to tell the buried horror stories; many include poignant portraits and interviews. Photographs are crucial elements in the telling, since they allow others to see and hear the voices of real people, like ourselves, who are victims of federal abuse. Sharon Stewart's *A Toxic Tour of Texas* (1989) is a narrative photo essay that incorporates the stories of people living around the polluted sites and a section of "motivations, reflections, strategies" from community activists. It has received wide press coverage, been used for environmental and legislative hearings, and was exhibited at the state capitol and at the General Land Office in Austin, Texas, among other places. Stewart documents people making do

with high levels of pollution as they go about their daily lives—for example, a windsurfer who sails at the Texas City Dike in water with levels of lead six times the Environmental Protection Agency's maximum, says: "Well, it's all I got. It could be better. It certainly would be nice if you were assured that it was not harmful to your health...." How does this affect the way people regard themselves and the land? Activist Lorrie Caterill says of children whose playgrounds lie next to landfills: "They say, 'I grew up with a dump in my backyard, why should I care if my street's cluttered. Nobody cared about me then.'"

With Eugene Smith's *Minimata* as a model, the issue of nuclear weapons, nuclear power, and hazardous waste has attracted activist artists (especially documentary photographers) in fits and starts since the forties, when virtually no one made "high" art about the bomb. The artist's relationship to the almost inconceivable figures involved and the scale of the task at hand mandates a certain detachment. The 1989 Exxon Valdez oil spill in Alaska inspired a great aesthetic spill of art

CAROLE GALLAGHER, Marjorie Black, downwinder, at her ranch south of Sheeprock Mountain, Utah, 1988 (copyright Carole Gallagher from American Ground Zero: The Secret Nuclear War). As Gallagher demonstrates in her book, Mormon Utah was chosen in the 1950s as a sacrifice area because its religious and patriotic citizens (described as "a low-use segment of the population") would not question the government that planned to risk their lives, their land, and their livestock. Gallagher shows rural, often Mormon, culture through the disillusioned faces, the painful interviews, and the ominously beautiful landscapes. The fence in the foreground of this picture became a radiation "hot spot" after an atomic cloud passed over (one of 126 in twelve years): "My husband went down to fix a fence," recalls Black, "and he came home and his face was just purple like a fever. His lips cracked and he broke out with blisters. He was nauseated, all the symptoms." Another time, the government told local residents not to let the children eat the snow; a slight snow fell near the Blacks' house and the paint peeled off down to the base metal.

image. Property values, health, jobs—you can kiss Maine goodbye...."

Like most states, Maine has its "Cancer Valley"—Rumford, Dixfield, Mexico and Peru. "Choose a house on any street, they say, knock on the door and it's likely the person who answers will have cancer." A survey is underway to determine which health issues are "simply local folklore" and which can be addressed by studying air quality in the area around the Boise Cascade paper mill in Rumford, where a stinking fog is relatively common. Previous studies have been "inconclusive."

decrying the desecration of nature and animal life; the blame was so obvious that, for once, Exxon got named again and again. However, too often environmental artists fudge and generalize under the illusion that their work will have a broader impact on an ill-informed audience than it actually does.

Although some impassioned works have been made, none are on site—for obvious reasons; the nuclear industry isn't a great supporter of oppositional art. The most broadly effective works have been those by photographers documenting the impact on people and places. Those using local contexts to make more general statements may reach a smaller but directly concerned audience. Until recently, landscape photography would have been considered an unlikely site for such moral and ethical stances as these. Now, as photographer and critic Max Kozloff has observed, "instead of discovering the ephemerality of sensate life in an enduring scene of beauty, the viewers must face the fragility of the scene itself."

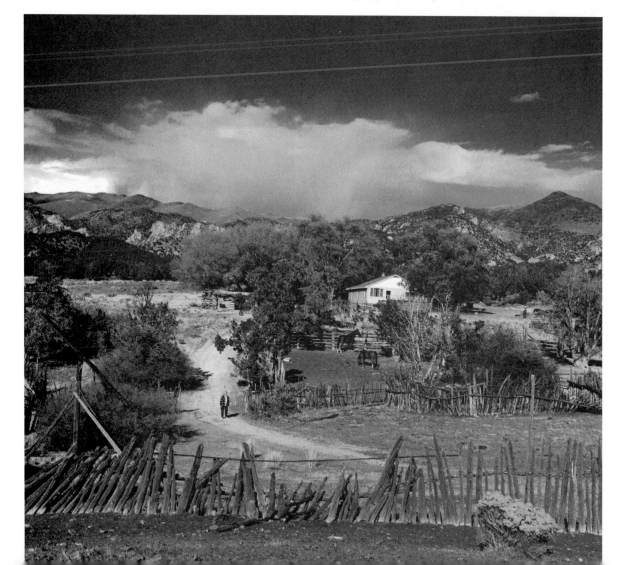

Out the Picture Window

Why landscape now?...Landscape has been appropriated by our cultural establishment
as "proof" of the timeless virtues of a Nature that transcends history—
which is to say, collective human action. If we are to redeem landscape photography
from its narrow, self-reflexive project, why not openly question the assumptions
about nature and culture that it has traditionally served
and use our practice instead to criticize them?
— DEBORAH BRIGHT

 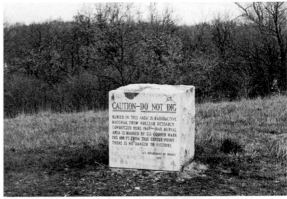

DEBORAH BRIGHT, Details from *How the West Was Won*, 1985, phototext installation. The text reads, in part: "In a remote spot in the middle of a forest preserve about twenty miles west of Chicago lies the abandoned site of the world's first nuclear reactor [1943].... With the establishment of the Argonne National Laboratory in 1954, this site was returned to forest—the reactor buildings and laboratories were bulldozed into the ground." The "bookends" of this (ongoing) event and Bright's project are two rustic stone monuments on the now "parkland" site, marking, on one hand, the nuclear accomplishments, and on the other, a warning: "CAUTION—DO NOT DIG." The title and some of the texts are an ironic commentary on the frontier mentality of the atomic military. The photographs are contextually charged but visually innocuous, dependent for their meaning on the history and use of the land itself.

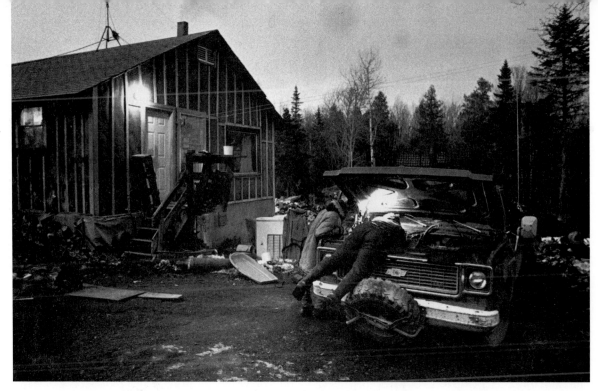

Ervins Bubier working on his woods truck along with his son, Tommy. Perry, Maine, 1987 (Photo: Pam Berry, courtesy of Salt). "Piecing together a year's work is a way of survival for many rural Mainers. Some of this and then some of that—[a tradition that goes back centuries]. For the Bubiers in Washington County that means cutting wood, welding, repairing cars, herring fishing and when all else fails, public assistance."

The most important Maine photographic institution relating to place is the Portland-based Salt Center for Documentary Field Studies. Some 250,000 photographs and 2500 hours of interviews have been collected since the group began as part of a high school program in 1973. Focusing at first on gathering life stories and documenting the traditional crafts, Salt then concentrated for four years on the isolated Down East town of Eastport, where, for the first time in 80 years, population was increasing, though the new arrivals were "from away." The organization publishes a magazine and continues to report from the Maine that Mainiacs know.

DESPITE THE FACT THAT LANDSCAPE PHOTOgraphy, as Bright points out, is favored by the apolitical and conservative because it appears to have no content, some of the most sublime images have been used as propaganda. Environmental organizations have long published books and calendars designed to instill a love of nature in an indifferent public: recently they have gotten tougher and more overtly ideological. David Brower, former head of the Sierra Club and now director of the Earth Island Institute, acknowledges that "the beauty of their publications' prose and images may have been too tranquilizing, leading readers to think: Look how much there is! Surely it is inexhaustible." However, it's equally possible to overwhelm people with an avalanche of seemingly hopeless information. "If you only had tough pictures, no one would look at them. The trick is to keep people engaged," says photographer Robert Glenn Ketchum.

Landscape photography is conventionally used to seduce and entertain. Concerned photographers have to compete with *Arizona Highways* and the popular scenic calendars beloved of environmental fund-raisers, which have been dubbed "eco-porn." And they must deal with the higher-toned versions made popular by Ansel Adams's glorious and misleading images of the West, which succeeded the tough, functional (and also grand) nineteenth-century expeditionary photographs. The Adams school is alive and well today: engrained notions of "high art" are not easily evaded. The overburdened word "beautiful," write Estelle Jussim and Elizabeth Lindquist-Cock, stands for "the last trace of the religious experience left in materialistic America."

A 1995 Salt exhibition and book was called "Maine, a Peopled Landscape." The title might seem odd except for the fact that visiting artists have long pictured "the rockbound coast of Maine" as an unpeopled landscape, inhabited, if at all, by grizzled fishermen and an occasional "farm girl." No sign of the long-haired young lobstermen in white rubber "gogo" boots or the junk-food addicted young mothers who show up at County Court asking for restraining orders against their abusive boyfriends, or the hardworking schoolteachers who cope with underfunded and culturally inadequate educational programs, and all those working several jobs in order to be able to stay in the state.

Olive Pierce has summered, and then spent more and more time on the Maine

180

There are activist photographers who have been struggling since the seventies to kick the Adams influence and to reinvent beauty in the service of the pragmatic and didactic motives informing those unintentional masters of the nineteenth century—Timothy O'Sullivan, Carleton Watkins, William Henry Jackson, Eadweard Muybridge, et al. Still drawn to "nature," contemporary western photo-activists are struggling to confront its less-than-god-given modern incarnation. It is an uphill struggle, however, because they are no longer introducing new and astounding subject matter to an avid public, as were their predecessors. On the contrary, informed by revisionist history, they are contradicting cherished fantasies when they display the ramifications of human occupancy. They juggle terrifying messages with the inherent beauty of landscapes—the unexpectedly gorgeous colors of pollution-generated skies and waters, blasted earth surfaces. David Hanson's *Wasteland*, an aerial series on the Montana Power Plant at Colstrip is a prime example, as are Peter Goin's books, *Nuclear Landscapes* and *Humanature*, and Richard Misrach's lunar military landscapes, with their nuked craters, gutted vehicles and weapon remains, parched and bathed in a golden glow of desert light. Lured to western deserts by their beauty, Misrach remained to chronicle the creeping ugliness at their hearts—from missile ranges to dead animal pits at local dumps to the detritus of settlement (plate 10). Misrach defends himself against the criticism that he is making "poetry of the holocaust," saying he has "come to believe that beauty can be a very powerful conveyor of difficult ideas. It engages people when they might otherwise look away." His work is the best-known example of a landscape art turned upon itself.

Photography is really hard because it's so easy.
—WILLIS HARTSHORN

Conventional landscape photography tends to overwhelm place with image. It is usually presented in fragments rather than in grounded sequences. Once wrenched from its context, the image, no matter how well intentioned or well researched, floats off into artland. In exhibitions of unrelated or loosely related landscapes with vague or lyrical titles identifying the subject or perhaps the site, a false image of unity is lifted from a fragmented world. No matter how aesthetically pleasing the results may be, places are boiled down into commodities. The photographer, having "been there," feels she's captured the place, but communicating it is another matter altogether. Cryptic titles and captions, or none at all, further distance the viewer from the subject by transforming it into a nonreferential object. Juxtaposition of two or more images sometimes proves a compelling strategy for making points; so do collage, aerial views, inventive installations, handwritten or autobiographical captions, names, dates, times—bits of information that bring the viewer closer to the images, traces of the awe and delight (or horror and discomfort) of being *there*.

In order to illuminate place not only for the artist but for others, photography must be more than a vignette or a series of vignettes. It must offer a sufficiently thorough and multilayered view to function as a visit or revisit to the place itself. In a series (whether in a book or not), one image can inform another and images and texts can inform one another, extending the sense of presence beyond the individually framed view.

MARK KLETT, *Auto petroglyph, Canyonlands, Utah, 6/21/89.* This rock drawing might have been made by a modern Navajo artist. Its modest scale and careful execution echoes the older and ancient rock art in the area, suggesting a certain respect for the subject as well as commenting on the extent to which the automobile has permeated our landscape. Klett says that the western landscape "is not so much a paradise to long for... as it is a mirror that reflects our own cultural image."

coast since the 1950s. She began photographing on "the Neck," near Rockland, in 1987, and her book *Upriver: The Story of a Maine Fishing Community* documents longstanding friendships and respect from the point of view of an acknowledged outsider.

"At first I was worried that the pictures I took and gave to people as offerings might offend them," she writes. "I feared that my view of their lives might seem too harsh. I tried for a while to soften my prints until I realized that I was compromising the truth of what I

saw....In Maine the terrain is land mined with cliches—the weathered house, the stack of lobster traps, the boat riding at anchor in the fog. To break through to a deeper layer of observation and to translate what is seen into a photograph that stands on its own as

But without generous caption information, even series can become simply handsome glimpses of a place that disappears from consciousness as fast as it disappears from sight.

The most innovative array of solutions to this dilemma is the *Laguna Canyon Project*, a two-decade-long interactive artwork by photographers Jerry Burchfield and Mark Chamberlain, who in resisting "countrycide"—the destruction of a beautiful nine-mile canyon by developers—have created a number of innovative actions, political and legal strategies, and photo-documentations. These include the "Tell," a giant communal image wall (plate 15), and, at ten-year intervals, two continuous photographic strips of the canyon road in daylight and "nightlight" which is probably the largest regional documentation ever undertaken. In the process of this mammoth endeavor, public and media attention was drawn to the Canyon's plight and the artists have enjoyed solid community support. They see the Laguna Canyon Road, a natural corridor to the Pacific and one of the largest open spaces left in Southern California, as "symbolic of the last nine miles of the westward migration." They have also proved the power of the cohesive landscape panorama, as opposed to the presentation of place as a discrete object seen from a single viewpoint, and contradicted the miniaturization of scale inherent in photography.

Between an exposed photographic plate and the contingent acts whereby people read that inscription and find sense in it lies the work of culture.
— ALAN TRACHTENBERG

Then there is the dilemma of meaning. Estelle Jussim and Elisabeth Lindquist-Cock state uncategorically

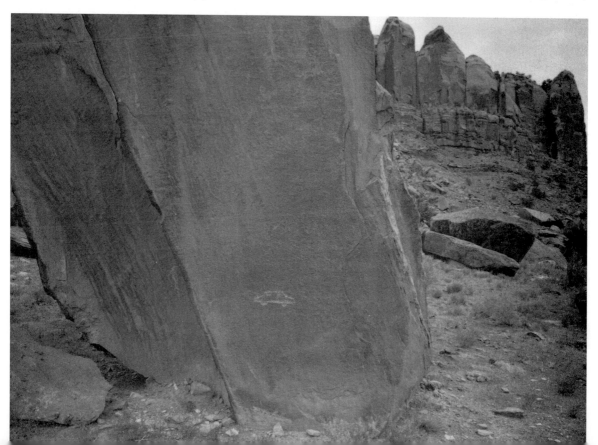

a picture has been my challenge."

Among the "word pictures" by native Mainer and novelist Carolyn Chute that accompany Pierce's own text and pictures: "Some call home by a number. Door numbers. Phone numbers. Don't that tickle you?"... and "Remember when you were a little kid? On gloomy days the fog horns mooed like huge sad cows and you would see the clothes hung on the lines like broken people"... and "Without Land, without a people and a history, you are a pauper. A fact of life. You cannot replace these with trinkets and little pretties and paper things that count as laws."

Clearcutting affects Georgetown directly as silt and chemicals leach out through the rivers to the marine environment. Located

that "landscape construed as the phenomenological world does not exist; landscape can only be symbolic." Many documentarians would disagree, yet the symbolic can also be seen as the thread that ties the local to the outside viewer. Photographer Mark Klett says his goal is to "lessen the distance one often feels when looking at landscape photographs....The longer I work, the more important it is to me to make photographs that tell my story as a participant, and not just an observer of the land."

Given the lack of public skills in reading photographs, given that photographic content is sometimes buried in beauty, contemporary landscape photographers are often condemned to making pictures as pretty as those of their predecessors. Dramatic clouds and sifting light can overwhelm more mundane information. Yet who can resist beautiful landscape pictures of one kind or another? Those photographers who reject strong composition and moving "effects" to make consciously "flat" images can produce works striking in their simplicity but eventually difficult to distinguish from others like them, stalling the memory factor that is of utmost importance in picturing places. And what viewer is moved to identify with a place or spends much time with neutral, factual images unless there is a hook—heightened beauty, familiarity, unfamiliarity, repulsion, fear or attraction? The role of aestheticization is the most difficult issue within the issue of communicating not only how the landscape looks, or seems, but how it *is*.

A prime example is *The Great Central Valley*, a large-format paperback book with color and black-and-white photos and long texts on the geography, history, and culture of "California's heartland" by three "locals"— photographers Robert Dawson (plate 9) and Stephen Johnson and writer Gerald Haslam (all raised in the Central Valley). Lively and encyclopedic, it could teach

DREX BROOKS, *Bad Axe Massacre Site, Wisconsin*, 1992, gelatin silver print. Brooks' book, *Sweet Medicine* (after a Cheyenne cultural hero who taught people the right and good way to live) documents the sites of major battles or treaties with and massacres of Native people during the takeover of the West. Once the histories are known, these lonely, beautiful, bleak, ordinary, pleasant or ludicrous places are transformed. At the junction of the Bad Axe and Mississippi Rivers, where a stage for suburban living has been set on a peaceful natural scene, the underlying history is invisible. Yet here, in August 1832, the Sauk and Fox leader, Black Hawk, and the remainder of his people fought their last battle and were massacred by whites. The rivers ran red with blood. Black Hawk escaped death and was imprisoned. He said, "I loved my towns, my cornfields, and the home of my people. I fought for it." A Wisconsin football team is now called the Black Hawks.

the inhabitants of the area a tremendous amount if— and it's a big if—they had the time, money, and inclination to explore the 253 pages of this book, which should indeed be on every Valley coffee table. Ideally, models like *The Great Central Valley* or Kenneth Helphand's and Ellen Manchester's *Colorado: Visions of an American Landscape*, and other works mentioned here could be applied to any specific place in collaboration with those who live there.

between a major river and a long tidal estuary, Georgetown's detritus offers a synopsis of life upstream. Each fall, the town's Conservation Commission sponsors participation in the national Coastal Cleanup. The commonest finds are all kinds of styrofoam, cigarette butts and lighters, plastic containers, tires, shingles, lobster traps and tangled rope. One year we took over 400 pounds of rubbish from Stage Island, littered mostly from upriver and the sea.

Linda Tatelbaum writes of a blueberry field strewn with cone wrappers. "Does this spot mark the exact distance it takes to eat a slush-cone, as measured from the point of origin, the village store a mile below us? Was it one child on a bike, one adult's stolen pleasures?...But then, who's to say that humans

The deterioration of one small field, the gradual disappearance of grass and the appearance in its place of greasewood, cholla, tumbleweed, or the reappearance of certain grasses and wildflowers, the fences, roads, development, could (and sometimes do) occupy a photographer for years, as could historical research on how that place once looked and was used. Then what? How do we bring such loving records together to heal the land and its communities? How can the contents of archives and exhibitions be made more broadly available to those whose fields and streams need help?

One of the ways contemporary photographers have found to be subversive as well as aesthetically appealing is to shoot what can't be seen—what has happened to the land (as in Skeet McAuley's sylvan photographs of the invisible Alaska Pipeline), or what has happened on the land. When Drex Brooks, a Salt Lake City-based photographer, began photographing the sites of massacres of indigenous people and other cataclysmic events of the contact period for his book *Sweet Medicine*, he spent as much time in the library as in the field, digging for the incriminating or inspiring quotes from whites and Natives that accompany the images. Knowledge of the context is crucial. The viewer must be encouraged to look under the surface of the images to the place's past, to the histories we are not taught in schools. Otherwise, what would we associate with Brooks's Trailways tour bus (Sand Creek Massacre site), the swimming float with chairs on a lake (Bad Axe, Wisconsin), or the evocative hill with a mowed path curving across it (Bear Paw Mountains in Montana, site of the surrender of the Nez Perce in exile)? Brooks points out that Euro-American cultural landmarks and battlefields tend to be full-fledged parks, with mowed lawns, interpretive markers, and visitor centers, whereas Indian sites are often unmarked: "There's no way the average person driving by would even know that something terrible happened here."

The investigation of a specific site is a matter of extracting concepts out of existing sense-data through direct perceptions....One does not impose, but rather expose the site....The unknown areas of sites can best be explored by artists.
— ROBERT SMITHSON

Photography presents one set of models for looking at the global consequences of the use or abuse of local land. More (and less) specific artworks dealing with these issues in place, or on site, present a different set of models and problems—especially when so-called environmental or ecological artists try to project global issues onto local places which often are not their own, but selected or commissioned through national competitions. (Given the huge expense of constructing such works, there is rarely any other option.) Many of these ecologically oriented artists, whose site-reclamation work is impressive in the context of art and general environmental issues, have only a tenuous connection to the local as I understand it, so I will only trace the history and mention a few works here in order to establish the relationship between this kind of land art *in* place and an art that is more deeply involved *with* place.

Although they may be aware of local-global connections, few artists are equipped to do more than comment on them. How does one deal with multifaceted situations like how water from the Little Colorado River, contaminated by Utah's uranium mines, ends up in the agricultural fields of California where so much of the nation's produce is grown? Art reclamation must stem from a real sense of informed urgency. It should take place only if art will improve rather than merely decorate or even comment on devastated

are bad for littering the earth? Maybe those people with littered yards find the design as beautiful as a cluster of daffodils or a restored stone wall. If the natural order includes us, shouldn't it include what we fling as much as what we arrange?"

When I was a kid we dumped "wet garbage" off the rocks below my grandmother's house—on an outgoing tide, which didn't keep the beach from being swamped by bright red lobster shells, orange peels and other persistent debris. At the end of the

Point some families had wooden garbage shoots into the bay. We live too far down the bay for this, so we buried the "garbage" in the meadow, burned the paper, and tossed the "rubbish" in a dump deep in the woods.(I went back there a few years ago

184

sites, only if lessons can be learned that will have some impact on the future of local communities. Sometimes the role of art is to provide information that can be used locally, but we are easily glutted on information for information's sake and often fail to act on what we're learning. Environmental or ecological art can never be more than a shot in the arm until it becomes part of the broader grassroots movement that transcends private responses to fundamental social reconstruction.

Since the late sixties, when Robert Smithson initiated the notion of working with "entropic landscapes" to reclaim damaged nature as culture, a few brave and persistent artists have lobbied for funding to reclaim mines, landfills, clearcuts, and other industrial wounds, though rarely in their own neighborhoods. In the late seventies, when more stringent environmental laws took effect, companies were taxed and fined in order to cover restoration costs and provide new sources of funding for the enterprising artist or landscape architect who was willing to take on the bureaucracy. This opened the door for more artists to make grand-scale works on the land.

In 1978, the King County Arts Commission in Washington state—which continues to be a leader in the field—embarked on a major group of land reclamation artworks, breaking significant ground despite

the scarcity of other-than-aesthetic success. In 1985, Paul Klite (artist, musician, physician, producer of the innovative independent environmental radio program "Terra Infirma," and founder of the Rocky Mountain Media Watch) wrote an important report for the Colorado Council on the Arts and Humanities and the Colorado Mined Land Reclamation Division, in which four sites that were ripe for rehabilitation were detailed and solutions recommended. Typically, through no fault of Klite's, nothing much came of it. An artist picking up on one of these sites would have had years of work cut out; bureaucratic red-tape and fund-raising precede the actual artmaking by such a long period that few plans survive. Most artists want to make art, and they are reluctant to spend the immense amount of time and energy it takes for the community research that will determine whether the art, once made, will do more than provide a Band-aid or cover-up for corporate abuse.

JOHN CRAIG FREEMAN, *Operation Greenrun II*, digital mosaic laser prints with night lighting, 10 x 40' each, on a line of eleven billboards, Highway 93, Rocky Flats, Colorado, November, 1990-April, 1991, sponsored by Greenpeace (Photo: Bill Stamets). The eye-catching dayglo texts and huge serial images (eerily masked nuclear workers on one side and an underwater atomic explosion on the other) lined the road just outside the Rocky Flats nuclear weapons plant, where plutonium triggers were still being manufactured 16 miles upwind of Denver. The texts read: TODAY...WE MADE...A 250,000 YEAR...COMMITMENT; and, on the other side: BUILDING...MORE...BOMBS... IS...A NUCLEAR...WASTE. Thanks to the intrusive nature of the billboard, it has become a challenging (and contradictory) medium for progressive artists. This series attracted flack from several groups: those who felt that the environment was being raped in order to save it; the plant's workers, caught between jobs and safety; those who avoided the political issues in favor of unblemished scenery; and those who pointed out that the scenic beauty was rather drastically deflowered by the presence of a giant nuclear plant and leaking plutonium. Extensive media attention insured that even those who never drove by got a hit of the artist's message.

and found a little red and white wooden windmill I'd had as a child.)

Finally Georgetown got a "dump," which I've watched begin, become a "landfill," then be transformed from Fred Fox's domain of set-aside retrievable objects and smoldering piles of garbage assiduously attended by seagulls to the current clean, efficient, still friendly "transfer station." The pay-per-bag option has been considered in Georgetown and is used elsewhere in Maine, but it is likely to increase "private" dumping in the woods and roadsides by those who don't have the money or won't spend it.

Acid rain carries toxic heavy metals from unregulated coal-burning power plants in the midwest to high elevation trees in New England, weakening them until they

During the eighties it became a matter of course to call in artists to make proposals to reclaim or beautify landfills and sewage plants. Parks, bicycle walks, artificial wetlands, and wildlife refuges are now part of the sculptor's vocabulary, and it would be impossible to do justice to all of the projects underway today. Rather than playing on our fears or ideals and asking us to act on them (as activist and "political" artists often do), these artists are trying to turn this impetus into renewed, rejuvenated places, which sometimes evoke local social and ecological history.

The leading figures in the field of reclamation art are the longtime team of Helen Mayer Harrison and Newton Harrison, who work out of San Diego, and have often projected visionary reconceptualizations of their home turf. Knowledgeable in several disciplines, the Harrisons are known internationally for their scientifically viable suggestions about how to heal vast, damaged landscapes and waterways. By knowing the parts as well as the whole, by employing storytelling as a device with which to capture and inform their audiences, by using the artist's eye in the public interest, they provide models and metaphoric solutions in the form of many brilliant art-life projects— which, unfortunately, almost never get executed. Is this because the world isn't ready for artists who think across boundaries like this? Do they think too big for artists? Or is their approach flawed in some way that reflects the discipline and context of contemporary art itself, so long inbred and separated from common ground that its peculiarities are ineradicable?

I had hoped to work with the Harrisons on a project for Boulder, Colorado, when I was living there in the late eighties. They planned to relate the area's whole hurting watershed to the city and its surroundings: among the components were to be a mural in the center of Boulder that mapped and explained the watershed, a "constructed wetland" functioning as a filter at the local sewage plant, and the marking of symbolic points in the mountains crucial to the water supply. I attended a groundbreaking meeting at the sewage plant where artist and municipal management traded ideas. Then the administration changed, the funding never came, and the project fell through, to my great disappointment, as I had hoped for once to follow a public project from the beginning through all its bureaucratic labyrinths to completion.

If it had been the purpose of human activity on earth to bring the planet to the edge of ruin, no more efficient mechanism could have been invented than the market economy.
— JEREMY SEABROOK

If place-specific artists have perhaps been intimidated by the technological scope of hazardous waste issues, they have felt somewhat more at home with domestic trash. Stuff is being used up the way the land once was: consumerism has taken the place of expansionism. We are so inured to garbage on our streets and roadsides that it only shocks us to see it in museums. The environmentalist's credo—*reduce, reuse, recycle* —has yet to be taken seriously, for all the recycling busywork (which helps, but is not enough). Homeless people are probably our greatest experts in the field of garbage analysis, the unacknowledged leaders of the recycling movement. They are joined by William Rathje, an archaeologist at the University of Arizona who, as director of the "Garbage Project," has spent twenty years plowing through the time capsules that are the landfills and dumpsters of contemporary life, exploring society at its bottom line.

Like many artists and archaeologists before them, Rathje reads trash as a sociological text. (In the mid seventies the Brazilian American artist Regina Vater

succumb more easily to winter. Red spruces are actually changing their chemical content to cope with the metals, although the balsam firs right next to them are not. In summer, 1995, Phippsburg, across the river from us, turned up on national maps as the site of the second highest maximum hourly average ozone concentration in New England. Since then, air requirements are being toughened.

The only land art that comes to mind in Georgetown and environs are some lovely ongoing organic scultures by Marguerite Karhl in the woods around her house in Arrowsic and a temporary piece Ron Leax made in the woods several years ago, featuring a shelf of books weathering through the months; it was taken as a site of devil wor-

translated this into place-reflective art when she photographed the trash discarded in neighborhoods occupied by different social classes.) Local dumps are a key to local affluence and our national creed of planned obsolesence: wealthy people throw away working appliances when they remodel, so they can be replaced by others in a different color. About 30 percent of the nation's garbage, Rathje says, comes from demolished buildings, and Americans throw away nearly 20 percent of the food they buy in grocery stores, especially fresh produce. At the same time, "greenwashing" by culprit corporations boondoggles us with names; we buy products named after natural forces—Surf, Tide, Dawn, Brightwater—and their packaging turns up in landfills. The beneficently-named group "Oregon Citizens for Recycling" was in fact formed by Union Carbide, Dow Chemical, Chevron, Exxon, and Occidental Chemical, which spent two million dollars defeating a ballot measure offering more effective recycling that might have cost them money.

"What would it take to accomplish the serious wrenching full scale readjustments that are in fact necessary to save the earth, including reduced standards of living, consumption, and growth; severe population reduction, and a new, modest, regardful relationship with the earth and its species?" asks Kirkpatrick Sale. There are artists who would love to take a whack at it. Milenko Matanovic, for example, encouraged the rest of us to share the public burdens in a media-targeted project called "Trash Hold"—an "eco-robic excercise to 'trim our waste.'" Executed in Chatanooga, in 1991, it involved participants (the higher profile the better) who for one week dragged around specially designed bags of their personal garbage in order to publicize the extent of individual use. In a closing ceremony they gathered to recyle all but twenty of two-hundred-sixty pounds.

Jo Hanson began her "Art That's Sweeping the City" in the early seventies, sweeping up the trash in front of her San Francisco home as a performance, and then exhibiting it in one form or another to call people's attention to its accumulation. A long list of "garbage girls" (and some boys) among them Christy Rupp, Ciel Bergman and Nancy Merrill, Jerrilea Zempel, Cecilia Vicuña, Dominique Mazeaud, Kristine Smock, Michael Bramwell and Cheri Gaulke, have made rubbish-based artworks, exhibitions, and installations over the last twenty years. A disproportionate number of these artists are women, who identify, for obvious reasons, with those who do the dirty work.

In the early seventies, having defined women's social role as "unification...the perpetuation and maintenance of the species, survival systems, equilibrium," Mierle Laderman Ukeles—big sister of the garbage girls—asked the decidedly local question that continues to resonate today: "After the revolution, who's going to take out the garbage on Monday morning?" If many seem to have given up on that particular revolution and replaced it with "paradigm shifts," the trash remains. Ukeles developed her "maintenance art" by working from home and childcare to museums to office buildings to the whole city of New York, becoming the (unsalaried) "official artist in residence of the New York City Department of Sanitation" in 1979. One of her many functions is to humanize and thank those who do the dirty work. She has shaken the hand of each of the eight thousand New York City sanitation workers, choreographed ballets with garbage trucks and barges, built celebratory gateways and roadways of trash, recyclables, and workers' gloves.

Landfills have been Ukeles's longstanding concern. What could be more local than a landfill, embracing all our buried secrets? "Can the same inventiveness that we use for production and accumulation of goods be

ship by a local hunter when he found deer tracks (cloven hooves!) around it.

There is little land art being made in Maine, but parks take its place. Georgetown's Reid State Park, on land donated by a local boy who made good, is happily unimaginative. Parking lot, concessions, and bathing lagoon back up the mile and a half of ocean beaches and tidal "river," which stand on their own by the relentless waters. Less known is "Ledgemere" in Five Islands—rocky coast and wooded trails on private land, open to local residents only.

Before the clearcutting ban, RESTORE: The North Woods, based in Massachusetts (one strike against it) proposed a 3.2 million-acre Maine Woods National Park. It was opposed by many native Mainers who

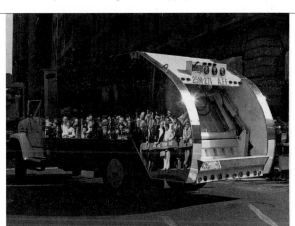

MIERLE LADERMAN UKELES with the New York City Department of Sanitation, *The Social Mirror*, 1983, mirror-covered garbage truck (Photo: courtesy Ronald Feldman Fine Arts, New York). The trucks were "floats" in a parade and the onlookers—those who had produced the garbage—were in a sense incorporated back into their place, their refuse, or refusals.

applied to its disposal?" asks Ukeles, suggesting that the problem of citizens' unwillingness to take responsibility for the garbage we produce reflects our inability to visualize our relationship to our world as a whole. Working on a grand scale at the Fresh Kills Landfill on Staten Island, she observes that when it is filled up—becoming a ragged pyramid roughly twice the size of the largest pyramid in Egypt—it will be our largest social form, a monument to what we have "created in common, from what we have all made together."

Ukeles's magnum opus is *Flow City*, almost completed at the new Marine Transfer Facility on a Hudson River pier. It consists of a series of three participatory environments and observation points: a Passage Ramp made of trash, a Glass Bridge for viewing the work environment, and a Media Flow Wall to inform and connect with other facilities. Public access will expose for the first time the guts and underbelly of urban circulation. For Ukeles, Patricia Phillips observes, "public art

provides a unique position from which to forge connections between the public sphere and the private."

Those garbage artists who are exploring local places rather than making general comments on global issues see themselves as salvage artists in both a social and aesthetic sense, salvaging materials, salvaging places and their memories, then combining them in objects that they hope will transcend the decorative. In 1990, a bicultural, bilingual group of Vermont and Quebec artists collaborated on a project called "Deadlines/*ça presse*," a two-part show of artworks about acid rain; partially inspired by the Canadian interdisciplinary artists' group Boreal Multi Media, from rural LaMacaza in the Laurentians, it traveled to schools and other sites in both countries. There are thirty thousand dead lakes in eastern Canada, thanks to a fine polluted stew including the aerial garbage from midwestern U.S. smokestacks. The show was conceived as a border-crossing wake-up call. The real test, however, is how audiences understand and are moved by the art. An exhibition on environmental distress at the Burlington, Vermont, airport provoked one baffled and annoyed airport employee to comment that he'd learned a lot about art; but the idea was that he learn a lot about the environment.

Disregard for local conditions can be disastrous. In 1985–86, Michael Heizer, a well-known early earthworks artist who is more often accused of raping Mother Earth than reclaiming her, executed *Effigy Tumuli* in Ottawa, Illinois, working in conjunction with the Ottawa Silica Company and a philanthropist in an attempt to reclaim a forest the company had destroyed, then donated to the state. Billed as "the largest site sculpture in the world," Heizer's piece consists of five earth mounds in the geometricized shapes of indigenous wildlife: a frog, a water spider, a turtle, a catfish, and a snake, modeled on the prehistoric Mound-

feared not only for their jobs and land, but for traditional hunting and fishing rights and access for the popular snomobile or skidoo. Two bumper stickers tell this story: "RESTORE: THE NORTH WOODS" and "KEEP MAINE FREE. NO RESTORE FOR ME."

(Me. is the state's postal code, lending itself to individual/collective whimsies.)

In Buxton, farmer Robert Shephard made a "Barn Yard Golf Course" where the player (with tennis balls) must dodge hulks of rusting farm machinery and old cars. In

Brunswick, Ernest Jewett Jr., 69, who has been accumulating junk in his yard since childhood, says the cars, buses and trucks are "just my own private collection, more or less."

Eric Rand of Little Diamond Island decided that because he was so good at

builders' effigy sites in the area, built for ceremonial purposes and sometimes burials. "The principle of cooperating with people to make this thing buildable was where the real challenge lay," said the artist. Indeed. The mounds, which replaced a popular local rifle range and dirtbike trails, are visible as a whole only from the air. Aside from the problem of local opposition (including vandalized earth moving machinery and bullet-riddled signs) and the secularization of Native religious sources, nature also took a swat at Heizer's piece; the grass which was supposed to cover the mounds never materialized in the poisoned soil and in a decade erosion has turned the effigies into blobs, rapidly being reclaimed by the earth. The "park" is now closed.

Erika Doss has written an acute analysis of *Effigy Tumuli*'s failure in its social context, exploring "opposing definitions of public space" from the viewpoints of off-road vehicle buffs (a romanticized if updated cowboy activity), corporate philanthropy, artists, and audiences. She quotes the late Paul Smith, a local biker and diehard opponent of the project: "They might reopen it, but nobody is going to come to see it anyway. There is still nothing to it but a few dirt hills. You can't tell what it is unless you read their little signs. The conservationists call what we do on our dirt bikes 'land abuse,' but we call it 'land use.' We took a wasteland and we used it. They ruined it so nobody uses it."

Heizer has repeatedly described his work (including two monumental architectural sculptures in the Nevada desert) as "American art," calling upon the scale and ambition of the frontier mentality. (British "walking artist" Richard Long has called monumental land art a megalomaniac American invention involving bulldozers and the control of nature.) Heizer is still working on a piece one mile long and five-

hundred feet high in the long-suffering state of Nevada. It will in a sense replace a nearby mountain, which is being removed by an Anaconda mining operation and donated piecemeal to the artist.

Classic "earth art" or "land art" like Heizer's, along with many other major earthworks executed mostly in the sixties and seventies, is a curious hybrid—a monumental art object in the landscape which takes much of its power from distance: distance from people, from issues, and even from places. It is site-specific but not place-specific. This macro-view of art on the land disturbs me because artists tend to wander in with a preconceived idea, often a pretty grandiose one, rather than giving the land itself time to speak. Surrounding landforms are usually secondary to the earthworks rather than part of them, and the place's own history and identity are rarely acknowledged.

Any place is diminished when it becomes merely a backdrop. Although art on the land was touted at one point (by me, among others) as an escape from the "precious object" and commercial-institutional white rooms, such work remains confined in modernist isolation. It has not escaped the definition of object art as a view, a spectacle, a picture. Land becomes the raw material or the space around the art, a kind of mat

EDWARD RANNEY, *Star Axis, looking south, 1/7/83.* This masterful photograph of a monumental land art work in progress exposes both its potential grandeur and its devastation of the land, as a New Mexico mesa is gouged and littered in service of an artist's vision. Ranney writes that artist Charles Ross, who has been constructing *Star Axis* for over twenty years, is moved by a desire "to integrate our complex knowledge of the space age with a profound sensory experience of the heavens." Ross himself says, "By entering the earth to reach the stars, you can see and feel how the human form is scaled to fit the cosmos." His naked-eye observatory will place the viewer in scale with Polaris' orbit, telescoping time and illustrating precession. Ranney, who lives in New Mexico, has focused for years on the intersections of ancient and modern alterations of the land and their spiritual impacts.

catching fish and did so much damage, the ethical choice was to become an artist. "There's a few of us who say, 'Hey, fishing's provided me a way of life for a long time. It's time for us to give something back.'" While he brainstorms with fishermen and scientists, he is making life-size wire sculptures of tuna, cod, skate, and seals, made from found materials, hoping, ironically, to support himself by art while working to build a healthier fishery. He asks his fishermen friends if they fish for living or because they love it. "The question makes many squirm....'Geez, don't ask me that! Why'd you ask me that for?'"

within the frame of the photograph. In fact, most of us envision rather than visit the classic land artworks, our impressions mediated by the glamorous aerial views we've seen in publications. As tourists, or pilgrims, to the great land art sites, our expectations determine to a large extent what we see out there in the great unfamiliar, and what we overlook.

Land art is identified with the American West, which offers immense space and inexpensive real estate. In the sixties and seventies, it tended to be made and most admired by citydwellers—often based in the East, though they may have been born elsewhere —people who loved the outdoors, who spent time in open spaces. The art is often aggrandized by the scale of its surroundings, although it goes both ways: the landscape can also dwarf or flatten uncongenial art. Scale and distance are in any case still perceived as necessary components, and carry certain "spiritual" implications as well. The artwork is endowed with the land's emotional power, and the viewer is as affected by the space as by the object, often more so.

Land artists should not be exempted from a place

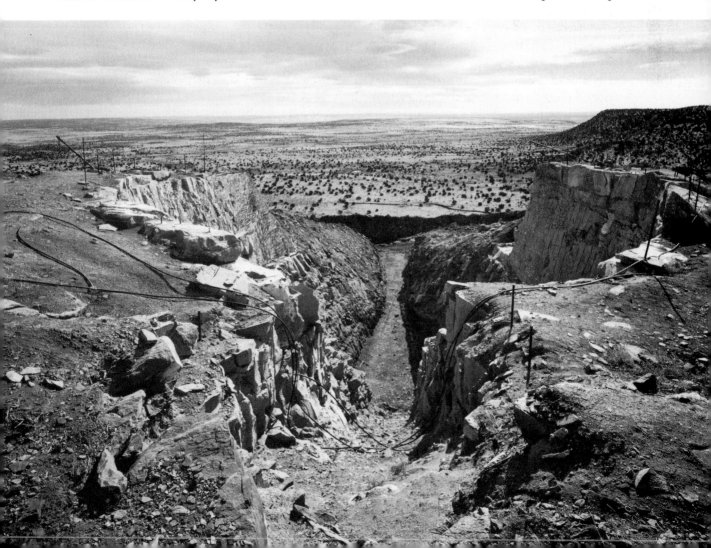

The Former Todd's Store, 1995 (Photo: Peter Woodruff). With its gas pumps gone and bordering Robinhood Cove, the store is now a fitting part-time home for Will Ansel, a dedicated part-time boat builder who has been working on this twenty-seven-foot Block Island inshore dragger for some four years now. He has built several other boats here and elsewhere and sailed them in local waters.

190

ethic, a respect and responsibility for place that is rooted more deeply than an aesthetic version of "the tourist gaze." Artists working on major earthworks have more opportunity to become intimate with a place than those parachuted in from elsewhere for a commission or because they like the view, so their responsibility is augmented. The real story is told by traces on the land of geological, biological, anthropological use—the farthest spaces and the closest detail underfoot. These are presumably of great interest to visual artists, not merely as forms and colors constantly changing when light and shadow sweep over them, not merely as raw materials, but also because of what they have to say about who we are, what cultures and ecosystems have lived and merged and disappeared into this place. If land art is to evolve into something more than artists indulging their desire for scale and monumental presence on the land, and documenting their individual passages through it, that old populist question has to be asked: Who is it for?

Land artists often pay lip service to "ecology" while serving the function of "beauty strippers" (as in those narrow wooded strips along highways that deceive the passerby into thinking they are backed up by real forests). While ecological artists can point out existing

FARMER JOHN MURALS (Photo: Peter Kenner, reproduced courtesy of Farmer John Brand). One of the country's great murals commemorates rural life and animal husbandry with lively empathy on the brick walls of the Farmer John Brand, Clougherty Meat Packing Co. in the desolate industrial suburb of Vernon, California. Les Grimes, who had once painted movie scenery, worked on it from 1957 to 1968, when he died in a fall from the scaffolding. The murals were then augmented, but never finished, by Arno Jordan. The life of a farm, its landscapes, and its happily wallowing pigs, was brought with realist (and somewhat surrealist) humor and exuberance to the walls where those same happy pigs met their fates. Artist Susan Hopmans was so taken by the murals that she published a small book on them in 1971 with Kenner's photographs.

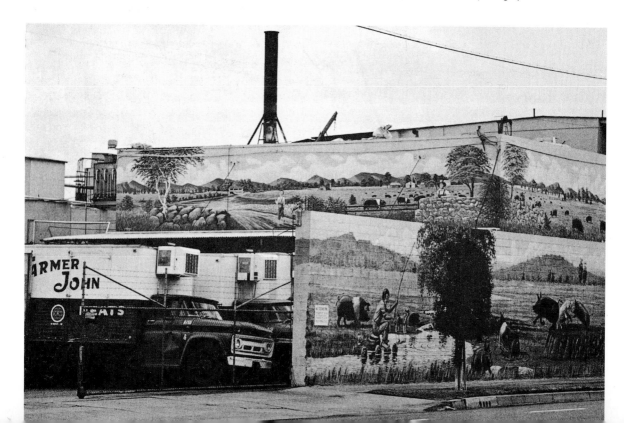

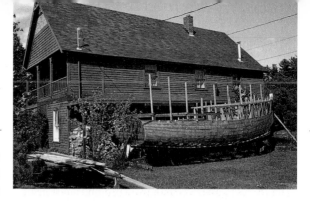

This one is called the Guillemot, after a seabird that guided him out of a tough spot when he was sailing in the fog. The process becomes something of a public performance, since his house stands just opposite the Georgetown Post Office on the road to Reid State Park.

eco-systems and existing abuses, or "reclaim" the damage, they can also point to the culprits and create social critiques that might bring about change. If they are simply paid by corporations to cover up corporate negligence, to metaphorically replace topsoil while ignoring the poisons that continue to lurk beneath, they become accomplices rather than healers.

In his *Revival Field* (an exemplary ongoing work first executed in 1991), Mel Chin chose to transform the land from within rather than reforming it from outside: the result is rings of hyperaccumulating plantings that are effective toxic cleansers but abjure a monumental profile. I would like to see more artists look closer, like this, turning the macro-dialogue on land art toward a micro-view of the land rather than the art. When too much focus is placed on the art as such, we lose something in the way of depth, meaning, content, context, which necessarily relates out to more people rather than vanishing into the art world.

A rural public art would be very different from the prevailing notion of land art, involving not art tourists

TEX WELCH, *Street Sign for Tatum N.M.* (Photo: Anna Christine Hansen). Welch's father, O.J., began making metal cut-outs as a hobby; when Tex Welch lost his job in the oil fields, he started Westcraft Metal Arts as a business to produce signs, bootjacks, weather vanes and other objects. The street signs for Tatum's main roads are all Welch creations, scenes from the Southwest.

but local people for whom desert, farm, or rangeland is not exotic. Place-specific art illuminates its location rather than just occupying it. One way to understand what a place-specific rural art might be is to look at what the people there like to look at.

Farm families see a lot of the outdoors in the course of their work; when they are indoors, they want to know it. Houses on working farms, despite handsome views, are less likely to have picture windows or lots of glass than suburban houses that open onto nothing more than the street and their own mirror images. I'd like to see a survey of the views from rural kitchen windows and of the pictures hanging in the living rooms. Are they photographs? Paintings? Landscapes? And if so, are they landscapes that mirror what lies outside the window or do people in the prairies prefer alpine views while those in the mountains prefer cowboys among cactuses? I suspect that the more familiar views, especially if idealized, win out.

Aside from the ubiquitous landscape painting— white house, red barn, green fields, black-and-white cattle (mostly painted by visitors and summer people) —there is little "high" rural art being made on farms or about farming from the inside, given isolation, long work days, often conservative politics and limited finances and education. Yet farm people are as likely to want solace and escape, or affirmation of their ways of life, as the next person. (William Kittredge says of Westerners who love Charlie Russell's nostalgic cowboy paintings: "these were country people who didn't know much about painting but loved the idea that somebody had taken their part of the world so seriously.") For landbased people, art as decoration has its place, as it does for all of us, but art defined by

separation between land and life, place and self, is largely irrelevant. An occasional mural, a local fair or rodeo, ornamental ranch gates, a religious or patriotic celebration, even graffiti, are more likely to represent land-related concerns.

Little attention is paid by anybody, inside or outside, to the vernacular artists who have burst out of the usual and sometimes even out of acceptable decorative conventions. A good many vernacular artworks are just figures with no ground which seem to deny their place in place. But it is possible that the common ground is taken for granted, that "everyone" will know just where those figures stand. Other paintings recall childhood or surrounding places in exquisite detail that only a neighbor would appreciate. Self-taught art—from quilts and paintings to embossed leatherwork or welded ironwork or root-and-burl sculptures—is an exercise in rehabilitation and restoration, an assertion of existence and of the importance of one community, one place.

In the well-named and admirably expansive 1984 exhibition *We Came to Where We Were Supposed to Be* (a phrase from the local Paiute-Shoshone), the work of Coeur d'Alene, Nez Perce, Shoshone, Mexican American, Basque, Finnish American and Mormon artists was brought together. Sponsored by the Idaho Commission on the Arts and curated by Steve Siporin, it included buckaroo saddles, quilts, rugs, parfleches, belts, embroideries, waxflower ornaments, cradle-boards, wagon wheel fences, whittled fans, baskets, mailboxes, miniature machines, whirligigs, tools, fishing flies and branding irons, as well as conventional sculpture and painting. While few of these items "picture" the landscape, all are integral parts of or comprehensible references to life within it; they are kinetic acts of identification with place. Few false (and unnecessary) distinctions were made between utilitarian object and "useless" art. "This idea of art *creating* community cultural realities challenges our usual notion of art—especially folk art—as a static reflection of societal values."

In England and Australia, there is a growing number of rural community arts projects, often organized with young people, elders, or the unemployed. It hasn't happened much here yet, although the Land Stewardship Trust, based in Stillwater, Minnesota, has been successfully circulating Nancy Paddock's one-woman one-act play called *Planting in the Dust*, which can be staged with only a kitchen table, a chair, and a rocking chair in a small performing space. Based on rural oral histories, it has been well received by churches, historical societies, schools, and conservation groups. Its motto: "Let's stop treating our soil like dirt!" Its credo: "The land belongs to itself. If anything we belong to it...as much as earth worms or corn plants. We rise up a while and sink back in....we borrow our lives from it."

Plate 1: *Sagadahoc Bay*, 1996 (Photo: Peter Woodruff). Looking out to sea from between Far Beach and Far Far Beach on the edge of Bedroom Bay, with Kennebec Point extending to the right, Indian Point and Salter's Island to the left and Seguin (which both Indians and Champlain called "the hump" or "the turtle") in the distance.

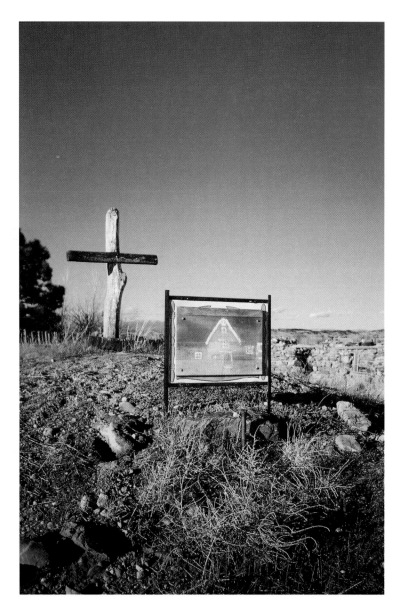

Plate 2: ANTONIO ANAYA, *Church on the Hill*, Galisteo, New Mexico, 1994 (Photo: Lucy R. Lippard). This little painting stands on a mound of rubble amid old adobe houses, commemorating a little nineteenth-century church. It was replaced in 1884 by another church, which is also dedicated to Nuestra Señora de los Remedios. The artist's nearby home is surrounded by a changing yard-art display of found and created paintings, sculptures, stuffed animals, and other objects. The Anayas were among the village's early settlers and remain a large and influential local family.

Plate 3: SKEET MCAULEY, *Spanish Church Ruin on Ancient Pueblo Site, Pecos National Monument, New Mexico*, 1983 (Copyright Skeet McAuley). This image is a palimpsest of impositions. The Spanish imposed their culture and religion on the very ground where the Pueblo people lived, then after the Pueblo revolt of 1680, the Native people took their revenge and built a large kiva in the ruins of the mission's *convento*, reasserting their own values. The terrible droughts that contributed to the eventual abandonment of the Pecos Pueblo are ironically suggested by the brilliant green grass and sprinkler, trademarks of its current caretakers, the National Parks Service. "Anachronism is one of McCauley's subjects," writes Scott Momaday, who calls the photographer's work the "concentration of the American earth, its surface and its depth."

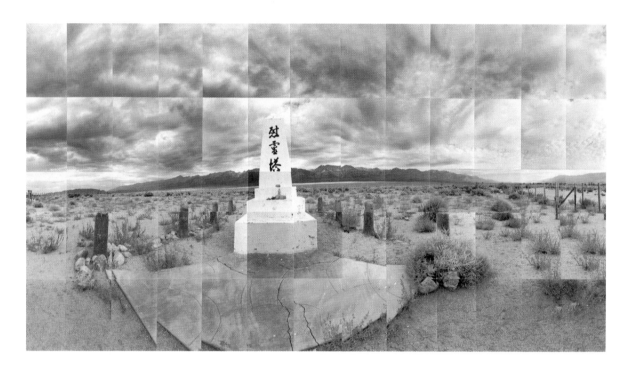

Plate 4: MASUMI HAYASHI, *Manzenar Relocation Camp, Monument*, 1995, panoramic photo-collage. From "American Concentration Camps," 1990-95, a series of 360-degree panoramas made up of many sequential snapshot fragments. Hayashi is concerned with mapping space and suggesting panoptic surveillance methods by "surrounding" the viewer, who "becomes both prisoner and guard within the photograph's memory." Her photo collages also represent "the gestalt of looking at many fractured images and seeing a unified whole." Installed as a whole, the series is "the collective voice that reaches out beyond memory." The actual voices of internees are also heard in taped interviews with survivors. Hayashi was born at the Gila River Relocation Center in Arizona, and her photographs (funded in part by her government reparation) are her own contribution to this dialogue. From each site, she collects rocks for her Buddhist home shrine, acknowledging a still deeper relationship to these places, a process of "making peace with the land" paralleled by her concurrent series on EPA Superfund sites.

Plate 5: NANCY O'CONNOR, *The Trees That Brought Faith to Me*, 1979, text by Milam Thompson, Cibachrome photographs with oil, tempera, wax pencil, varnish, 39" x 45" (copyright Nancy O'Connor). For twenty years, since attending a memorial service for a cowboy named Spencer Cook, Nancy O'Connor has been researching, documenting, and making art about the lives of African American cowboys (some third or fourth-generation) from Lewis Bend, near her Texas hometown. She has gathered over 3,000 hours of audio—ranging from church services to ghost stories to recipes—and a collection of objects and old photographs. The first-person narratives, matter-of-fact and poetic, are remarkable testimonies to a disappearing way of life and the spiritual value of connection to the land. In this piece, O'Connor's longtime collaborator Milam Thompson, at the age of seventy-four, pays homage to the tree as a source of food ("It was the tree that I have got my eats from such as pecans, grapes, ploms, peaches...."), of money ("I have sold a few dollars worth of fur in my day"), of memory ("As I look at these Trees it brings my mind back to my boy hod days," when he climbed tres and rode their limbs like horses), of nocturnal adventure ("I love to shine eyes up in trees"). He recalls trees by the streams as footbridges, washing and chopping block, and writes, "I have look the trees more than any one thing in the world they have meant so much to me...oh the tree is a great thing that God maded on the earth...."

Plate 6: DAVID BUCKLAND, *The Farming Couple; The Futures Man*, from *The Agri-Economy*, 1989, commissioned by First Bank System, Collection Minneapolis Institute of Arts. James and Elaine Braulick moved to their 240-acre farm on their wedding night in 1948, raising soybeans, corn, small grain, and a few cattle. They still lived there in 1989 but had sold and rented some of their land. James says of Elaine that she still drives the tractor, but "can't lift bales any more like she did when she was young." Of their eight children, one daughter still lives on a nearby farm, although both she and her husband work in nearby towns. Braulick concedes that it would have been impossible for him to start farming, the way things are today. Charlie Gallup, the Futures Man, who has a degree in Ag-Economics, says, "The farmers are becoming more and more educated in the futures market. They have had to.... No longer can you just be good at growing your crop,... you have to be good at marketing it too."

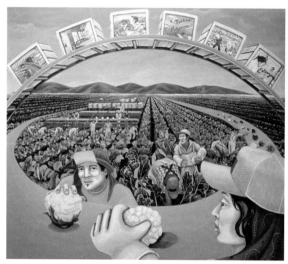

Plate 7: JUDITH F. BACA, *Founders of Guadalupe; Farmworkers at Guadalupe*, 1990, two of four murals, 8' x 7', Guadalupe, California. The murals tell the complex multiethnic history of a Northern California town with a population that is 80 percent Mexican heritage and 20 percent a mix of Chinese, Portuguese, Filipino, Anglo (and Japanese, before World War II internment). The community is dependent on several large industrial farms, with an exaggerated reputation for gangs and crime. Baca, an international muralist and experienced urban youth worker, "read" the town differently. LeRoy Park, the murals' planned site, turned out to be "not an outlaw haven but a fiercely held center of civic pride." Reviewing the social and physical territory, she was welcomed as "our muralist" and offered the former Druid Temple on Main Street as her studio. She hired five local teenagers to begin a town chronology and gather family photos and stories; they also made a float for the town Christmas Parade. Baca researched the history, called town meetings, and expressed the community's hopes and memories in the four murals. The project's 6,000 slides and historical archives have become a pilgrimage site and potential tourist attraction. "If there was no mural, this would still be art," she says.

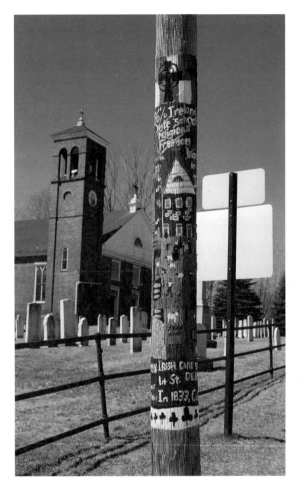 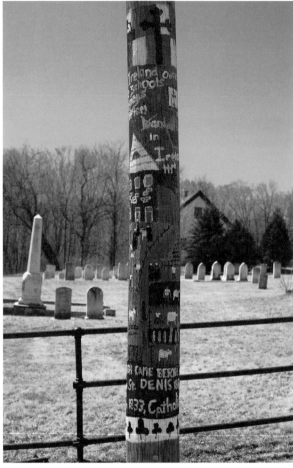

Plate 8: NATASHA MAYERS, *Two views of St. Denis Church, Irish Immigration* (with eighth graders Noah Mayers, Darrell Hartman, Elizabeth Ferguson and Ida Koller), 1994 to present, Whitefield, Maine. Mayers, who is also a modernist painter and prolific community muralist, has been painting her small town's history on local Central Maine Power (CMP) utility poles, some fifty of them to date. Sometimes they are lessons in the history of immigration with her son and a friend whom she was home-schooling, sometimes they are made with other schoolchildren, sometimes on her own. The pole next to the St. Denis church tells the history of the Irish who came to Maine in search of religious freedom, before the famine. Other poles tell how the rich could buy substitutes for the draft during the Civil War or what people in Whitefield did before TV and describe an early land struggle between the "Liberty Men" who had settled the area and the Kennebec Proprietors who claimed to own it. Sometimes Mayers makes portrait poles for people who live in a nearby house or memorial poles for those who have recently died. Despite CMP's reluctant approval and then withdrawal of permission to paint, the opposition of a few towns-people and occasional vandalism, the poles have been well received locally and also enjoy broad media coverage. Mayers' favorite sign of acceptance was an invitation to speak at the Grange, where members suggested more pole ideas and history stories prompted by her slide talk.

Plate 9: ROBERT DAWSON, *Soil and Stubble Nea Yettum*, 1995, from "The Great Central Valley Project" (GCVP). The rich soils below the Sierra foothills looked like "paradise" (*yettum*) to Armenian survivors of genocide who started a new life in California. William Saroyan recalled his childhood in the San Joaquin Valley: "We had come to this dry area... and we had paused in it and built our houses and we were slowly creating the legend of our life." Now Hmong and Hispanic workers are imagining their lives there. Agriculture is giving way to other kinds of development; GCVP writer Gerald Haslam writes that "it sometimes appears to natives that the shopping center has become the territory's leading crop." Dawson, described by curator Sandra Phillips as "a non-operatic Ansel Adams," is now working on another project in the region, with writer Gray Brechin: "Farewell, Promised Land," explores the environmental consequences of these visions of paradise.

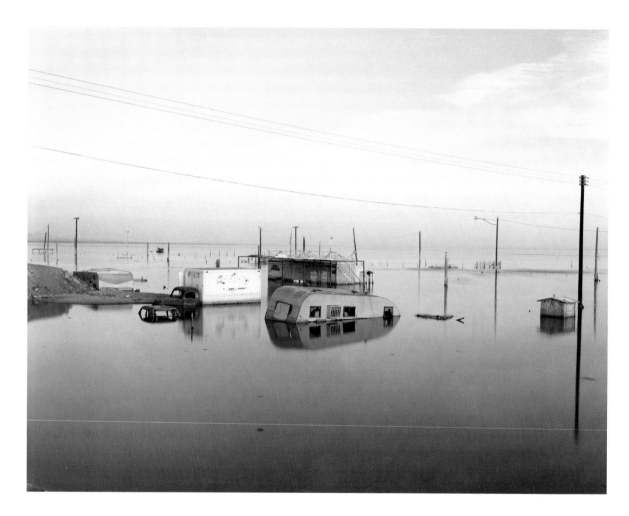

Plate 10: RICHARD MISRACH, *Canto III: The Flood; Submerged Trailer, Salton Sea, California*, 1983. Misrach began to photograph the desert in 1979 and from 1983 to 1985 he gathered the third of his Desert Cantos (inspired by Ezra Pound's epic poem) around the Salton Sea. A human-made lake created in 1905-07 by mismanagement of irrigation waters released from the Colorado River, the "sea" became a tourist and recreation site, only to be inundated in the 1970s and 80s. As Anne Tucker remarks, this disaster "took on the characteristics of a theme park or flood museum." Trailers, trucks, and cars surrender their mobility to lethally still waters and the submerged landscape is defined by overhead wires. The image is one of extreme stasis, a metaphor for photography itself.

Plate 11: PETER GOIN, *Virginia Beach*, 1992, from *Humanature*. In a classic illustration of the management of nature, every year the city of Virginia Beach spends hundreds of thousands of dollars restoring the beach to maintain its tourist economy. In 1992 around 100,000 cubic yards of sand was hydraulically dredged from Lynnhaven Inlet, stored at a stockpile, then hauled to the beach by dump trucks and graded by a bulldozer and scraper. (One of 1994's hottest-selling children's toys was a straightforward 30-minute video of bulldozers tearing up a road.)

Goin, a photographer, write and teacher based in Reno, Nevada, has previously published series on the Black Rock (Nevada) Desert, nuclear landscapes, the Mexican-American border, and Lake Tahoe, among others. His 1996 book, *Humanature*, examines the ways the fundamental health of the land is dependent on our cultural perception of landscape. "The more I learn about how a landscape is made and transformed," writes Goin, "the more I recognize that the earth *is* now a human artifact...."

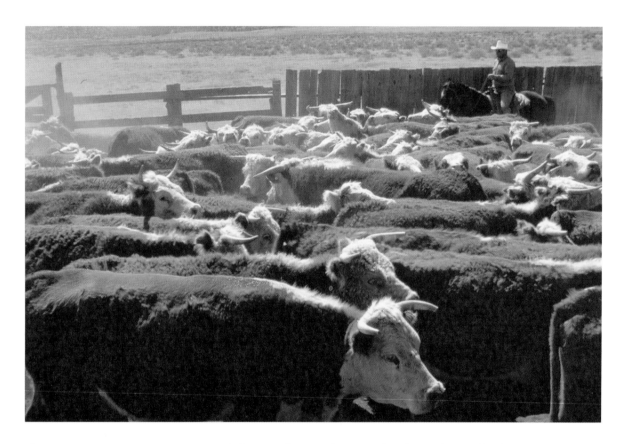

Plate 12: CHRISTINA SINGLETON MEDNICK, *Galisteo Roundup*, undated. In her recent book on the San Cristobal Ranch in the Galisteo Basin, New Mexico, Mednick notes that although the first longhorns came to the state in 1598 and several generations of Hispano families had previously lived there, this land-grant ranch registered its first official brand in 1890. Its current owner, Texas and Los Angeles businessman Henry Singleton, runs around one 1,000 cattle on the ranch's 81,000 acres. "Ranch managers and cowboys now ride pickup trucks more than horses, returning to houses and families at night instead of camping with a bedroll, writes Mednick. "But they are immersed in animal life, earth, water, and sky all day...." On the same ranch, a crumbling log house remains from the movie set where John Wayne filmed *The Cowboys* in the 1950s. But San Cristobals' ranch manager Harper McFarland, who lived at San Cristobal for forty-seven years says: "It's not like your movies, I'll say that."

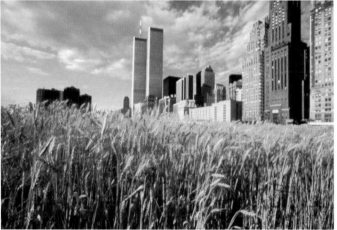

Plate 13: DAVID T. HANSON, *Excavation, Deforesta-tion and Waste Pond: June 1994* from *Colstrip, Montana series*, Extacolor print. Hanson's aerial photographs of a wracked and poisoned earth are eerily beautiful even as they illustrate the extent to which mining is responsible for the "final stage of the utilitarian landscape... [which] perceptively decoded... literally *represents* the culture and its values." The Colstrip series preceded Hanson's more ambitious "Waste-land" survey of Superfund hazardous waste sites, exhibited as triptychs with a topographic map and text. He employs aerial views for access, personal health, and because they communicate the scale and context of these "meditations on a ravaged land-scape... [which] depict the conflict of the real and ideal, of order and entropy." Australian Aboriginal people, he has learned, consider the greatest monu-ments not to be additions to the landscape, but the promise to leave the land just as they found it.

Plate 14: AGNES DENES, *Wheatfield—A Confronta-tion, 2 acres of wheat planted and harvested by the artist,* Summer 1982, Battery Park landfill in lower Manhattan (Photo: copyright Agnes Denes). *Wheatfield,* in the shadow of the World Trade Center towers, took ten months to clear, till, plant and harvest. The clash of values, of urban and rural landscapes, was reflected in the fact that the real estate—a block from Wall Street, facing the Statue of Liberty—was worth $4.5 billion and the 1,000-pound harvest was worth $158.50. Wheat, a symbol of hope and "the staff of life" represented food, energy, commerce, world trade and economics as well as referring to waste, mismanagement, world hunger. Denes described it as "an intrusion into the Citadel, a confrontation of High Civilization... [and] a small paradise, one's childhood, a hot summer afternoon in the country, peace, forgotten values, simple pleasures," likening the work to planting the seed of a concept and watching it grow. Her complex "philosophy in the land," begun in 1968, is currently expressed in the huge *Tree Mountain* project in Finland—"a living time capsule" contracted to be maintained for 400 years in homage to future generations.

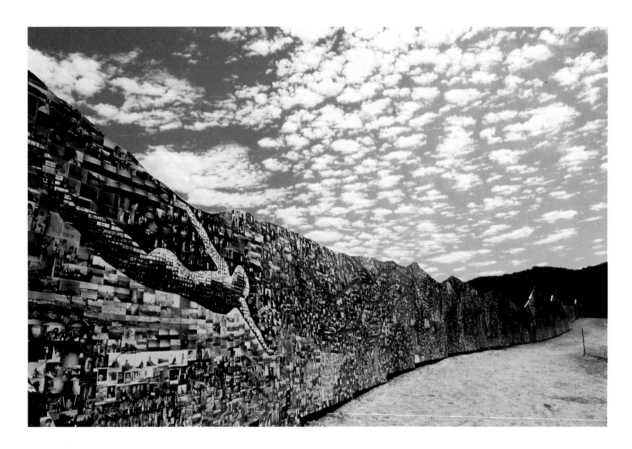

Plate 15: JERRY BURCHFIELD AND MARK CHAMBERLAIN, *The Tell*, 1989, 600-foot long sculpted mural, Phase VIII of the Laguna Canyon Project (see p. 180), sponsored by Los Angeles Center for Photographic Studies and BC Space Gallery (Photo: J. Burchfield). *The Tell*, "the largest photographic mural ever made," was constructed in the heart of Orange County, California's "last unspoiled coastal canyon," adjacent to a massive proposed transportation corridor. Thousands of people contributed some 80,000 family and local photographs that were collaged to a mountain-contoured wall to create larger symbolic images. Hundreds of people came to help construct this "uncensored story of California life." (A "tell" is an archaeological term for a mound of artifacts.) Colors and images gradually changed with natural light and exposure. A few months later, seven to ten thousand people marched to the site in a public protest; the major development was defeated and a natural park created, but part of the canyon has been bulldozed, sparking more art works and a continuation of the Laguna Canyon Project.

Plate 16: SHERRY WIGGINS, BUSTER SIMPSON, JIM LOGAN, *Fenceline Artifact*, 1992-96, Denver International Airport, found implements, fence materials, rocks, galvanized metal birdhouses, porcelain enamel signs, cottonwood and hackberry trees, gravity drip irrigation system, 1000' long, sponsored by the Denver International Airport Art Program (City and County of Denver Mayor's Office of Art Culture and Film). Wiggins (a public sculptor) and Logan (an architect) live in Longmont, Colorado; the Seattle-based Simpson has been making place-specific public art for some 25 years. This piece celebrates the historic farming landscape destroyed to make the new airport. Some 35 pieces of old equipment (huge piles of bailing wire, a hay conveyor, grain augers, rakes, harrowers, seeders, plows) were collected from the condemned farms and stand as sentinels on the border between past and present. The farmhouses are replicated as birdhouses with signs showing the original building and telling its story. Long wooden grain troughs help the piece gradually subside into the landscape. Although there is a picnic area, and the artifact line is shaded by newly planted cottonwoods to make it more of a "real place," pedestrian access has still not been provided.

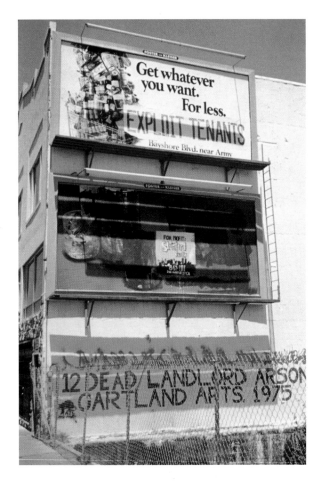

Plate 17: URBAN RATS (Susan Greene and Joel Katz), *Land-lord Arson Mural*, 1983, 16th and Valencia, San Francisco. Landlords in this poor neighborhood waiting to be gentrified knew the value of their property was rising but speculation was trickier when the tenants were low-income people and welfare recipients. A spate of fires eventually consumed many such properties. The Gartland Apartments which stood on this site had its doors wired shut for security and when the fire was set, twenty-five people died. That history was disappearing when the Urban Rats (a loosely knit group of artists and activists who did street murals, billboard alterations and public art events from 1982-84) stepped in. "Suddenly," they recall, "this place that you didn't hardly notice has a story, peopled with lives, names, and meaning." When the corrected billboard was written up in the papers, the mural was destroyed, despite local people rushing out to save it and even fighting with the men hired to demolish it. Memorial events and installations (gravestones, old TV sets) continued to be set up in the pit. Eventually a low-income housing unit was built there.

Plate 18: *Rincon Criollo Casita, East Harlem, N.Y.*, 1989 (Photo: Betti-Sue Hertz) (see page 260).

PART

FOUR

The Last Frontier(s):
City and Suburb

Although myths are the products of human thought and labor,
their identification with venerable tradition makes them appear to be products
of "nature" rather than history—expressions of a transhistorical consciousness
or of some form of "natural law."... But the actual work of making
and transmitting myths is done by particular classes of persons; myth-making
processes are therefore responsive to the politics of class difference.
—RICHARD SLOTKIN

"Dallas, the city where the East peters out," recently redefined itself
as the city where the West begins with a lifesize bronze public sculpture
of a 19th-century cattle drive, complete with 70 steers, an image
that belies its history. Detractors suggested that 70 bronze oil derricks
or microchips, or 70 Neiman Marcus shopping bags, might have been
more appropriate, or perhaps *"a herd of lawyers, bankers*
and insurance men stampeding through town."
— NEW YORK TIMES

Alternating Currents

*Consider the proposition that Nature as we know it was invented
in the differentiation of city and countryside, in the differentiation of mental
and manual labor, and in the abstraction of contemporary culture
and consciousness from the necessary productive social work of material life.*
— MARGARET FITZSIMMONS

*The isolation of the city and the refusal to grapple with its environmental problems
will only hasten the deterioration of the countryside. It is in the common interest
of the city and the countryside surrounding it to manage the region
as an interlocking, interdependent system.*
— ANN SPIRN

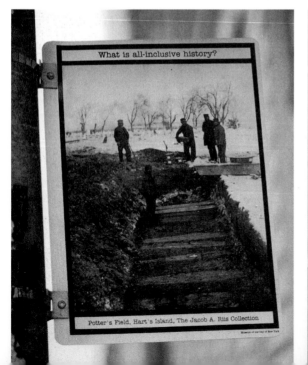

What is all-inclusive history?

Potter's Field, Hart's Island, The Jacob A. Riis Collection

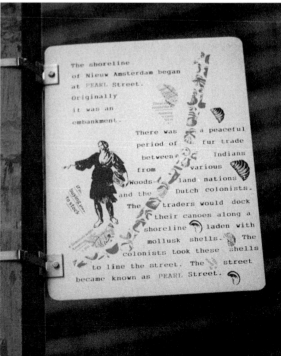

The shoreline
of Nieuw Amsterdam began
at PEARL Street.
Originally
it was an
embankment.

There was a peaceful
period of fur trade
between Indians
from various
Woodsland nations
and the Dutch colonists.
The traders would dock
their canoes along a
shoreline laden with
mollusk shells. The
colonists took these shells
to line the street. The street
became known as PEARL Street.

The Vein of Maine almost vanishes into bedrock in this section. Maine is still a rural state, with 1.2 million people scattered over 30,800 heavily forested square miles. Only 35% of Mainers live in urban areas. My precious Georgetown time over the years— summer or winter—has not been spent in cities, and the state boasts only one place that can truly claim that name. Portland is the largest urban center, with a population of 60,000; Augusta, the capitol, is third with only 33,000. Portland, the hub of island-dotted Casco Bay, is some 50 miles and over an hour away from Kennebec Point, and I can claim little intimate knowledge of it aside from the airport and the lively Maine College of Art. For "urban" parallels, therefore, I will

THE U.S. POPULATION TODAY IS 75 PERCENT urban/suburban, but there remains an emotional tension between city and country, an alternating current that pulls at most Americans at various times in their lives. If the city represents the high voltage of the new (or at least the novel) and the country represents the calming tradition of the old, we are always looking for ways to balance our needs for both. I lived in Manhattan for my first nine years and returned at age twenty-one for thirty-seven adult years. While my current addresses are rural, my local knowledge of cities (and this part of the book) are New York-based and New York-biased.

The city has been seen as a field of indifference to the rest of world, as a triumph of objective over subjective, male over female, culture over nature, materialism over spirituality and idealism. The inherited rural kinship systems of ancient cities were replaced with civil communities, which in turn broke down with industrialization (or perhaps before, with the medieval plagues), when cities became increasingly impersonal. The idealized vision of the Puritans' "City on the Hill" (exposed and exemplary to those living "below") notwithstanding, most positive American mythologies depend on a rural context. During the nineteenth century, as the colonization of the countryside by

REPOHISTORY, Four signs from *The Lower Manhattan Sign Project*, 39 two-sided, silk-screened metal street signs installed on lamp posts throughout lower Manhattan's financial district from June 1992 to June 1993: *Potter's Field, Hart's Island* by Jayne Pagnucco; *Origin of Pearl Street* by Sabra Moore; *The Meal and Slave Market* by Tess Timoney and Mark O'Brien; *The Other J.P. Morgan (Exchange Place)* by Greg Sholette (Photos: Tom Klem, courtesy of REPOhistory). REPOhistory was founded in 1989 by a multiethnic group of activist artists, writers and historians to repossess the city's history, defining history as created and transmitted by the people who lived it, and calling attention to forgotten sites and events. Their focal question was "Whose History is Remembered? Whose Will We Forget?" The group continues to initiate projects based on these principles in and outside of New York City, among them: *Choice Histories: Framing Abortion* in 1992; *Queer Spaces* in 1994, commemorating the Stonewall Uprising; and *Entering Buttermilk Bottom* in Atlanta (p. 111).

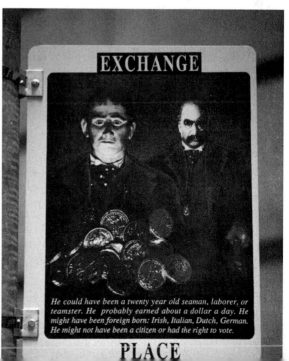

concentrate on Bath, "City of Ships," with a population of 10,000. Bath is defined in the state's imagination by the Bath Iron Works (BIW), known locally as 'the yard,' and by the Carlton Bridge across the broad Kennebec, accessing the coast to the north.

Looking up Front Street, Bath, to the Bath Iron Works Crane (Photo: Brad Hewes, Kennebec Camera). From 1972 to 1979 BIW's crane was the biggest in the western hemisphere and it was said that its lettered "BIW" stood for "Biggest in the World."

196

capital accelerated, the Jeffersonian ideal of a nation of small towns and farmers waned. Ralph Waldo Emerson's ideal "City of the West" was an attempt to reconcile nature and civilization, intended as a human community with open gates and open arms. Instead, cities, aided by absentee landlords and proto-agribusiness, began to suck up country energy and resources. By 1880, urban populations in the western U.S. were already growing at four times the rate of the countryside.

Herbert Gans observed in the late sixties that American society gives its allegiance to two poles—the micro-unit of the family and the macro-unit of the nation, while local community falls through the cracks. Today, one of those poles is collapsing: under half of eligible Americans voted in the 1996 presidential election. This decline in participation in social policymaking can be seen as a product of a dehumanized urban ambience, the loss of a sense of local power in places where "neighborliness is often exhausted by a nod of the head."

The clichéd image of the cold, heartless city and the warm, cuddly heartland of small towns has long since been disproved. There is no Eden. But the sheer size of the metropolis can be intimidating as well as exhilarating and seems to bely communal intimacy. What, then, constitutes the lure of the local in this environment presumed to transcend any such affect? How do cities look and feel to those who live in them? And what are their relationships to the land they are built on, to the land people left to come to them?

Cities are enormously complex palimpsests of communal history and memory, a fact that tends to be obscured by their primary identities as sites of immediacy, money, power and energy concentrated on the present and future. Many people come to the city to escape the "local," the isolation of rural life, the rigidity and constrictions of smaller towns.

We who live here wear this corner of the city like a comfortable old coat, an extension of our personalities, threadbare yet retaining a beauty of its own. This is the intimacy of cities, made more precious and more secret by our knowledge that it is one of many cells or corners in a great city that is not so much a labyrinth as a web or a shawl. We wrap ourselves in the city as we journey through it. Muffled, we march, "like Juno in a cloud," drawing it around us like a cloak of many colours: a disguise, a refuge, an adventure, a home.
—ELIZABETH WILSON

The urban ego is in fact parochial; New Yorkers (like Parisians or Bostonians) are among the most provincial people in the world. They are often as bound to their own neighborhoods and as ignorant of the rest of the city (aside from midtown) as any small towner. A city is a center plus the sum of its neighborhoods, a collage created by juxtaposing apples and oranges. When I first lived in New York I would sometimes take the subway to a stop I'd never been to and spend hours walking in new territory, foreign countries. It was always interesting even when it was boring. All those people, all those little rooms. What were they doing in there? What lives were being played out so near and yet so far from my own? I loved my own life and didn't envy the women closed behind those doors; but at the same time I pictured an intimacy, a reassuring monotony that I knew I had surrendered forever.

Bath, built on filled-in salt marsh, is not as old a town as Georgetown; in the 1700s, when the island was the real center, Bath was known as "the twenty-cow parish." Today the Bath Iron Works, founded in 1826, is the state's largest private employer. Although its work force is slowly being downsized, its docks are seldom without a dark gray Aegis destroyer or two. The yard is actually several yards—the main plant on the Bath waterfront, the East Brunswick manufacturing facilities, and a Portland drydock.

The pretty little city on the Kennebec's Long Reach is proud to have been voted the 17th most liveable small city in the U.S. Yet Bath lost its two movie theaters decades ago and its only retail bookstore three years ago. There is one upscale restaurant in town. The

Women in particular come to the city to break away from family expectations, domestic confinement, or to escape boredom and past mistakes. Some thrive on the crowds and new anonymity; others spend the rest of their lives thinking that someday they'll go "home." My own experience reflects Elizabeth Wilson's contention that the disorder of the city is a woman's medium, implying that it allows us to slip through the cracks of order: "The city is 'masculine' in its triumphal scale, its towers and vistas and arid industrial regions; it is 'feminine' in its enclosing embrace, in its indeterminacy and labyrinthine uncentredness. We might even go so far as to claim that urban life is actually based on this perpetual struggle between rigid routinized order and pleasurable anarchy, the male-female dichotomy."

Where the citydweller may revel in her daily anonymity and freedom from self within crowded spaces, she also struggles to find an emotional community that will offer the intimacy for which Americans pine, even after we have made the choices that make it less and less likely. In small towns, if you go to the store, you must be prepared for at least minimal social intercourse. In cities, you can go out and float in your own space for hours, expending no more than an occasional monosyllabic request for food or services. You don't even have to say please and thank you if you're in an area where you don't expect to be seen again or where you just want to burn your bridges. However, spaces take on the aura of your interactions in them. There is a hardwon median between idiotically artificial courtesy and complete, even hostile, disregard.

Urban experience, vast and elusive, epitomizes the multicentered experience that fuels such energies. I'd include the arts among them. "One of the most fascinating aspects of place in recent years is that it has become more homogenous in some ways"—through mass culture—"and more heterogeneous in others" (through specialization and ghettoization), according to Sharon Zukin. The city is a social network, a web that entangles everyone who enters it, even the loneliest. Visually articulated by the syncretic cultures it contains, it is defined by a dialectic between the opinions of locals and of outsiders. Looking around in a city is visual overload (whereas looking around in a suburb tips the opposite end of the scale). Impressions are confused and even chaotic. Longtime residents rushing here and there often forget to look at their surroundings while newcomers and visitors get lost and overwhelmed.

The city is the site of delightful and terrifying encounters that could not happen anywhere else. But each city is different, evoking different feelings in its residents and visitors, attractive to individuals at different moods of their lives. The light, the climate, the style, the materials, the flora and fauna (or lack thereof), the spaces and proportions, not to mention the demography and population, make cities and their neighborhoods unique. Cultural geographers have argued about whether the city is a series of reflections of "reality" held as images in the minds of its observers, or whether it is in itself a concrete representation, a collective work of art, a symbolic creation of those who inhabit it or those who control it.

Anne Spirn describes the city as an "infernal machine" with nobody coordinating it, nobody in charge, nobody taking responsibility or understanding the cumulative ecological effect of all the fragmented construction. Yet the city produces spaces and buildings, and even parks, that share its scale and impersonality. Class stratification is one component; especially in midtown New York, where the range of stores, restaurants, and modes of public transportation serve very different clients. Country

shopping center that did in downtown has some ten stores and the two main downtown streets—Center and Front— are increasingly reduced to selling antiques (seven shops at last count) and other "specialities." The imposing old Customs House now houses boutiques. Both the fishmonger and the large hardware store left downtown for sites near the shopping center. One old drug store hangs on, despite heavy competition from two chain stores. The heart of the town remains Reny's Department store, a local chain that offers great bargains and a cluttered, old-fashioned atmosphere. (*Maison René's* or *L. L. Reny's*, it is called fondly.) The Victorian County Court House remains on moral and geographical high ground, looking down on the town from High Street.

198

estates may be inaccessible, and elite suburban neighborhoods guarded, but in cities, rich and poor occupy the same spaces. The habitats of the powerful and the powerless exist within tighter confines, side by side in sharp contrast. (As a child, I had a sitter who often detoured from our culturally determined route to Central Park; she took me to weddings in Fifth Avenue churches, as well as to a German bar in Yorkville where her boyfriend worked.) So long as we behave ourselves, any of us can loiter briefly outside the Plaza Hotel or Park Avenue apartment houses to glimpse the stomping grounds of the rich and famous, and the rich and famous must now and then drive through the Lower East Side or the South Bronx, or the outwardly colorless byways of Forest Hills or Sunnyside.

> City life has transformed the struggle with nature for livelihood into an inter-human struggle for gain, which here is not granted by nature but by other men....What appears in the metropolitan style of life directly as dissociation is in reality only one of its elemental forms of socialization.
> — GEORG SIMMEL

Nature is fragmented and isolated in the city. Those who have no urge whatsoever to live in the country have houseplants to recall the existence of "nature," or to reassure themselves that nature can be or has been tamed: they go to parks to see trees. The more affluent have rooftop gardens, tiny designer back yards and bucolic weekend retreats. The less affluent cultivate community gardens. Even those who love the city and can live there comfortably look for ways of escaping it periodically, either by the Fresh Air Fund, vacations or, for the more privileged, weekend homes featuring lawns, trees, and other simulacra of small town life—visited, but not committed to. In 1956, Marshall McLuhan wrote that the city was in fact a return to the simultaneity that governed tribal cultures, in which "all experience and all past lives were *now*." From the Native American historical viewpoint, cities simply replaced civilization. Artist Jimmie Durham decries the deracination of civic centers from their landscapes: "At one time New York was a city *on an island*: it was a city with a location in the physical world. Unlike villages or settlements, cities always establish themselves *against* their environment....Where are we? We are in the European City. The U.S. is a political/cultural construction

The heart of Bath's cultural life is the gothic revival "Chocolate Church," showcasing visiting and local music and theater. Maine Artisans, also downtown, handles local artists' craftworks with some success. "Fine art" is mostly limited to coastal scenery. The accomplished Indian Point landscape painter Stuart Ross ran his own gallery on Front Street for a season, enjoying the intimate atmosphere and local audience but unable to make it pay off despite the quality of the work (and gallery sitting isn't most artists' favorite task). The director of the Bath-Brunswick Chamber of Commerce has warned that "artists and workers need to be trained to interpret their attractions in a way that enhances a visitor's appreciation."

At the same time, poet and native Mainer

against the American continent....There have been many, but it is hard for us to imagine a 'great sylvanization', like a 'great civilization.' Civilizations, cities, build signs and monuments by definition and are then recognized by their signs. The sign of forest dwellers is the absence of monuments."

As soon as we move to a city, we search for our own center in it. In the absence of valid communal centers, cities need artificial symbolic centers like Saint Louis's Arch, Washington's Monument, or particularly obtrusive office buildings that function (only) visually as the church spire once did, marking the place where power is abstracted and institutionalized. Landmarks have to be imposing and/or charged with celebrity status to claim attention. New York's Chrysler and Empire State buildings are classic examples. Like earlier skyscrapers, they were probably inspired to some extent by the "stateliness of the American landscape." Now they are outgrown but not outclassed by the bland towers of the World Trade Center. Giant complexes like Battery Park City in Lower Manhattan, created by celebrity architects and usually accompanied by large-scale, expensive public art, are "designer" objects "of quality," veiling the reality of social polarization in "real life." Generating ideological vibes of domination through spectacle, such control centers can be seen, Darrel Crilley observes, "not as signs of enduring vitality, but as enormous and cautionary symbols of changes underway in the relationship between property development and aesthetics."

> *I view great cities as pestilential to the morals, the health and the liberties of man. True, they nourish some of the elegant arts, but the useful ones can thrive elsewhere, and less perfection in the others, with more health, virtue and freedom, would be my choice.*
> — THOMAS JEFFERSON (in the midst of a yellow-fever epidemic).

The city's image remains negative, or Un-American, in opposition to the "family values" purportedly nourished outside of these "dens of iniquity." One reason for this bad press is that cities have traditionally been the homes of the sinful arts. Marxists have noted that in order to maintain its dynamism, capitalism must keep destroying and recreating itself, whether through

MARTY POTTENGER, *City Water Tunnel #3*, 1995, performances on and off site, video (with Mary Ellen Strom), photography exhibition, memorials; sponsored by Dancing in the Streets, New York (and numerous other individual and organizational collaborators). "Sixty-four miles long, 800 feet down in hard rock, the first shovelful dug in 1970, the last check signed in 2025, City Water Tunnel #3 will bring New Yorkers the next best thing to oxygen." This ongoing community performance project on a mammoth piece of New York's urban infrastructure was conceived by a performance artist who is also a 20-year construction worker and union activist. Pottenger tells the story of City Water Tunnel #3, the largest civilian public works project in the western hemisphere, and of the people who work on it, from the planners, geologists and engineers (many of them women) to the sandhogs (tunnel workers) who are the heart of the project. She was told by Chick Donahue, the sandhogs' unofficial historian, "You go into the West Indian or Irish community, say you have anything to do with the Sandhogs, and they will welcome you with open arms. That's over a hundred years history of jobs... this is a father-son union for the most part." From this unconventional subject matter, Pottenger has crafted a moving and open-ended fusion of art and work. As well as winning an Obie for Off-Broadway performance on the subject, she has done storytelling circles and lunchtime performances at different "hoghouses" (work site trailers); she has traveled to the upstate watershed region to bring in people whose families have been involved in New York's water system for over a century; she plans tours of the cathedral-like space at the Roosevelt Island Valve Chamber, guided by former workers, not only for the public but for office workers who have never seen the actual site; she made a temporary "Slicker Memorial Wall" in honor of the 22 men who have died so far in the tunnel, recreating a "hoghouse" where the men hang their bright yellow slickers between shifts; and she has set up a memorial fund, hoping to install rough-hewn-rock "Tunnel #3" water fountains in a park in each borough. "Massive social change happens in one-on-one relationships," she says of her emphasis on stories. "That's when people really extend themselves."

Patricia Ranzoni sees "cultural thievery" in the way those touted as "Maine writers" and "Maine artists" are so rarely natives. It inspired her book *Claiming*, which is kept at the local barber shop and inspired the farmers up the road to write her "a beautiful letter."

The Maine Maritime Museum, originating in one of the elegant old "captain's houses" on Washington Street, expanded in the '80s to a striking modern waterfront museum that occupies part of the old Percy & Small shipyard. During the summer Tall Ships appear and disappear, open for tours. When they enter or leave the river's mouth, they dwarf the Sugarloaves as they pass Kennebec Point. Under full sail they are poignant apparitions from the past.

planned obsolescence or a novelty-driven art market. For economic as well as aesthetic and educational reasons, artists are attracted to change.

The city visibly illustrates the dialectic between the heterogenous market, where everything is for sale, and the homogenous place, where people resist the processes of defamiliarization and change. As new ideas and new money-making schemes pop up each day, the most imposing structures can prove short

lived. The social cacophony of a big city multiplies exponentially with its diversity and excess of nervous energy. At the same time, the dissolution of its familiar landscapes has the same effect on its inhabitants as slower changes in the countryside. The rug is pulled out from under our sense of self when stores close or switch functions, when vacant lots appear or disappear, or when buildings are remodeled. Even when the changes are for the better, the ghosts remain.

HOUSTON CONWILL, JOSEPH DEPACE, AND ESTELLA CONWILL MAJOZO, *The New Ring Shout*, 1995, illuminated polished brass and terazzo floor, 40' diameter, Federal Office Building, New York City. Conwill's maps/cosmograms serve as historical references and dancing grounds, tracing the tragic and triumphant journeys taken by African Americans. In this case the cosmogram is superimposed on a map of New York City. The blue ring signifying water is inscribed with quotations in fourteen languages, and the inner white ring bears the names of twenty-four African Nations subjected to the slave trade. This circular reflection of the ring-shout spiritual is aligned with the boundary of the eighteenth-century African Burial Ground and located in the high rotunda of the new building built over it. Conceived as a tribute to the Africans, Indians, and Europeans buried there, the earth-colored ring contains symbols and a multilingual spiral songline—lyrics from "twelve songs directing a transformative journey along twelve global water sites marking the migration of diverse peoples to New York." Local people can literally "move through" their histories, connecting with the languages of both body and mind.

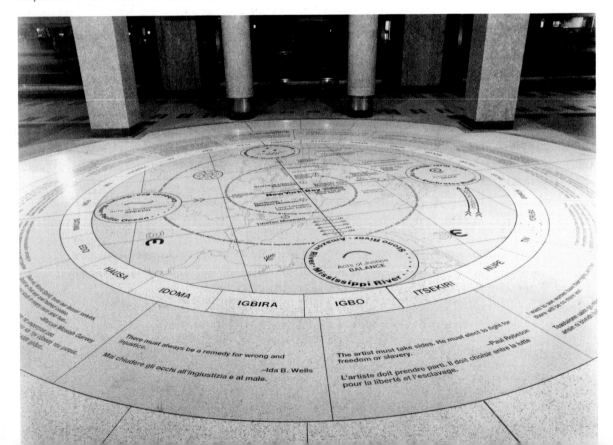

Ups and Downs

*While they are raising millions to turn Ellis Island into a memorial,
they are also preparing to erase Times Square, which is our Ellis Island, Manhattan's only operating
Port of Entry for those who don't feel at ease in the more cultivated parts of town.*
— HERBERT MUSCHAMP

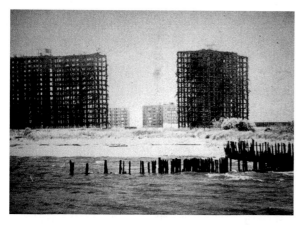
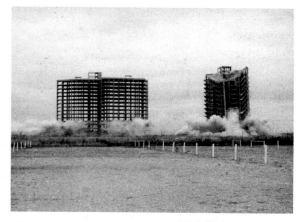

CHARLES SIMONDS, *Proposal for Stanley Tankel Memorial Hanging Gardens; destruction of high-rises in Brooklyn, New York, 1976* (Photos: Charles Simonds). These high-rises were begun by the city as low-income housing and leveled with explosives some three years later after being successfully protested by the Breezy Point community led by Stanley Tankel—director of a watchdog regional planning association, who died soon afterwards. When the bare skeletons still loomed over the landscape, Simonds proposed that they be made into hanging gardens (as in Babylon). The land was eventually incorporated into the piecemeal Gateway National Park, which offers inner-city access to nature through the acquisition of many small city-owned patches of land. (Environmentalism or NIMBYism?)

The Bath Iron Works Harding Plant on Christmas Eve, c. 1986 (Photo: Peter Woodruff).

202 CHANGE IS INHERENT in cities, which face the future rather than the past. Urban neighborhoods, except those protected by their landmarks or wealthy inhabitants, are constantly rising and falling with the breath of economic life and death. Residential neighborhoods deteriorate as their original settlers move onward and upward, or they are redlined for development or gentrified or invaded by incoming industry. The abandoned country towns, the ghettoized working-class neighborhoods, the rusting steel towns, the deserted downtowns contrast with exurban building booms. High-rises give way to parking lots while parks are buried beneath highways and lone one-family houses stand beleaguered among skyscrapers. The whims and ravages of capital wreak havoc on vulnerable communities of work or dwelling place. The American landscape is strewn with the detritus of unconsidered change and shortsightedness.

Along with the Mortgage Subsidies Acts and the Housing Act of 1949, the Cold War inflation of militarism and threats of nuclear holocaust which spawned the National Defense Highway System were major sources of suburban temptation and white flight. Expressways dismembered poor neighborhoods, destroying local communities; they also enabled both the dispossessed (and the wealthy who had also fled) to return to work in the inner city—to sustain, and to bleed it, respectively. As real estate prices rose and construction diminished from the sixties through the eighties, lower-income working people were pushed further and further out of Manhattan, commuting at more and more cost (to themselves and to urban traffic and pollution) from exurbs and suburbs that had lost their own identities as they merged in a vast peripheral field of escape routes, "a centerless web".

In rustbelt metropolises a similar process led to the abandonment of the inner city to the poor. As city and inner city were wrenched apart, the urban complex became heartless, despite attempts at "urban renewal" which often had just the opposite effect. Life histories as well as economic histories can be traced in these dour landscapes. Unemployment, bleakly reflected in geography, is a key to the disintegration of many black and Latino neighborhoods nationwide. Young men and single mothers in particular are the victims of local white capital flight, stranded in poor neighborhoods as small businesses vanish. Long commutes are impossible for those earning a pittance, and finding acceptable child care is a major obstacle for working women.

Just as some farmers have fallen back on marijuana as a crop, jobless urban youth have been sucked into drug dealing, which sometimes seems to be the last economic straw for ghetto life, but in fact brings death and destruction, along with money. (Mike Davis has compared L.A.'s drug dealers to the rogue African chieftains who were the middlemen in the nineteenth-century slave trade.) Tourism is a more legitimate, if distasteful, way out. Youngstown, Ohio, one of the hardest-hit areas in the Rust Belt, lost its battle to save the mills in 1978. Now it is the site of the Historical Center of Industry and Labor, designed by postmodernist Michael Graves, which resembles nothing so much as a prison based on nineteenth-century panopticon surveillance plans.

These are the same steeltowns which, in their heydays, were icons of triumphant modernism for industrial purist painters such as Charles Sheeler. In their declining years, a good many artists have been attracted to the tragic remains. Some, like Canadian artists/organizers Carole Conde and Karl Beveridge,

Bath's ups and downs, and to some extent the state's as well, have been tied to BIW's fortunes. In 1925, victim of the postwar drop in demand for ships, BIW went into debt and was sold piecemeal in a foreclosure auction by a New York junk dealer. Two years later, however, a new company was incorporated under the same name, building a turbo-electric yacht for J.P. Morgan and an America's Cup defender for Harold Vanderbilt as well as holding a Navy contract for the first destroyer produced since World War I.

Bath was a boom town during War II. From 1941 to 1946 the yard produced Navy destroyers at a rate of 21 a year. By 1943, 30,000 men and women were working around the clock in three shifts. Nearly one quarter of the war's American destroyers were built there, with a

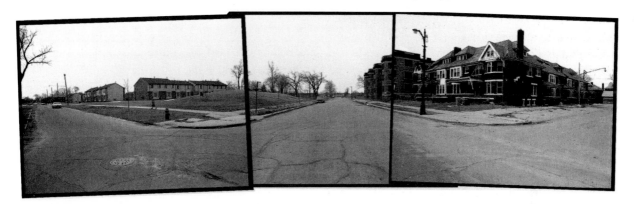

concentrate on the social ramifications of factory shutdowns and runaway shops to Asia and Central America. Others, such as Raymon Elozua (son of a South Chicago steelworker who has worked the mills himself) could not fend off an element of nostalgia merged with the pain of being saddled with a work ethic but no work. Other artists focus on the relics of outdated technology, the haunting ruins—enormous hulks of useless machinery with idiosyncratic, often domesticated, names ("Lackawanna Buddha," "Big Bess")—as did Steve Cagan amidst Cleveland's shutdowns in the early eighties, photographer Margaret Evans and painter Suzanne Roth in their "Post Industrial Steel Town Series" (1987), and Patrician Layman Bazelon in her "Steel" series (1995). The most effective "cultural work" on the subject came from the grass roots: the *Mill Hunk Herald*, a hard-hitting, irreverent, and emotional worker-written newspaper out of Pennsylvania's dying "Mon" (Monongahela) Valley.

Coleman Young, mayor of Detroit for almost twenty years, contended that Motown's abandonment "was planned and encouraged by federal policy." After the suburban drain came the riots of 1967, calling attention to a policy of racial exclusion disguised as "renewal" aimed at African American communities.

BLAISE TOBIA, *Abrupt Transition #1*, 1982, (Copyright Blaise Tobia). Tobia was active in the "Detroit Peace Community" which called attention to the morally indefensible relationship between defense spending and the physical and moral breakdown of the city of Detroit. He photographed significant examples of changing land use and juxtapositions of the prosperous and the deteriorating. On the right, once-substantial middle-class apartments stand next to the ruins of newer, more fortress-like attempts. On the left side of the street bland rows of housing and neatly mowed lawn testify to a third try. In a prototypically American approach, the old is constantly abandoned in favor of the new, rather than maintained or rehabilitated.

This is the urban counterpart of the frontier policy on rural lands: use it up and move on to greener pastures. The rings of destruction drawn by urban renewal literally mirror those created by nuclear destruction, says Kyong Park, founder of Storefront for Art and Architecture in New York City. The parallel "between urban implosion and nuclear explosion continues at the abandoned Hudson Department Store," known locally as "the ground zero of Detroit." Dan Hoffman is mapping the "erasures" and cumulative vacant lands that result from unconsummated urban renewal, seeking the patterns of the "lost city" that have made Detroit "an unprecedented landscape of flattened visions." A major issue is the amount of public money spent on removal of uninhabited houses perceived as

launching almost every two weeks. Carlton Bridge was lined with cheering spectators for every ship that left the Kennebec. Those of us on the coastal peninsulas lived under strict blackout rules, with heavy rubber curtains when night fell, and Bath was said to be a major target for espionage, sabotage, even potential bombings, should the war come to the U.S. In fact, a submarine was actually found near the mouth of the Kennebec.

In 1947, a flush BIW bought the Pennsylvania Crusher Co. and in 1961 acquired Hyde-Windlass, which had been a part of BIW until 1895. In 1968 BIW inappropriately merged with Congoleum-Nairn, a furniture manufacturer. By then, the downswing was underway, although in 1985, after a 3-month strike, came a contract for an Aegis Cruiser

dangerous to neighborhoods because they are often used by drug dealers: the "poignance" of this now-standard procedure, Hoffman says, "is emphasized by the fact that little or no housing is being built to replace that which has been removed. It could be said that unbuilding has surpassed building as the major architectural activity in the city."

Yet Park also sees Detroit as a "city of resistance," fallen so far into ruin that it may have a better chance of rising from the ashes than most. A resistant local art project was begun in 1986 by Keith Piaseczny, then director of Detroit's Urban Center for Photography, which was founded to confront the aesthetization of photography by fine arts, commercial and journalistic photographers working together. In 1986, Piaseczny photographed a woman holding a child on a downtown porch. When he went back to give her a print, the house had been gutted by fire. So he mounted the enlarged portrait in a window, next to an eviction notice.

This was the beginning of an activist series executed by some twenty photographers in the summer of 1987, consisting of enlarged photographic records of decay and abandonment publicly displayed with the stenciled caption "Demolished by Neglect." Empowered by specific contextualization, and hardly compatible with the city's campaign to spruce up its reputation, the work was accused of being too negative—a clear case of kill the messenger. The images attracted so much attention that the city arts council tried to rescind a grant to the Center because the project "contributed to visual pollution" and "defaced public property" with the aid of public moneys. The photographers, on the other hand, claiming they sought "to bring an end to the defacement of our cultural heritage," held an exhibition of a neglected archive of historical photographs of Detroit, ghosts of a proud and beautiful city unknown to most current residents.

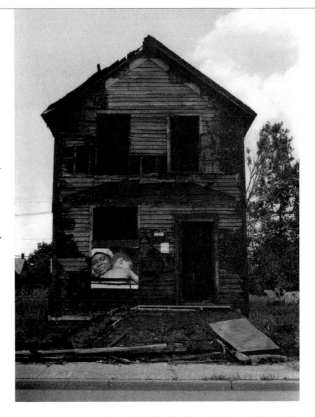

KEITH PIASECZNY, *Demolished by Neglect*, 1987 (copyright Keith Piaseczny). Piaseczny, trained as a photographer and sociologist, points out that while people become immune to abandoned urban sites, they can refocus on them through photographic images, which "are somehow more disturbing, have a stronger impact than *the reality*."

Some photographers went on to document and confront present-day problems. For instance, Jim Dozier installed a large triptych of a lung cancer victim and his X-rays across the street from the main entrance of an incinerator under construction that was soon to emit dangerous dioxins.

From "slum clearance" to "urban renewal" to "redevelopment," the nomenclature of efforts to re-engineer cities has gone from blatantly imperialistic to pseudo-

with an advanced radar system, first of nine Aegises over the next decade; they cost around $250 million each and continue to be the yard's main source of income. In 1986 BIW was sold again to Prudential Insurance Co. for an inflated $580 million.

In 1992, the Berrigans did a Ploughshares protest at BIW, supported by the small but passionate local activist art community; the case against them was dismissed for fear of adverse publicity. They tried again in 1997.

In 1994 the Navy kept delaying its deci-sion on new contracts and the city of Bath and the whole state of Maine braced for bad news. In June it was announced that BIW had won a two-year contract. "When the good news comes in," said the owner of Gilmore's Seafood Market, "people buy

optimistic to a neutrality that almost admits past mistakes. All three were and are condoned on grounds of social dangers and disapproval, rather than focusing on the real need for decent, affordable housing. A 1939 editorial cartoon from the *New Orleans Times Picayune* showed a cheerful man with a sack of tools labeled "slum clearance" approaching (with a smile) a shabby house and a dour family—an elderly woman labeled "disease," a down-in-the-mouth man labeled "dispirit-edness," and a capped youth labeled "delinquency."

> *Public housing, as architecture, was visibly permanent —a solid investment of the taxpayers' money—while the individual units were usually small and spartan, since they were not supposed to encourage the idea that this was a place to settle into for long. In contrast, a timeless quality lay over the suburbs. Everyone assumed that things would continue as they were here, with larger cars and more roads, newer houses and better schools, forever and ever.*
> — GWENDOLYN WRIGHT

Federal housing in the thirties, like company housing before it, imposed strict paternalist regulations on lives and lifestyles, encouraging restrictive covenants that ensured racial homogeneity. It operated incog-nito, avoiding the "stigma" of "public housing." The New Deal's Public Works Association allocated half its housing for "Negroes" but maintained segregation by stipulating that no African Americans would enter public housing in a white neighborhood, and that racial proportions would not change in a mixed neigh-borhood (as though these random ratios had in some way been proven ideal). Federal programs favored not the destitute but the "deserving poor" and the people displaced often couldn't afford public housing. The undeserving poor were supposed to vanish. As poverty became more visible during the Depression, "nice" neighborhoods resisted public housing, a forerunner

of the NIMBY syndrome. Slum clearance was often led by well-meaning middle-class women. In the early fifties, my mother was one of them; she worked in Charlottesville, Virginia, to replace slums with decent housing in the face of opposition from absentee land-lords with whom she socialized, awkwardly, at local cocktail parties. In those days, the real estate lobby opposed public housing as "socialistic"—the poor were *obviously* getting something for nothing.

Under Title I of the 1949 Housing Act, even a partially deteriorated neighborhood could be torn down and redeveloped, with the government paying two thirds of the cost—a bonanza for developers. With the Urban Renewal Act of 1954, called by some the "Negro Removal Act," the way was paved for displacing communities, replacing them with luxury apartments, convention centers, office buildings, and large profits all around. This wave of postwar urban demolition led to the destruction of local neighborhoods and the erec-tion of massive dehumanized and dehumanizing projects. "Between 1949 and 1968, 425,000 units of low income housing, mostly the homes of poor minorities, had been razed for redevelopment," says Wright; only 125,000 new units had been constructed, over half of which were luxury apartments.

Housing authorities also preferred huge projects to smaller ones that would blend into existing neighbor-hoods. High-rise islands rose in the cities; the change in scale was supposed to "help residents break with their past surroundings and acquaintance." It certainly had that affect, but hardly for the better. People are ambivalent about getting a better place to live if it means leaving friends and familiarity. Residents tended to like their small but modern apartments but disliked their larger contexts—the barren public spaces that precluded neighborliness. The vertical local failed to live up to its horizontal heritage.

lobster, take it home to momma." The owner of a sandwich shop frequented by workers said, "We're exuberated. As BIW goes, so goes the city."

"What's good for BIW is good for mid-coast Maine," was the way someone else put it. (25% of Maine's federal aid comes through defense spending.) However, conversion from a defense-oriented economy was becoming increasingly necessary and in that direction there were few hopeful signs. Failure to come up with commercial ideas and contracts means that the Iron Works is still totally dependent on the Defense Department. "Can't get off the tit," says one long-time worker.

In 1994, 900 workers were laid off, bringing the workforce down to 8,000. And

By the sixties, slums had become ethnicized as "ghettos," confining social evils (and resistance) in specific places. The word "community" has since been superimposed on disparate neighborhoods as a euphemism for ghetto rather than for a truly close-knit group. "Communities," despite this kind of lip service, are given short shrift when financial push comes to shove. Freeways, high-rises, and gentrification are consistently allowed to slice through or dismantle fragile ethnic or marginal economic communities. These are the economic and political frames within which it is necessary to consider any picture of the "local" in urban areas.

The boarded-up buildings and garbage-strewn vacant lots of the "post urban landscape" are often produced by "redlining," in which landlords, bankers, and developers mark off certain neighborhoods for their own eventual profit, making sure they receive no financial support, become uninhabitable for even the most desperate poor, and are then scheduled for demolition—a clean slate. Despite the 1977 Community Reinvestment Act, an attempt to combat redlining and punish banks when they fail to meet the credit needs of poor neighborhoods—few "communities" can hold up and fight back under such conditions.

The recent failure of those postwar projects has again encouraged public housing on a smaller scale, on scattered sites that fill in vacant lots in existing neighborhoods. This desirable "scattering" technique also depends on a nonexistent low-income housing market outside public projects, as well as on affordable rents (which are susceptible to increased demand). It remains to be seen whether changing criteria can better meet the needs. David Moberg outlines the progressive bottom line for public housing: "regular maintenance, decentralized authority, better screening and eviction of bad tenants, more

JON POUNDS AND OLIVIA GUDE WITH PULLMAN RESIDENTS, *Pullman Playsculpture*, 1985, 55' long, detail of redwood playground (Photo: Jno Cook). The artists live in Pullman, a town within Chicago famous for the construction of Pullman cars and the 1894 national strike against capitalist/philanthropist George Pullman who built the town as model workers' housing. "Choosing not to choose between an interest in historic preservation and the everyday needs of young families," artists worked with a huge volunteer force of community adults and children to reclaim a derelict city playground. The train is accompanied by a "station platform" with benches and "ticket booths" around a sandbox, and the "arrivals" board announces a train from "Terre Haute, Indiana, the birthplace of Eugene Debs, leader of the Pullman Strike." This was one component in Gude and Pounds' eight-year *Pullman Project*, begun in the summer of 1981. They also chalked writings and drawings throughout town and stenciled spray paintings on a retaining wall along the train tracks to provide information and recreate scenes of striking workers and the occupying army during the 1894 strike. While they were executing the work, they carried with them an elaborate set of plans to explain their activities to community members and police. The transitory nature of that part of the project evoked historic amnesia, just as their permanent Roseland-Pullman mural and this playsculpture countered it.

social services and neighborhood businesses and better links to jobs...." Or, as Gwendolyn Wright puts it: "For public housing to work, it needs both the active involvement of tenants and a commitment to integrate subsidized housing into diverse neighborhoods." Some small cities have succeeded in keeping their

the unions signed a disastrous "teaming contract," so unpopular that the workers' dissident paper, *The Advocate*, complained "We have watched the union's leadership develop management decisions and dictate them to us."

For a town struggling to expand its industrial tax and employment base beyond BIW, it was good news when in 1995 Stinson Seafood—one of the city's largest employers, which has processed sardines there since the 1940s—decided to stay in Bath.

Then in 1995 BIW was sold yet again, this time to General Dynamics (which owns Electric Boat in Groton, Connecticut, builder of nuclear submarines) for $300 million in cash. Some saw the transfer back to ownership by professional shipbuilders as a hopeful sign.

207

lower income housing and population out of sight—either scattered around lower middle-class neighborhoods or outside the city limits next to the strip joints and the trailer parks. Yet some fear that the admirable goal of dispersing the poor and creating mixed-income communities could simply lead to another surge of white flight and "urban renewal." And here NIMBYism kicks in again; with two faces. On one hand, middle-class communities reject public housing, halfway houses, drug rehabilitation centers, and even homes for the elderly because they are considered "bad for the neighborhood" (or for real estate values); on the other, communities have a right to protest the incursion of pollution, incinerators, and dumps.

Peter Dreier and John Atlas of the National Housing Institute point out that "the bulk of federal housing assistance goes to the affluent, not the poor...HUD provides subsidies to only 29 per cent of the low-income renters eligible for assistance.... Only one fifth of middle-class taxpayers—those with incomes between $30,00 and $50,000—received any mortgage subsidy," while 44 percent of 1994's $51 billion homeowner subsidy went to the richest 5 percent of taxpayers—those with incomes over $100,000.

> Why should we bother to pause and think about these buildings and what they represent? Why pick among fragments to create an archaeology of doomed buildings?...Because these musty, dirty places and the belongings and markings left behind convey some of the worst of the American experience. Because in their remains can be read the yearning for respect, for love, for a modicum of order and security. Finally, because it is here, inside abandoned buildings surrounded by ruins, that we feel most intensely the need to create a better world....Together with the former residents, we need to write the history of our ghettos, from the inside; otherwise, the official story will prevail.
> — CAMILO JOSÉ VERGARA

Many project residents don't want to be moved so much as they want their homeplaces made liveable. Nevertheless, demolition is often the solution of choice. On the occasion of the 1994 dynamiting of Columbus Homes in Newark, New Jersey, the mayor said, "this is the end of an American dream that failed." A fifties promotional postcard for those very "homes" read: "Designed for Living. You should see these low-rent, modern apartments before they are all rented.... Visitors are impressed by the many modern conveniences it offers—closeness to churches, schools, recreational facilities, downtown shopping centers, and scenic Branch Brook Park." Exploring the nightmarish abandoned buildings of Columbus Homes in the early eighties, photojournalist Camilo José Vergara, author of the important book *The New American Ghetto*, found wall-sized drawings, diaries, snapshots, letters, poems...and an old urban planning book. The demolished high-rises will often be replaced with lowrise "townhouses"—a pseudo-classy image that may well prove as ephemeral as one such project already has; built shoddily on the site of another demolished Newark public high-rise, it had to be razed after a windstorm.

In response to the national housing crisis of the eighties came a rash of grass-roots housing organizations, urban block associations, rent strikes, and other activist solutions. The homestead movement, rehabbing buildings with "sweat equity" (volunteer labor by the future inhabitants) helps lower-income people remodel abandoned and substandard city-owned housing. Some grass-roots programs really work, but their success is unrecognized in political rhetoric pushing hackneyed government programs that have already been proven failures. With landlords preferring gentrification, the grass-roots groups advocating local self-motivation, self-determination, self-

But more nailbiting ensued as the contracts were delayed several times; BIW needs at least two ships a year to survive. Its only rival for the Aegis is Ingalls shipyard in Pascagoula, Mississippi—Trent Lott's turf; before his regime, William

Cohen and George Mitchell took good care of BIW in Congress. Finally a Navy contract came through for 3-4 more Aegis destroyers. That was the year Congress gave the military more than it asked for.

Morale at the yard has plunged since

General Dynamics took over. Resisters calling themselves the "Tea Party" ousted the union leadership in favor of a more progressive group. And in summer 1996 Local S6 and the other unions resoundingly rejected management's replacement of a promised

reliance—as applied to communities, rather than individuals—find their heads under the axe. "We want our house improved, but not so much that we won't be able to live there any more," as one elderly black woman in Cincinnati put it.

If in fact there is a connection between the places that we inhabit and the political culture which our inhabiting of them produces, then perhaps it makes sense to begin with the place, with a sense of what it is, and then try to imagine a way of being public that would fit the place.
— DANIEL KEMMIS

For years, including those when many younger, poorer artists moved in, Manhattan's Lower East Side, or "Loisaida" as it is called in homage to the prevalent Puerto-Rican pronunciation, was riddled with drugs (it still is, if less visibly). On the corner of 3rd Street and Avenue B, in particular, you could walk by hundreds of people lined up at a drug "supermarket." Then, suddenly, in the late eighties, when the neighborhood was being seriously gentrified, the New York City Police Department's Operation Pressure Point appeared, far from coincidentally: "In less than three or four months, it was empty. It was like a desert. So why'd they wait so long? That's what I don't understand," says Loisaida native Rafael "Blackie" Pacheco. Others in the neighborhood did understand, though.

"Operation Pressure Point started because the drug dealing was so extreme and the developers wanted to come in.... [Now] they get moved from block to block.... The worst thing is a drug addict apartment. They decide to have a fight, they take down the door. It's not contained in the apartment. It affects the whole building in a creepy, insidious, total way, and there's nothing the landlord can do." People are still shooting up in burned out buildings, but they are off

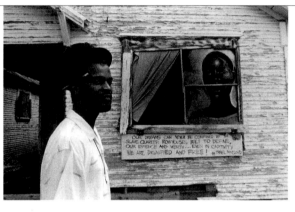

ISRAEL MCCLOUD, *Our Dreams Can Never Be Confined*, 1994, Project Row Houses, Houston, Texas (Photo: Stephen L. Clark). The text below McCloud's proud face, restrained by the window frame, reads: "Our Dreams Can Never Be Confined by the Slave-quarter Rowhouses, Built to Define Our Essence and Worth.... Even in Captivity We Are Dignified and Free." Project Row Houses —a one-and-a-half-block compound of shotgun houses in Houston's Third Ward—has been described as "Houston's most whole-hearted answer to fusing arts and community revitalization." The brainchild of activist artist and curator Rick Lowe, it is centered on "art-lab" houses that are periodically transformed by art relevant to the African-American neighborhood. Before the lease was signed and rehab begun, the project's first exhibition was up: the "Drive-By Show" of paintings on the boarded-up windows, including McCloud's. The compound also harbors the Project Gallery, the Spoken Word House (home to the Roots Collective, which holds poetry slams and other events), a classroom, residences, childcare and guidance for teenage mothers, summer camp, workshops, and Project Chrysalis for at-risk sixth graders. Designed for historic preservation and urban revitalization, the whole enterprise brings, as Shaila Dewan observes, "a message of self-esteem to its neighbors" and "'cultural capital' out of the museum district and into the hood."

the street, clearing the way for progress. A cartoon (by "Auth") shows a man saying to his wife as they peer down from their apartment at the city far below: "The problem of the ghettos? The ghettos, my dear, are a solution, not a problem."

Isolation epitomizes the ghetto, which has become a fortress, a last bastion, to keep some people in and others out. Ghettos are the direct results of both well-

profit-sharing plan with a performance incentive bonus. Many believe there will be another strike when the contract comes due in August 1997, but late summer is a terrible time to strike—summer jobs are no longer available and winter heating bills loom.

Some feel that the contract was deliberately moved up from June for that very reason.

"This is a city where rumors run through town as quickly as shipyard workers heading home at the end of a shift. It's a place where welders say you can't believe 99.5 percent of what you hear, where sandwich shop workers have 'reliable' sources, and where women sitting on curbside benches insist they are not hearing anything—except for the couple dozen stories they proceed to tell." One former worker said

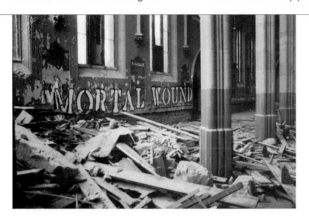

JOHN FEKNER, *Mortal Wound*, c. 1980, stencil. The wrecking ball had already struck Saint James Cathedral in Newark, New Jersey when this photo was taken. Fekner recalls that the structure was perfectly sound and it took months to destroy, stone by stone, window by stained-glass window. This is a particularly poignant example of Fekner's "Warning Signs," created in and around New York City from 1978 to 1984. His giant guerrilla stencils captioned the urban landscape: "Decay" and "Industrial Decay" on appropriate sites and abandoned vehicles in Queens; "Falsas Promesas/Broken Promises" on the walls of Charlotte Street in the South Bronx, where political candidates were wont to come and promise the world; "Wheels Over Indian Trails" and "Rechiquakie Indians" on overpasses on the way to Laguardia Airport. Fekner was concerned with both "the knocking down of structures that could remain standing and be utilized and the structures that remain standing that should be knocked down and destroyed."

many years, documenting their ups and downs. He compares his work to a family album in which the figures are buildings rather than people. Fascinated by the process of urban decay (though never forgetting what it does to the people living there), he says he records the dreams as they bloom and die, comparing an abandoned housing project to "a giant piece of folk art," and even suggesting an Urban Ruins Park for Detroit.

Vergara distinguishes between "green ghettos" (dominated by "vacant land overgrown by nature and ruins"), "institutional ghettos" ("publicly financed places of confinement designed mainly for the native-born," and "new immigrant ghettos" (mainly Latino and West Indian). The demolition of Camden, New Jersey's row houses created a green ghetto. Although some wildlife and weeds thrive, it is not a landscape of hope, of what will be there, but a blatant symbol of neglect, of despair, of the loss of what was there—a once-thriving working-class neighborhood "counted among the best ordinary urban dwellings in America." These are not the greenbelts of planners' dreams but tabula rasas awaiting the next development, in every sense of the word.

This is a block with a bad reputation, I know. That was mainly due to the methadone clinic that used to be on the corner over there. Like you had people, real sick people, passing out on the sidewalks here. Our kids had to step over them on the way home from school. But the good part of this block is that this block is like family, and, you know, like every family, it's got its own certain trials and tribulations, but everyone nevertheless feels real good about the place.
— RICHARD OF EAST 13TH STREET

intended and deliberately hostile public housing policies that have made public projects the end of the road. They are also home turf, from which symbolic, emotional, and practical relationships to the surrounding society are forged. The framework is constructed from the outside, but the internal content is partially self-determined.

Deploring official indifference to "the power of the physical surroundings to shape lives, to mirror people's existence and to symbolize social relations," Vergara insists upon a non-statistical look at these little-known enclaves. He has photographed urban neighborhoods in the East and Midwest over

In Boston's West End, identified as a "slum" when it was being torn down, Herbert Gans found that the residents' lives were focused on the interiors of their

higher-ups, then confirmation.

In 1996 BIW agreed to cap the last section of its 30-year-old Dauphin Dump, a toxic waste heap in the residential neighborhood of Tarbox Hill that was closed by the state in

210

homes, which were lovingly cared for and decorated. Unlike suburbanites, for whom outward presentation is all important and who tend to lean over backward in the opposite direction ("What will the neighbors think?"), he found these people less concerned with the status aspects of the exteriors they presented to the world. Close quarters were not a problem either: "Everyone can hear everyone else, but nobody cares what anybody is saying; they leave their neighbors alone." In *Manchild in the Promised Land*, on the other hand, Claude Brown wrote, "I always thought of Harlem as home, but I never thought of Harlem as being in the house. To me, home was the streets"— an attitude that still prevails among many young urban homeboys.

In big cities, the "old neighborhood" has a less unified flavor than in small towns, since so many residents are transient. You never know most of the people you live with, but visual familiarity with place tends to soften the rough edges of living among strangers. Even New York-born "natives" have usually moved around the city a good deal, and every ten square blocks or so the neighborhoods vary tremendously. The real urban communities are tiny microcosms within already small neighborhoods, which are in turn perceived differently by different residents. For example, the role of the church parish and parochial schools can be significant: I once had a babysitter in Little Italy who, when I asked her if she knew another local girl her age who lived a few blocks away, replied with a surprised, "Oh no, she'd be Saint Anthony's." (Her own Catholic church, St. Aloysius, was torn down a few years later; a hotel has recently risen on the site, now SoHo.)

I feel little connection with the Upper East Side brownstones where I lived as a child (then affordable for a working mother), though if I walk across East

68th Street I can look up and recall throwing water and coffee beans on people's umbrellas from an apartment far above. The Third Avenue elevated train, a scary roaring dark place I had to cross under to get to school, is long gone. Carl Schurtz Park on the East River and the Mother Goose Playground in Central Park still ring some bells, but my New York nostalgia is mostly reserved for the sites of my first time of freedom—young adult years on the Lower East Side before it was an art "scene."

My first home of my own was a one-room coldwater flat on Avenue A. It had a fire escape, a view of another tenement across the street, a blocked-up fireplace that yielded a Dough Boy whiskey bottle and a 1916 newspaper, an interior window opening onto a closetlike sleeping place, an enameled tin bathtub cover that doubled as kitchen counter, and a shared toilet outside in the hall. I was struck by the total absence of interior or exterior ornament; this building, and its neighbors, had been built with no fripperies, to contain as many people as possible for as great a profit as possible. Thousands of these nineteenth-century tenements are still in use. In 1959, I paid eighteen dollars per month rent; it is now an expensive "studio apartment."

Thirty six years after I moved out, I went to the Lower East Side Tenement Museum on Orchard Street, which gives tours of a nearby building preserved as it was when boarded up in the fifties. I was unprepared for the wave of nostalgia as I accompanied some local schoolchildren, mostly Black, Asian, and Latino, through the tiny apartments. Two of the tenement rooms are beautifully and unpretentiously restored "period rooms" from 1878 to 1935; the others remain empty. With their peeling wallpaper, exposed pipes, and chipped kitchen cabinets, they look exactly as my first home looked when I moved in—at the beginning of an urban life now completed.

1984. Eight years later runoff was contaminating about a dozen local wells. Neighbors sued the shipyard which eventually bought 17 houses at over assessed value, compensating those who did not want to move. In 1996,

the vacant Tarbox Hill homes were donated to two local non-profit agencies. The site will be monitored for another 30 years.

There is not much impetus to hold BIW accountable for its environmental short-

comings when the whole state depends on its economic health. One battle was won after the Trufant Marsh on the Kennebec, bordering BIW's South Gate, became the center of a 5-year fight between BIW, the

Two Jewish women about my age in the group were beaming with recognition as the guide provided a detailed social history of the neighborhood. They said their parents and/or grandparents had come through here in the heyday of its immigrant vitality. My own memories were more recent, unattached to an ethnic heritage, but decidedly cultural nonetheless.

The street life in tenement neighborhoods is often lively and very attractive to young middle-class people who have been sequestered in the suburbs or small towns all their lives. Its very dirt, poverty, and density can be exhilarating for those who do not expect to live that way forever. I remember returning to the Lower East Side around 1960, after a brief sojourn in the country, breathing in the polluted air and the Latin music, scanning the overflowing garbage pails, the kids playing in the streets, the burbling hydrants and the crumbling tenements. I was overwhelmed by the sheer energy of it all, and by a warm sense of coming home; it made me feel safe and part of a community, even though I wasn't. My father, who had worked his way up and out of a New England milltown, was appalled: "You *live* in this place?" he asked in disbelief as we climbed the dark stairs, embraced by a suffocating smell of drains. All very well for a middle-class fugitive, a decent trade-off—urban squalor for freedom and a creative community.

My subsequent geographical-economic movement around lower Manhattan as a self-supporting (as opposed to trust-funded) art type was a relatively common experience and serves to illustrate the way artists inadvertently and ignorantly become the flying wedge of gentrification. In 1958, I moved to a city that was entirely unlike the one where I had lived as a child during World War II. The Upper East Side, for example, was now out of bounds for anyone with an artist's income, and lower Manhattan had taken on a very

different history. I lived briefly in Greenwich Village (no longer a bohemian stronghold) and in a few months moved into a sequence of tenements—two near Avenue A, and one near Avenue D—costing between eighteen and fifty-five dollars per month. I spent several years living with an artist in a loft on the Bowery (sixty-five dollars per month), then, for about the same price, in another tenement on Grand Street in west Little Italy. In 1968, I moved into a loft building three blocks north, in what was just beginning to be called SoHo ("South of Houston" Street). A group of artists bought a co-op very inexpensively, a stroke of luck that permitted us to pursue our often unlucrative creative careers for years to come. (The initial maintenance fee was $125 a month, which I found staggering at the time.)

SoHo is distinguished by handsome nineteenth-century brick and cast-iron industrial buildings. Once a hive of light industry, it was called "Hell's Hundred Acres" for its inhuman sweat shops. When the small-manufacturing blocks inaccessibly sandwiched between residential areas fell on hard times by the late sixties, artists filled the void. We were looking for big spaces and cheap rents, and were willing to live with few amenities and under constant threat of eviction from city agencies. We naively thought that we had come home, that the area from West Broadway to Broadway, Houston to Canal streets, would remain "ours," since we were transforming it. It did not occur to us that we were "improving" the neighborhood for the landlords, developers, and rich tenants who would soon invade and profit from our "pioneering."

My three-year-old son and I moved into our loft the same day that a wood-refinishing firm, which had been there for many years, moved out. (For months we got frequent requests for the erstwhile freight-elevator man; his lasting popularity was a mystery until we

city, and statewide environmental groups; protective zoning was adopted in 1989. But in 1995, when BIW still claimed plans to diversify into commercial shipbuilding, city planners recommended zoning changes to remove the wetland protection and facilitate BIW's expansion into Trufant Marsh.

Bath's charm as a city is, for me, rooted in its combination of history and work— typical of Maine coastal towns despite their ravages by development. Thanks to the Iron Works, Bath has not become the upscale

discovered he had employed a woman to give coffee-break blowjobs in our basement.) We all thought we were settling in for the rest of our lives. By the time I left, twenty-six years later, only four of the original nine tenants remained, counting my son. There are still a few small manufacturers left in the neighborhood, but those artists who were not lucky enough to buy early on were priced out long ago.

In the late sixties, political art and performances in public were commonplace; we "pioneers" often knew each other. It was truly, and briefly, a community for those of us who needed one. Like the working-class communities studied by Gans, however, our "spaces" were the focus of our intellectual and emotional lives; we were for the most part indifferent, if not oblivious, to what the outside of the building and even the hallways looked like. Later, with the onset of more serious gentrification, some wanted to leave the exteriors unlighted and as shabby as ever, to deter robberies. Our building eventually gave way to fresh exterior paint and pristine interior whiteness as real estate values shot through the skylights.

SoHo has become a case history in the legend of urban pioneers, the forerunner of a larger nationwide movement. When many middle-class people who had left the cities for the suburbs in the fifties began to return in the seventies, they "repossessed" working-class and industrial neighborhoods, ineluctably changing the city's geography and economy. With artists serving literally as an unwilling avant-garde, areas as unlikely as Williamsburg, Hell's Kitchen and the primarily black and Latino communities on the Lower East Side were gentrified. They began to be described as the new "urban frontier" or "Indian country." Wealthy pioneers (more comparable to the speculators than the settlers) were not willing to rough it, but they were willing to pay.

Any illusion that the special zoning intended to reserve the neighborhood for cultural workers ("AIR lofts," for "Artist in Residence") would hold up was dispelled by the mid-seventies. On January 14, 1979, a *New York Times Magazine* cover story (belatedly) proclaimed REDISCOVERING THE CITY: THE NEW ELITE SPARKS AN URBAN RENAISSANCE. High culture was the bait; the renaissance had already been sparked by artists. Gay men too, have played an involuntary gentrifying role, revitalizing parts of the inner city by superimposing their cultural values on their own urban "ghettos" (Christopher Street in New York, The Castro in San Francisco, South Beach in Miami, among others), while displacing the inhabitants.

The circulation of capital can be followed through the SoHo landscape like cobalt through a bloodstream. Lofts became chic. We were invaded by wealthy dilettantes, doctors, lawyers, and proto-yuppies. Paula Cooper and Ivan Karp opened the first art galleries, but they were soon followed by many others, some selling schlock. Then followed the plague of boutiques and restaurants, few of which the original artist residents could afford to patronize. Rents skyrocketed, and longtime tenants were pushed out. Familiar faces disappeared as the small Italian businesses were displaced. (A few, like one of the local liquor dealers, hung in, and went succcessfully upscale.) Luizzi's, the neighborhood family restaurant where we ate almost every day before we had a stove, where my kid had had the run of the kitchen and the resident dog, Coco, had wandered outdoors like he was in a small town (until he was run over on Houston Street) was bought out by something fancy, overpriced and French. The drycleaners disappeared. The Puerto Rican *bodega* across the street that sold beer and lunch to the neighborhood workers gave way to a ridiculous jewelry store.

destination of those who demand that quaintness be partitioned off from real life, however nice that might be for the local tax base. I remember Bath in the 1940s, when its raucous boom-town identity made it seem like a real city, even to a child from Manhattan. In its later, sleepier and depressed years it began to seem more like a backwater. (I was illogically amazed when I heard that a highway rest stop suddenly in the news as the target of police attention was the local gay men's meeting place.) In

Shooting a movie in SoHo at Grand and West Broadway, 1996. (Photo: Andrea Robbins).

Over the years, things went from bad to worse. An exorbitantly expensive fish store came and went on the site of an old workers' luncheonette, to be replaced by a SoHo souvenir shop. Cavernous, almost empty clothing stores with isolated racks of black garments now vie for space with antique shops and stores selling exotic doodads. The 80-year-old Joe's Dairy survives, with longer-than-local lines for its fresh mozzarella. Community activist Anthony Dapolito has managed to maintain Vesuvio, his parents' tiny bread bakery, although its matriarch is gone; now it's written up in guide books. Tour buses come through, and the doors to our houses are blocked by film set paraphernalia. The upscale chains have arrived— Starbucks, Sunglass Hut, Smith and Hawken. Two hotels are under construction, and shopping reigns supreme. The art business, which started it all, is in a decline. I'm glad to be gone.

SoHo has been gentrified twice. During the first boom in the seventies, it became the artists' quarter. In the late eighties there came a recession, empty stores and lower rents. Then "recovery", and the second boom arrived in the nineties, when, according to Elizabeth Hess in an article called "The Malling of SoHo," "it

feels different. There's a sense that SoHo will never be the same; it will never again be synonymous with art, community, rebellion, or dissent. SoHo is dead—at least the avant garde SoHo that lured artists from all over the country to live here. This time around, dealers as well as artists have lost control of the streets. Where will the art world go?"

We learned from the SoHo experience how crucial the role of "cultural revitalization" is to the real estate business. The culture being revived, of course, is culture with a capital C, as in red-carpet culture, "high" or "fine" art, which supports the entrepreneurs more than the producers—not culture with a small c, "the medium through which people transform the mundane phenomena of the material world into a world of significant symbols to which they give meaning and attach value." It is not the culture of the communities already in place. There is little trace of the Ukrainian culture on the Lower East Side, and there is no Italian Heritage Center in SoHo (or in the core of Little Italy, further east, which is increasingly Chinese). We "cultural workers" began to understand how artists served as unconscious buffers between classes and neighborhoods. When Mayor Ed Koch initiated artists' housing on the Lower East Side in 1984, we were able to protest the way cultural workers were being used to displace other communities.

Perhaps the most pointed spatial criticism by artists of the city's disregard for the disenfranchised was "The Real Estate Show," which opened with much surreptitious hoopla on New Year's Eve of 1980. A group of downtown artists simply took over a derelict City-owned building on Delancey Street near the Williamsburg Bridge. (Ironically, the building, built in 1916, was last used as a federal Model Cities office.) The artists liberated some electricity from a nearby pole and filled the place with an eclectic chaos of art

summers Bath is modestly flourishing, the nearest shopping town for the seasonally bloated populations of many outlying communities. In winter it turns in on itself.

Getting to work becomes harder. The beauties of empty beaches and woods are open to the hardy. A perennially late spring is famous not for its romance but as "mud season." Soon Bath will be enduring bridge construction and struggling to freshly identify itself.

protesting absentee landlordism, eviction, and redevelopment; it was dedicated to Elizabeth Mangum, a middle-aged African American woman who had been killed by police while resisting eviction in Flatbush. The show was closed down by the police after a day, but the site continued to be visited (by much press and by famous artist Josef Beuys). The same New Years Eve, another group of artists dug a ditch in a vacant lot on Spring Street and ensconced themselves as a temporary conference center to discuss social ills and solutions.

People in the neighborhood—even the cops guarding it against a renewed invasion of art—liked the Real Estate Show. One woman suggested that it remain as "a tribute to the block." Representatives of the City met with the artists and allied local organizations protesting the dismemberment of their neighborhood. Other, unsatisfactory spaces were offered for art shows, one of which became the still-functioning ABC NO Rio Dinero (named after a semi-obliterated sign found on the site) on Rivington Street, which continued to hammer at the issues the Real Estate Show had raised. Fifteen years later, the building still stood amid other abandoned structures that were never rehabilitated, still a morality show, a monument to continued waste, still captioned REAL ESTATE SHOW in fading letters scrawled across the facade. In 1995 it was finally torn down.

Home in the Weeds

I am not the garbage, the booze, the guns, the dirt,
I am the song, the baptism, the wedding.
I am the newborn child that grows among rank weeds.
— MIGUEL ALGARIN

DON BARTLETTI, *Highway Camp, Encinitas, California,* July 25, 1989 (copyright Don Bartletti/*Los Angeles Times*). Three brothers and friends from Huehuetenango, Guatemala, sleep on a terrace over Interstate 5 near San Diego, above the street corner where they await drive-by offers of daily work. This is how the people who provide cheap labor to support the American dream are forced to live. Recent attacks on undocumented immigrants, like California's (now rescinded) Proposition 187, the current welfare "reform" bills, and unrealistic proposals like "The U.S. Needs 16 Miles of High Steel Fence at San Diego Border" (on a t-shirt shown in another Bartletti photograph) are not only counterproductive, since the U.S. needs immigrant labor, but impotent to stem the flow of desperate workers fleeing warfare and economic decay in Central America. Bartletti's photographs are intensified by his long-term commitment and unusual access to borderland citizens; publication of these images is one step toward tolerance and improved conditions.

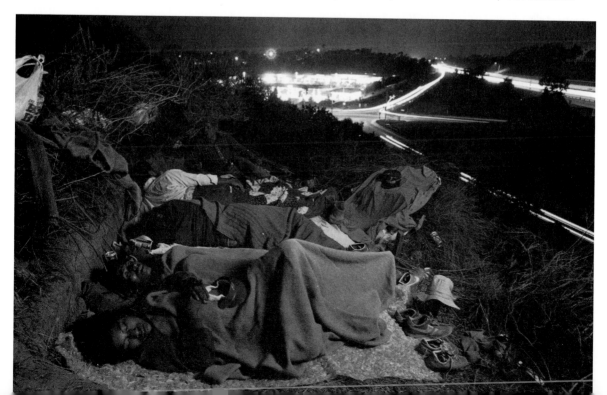

"I've always told people who come here, 'It's a wonderful place to live, it's a horrible place to make a living.' You've got to know that your lifestyle's going to include getting along on what you get."— Ed Walden, great great great grandson of the founder of Greenville, Maine.

Maine enjoyed, or suffered, a population surge in the 1970s and 1980s, with southern towns doubling and tripling in size. Younger and better educated newcomers caused property values to escalate and a 'circuit breaker bill' was enacted to offset higher taxes based on ability to pay. Affluence and growth in mid-coast Maine had little affect on more isolated rural areas. The gap between rich and poor is widening. For most residents the changes came too fast, and voters man-

DEPRIVED OF "KNOWING THEIR PLACE," THE homeless are adamantly "out of place," confusing the boundaries maintained by those who think they know their places. Their poverty forced into public view, the homeless remind everyone of the hypocrisy and greed that underlies a city's structures. Many are working people with families, brought down by a single stroke of bad luck—eviction, fire, job loss, illness, the kinds of things that can happen to anyone. Some have AIDS; some are addicts; some are mentally ill; some suffer a whole litany of afflictions for which society takes less and less responsibility. Even in pathos, even when their anger is dulled and they seem almost saintly in their endurance, the homeless threaten a society that brags it's the best in the world.

Homelessness runs counter to the wider population's illusions of what their public spaces are or should be. Yet the public domain is a place where no one has or takes responsibility, so the homeless are people for whom no one is responsible. One of the best overviews of the city from viewpoints sympathetic to the homeless is a book based on an art exhibition organized by artist Martha Rosler: *If You Lived Here: The City in Art, Theory, and Social Activism*. Rosler contends that art functions socially "to crystallize an image or a response to a blurred social picture, bringing its outlines into focus." Yet for the most part, art about the homeless suffers from contextual oversimplifications and lack of understanding of the specific audiences and geographic subjectivities that mediate our relationships to places.

James Lardner elucidated one specific context in a *New Yorker* profile of "the Hill"—a homeless encampment under the Canal Street end of the Manhattan Bridge. In 1909 the site boasted a grandiose neoclassical arch and a pretty little park with a fountain. The seventy-five or so intervening years have been lost in obscurity, since "historians have yet to give to the neglect and deterioration of the city's great monuments of architecture and engineering anything like the attention lavished on their design and construction." By the late eighties, the place had become a weed-strewn vacant lot—a refuge for those who eschewed cardboard boxes for more permanent jerry-built shacks, some of them wildly innovative in their construction. One, built by Juan Samuel Ramirez, adopted the frontier theme with a wagon wheel labeled LA PONDEROSA, referring to a ranch on the TV series *Bonanza*.

"People fight a lot on the Hill," wrote Lardner, "but they exhibit a degree of neighborliness not to be found in every high-rent apartment building." The Hill's inhabitants "were living on a site that was all but abandoned before they got there. They have as much right as most non-homeless people, perhaps, to feel that they have improved on what came before, and more right than most to think of themselves as having built a community from the ground up." For a while, even the police acknowledged this by keeping a protective eye on the people living there.

In 1991, the Hill became art. Gabriele Schafer (from West Germany) and Nick Fracaro (from Illinois), came to the Hill with a vague idea of doing a theater piece with the homeless—"something that would link them with the nomadic tradition stretching back through the centuries" and assert homelessness as a choice. They built a tipi and moved in "without a script and without any performance dates." They drew portraits of the residents, did some gardening, and, most acutely, handed out disposable cameras with which residents could shoot back at the tourists photographing them. ("Do unto others what they shouldn't be doing unto you," is how Ace, a Hill resident, described this process.) The results were exhibited on the site (in the tipi, by then called "The Living Museum of the

dated a comprehensive planning bill that encouraged communities to think about where they were going.

In Maine, as across rural America, "low road" economics, based on cheap labor and cheap natural resources, is nearing a dead end. Global competition, branch plant mobility, and technological change are making old economics obsolete. Despite state subsidies, industry is being clobbered by imports. Maine lost 45,000 jobs between 1989 and 1994. Around 1990 the number of service jobs began to surpass manufacturing jobs for the first time. Some predict that the recession will last another twenty years.

Nomad Monad") as "photoscalps" captured in a "last stand"—yet another phantom of the frontier. A year or so after Lardner published his article, the tipi was burned and a rash of suspicious fires caused police to close the community down.

The photographer is the philosopher of the shards of glass that sprout between the cracks of the concrete sidewalk.
— MIGUEL ALGARIN

Inumerable photographers have documented the plight of the homeless over the last decade, with results ranging from condescending, sentimental, even racist images, to moving, empowering, and genuinely informative ones. From Los Angeles, the national capital of homelessness, Anthony Hernandez's "Landscapes for the Homeless" are large Cibachromes of the detritus of nomadic life, omitting the human presence. A more overtly engaged approach was that of Oakland photographer Scott Braley, who first spent eight months photographing Rufus Hockenhull's life as a homeless black Vietnam vet and then taught Hockenhull to photograph his own landscape of homelessness, alcoholism, and mental illness.

Around the same time, in Washington D.C., Jim Hubbard embarked on a similar but much larger scale project called "Shooting Back"—after a homeless child explained why he was photographing his world. The participants, who lived in shelters, ranged in age from seven to eighteen; they photographed their immediate surroundings, children's views of the society that has condemned them to that place. (According to Jonathan Kozol, 40 percent of the poor in America are children.) Poet Carolyn Forché described the images as "the landscape of those who suffer from exposure to anonymous space and the practice of human warehousing"; its recurring motifs, she says,

are "incarceration and ruin." One child photographed a handlettered sign: I WILL KILL ANYONE DESTROYING MY PROERTY (*sic*).

The most impressive, and ongoing, artwork done with (rather than about) the homeless is the Los Angeles Poverty Department (LAPD), founded by performance artist John Malpede, who tired of the New York artworld, moved to L.A. to work as a paralegal on Skid Row, and found himself using performance techniques to find out what was going down on the streets. His workshops developed into a unique improvisational theater troupe made up primarily of homeless people. In its dozen years of existence, LAPD has traveled around the country and inspired similar work among artists and street people. I saw LAPD perform in Boulder, Colorado—a university town not known for its squalid side. One local participant described himself as "an individual far away reaching for a space in life." In a related discussion group, a Boulder resident made it clear that people didn't realize how difficult it is to live in a town with little lower-income housing, where college students snap up the minimum-wage jobs, where "quality of life" and open space are favored over poor people. As a result of LAPD's visit, a homeless theater program was set up in Boulder. (Some money was stolen, though, and the program was subsequently closed.) For all its pitfalls, art like this helps the public to perceive the places where the homeless live as real places inhabited by real people with lives, however chaotic, rather than as "objects" left on the corners of other people's places.

In the eighties I read a newspaper article about a homeless woman, a carpenter by trade, named Kea Tawana (she looked to be white and in her fifties or sixties) who spent five years building from salvaged lumber a remarkable three-story, ninety-foot-tall ark in the center of Newark, New Jersey, because she

Over New Years of 1990, Natasha Mayers, with some 30 members of the Union of Maine Visual Artists, organized "Artists for the Homeless" to make art in 20 store windows on Portland's Congress Street. She thought support for the homeless (some made window works of their own) would be relatively uncontroversial, but five works (including her own) were censored by landlords. One "expected a nativity scene"; she had in fact made one, based on the line "You never know who you might be turning away..." Participating artist Abby Shahn observed, "It's impossible to raise these issues without being controversial. The distribution of wealth along Congress Street is glaring. The contradictions are very powerful." Mayers added, "The act of censorship

"needed a decent place to live"; on the eve of the ark's completion, authorities condemned it to make room for a high-rise. In response to this kind of brutality, which is common nationwide, a group in Atlanta called the Mad Housers began helping to build rudimentary shelters for the homeless, "in recognition of the inability of the existing social order to meet the requirements of those citizens who are unable to compete effectively." Like the homeless themselves, the Mad Housers operate outside of regulatory frameworks. Bailey Pope described the project in terms of the "physical division of here from there" (walls) and extension of self to other (doors, which open to dialogue and the development of community).

The Mad Housers spread to Chicago, where the story of their wildly successful "productive protest" is instructive. Having constructed a group of huts along a commuter railroad track, the homeless residents were praised for replacing an ugly abandoned space with a clean, green community. They attracted much attention, first from train passengers and employees, who donated food and clothing, and then from the media and a much broader public. As its fame grew, Chicago Mayor Daley decided the shantytown was too visible and had to go. Residents, activists, and a large support base girded for battle, vowing to block demolition crews. The city finally won by moving the hut dwellers to the top of the city housing waiting lists (over thousands of people, some of whom had been waiting for years), and the huts came down. Thereafter, the Mad Housers took care to build discretely, keep their sites secret, avoid media attention, and keep up the good work.

The antiregulatory approach has proved appealing to artists, among them: Jon Peterson, who made fiberglass street sculptures in L.A. and New York City in the late seventies, which he called "Bum Shelters";

Athena Tacha, who proposed a very simple but structurally handsome honeycombed movable homeless shelter in the eighties; Donald McDonald, architects from San Francisco who have constructed plastic sleeping boxes with tiny windows; and Brad McCallum, who designed a tent that fit over a park bench. Krzysztof Wodiczko, best known for his giant projections onto the sides of building, expanded on homeless people's own adaptions of the shopping cart as mobile home by inventing an ingenious, if ingenuous, "homeless vehicle"—a body-sized, missile-shaped expandable bed/cart (complete with metal basin and returnables receptacle). Conceived in 1988 literally as a weapon against social neglect and a survival strategy, the vehicle provided "both emergency equipment and an emergency form of address" for the evicted. Another version of the mini-mobile home has been seen recently on the streets of Manhattan's Lower East Side: a little house on wheels dragged around town to various sites by the artist couple who live in it and exhibit their raunchy drawings in the windows. Such fragile "housing" proposed or executed by artists raises questions. Some argue that such stopgap measures accept the necessity for homelessness and fail to deal with its social causes; others insist that since homelessness is a fact, anything that can be done to alleviate the suffering or call attention to it is worth doing.

Like indigenous people in the nineteenth-century West, the homeless are either perceived as a negligible part of the "landscape" or slated for internment. The connections with the myths and military ideologies of the old West lie in the issues that surround any contested territory: land and housing, displacement of the "savages" (poor residents), homesteaders and squatters, and "civilization" (wealthy newcomers). Violence, both economic and physical, is taken for granted. As Neil Smith explains, "the frontier motif

doesn't get rid of an image, it draws attention to it." Homelessness continues to rise in Maine, thanks to the lack of affordable housing, lack of support for the mentally ill, domestic abuse and violence, government cuts, and tough economic conditions. In the first half of 1995, it increased by more than 10 percent. The Tedford Shelter in Brunswick often has no beds. Gary Lawless, a respected radical poet and bookstore owner who teaches writing to the homeless, says, "The greatest gift you can give someone is to listen to their stories...Why should [their talent] be a surprise? Because you have one leg or no paycheck, does that mean you can't write something beautiful?"

makes the new city explicable in terms of old ideologies....[It] rationalizes social differentiation and exclusion as natural and inevitable." Smith calls developers "real estate cowboys," but "ranchers" would be a more accurate description, given the profits involved. He quotes one developer who illogically and ahistorically denied responsibility for the homelessness he had promulgated: "To hold us accountable for it is like blaming the development of a high-rise building in Houston for the displacement of the Indians a hundred years before."

A classic New York version of the Wild West show came in 1981 with the much-publicized making of the movie *Fort Apache: The Bronx*, an all-out media attack on the South Bronx, starring Paul Newman. It became a rallying point for the Committee Against Fort Apache (CAFA), a broad coalition of roughly one-hundred local organizations, ranging from former Young Lords to the Catholic Archdiocese. The film took a struggling neighborhood—beleaguered by civic neglect, bad press, landlord arson and redlining—and presented it as an inferno of crime and abnormality: "a 40 block area with the highest crime rate in New York. Youth gangs, winos, junkies, pimps, hookers, maniacs, cop killers," according to the movie's advertising campaign.

The cavalry was played by the cops, who saw themselves holed up in their "fort," a "thin blue line" maintaining "civilization" against the local "savages." In the movie, one of them describes the community as "seventy thousand people packed in like sardines, smelling each others' farts, living like cockroaches," including "fifty thousand potential cop killers." The film's final solution was "bulldozers.... that's the only way. Just tear it down and push it into the river." Life then imitated Hollywood: most of the housing in the forty blocks was in fact demolished, and the remodeled

An Old West Lynching in the South Bronx, 1981 (Photo: Jerry Kearns). The Committee Against Fort Apache rallies in the Bronx and hangs actor Paul Newman in effigy.

precinct rising from the ruins got a new nickname: "little house on the prairie." Richard, the voice of East 13th Street in Manhattan, predicts a similar fate for his neighborhood: "We've all seen neighborhoods rise and fall like little countries. In five years I bet you won't even see our asses on this block. Only this time, I don't know where people will go. There's always the Bronx. Lots of family up there. You know, you'll be walking on the East Side sometime and you'll see Richard got pushed right into the East River! Chased by fucking bulldozers, man!"

In the late seventies and early eighties, the Lower East Side and East Village became a hotbed of punk, new wave, avant garde art as groups of dynamically disenchanted young visual artists rebelled against the expectations of an artworld career and identified to an unprecedented extent with the disenfranchised in whose midst they lived. This was both a political and an aesthetic choice, and the art that resulted was more profoundly influenced by the city as place than any other modern movement I can think of. Groups like Group Material, Fashion Moda (the "cultural concept," or alternative space, in the South Bronx), Collaborative

From around 1870 to 1920 a wave of Acadians migrated from Quebec to Maine, often in covered wagons, becoming "Franco Americans" in the process. "They spoke only French, worshipped exclusively in the Roman Catholic faith, held politically conservative values, and did not assimilate in Yankee society until after World War II." When dance critic June Vail came to live in Brunswick in 1970, she recalls hearing "French every day in supermarket aisles, shops and restaurants. Today I only rarely pick up those distinctively nasal tones." Nevertheless, Franco Americans are roughly 25% of Maine's population; their cultural centers are Fort Kent and the milltowns of Biddeford and Lewiston, which still hold annual French festivals and once had French newspapers.

Projects (CoLab), Political Documentation/Distribution (PADD), Contemporary Urbicultural Documentation (CUD), and the loose-knit ABC No Rio artspace on the Lower East Side, *World War 3* comics, community muralists such as Cityarts and Artmakers, and individuals like Robbie McCauley and Ed Montgomery, Christy Rupp, Rebecca Howland, Tim Rollins, David Wojnarowicz, Kiki Smith, Justen Ladda, John Ahearn and Rigoberto Torres, Seth Tobocman, Jenny Holzer, Lisa Cahane, Mike Glier, Julie Ault, Bobby Gee, Alan Moore, John Fekner and Don Leicht, and David Wells—all lived, worked, and participated in seamy urban places. Young, cool, into "new contexts," they came to know these "ghettos" and the people economically confined there more intimately than most artists know the places they live in for economic convenience. Many of their projects were collaborations within the neighborhoods. In those early years, Loisaida and the South Bronx were the hottest art spots in town. Downtown, gentrification was already well on its way. The hype around the so-called Lower East Side Art Scene soon polarized the area, breaking all but the strongest alliances.

Photographer Geoffrey Biddle's book *Alphabet City*, on the Puerto Rican Lower East Side, was begun in 1978, then resurrected "after the scene" in 1988 with the addition of brief, compelling interviews recorded as his subjects looked at their earlier photos. Thus, the book is a "retrospective": it is about memory, time passing, change for better and worse. With a startling intimacy, and without condescension, Biddle chronicles the dying spaces of the bleak avenues from A to D and the resistent vitality of those who have been dumped there. Many people are photographed in their homes, squeezed by gentrification to double and triple up in the housing projects "in numbers the census won't show but that the city guesses at by monitoring gas and electric use." The neighborhood is epitomized by

GROUP MATERIAL, *People's Choice/Arroz con Mango*, January 1981. The young collective Group Material had a storefront gallery between Second and Third Avenues and curated this show of "the Art of 13th Street" by going from door-to-door on their block asking people for their favorite art works— "the things that you personally find beautiful, the objects that you keep for your own pleasure, the objects that have meaning for you, your family and your friends." The exhibits, forming a collective self-portrait of the block, ranged from a doll to family pictures, a snake skin, a rope sculpture, "masterpiece" reproductions, needlework, sports trophies, political posters, an unearthed oil by Abraham Walkowitz, and a Robert Morris S&M poster taken from the apartment of a man who hanged himself. The bulk mailing didn't reach the art world in time for the opening so it was an entirely local (and highly successful) evening.

In 1971 the University of Maine opened a Franco American Center and later a Franco American student newspaper. In 1993 both houses of the state legislature were headed by Franco Americans.

Rhea J. Côté Robbins, who edited *Le* Forum at the University of Maine for ten years, is researching Franco American women and has begun The Franco American Women's Initiative to publish material on Quebecois and Acadian women. She decided to initiate dialogues around Franco American women's issues because she herself was looking for "a net that doesn't let the Franco American woman's soul fall through." "I am from Waterville," she writes, "and my *maman* was from Wallagrass. In Franco American lore, that's North and South." She writes

221

its harsh, often fearful streets, leading to the East River through tenements and small stores to public housing projects built in the forties and fifties to a strip of park reached by bridges over FDR Drive.

Here are four residents' views of a changing "Alphabet City":

They're charging....a thousand dollars. That's not for the Black or the Puerto Rican. The only reason you makin that kinda money is because you're involved in drugs. So automatically they're pushing the good people out.
— EVALENE CLAUDIO

I see a change for the better, because I see a lot of preppies that are coming down, fixing old buildings. There's a new vibration, putting the neighborhood back. There's uniformed cops on every corner. It was a shooting gallery, now it's an art gallery.
— DAVID GARCIA

There ain't no good future in this neighborhood. If you lived here for like twenty years, best thing is just to get out now....there's nuttin here to advance to. Move to another building that got more mice or something? Nah.
— HOWIE WHEELER

Lately, I see a lot more white people in the neighborhood. I'm not gonna let them take over. Not my home....If they try to move in, we're gonna beat them up, make them think about it twice. That's how it is. They already look at us like we nobodies, and now they gonna try to take away what we got....One day, we're gonna get our sunlight.
— RICHARD MORALES

In 1988, within this context, the frontier melodrama —real estate versus community, racism versus respect—enjoyed a downtown rerun. The Lower East Side "community," centered on Tompkins Square Park between Avenues A and B, was smaller than the South Bronx and already a veteran of gentrification battles. It was more racially mixed, and much more visible. The battles in Loisaida took place in view of all downtown; the media did not have to be cajoled into "foreign" territory.

Loisaida also had a very different history from the South Bronx. In the fifties, poets and artists of the Beat Generation (as well as working-class gays and lesbians) trickled into what was then dubbed "the East Village," Greenwich Village having become too expensive and commercial for the avant-garde. The 10th Street galleries—New York's first "alternative spaces"—bloomed on the western border. From the mid sixties on, the area provided cheap housing for the creative and countercultural young who mixed cheerfully with diminishing Ukrainian and Jewish communities, an increasing African American and Latino population, and some overflow from nearby Chinatown. Despite a heavy drug scene and police presence, a certain community renaissance also took place, in which some artists were deeply involved. In the seventies, El Bohio, an old public school on 9th Street between Avenues B and C, became the cultural heart of Loisaida. Charas, the organization running the building, coexisted and often collaborated with the burgeoning alternative "punk" art and club scene,

GEOFFREY BIDDLE, from *Alphabet City.*

about eating *tourtières* (pork pies) and *creton*, and dancing jigs, about birthing practices and knitting patterns, the arts and the church, about losing the language, and ties to France. Artist Celeste Roberge has subtly addressed her Franco American identity in

her art, recalling her education by nuns from Quebec:"It made me comfortable depicting surreal things....If you remove Catholicism from Franco Americanism, you don't have Franco Americanism."

Georgetown has a few French names on

its mailboxes; most of these families have been in the area for generations and have assimilated, though most remain Catholics. The 300-year alliance between French and Indians was recalled in the 1995 ordination procession of Reverend Michael R. Cote,

222

which almost immediately attracted hyperbolic media attention and gave way to a rising tide of proto-Yuppies. Around 1983 some artists began to organize against "yupper-income housing," including a PADD project called "The Lower East Side Is Not for Sale," with site-specific works around the neighborhood and exhibitions at Charas and at ABC No Rio.

> *It's like a lot of bored people from good backgrounds getting into the bad of the neighborhood. And here we are struggling like hell to get rid of the bad, you know? We find no romance in junk and shit....I mean we got to look at all the shit on the streets everyday. Who wants to see it in a gallery too? Know what I mean? You might think the art is for someone. Who? I can't honestly say it looks like it's for us.*
> —RICHARD FROM EAST 13TH STREET

In 1984, a city-sponsored reconstruction project was rejected by local residents as a gentrification ploy. By then, gentrification had taken hold in earnest. The SoHo model was applied, though with less saturation): small shopkeepers were ousted in favor of boutiques, galleries, restaurants, and suddenly expensive housing; classy spacious white galleries replaced local small businesses; European art dealers arrived; crack dealers hung in, despite a drug crackdown intended to clean the place up for the middle class. Loisaida was also a center for the city's small but lively squatters movement. (Neil Smith has pointed out that "before 1862, when the Homesteading Act was passed, the majority of rugged frontier heroes [moving west] were illegal squatters.") Miguel Algarin described the process: "You can either comply with the law or grab the moment. Take over a building. Go downtown and argue for the deed of ownership. The squatters of Loisaida and Harlem are doing it. They risk having to learn how to pipe a building, how to gut it, how to

The Lower East Side Is Not For Sale, 1983-84, a project of Political Art Documentation Distribution (PADD) to combat gentrification in the East Village. In 1984, street corners and walls were designated as "galleries": The Guggenheim Downtown (before there was a real one), Another Gallery (a comment on the trendy East Village art scene), The Leona Helmsley Gallery (on the wall of the long-disputed Christadora building on Avenue B, which she owned at the time), and the Discount Salon. Art works were wheat-pasted to the wall; openings were held on the street. A work by Day Gleason and Dennis Thomas appropriately depicted a Monopoly set with local street names. Nancy Sullivan's piece —*Make Your Reservations Now*—was intended as a take-off on all the posters for plays and art shows peppering the East Village as artists "homesteaded" the low-income community. Ironically, she points out, within five years, the artists had failed to hold their "reservations" and the territory was upscaled, lost to both "indigenes" and "settlers."

Maine's newest Catholic bishop, of French descent. It was led by a Passamaquoddy and two Penobscot men, representing "the first Catholic Mainers."

Despite its demographics, Maine is not free of racism, which is always encouraged by economic recession. The summer of 1996 was marked by several incidents of vandalism, insults, spray-painted racial slurs combatted by anti-racism rallies and much handwringing. Columnist Nancy Grape pointed out that not one speech by the 31 candidates for Congress in 1995 mentioned racial inequality: "Apparently it's not our problem, despite demographic changes and tourists, college students and residents who expect to be treated with respect...."

The Ku Klux Klan was briefly powerful in

build a roof. They risk in order to construct the life that is happening to them."

By 1988, the lines were drawn between the gentrifying newcomers and developers (backed by the police department) and the earlier residents, artists, squatters, and homeless. The battleground was Tompkins Square—a one-by-three-block city park created from swampland in the 1830s. It has tall old elm trees, not much grass, benches, winding walks, a playground, and some basketball courts; it *had* a bandshell where the Grateful Dead played in the sixties, and a large homeless population. The square has a protest history that goes back to the 1850s. In 1874 a workers demonstration, seven thousand strong, was brutally broken

SETH TOBOCMAN, *War in the Neighborhood*, 1996, from a book in progress. Tobocman is a longtime housing activist on New York's Lower East Side who is a cofounder and editor (with Peter Kuper) of *World War 3*, the pioneering real-life political comic magazine, now eighteen years old. Nationally distributed but integrally involved with local grassroots issues, *WW3* blurs the boundaries between art, publishing, and daily street-smart organizing.

The Dark Satanic City is its major character, as it is in Tobocman's slashing graphics. *War in the Neighborhood* is a graphic novel about the ongoing housing struggle on the Lower East Side, with Tompkins Square as its vortex. Rejecting abstractions about world issues, Tobocman and his colleagues are "talking about the way people live here and the way they feel here, talking about our lives."

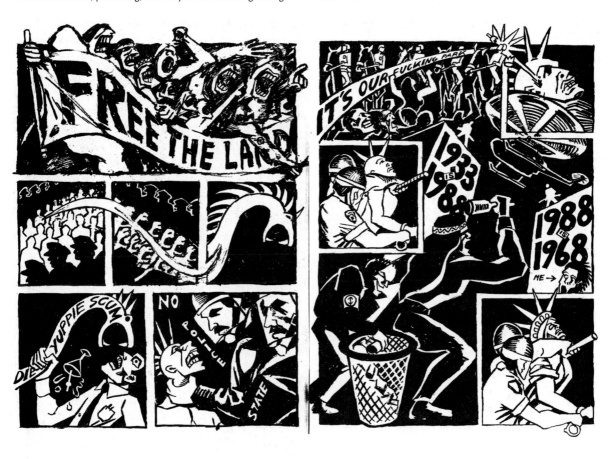

Maine in the 1920s, as a backlash against mostly Catholic immigrant labor, although it was also aimed at African Americans and Jews. Mississippi editor Hodding Carter came to study at Bowdoin College in 1923, just in time for the first KKK parade in New England; he saw his first burning cross in Camden, Maine.

An increasing immigrant population challenges Maine's monoculturalism. The local paper recently showed the top winners of the New England Bluefish Open on the Kennebec receiving their prizes in Bath's Waterfront Park. They were all from Freeport, and they were named Cuong Ly, Cuong Tang, and Hong San.

224

up by police; an Irish worker asked "Is the Square private, police, or public property?"—a question that might have been asked in 1988.

In the sixties, police brutality was aimed at hippies who refused to keep off the grass. By 1988, people were living in the weeds. Teaming up with progressive elements of the local working communities, young lefties, anarchists, and artists, many of whom were also locals, specifically opposed a pricey condominium on Avenue B, formerly a settlement house and community center (the value of which went from $62,500 in the late seventies to $1.3 million in 1983 to several million in 1987, when a single penthouse apartment was listed at over $1 million.) The protesters introduced a countercultural ingredient that made the struggle reminiscent of land rights battles in rural areas or the Berkeley People's Park confrontations, in which the struggle over a patch of "liberated" land between students, lefties, and street people versus the University of California, the state, and "the Establishment" made sixties history.

"Housing is a human right," "Gentrification = Class War," "Out Yuppie Scum" were among the slogans. The tinder was sparked by exaggerated police hostility during raids to destroy "Tent City," the shanties erected by the homeless in this last of city parks to resist a midnight curfew. It ignited on August 6, 1988, with a police riot: mounted police backed up by hundreds of footsoldiers were later called "out of control" by an investigative commission. The overkill was ineffective: the cavalry beat a retreat and eventually lost the media battle as well. Tompkins Square became a "liberated space"—briefly. In December, more than three hundred homeless people were evicted, their belongings hauled off in garbage trucks. Two homeless people froze to death. The squatters movement was targeted for legal harassment; several squats were demolished, to be replaced by nothing; others fell to suspicious arson, blamed on developers. Some of the homeless were taken in by those squats remaining. Others eventually set up a new tent city in a vacant lot nearby, dubbed "Dinkinsville" after New York's new African American and supposedly progressive mayor. They were in turn evicted in January 1990. In September 1990, another "riot" ensued when police interrupted a benefit concert for Tompkins Square squatters.

The homeless community was evicted again in 1991, but in the process the homeless burned their own tents in protest and the City backed down for a while; the Police Department declined to keep evicting squatters who just moved back in when the City did nothing with the empty buildings and the City scrambled for funding to plan ahead. (One of several ironic turns is the role of well-intentioned non-profit groups who, by supporting the City, help to evict the squatters.) During another riot on Memorial Day 1991, sparked by a still-unsolved murder, a local business was destroyed (some say it was police provocation) and Tompkins Square Park was shut down, only to be reopened with a curfew and strong police presence. Now the homeless stay up all night and come to the park to sleep during the day. In August 1996, the courts ruled against a group of 13th-Street squatters and rebellion is simmering again. "Whatever else happens," says a longtime Tompkins Square activist, "A lot of people have gotten apartments for around $75 a month in New York City. Kids have grown up in these houses—though not as many as we'd hoped."

The Grass on the Other Side of the Fence

The suburb is at the frontier of metropolitan expansion....
A pioneering spirit of doing things oneself.
— YI-FU TUAN

[Suburbia] seemed to me a voluntary limbo, a condition more like
sedation than exile, for exiles know what's missing.
— REBECCA SOLNIT

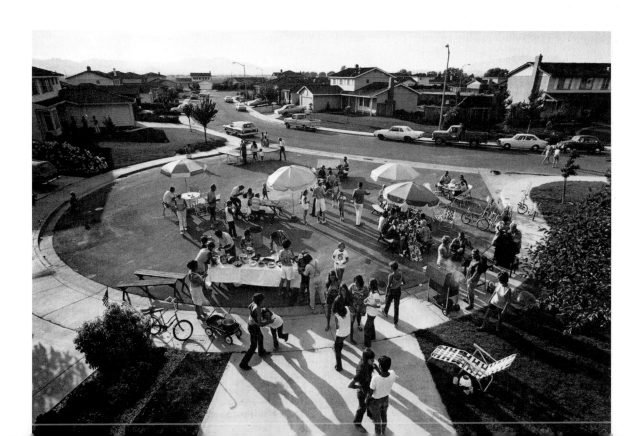

Maine has plenty of more or less suburban towns and Southern Maine suffers the sprawl found in more populated states, which is creeping up through "mid-Coast," although many of the businesses lining the highways cater to tourists and are only open "in sea-son." Falmouth, Cumberland and Yarmouth, North Portland's relatively affluent bedroom communities, have populations of around 7,000 each. Subdivisions are booming in Brunswick and the space between Bath and Brunswick is almost filled in.

There haven't been so many construction plans since the 1980s. The names of new subdivisions in Brunswick: River Bend, Wood Pond, Deerfield, Twin Echo, Baxter Lane, Burgess and Theberge subdivisions (both local names, local owners). Georgetown has

THE FRONTIER MYTH HAS EVEN BEEN APPLIED to the suburbs, to those "pioneers" who venture out of the city as well as into it. In the process, the communal aspect of the village ideal has been subsumed by a preference for increased privacy, for the exclusive, for private enterprise at the expense of public welfare. Although for a century the U.S. has not been a rural nation, a single-family house with trees and flowers and a big lawn remains the American dream. Nowhere is the search for the ideal home, the balance between city and country, so nakedly exposed with all its frustrations as in the history of suburbs, where over one third of the U.S. population now lives. City living exists in vibrant defiance of that dream; suburban living compromises it. If the city has stood for vice, and nature for virtue, then the suburb is morally somewhere in between.

The suburb as we know it was the product of Victorian culture. One early suburban prototype, Llewellyn Park, New York, which multiplied and "democratized" the English manor in a parklike setting, was planned by a rich merchant who had grown up in Maine and had a taste for rural life. Such early suburbs were "stage sets" for an "artificial life in an inorganic community" pretending to be "natural." Owning one's own home became a rite of passage into the middle class. Detached houses were supposed to reflect the republican ideal, and the bait of a private home was used to lure immigrants into assimilation.

By the late nineteenth century, with the advent of the railroad, then cable cars, the suburb had gained popu-larity with the middle class, and by the twenties the automobile made it available to many people, though accomodations differed drastically. With an autocentric culture on the rise, suburbs grew twice as fast as cities. The number of motor vehicles registered nationally rose from nine million to twenty million (today there are around 122 million), while only 46 percent of the urban and suburban population owned their own homes. In 1925, H.P. Douglas described the suburbs as "an unscrambling of an overcomplex situation." In Radburn, New Jersey, a designed development boasted "widespread parks, safe footpaths for pedestrians, giving easy access to the homes of neighbors, [which] all lead the way to friendliness and neighborliness." Some onlookers were not so enchanted. Christine Frederick, in a 1928 article titled "Is Suburban Living a Delusion?" dismissed the "neat little toy houses on their neat little patches of lawn and their neat little colonial lives, to say nothing of the neat little house-wives and their neat little children—all set in neat rows, for all the world like children's blocks."

DEVELOPERS GO BUILD IN HELL
— BUMPER STICKER

The development explosion is akin to the population explosion. After World War II, prosperity renewed expectations of the fulfillment of the American dream. Planned obsolescence and consumer culture took hold in earnest. In 1945, a *Saturday Evening Post* poll reported that only 14 percent of the American population wanted to live in an apartment or a "used house"; 80 percent of everything built in America has been built in the last fifty years, and in 1992 there were 1.2 million housing starts.

Development as it is defined today began with "ribbon development"; houses were built in strips along rivers, railroads, and the main streets of small

Previous page: BILL OWENS, from *Suburbia,* 1972 (copyright Bill Owens). This series was taken in Livermore, California, when the photographer had just returned from the Peace Corps and was "fascinated with the American lifestyle." Gathering places are not easy to come by in suburbia, but this is clearly a successful community get-together in an unlikely spot.

many small subdivisions, but only one—Beaver Valley—has acquired quasi community status.(It is said that residents once hired a trapper to get rid of their eponymous beavers, who were flooding a road.)

What is most obvious is the suburban-ization of rural areas through the kinds of houses being built, their lawns and yard decorations, and in Georgetown, the appearance a few years ago of white on green street signs on all the rural roads. In 1996, even the smallest private roads sprouted signs, as an aid to the fire department. Historian Billie Todd was consulted about original names; in one case she provided a list of family names that could apply to one lane, among them Eaton. The road is now named "Eaton Run."

towns. Public transportation was simple; most townspeople lived near streetcar stops. Then came what Leo Marx has called "the machine in the garden." Automobiles and the electric streetcar (clean and cheap, heir to the horse streetcar, which was neither) had been invented at around the turn of the century. But a collusion of government and private industry made sure that cars won: automobiles were heavily subsidized with tax dollars, and public transport was not. In 1925, General Motors "undertook a systematic campaign to put streetcar lines out of business all over America." The ascendance of automobiles socially disables those who can't, or can't afford to, drive. (In many communities today, schoolbuses are the only public transport, and they are hugely expensive. The elderly and carless must depend on taxis or rides from friends.)

As Kenneth Jackson has observed, "although the motorcar was the quintessentially private instrument, its owners had to operate it over public spaces." So roads, neglected during the railway boom, began to absorb huge amounts of state and federal money. Even during the Depression, highway building ran amok under the auspices of enthusiasts like the notorious Robert Moses, whose forty years in power (roughly the twenties through the sixties) "set the pattern for imposing the automobile on cities all over America, and for destroying the countryside that surrounded cities." After a few lessons, Moses himself never drove a car.

James Howard Kunstler, whose book *The Geography of Nowhere* is a powerful argument against the paving of America, blames modernism's embrace of industrial aesthetics for the divorce from history and tradition, destruction of age-old social arrangements, and "a crisis of the human habitat." Cars, he contends, have deprived us of the skill of "good place-making" by helping people to escape their own reality, wandering out of their neighborhoods as "Sunday snoopers." He says that our world would have been different if streetcars had won. The whole country had to be remodeled to accomodate cars: "The further apart things spread, the more cars were needed to link up the separate things, the more asphalt and cement were needed for the roads, bridges, and parking lots," which consume such enormous proportions of the public budget. Yet rugged individualism rides on unabated, even as fuel supplies and empty spaces dwindle. Business is still the frontier; there is still land to be developed. Ominous signs heralding "the future home of…" continue to blossom by roadsides mowed and sprayed to deter native vegetation. "They call this progress," wrote William Faulkner, protesting the demolition of a

NANCY BUCHANAN, *Full House* from *Home: Developing the Whole Picture*, 1993 through the present, CD-ROM. *Home* is an interactive journal on the subject of development, with emphasis on the cyclical nature of Southern California real estate "booms," or "bubbles." Buchanan has been at the forefront of integrating progressive, concerned art with computer technology. In this complex visual/verbal survey, which is growing at subdivision rate, she asks how we view our landscape; how nostalgic and/or "marketing" images shape our conception of land and history; what contradictions are hidden when one perspective on development is privileged? Thoughts are associatively connected; images, texts, and video clips are grouped in categories that correspond to the process of developing a photograph. Buchanan's Web site is buchanan http://cmp1.ucr.edu/buchanan web. HTML.

Some small towns in the area are surrounded by sprawl, or perhaps have been too success-full in their attempts to lure tourists and are now struggling with the price of success. The narrow streets that make villages attractive become very unattractive when clogged by cars. Freeport, once a lovely little seaside village, is now a perfect example of con-sumerism run amok. Home originally to L. L. Bean, it now shelters innumerable discount outlets and is overrun with tourists for whom Maine means shopping.

A 1996 newspaper story— "Gray Struggles for Village Image"—tells of a Maine town that wants to maintain its own center rather than be a pitstop on the way to ski slopes or the coast. Gray is battling strips, fast-food franchises, gasoline alleys, while the build-

228

historic courthouse in his hometown. "But they don't say where it's going."

In the fifties, in accordance with the conservative emphasis on private enterprise, nuclear families, and Cold War paranoia, social life began to focus on private places such as swimming pools, country clubs, back-yard patios, and even bomb shelters. At the same time, the increasing use of glass in one-story "ranch houses" (the frontier again) opened up spaces and lives to public view. Picture windows gave onto the street— something of a contradiction, since privacy is one of the suburb's touted advantages; perhaps the idea was to display the perfection of the life lived within, to boast that there was nothing to hide. Concern for appearance and keeping up with the Joneses has been considered the source of the suburban lawn and garden fetishes often mocked by those unacquainted with the real plea-sures of creating one's own landscape, however tacky. Parks were supposed to be redundant in the suburbs, where everyone had their own little private park-yard, but nowhere is a communal space more needed.

In a parallel evolution, California-type suburbs and neighborhoods with no sidewalks did away with the communicative channels, discouraging daily contact between neighbors who are separated by more than a large lawn and lots of shrubbery. (I'll never forget my first visit to Los Angeles, in the sixties, when I tried to take an early morning walk around a Beverly Hills neighborhood; cars whizzed past me dangerously close, and the people in them stared and frowned at this alien behavior. It was not relaxing, and I began to understand the use of the word *pedestrian* for second-class.)

By the early sixties (as in the twenties) the orderly predictibility of the suburbs was wearing thin for a younger generation. A more jaundiced eye was cast on suburban "normality," as the postwar ethos was reexamined. The vitality of urban life became attrac-tive again through the writings of Lewis Mumford, Jane Jacobs, Paul and Percival Goodman; sixties ideal-ism and populism began to emerge. At the same time, the condominium concept was imported from Puerto Rico, and available urban housing diminished as renters were replaced by owners. In 1973, threats to the suburban dream having become very real, Nixon imposed a moratorium on government funds for low- and middle-income housing. The cities were in effect punished for their renaissance.

Nothing chills the heart like symmetry, for symmetry is ennui and ennui is at the heart of grief.
—VICTOR HUGO, *LES MISERABLES*

The description of a suburb varies from place to place. Suburbs take their character (or lack thereof) from their landing. In general, the more irregular the topog-raphy, the more attractive, and expensive, the place. There are straggling towns with old houses, farms, many trailers and mobile homes, born of temporary economic opportunity or abandoned hopes, towns that once aspired to urban independence but were left by the highwayside. There are amorphous subdivisions and the treeless rows of identical tract houses that Robert Adams, Lewis Baltz, and other "new topogra-

ings that are left in its downtown "illustrate the potential for a traditional New England village." It doesn't need to swap gas stations for gift shops and wants to hang onto a mixture of small businesses that would maintain its rural character.

Towns like this have a better start than those condotowns being concocted from scratch, since a village center can't be faked, for all the rhetoric of "New Urbanism." Another 1996 headline read "Munjoy Hill to get Village Look." Munjoy Hill is one of the

Portland's oldest workingclass neighborhoods, and in places among its most rundown. The Look—primarily cosmetic—is to be achieved by building brick crosswalks, planting trees, and placing a 34' cobblestone octagon in the center of the

phers" have photographed on the flat Western plains. There are the classier woodsy, hilly development, bedroom communities that have evolved into towns, towns that have devolved into bedroom communities. There are the wealthy "residential communities" that make greater attempts to disguise their homogeneity. Every region has its own versions of this middle-ground living.

At the turn of the century, sanitized ethnic regionalism became fashionable. In the twenties, preservation and restoration programs burgeoned all over the U.S. The idealized evocation of village life and the reinvented architecture of the past resurfaced complete with modern improvements. By the mid twenties, the Architects Small House Service Bureau was boasting of the "architectural melting pot" available, although most of the designs were English. Nevertheless, the popularity of Cotswold cottages, Swiss chalets, Inca temples, Italian villas, and Spanish missions might be seen as evidence of a growing internationalism among Americans. Hybrids have always been a speciality in California, where Mediterranean Spanish-North African influences were strong.

As the suburban ideal filtered through the working class, elaborate houses were scaled down to narrow lots; subdivisions were built on barren rather than

pastoral sites and included few public amenenities. Yet even when the houses were standardized, people identified with them and worked to personalize them, while carefully maintaining the symbolism of upward mobility.

One of the more disturbing reports from many sociological surveys about American responses to place is the fact that most people prefer to live around people who are "just like us." Grady Clay has scrutinized what he calls "turfing," landscape devices "serving both to keep 'them' out and to keep 'us' within....as much message-sending as it is fence-building." These range from ethnic murals and gang graffiti to "private place-making": country clubs, public streets made private, "estates," and gated communities. He points out a number of "screening devices" common in high-income areas, including ditches, hedges, upward slopes, gates, gardens, veiled entrances and high side

ROBERT ADAMS, *Agricultural Land in the Path of Development; Denver; Land Surrounded, To Be Developed; Mobile Homes, Jefferson County, Colorado*, 1973 (copyright Robert Adams). Adams, who lives in Longmont, Colorado, was one of the earliest and most influential landscape photographers to cast a jaundiced eye on human-made "nature." These Colorado subdivisions creep across farms and ranches, swallowing up the grasslands. When they arrive, they may be mobile homes or fake Cotswold "cottages" evoking aristocratic England.

main street, to reflect the shape of the Portland Observatory that is the hill's major landmark. Granite bands will recall the old trolley tracks that once ran here. Merchants are contributing flower boxes and schoolchildren are cultivating seedlings in hopes of creating an authentic gathering place.

Speaking in Portland at an alternative transportation conference in September 1996, J. H. Kunstler extolled the New Urbanism, and blamed zoning for obstructing "restoration of the human habitat in America.... Zoning is not civic design. Zoning is a crude classification technique...It produces a cartoon of a town." Ending his talk in a blaze of optimism, he fantasized that "One fine June morning in 1997, all the city planners and zoning board members, and architects,

230

fences, and he notes the "hardening process" as houses and buildings are remodeled to strengthen the fortress into a style architects wryly refer to as "riot renaissance."

The Los Angeles rebellion encouraged the image of poverty as unique to the inner cities, ignoring rural poverty, which tends to be out of sight and mind. But there are ever-more visible skeletons in the closets of that homogenized suburban regional landscape as well. Although the image is cracking, suburbanites have held an unrealistic view of their habitats as pure and happy. In the sixties, Richard Sennett wrote about a wealthy Midwestern suburb that rejected an affluent black family because it might disturb "the peace"— despite the fact that this suburb had a divorce rate four times the national average, a juvenile crime rate equal to the inner cities, and a high incidence of mental illness.

Suburbs do not age well in the public eye. A section of Addison, Illinois, a bluecollar Chicago suburb, suits its primarily Latino residents just fine, but a tonier part of the village has supported razing this "blighted area" in order to sell the land to developers. Housing inspectors cited residents for soiled carpeting, dirty dishes, and holes in window screens; residents say they ignore these details in white areas. Of the nearly one thousand apartments slated for renewal, almost 90 percent are in *Hispano* neighborhoods that are considered by their inhabitants "middle-class" and part of "the American dream." The Justice Department has joined in a class-action lawsuit against the village to halt further demolition, claiming discrimination against Hispanics.

Intellectuals tend to disapprove of suburbs, although many live in them. I was on a panel recently with an articulate sociologist whose tolerance stopped at the door to suburbia, which he pictured as a dreadful lifeless place where dreadful lifeless people lived. It turned out he was one of them. When I asked why, he muttered "well, I met this woman...." It was a love story. Why couldn't he acknowledge the fact that his

and even the lowly traffic engineers, are going to wake up and say *suburban sprawl is an experiment that has failed and we're not going to build any more of it.* And from that day forward we will become again what we once were: a land full of places worth caring about in a nation worth defending."

When the farms around Portland began to fall to industrial parks, Roger Knight, of Smiling Hill Farm, opened an ice cream parlor and petting zoo to sustain his land. Wolfe's Neck Farm in Freeport is set up as a sustainable agriculture educational center that holds conferences and sells beef from its 900 acres of grass on the edge of Casco Bay.

Georgetown has little industry, aside from small boat building. A feldspar quarry was worked from around 1872 by an ancestor of

neighbors too had their reasons to be in this place? This scholar was very impressed by *The Geography of Nowhere*, in which James Howard Kunstler declares that suburbia is "over," that since the fifties, "two generations have grown up and matured in America without experiencing what it is like to live in a human habitat of quality." "Quality"—so reminiscent of the "folks on the hill." Professors at the University of Colorado in Boulder who live in the attractive, if bland, fifties development Martin Acres, now practically the only affordable houses in a real-estate boom town, are apologetic and call it "Martian Acres." Outside of cities, mobile homes, banned from classier parts of suburbia, have become common, with the new "doublewides" providing an option to the stigma of living in trailer parks. A museum of suburbia would be a fascinating way to dispel some of the stereotypes.

For decades, the suburb remained the homogenized mass-cultural image of how we should live. In the nineties, the great "lifestyle" challenge has become designing a house, place, and way of life that satisfies

JOEL SISSON, ET AL., *The Green Chair Project*, 1991 through the present. "Can you imagine that Sunday dawn when we'll all be running around putting these chairs in everybody's yards. Then, the amazement of the households when they come out and see all these green chairs lined up and down the street. What do you think the kids who built the chairs would be feeling?" Artist Joel Sisson, assisted by Chris Hand, conceived of this project as a way of bringing together his Minneapolis neighborhood where "poverty, crime and alienation live," and "giving something back" for what he has learned there. In the project's first year, he scraped together funding to pay eleven local teenagers, some of them gang members, to build sturdy green wooden Adirondack lawn chairs which were then placed in people's yards early one morning as a surprise—a unifying experience for everybody on two blocks of Pleasant Avenue South. The next summer some forty kids constructed almost 1,000 chairs which were given away and sold for seed money for the next year. 1995 was the year of "The Big Chair"—an "instant landmark for neighborhoods that need attention." And in the summer of 1996, 2 huge chairs and 50 small ones (for each state) were erected on the Mall in Washington D.C. with the help of local high-school students.

and balances individual needs and desires for freedom and security. Most of us, however, move into houses built and modified by others, which is just as well. Recycling permits a certain interaction with others' lives, a breakdown of the isolation that submerges us. In the sixties, sociologist William M. Dobriner complained that when the classic Levittown, on Long Island, was built in 1950, it was clean and quaint and hopeful, but twelve years later it had not worn well:

Now, individualism, indifference, neglect, and taste good and bad have changed the balances. Do-it-yourself paint jobs: red, aqua, chartreuse, cerulean and pink trims. Jerry-built dormers stagger out of roofs. The expansion attics are all fully expanded. You see a half-finished carport, patched concrete, broken asbestos shingles, grime and children's fingerprints ground into a peeling light-blue door, a broken picket fence, a dead shrub, a muddy trampled lawn....

On the contrary, it seems both human and hopeful when an artificially homogenized happy-face facade has given way to a multifaceted place that reflects difference, the lives within it, and the social forces that form it from without, even when such a reflection exposes some ugliness. A younger writer visiting Levittown in the nineties, faced with the same transformation, had a different response. Conditioned by aerial photos showing "an endless grid of treeless streets lined with bare, stencil-faced boxes, houses for pod-people," Ron Rosenbaum found the place grown "positively hairy with a veritable frenzy of individuation...Levittown turned out to be not the epitome of suburban self-abnegation but a tribute to the ineradicable drive for self-expression."

If the bland face of the suburbs has been somewhat altered by a blush of small-town coziness, they are populated largely by people from cities, who are accustomed to a different quality and quantity of social

the Kennebec Point Browns who owned Middledyke Farm on the Bay Point Road. (Granite was also quarried on Salter's Island, and used for the Civil War Fort Popham; today the state has less than six active granite quarries despite the fact that the material is coming back into fashion.) Later, Middledyke Farm was a chicken farm, until the bottom fell out of Maine's "broiler" business in the 1960s. Now it is Woodex, manufacturer of wooden ball bearings. In our immediate area, the only other industry is Mainemoss, on old quarry land, where a Brown son in law has harvested Irish Moss seaweed for its carogenen and now deals in earthmoving and town road maintenance.

The big news in Bath for some time now has been what to do about the crumbling

interaction. But rural people are also bemused by suburban transience and homogeneity. Micki Clark, leader of the Open Lands Coalition in Douglas County, Colorado, home of Highlands Ranch, the fastest-growing "planned community" in the country: "Yuppies have a couple kids and then they want a place that fits their idea of a small town in the Midwest. But I grew up in one of those Midwestern small towns, and believe me, it doesn't look like Highlands Ranch. For one thing, in a small town, half the people are poor."

Her hometown would also be unlikely to be called Highlands Ranch. Naming is zoning's accomplice in the housing market. Just as inner-city projects are called "parks" and "gardens" in the face of contrary evidence, a large number of suburban towns include the words "green," "wood," "forest," "hill," "vale," or "dale" in their names, whether or not these exist. (Often they did, but have been replaced or rendered invisible by the subdivision that has stolen their names). Sometimes suburban towns aspire to aristocracy and age with titles like "Briarwood Manor" or "Hacienda Vieja," or they borrow exoticism: "Paa-ko" is a snazzy new development on New Mexico's Turquoise Trail named after a nearby Pueblo ruin. The word "pleasant," in all its blandeur, is still popular.

Ron Rosenbaum, a Bay Shore native, wonders what happened to "pleasant" in a Long Island that has become a tabloid hell ("heck," he suggests, might be a more appropriate term):

What happened to the incredibly boring place I grew up in, where I swear nothing ever happened? What happened to turn it into this charnel house of sensational spouse slayings; fatally attracted judges....cold-blooded, steroid-juiced young killers; kidnappers with dungeons; horticultural serial killers? A veritable Babylon and not the colorless stop on the LIRR right after Amityville, Copiague and Lindenhurst.

Rosenbaum can't get over the transformation of a familiar Long Island of beaches and diners; a Long Island that was home to the first supermarket, where the first Levittown led the way to plastic supernormality, the domain of those who wannabe someone or someplace else; a Long Island where status reigned along with customized cars and a Jewish Italian culture (epitomized by Massapequa's nickname: Matzoh-pizza)...Above all, a Long Island "disdained by mainland culture." With tongue usually in cheek, Rosenbaum blames Long Island's erstwhile blandness on the unimaginative name itself, and on its isolation: "The only link to the mainland of America from the 516 area code are the ferries to New London and Bridgeport: Nothing goes through Long Island to get to somewhere else." He quotes Thomas Pynchon, another native, describing their home turf as "a country where the elfin architecture of Chinese restaurants, seafood palaces and split-level synagogues is often enchanting as the sea....Only the brave escape."

Zoning has always been an important factor to those who control the suburbs, taking up where company regulations and unlegislated exclusivity left off. Zoning ordinances define the suburbs because one of their main characteristics is a lack of boundaries. Suburbs are neither here nor there. They have no center. Neighborhood grocery stores allowed inside suburban boundaries have little company. Light industry was banned to emphasize a residential image, thereby encouraging the commercial strips springing up on the outskirts of each subdivision, which in turn further blurred the boundaries between one suburb and another. Independent of the city that spawned them, many aren't even suburbs any more. The loss of contrast, of different histories, settlement patterns, and cultural markers results in undifferentiated sprawl and a supremely disorienting landscape, now

3100-foot Carlton Bridge, which has spanned the Kennebec since 1927, replacing the old ferries. It is heavily used year round but especially in the summer, when traffic slows to a crawl, or a standstill, whenever shipyard shifts let out and coincide with droves of tourists heading up the coast. Then the drawbridge goes up to let a fancy sailboat through...

The city wanted another drawbridge so as to keep the waterfront north of the bridge open to large vessels like Stinson Sea Food's boats, and Tall Ships. The city council fears the death of waterfront development on that side of the bridge and worries about too high a profile ruining the view of the city. Others point out that if the drawbridge went up and down all summer for

recognized as an environmental hazard as great as the pollution and decay of the inner city. (Yet amazingly, according to the American Farmland Trust's 1993 "Farming on the Edge" survey, 56 percent of all U.S. agricultural products and 86 percent of its fruits, nuts, and vegetables are still produced in areas ringing the nation's cities, even as they fall daily to the creeping blob.) Another product of sprawl is the "technoburb" found along highways like the prototypical Route 128 outside Boston: mysterious buildings in yardlike settings are called "research parks," and there is little indication of what goes on inside them. Replacing easily identified heavy industry, they blur the lines between city and country, home and business.

As cities swallow up the closer suburbs, new ones are spawned, increasingly independent of the city for shopping, services and even employment. This phenomenon has been identified as "edge city" by Joel Garreau. While there are now only forty-five downtowns the size of Memphis or larger, he says, 181 edge cities that size have been built in the last twenty years. He traces their development through three phases: people move beyond city limits; then they buy everything there; then they take their jobs there, "moving the

RUTH WALLEN, from *The Camelot*, 1990-94. A page from a pop-up color bookwork (part of a larger work called *Legends*) on water use in San Diego County, where the population has increased 30% since 1980. Images and texts were taken from the brochure advertising a development called "Camelot at Eastlake Shores," around a human-made lake in Chula Vista—the driest part of the county. To emphasize the operating levels of fantasy and illusion in California development and its marketing strategies, the book begins with a picture of the Camelot-style tower and ends with its demolition. The text reads: "...once there was a spot *for one shining moment* that was known as Camelot." This image carries another "Arthurian" quote: "I think I've stumbled on my future..."

I've stumbled on my future..."

King Arthur upon meeting Lancelot,
the greatest knight to sit at his Round Table.

small boat traffic, the bottleneck would only be worse—hardly good for the city's image. As it is, the Carlton Bridge threatens to consume funds for years to come. (Maine already receives the smallest portion of federal highway money in the U.S.) But the governor concedes that a whole lot of cars have no alternative. The final decision was to build a taller fixed-span bridge, four lanes instead of two, alongside the existing bridge, which will carry the railroad. Clearance may be provided for Coast Guard and tour boats. In the meantime, everybody dreads the beginning of construction, which will wreak havoc in the very center of Bath, and will contribute mightily to its future identity, for better or for worse. The cars will keep coming. Commuters have no

234

realm of men out to the realm of women." The next as-yet-unrealized (and some would say unrealizable) step is "bringing civilization, soul, identity and community to this brand new place," along with light industry, which might eventually cohabit with the arts: "Show me where you go to get your car fixed and I'll show you where the art galleries are going to be." Optimistically, Garreau suggests that this future phase will concern itself with aesthetics and amend the faceless ugliness that now characterizes these new cities. All in all, edge cities seem to reproduce the original city model, where the rich inhabit the center, the poor have to commute longer and longer distances, and "in every urban area beyond a certain distance from the edge, the property values, income levels and education levels start going up again. That's the de facto greenbelt where all the people who romanticize the land live."

Another kind of "edge city" is described by Jimmie Durham.

I expect it is no longer true, but when I was young towns still had edges, no-man's lands, that were not yet the surrounding farms. This was where the city's refuse was casually dumped, so that the edge of town was not a "natural" place. There lived raccoons, opossums, rats, snakes, bobcats, skunks, hobos who were in fact outlaws (not homeless street people), families of African Americans and displaced Indians. All of us, shunned by the city, used the city's surplus. I so loved the dumps, where one could find the products of civilization elegantly, surrealistically juxtaposed with pieces of wood, magic rocks, bones and wild flowers, that they have remained the metaphor by which I define myself. The city could not see us, could not admit of our existence, could not control us. We used it.

Once sprawl strikes, topography is sacrificed to straight or curving grids: streams and hills are obliterated, trees removed, vegetation imported, and everything homogenized. "Nature will not be reduced to a mere symbol of the natural," wrote Murray Bookchin, hopefully, many years ago. Yet when space in the valleys runs out, or when the owners want to be above it all, houses and roads begin to crown the ridges, forever changing the sense of proximity to nature (and ruining the view for all in sight). Built on steep inclines, such "trophy houses"—usually large and obtrusive—hasten erosion and loss of topsoil. In California, as John McPhee has explained so convincingly, this has reached epic proportions. As Californians move inland to other Western states, history is repeating itself. Sprawl's first name is of course "Los Angeles," which, as Carey McWilliams demonstrated in his

choice. Tourists could bypass Brunswick and Bath entirely, continuing on the Maine Turnpike and skipping a whole coastal section of Route 1 (including another major bridge bottleneck at Wiscasset)until much further north. This could be econo-mically disastrous for the region.

Transportation has become a prime issue in Maine. Voters have resisted changes.They defeated a proposed expansion of the Maine Turnpike (although it keeps reappearing on some agendas). tourists. According to the National Resources Council of Maine, the Turnpike is only "unacceptably" congested nineteen hours a year, or less than five tenths of its operating hours.

Voters also created a waterfront morato-rium in Portland to save some of the water-

RUTH ANN ANDERSON AND SUVAN GEER, *In Living Memory*, 1994, Los Angeles, posters, 64 x 48". This collaborative eco-art project "designed to draw attention to the changes in the local ecology by honoring elders of the community" produced bus shelter posters and a video, based in oral histories from a diverse group of senior citizens "remembering Los Angeles within the space of one lifetime." They recalled lost landscapes of clean air, crystal oceans, and the scent of orange blossoms along Wilshire Boulevard. In public dialogues with high school students, artists and local environmentalists, "the elders were seen not as romantic figures of outdated experience, but as vital ties to ongoing efforts to preserve the local resources." One of the elder participants went on to work with students at Roosevelt High School on their local history.

1943 classic, *Southern California: An Island on the Land*, marked the emergence of a new urban form—many cities merged into a region—much of which the rest of us would define as suburbs.

The L.A. phenomenon has been blessed with an impressive file of critical literature, from McWilliams's work to Mike Davis's cultural-geographical thriller written fifty years later: *City of Quartz: Excavating the Future in Los Angeles* (the original cover of which pictured not a Mission mansion, but a glittering night view of the Metropolitan Detention Center). Davis describes a century of unsavory (and often racist) history replete with ruling-class, corporate, and gov-ernmental wheeling and dealing at the expense of the general population. If there were books like these about the social forces and financial speculation that have fueled and bled each city in the U.S., such local knowledge might enable citizens to be more wary, and more combatative, about the fates of their places.

Davis opens his book with a view of "the ruins of [L.A.'s] alternative future"—the stone foundations which are all that remain of the Socialist city of Llano del Rio (1914–18): "The desert around Llano has been prepared like a virgin bride for its eventual union with the Metropolis: hundreds of square miles of vacant space engridded to accept the future millions, with strange, prophetic street signs marking phantom intersections like '250th Street and Avenue K'." It sounds like a movie set. Davis goes on to describe the whole "facade landscape" in which appearances are more important than substance. (Los Angeles once planted plastic vegetation along freeways where the real stuff had been killed by pollution; artist Bonnie Sherk parodied such panaceas in the early seventies when she created temporary "portable parks" along and under a San Francisco freeway, including Astro-turf, palm trees, hay bales, and a real cow, offering a bucolic hallucination to passing cars and picnic spots for local workers.)

front from gentrification. "The Waterfront should be exactly what it is for, waterfront people. Not yuppies down on the chicken coops," says John Macgowan, owner of the Custom House Wharf, about Portland's waterfront condos. "Most of them figure they would make a profit on the sale of places. They don't want to live there." (This reminds me of what an *Hispano* neighbor says of the Anglos in our village: "they don't stay.") A fish market manager on the same wharf says:" This wharf does resist of change. I think because the businesses on the wharf are really well established. There isn't really any need for change. That might bother some of the people who are looking for development." He said this in 1987. As a Salt publication points out, one year later the

The larger, unspoken malady affecting South Central stems from the idea that the land is valuable and the present tenants are not.

— CYNTHIA HAMILTON

By the late eighties Los Angeles's urban infrastructure was collapsing under population growth, pollution, and traffic, and a cap had to be placed on new construction, based purely on sewer capacity. Yet short-term thinking continues to prevail on all fronts. On the crowded Freeways, the car pool lanes are comparatively empty. When light rail mass transport was finally proposed, homeowners opposed and deposed it, although some commuter rail lines have been put in place. (Davis's blow-by-blow descriptions of these battles and all their local undertones are as valuable as his overviews.)

With L.A.'s horrible example before their eyes, some urban centers have made concerted efforts to stop "spread city" (which Bookchin blames for deurbanizing urban dwellers and restoring in them "all the parochial qualities of the rural dweller without the compensations of a community life"). Portland, Oregon, is the rare city that has been paying attention to its future for some twenty years. Despite a 30 percent population increase, it reportedly remains a vital, liveable place with an exemplary "Metro plan" that has "frozen" the urban growth boundary beyond which no new malls or commercial development are permitted. An elected regional government controls zoning, setting limits to isolated suburbs that can swallow up the countryside. On a personal level, this means smaller yards, more neighbors. Two goals guide the Metro plan: everybody has a view of Mount Hood, and every kid can walk to the library. There are few parking places and little freeway building. Air quality improves as people use public transit and walk more often to work, school, or commercial areas. It is only a five- or ten-minute drive to the country. Developers and property rights advocates oppose this new urban vision as "social engineering."

They are probably correct when they say that such responsible living runs counter to the evident American desire (perceived as a right) for bigger and bigger "traditional homes" and as much space around them as possible. There are historical precedents for such attitudes: "In colonial New England the church authorities forbade anyone to live more than a mile from the meeting house. Yet people continued to move out, and Captain John Smith complained that the very first colonists in Virginia wanted to abandon Jamestown and settle far from neighbors." There remains a constant tension in modern life between the need for autonomous time and space, or privacy, and the pressures of social and economic convenience, not to mention the need for community.

Over the last two decades, suburbanites holding their ground against encroaching urbanism have battled with remarkable vehemence over social status (and accompanying land values) as reflected in the boundaries and names of areas with more and less prestige, and over "fiscal zoning" as the "slow growth" (not to be confused with low growth or no growth) and "homeowner control" movements arose. Strange bedfellows have emerged within this movement: wealthy suburbanites and environmentalists (often the same people) join forces with various stages of the middle class to defend the suburban image, not only from the destruction of what passes for "nature" (and its potentially catastrophic ramifications) but also for security from an invasion of the Latino, Asian, black, or just plain poor. Developers are not always perceived as the villains. Some homeowner associations (nationally) are actually organized by developers in order to protect their investments. The Ku Klux Klan and other

Casco Bay Lines Ferry terminal pulled out out of the wharf. A decade later, the illusion that things can stay the same has given way to apprehension about the future.

Yet Mainers remain stubborn about some things. Portland's non-profit Fish Exchange is the first open display fish auction in the eastern U.S. The eight biggest fish producers in Portland buy nearly 40 percent of the fish in the local auction, providing jobs and taxes. In July 1996, the Fish Exchange decided not to use remote electronic bidding in its daily auctions— even though they recognize it as the wave of the future—for fear of damaging local business and time-honored commercial relationships. "Changes will happen...In my mind people are more important than computers any day," said Boston fish buyer

bigots have found fertile ground in the fields of exclusionary zoning, segregation, deed restrictions, and building covenants, all of which mask a horde of other disturbing issues (antibusing, English Only, sale of public lands, defunding cultural and social services). Yet in 1986, in California, slow-growth propositions won by nearly 70 percent—in black and Chicano as well as white neighborhoods—a clear mandate for decentralized, locally responsible grass-roots community planning and democratically evolved land use decisions, rather than merely lip service to these ideals in service to conservative agendas.

Cluster housing, which first came to prominence in the forties, offers another form of the village ideal, often modeled on idealized visions of Italian hill towns and New England villages (although the Indian pueblos and *Hispano* cluster compounds of the Southwest provide an earlier native model). Today, clustered sustainable communities have been revamped to become the latest attempt at ecologically rational urban design. They are both a more hopeful and a more nostalgic version of edge cities. Andres Duany and Elizabeth Plater-Zyberk, the darlings of the reform suburbia movement, or "new urbanism," are the designers of such neotraditional middle-class enclaves as Seaside, Florida, and Kentlands, Maryland. They say they are exploring ways in which private property can define public spaces. Not everyone is equally enthused about their ideas. Richard Sennett has called them "artists of claustrophobia, whose icons, however, promise stability, longevity, and safety....Placemaking based on exclusion, sameness, or nostalgia is socially poisonous and psychologically useless."

You gotta be poor to understand [our problems].
— FELICITA CAMINERO OF HANCOCK COURTS HOUSING PROJECT IN LAWRENCE, MASS.

The fragmentation of community and the desirability of organizing across class and ethnicity has been addressed by a national "transcommunal" movement to cope with substantial issues affecting everybody. Like Richard Sennett, transcommunalists believe that localities can act on the economy rather than defensively reacting to it. Proposing to (inter)act on rather than simply acknowledge multiculturalism, the movement is exemplified by the Merrimack Valley Project, in eastern Massachusetts, home of vast, towering, and abandoned brick mills. Lawrence and

MEL ROSENTHAL, from *The Villa Sin Miedo Project*, 1982. Rosenthal's work has long focused on the changing South Bronx, where he grew up. In 1982 he and writer John Brentlinger went to Puerto Rico to interview people from the South Bronx who had returned to the island and got involved in the struggle for the "town without fear," a squatters' settlement that was destroyed by a paramilitary swat team four days after they arrived. These horses, along with all the Villa's other animals, were killed in a scorched-earth sweep. Rosenthal and Brentlinger, who feel that the government attacked the community with such violence because "it could not permit poor families to resolve their own problems," joined the refugees in a camp and then at their new site in the mountains. Their book and exhibition—*Villa Sin Miedo, PRESENTE!*—are used as organizing tools with the Puerto Rican flag and fresh cut flowers commemorating the valor of the Villa people. Rosenthal, whose work focuses on the displaced, also asks us to think about why we see so many documentary pictures of poor people and their places, and so few of the rich and their habitats.

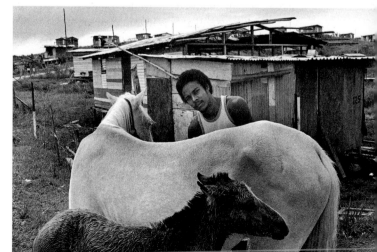

William Gerencer. Not to mention the fact that if you're used to close inspection of your fish before you buy, a computer just doesn't hack it. "Would you rather have that cod cut and filleted in Portland or Nebraska?" asked one local buyer.

Malls are not just hangouts for the young. Older people too gravitate to them. "It's hard being a senior citizen. It's a monotonous life. When you're constructive for a good many years and then you have to relax and do nothing— and you're alone—

that's worse. So you come out here to see the living more or less. " (Harry Lerman at Portland's Maine Mall—the biggest of its kind around.)

Lowell are the area's two major textile towns; they flourished for less than a century before falling to cheaper labor in the South. (Lowell enjoyed another, even briefer boom when Wang Computers called it home from the sixties to the eighties.) Lawrence, the hardest hit, now has an official Latino population of 42 percent.

The project, modeled on the Brass Valley Project, builds on the longing for community destroyed by deindustrialization. It developed when people living along the Merrimack River from Lowell to Newburyport began to talk to each other about their shared territory. It visualizes reindustrialization and local control over land, resources, and development (including employee buyouts of factories, tenant-owned housing, home-care cooperatives). For seven years now, led by organizer Ken Galdston, people from working-class and wealthy towns, unions, hospitals and businesses have been meeting across class and ethnic lines in order to discuss their common needs and goals. They are making regional connections among towns as disparate as the destitute Lawrence and the more upscale town of Andover (known for its prep school), towns that have been "looking inward" along the American grain of individualism since Puritan times: "Middle-class Protestant congregations from the suburbs, historic do-gooders from abolition to Nicaragua, are taking the risk of joining with poor people who live next door. The women at the [housing project] Hancock Courts are taking the risk of joining with suburban liberals who may abandon them in an instant." Having already won some battles, and not expecting miracles, the project will, says George Packer, "leave behind fifty or a hundred or 300 people who at least share an idea that their destinies in the valley are somehow connected."

JEFF GATES, *In Our Path*, ongoing, interactive Web site (http://www.tmn.com/iop). In 1982-83 Gates photographed the Century Freeway Corridor in Los Angeles; in 1989 he was asked by a public interest group to retrace his tracks and document the changes. (At one point he found himself on the bleak dead-end corner of "Success Ave. and Imperial Hwy.") The freeway, proposed in 1958, opened in 1993 (thirteen years late). As Gates wandered the adjacent neighborhoods, some of them now razed, he heard a lot of stories about how the freeway affected the lives of those in its path, especially Ralph and Esther Keith, who began the protests of the way they and their homes were being treated by Caltrans (the State Department of Transportation) as early as 1965. He also identified multiple issues—from the hiring of minority truckers to clear the toxic dumps in the freeway's path to the ongoing saga of public transit in Los Angeles. Gates has translated a traditional documentary into the hypermedia environment, where places can be surveyed from multiple viewpoints and "the viewer decides the path or paths to take."

The valley project geographically parallels the development of the commercial strip, which began when waterways were the main commercial routes—as paths then trails then roads and railroads along the river banks. Strips acquired a new life when the automobile triumphed. Grady Clay divides the history into several stages: "Strip I," often still in use, began as animal and Indian paths along the riverbanks; "Strip II" is a wider version, gradually improved for wagons;

On the Strip South of Brunswick, 1996 (Photo: Peter Woodruff). The Siesta Motel features bright-colored chairs, a cactus, and a stereotyped Mexican asleep under his sombrero; it's from another era.

"Strip III" is an early bypass, appearing in the twenties with automobiles—newly paved roads running behind the houses built to face the original river roads; "Strip IV," in the thirties and forties, is the first highway, ushered in with heavier roadbuilding equipment that was able to carve out wider and deeper cut-and-fills; "Strip V" is the massive, dangerous interstate system that barges through existing road systems and communities, leaving houses stranded between channels of speeding cars, and barns separated from their fields. The strip that most of us know and love-hate by that name is the "pit strip" (gas stations, motels, fast food chains, garages, auto-body shops, first and secondhand car lots) that leads into and out of towns and cities of all sizes.

A public space attracting a mixed population, the "strip," says J. B. Jackson, is "flashy and temporary....designed to attract...a jumbled reminder of all current enthusiasms" and "a chosen area of brief informal communication and social interaction. In medium sized towns the strip is where the action is at night." Strips have been called everything in the book: veins leading to the heart of town, "a massive elongated bloodclot," "the dirty old man of the urban scene," "one long rip-off," "the urban/suburban scapegoat [where] the essence of urban forces is revealed." Whereas the early riverside strips had to take into account the natural environment—floods, gravity, local energy—from the twenties on there has been little regard for topography, waste, or ugliness. As Clay says, "the strip is trying to tell us something about ourselves...namely that most Americans prefer convenience; are determined to simplify as much of the mechanical, service, and distribution side of life as possible; and are willing to patronize and subsidize any informal, geographic behavior setting that

helps. The value systems of the strip derive from the open road rather than from the closed city. Strips become the city's vital contact zones with surrounding regions, and their fast changes reflect population and taste shifts on the urban fronts."

"The road is a very powerful space, and unless it is handled very carefully and constantly watched, it can undermine and destroy the existing order....Roads no longer lead to places, they *are* places," writes J. B. Jackson, the rare place-writer who was actually fond of both motorized vehicles and commercial strips. He sees the road as the center of a new kind of vernacular community that is no longer drawn together by shared space but is "based on shared uses of the street or road, and on shared routines."

Strips derive from the grid system that originated in the late eighteenth century—a typically pragmatic American way of distributing land to citizens and dividing towns and states. If roads and streets were originally considered social institutions, connecting and unifying, the roads of a grid "lead nowhere at all: they are centrifugal in nature." In some places, the grids are reconciled with the old meandering roads that followed rivers or topographically oriented trails. It is easier to read local history in the twists and turns that here and there subvert geometry than from the occasional brown roadside historic marker.

Shopping malls are liquid TV for the end of the twentieth century, a whole micro-circuitry of desire, ideology, and expenditure for processed bodies drifting through the cyber-space of ultracapitalism. Not shopping malls any longer under the old sociological formula of consumption sites, but future shops where what is truly fascinating is expenditure, loss, and exhaustion.
—ARTHUR AND MARILOUISE KROKER

Wal-mart is always in the news. It won top place for ugliest new building in a *Maine Times* survey. A photo in a Portland paper shows a nice little porched house being moved off the future site of a Wal-mart. In 1994, however, Wal-mart gave a Brunswick school $500 to study the environment and the socio-economic effects of development on the Androscoggin. In Bennington, Vermont, Wal-mart endeared itself by remodeling an old retail building instead of constructing an ugly new box and contributing to the sprawl. These buyoffs at least set a precedent of helping as well as hindering towns, although such gestures cut little ice with the small businesses that stand by and watch their clientele sucked into the Wal-mart maw.

Malls are a relatively new ingredient in the city-suburb-road-strip equations. The first, Country Club Plaza in Kansas City, was built in 1924; but it was postwar optimism and affluence, and their chariot, the automobile, that expanded its popularity. In keeping with the village ideal, shopping centers (and pedestrian malls within the existing centers) were touted as "town squares," false centers minus any communal responsibility or rights. Through this "acceleration of need," As Margaret Crawford calls it in her chilling analysis "The World in a Shopping Mall," shopping is linked "with diversion and pleasure." Malls offer new combinations of products and behavior. Dependence on commodities becomes an inescapable part of daily life (as in Barbara Kruger's famous image "I Shop, Therefore I Am" reproduced on shopping bags). At the same time, though, malls are physically separated from "real" life, moated by giant parking lots, out of bounds for protesters and panhandlers. Where villages were created as islands in nature, now the shopping center is an island in culture—a controlled fortress guarded from the rest of the world by private security and laws protecting private property.

Malls in large towns tend to be class specific. Urban designer Edward Robbins cites the example of Fashion Island Mall in Orange County, California, which did not welcome residents of a nearby retirement community: the presence of the elderly made mall patrons uneasy, so an existing bus stop was moved eight blocks away, across a highway that was difficult to cross, and that took care of that. "The familiar argument here is that the old people weren't good consumers; but.... I think the wealthy burghers of Orange County simply didn't want to associate with these particular old people; they differed too much from the image to which the burghers aspired."

L.A. malls target specific ethnic groups—blue tile temple roofs for Koreans, Zen gardens for Japanese, postmodern for Anglo yuppies, high-tech in dense urban areas, and "Spanish" everywhere else. Although exclusive on one level, on another malls respect no boundaries, edging into the territory of theme parks and even local historical societies. Crawford describes the "festival marketplaces," where historic landmarks are incorporated into the shopping process, as in New York's South Street Seaport or Boston's Faneuil Hall. Capitol Mall in Washington, D.C., can be seen as a giant museum shop, complete with dinosaur, castle, and antique carousel. The West Edmonton Mall in Alberta—once the biggest in the world, since outdone by the "Mall of the Americas" in Bloomington, Minnesota—has a "Bourbon Street" section with mannequins of New Orleans "street people" (including whores and panhandlers). Charter jets from Tokyo bring Japanese tourists for shopping expeditions.

ANDREA ROBBINS AND MAX BECHER, *Holland Mall*, 1994, original photograph in color. This red-roofed, green shuttered mall, based loosely on Dutch architecture, caters to Holland, Michigan, which took advantage of its name and history to create a "theme town." Founded in the nineteenth century by Dutch settlers who quickly assimilated, the town later "realized the many economic advantages of politely defying the melting-pot pattern." In 1964 it acquired a 200-year-old windmill pocked by German bullet holes. There are, of course, fields of tulips, and an annual town festival of klompen dancers. Robbins and Becher are concerned with the impositions of colonialism and the "transportation of place," which in this case involves the contradiction of place in favor of lukewarm fantasy.

"The mall has become the world." A group of Southern artists have suggested "inverted malls": The back becomes the front as customers climb in through the loading docks; garbage, and delivery trucks pull up to the front door. The infrastructure would be visible, for instance, with recycling bins in the parking lots. Stores that use a lot of cardboard would recycle everyone's cardboard; groceries and restaurants would generate compost for the garden store, and so forth, establishing a local network of use and reuse.

Malls in urban situations, and in the increasingly dangerous suburbs, are perceived as safe and comfortable, partly because, for all their impersonality, they are *interior* spaces, suggestive if not productive of a domestic intimacy and shelter. They replace parks as leisure destinations, substituting commerce for nature. In smaller towns, shopping centers (not usually enclosed malls) are more "democratic": they may be as big as a now abandoned "downtown," but they are all store and parking, lacking streets, breaking any connection with specific neighborhoods. The supermarket is where you run into people, but the atmosphere is not conducive to chat. There is nowhere to sit, and you can't block the aisles; at best you can have a brief conversation in the somewhat more open spaces around the produce. (A friend and I once danced to the Muzak through the aisles of a supermarket, in a spontaneous attempt to socialize the space or at least break the commercial spell. People were startled and amused but did not join in. We were merely a spectacle, young enough to be considered cute instead of crazy.)

To restore urbanity as a meaningful terrain for sociation, culture, and community, the megalopolis must be ruthlessly dissolved and replaced by new decentralized eco-communities, each carefully tailored to the natural ecosystem in which it is located.
—MURRAY BOOKCHIN

Time was, it was necessary to keep a clear eye on the gas tank and long serviceless stretches, especially when driving through the West; there are still such places, but fewer and further between. Megalopolis, the urban strips that connect, with little rural respite, all the major towns down the East Coast (as well as major parts of the West Coast and Midwestern corridors) have continued to grow. In Colorado, for instance, a megalopolic strip is being formed between Fort Collins and Pueblo, heading for Albuquerque, Las Cruces, or even El Paso as the gaps are increasingly choked by condos and developments that seem to sprout overnight.

Once the strip-and-mall mentality has been introduced, communities can change drastically in five to ten years. Sprawl is followed and compounded by Wal-marts and their ilk. (There are over twenty-one hundred Wal-marts nationwide, with many more in the works, in every state of the union.) Some towns with "their backs to the Wal" have engendered a successful national campaign led by New England "sprawlbuster" Albert Norman. Connecticut, on the path of a megalopolic juggernaut swallowing the few gaps between New York and Boston, is a particularly vulnerable target for expansion. In the next decade, a large proportion of the state's farmland and open spaces will come up for development. Groups called Protect Our Small Town (POST) and Citizens Against the Wal are poised to protest. One of the union's earliest settlements, Connecticut is being recycled, according to Norman, as yet another "wide-open frontier" vulnerable to exploitation.

The Best-laid Plans...
and Public Places

*We must be consistently aware of how space can be made
to hide consequences from us, how relations of power and discipline are inscribed
into the apparently innocent spatiality of social life.*
— EDWARD SOJA

In August 1996, the Bath City Council endorsed four waterfront plans for study, associated with the Carlton Bridge replacement. (The city can ask the state for up to 10 percent of its $750 million cost, though what is asked will not necessarily be given.) The councillors are discussing what Bath wants to be: "Are we a tourist destination? Do we want light manufacturing? What are we trying to do with our downtown?" Commercial Street, which lies along the water, but has little commerce, is a focal point.

Despite its role as gateway into coastal Maine, and roadside signs for the Maine Maritime Museum, Bath has never been much of a tourist town. Since the overhead highway to the bridge split it in two and bridge traffic jams reached epic proportions,

PLANNERS AND DESIGNERS TALK ABOUT connecting "iconic" public spaces to "organic" public spaces, or the "formal" with the "informal." Increasingly, our public spaces are neither. Obscured by a certain deceit, they may be disguised as private spaces or they may be private spaces disguised as public. Having tried leafleting and political theater in malls, for instance, I can vouch that they are strictly controlled and patrolled private spaces. "Public" space implies that it is governed by rules, but these should be reached through public consensus, by those who live there. Some reactionaries have argued that the way to get cities under control is to *reduce* communal spaces, close everyone into their own territories so they will be financially and emotionally forced to defend and maintain them—a bunker mentality.

The contemporary loss of the processional, or ceremonial, aspect of older public buildings built on ancient models to inspire respect or intimidation within daily experience is not always a tragedy. Frequently, though, this aspect has been replaced by a newer aspect that merely reflects all too well the dulling bureaucracies housed within.

When architectural critics bemoan the disappearance of appealing public spaces, they tend to be talking about passive meeting grounds, rather than places where an active social life, even dialogue, can occur. Places that are merely *accessible* to citizens, rather than controlled by them through use, are not truly public places. If access is minimal, perhaps it threatens to erode power, always best elevated and cut off from those who would share it. Sharon Zukin points out that even those buildings that are owned by taxpayers are now being moved out of towns so they are less and less accessible.

Always settling for too little, grateful for even the most unimaginative open spaces, we become less and less aware of the gap between space perceived and experienced, on the one hand, and space conceived and imagined on the other; between the way things are (what we actually see) and the way things should be (what they want us to see or what we would like to see)—"they" being the policymakers, planners, bankers and developers who determine what our public spaces will look like. Henri Lefebvre made this distinction right after the 1968 Paris rebellion, observing that perceived space has been produced, haphazardly, by the process of use, while conceived space is a designed infrastuctual product. Places themselves shift functions, sometimes before our very eyes, as when a playground becomes a battleground, or a subway car becomes a theatre with a captive audience. Sometimes the conceptions don't work as expected: malls were not planned as teenage hangouts; heating vents were not planned as homeless campgrounds.

SHEILA LEVRANT DE BRETTEVILLE, *Path of Stars*, New Haven, Connecticut, 1993, granite and colored concrete, 24" square x 6' deep (Photo: Michael Marsland). This public art work, consisting of twenty-one medallions permanently embedded in the sidewalks at four entry points into New Haven's downtown Ninth Square neighborhood, celebrates the working people who have sustained its sense of community, blurring the boundaries between ordinary and extraordinary. The stars (their terra cotta, black, gray and cream colors echoing the architecture) cover three centuries of residents, ranging from a 17th-century ship captain to a 19th-century typesetter and union activist to the owner of the first Chinese restaurant in the city to Julia Di Lullo (pictured here), longtime sales manager at Horowitz Bros., who was present at the dedications. De Bretteville assembled the names through historical research and talking to people living in the Ninth Square today. She suggests that new stars be added each year—an annual celebration of the place and its residents, reminding us that memories start yesterday.

It is possible for the landscape to provide us with some symbols of permanent values.
— J. B. JACKSON

people have tended to rush straight through. But now Bath, like every other struggling small town in the country, is revving up its tourist engines. In the 1980s, Front Street was modestly tarted up with brick sidewalks and old fashioned light poles. In 1995,

"tourism taskforce" volunteers with the Bath Business Association (BBA) put flowerboxes on downtown sidewalks and street lamps, claiming, "there is a pride in Bath that really is coming to life." (The flowerboxes had been tried before and failed because of lack of

involvement; this year's support might be seen as an indication of economic uneasiness.) BBA also sponsors Christmas decoration contests, Halloween window painting competitions, hayrides, scare-crow making and other concocted community exercises.

244

If we do our work well, reality will appear even more unstable, complex, and disorderly than it does now.
—JANE FLAX

Public space has traditionally been male space, while women are meant to remain secluded in private or domestic *places*, although places too can be sites of male privilege—as in the proverbial "castle" where men can do anything they want, however violent or abusive. As social relationships between men and women change (although not as fast as we think they have), the nature of public space also undergoes subtle transformations. From spatial division and segregation (in religious, labor, business, and social contexts) to spatial domination and restriction (by law, architecture, custom, class), boundaries in space deprive women of information they need for equality: "For women to become more knowledgeable, they must also change places," writes Daphne Spain. Feminist geographers are demanding a redefinition of public space compatible with feminism's blurring of the boundaries between personal and political, private

and public. Although aware that they are still necessarily defined by exclusion from the male discourse that has defined the discipline, some feminist geographers are trying to go beyond obvious opposition to patriarchy and capitalism and the overgeneralized dichotomies of production/reproduction, public/private, male/female (which are themselves social constructs) into the more labyrinthine spaces where class, race and gender intersect. Feminist (and women) artists and writers are also preoccupied with their spatial imaginations, with concepts of inside and outside, expressed from the body to domestic to public to geopolitical spaces.

Feminist analysis of the city tends toward detailed research into the complexity of women's lives. Private spaces, for instance, are not inherently bad places to be, when they are chosen voluntarily. Public spaces can be re-formed by women of all classes who move between public and private, workplace and home—but it is crucial to the process of degendering and decentering that the experience of white middle-class women is not assumed to be the norm. Take, for instance, the ways in which urban spaces differ day and night, weekdays and weekends, the ways they are peopled at different times, reflecting working lives and power relations. Or take the notion of "the other side of the tracks" from both sides of those tracks, as bell hooks writes in her

WILMA NEEDHAM, *Some Fine Women*, 1983, two-image projection. Slides were projected for an hour each night on the wall of the former Zeller's department store (which was staffed mostly by women) in downtown Halifax, Nova Scotia—the view from the artist's apartment window, allowing her to "enter the community of women into which I had moved." A postcard was available at a nearby mailbox with a complete list of the names of the forty Canadian women profiled (many of them rural). This image is of Portia White, an international opera star born in Truro, Nova Scotia, in 1910, who became a gifted teacher and began a music library in Halifax. "Some" is a Nova Scotia (and Maine) vernacular expression meaning "very."

In 1994 a graduate class at the Harvard School of Design used Bath as a case study and worked on projects with city staff. The Comprehensive Core Planning Committee is still at it, having completed a 200-page document calling for marketing the city as

a technological center, developing a hotel or convention center, expanding wharf and waterfront improvements, fixing up run-down neighborhoods and increasing volunteerism.

In 1996, an architecture professor at the

University of Tennessee, son of a Bath city councillor, put in his oar, recommending that the city acquire the Coal Pocket prop-erty off Front Street, have a public boat ramp, and create a unified space along the riverfront. Councillors agree that any project

meaningfully titled essay "Choosing the Margin as a Space of Radical Openness." "Feminist geographers are understanding the contemporary city not as the increasing fragmentation of a still coherent whole," writes Gillian Rose, but in terms of "a challenge to that omniscient vision and its exclusions."

By resisting the closure that comes all too often with theorization, feminists are recreating spatial categories on their own terms, including lessons learned from local activism and advocacy planning, from dredging up sources ignored by even the most liberal male geographers. A good example is Christine de Pizan's *The Book of the City of Ladies* (written between 1399 and 1430) which offers a "new town" created from archaeological and architectural meta-phors, using "the pick of understanding," "the trowel of your pen," and "mixing the mortar" to fortify the city. In her critique of planning doctrine, Barbara Hooper cites Pizan as well as Frances Wright's utopian community Nashoba, Charlotte Perkins Gilman's proposals for a feminist housing project, Melusina Faye's contributions to a "domestic revolution," and the settlement house movement, among newly con-sidered antecedents of city planning.

Contemporary urban design is a subject so vast that few experts seem to be able to get a grip on that median strip between reality and desire and have remained incapable of changing the urban karma. Given the fact that city planning has failed so miserably so often, the field itself should be scrutinized more carefully than is possible here. Postmodernist planning seems intellec-tually aware of the issues and the realities, but it is overtheorized and, when practiced, is too often mired in a blowzy and superficial architectural style.

I'm always being asked why I don't talk more about architecture. Perhaps it's a feminist hangup, or a personal limitation; I just don't respond to most of

what is out there as I do to organically evolving forms and less manipulated spaces. Architects and planners can only offer a shell—the more open and flexible, the more likely it is to encourage a built environment that meets its inhabitants halfway. I'd like to see what Stephen A. Kurtz has written about apartments applied to larger contexts: "People are remarkably unaware of how they can alter the basic configurations of their apartments and consequently will spend years accomodating themselves to unnecessary inconve-niences. At the same time, because they never touch the shape of the space they have been given, their rela-tionship to it remains passive and alien."

We will never solve the problems of cities unless we like the urbanness of urban life. Cities aren't villages; they aren't machines; they aren't works of art; and they aren't telecommunications stations. They are spaces for face to face contact of amazing variety and richness. They are spectacle—and what is wrong with that?
— ELIZABETH WILSON

Ralph Waldo Emerson's notion of the city as a "human community" continues to be the stated goal of city planners, but I tend to agree with the (early) Richard Sennett, who wrote in 1970 that "a prohibition on preplanned, functional space is important; because it permits great diversity to arise in city neighborhoods, and because it permits whatever social encounters and conflicts exist in the neighborhood to 'take hold' in the character of the neighborhood itself." In this he reflected the inspiring (and to present-day eyes some-what naive) optimism of Jane Jacobs, who wrote in 1961, "it is the thousands of individuals who create, by making their own choices and operating without guid-ance from the planners, the exciting fabric of the cosmopolitan city." Sennett at that time was arguing still more radically for virtual anarchism in order to

that puts more boats on the river will help downtown Bath.

Like Bath, Brunswick and Wiscasset have recently fixated on development of or for waterfront recreation. Brunswick, although surrounded on three sides by water—the Androscoggin and New Meadows rivers and some shorefront—has no image as a coastal community. With an eye to tourism and "quality of life" standards, the town is building a fishing park, a wetlands park, bike paths and canoe portages around dams. Wiscasset is planning ahead for the closing of Maine Yankee, which will bring a huge loss of tax revenues.

In 1995, the expansion of the Bath Savings Institution was described as the "single most important downtown project in 20 years." It

246

force people to take control of their own lives, their own cities. Murray Bookchin, in the early seventies, also condemned city planning as primarily remedial, behind the times, and steeped in mistrust of populist spontaneity. A decade later, Colin Ward held that contemporary urban design is a megalomaniacal fantasy; its idealized drawings, he said, bear little relation to social conditions, to class structure, and the influence of design on governmental processes and communal life. "The most grandiose and expensive models for a mechanized future have been imposed on the poorest and most dispirited communities." On the other hand, Ward can be overly fatalistic, insisting that cities have always been "bywords for misery and despair," and their decline, "with their industrial *raison d'être*, is nobody's fault, it is simply one of the facts of urban history."

Urban planner David Lee suggests the following criteria for "a great public space": It is not anyone's private turf; it should be memorable enough that you would want to have your picture taken there; it is a place you couldn't wait to go to without your parents, a place where there is sunlight sometime every day, and there can be music, poetry, art, and speeches—enough visual drama and/or activity that you can send your out-of-town guests there to amuse themselves while you try to get some work done; it should not cost a lot to get to, and it should be clean, but not too tidy. I'd add to this list that it should include a place where peace and quiet is as available as entertainment—though I know that none of these qualities will enhance anything but the most superficial public interaction. Public spaces created for privacy are too easily transformed into private places that exclude the public. These "great places" are primarily about opportunities for private enjoyment. None of them can replace a main street, regular intergenerational dialogue, local or civic organizations, even a church or a workplace despite all their implied restrictions.

This need to pin down the notion of "great" places seems to obsess us like the equally unnecessary need to identify once and for all a definition of "great art," while forgetting that a vast range of tastes is involved. In May 1995 the results of the Lyndhurst Foundation's "Search for Great American Public Places" were released. (Interestingly, it went without saying that these were human-made places.) Suggestions were solicited here and there from the public, but the sixty-three "winners" were ultimately chosen by "a panel of experts" (consisting of writers, developers, architects, designers, teachers, and politicians) directed by Gianni Longo. The panel responded with "a sense of urgency" to supply models for "the builders, bankers and developers who are generally not exposed to them and yet make all the decisions affecting the appearance of our towns," as panel member James Howard Kunstler put it. (One alternative would be to strategize about how to keep these people from making all our decisions.)

The chosen models range (alphabetically and otherwise) from Acoma Pueblo and the Appalachian Trail to Xenia Avenue (the main street of Yellow Springs, Ohio), and something called Yorkship in Camden, New Jersey. It is a fascinating and inevitably eclectic list: a different panel would have come up with a different list, and yet another panel with yet another list, though there are some predictable entries amid the puzzling ones. Many of the obvious great American public places are noted as "endangered," including Santa Fe's Plaza, New York's Coney Island, and Times Square. I can only speak for those places I know, but I would have added many more as "endangered" by well-intended over-redevelopment and tarted-up tourist traps. The list focuses on the East Coast, Southeast, and West/Northwest coast, clearly reflecting the

will provide Bath's first parking garage—38 spaces. Since there is already a municipal parking lot behind the main street, and I've never had trouble finding a parking place, I assume dreams of commercial growth and tourist hordes fuel this project.

For all Bath's attempts to be a tourist town, public tours of the Bath Iron Works have been denied anyone except the occasional group of workers' relatives, schoolchildren or businessmen. Reasons given were safety and military secrets. In the fall of 1996, after months of planning, the precedent was broken and the gates opened for two buses of visitors, sponsored by the Maine Maritime Museum and the Bath Bed and Breakfast Association. Museum director Tom Wilcox said, "The challenge for a history museum is to relate history

makeup of the panel (with a few exceptions, such as Daniel Kemmis, the astute writer on civic responsibility and mayor of Missoula, Montana). "Nature" as a whole, and the Midwest and the West, in particular, are overlooked: New Mexico is the only South/Mountain Western state represented; there is "nothing" in Arizona, Colorado, Wyoming, Utah, Nevada, the Dakotas, Idaho, or Montana, and "nothing" in Chicago (one of my favorite cities). Surprisingly, not even Charleston, South Carolina, made the list.

Longo is also involved with a more democratically oriented group called Urban Initiatives which holds community meetings with small to large cities and regions all over the country, helping them to identify and then to expedite their local goals for improving their places. The first of these was held in Chatanooga, Tennessee, in 1984, right after it had been voted America's dirtiest city, which jolted its citizens into envisioning what they would rather be. Today, according to good press, Chatanooga's river is full of fish, its air is clean, traffic jams are gone, a freshwater aquarium and teenage pregnancy center have been installed, a downtown park and an old theater renovated, and the country's first "zero-emission" urban industrial park is attracting manufacturing companies downtown.

Far from being a place of self-absorbed privatism or indifferent alienation, the late-nineteenth and early-twentieth-century urban neighborhood created a rich public life that mediated between the privacy of the family and the impersonal crowd of the metropolis. Shared experiences in local business, workplaces, and voluntary associations fostered a complex mesh of relationships that linked thousands of individuals [of all classes] to each other and their neighborhood.
— ALEXANDER VON HOFFMAN

Busy with our daily lives, few of us are even aware of how our locales are changing until it is too late to affect decisions made elsewhere. In my lifetime, the whole concept of "downtown" as a public space has altered. It is no longer where the action is, where people gather to shop, hang out, show off, promenade, cruise, and meet for a movie, lunch, coffee, or a drink; it has been fragmented and homogenized until big cities function merely as extended shopping malls.

DIONISIO RODRIGUEZ, *The Brackenridge Park Bridge*, San Antonio, cement, 1950s (Photo: Kathy Vargas, from *Art Among Us/Arte Entre Nosotros*). Here Rodriguez simulated intertwined tree limbs in cement. He also specialized in huge cement flower baskets, and made a full size roofed well house with a deer, for private yards. According to fellow cement artist Sam Murray, Rodriguez was very secretive about his process. Cement work (including the realistic tree stumps found in southwestern graveyards) is heir to the more traditional woodcarving in the Mexican American community, though it is popular in San Antonio across ethnicities.

to the present." The Maritime Museum shows how ships were built in the past, and the Bath Iron Works, showing how they are built now, has been the missing link. Not that this will become a common occurrence. A yard spokeswoman said two or three tours a year might be possible now. "It was nice to have people in and show off what we do."

The BIW tours may be harbingers of a new "alternative" tourism, which focuses more on respecting what people do in places than on idealized or concocted views of a place.

Public spaces have been broken down into those dominated by popular culture (streets), by mass culture (malls), by high culture (museums), by corporate culture (office buildings), and by official culture (government structures). Moreover, popular and mass culture have become almost placeless because of their electronic base. Is the World Wide Web a place? And if so, is it public or private? What about all those "home pages" where the number of "visitors" are avidly courted and counted? Such intangible "places" are all the more susceptible to control—for example, the ongoing, but losing, struggle for public control of public-access TV. Stanley Aronowitz has suggested that talk radio is the new public space, but it too is firmly controlled: dissenting callers are screened or jeered off the air. In a real public space you can debate and communicate with those on the soapboxes. There are no "moderators" except for what unspoken custom and courtesy are left.

In artificially constructed cities, says Bookchin, "neighborliness is mistaken for organic social intercourse and mutual aid; well-manicured parks for the harmonization of humanity with nature....an eclectic mix of ranch houses, slab-like apartment buildings, and bachelor-type flats for spontaneous architectural variety; shopping-mart plazas and a vast expanse of lawn for the agora...." Some days it's hard not to be as cranky as Bookchin sounds here. (My nearest grocery store, on a small plaza in a suburban development town with a Spanish name, is incongruously called "The Agora.") One way to forestall frustration is to map one's own community and its cultural and class interconnections. This process facilitates memory and can raise political and historical consciousness, pointing us in the direction we'd like to act. A student of architect Denise Scott Brown mapped and photographed every site in a local social services directory in Cambridge,

Massachusetts, in order to flesh out the terms *public* and *private*. From detox centers and ethnic community groups to libraries and schools, said Brown, "the relation each had with its street and with its community, when you saw the whole lot together, was very moving."

It seems that we as a society are beginning to listen more carefully to the echoes from a lost or neglected world of "local attachments," even from churches or sports clubs or other organizations that the ultra cool might ordinarily avoid like poison. But we don't know how to reconstruct them organically in our own contemporary image, and it's pretty clear that the artificial versions don't work. Even as cities become increasingly abstracted from the experiences that form them, "featureless distancing" and "spatial disjuncture" make the urban landscape generally unsatisfying. The need grows for "a truly associational space."

Margo Huxley says cities are "our treasure houses of cultural capital and wisdom, and to destroy them would be to will a state of collective amnesia," and Dolores Hayden recommends that we "learn to design with memory rather than against it." I like that idea, which, I assume, precludes the thoughtless destruction of buildings and neighborhoods, and includes a frenzy of rehabbing, remodeling, and revisioning. Different people will be plugged into different memories, not all sweet or even bittersweet. Some will have short memories, others will cultivate longer ones.

Keep Off the Grass

I built the tent around a park bench. I had a garden outside.
I've got a place, I've got a garden.
— NATHANIEL, FORMER "MAYOR" OF TOMPKINS SQUARE PARK

MARGARET MORTON, *Nathaniel's Garden, Tompkins Square Park, NYC*, 1990 (Copyright Margaret Morton, photo courtesy Lowinsky Gallery, New York.) Nathaniel acquired the mayor's title because he often represented the Tompkins Square homeless (over one hundred people who were living in the park). Morton and Balmori described his garden as formally arranged, with a concrete planter, "a large mound of earth, leaves, sundry objects, and an area edged at the front by a metal strip" that countered the makeshift tent. "A sense exists of something composed...."

People came by and added things. Nathaniel grew a few sunflowers and had a pet praying mantis. With his neighbors, he was evicted without warning by the police at 5:30 on a freezing December morning. "The only way to win the revolution is gardening," says a member of a Lower East Side squatters' group called Foetus. Morton has also documented an even more drastic attempt at placemaking—the homes created by homeless people in the tunnels beneath Grand Central Station.

Though we have cannons too—at Fort Popham, in an Arrowsic front yard—in Maine, the cannon in the park is often the anchor in the park, giant rusting hooks, hauled up forever, recalling the ships above and the depths below.

Rural Georgetown has no local parks (aside from Reid State Park on the shore), but maintaining public open space is a priority. At Five Islands, where land around the town wharf (including a major prehistoric midden), is town property, there is also a plaque

on a boulder by a pond to mark the Adolph Ipcar Nature Preserve, named after a committed citizen of Georgetown and former dairy farmer.

WHEN I THINK OF APPEALING PUBLIC PLACES, I think of parks—the ones that are real places, that don't look like architects' drawings. I think of New York's Central Park, where I spent much of my early childhood—vast spaces with big old trees, ponds, rock outcroppings, playgrounds, warrens, and crowded gathering places used by a mixed population. As a child, it never occurred to me that it was constructed, that it wasn't "nature," that it hadn't always been there.

In the late 1850s Central Park was a barren, rocky, swampy industrial wasteland. Among the scattered shanty towns and poor neighborhoods that were demolished to make way for the new amenity were old Irish and African American communities. According to Roy Rosenzweig and Elizabeth Blackmar, the park's social history exposes ideological differences between Frederick Law Olmsted and his neglected partner Calvert Vaux, both romantic naturalists. Olmsted perceived the park as a work of art, injecting culture with the salutary influence of nature. Vaux, on the other hand, saw the park as a designed space that would find its character through democratic use. At the time, working people had little leisure time, and Central Park functioned more as a site of social display for the uptown rich than as urban relief for the downtown poor. The rich were encouraged to build villas so the poor could enjoy gawking at them, since, Olmsted declared, humble folk "delight in viewing magnificent and imposing structures." Paul Shepard highlights this patronizing line as the moment when "a kind of American doubletalk reconciling villas with democracy and privilege with society in general had begun."

As New York's population grew, and as work hours were shortened, Central Park gradually did become more of a "people's pleasureground." (Olmsted would have been surprised to find that his "Ramble," already a botanically intricate site when he found it, had

become a mazelike tangle of unofficial paths, called "desire lines" by planners and frequented by gay men.) Central Park is a series of interlocking landscapes whose specific characters depend on the neighborhoods they abut: the residential East Side population differs from that of the West Side; South is Midtown businesses and hotels, North is Harlem. It is nature created rather than nature preserved. (It isn't "nature" at all if nature is a place where we are not.)

Public parks evolved from two socially distant directions: from private estates and gardens, and from the common green or shared pastureland. An intermediary creation in nineteenth-century America was the park-like cemetery, which was pushed beyond city limits when urban land became too valuable to waste on the dead and death itself became less socially acceptable. City parks were also inspired by dual motivations—raising real estate values for the rich and providing places for the poor to be in touch with nature. Journalism and photography (especially Jacob Riis's *How the Other Half Lives*, 1890) played a major role in rallying public opinion to support social reforms that included the construction of urban parks and playgrounds.

Artist Robert Smithson remarked that Olmsted's North Meadow, intended as a "bold and sweeping" point of departure for "lateral and horizontal views" is now "filled with ball fields." This fulfills Vaux's promise, although perhaps not his expectation, that the park would find its own identity. That identity of course changes depending on the economic climate and cultural geography of the city itself. Parks can be microcosmic reflections of a multicentered society. Urban parks—or at least those not confined within a homogenous neighborhood—provide one place where activities and classes have traditionally overlapped. Ideally, tolerance is practiced very literally in parks: they are places where you can't control the

Our other major open public space is some 300 acres bequeathed to the Audubon Society by Josephine Newman, nee Oliver—an extraordinary woman who was a well-known bryologist (mosses), owned a Melville manuscript, and was married to songwriter Roy Newman. In Georgetown Jo Newman is almost legendary. In her old age she lived alone in her isolated old house, cut her wood, and walked her property. I barely remember her, but my grandmother was a friend and often talked about her. I have walked the (mosquito-infested) trails and Robinhood Cove shorefront of her property after her death. The tragedy of the place is that Newman was unaware that her 200-year-old house would be demolished because it was too expensive to maintain.

noise kids make, where you can heckle the soapbox politicians, and be warmed or shocked by blissful, oblivious lovers.

Washington Square in New York's Greenwich Village is a tiny but dazzling example of such a microcosm, featuring daredevil rollerbladers, skateboarders, mimes, and other acts, a wide range of acoustic music and sing alongs, absorbed chess players, potential and sexually diverse pickups, a panoply of drugs for sale, skillful thieves, sandboxed toddlers, and an occasional brawl. It also boasts some small "hills" with a rubberized surface for thrilling bike rides, reminiscent for me of the low mound in City Park in New Orleans, built, to the amusement of us transplanted Yankees, "to show the children of New Orleans what a hill looks like."

Today, as J. B. Jackson observes, the American city park is no longer loved as it once was, and "the prosperous neighborhoods the park did so much to foster now see its presence as a social and economic liability." Contending that park designers "have ignored the oldest and most popular kind of play space in favor of the aristocratic garden," he suggests from a more populist viewpoint that the poor preferred their nature in livelier, less formal, less structured environments—the beaches, riverbanks, woods, and even churchyard playing fields of European village tradition (what the French called *terrains vagues*). Overdesigned parks underestimate their users' inventiveness and can even play a dangerous role in training youth to expect structured or passive entertainment as the norm. While deploring the deliberately artificial "sports parks" for skateboarding, cycling, rock climbing, all-terrain vehicles, and so on, which are springing up to assuage a restless younger generation, Jackson optimistically suggests that such spaces might mature to give the term park "a wider and more contemporary meaning:

the park as a public, open-air space where we can acquire self-awareness as members of society and awareness of our private relationship to the natural environment." Can a public space escape its imposed character through use and through the changing users?

Far more ominous than these sports parks or lack thereof, though, is the trend toward debt-ridden cities abandoning their parks altogether. According to Mike Davis, Los Angeles has "adopted the principle of apportioning its reduced park budget through a formula based on park size, while encouraging parks to operate as 'businesses' based on user fees. Since the wealthy areas of the city have disproportionate shares of park area and fee-generating facilities, the result is 'recreational apartheid' and a calamitous deterioration of public space in the inner city as parks become increasingly run down, unsupervised and dangerous." Environmental psychologist Cindi Katz deplores the privatization of public spaces and the recent popularity of indoor playgrounds for "safe play." It's not that there is no money, she observes, but that choices are being made: "bridle paths are restored, bronze eagles are polished," while hundreds of thousands of poor children, many of them "latchkey kids," are abandoned along with the parks, their last chance at benign outdoor havens.

Parks remind us that the city is built on "land," that the city too is a "natural place," although sometimes a grotesquely fragmented one. They provide glimpses of the ecological history of a place: boulders, says landscape architect Jean Gardner, help to tell the story of the path of the Wisconsin Glacier through the New York City area. The remaining vegetation, different in each borough, "picks up the storyline and adds new characters, creating a botanical adventure that the curious can explore in detail." When park designs run counter to ecological systems, they deteriorate rapidly,

Since 1992 Bath has had a model Community Forest Committee, appointed by the City Council, which has developed a computerized inventory of all the town's trees—over 3,000, of 65 species. The Committee is setting up a long-term management plan for maintaining and expanding Bath's "urban forest." A key figure in its achievements is Bath City Forester Fred Pecci, who has been on the job for 53 years. An Adopt-a-Tree program allows landowners and small businesses to take responsibility for specific trees. There is a "picture postcard tour" of Bath's trees, and a brochure that is a self-guided tour to "Historic Bath Seen Through Its Trees": "Make History—Plant a Tree!" One of the goals is to make the forest sufficiently

252

particularly when constant human care is withdrawn. Gardner suggests the replacement of Olmsted and Vaux's exotic plant species with indigenous ones that would enrich local ecologies, a plan that is crucial for an area like Manhattan with its incredible ecological burden (a density of eighty thousand people per square mile by the early seventies).

Ecology, "nature," history, and memory come up through the cement and through city lives, physically and psychologically. San Antonio's River Walk, for instance, resembles a canyon in barren country or an excavation into another time—future, not past. Suddenly, in the midst of a hot, dry, lively, but not very scenic city comes this green and cooling plunge into "nature"—a pleasant if highly managed and commercialized oasis in an urban desert. Alan Sonfist's *Time Landscape* in downtown Manhattan is the opposite— a curious tangle of untended vegetation, it represents a patch of precolonial forest (planted in 1978) getting a second chance. Neither a park nor a simulacrum, it is a poignant hybrid between art and nature. Sonfist has continued to make "time landscapes" that expose the natural/cultural landscape in urban settings. As Barbara Matilsky points out, this is a far-reaching concept that "can be implemented on any scale in any region of the world." Charles Simonds's unexecuted plan for a Loisaida Museum of history *and* flora and fauna, proposed in the late seventies, with vines tumbling out the windows of an abandoned tenement building, offered another syncretic image of nature and culture revived.

Trees and flowers aren't potentially as controversial as decorative or commemorative sculpture, play structures, fences, even fountains, can be. Although green can be boring, especially when overregulated, it is decidedly a most attractive addition to most neighborhoods. But urban open space is not necessarily green.

City parks can be concrete basketball courts and playgrounds, or playgrounds with scrawny shrubs and trees fighting the odds, and maybe a public swimming pool. Or they can encompass modest community gardens in vacant lots laboriously cleared of decades of accumulated detritus, more elaborate community gardens (with some support from the outside), and philanthropically financed "vest-pocket" parklets in midtown (pleasant breaks in the urban rush, providing welcome relief for the exhausted walker, but often overdesigned and hardly cozy). The nineteenth-century parks with their decaying elegance and amenities are no longer taken for granted. Access is always an issue. Should community parks and gardens be fenced or gated and only accessible to local residents? (This question has different implications in classy, grassy Gramercy Park and in cemented-over Bedford-Stuyvesant—a hard-core Brooklyn neighborhood known for high poverty and crime rates.) Who is this park for, and who controls the access? They are rarely the same group. Architect Susana Torre has pointed out the gendered occupancy of vacant (as opposed to "open") spaces in the devastated Bedford-Stuyvesant neighborhood: "Boys playing basketball are in one 'cage'; mothers with children are in another 'cage'; they are all at each others' throats." (She proposes a "folded" landscape in which visually continuous spaces remain functionally separate.)

The battle in May 1969 for control of the Peoples Park in Berkeley was a turning point in progressive thinking about the conflicts between neighborhoods, downtowns, shopping plazas, as well as one source of the revolutionary ecology movement. Hippies, students, and Berkeley citizens fought the police for over a week to retain a park playground that had been spontaneously created from a garbage-strewn vacant lot owned by the University of California, which then

diversified so that if a disease as lethal as Dutch Elm strikes again, it can't cut such a swath. Better prepared than most, Bath also participates in a national program to restore Elm trees, which begins in Maine and will work its way south.

Sandwiched between car dealerships and fast food franchises, one of last remaining green spaces on the strip between South Paris and Norway, is the 3-acre Bernard McLaughlin garden. McLaughlin tended the garden for nearly 60 years and it has attracted horticul-

turalists from around the world for its ninety-six lilac varieties, extraordinary irises and sempervirum. After his death this anomaly in stripville attracted much sentiment. Rumor had it Shaw's grocery store chain, now based in Massachusetts but originally from Maine,

reclaimed it only to pave it over into a parking lot and soccer field. The struggle inspired some young Berkeley planners to write a "Blueprint for a Communal Environment." Working from models as varied as Southwestern pueblos and Medieval and Renaissance European villages, they proposed to ruralize the urban context by opening up adjoining yards and dismantling the surrounding fences, to form a new kind of commonland of parks and communally cultivated gardens, as well as a "people's market." Pedestrian streets, roof openings, and platform bridges between houses were to further open paths of communication. Although they are rarely executed, such models are important to keep in mind as hopeful beacons.

The notion of a "pedestrian city" has been popular on and off, in surges often related to energy crises and fuel-guzzling orgies. It can be traced back to Frederick Law Olmsted's "emerald chain" of parks in Boston (now broken by highways). In 1971, with the Berkeley blueprint an idea in the air, Mac Gordon, William Hodgson, and Oliver Hamill proposed "The Greening of Ruppert Project," based around an abandoned brewery in New York City. It was to be an eight-block greenway running from Central Park to Carl Schurtz Park on the East River, grandly envisioned as "the first of a series of pedestrian and bicycle paths that would eventually link up all the city's parks in a really organic way. The parks are like lungs, and the paths would be green arteries for them." It didn't happen.

Smaller cities and towns have maintained green belts and open spaces with varying degrees of success, depending on the extent to which municipal governments are in the developers' pockets. They have had to come to terms with the fact that the mountains, woods, lakes, coasts, or deserts they have long taken for granted are not inviolable. Farsighted and relatively wealthy towns have considered "comprehensive

plans," in which future land use is mapped out and overdevelopment slowed or even stalled. Less wealthy populations tend to disrust regulation and perceive such plans as blocking their only chance to profit from their land, which may be all they have. The "open space" concept of leaving land unused or out of bounds for development has engendered conflicts between the notion of passive and active enjoyment of nature (including leisurely contemplation) which have divided advocates of wildnerness and wise use.

Questions of access and multiple uses are important for city and borderland parks, as they are for the great national parks. Overregulated places become abstracted into mere spaces, but heavy use calls for much-debated policy decisions. Mountain and plains parks trails are contested by hikers, strollers, cross-country skiers, trail bikers, horseback riders, sledders, sunbathers, and users of motorized vehicles. Each group has its own needs and criteria, each goes its separate way in a melancholy reflection of the national fragmentation and specialization that tears the notion of the local from limb to limb.

Mediators between nature and culture, gardens are, paradoxically, communal places that encourage solitude and self reliance. There is something impersonal (public, perhaps) about the notion of a park, whereas even a public garden evokes a more intimate (private) landscape. Canadian artist Glenn Lewis has pointed out that gardens are metaphors for both the center, or home, and for the four directions they symbolically "look out on." The communal gardens flourishing in urban vacant lots and their funkier independent siblings bridge the gap and establish a comforting sense of place, transitory though it may be.

Since the sixties, community gardens have been a focus for local resurrection, on the model of community allotments (which appeared in this country with

wanted to pave it over as a parking lot for one of their stores, although they adamantly denied it. A Save the Garden group bid $200,000 for the land, but has raised only $10,000 and is now split by dissension; as of this writing, the rescue effort seems doomed.

Georgetown has its share of skilled craftspeople, including the man who sells key lime pies and fanciful tables simulating sea creatures, and the anonymous makers of the wonderful cloth-and-pipestem mosquitoes and beer-can airplanes found at the annual

Working League Fair. For a couple of years, a brand new suburban-looking house/store located in a prime spot at the corner of the Bay Point Road and Route 127 to Reid State Park was a rather pallid local art and crafts gallery. But our highest profile artwork is the

254

the "victory garden" of World War I). Clearing and planting a vacant lot, a desert of urban rubble, can become a symbol of hope in the very process, involving youths and elders in a constructive format for transformation. Community spirits are raised along with vegetables and flowers. Gardens probably please more people than any single artwork ever can. Having understood this, artists Sabra Moore and Roger Mignon spent several years planting their own garden in a triangle between buildings in Brooklyn. When it was peremptorily destroyed by a new landlord who failed to recognize an improvement to his property when he saw it, Moore posted images of the garden around the neighborhood in protest, generating a good deal of support as well as offering a memorial to the fallen flowers.

Community-originated projects fend for themselves and are rarely made privy to civic decisions and official overviews of their neighborhood's future. For the most part, they are literally grassroots endeavors, often key sites of social advocacy, created by activists such as Manhattan's Green Guerrillas. (They have also evolved into broader networks with stricter regulations, as in Operation Green Thumb.) In the sixties, "tree lady" Hattie Carthan of Bedford-Stuyvesant, Brooklyn, greened her own failing neighborhood; a huge old magnolia tree became the symbolic *axis mundi* of the struggle to survive and it was finally designated a living historic landmark, the centerpiece of the Carthan-inspired Magnolia Tree Earth Center —a web of greened vacant lots and an exemplary spread of neighborhood environmental programs including a library, job training, after-school activities and other programs. In 1977, the City Beautiful Council of Dayton, Ohio, published an impressive *Community Gardens Handbook* with information ranging from Corn Smut, Bush Hogging, and Tractor Rental

to the problems of Mrs. Florence Love, who claimed her adjacent property was being trashed by community gardeners.

It's an ill wind that blows no good. Gardens engendered by urban decay have proved effective social organizing tools and sites of resistance. One of the results of Los Angeles's rebellions in the sixties and nineties has been a wealth of rehabilitative garden projects like *Saber es Poder* (To Know Is to Enable), described as an

Broken View, 1996 (Photo: Caroline Hinkley). For nine years I lived part-time in different little cabins in Chautauqua Park above Boulder, Colorado. Nestled below the foothills where the hiking trail started up into the mountains, there was a stunning view of the local landmark—a row of oddly tilted cliffs called the Flatirons. The first year I was there, a small brown restroom was built at exactly the point where the hiker first entered the magnificent view, now focused forever on this brown, "rustic" and intrusive little building.

Working League quilt, a new one sewn each winter by a faithful quilting circle and ubiquitously offered up for raffle tickets all summer by a dedicated little group who set up tables at the supermarkets and other centers. In 1996, a particularly handsome quilt depicted

the last sailing ship built in Georgetown. It was coveted by all—the subject of much discussion and insistences that "I'm going to win it this year, I just know I am."

Georgetown roads boast two vernacular public art works that have become land-

marks. The first is the Turtle (or Lizard, as some insist on calling it), a humped rock painted green, with an eye, that appeared, I think, in the 1960s. The second is a large American flag painted on a flat rock at the entrance to Reid State Park. Both are

interface "where design accomodates secret codes and marginal cultural spaces within public streetscapes." The Uhuru Garden in Watts is an "urban refuge" and open market. Food from the 'Hood, created by a high school biology class in South Central L.A., not only provides healthy foods for the neighborhood but has grown into a national distributor of salad dressing with proceeds going to college scholarships. The idea is spreading; they are thinking of franchising their logo to a group of New York kids who want to sell applesauce. A group in uptown New York is starting a vineyard to produce "Harlem Chardonnay."

Such enterprise is healing as well as practical. In 1979-81 artist Marc Blane, drawing comparisons between ancient and contemporary ruins, and inspired by the raw material of inner-city vacant lots, began his Rubble Reconstruction Company to construct Rubble Parks, with the aid of the South Bronx Development Organization. With cyclical transformation rather than disguise in mind, he proposed "excavating the urban relics of modern culture, mining the power of these relics and connecting their origins, nature and customs." Gail Rothschild's 1989 sculpture *Gaia Earthmother*, made when she was artist-in-residence at the Henry Street Settlement, guards a garden of medicinal herbs in a rough neighborhood; it is watched over by a group of local "caretakers," many of them elderly women who use the herbs they grow. In South Burlington, Vermont, in 1979, the Chittenden Community Correctional Center instituted "horticultural therapy" for the inmates, harvesting a huge and lucrative crop of vegetables. In Marin County, California, artist Sharon Siskin combined AIDS education with gardening in an art installation and memorial garden called "Planting the Seeds of Hope." Landscape architect Karneal Thomas, a Harlem native, designed "Success Garden" in a drug-infested Harlem lot by taking local

teenagers on tours of their own neighborhood to open their eyes and then encouraging them to create something better: "Designing gardens forces you to think about the future."

Inspired by Jane Jacobs's concept of local "street guardians," another African American architect, Sharon Sutton, worked on a "street museum" in the inner city of Lancaster, Pennsylvania, in 1978. Although it never fully came to fruition (built by local children, it was not supported by their parents and was soon ruthlessly vandalized), she had better luck with later projects. The idea of local youth creating public artworks with recycled materials found in the neighborhood remains an exciting one, its best-known example being the painted bricks of Tim Rollins + KOS (Kids of Survival) which originated in a South Bronx school. Some of these projects are conceived from within, some from without, some from the bottom up, some from the top down; some are called "landscape design," and some "public art projects."

By virtue of artists' participation, some gardens are designated "art." An early model was Bonnie Sherk's *The Farm*, a multipurpose "frame for living" in San Francisco in the seventies. In Chicago more recently, Ben Sturge, a painter who decided to move off the canvas into blighted city properties, has become a moving force in urban land transformation—often unfortunately called "beautification," which implies cosmetic rather than social change. In 1995, Aljira, a center for the arts in inner city Newark, New Jersey, cooperated with Brazilian-American artist Jonas dos Santos on an "Eco-Artreach" project at the Saint Columba Neighborhood Club Community Garden, which involved outdoor performances with artwork-costumes. "Urban Paradise," a 1995 exhibition of artists designing gardens for New York's Public Art Fund, includes daughter-and-mother team Alison and

255

refurbished yearly by unknown hands. And perhaps the Smoky Bear sign alerting us to fire danger also qualifies. It too has been there a long time and is faithfully maintained. Perhaps I am biased in its favor (in the early

fifties, our house almost burned down when a neighbor's brush fire got out of hand on a dry and windy day; the volunteer fire department, with the aid of a miraculous gust of wind, saved it. The Smoky sign came later.)

Visible from the road into Popham village is a modest but impressive castle display by Clarence Perkins, made between c. 1945 and 1984. Its stones, shells, bits of glass, plastic toys and jewelry were augmented by local

256

Betye Saar's collaboration in progress called *Roots and Wings* (for the two things parents should give their children) in which bird houses and whirligigs will surround a silver woman in the garden of Public School 152 in Queens.

Good intentions do not guarantee effective results, though. Meg Webster's *Kitchen Garden*, planted in front of the Contemporary Arts Museum in Houston, was intended as an interactive community project that would provide food for the hungry or homeless. But, as Frances Colpitt pointed out, its "scraggly" presence in an upscale neighorhood precluded any such practical ends—although the mere existence of the garden "growing, blooming, wilting and dying" was "provocative, inhabiting as it does some undefined region between a small-scale farm and an inspired work of art." (Webster, who learned from the experience, has gone on to more community-involved projects.)

Another interesting failure was Jennifer Bartlett's unexecuted project for a walled garden at Battery Park City in 1989, which was attacked as "the Selfish Garden." According to one detractor, Bartlett's whimsical and site-unspecific design, constructed on a grid as a series of twenty-four walled "rooms" or concrete boxes, was based on her well-known paintings rather than on gardening experience; perceived as elitist, self indulgent, crowded, and ecologically and horticulturally negligent, it cut off the river view, to boot, and was finally canceled. (However a private version at her own home—small scale cement boxes full of waving grasses—proved very beautiful.)

The classic example of a success that failed to survive was the Garden of Eden, designed and executed over a decade by local eccentric Adam Purple (aka John Peter Zenger III) on a series of vacant lots on Eldridge Street on New York's Lower East Side. No funky amateur creation, the garden was exquisitely designed and planted in a mazelike series of concentric stone rings centered on a yin-yang symbol and intended to expand "forever" outward. Purple saw himself as

HAHA, *Flood/Diluvio: A Volunteer Network for Active Participation in Healthcare*, Chicago, 1992-94 (Photo: John McWilliams, courtesy Sculpture Chicago). Haha, a Chicago-based collaborative (Richard House, Wendy Jacob, Laurie Palmer, John Ploof) makes art in real-life contexts. This storefront hydroponic garden plus meeting and education space on Greenleaf Street offered a model for year-round community gardening, directed at growing food for people with HIV. With its delicate and complex system of pumps and interconnections, the garden also served as a survival metaphor for the fragile body. Flood artists and volunteers worked both in the garden and in the community. "The garden," says Haha, "is a covenant, emblematic of the complex and manifold links of care between a community and an individual." The storefront outlasted the "Culture in Action" exhibition for which it was developed by almost two years and in 1996 a new center opened, run by a coalition of neighborhood organizations to house a food pantry, grocery center, the Flood storefront garden, classrooms, offices for outreach and counseling on AIDS awareness.

people sending him things from Florida. In the midst of this stark little seaside town it stands out as an assertion of fantasy.

I was told about a yard full of leprachauns and other creatures on Arrowsic, but it had vanished by the time I got there. Excess is not a Maine characteristic. The most commonly colorful display is that of found lobster buoys that have washed up on the shore and are hung on the side of a barn. And then, of course, there are the car graveyards, which have a certain eclat of their own—mountains of crushed and colored metal just waiting for a local John Chamberlain to resurrect them.

a reverse Prometheus, bringing fresh water to put out the urban fires (and replacing the topsoil by carrying horse manure by bicycle daily from Central Park). Yet he and his many local and outside supporters lost the battle with the New York City Housing Authority, which declined to give its allegedly lower-income housing tenants the benefit of a readymade source of beauty and hope. The garden was destroyed in 1985, its memory a monument to bureaucratic lack of imagination.

Pursuing the theme of gardens as healing sources, Santa Fe artist Ada Medina and landscape architect Edith Katz have proposed *Curandera's Garden: Sur y Norte*. Conceived as a "heterotopia, a site of co-existing differences," it offers one of the more interesting concepts of planting as a celebration of local culture, inviting "participation and modification by local people according to their own cultural traditions, practices, memories and needs. It explores the role of landscape to evoke ancestral memory and to affirm cultural identity." (*Curanderismo* is a form of "folk healing" that reflects this history.) Connecting body and land, the garden would feature monumental *milagros* (healing charms in the form of body parts), a well, a *zocalo* (plaza) and the shrine/*nichos* found in *Hispano* yard art. Brightly colored wooden chairs would be available for contemplation and meditation. Sacred and quotidian are combined in this plan, as are the traditional and the technological through intimate video installations. Drawing from sources in pre-Columbian indigenous cultures, from the Spanish, Arab, Jewish, African cultures, and from those of mulattos, *criollos* and *mestizos*, Medina and Katz incorporate through herbal plantings a history of the Southwest, as well as its topography in microcosm. The artists hope to create a narrative "compressed and selective like human memory itself."

The lawn must be mowed, irrigated, raked, and treated with fertilizers and pesticides. A single lawn seems insignificant, but multiplied by thousands of acres in a single city, the cost becomes substantial: depleted energy and water supplies, and polluted water.
—ANN SPIRN

Lawns and yards, like gardens and parks, provide symbolic clues as to "who lives here." The All-American lawn has been described as "a moral landscape" and "this unnatural creation that is always reminding us it can't take care of itself." The lawn is a cultural artifact, one of many unforeseen consequences of our historical experimentations and expectations imposed on nature. It enhances both intimate glades and the wide-open spaces Americans are so fond of, carrying with it a class-based luster derived, like our suburban names, from the British aristocracy. "Turf management" is the linchpin of the conventional suburban garden, which is itself a microcosmic reflection of the larger human urge to control nature.

Local diversity, for instance, is threatened by invasive imports—the few dozen plants found in every suburban garden. Yet Sarah Stein contends that, handled responsibly, even the tiny domestic garden can play a critical role in supporting the greater ecosystems surrounding it. Organic gardening, once considered the perview of aging hippies and earnest enviros, has gone mainstream as gardeners begin to see their properties not just as collections of attractive vegetation but as potential habitats for the local wildlife population. If this view ever permeates the national psyche, the ties between human invaders and the land they like but don't hesitate to change will become much more obvious.

Horticultural tidiness is close to godliness in those communities that insist garage doors must be closed, houses must be painted certain colors, vegetable

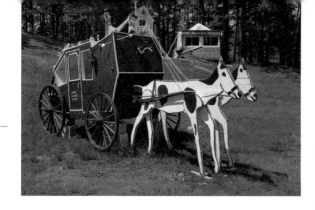

PHILIP DAY, *Loony Lagoon on Witch Spring Hill, Bath*, 1989-present (Photo: Peter Woodruff).

258

gardens do not belong in the front yard, and all lawns must be mowed. Canadian poet Renee Rodin found herself in a battle with municipal authorities over her wild, unmowed front yard; she was saving water, protesting the "noise pollution" of the mowing season, and she just liked the way it looked. Her signs announcing WE ARE CULTIVATING TOLERANCE and PLEASE KEEP UP THE GRASS cut no ice with her neatly trimmed neighbors and were vandalized. Even her back yard, featuring blackberry brambles and an old grocery cart covered with morning glories, became a target (some of Rodin's neighbors admitted to enjoying the wildflowers, the quiet, and memories of the days when "little patches of urban wilderness" regularly broke the current sterility). Her son said he'd seen on TV that an unmowed lawn indicated drug dealers in residence, but when there was a drug bust nearby, "it was at the home of one of the 'nicest' lawns in the area."

Along with lawns and gardening, cultural markers and coded styles of yard decoration are another way of declaring territory, a form of subcultural resistance to the dominant culture. Elaborate weathervanes and carved figures in yards go back to the eighteenth century in North America. On San Antonio's Mexican American west side, lovingly homemade Catholic yard shrines are ubiquitous, and in lower-middle-class Midwestern and Northeastern white suburbs, flamingos, fawns, gnomes, rococo birdhouses, and "negro jockeys" have given way to mass-produced butterflies on the garages, red-barn mailboxes, plywood cut-outs of geese, spotted cows and "Annie Fannies" (two-dimensional women "gardeners" bent over so their

panties show). Mirror balls (originally called "witches' balls" and placed to ward off evil) are rare now, although there is a lawn ball club based in Pittsburgh. Some people hold off until Christmas, when secularized ornaments have expanded from the wreath on the door and candles in the windows to elaborate light displays covering whole houses and entire yards; so much energy goes into their installation that they appear immediately after Thanksgiving and remain for months. Local Christmas lights contests are common, and encouraged by power companies for whom the holiday is a bonanza.

Thanks to racial discrimination, cultural markers are less obvious in mixed suburbs than in homogenous neighborhoods, where people feel freer to celebrate their identities and idiosyncrasies. (There was an uproar in Beverly Hills in 1978 when a Saudi Arabian sheik painted the classical nude statues around his estate in flesh tones with black pubic hair.) Those who do not accept mass-produced ornamentation and invent their own yard art, often from recycled materials ("junk"), can be outcasts in suburban contexts, although in some communities they are welcomed as the artists they are. Some labor in the warmth of grand religious or patriotic visions; others are recalling cultural customs or celebrating mysterious obsessions; others fiddle with objects for fun (like Walter Schell of York, Pennsylvania, a roofer who carved a bear behind a tree in his yard and rigged it up to wave at passersby).

Cultural interpretations of space and privacy vary, just as there are different habits in conversational distance and different yard zones in suburbs and small towns. Georgian Magnolia Moses says "white people's gardens are all shaped up"; her neighbor, Richard Westmacott, author of *African-American Gardens and Yards in the Rural South*, says that if Moses were given money for plants she would show the "kind of playful

inventiveness" found in African-American yards, music, quilts, and art.

A certain generosity and optimism is at the heart of most vernacular art, but African American women in particular tend to be called to this medium by an urge toward spiritual fulfillment rather than merely thrifty decoration or entertainment. Like some of their white and male counterparts, they are motivated by a compulsion to speak and give, to share their dreams and visions with others. Their art resonates with the joy of internal visions offered to the outside world. This communal impulse, particularly evident in southern African American communities, can be traced back to African tradition. Yard art, says Robert Farris Thompson, can "make of house and property virtually one vast *nkisi* charm… embedding spirit in earth, keeping the spirit in a container to concentrate its power, and including within the earth material signs which told the spirit what to do." Historically, in central Africa, *nkisi* also included collecting trade items and magical objects, which were then displayed on a table outside the door.

In the contemporary South, one still finds the traditional "swept-earth yard," which came from Africa but was widely adopted on plantations where grasses were "weeds" that hindered work and choked off the cotton. Yards may also feature whitewashed tires circling plants for protection, colored rags, bundles, bones, and bottles hung on trees, "motion emblems," wheels of unity, mirrors, and shining objects such as hubcaps, herb plantings, rock piles, and cosmograms —all of which solicit healing and encourage or discourage spirits. Sometimes the visual languages of tomb and home are mixed; gravelike decorations and sometimes even head stones appear in yard shows.

The creation of full-scale yard environments has tended to be male work, perhaps because, as John Beardsley has suggested, they are "a form of public address" and sometimes emerge from presumptive ecclesiastical authority. Although flower and vegetable gardens are women's traditional "yard shows," at some undefined point, ornament can begin to overshadow planting. Well-known vernacular artist Mary Tilman Smith, for instance, was initially inspired by domesticity—an attempt to clean up her yard, which became in the process an artistic autobiography. Working with paint and old roofing tin, she collected other throwaways, listened to her voices, and created monumental images of the spirits who were summoned. Nellie Mae Rowe, another Southern artist who evaded the confinement of neat social conformity, had a sign in her yard (which was filled with assemblages that may have come under criticism from local housewives): "MY HOUSE IS CLEAN ENOUGH TO BE HEALTHY AND DIRTY ENOUGH TO BE HAPPY." The "Purple Lady" in Suffolk, Virginia, appropriated a larger and more public space by painting all the telephone poles purple for a quarter of a mile around her house. The sheer grace of this work can be overwhelming, even when its meanings, originating in the richness of an unfamiliar communal life and place, are elusive to outsiders.

MARY TILMAN SMITH 1987 (Photo: William Arnett). Smith is pictured in her yard in Hazlehurst, Mississippi.

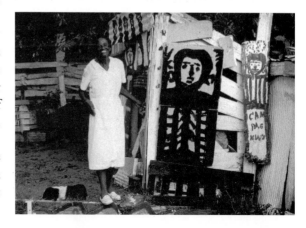

water, a huge lobster named Snap with his own trap and buoy, a moose, a hound from hell tearing the britches off his quarry, a rainbow, a toucan, a lighthouse, a ghost, and most recently, a working bowling alley. A robot is made from an array of appliances, a steam engine from an old oil drum and hubcaps. Some things spin when they catch the wind. Loony Lagoon attracts tourists, admirers and an occasional vandal. "I like it when people stop their cars and talk about my dubbins," says Day. "Kids like the things I make. That's nice."

Yard art is not confined to rural and suburban contexts. Throughout the South Bronx, East Harlem, and Loisaida, colorful *casitas*, or little garden houses, have sprung up in city-owned lots. Betti-Sue Hertz, a New York artist and cultural activist, director of the Longwood Arts Project in the South Bronx, has for years done extensive research and her own visual projects on the phenomenon. *Casitas* are semipublic spaces used for social clubs, cooking, card games, and small-scale farming. These communal projects, which are almost exclusively male domains, may include a chicken coop, rain barrel, porch, patio (for summer barbecues), benches, gardens, and small murals (frequently of the Puerto Rican flag), all protected by a chainlink fence and enjoyed to the beat of *plena* music. Public display is part of the project, and, as such, *casitas* turn inside out, exhibiting in the *batey* (front yard) the stuffed animals, plaster and plastic madonnas, paintings, and sculptural plaques that might ordinarily be found in living rooms.

"We are guerrillas. We did this on our own…Ten of us worked on it. A *casita* in an asphalt jungle. All around are big, tall houses. We are building back our roots," asserted one South Bronx resident. The *casitas* are rural strongholds of "creolization" in an often bewildering urban environment. They can be traced back to Taino *bohios* (or Native huts) and *Jibaro* ("hillbilly") culture, representing "a firm commitment to tradition, a way of life, and a culture" supported by pride and memory: "I built this to look just like the house my grandmother has," said Luis Dias. Stabilizing communities and serving as summer homes (although sometimes they are inhabited year-round), they may be allowed to decay or are even deliberately destroyed in the autumn, only to be built back up again in the late spring, in a manner reminiscent of rituals from many ancient cultures.

Casitas are also reminders of Puerto Rico's squatter movement, and can be seen as a land-rights tentative in an urban context. They are built "illegally" in vacant lots, claiming (and reclaiming) space "in quiet defiance of the multitude of real estate development deals that take place in the South Bronx and East Harlem all the time." Hertz attributes this architectural resistance against city life to the fact that the *casita* makers are powerless to determine larger issues of housing and land use. *Casitas*, she says, "are a homemade response to the restrictions of urban life."

SITE PROJECTS INC., *Ghost Parking Lot*, Hamden Plaza Shopping Center, Hamden, Connecticut, 1978, twenty used cars, bloc bond, asphalt. The idea was to reinvent the relationship between the two components of the suburban shopping plaza—automobiles and asphalt—and to suggest "the blurred vision of motion itself, the fetishmism of the car, indeterminacy of place and object." The cars are both buried and emergent; their frozen images suggest the futility of trying to stop their trajectory; at the same time, they are inseparable from teir location. SITE's goal has been to fuse art and architecture so that "buildings can absorb information from their surroundings and then convert it back into a new form of public communication through a process of inversion of meaning…."

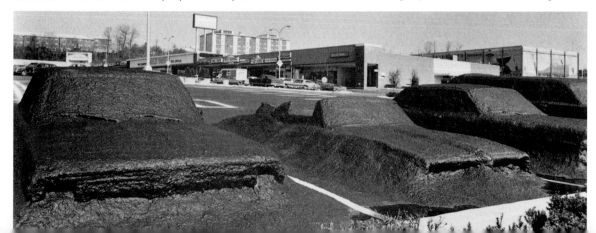

Looking Around

Our people—the indigenous population, so to speak—
see you new people all busting your ass in here and making it nice
and doing these interesting exhibitions and doing workshops for the kids,
but we still don't know why you're doing it and why here?
Like you don't even know us. There's something unreal about it, right?
When people from this block come into this gallery,
they may seem to be looking at that painting over there
or whatever-it-is over there, but what they are really doing is remembering.
That's where we had the bar that Junior sold drinks for fifty cents.
That's where we had the pool table. That's where I met my girl friend.
That's where that dude got shot.
That's where little Elizabeth was crowned Princess of East 13th Street
and did her victory disco dance....
—RICHARD OF EAST 13TH STREET

Public Art:
Old and New Clothes

[Public art today] has more to do with our inability
as individuals to conceive of, or create,
a public arena in which what we proclaim about ourselves
is consonant with who we actually are.
— EUGENE METCALF

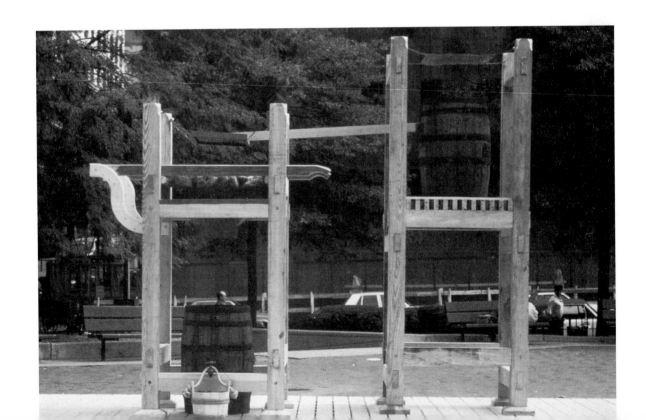

Precisely because so little public art attends to its cultural location, rural states like Maine see it as an urban phenomenon. Yet Maine adopted a percent for art program in 1979, one of 26 states to have done so, and 95% of the state's schools participate.

Georgetown artist Dahlov Ipcar is a major contributor to the state's percent for art programs with her delightful animal murals placed in several schools and libraries, though there is no mural of hers in public in Georgetown itself (there are some

framed works at the school).

In 1960 the internationally respected sculptor William Zorach, a Georgetown summer resident, with support from the Bath Garden Club, offered his lightly draped (or nearly nude) female figure, *Spirit of the*

MY CONCERN IN THIS BOOK HAS BEEN TO interweave pressing issues concerning land, culture, and place with the possibility of an art boasting stronger contextual ties and audience access. E. F. Schumacher's insight-turned-bumpersticker—"Think Globally, Act Locally"—has long been applicable to community arts and can still be constructively applied to a place-specific public art. This would be an art that reveals new depths of a place to engage the viewer or inhabitant, rather than abstracting that place into generalizations that apply just as well to any other place. Place-specific art would have an organic connection to its locale and cannot be looked at primarily as an object outside of the viewer/inhabitant's life. It must take root outside of conventional venues and would not be accessible only to those in the know, enticed by publicity and fashion. It should become at least temporarily part of, or a criticism of, the built and/or daily environment, making places mean more to those who live or spend time there.

JANE GREENGOLD, *A Drop in the Bucket*, 1985, wood, copper, and sponge, 21' x 24' x 10', sponsored by Creative Time, New York. The site of this sculpture was once Collect Pond, Manhattan's largest natural body of fresh water, which was polluted by tanneries and other industry in the 18th century and obliterated with fill between 1803 and 1811. Greengold created a fictional character, Charles Cooper, who tried to stop the pond's pollution and, failing, invented a water-purifying device. The sculpture, a "re-creation" of that filter, was originally intended as a fountain but a city drought ironically dried up the source. The work was accompanied by a "1786 broadside" give-away that informed viewers what the work was, and a booklet that combined a factual history of the pond and fragments from Cooper's personal journals, all meticulously researched. This is one of a series of works by Greengold that are models for the integration of narrative history, fiction, and powerful sculptures or installations. "The ideal memorial," she wrote, "would have been the actual recreation of the pond itself from the still live springs now feeding the air-conditioning system of the Criminal Court building." She did, however, succeed in getting the city to name this tiny area "Collect Pond Park."

Here in this last section I want to delineate a (perhaps narrower and more literal) place-specific art that might combine many of the issues raised in rural, urban, and small-town contexts. As I said in the Introduction, a truly place-specific public art is still in its infancy. For all the art that is *about* place, very little is *of* place—made by artists *within* their own places or *with* the people who live in the scrutinized place, connecting with the history and environment. I have concentrated on this unfulfilled area, hoping that the juxtapositions would themselves create a critical context.

Certainly there has been a good deal of progress since 1973, when the innovative magazine *On Site* ("The Publication on the Visual Environment") sponsored a mock design competition to "replace the cliches" on the Americas Plaza next to the Time-Life building in midtown Manhattan. Every competitor won, and all 150 submissions were printed in a special issue of the magazine. The editors dismissed "potted trees, Helvetica graphics, do-nut sculptures, [and] concrete benches," noting that *all* of the entries were more interesting than what was already on the site—a banal abstract sculpture, some unprepossessing fountains, and a lot of pavement, on a tedious model of suburban setbacks.

The entries were notable for failing to consider place-specificity. Ben Haygood's design featured on the cover, suggested a field with one tree and some spotted cows separated from the street by a cattle-guard that doubled as sidewalk. (Cute, but a one-liner.) Several other artists favored similar superimpositions of a rural scene—a bucolic pond, a forest of realistic stone trees, or a meditation mattress surrounded by "memory lane" billboards of natural landscapes. One project suggested the opposite—a miniature highway crossroads, while others resurrected fictional pasts (a monster pit with hideous hand

263

Sea to the popular park around Bath's Patten Free Library. Despite the sculpture's conservative style, all hell broke loose. The Bath American Legion Post accused Zorach of being a former communist. I wrote my first letter to the editor of the Bath Indepen-

dent. Justice triumphed; the sculpture survived the attacks and continues to kneel happily in her fountain in Library Park.

A peculiarly retrograde tribute to new military technology is a small stone relief dedicated to the builders of the Aegis,

outside a BIW building on Washington Street. It features unflattering "peasant style" figures of the ironworkers who build the Aegis ships.

In 1992, some Bath city leaders complained that murals detracted from historic

rising from it), or distant pasts (an Aztec temple; Renaissance pedestrians). But not one would-be designer looked at the place itself, visualized the strata of history reflected in surrounding buildings and streets, or exposed Time- Life's influence on urban lives, and the fake hemispheric harmony implied by the "Avenue of the Americas" in contrast to the "crazy melange of rundown buildings, assorted storefronts, restaurants and bars" that characterizes Sixth Avenue (the street's former and still- prevalent name). Twenty years later, such a competition would certainly have included at least some consideration of this aspect.

Since the late sixties, I have collected an enormous file on "art out there" (this was to be the title of a book on useful public art that playground designer Sheila Berkley and I planned in the early eighties, but never wrote). Many of the artists who have devoted themselves to this kind of project over the last thirty years are still on track, although they all complain bitterly about the conditions of their trade. Many more have dabbled in the public realm only to fall by the wayside. The artworld's novelty express train, which rewards anything big and superficially new while ignoring those making small-scale or nonobject public art for the long haul, is partially responsible for the attrition among public artists. So are the politico-economic climate and the ever-present thickets of red tape. Artists are trained to think of themselves as "free," and the challenge of public art lies in dealing with other people's freedom as well. Within the individualist tradition of modern art, any regard for audience is often scorned as a restriction, or even censorship.

The absence of a considered cultural policy in this country means that the social role of public art has never been fully defined. As Arlene Goldbard and Don Adams have often reiterated over the last twenty years, public money is necessary to support the idealistic,

socially conscious artists who work in communities that have few internal financial resources. In the U.S., such art is a poor cousin to the "red-carpet arts" (ballet, opera, symphony) and the insular avant-garde. (Recently, though, the carpet is being pulled out from under all of them by an increasingly unsympathetic government.)

My own short definition of public art: *accessible art of any species that cares about, challenges, involves, and consults the audience for or with whom it is made, respecting community and environment.* The other stuff —most of what fuels public controversy and the mass media's rhetoric on public art—is still private art; no matter how big or exposed or intrusive or hyped it may be. Permanent and ephemeral, object and performance, preferably interdisciplinary, democratic, sometimes functional or didactic, a public art exists in the hearts, minds, ideologies and educations of its audience as well as in their physical, sensuous experience.

Although a place-specific art world would necessarily be "public" in that it exists beyond artworld confines in the place with which it intends to communicate, not much "public art" achieves place-specificity. Nevertheless, some of the same questions have to be asked: Who defines the public—locals? Passersby? A targeted audience? An art audience? Specific social classes? What defines a public space—ownership? Power? Location? Ambiance? Effect? And what kind of art occupies it best —decorative? Entertaining? Didactic? Prestigious? Dominating? Subversively understated? And, more place-specifically, what would a rural public art be? How does and can an art "out there" communicate these relationships about place? What are the responsibilities of an exhibition, public project, or artwork about place to the place it takes place in, and to those who live there? I have more questions than answers because the last word, or image, will be the artist's.

land (formerly the Portland School of Art) recently bought and ingeniously remodeled the old Porteous Department Store on Congress Street in the very center of town. The facade will incorporate a piece by Mierle Laderman Ukeles, who conceives of the art school as "an electric utility, that pulls in energy and distributes it." At one point she was hoping the work would help dispose of artistic waste products as well as telling the history of Portland through artifacts.

An interesting avant-garde project was curated by France Morin in 1996 at the Shaker Village in Sabbathday Lake, where she invited several nationally known artists to live and work with the remaining Shakers. Later they were to make art influenced by their experiences, but not necessarily

How can these changes be built into art education (both studio and art history courses, which remain absurdly separated in most colleges), into the career mechanisms, into the possibilities that a life of artmaking holds for those tempted by such risks? With few exceptions, the art schools and university art departments in this country still teach nineteenth-century notions about the function (or functionlessness) of art. Most art students, even sophisticated ones, know little or nothing about the history of attempts to break down the walls. There are a few strong "art in a social context" courses sprinkled around the world (the first I knew of was at Dartington College in Devon, England; it is now defunct). There are very few programs that offer prolonged, in-depth experience working with communities and other "public" entities. Little has been written on the actual day-by-day, year-by-year processes of making public art—what an artist has to go through to execute the "product," which is then reviewed in the art press with minimal understanding of the "public" audience's viewpoint, and in the

OLIVIA GUDE with community members from Chicago's southwest side, *Where We Come From... Where We're Going* (detail), 1992, 11' x 120', acrylic paint on concrete, 56th and Lake Park, Hyde Park, co-sponsored by the Chicago Public Art Group and the Southwest Catholic Cluster Project (Photo: Chicago Public Art Group). Gude began using texts in her work after watching a young couple carefully read over one hundred names on her Roseland-Pullman mural and musing on the importance of community contributions and dialogue as part of a mural's meaning. The texts on this work were gathered by standing on the future mural site and asking passersby, "Where are you coming from? Where are you going?" The answers are presented in overlapping and interlocking stories about shared geographic spaces. They range from mundane and practical to political and metaphysical. "The variety of quotations within the mural," writes Gude, "suggests that people within a diverse community do not necessarily hear each others' voices" and reflects the "often contradictory influences in a multi-cultural, multi-class neighborhood."

general press with minimal understanding of the artist's context, hassles, and intentions. The resulting polarization does nobody any good. The limitations of the hushed and pristine gallery and the often-unreadable pages of art magazines are stunting the growth of an art that dreams—however quixotically—of striding fearlessly into the streets, into the unknown, to meet and mingle with other lives.

The cult of the "new" is a virus that has done public art little good. While I use the word *new* as much as the next person, I know that a truly public art need not be new to be significant, since the social contexts and audiences so crucial to its formation are *always* changing. The word *context* is far more significant to much of the best art made over the last thirty years, but its use (and overuse) continues to be more rhetorical and theoretical than pragmatic or political. One reason is that art (high art, fine art) itself has no real context in this society outside of the marketplace. The distance between the artworld and the world in which most of us live remains vast. It's no accident that for many artists who do consider context, decontextualization is as important as context, displacement is as important as place, exile is as important as roots, and homelessness is as important as home.

Landscape architect Gary Dwyer has argued passionately for something he calls "honest contextualism," distinguishing site analysis from understanding a place in an "ethical and moral posture of responsiveness." Dishonest, or superficial, contextualism, however, characterizes much art about place. Artists and sponsors applying for subsidies and recognizing the need for support (or at least lip service) from "the community" often exaggerate or misrepresent the extent to which a piece relates to place.

A good example of the way artists' stated intentions do not coincide with their product was Gary Rieveschl's

270

and Michael Fotheringham's 1989 *Concord Heritage Gateway*—one of the detailed case studies on how public art does and doesn't work in Erika Doss's *Spirit Poles and Flying Pigs*. The artists were attempting to endow an undistinguished suburb (Concord, California) with some visual distinction. Their ninety-one slanting aluminum poles ($96,000) and accompanying landscaping ($376,256) were mostly designed to be appreciated by motorists driving by at thirty miles per hour. The rest of the piece consisted of a lone oak tree commemorating the Ohlone and Miwok Natives displaced by colonization (purportedly symbolizing "social unity achieved through individual integrity"); a grove of non fruit-bearing pear trees (symbolizing—but *only* symbolizing—the agricultural practices of the Spanish land grantees who founded the town, then named Todos Santos); and a formal garden representing the Anglo contribution. The poles themselves did double symbolic duty, signifying both "the rise of technology in the lives of individual citizens" and Ohlone ceremonial poles forming a "spirit place" where pedestrians are encouraged to mull over history and "the spirit of our times." The only clues to this tangle of hermetic meanings are to be found (or not) on an unassuming metal plaque hidden away in a restaurant parking lot. Although public meetings were held throughout the process, few attended, and one local resident suggested that the poles stand "as a monument to the complacency of a community which ignored the pleas of their public officials to participate in their own government." Internalized powerlessness throws a wet blanket on community participation, but the responsible artist is aware of the consequences and bends over backward for feedback (as Andrew Leicester did in the face of opposition to his flying pigs in Cleveland) *before* rather than after the fact.

It is a lot easier to make locally meaningful art in a *place* than on a "site." Art in a more neutrally "public space" (park, corporate, and development contexts) is already displaced. When an artist tries to bring back the original place that lies under the site, s/he runs the danger of creating a nostalgic facade or a stage set—a small-scale theme park for "tourists" from other parts

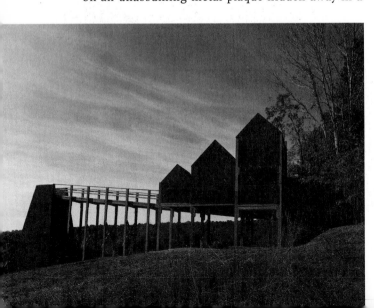

ANDREW LEICESTER, *Prospect V-III*, 1982, Frostburg State College, Frostburg, Maryland. Leicester's exemplary memorial to miners and the mining industry is both a monument and a container for memories. The exterior pays homage to vernacular architecture. The interiors of the series of "cottages" shelter the more personal artifacts given him by mining families in the area. There is a frieze of black butterflies (black lung), a "Pillar and Room" named after a dangerous extractive process, and "Rooms of Memory" filled with memorabilia. From the rotunda hang work clothes on pulleys; a coal car track and mineshaft symbolize a working life and death. Leicester, a British sculptor long based in Minneapolis, who is interested in geology and industrial archaeology, was determined to make a piece that was not a feel-good nostalgia trip but a reminder of hard work, dignity, and oppression. He toured mining sites and interviewed retired miners who recalled for him the sad history of Maryland's mountainous panhandle. Despite Leicester's persistent attempts to create more mining memorials in other parts of the country, he was able to build only one—*Toth*, in Rapid City, South Dakota, which he felt was far less successful in galvanizing community support than this one. "Community projects require constant nurturing," he says, "and the artist has to be readily accessible to address every problem as it occurs."

and coastal environs in their trusty motor launch, the Minnie and Mary. Five Islands is one of the places they visited, and Bath was one of Herman Bryant's favorite places, so there are marvelous images of a four master under full sail, the launching of a five master, and the Monitor under construction, all from around 1900, as well as on-board shots of the "Gunboat Topeka" from 1903.

Two of the most interesting images in Grant's book are of Malaga Island. One is of the trim little schoolhouse perched on a bluff above the shore, on which a wooden dory is pulled up; the other shows a family standing in front of their tiny clapboard house, flowers in the foreground, a wash hung on a backyard line. As Grant points out, this picture demonstrated none of the

of the city. Darrel Crilley complains, for instance, that Siah Armajani's handsome cast iron railings at Battery City Park, incorporating poetry by Walt Whitman and Frank O'Hara, are "decorated with signs of locality" and illustrate "urban life in a depoliticized form" that ignores the much-needed public housing projects subsumed by Battery Park City.

Anything "public" concerns power, and the public art industry is the result of a broad recognition of its ability to dominate or at least alter a landscape. Despite its roots in left-leaning community arts, some of the rhetoric on public art as "people's art" falls under Stuart Hall's rubric of "authoritarian populism"— manipulated by conservatives in and out of the art world, and in and out of the censorship and decency debates that have dominated media coverage of the arts in the last decade. Such dictated populism and co-optation of democracy by less-than-liberal funders and donors, as Rosalyn Deutsche points out, "depends on neutralizing contradictions between the people and

NANCY HOLT, *Spinwinder*, 1991, painted aluminum, stainless steel rope, clay, artifacts, 18' x 25.5' diameter, University of Massachusetts, Dartmouth, commissioned by Massachusetts Art in Public Places Program (Photo: Nancy Holt). *Spinwinder* was inspired by the bobbins, spools, spindles and guide wheels of early Anglo-American textile manufacturing, which began in this area. The tubes spray out like threads from a central cylinder, forming a dome-shaped inner structure which can be entered and turned by hand, as can the six spools. Beneath the exposed clay circle at the center ("a quiet circle of Mother Earth") are buried artifacts from the textile industry. This branch of the University of Massachusetts was formed from the textile colleges of Fall River and New Bedford, where the artist's grandfather, Samuel Holt, founded the design department in 1895. Several of her many public sculptures have incorporated the history of the places they stand, as well as their places on earth in relation to celestial movement and alignment.

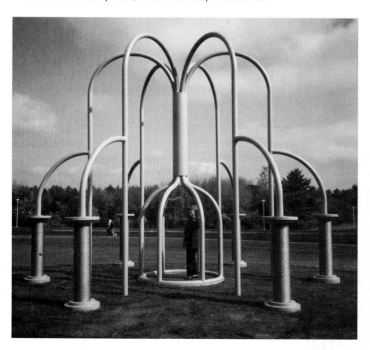

272

the power bloc, antagonisms that form the basis of popular-democratic, as distinguished from populist, movements." Issues of public art are easily exploitable, and provide distractions from the political sources of public powerlessness. In addition, left and right often meet in their preference for "traditional values," as represented by banal realistic sculpture and their suspicion of anything unexpected. Across the board there is a justified mistrust of certain empty, expensive modernist monuments that spoil rather than enhance the public spaces they adorn.

> [Art can contaminate public space and experience] with the most pretentious and patronizing aesthetic environmental pollution. Such beautification is uglification; such humanization provokes alienation; and the noble idea of public access is likely to be received as private excess.
> — KRYSZTOF WODISZKO

The *public* in public art can be read two ways—passive or active—as private art in public spaces or as art intended to be understood and enjoyed (or even made) by "the public." Of course, the definition of *the public* is much disputed, implying at the very least a larger-than-usual art audience and at most a culturally and socio-economically varied audience. If "public" is taken to mean merely "civic," then art becomes complicit with all the state's abuses of citizens' rights; alternatively, "public" is understood as a place determined by the people who use it. Like programs in which a miniscule percentage of expenditure on a building is earmarked for art, public art is used to "democratize" (in name only) spaces that are in fact private and controlled rather than fluid and transformable according to public need, pleasure, and desire. Art is also used to whitewash corporate reputations soiled by pollution and white-collar crime, and as sugar coating for destructive

development. During the eighties, more "public" art was subsidized by corporations than by government. With the steady erosion of the National Endowment for the Arts, this "privatization" will further define expensive art projects. All the more reason to develop those areas of public art production that can still be controlled by artists and their audiences.

Artists unaccustomed to consulting their audiences before, during, or after the artmaking process are often in for some unpleasant surprises, leading not to collaborative compromises but to craven concessions. "The public artist gives up the gallery artist's privilege of imposition," Vito Acconci has noted accurately. "Public art, in order to exist in the world, agrees to certain social conventions, certain rules of peaceful existence....Using manners as a cover, public art can lie low; instead of attacking, public art insinuates." (Insinuation, however, is a lot less potent than subversion, another act often claimed by public artists.)

Subtlety and irony often veil a failure to communicate. The wonderful, intricate ideas that artists often have when confronted with the complexities of place tend to get translated into wonderful, complex pieces that need lengthy explanation in a catalog essay which viewers probably will never read. The "general public's" intelligence is often underestimated, but they need clues—as do artworld audiences, much as they hate to admit it. Questions like "What does it mean?...What am I looking at?" may be uncool, but they are nevertheless important. If they were asked more often, there would be more responses. Public art is often accused of pandering to "the lowest common denominator"; in fact, the best public artist aims for the "highest common denominator" rather than no common denominator at all.

Is community art not public art because its audience is relatively limited in size and economic clout? Is audi-

But the bad growth of the last ten years is too brittle. Unwritten law (disputed by some landowners) says that Indians can cut brown ash anywhere, but the paper companies' skidders run right over the rare tree. (Says

Passamaquoddy Sylvia Gabriel, they "don't know their ash from their elbow.")

Mary Mitchell Gabriel, member of the same well-known basketmaking family, received at age 85 a $19,000 National Heritage

Fellowship for keeping tradition alive. As a child, Gabriel lived in the isolated Indian Township, speaking only Maliseet-Passamaquoddy. Her grandfather was Joe Mell, a famous wilderness guide and canoe builder. Her

ence size the measure of public art? Or is it measured by the effect of the work on the people who actually experience it? And how can these elements be weighed? I ask such questions to broaden the way we think about how people respond to places and their visual components—formed by "artists" or by "not artists." Mary Jane Jacob attributes changes in the composition of the audience and its "position at the creative center" to the emergence of the "new public art." So far, however, this remains wishful thinking, a goal rather than an achievement. The participatory audience has always been placed at the center of community arts, and there is still only a fragile bridge between community arts and the so-called public art that emerges from the world of high and avant-garde art.

Artists do think about these issues. John Malpede, the former New York performance artist who founded the unconventional homeless theater group LAPD, defines the ongoing challenge of public art as "the opportunity to put yourself in an arena with people you wouldn't normally be with." Patricia Johanson emphasizes the need to "maintain viewer autonomy," which I take to support layered places that can be both read and read into. Judy Baca asks, "If public art's purpose is to be public memory—and I believe at least part of it is—what shall we memorialize in the future?…Who is the public now that it has changed color? How do we people of different ethnic and class groups use public space differently?" She tells the story of being called to an L.A. high school on behalf of a local kid who had worked with her on the *Great Wall* mural; he was getting thrown out again, and he had promised her he would stay in school. She arrived to find the principal "towering over the young *cholo*," who was "holding his mug" ("retaining dignity in adverse circumstances"). "You've written on the school's walls and you simply do not have respect for other people's

property," said the frustrated principal. When he asked the boy if he would do this in his own home, Baca says she "couldn't help but smile.... This boy was an important graffiti artist in his community. I had visited his house and seen the walls of his room, where every inch was covered with his intricate writings." It was his idea of beauty and order. "In the future," she asks, "whose idea of beauty and order will be seen in public spaces?"

Wondering if the concept of "public" is capable of representing "a common place that accepts differences," Patricia Phillips contends that "public is an animate idea.... The play of variables mixing from so many areas asks for constant, supple revision.... Where does the audience for public art come from if public life is so dangerously depleted?" She suggests that public art could "have a recuperative social and political capacity to replenish a depleted public domain."

Within this chicken-and-egg conundrum, what concerns me here is the relationship of public domain to place. Since place is potentially anywhere, does it become public when articulated by art (or visible use)? Someone's private yard, landscaped or decorated within an inch of its life, may be more defined as a place to passersby on the street than some "public" places cosmetically neutralized by plunk art. And does a dormant place articulated by art become public whatever the ownership and however large the audience? A "dialogic public art," writes Phillips, "would not find its meaning through its situation in a forum but would create the forum for the poignant and potent dialogue between public ideals and private impulse...." Questions of audience raise the issue of who is part of the dialogue, who is isolated, or provincial, or out of it. White, cosmopolitan, and/or art school trained artists could learn something from various other cultural communities, including activists who perceive the

mother made sweetgrass baskets and she recalls the braiding parties where the woman who braided the most, 75 or 100 yards, won a pie. Her grandmother, from whom she learned most, made larger baskets, clothes hampers and picnic baskets. When asked if this was her hobby, Mary Mitchell Gabriel replied, "Hobby? this is my life. Every person who looks at my basket asks 'How long did it take you to make this?' You could say forever."

When I was a child in the forties, about once a summer an Indian woman would appear at our door selling baskets, which could also be bought at local hardware stores for as little as $1.79. Micmac basketmaker Richard Silliboy recalls peddling baskets door to door, an experience that left him ashamed of being "different as natives, different as

274

mainstream artworld as absurdly isolated, incestuous, and irrelevant—out of touch not only with grassroots audiences but with social reality, with its own context. From an activist angle, a public art can be amenable to strategic imagery; it can expose audiences to the unexpected, offer a place/space just open *enough* to accomodate intervention. An activist public art can reform the place and space it occupies, often in opposition to the uses set out for it by those who produced that space; or it can defamiliarize and splinter that space into reformable parts. A few years ago, for instance, four progressive artists got away with some twenty minutes of riding up and down the escalators in New York's Rockefeller Center, wearing pictorial sandwich boards which opposed Reagan/Bush domestic policy. The idea was to take the issues to a place that bore some responsibility for them. Malls and hotel lobbies, and even museums, are other effective targets for guerrilla art performance, since it takes a while for guards to catch on or figure out how to cope with it.

There is a healthy overlap between public art and its activist branch, site art, land art, and place art, each of which reflects on place—or placelessness—one way or another. Site-specific art conforms to the topographic details of the ground on which the work rests and/or to the components of its immediate natural or built environment. (In postmodern jargon, though, the word *site* is used so broadly as to become virtually useless in this context.) At its best, urban landscape art (overlapping with "landscape architecture") at its best creates a place. Land or earth art—usually found in parks or fields or deserts—deals with existing landforms or "natural" spaces by adapting to them, adding to them, reclaiming them, overpowering them, or altering them, sometimes drastically (see p. 189). Place-specific art may incorporate some or all of these elements but can add a social dimension that refers to the human history and memory, land use, and political agendas relevant to the *specific* place.

A gradual convergence has taken place between one branch of public art and landscape architecture and design. Some formally and spatially inventive site-

VIET NGO, *Lemna Project at Devils Lake, North Dakota*, 1990, 60-acre earthwork with duckweed. This "snake on the plains" is a vast visceral created wetlands which is both a work of art and a wastewater treatment plant. Lemna, a tiny aquatic plant, converts pollutants into high-quality food for wildlife. The Lemna process is the concept of Vietnamese American sculptor and civil engineer Viet Ngo, who opposes the isolation of art from life. He designs his treatment plants as "waterparks" to "add beauty and meaning to the communities they serve while purifying the water.... Infrastructure is an important medium of artistic expression." The jetties and the roads along them are named after planets and the islands (which are wildlife sanctuaries and nesting areas) after their moons. The serpentine canals force water to flow in a meandering pattern for maximum contact with the cleansing plants. As it is based on gravity flow, there is no pumping, one of many advantages to this natural and relatively inexpensive process. Schoolchildren tour the plant to learn biology and environmental responsibility, the harvested biomass is used as fertilizer, and earth from the site has topped a former city landfill that will be a flower garden.

basketmakers, different because we were going door to door." As a member of the Maine Basketmakers Alliance, Silliboy now operates a shop selling his own and others' baskets as well as old ones. (He recalls finding a pie basket made by his mother 40 years earlier in New Brunswick; he recognized it instantly, having learned from her as a child while harvesting potatoes in Aroostook County.)

Silliboy is adamant about Native people selling their baskets and not letting others shop them out of the area. In 1995, faced with the decline of the brown ash and lack of interest by younger people in the hard work of pounding splints for traditional baskets, the Maine tribes began an apprenticeship program to save this public art.

specific art since the late sixties has related to specific place in the sense that artists have incorporated considerations of topography, wildlife, and plantings (and sometimes history) into their forms—though usually without making their sources explicit to the viewer. Artists have frequently expressed interest in broader urban design (and a few have managed to get a foot in the door) so they could deal with the whole place rather than having their work serve as a panacea for screwed-up "placeless places." In the sixties, landscape artist Patricia Johanson began to think and write about a "total environmental design—aesthetic, ecological, psychological, and social—such that the person would be placed *inside* the work of art, and the idea of 'function' would expand to include *many* functions." She went on to contend that if artists were perceived as "creative intelligences rather than as isolated idealists pursuing a lonely vision, the *principles* of art could be used to forge links between the built world and the natural world, thus highways, cities, flood-control systems and other projects that affect our daily lives could be designed not only as works of art, but also as life-supporting places that could be made available to the public." These have now become recognized ideas whose time has come, though their funding has not. Johanson's first major project in a decade—*Endangered Gardens*—is just coming to completion in San Francisco.

In a broad sense, a good deal of the successful public art over the last three decades is peripherally concerned with place, if only because place and community are entwined and a receptive art must deal with the social as well as the aesthetic context. Alternatively, one could argue that most good public art at least *becomes* about the place it is put, even if it started out contextually weak. Most bank plaza and outdoor lobby art, on the other hand, bears little or no relation to its surroundings aside from, perhaps, color and scale. Although it too can create a landmark of some kind ("Take a right by that big orange thing"), it does not create a place.

CLIFF GARTEN (project director), et al., *Saint Paul Cultural Garden*, 1991-95. This unique collaboration between visual artists and poets, conceived and coordinated by sculptor Cliff Garten, is a six-"room" park on a reclaimed urban promontory over the Mississippi in St. Paul, Minnesota. Developed from often heated dialogues among the participants, it is intellectually and politically provocative about the situation of difference in a multicultural city, as well as being beautifully designed. The scattered overall plan and each sculptural ensemble were designed by Garten with details in two of them by Ta-coumba T. Aiken (a mosaic) and Armando Gutierrez G. (*nicho* tracery). The poets whose short commissioned pieces provided the garden's connecting threads were Sandra Benitez, Soyini Guyton, Roberta Hill-Whiteman, John Minczeski, David Mura, and Xeng Sue Yang. Their words evoke water, frost and fire, the river remembering its ancient name, the river forgetting us, the river harboring sorrows too deep to surrender, the river as a border that binds rather than separates. As David Mura wrote later, this is an "American garden... and it says, I think, that we can heal the wounds of history if only we learn from them.... It says there must be a place for all of us here, not just for some.... It offers a way for us to think about what America was, what it is, and what it can be...."

Places with a Present

We modify the past as we live out our own lives.
— RALPH ELLISON

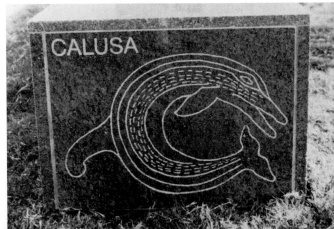

Artists and writers have been coming to this part of Maine for over a century, attracted by natural beauty, cheap land, and the possibility of a simple life and community. Some have ended up year rounders, others get restless and leave when summer lethargy is shredded by brisk northwest winds and crisp dark blue days, when the lowering sun makes the water sparkle like diamonds.

Thousands of seascapes have been painted here, by modernists, traditionalists, and postcardists. In places like Monhegan Island, images almost overwhelm reality. Donna Gold asks "What does being an island of artists do to an island?" She examines "the cross-fertilizations of Maine art.... the impact of artists on Maine....the connections between those who come to Maine for its

WHILE THE NOTION OF PLACE IN ART HAS become more broadly interesting to artists and institutions in the last few years, it is applied so generally as to become locally meaningless. Everything from art criticism to cultural representations to conventional paintings is embraced as a "place"; "location" has become as abstracted as identity and culture, just as the word *site* has long since departed the geographical realm for that of the broadly understood "social site." Borders, boundaries, margins, peripheries, migrations, and centers have become ubiquitous terms and are bandied about with little connection to lived experience. In fact, this phenomenon could be read as part of the deracinating process by which art, like its makers, has been cut loose from any real location and has been forced to create its own.

Take, for instance, a 1995 exhibition at the Art Institute of Chicago called "About Place." It brought together an impressive group of hemospheric works that (despite intermittent images of maps and landscapes) were concerned with "places" understood generally rather than specifically. They ranged, almost arbitrarily, from Brice Marden's abstractions to Vija Celmins's aquatic and celestial surfaces, to Andrea Zittel's ingenious living arrangements, to Anna Devere Smith's performances about people's responses to

ATHENA TACHA, *Memory Path*, 1990-91, Selby Five Points Park, Sarasota, Florida, polished red granite with sand-blasted photographs, c. 1' x 40' x 60' (path is 18" wide and c. 235' long). The triangular park, where an irregular shoreline meets the urban grid, is in downtown Sarasota and at the heart of the city's history. Tacha used an extant mound to refer to the original inhabitants, the mound-building Calusa. From the mound winds a low red wall that provides seating, articulates the lawn, and documents the city's history through fifty sand-blasted photographs rhythmically placed along the surface. They were chosen with the participation of residents after Tacha published her invitation in the local paper, and with the help of the city historian.

current events, to Doris Salcedo's poignant art of political memory, among others. Much of this work is about things that happen in places rather than about the effect on the places themselves, or the influence of the places on the things that happen. The art is not set free within the place itself to work its wonders or to give voice to those forces that have formed the place.

The location or place referred to in this and similar exhibitions is conceptual (and often romantic) rather than a social or geographical reality; perhaps it is the reality of rootless geopolitics. Dave Hickey, who wrote one of the catalog essays, takes this for granted: "We may safely assume, I think, that the visual content of any Euro-American art that is self-consciously about 'place,' is likely to be routinely, and often radically, displaced from the local that constitutes its true subject...we know that the real 'place' under scrutiny is, in fact, the cultural position from which we purport to view nature."

Yes indeed, and that's a problem. Why should we assume this? And why isn't the word *place* allowed to retain any meaning apart from cultural positioning? The global art world is only theoretically decentered; intentions and "discourse" are far ahead of esthetic realization. Cultural positions are relevant if the place itself has some substance—an identity, a history of use or some identified absence. What about those artists who are not trying to "defamiliarize and dislocate our access to nature" but, instead, are trying to do precisely the opposite? Hickey also assumes "that all styles are local, that nothing arrives in the condition it departs...." He is talking about images and art objects seen from the viewpoint of the artist-tourist (in which "geography has subsumed history as the first condition of cultural urbanity"). I want to see the discussion go beyond this view of the margins from the center, to see the artists truly enter the realm of the decentered,

stunning vistas and those who were born here and have chosen to remain here without a foothold in any other art world."

Georgetown's illustrious artistic past is unknown to most passers-through, but everyone driving to Reid State Park or Five Islands passes the former studio of sculptor Gaston Lachaise and visitors to the Robinhood Marina are in glancing distance of the homes of Marguerite and William Zorach and Dahlov Ipcar. Marsden Hartley painted on Indian Point and John Marin has also recorded the area—his views of Small Point and of the lovely old Phippsburg church on the river are among his most popular works.

Georgetown has always had a large summer artist population and little roadside galleries come and go, But there are surpris-

or in a more positive light, the realm of the multicentered. Position isn't place, however subtly it may determine the ways a place are perceived. There are vestiges in every place that are not altogether culturally determined, or that interact with cultural assumptions to form a kind of hybrid location.

Even as Madeleine Grynsztejn, the curator of "About Place" calls for "a sense of place that is extroverted and outward-looking, as opposed to self-enclosed and defensive," the art itself, almost across the board, refers to an individual or official view of location. Of course, I can't dispute that wherever the individual stands at the moment is her/his place or position from which to speak. Everything reflects on or stems from place, but this doesn't mean it's necessarily *about* place —or not about place as I define it in this book, anyway. Grynsztejn goes on to say that place as she understands it is "the physical foundation for a series of metaphysical proposals." This physical foundation, however, turns out not to be the place but art and the art object— enterprises defined by their separation from life or by decontextualization. The "About Place" catalog texts are smart and provocative, though sometimes they stretch to the point of absurdity in order to make the art in the show sound relevant to the theme. But then, as Hickey writes, in the present context for art, avant-garde artworks "depend for their very visibility upon their ability to violate our local expectations....Thus, they never stand in a simple one-to-one relationship to these contexts, nor directly express the subjects to which they are addressed."

Too much art "about place," then, is more about art and the place of art than about the actual place where artists and viewers find themselves. Places, even contexts, become absences rather than presences, and context has to be the very bottom line of a place-specific art. None of which is to say this contexualized art is categorically better or worse than anything else, but let's call a spade a spade: a profoundly local public art has not caught on in the mainstream because in order to attract sufficient buyers in the current system of distribution, art must be relatively generalized, detachable from politics and pain (not to mention ugliness). Yet an exhibition about place which ignores its location is a masquerade. We need *some* artists to draw back from abstractions and consider shared experiences.

A "place ethic" demands a respect for a place that is rooted more deeply than an aesthetic version of "the tourist gaze" provided by imported artists whose real concerns lie elsewhere or back in their studios. Suzanne Lacy describes a spectrum of artist's roles from private to public as experiencer, reporter, analyst, and activist. But to make an effective art of place, an artist must be *all* of these things. The field is necessarily interdisciplinary. In conventional theme shows about place, outsiders may bring fresh eyes and insights, and they can make wonderful things that have little do with the host site. Such works might qualify as significant art *about* place but certainly not art *of* place. Even Lacy's description of the culturally democratic approach involuntarily exposes the shortcomings of a "visiting artist": "The artist enters, like a subjective anthropologist, the territory of the other, and presents observations of people and places through an awareness of her own interiority. In this way the artist becomes a conduit for the experience of many others, and the work a metaphor for relationship."

Lacy, whose increasingly large-scale participatory "performances" orchestrated by the artist in long-term collaboration with the community are perhaps the most important "new genre" public art being made today, does this brilliantly. But many artists are less successful at being conduits or caralysts for expe-

ingly few local outlets for local artists, even during the tourist season. The most notable was Anne Weber's informal, sophisticated and very out-of-the-way spot on a hill above the old stone schoolhouse on Bay Point Road, reached by walking through a mena- | gerie of sheep, ducks, donkey, and dogs. Weber exhibited (indoors and outdoors) a personal and almost always interesting mixture of internationally known artists and Maine's vital avant garde, which has all too few venues. Now the best gallery in town is | the Town Office, attached to the school, which gives one-person shows to a broad span of local artists whose work is scattered on its business-like walls but is guaranteed a large audience. Up the road is the town's most venerable commercial institution—

riences they themselves may not have had, or be able to have, precisely because they are not local. Artists don't get rich off site art: most of their stipends for public commissions are spent on materials and construction. But they do have the chance to make things they couldn't afford to make otherwise. Commitment to place-specific projects implies a deeper level of acquaintance with a place and far more time spent there than is usually permitted when artists are given only enough money to breeze in and breeze out. They have a responsibility to do their homework, and if they can't hang around for long enough to understand where they are, or better yet to enter into a full collaboration with someone who does, the most obvious shortcut would be to invoke the voices of local inhabitants and artists. Teams consisting of imported artists and local people—artists or nonartists—would be one solution. Lacy's pot-luck-dinner organizing, which introduces the artist to the community and community members to each other, offers one model for such a partner-finding process, as well as a way for the imported artist to set into motion interactions that are already potentially "in place."

JERRY WEST, *Recuerdos y Suenos de Santa Fe*, 1989, mural in Santa Fe City Hall (Photo: Robert Peck). West, a painter and community muralist who was born and has lived most of his life in the area, dedicated this "memories and dreams" mural to "the people of Santa Fe, past, present, and future," and their peaceful cross-cultural coexistence. The center figure, Amarante Tapia, was for many years custodian of the public school that once stood on this site. He sweeps the school and starts down the street toward the plaza, "stirring up the dust of our collective histories," followed by some 300 people from all times and walks of life (many of them identifiable today, including Zozobra —Old Man Gloom—who is annually burned at the Santa Fe Fiesta). West studied thousands of old photographs and conducted some thirty interviews on people's opinions of the city; he gave on-site talks during the six months he worked on the mural and then moved outside for presentations, welcoming the local population into the process.

Perhaps when place is the focus, the works should be more modest and the money should be spent on time to be there, at least until the dynamics of place-specific and community-sensitive art are better and more widely understood. If big, costly parachuting exercises are necessary, they could be preceded by a local groundbreaking ceremony in which artists who live in a place get a chance to say what's important to them about where they live. Local artists hate to see better-known international types get scarce local gigs. If they decide to protest or organize, the burden falls on them to prove that they might be good enough to compete with the imported stars on their own home

279

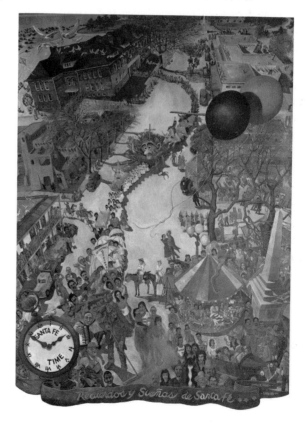

Georgetown Pottery, which sells a bland but popular selection of functional ceramics.

The Skowhegan School of Art up the Kennebec has recently begun to contribute some public art to the state with the help of its visiting artists. Mel Chin and his students made slide works for the local drive-in movie. Another group, impressed by Fred Wilson's work with museums, made subtle pieces in the funky Bates museum of natural history at the Hinkley Farm nearby. My favorite piece was the tiny knitted caps on occasional rock specimens in the endless shelves of geological display.

The "Place of Poetry" poster was assembled by Margery Irvine, who found that "young people in Maine don't think their state is anything special. When they read

ground. (A Native American friend compares this situation to Geronimo having to fight for his own land: why *should* the burden fall on locals?) The invited participation of, at the very least, a number of artists and other people who live in a place that's to be highlighted, and have lived there long enough and deeply enough to know the place, seems like common courtesy. And if the exhibition is truly place-specific, the "localness" of artists should be determined not by how long they have lived there but by their community involvement and the content of their work. Demographics should count for something too. Places are formed by people and their cultures. Art that ignores that ignores its audience.

The now time-honored practice of importing artists for place-oriented exhibitions is increasingly questionable, despite the relative success of the most important attempt so far—Mary Jane Jacobs's "Places with a Past," in conjunction with the Spoleto Festival in Charleston in 1991. This show of eighteen installations scattered around town, mostly in the historic district, was the first mainstream art exhibition to attempt to augment and comment upon an existing historical plan and viewpoint. It did so from the outside: both curator and all but one of the artists (a transplanted French team living in Charleston) were from elsewhere, although some had general connections to the region. As a result, the more obvious aspects of Charleston's history—slavery and the Civil War—were chosen as subjects, as though nothing had happened there before or since. The white artists tended to highlight fragments of history, but even when they did so innovatively, it was hard to impress the locals, who usually knew more (or different information) than they did.

The African American artists in "Places with a Past" often tried to deromanticize the same themes. For instance, Joyce Scott, from Baltimore, worked with a picturesque set of antebellum columns standing in isolation (the building was long since gone): she hung from them a colorful bundle figure that could only read as a lynching. Lorna Simpson and Alva Rogers recolonized the Governor Thomas Barrett House by using it as a stage to tell (enigmatically) the story of the Middle Passage. David Hammons moved out of the historic district and built *House of the Future* in an African American residential neighborhood with the help and advice of the community and a local builder.

The time map or dancing ground Houston Conwill, Estella Conwill Majozo, and Joseph DePace made on the floor of the former Avery Normal Institute (a post–Civil War academy for African Americans), tied local geography and narrative to African American cultural history. "We create maps of language that present cultural pilgrimages and metaphoric journeys of transformation and empowerment that can be experienced as rites of passage through life, death, and rebirth," says Majozo. "We are interested in the preservation and communication of wisdom across generations and cultures....We seek to unearth spirituality buried in contemporary secular existence, and our works are inspired by African

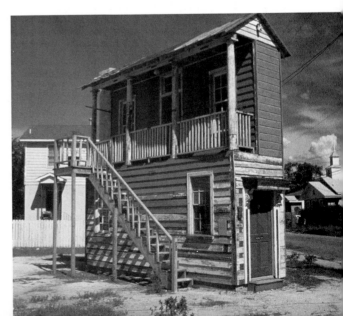

poetry, they seem to envy others, people born elsewhere. They'll say, 'I could be a writer too if only I grew up in...' anyplace but Maine." The poster, commissioned by the Maine Council for English Language, includes illustrations by MaJo Keleshian that move from

fiddlebacks to a windswept sunflower to snowy birches, and short place-specific poetry like Baron Wormser's: "In the late October light/The town and mill and river glow/ With a good-for-nothing beauty." Or Terry Plunkett's: "In Belfast, at Barbara's

Place/ men dance from the knees down."
It is an ironic part of the tension between regional and "national" that a local artist's view of a place is "regional," while the view of an outsider who is an artworld insider becomes "central." The cult of Andrew

American spirituals and blues which are in the West African oral Griot tradition."

Sophisticated exhibitions like "Places With a Past," which has become the model for art about place rooted less in local community than in myth filtered through the avant garde, tend to be strong in form and weak in connectedness. The relationships between artist and community, artist and place, have usually been serially monogamous, and often disillusioning. The artist goes "home" or on to something else, and once the initial excitement and novelty have worn off, the community is often insufficiently involved or interested to continue, extend, or even maintain the project on its own.

Ideally, such exhibitions would be followed up, or replaced, by local artists commissioned to commemorate historical sites. Public exchanges could be initiated on neighborhood (and town) history with artists or art

DAVID HAMMONS, *House of the Future*, 1991, America and Reid Streets, Charleston, South Carolina. When he arrived in Charleston to make a piece for "Places With a Past," Hammons, who prefers the street as his exhibition space, sat for a while on his chosen site waiting for people to talk to him and offer ideas. His work has often referred to the contributions of African-American builders and "an architecture of negritude," and this piece was inspired by the vision of local contractor Albert Alston, who convinced him that his original plan to make a "collage house" would look like "a house in disrepair, a house without dignity or respect." He suggested a place to foster local pride and awareness, so Hammons made "a learning center of construction materials and methods," then gave the interior over to local artist Larry Jackson, whose paintings were made and exhibited there. A quotation on the unwindowed side of this curious house is from writer Ishmael Reed, and across the street Hammons cleaned up and brick-edged a vacant lot to make it a park, centered on a 40-foot flagpole flying the American flag in Black Nationalist colors. He also appropriated a billboard for a photograph of neighborhood children looking hopefully upward. The City of Charleston pledged to maintain *House of the Future* as a permanent public work, fulfilling the artist's goal of giving something back to the community.

students facilitating them and getting ideas in the process. The most interesting art might emerge from unexpected angles on well-known sites or choices of unappreciated, unexpected sites, such as the lunch counters in the South where the first sit-ins took place, or places that have been the center of successful struggles for local autonomy, recently or historically.

While activist art is often most effective as intervention, interruption, a jolt to business as usual, a local art with such criteria can be resented as an intrusion. This complex of issues hasn't been fully explored, blending as it does into other fields and functions. The ephemeral can offer intimacy; a beautifully written "guide book" taken into the woods to be read beside a stream after a picnic, for instance—something that would require both attentive reading and attention to one's surroundings, in equal measure— might evoke more of the place and of its potential connections to personal experience than mere observation would. Because place-specific (as opposed to drive-by) art begins with looking around, the artist needs to understand far more about a place than what it looks like or the tales told by the local chamber of commerce. S/he also needs to know what her/his attraction or relationship to the place consists of. Artists from different backgrounds and foregrounds can bring out multiple readings of the places where they live that mean different things to different people at different times instead of merely reflecting some of the beauty back into the marketplace or the living room. But to do all that, artists need to know the place, and someone has to trust them enough to give them a free hand. That is always risky.

The time has come when people must evolve their own culture. Whatever kind of art comes from Texas should come from within Texas and not from New York.
— ROCKWELL KENT (1938)

Wyeth in Maine combines regional and national. However one may feel about his sentimental detail and lack of artistic development, Wyeth's classic works are genuine responses to a place he loves and this respect for place is easily communicated to others who love those places too. So for that matter is the art of making things that recall a more generalized sense of place.

Ralph Bishop of Troy, Maine, says of the twig furniture he builds, "When you sit on one of these chairs, you can curl up and escape the anxiety and the world around you. By touching the wood, in a sense you are touching your soul, the soul of the earth. It gives you a contact point to pleasant things." Although the source was more traditionally spiritual, the Wabenaki canoe maker had

In some ways, I am advocating an updated "regionalism." The movement for cultural democracy springs from the concern that the homogeneity of corporate culture—serving very few of us while affecting all of us—is melting down the multiracial, multicultural differences that are this country's greatest strength. Yet regionalism translated into community arts is caught between two institutional stools (I use the term advisedly). The "high" artworld perceives community art as lacking in the kind of "quality" defined by elitist markets and tastes rather than by active art audiences. Because the community arts often deal with history and memory, they are often accused (sometimes justifiably) of being merely nostalgic or cosmetic, of not dealing with contemporary issues. On the other hand, reactionary forces that would censor experimental art and might be expected to support community arts, mistrust the honesty, independence, rebelliousness (and politics) that emerge when people are allowed to form their own agendas.

Perhaps because it is first cousin to vernacular storytelling, theater (and its adolescent cousin, performance art), more than visual arts, has inspired the most innovative developments in community culture. Since the late seventies, performance art has provided a vortex between urban community and avant-garde arts, supported notably by Linda Frye Burnham and Steve Durland of *High Performance* magazine, which has gradually shifted its focus from groundbreaking but rarefied artworld performance to activist and community art (moving from urban Los Angeles to rural North Carolina in the process). The contents and agenda of the magazine have similarly shifted to a regional base and provide an important liaison between cities and villages.

BRAD MCCALLUM, *The Permanence of Memory*, 1995, installation at Battery 201, Two Lights State Park, Portland, Maine. In five rooms and a hallway of an abandoned World War II bunker, McCallum installed a series of bleak installations consisting of World War II souvenirs, audio tapes of soldiers recalling the war from differing viewpoints, and photo blow-ups focusing on the U.S. bombings of Asia and Europe. One room features a row of huge volumes, with a page for each of the 2,463 Mainers killed in the war, county by county, in which visitors are invited to write personal reminiscences of that person. McCallum's goal (he has also made memorials to handgun and urban violence victims) is to fill every page by the time the exhibition has traveled to the Maine State House in Augusta, American Legion Posts in Caribou and Calais, and a former armory in Bangor. Around this art work, which represents an intersection of cultural history, the psychology of memory and the architecture of memorials, McCallum, who lives in Portland, put together an eclectic and politically contradictory program with collaborators ranging from the American Legion, the State Parks Department, and the Maine Historical Society, to a university and a TV news channel. The piece also serves as a memorial to the centuries-old family farm that was destroyed by the army, despite promises to the contrary, in order to build the fortifications.

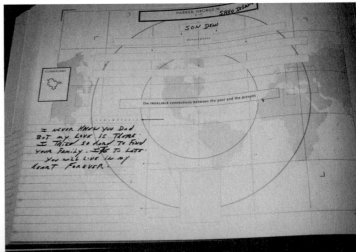

a similar goal. The double curves that decorated his craft represented the unity and balance between forces of nature. The canoe was said to have been invented by Gluscap, who mediated between the environment and the spirit world.

Harpswell quilter Wilbur Fletcher makes quilted versions of Casco Bay nautical charts. A retired aircraft technician and mechanic, he started making quilts in 1986 and usually gives them away as donations.

George Hardy, 79, is a North Deer Isle carver who has been a sailor, a logger, a boatbuilder, and a brick mason. Eventually he "began whittlin'....Used to carve nights, evenings, like that. Long winter nights, stormy days. Couldn't get out in the woods, couldn't do brick work. Snow storms. I'd

ROBBIE MCCAULEY, some of the participants in her *Mississippi Freedom*, on site: James Green, Veronica Cooper, Leroy Divinity, Kay King Valentine, Deborah Imbaden, Sameerah Muhammad, Kent Lambert, Claire Collins Harvey, Sadat Muhammad, Sheila Richardson. "I was drawn to Mississippi because I fear it," says McCauley. (Photo: Marie Cieri, courtesy The Arts Company, Cambridge, Massachusetts.)

Emphasizing partnership between artists and communities, the regional theater network in the Southeast is appropriately called Alternate ROOTS (Regional Organization of Theaters South). The Free Southern Theater, for instance, erupted from local organizing in Mississippi in the early sixties to become a key element in the civil rights movement. The Dakota Theater Caravan, based in Omaha, Nebraska (where it performed in diners and other unconventional venues), traveled into small Dakota towns like the one where its director, Doug Paterson, was raised. The troupe created plays on the spot from stories told by residents, bringing local tales into relief, opening up old rifts for healing, and mobilizing people to control their own spaces. Roadside Theater in Whitesburg, Kentucky, is a locally focused group based in the heart of coal-mining Appalachia. It is part of Appalshop, a multimedia organization that has produced an extraordinary body of film and television, theater, radio, and audio recordings since 1969. They document and revitalize the traditions that have held people together in the past, "on the premise that mountain communities can assume a larger measure of control over their own lives if they can gain control over the definition of their culture and the roots of cultural transmission." Understanding the past, and gaining support from it, thus offers ways to affect social change in the face of today's problems.

The value of such work is highlighted in a question asked performance artist Robbie McCauley as she was working on her "Mississippi Project": "Why don't I know the same history you know? McCauley answers the question in her work, through a process she calls "content as aesthetic." Moving south to Georgia as a small child, she recalls, "My first moments of literacy had to do with knowing how to read WHITE and COLORED signs on water fountains and bath-

rooms....Ripping down those signs became my life's work." Using improvisational dialogue and requiring her actors to play themselves as characters, and often to do so within their own communities, she "makes everyone part of that specific history and cuts against the antihistorical nature of American society. Artists have to do this. It looks like no one else will."

Charles Frederick, one of the most articulate spokespeople for a sophisticated community art, sees it neither as simple political expression nor as simple caregiving, but that which leaves "in place a new narrative for the community" and creates "active self critical subjects in history." The idea of community arts, then, can be at once more humble and more ambitious than most contemporary art that is about but not of a place. The goal should not be to tell a neighborhood, "Lucky you, here are some real artists come to make art for you," but to cultivate new artists and new voices from local sources. Good community artists "animate" what is already there. A healthy amount of dedication and commitment are demanded

carve birds, decoys. Used to give 'em away. Duck hunters. Years ago, everybody wanted 'em." In 1985, Hardy began to branch out into more whimsical subjects such as animals, Noah's Ark, a mermaid playing a fiddle. Now, "Everybody wants my stuff. Is it good?" he asks rhetorically. "Must be. They're buyin' it."

from both sides, as is recognition of the crucial maxim: "Don't force what don't fit."

In a very different way, photography (though usually off-site) can reframe a place in retrospect or in preparation for new or renewed experience. Sometimes this is done best in books, which have their own way of moving out from the centers, especially books with texts in which the people of a place speak for themselves. (I'm thinking of books like John Baskin's haunting *New Burlington*, Richard Balzer's and Fred Harris's *Street Time*, Janice Rogovin's *A Sense of Place/Tu Barrio*, Alex Harris's and William DeBeuys's *River of Traps*, Don Usner's *Sabino's Map*, and others mentioned elsewhere in this text.) Even more locally effective are projects like Don Adams's *Mendocino in Black and White*, which was also both locally participatory and a national community arts demonstration project: 250 photographs of life in Mendocino County, California, selected by 150 county residents, traveled to libraries, community centers, and schools throughout the county in 1994–95. *Art Among Us*, an exhibition and then a catalog organized by the Texas Folklife Center in 1986, is a fond and straightforward documentation of vernacular art on the Chicano west side of San Antonio, Texas. It offers a sense of community from the inside, a place rather than landscape described for outsiders only. Amidst all the exhibitions that purport to be about place, ranging from bland landscape paintings to esoteric photo-text pieces to borrowed indigenous concepts to public art by visitors, *Art Among Us* stands out as the real thing.

In 1980, Hans Haacke wrote that "purely visual art is increasingly unable to communicate the complexities of the contemporary world," recommending "hybrid forms of communication, mixture of many media, including the context in which they are applied as signifiers." The explosion of "installation art" in the interim, and the incorporation of video and digital media, has proved him right, although concern with context has often fallen by the wayside. As I agonized over the final selection of illustrations for this book, I reluctantly stuck to my initial decision to omit almost all indoor installation work in museums and galleries (even that of important place-concerned artists like Ann Hamilton and Jackie Brookner) in favor of more local contexts. In addition, the new set of problems video and cyberspace pose for place-specific art is suggested by an advertisement for a 1996 video festival: "You are here. You could be everywhere."

LISA LINK AND CAROLYN P. SPERANZA, *It Makes My Bread Sweeter*, Pittsburgh, 1994, digital photo montage silkscreened onto billboard paper printed in melon orange, cobalt blue, neon yellow, black and white, 9.4' x 21.3', sponsored by the Aliquippa Alliance for Unity and Development (Photo: copyright Carolyn P. Speranza). This community art project memorializes Mario Ezzo (1876-1939), an Italian immigrant who lived in a poorhouse and became a self-appointed street sweeper. As quoted on the gravestone at the left, he said, "You see, they give me money to live, so I keep this town clean like a table. It makes my bread taste sweeter...." He was first buried in a pauper's grave, but two months later the remains of this "wizened shabbily clad man" were moved to a local Catholic cemetery and he was given "a king's funeral." Link and Speranza were inspired by Ezzo's community spirit and, given contemporary attempts at urban revitalization in the area, they hoped it would be contagious. After extensive research they could find neither Ezzo's tombstone nor his picture, so they reconstructed him with computer imagery. He is sweeping a map of Aliquippa, near a street sign designating the site of one of the two billboards. As Murray Horne remarks, the artists were inspired by the community's history and reality while the community in turn became part of the creative process, "whether they simply observe and stand observed or become full-fledged participants."

Entering the Big Picture

*I would be able to start my own think tank if I had collected a dollar
every time I heard someone say that artists are uniquely suited
to be social visionaries, that artists can see beyond the constraints of realpolitik
to the true aspirations of a people, that artists are brilliant problem-solvers,
that artists can craft compelling visions of the future
that can galvanize social action.... So where are these visions?*
— ARLENE GOLDBARD

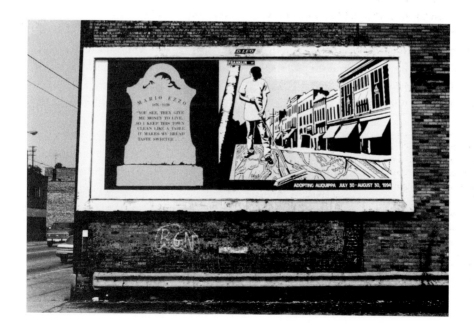

There is curiously little coastal art about the sea that includes the sea, that is not just another Scenic Overlook, a window into summer to take home for the winter. One exception is a work from the early 1990s by Ron Leax and Peter Woodruff, which elevated the time-honored sport of beachcombing to new levels. For their ironically titled *Cornucopia: Five Interactions with a Maine Beach,* the two regularly cleaned Read's Beach on Kennebec Point, collecting all human-made materials, which revealed the place's history and ecology. Artifacts found in mud and sand ranged from shark's teeth to a Maritime Archaic plummet to arrowheads, to colonial clay pipestems and pottery sherds, a bone net-needle and a glass boiler sight tube from a 19th-century steamboat, to the pure

ARTISTS CAN BE VERY GOOD AT EXPOSING THE layers of emotional and aesthetic resonance in our relationships to place. Even as they often fail to reach their communicative goals (or mine), a place-specific art offers tantalizing glimpses of new ways to enter everyday life. What kind of reciprocal art and/or landscape design might help the struggles against destructive practices fueled by greed and shortsightedness? Stimulate people's own ideas about what they would like to see in their environments and empower them to make changes? Connect very different neighboring communities?

To affect perception itself, we need to apply ideas as well as forms to the ways in which people see and act within and on their surroundings. All art is a framing device for visual and/or social experience, it is difficult for an artform to dispense altogether with the frame, or to change frames on the spot, offering multiple views of the ways in which a space or place can be and is used. The challenge is to establish more bonds radiating out from the art "community"—to marginalized artists, to participant communities and audiences, allowing the art idea to become, finally, part of the social multicenter rather than an elite enclave, sheltered and hidden from public view or illegibly representing privileged tastes in public view. The ideal should be an accessible core of meaning to which participants are attracted from all sides of art and life. Feminism and activism have created models, but we've barely begun to touch the depth of complexity with which art could interact with society. Alternatives to the currently limited notions of public art will have to emerge organically from the artists' diversely lived experiences—but they won't unless a broader set of options is laid out by those who are exploring these "new" territories. The element of place is literally *basic.*

I had intended to end with some exemplary models, until I realized that every work reproduced in this book is a model in its own way, providing one or more facets of the potential for a local art that would merge with and/or illuminate a place. Yet even my favorites seem to fall short on one or more of the criteria necessary to a well-rounded addition to a place. The criteria for art and for public interaction diverge so drastically that the education of public artists and their publics (including their critics)—together—is crucial. In trying to get these criteria and some models down on paper, I know I run the risk of evaluating and even prescribing works along lines that the artists never intended. But here goes anyway. An art governed by the place ethic I've proposed here would be:

SPECIFIC enough to engage people on the level of their own lived experiences, to say something about the place as it is or was or could be.

COLLABORATIVE at least to the extent of seeking information, advice and feedback from the community in which the work will be placed.

GENEROUS and OPEN-ENDED enough to be accessible to a wide variety of people from different classes and cultures, and to different interpretations and tastes. (Titles and captions help a lot here; it seems like pure snobbery—even if unintended—to withhold from the general public the kind of vital information that might be accessible to the cognoscenti.)

APPEALING enough either visually or emotionally to catch the eye and be memorable.

SIMPLE and FAMILIAR enough, at least on the surface, not to confuse or repel potential viewer-participants.

LAYERED, COMPLEX AND UNFAMILIAR enough to hold people's attention once they've been attracted, to make them wonder, and to offer ever deeper experiences and references to those who hang in.

destructive detritus of modern life—globs of launch grease from BIW; shingles and sheets of tarpaper, which kill clams on the bottom; and masses of plastic and styrofoam —environmental time bombs. They showed some of their "cornucopia" anonymously at an ecological art exhibition in Portland curated by Kennebec Pointer Susan Waller. Later, Woodruff made a satellite work describing Read's Beach through photographic panoramas mounted on the nautical chart, with a horizontal time line of photos of artifacts expanding exponentially into a floor-to-ceiling vertical. This multileveled but easily readable map of time and space on one small and changing site was designed as a local education project for schools, a model for projects on local sites around Georgetown.

EVOCATIVE enough to make people recall related moments, places, and emotions in their own lives.

PROVOCATIVE and CRITICAL enough to make people think about issues beyond the scope of the work, to call into question superficial assumptions about the place, its history, and its use.

Experience which is passed on from mouth to mouth is the source from which all storytellers have drawn. And among those who have written down the tales, it is the great ones whose written version differs least from the speech of the many nameless storytellers.
— WALTER BENJAMIN

To return to the preoccupations of Part I as related to public art, it is possible that the most effective place-specific art is that which "differs least" from the place itself; it might, for example, consist of clues and information rather than additional objects or places within places. Estella Majozo offers the blues formula— "call, response, release"—as a metaphor for the communicative art process, from society to artist to community. Connection of people and places, with the artist as medium or catalyst, comes first. How, for instance, could a whole village become a public artwork without disturbing or invading it? When a "portrait" of a place is constructed (by a photographer, sociologist, or chamber of commerce) it often consists of pictures of people, sometimes of people in generic or unidentified places, failing to ground them. This could be remedied by taking a page from the work of adamantly local artist Dan Higgins in Winooski, Vermont—people (alone or collaboratively) photographing their private, favorite, or memory-laden, perhaps frightening places, peopled or not (p. 38).

If places are stories waiting to be unearthed, artists could be the storytellers who can relate the local to the grander, more familiar and perhaps more insidious narratives. Every story told suggests those that remain buried and untold. To read a landscape in the geographical sense is to read its history in land forms and built structures, behind which lie the stories of the people who made that history, which in most cases can only be guessed at.

With adequate funding resources, preferably from state arts councils, which is an increasingly unlikely condition, public artists might set up social and political spaces in which energies could come together, dialogue and alternatives or opposition could be concretized. These might be seen in relation to the familiar "framing" strategy: what is already there is set in sharp relief by the addition of an art that calls attention both to what is there and what is missing. There are times, for example, when a long-obsolete object in wholly new context has as much to say by its surrealist disjunction as it did by its original function. Judy Baca's valid remarks about the "cannon in the park" notwithstanding, the out-of-context or defused absurdity of a locomotive or old fighter plane stranded ina city park is part of their appeal. With proper "captioning," they can be read as critiques of military-industrial pomp and the rapid obsolescence of technological brainstorms.

Another set of possibilities is art that activates the consciousness of a place by subtle markings that don't disturb it—bioregional or "cognitive" mapping, critical images in a newsletter or a booklet, altered old signs, new signs captioning the history of houses or families, sidewalk stencils suggesting the depths of a landscape, the character of a community. Model land rehabilitation or a monstrous temporary sculpture made from local trash collected from the roadside over a month's time could raise environmental consciousness. Place-conscious public artists are beginning to create "memorials" to vanished sites, buildings, cultural centers, even topographies—like hills that have disappeared into gravel pits, springs and streams

Aviva Rahmani, who moved to Vinalhaven island in 1990 from New York and California, began her *Ghost Nets* project almost immediately, as a continuation of earlier works concerning "the trap of the familiar versus paradigms of interdependence."

(The Maine metaphor is the gillnets which, once adrift, "stripmine the ocean.") She works on a striking site next to an abandoned quarry, looking out over a small fishing wharf and an island, out to sea. There she experiments in various ways with saltmarsh and

forest restoration, forage for migratory birds and fish productivity, documenting her study of microclimates with a "ritualized diary," and making seascapes that "take a familiar, trivialized format and look at it in more depth, as with the image of water impacting

288

that have been buried beneath concrete. In doing so, they help to save other places from the same fate.

A local historical society might have a changing display at post office, school, general store, library, town office to alert the community about artifacts and sites found in the neighborhood, or research being done on houses, genealogies, old maps and photographs. Collaborative mapping offers a particularly rich vein as yet unmined. If artists became involved, working with the local historians, amateur archaeologists, family archivists and others, the displays would probably become quirkier, more provocative, sometimes prettier, sometimes pithier, sometimes less informative. A longer-lasting home might be found for the installations that were received most warmly, or they might travel to schools. Ideally, each project would be subjected to feedback, input, and follow-ups in the local press and media, so wheels need not be constantly re-invented.

The virtue of temporary and ephemeral works is that both sites and places change. With "permanent" art, it is more difficult to decide if a place or an artwork has changed too much and the connection should be severed by removing the piece. Temporary works can stimulate people and move on; or they can change as the place changes, reflecting the reasons for the changes, good and bad, and functioning as a sort of a community weather report. The tourist literature of a place can be exposed and reconstructed by artists working with local media and government, or guerrilla-style. The perennially fascinating idea of "rephotography" could be sharpened up, undertaken with local participants and sponsored by banks, post offices, libraries, schools, and newspapers, which are beginning to show historical photos of familiar views, giving a town's residents a hint of the history that lies beneath every street.

"Parasitic" art forms, like corrected billboards (clandestine transformations of military and commercial advertising into oppositional messages; can ride the dominant culture physically while challenging it politically, creating openly contested terrains that expose the true identities of existing places and spaces as well as their function in social control. Appropriating bureaucratic signage styles is another popular strategy progressive artists have found for entering the picture. Signs literally get a message across: people are used to reading them, and questions presented on signs can hook us into thinking and looking around. (Historical markers are rarely read, though, so what can artists do to bring both readability and accountability to this medium?)

Jaune Quick-To-See Smith describes art in general as "the tangible, visible evidence of history, of all peoples, around the globe," and wonders how artists "lost their place in the educational line, why subjects like world history and social studies stepped forward and usurped our material, thereby forcing art to become the stepchild of public school curricula." San Francisco

GLORIA BORNSTEIN AND DONALD FELS, *Shore Viewpoints and Voice Library*, 1991-93, 6 silkscreened aluminum signs, 24" x 36", and voice mail system, sponsored by the Seattle Arts Commission (Photo: Rob Vinnedge). The signs called attention to the ironic use of the park by homeless Native Americans, the concept of ownership of property, and the lack of amenities in the park. The voice mail system offered six channels of information on history, future, and planning that synthesized a ten-year dialogue over changing uses of this place from a working waterfront to tourist industries. Listeners were invited to leave feedback and listen to responses. "We could have taken a more confrontational position with the Port of Seattle [which made and installed the signs and extended Voice Library's duration], achieving notoriety through confrontation," says Bornstein, who has been exploring "the geography of silence" in public works since 1977, "but we chose subversion... to generate city-wide conversations, showing the complexity of issues that the media misrepresented in binary oppositions."

rock in various ways." *Ghost Nets*, says Rahmani, "marries art and science in a series of collaborative, homely events and investigations," some of which involve local children, "in ways that do not overemphasize my identity-difference as an artist."

Maine's most committed activist artist is Natasha Mayers, who moved to the state after a stint in the Peace Corps some 25 years ago. Since then she has supervised dozens of mural projects, taught homeless people, "at risk" children, and mental

patients, tirelessly organizing exhibitions of their work all over the state. She has participated in any number of community events in her home town of North Whitefield, with her husband, playwright Art Mayers, and other local artists. They have made extraor-

artist and activist Yolanda Lopez and lyrical conceptualist Christine Oatman in San Diego have also stressed the importance of working with children, which, like art education in general, has typically been disdained in the art world, although the younger generation may be changing this. The new surge of interest in genealogy as a way of illuminating place has inspired programs nationwide which focus on elders ("national treasures") and their stories or schoolchildren doing oral histories of their own and others' families. Patricia Phillips suggests that as a form of radical education, public art might be used to fulfill a community service or learning component of high school curricula.

I keep on waiting for the artists to get out there to help decode the things that I don't see.
— JOEL GARREAU

A multicentered public art about place precludes consensus. Successful place-specific art can be made by people who live or have lived in or near the site, or by newcomers, and occasionally by visitors who have really done their homework. But in order to understand the identity of any specific place, *some* portable place must rest in our souls, even if it no longer exists, or never did. The artist has to "live here" in some way —physically, symbolically, or empathetically. A place-specific art cannot be a centering or grounding device unless the artist herself is centered and grounded, however recently. This is not to say that the alienated, the disoriented, the deracinated, the nomadic (that is, most of us) cannot make art *about* place...from the point of view of the outsider. Rootlessness provides its own insights into place: "All immigrants and exiles know the peculiar restlessness of an imagination that can never again have faith in its own absoluteness,"

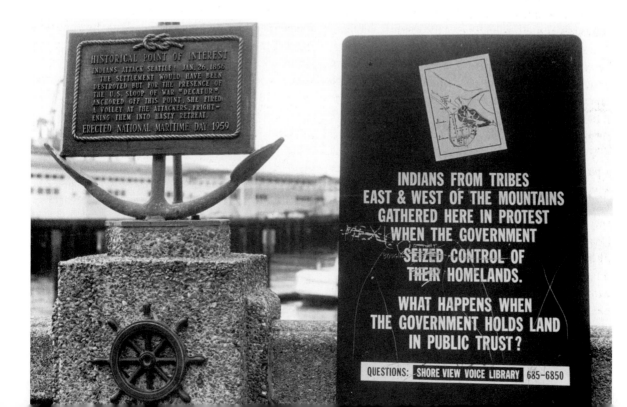

dinary political floats for the town's annual 4th of July parade, among them a pickup truck full of "corpses" demanding that Maine's Congresspeople take responsibility for events in Central America, a broccoli extravaganza protesting the Gulf War near George Bush's coastal Maine estate, and, in the summer of 1996, when clearcutting was the state's prime issue, a dramatic float on which "a forest" was actually destroyed by a chipping machine as it progressed, spewing wood chips in all directions.

A recent Mayers mural was made with children and adults in one day on the 48-foot wall of a pharmacy in Winslow, near Augusta, on the occasion of a booksigning for Margy Burns Knight's book on "talking walls." The bottom border was painted by

writes Eva Hoffman. "Because I have learned the relativity of cultural meanings on my skin, I can never take any one set of meanings as final." There is nothing fixed about any of these relationships. Empathy and exchange are the key. Richard of 13th Street, who brilliantly articulates the position of a "community audience," makes it clear that empathy is not enough: "You might think the art is for someone. Who? I can't honestly say it looks like it's for us."

As we scrutinize the sources and contexts of an art that is beginning to take form, the multicultural and interdisciplinary components of art about place become all the more significant. Nothing that excludes the places of people of color, women, lesbians, gays, or working people can be called inclusive, universal, or healing. Before we can find the whole, we must know and respect all the parts. To change the power relations inherent in the way art is now made and distributed, we need to continue to *seek out new forms buried in social energies not yet recognized as art* (a phrase I've used frequently over the last fifteen years). "We must shift our thinking away from bringing great art to the people," says Lynn Sowder, "to working with people to create art that is meaningful." (Art cannot be great without being meaningful, but to whom, and to what end?) Ideas catch fire in dialogue, when we brainstorm or play with possibilities, and someone else's eyes light up. Art itself can be that spark, both catalyst and act of recognition. Art can help heal a society that is alienated from its life forces. As spiritual-ecological artist Dominique Mazeaud puts it, an artist "seeing with the heart" will produce a different kind of art.

A map of the world without Utopia is not worth glancing at.
— OSCAR WILDE

What would it be like, this art produced in partnership with the imagination and responses of its viewers or users within a relational and reciprocal theory about our shared place and how it affects our lives? The next step must be a leap of imagination. The fact is, we need to change the system under which we live and make art as citizens and as art workers. Eventually, perhaps "public art" would no longer exist. Its successor might or might not be called art. Ideally, the people who created it would have a broad range of tastes and backgrounds; a national cultural policy would comprehend the diversity of artists, audiences, and sites, and would be forged collaboratively among those who make the art and those who are its receivers or respondents in any one place. "Artists" would participate in both private and public sectors, but the young and the lively of all ages would choose the public sphere, which should be as economically viable as the private. Public artists would be facilitators, maybe anonymous, rather than egocentric creators driven by an art market and perceived as peripheral to everyone else's lives. They would be trained in this kind of work within an interdisciplinary curriculum and they would spend much time studying their location and others' successful models—success being determined by in-depth interviews with those who live with the work.

In a richer soil, this "not public art" or "public not-art" could grow in all directions, becoming an available, popular, and challenging alternative to the existing commercial and institutional venues. It could be any form or style, but it might well bypass permanent objects, which would remain in more formal habitats —museums, galleries, or private collections. Process might be emphasized within temporary or constantly changing imagery and frameworks, markers of space and time, people-oriented actions and events, spiritual centers, and other gathering places. Works might take

the littlest children; at the sides, patterns from the old lace factory in town were spray painted over stencils. In the center was a large map with enlarged sites selected by the children, filled in with stories of Winthrop in past and present. Older people came to contribute stories and brought photographs. Mayers has done similar communal history work with school children in Saco and elsewhere, as well as her utility poles on Whitefield's history and environment (plate 8).

place in a few hours or develop with a place and its inhabitants over many years, even handed down over generations, like skills and stories in indigenous communities. Artworks would play a role in everyday life, either locally meaningful or politically catalytic or just plain fun and pleasurable. They might reinforce or broaden a sense of community, raise consciousness, recall history, decorate or inspire, help make the nonsuperficial aspects of their sites visible. Above all they would be responsive to what happens around them—affirming the good and criticizing the bad.

In this far more perfect world—socially compassionate, egalitarian, unbigoted, responsible, heterogeneous, peaceful, somewhat socialist, and respectful of art—culture would be recognized as a crucial social ingredient and would be funded as generously as science and social services. Public art would be part of curriculums from kindergarten through doctoral programs. Bureaucracy would be cut to a minimum, and all concerned would be trained in

collective process. Writers and other related workers would be involved in public art projects from beginning to end, so that words as well as images, physical residue or experience would be part of the collective communication.

Some of the ideas conveyed here will be (and have been) attacked as retrograde. So be it. I am tired of the prevailing disrespect for emotive retrospection, which is a valuable component of communication, if balanced by local knowledge and critical curiosity. One way soci-

REG DAVIDSON WITH GLEN RABENA, *Yaalth Tluu (Raven Canoe) on San Francisco Bay*, December 15, 1990, 28' long, carved from a single red cedar log. (Photo: Liza Mabin). This seagoing canoe and a 35-foot totem pole by Jim Hart were The Haida Project, sponsored by Capp Street Project and Headlands Center for the Arts. In the 10,000-year-old Haida culture, both pole and canoe symbolically unite sky and earth, sea and sky, supernatural and natural realms. This was the first canoe that Reg Davidson, a well-known Haida artist, had ever carved and he did so at East Fort Baker, an old U.S. Army warehouse on the headlands in the shadow of the Golden Gate Bridge, where for three months the public was invited to watch and interact. Seeing himself as a cultural ambassador from his village in the Queen Charlottes, British Columbia, he dedicated the canoe to his father, who had died during its making, and ceremonies were held at its launching. His brother and assistant Glen Rabena said, "Tradition is not dead. It's like a tree putting out new leaves and roots all the time. These trees are not dead. They have just been changed." The Haida project hoped to "explore the relationship between the way something is made and its significance in Western and non-Western cultures."

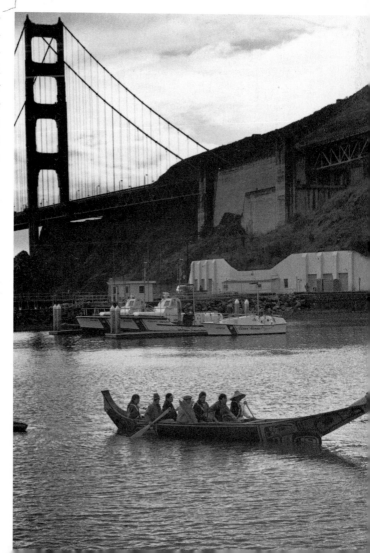

In the early 1990s, I planned but never executed an exhibition of site-specific sculpture in which Georgetown artists were to pick a local place they felt close to, collaborate with a non-artist native resident, and make a work communicating something of the past of that place to viewers. At times, however, this context seems to me to render art unnecessary. Nature, and maybe history, provide their own social esthetics. Artists might be supposed to have some special relationship to the environment, if for no other reason than esthetics. (Nature is "beautiful," art is "beautiful," therefore...) Yet it is increasingly obvious how difficult this relationship is to pin down in a manner that is esthetically/ecologically/communicatively effective.

292

ety disempowers people is to give them no credit for their thoughts and accomplishments. The popularity of "place" even in academia is suspect on some levels (academia being given to fads, like the artworld), but it indicates that a portion of the multicentered population is in fact longing to belong and is looking for ways to do so *without* becoming reactionary.

I've been asked whether attention to the local couldn't become "tunnel vision," resulting in "the loss of the big picture" and of the ability to communicate across boundaries. For now, I worry more about the loss of the small picture. Local does not have to mean isolated, self-indulgent, or inbred. In fact, those terms apply better to the artworld. Although homogeneity threatens our senses of place, it's still hard to find a place that is totally homogenous. Most places (even lookalike suburbs) are more layered and diverse from

the inside, and understanding the local history, economics, and politics is a complex, fascinating, and contradictory business everywhere. Local life, in fact, is all about communicating across boundaries, even if one lives in an economic "ghetto" of rich or poor. Part of the process of looking around is listening to each other.

Finally, art is—or should be—generous. But when working with place, artists can only give if they are receiving as well. The greatest challenges for artists lured by the local are to balance between making the information accessible and making it visually provocative as well; to fulfill themselves as well as their collaborators; to innovate not just for innovation's sake, not just for style's sake, nor to enhance their reputation or ego, but to bring a new degree of coherence and beauty to the lure of the local. The goal of this kind of work would be to turn more people on to where they are, where they came from, where they're going, to help people see their places with new eyes. Land *and* people—their presence and absence—makes place and its arts come alive. Believing as I do that connection to place is a necessary component of feeling close to people, and to the earth, I wonder what will make it possible for artists to "give" places back to people who can no longer see them, and be given places in turn, by those who are still looking around.

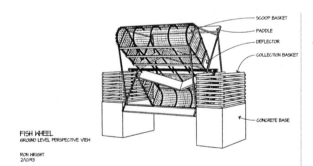

FISH WHEEL
GROUND LEVEL PERSPECTIVE VIEW

RON WRIGHT
2/10/93

JAUNE QUICK-TO-SEE SMITH (FLATHEAD), Northwind Fish Wheel, 1992–98, rusted metal, c. 5' x 4' (drawing: Ron Wright). Quick-To-See Smith is Salish, as are the Duwamish, whose former lands are occupied by Seattle, named after their great chief Sealth. She consulted with tribal members about their history and interpretation of the legend at the heart of this project (which also includes a canoe rack): During the battle between Northwind and Southwind, the hero, Southwind, finally breaks the weir of ice constructed by the devious Northwind and permits the salmon to run again. It is thought that this story goes back to the Ice Age, and Smith interprets it as a metaphor (white ice seen as white people covering the land). She wants to call public attention to the landless Duwamish's struggle for tribal recognition and the recovery of a landbase and long house; they lost their land in the mid 1800s and recognition was denied them again in the summer of 1996. Today, they must "melt" the "white ice" through the courts, and "clearing the river" can be read as winning back their fishing rights. This project has undergone changes over six years. It is now scheduled to be built (with the cooperation of sculptor Chris Bruch and Duwamish member Frank Fowler) at the Northwind Weir Park on the Duwamish River near Seattle. It will overlook a pile of rocks in the river that are said to be the remains of the ancient weir. The project includes construction of an estuary for the salmon.

The endnotes, listed by page, often refer to the bibliography for full references. If there is no endnote, please go directly to the bibliography under the author's name. If there are multiple entries for an author, the endnote indicates the correct source. If the bibliographical entry is not under the name of the person quoted, the cross-reference is provided. In the sources for the Vein of Maine, the following abbreviations have been used for local newspapers: TR, Times Record (Bath and Brunswick), PPH, Portland Press Herald; MST, Maine Sunday Telegram; MT, Maine Times (alternative weekly).

4

STEVE GONZALEZ, quoted in CELIA MUÑOZ's Herencia, see p.24.

6

The performance (c. 1982) was a collaboration with Jerry Kearns called My Place, Your Place, Our Place.

JOHN STEINBECK, The Grapes of Wrath, 1939.

PIERCE LEWIS, "Axioms for Reading the Landscape: Some Guides to the American Scene," in D. W. MEINIG, ed.

7

"concept of place": JEFF KELLEY made a particularly eloquent distinction between place and site in his "Art in Place."

8

J. B. JACKSON, Discovering the Vernacular Landscape.

This historical synopsis of notions of landscape is indebted to JOHN STILGOE's Common Landscape of America.

J. B. JACKSON, Discovering the Vernacular Landscape.

9

See J. H. KUNSTLER's The Geography of Nowhere.

CONNIE MAY FOWLER and MIKA FOWLER, "Okeechobeee, a Journey," Forum (Florida Humanities Council), Spring 1996.

NEIL SMITH, quoted in GREGORY.

10

CLIFFORD GEERTZ, The Interpretation of Cultures: Selected Essays, New York: Basic Books, 1973.

IÑIGO MANGLANO-OVALLE: phone conversation with the author, summer 1996; see also "Does the Public Work?" Art Papers, Sept-Oct., 1992; "Who Made Us the Target of Your Outreach?" High Performance, Winter, 1994, MARY JANE JACOB/ Sculpture Chicago, and PATTEN, ed.

11

READMAN and LÉGER: see Sylvie Readman, Montreal: Galerie Samuel Lallouz, 1992.

From my notes on DON MITCHELL's seminar on Cultural Geography, University of Colorado, Boulder, 1993.

12

WENDELL BERRY, The Unsettling of America. The extent to which the present terminology dictates our views is transparent in a random selection of "green advertising" from the early 1990s: A Chevron ad asks disingenuously, "Do people make changes so nature doesn't have to?"; Phillips Petroleum boasts of creating artificial reefs ("underwater paradise") below the surface of the Gulf of Mexico; G. T. Global Mutual Funds captions a stunning mountain landscape with "It's Your World. Invest In It"; Georgia-Pacific claims, god-like, to be "making sure the trees will always be here"; and Toyota's 4Runner promises "all the forces of Nature without the element of surprise." Toyota's slogan adds an erotic component ("I love what you do for me") and public concern: in tiny print you are reminded to "TREAD LIGHTLY [this phrase is a trademark] on public and private land..."

I would disagree with video artist Mary Lucien, who once stated in a San Francisco lecture that "for us on the East Coast, nature is in the past tense."

NEIL SMITH, Artforum, Dec. 1989. "Making M/other Nature,"

PRESIDENT CLINTON, on National Public Radio, April 1994.

DE LORY: see Peter de Lory: Short Stories, The West, Syracuse: Robert B. Menschel Photography Gallery, Syracuse University, 1993.

13

HENRY GLASSIE, Passing the Time in Ballymenone: Culture and History of an Ulster Community, Philadelphia: University of Pennsylvania Press, 1982.

14

REBECCA SOLNIT, "Elements of a New Landscape."

Tierra o Muerte—Emiliano Zapata's rallying call, reiterated in the northern New Mexico town of Tierra Amarilla, where significant land struggles took place in 1967 and 1988-89.

GRETEL EHRLICH, "River History," in ANDERSON, ed.

J. B. JACKSON, quoted in COSGROVE in MEINIG, ed.

FREDERICK TURNER, "Openings in Religion," in Rebirth of Value, Albany: State University of New York Press, 1991.

15

"USE OF MIRRORS,": see ROBERT FARRIS THOMPSON, Flash of the Spirit, New York, Vintage, 1984.

294 LAME DEER, quoted in PAULA GUNN ALLEN.

BELMORE: see AUGAITIS and GILBERT, eds., and DIANE NEMIROFF, ROBERT HOULE, CHARLOTTE TOWNSEND-GAULT, *Land, Spirit, Power*, Ottawa: National Gallery of Canada, 1992.

16
SIMON ORTIZ, in conversation with the author, c. 1995.

Plastic shamans: see WARD CHURCHILL, "Spiritual Hucksterism," *Z Magazine*, December 1990.

17
GRETEL EHRLICH, quoted in Least Heat-Moon.

REBECCA SOLNIT, *Savage Dreams*.

SAM GILL, "It's Where You Put Your Eyes," in DOOLING and JORDAN-SMITH, eds.

18
ARAPOOISH, quoted in MICHAEL KENNEDY, ed. *The Red Man's West*, New York: Hastings House, 1965.

FRED WILSON: It is hard to exaggerate the importance of Wilson's work with museum collections seen through the lense of African American history; see *Insight: In Site: In Sight: Incite: Memory (Artist and the Community:Fred Wilson)*,Winston Salem, N.C.: SECCA, 1994; *Mining the Museum*, New York: The New Press, 1994, and TONY WHITFIELD, "Fred Wilson: Mining the Memory," *Sphere*, Spring 1996.

ESTELLA MAJOZO, "To Search for the Good and Make It Matter," in LACY, ed.

19
DENIS COSGROVE, "Prospect, Perspective, and the Evolution of the Landscape Idea, *Trans. Inst. Br. Geog.*, 1985.

20
"topography generating memory..."; the great model is, of course, the Australian Aboriginal connection to the land; see PETER SUTTON, ed., *Dreamings: The Art of Aboriginal Australia*, New York: Braziller and Asia Society, 1988; and BRUCE CHATWIN'S classic *Songlines*, New York: Viking, 1987.

LAWRENCE GROSSBERG, quoted in GEORGE LIPSITZ, *Time Passages*, Minneapolis: University of Minnesota Press, 1990.

21
EDMUND LADD, in DOWLEY, ed.

23
YI-FU TUAN, "American Space, Chinese Place, *Harper's Magazine* no. 1490, July 1974.

MARY ANN BONJORNI: from a conversation with KIRK ROBERTSON in *Leaving Is Becoming About*, Carson City, NV: XS Gallery, Western Nevada Community College, 1989.

JOHN DEWEY, quoted by PATRICIA PHILLIPS, as "Mapping the Terrain" symposium, 1991.

24
Bay Point: see also Eleanor Stone, *Time and Tide*, unpublished manuscript, 1961; thanks to Kate Swift for calling this to my attention.

26
JULIE DASH, *New York Times*, February 12, 1992.

GEORGE LUKACS quoted in MARIANNE TORGOVNICK, *Gone Primitive*, Chicago: University of Chicago Press, 1990.

GERALD HASLAM: "Back in the Valley," *Sierra*, January-February 1995.

27
RINA SWENTZELL, at SITE Santa Fe symposium on "The Place of Place," September 1995.

PETER JEMISON, at "Mapping the Terrain" The New Public Art" symposium, California College of Arts and Crafts, 1991.

BLACK ELK, in *Black Elk Speaks: being the life of a holy man of the Oglala Sioux, as told through John Neihardt*, New York: Pocket Books, 1972.

28
"a house is not a home...": Describing his new multimillion dollar home in *Newsweek* (November 27, 1995), BILL GATES expounds on what amounts to its place-lessness; images of artworks or of other

places materialize on the walls of one room after another, programmed to the person who is there at the moment.

29
GWENDOLYN WRIGHT'S *Building the Dream* was invaluable as a source for much of the material below on housing.

Governor Angus King said that for $330,000 he had bought "a modest cottage that was built in the 1950s and then enlarged.... The people next door are retired schoolteachers" (MST, June 25, 1995).

30
Ohio State University survey, *New York Times*, March 31, 1988. Martin, in Allen and Schlereth, eds.

JOHN VLACH: *Sources of the Shotgun House: African and Caribbean Antecedents for Afro-American Architecture*, Ann Arbor: University Microfilms, 1975; and *Back of the Big House: The Architecture of Plantation Slavery*, Chapel Hill: University of North Carolina Press, 1993.

31
LABELLE PRUSSIN: quoted in THOMPSON. MICHAEL AARON ROCKLAND'S *Homes on Wheels* was a rich source of material for this section on RVs.

32
MARLENE CREATES: 1985 statement in conjunction with her project *Crossing Two Rivers*.

BARTH: MT, March 7, 1996.

33
JO CARSON, "I am of a Place...," *High Performance*, Winter 1993

"Ability to know a new place...": DOUG ABERLEY.

YI-FU TUAN, *Space and Place*.

34
MICHAEL MARTONE, "The Flatness." in MARTONE, ed.

"an area where nature acts...": GEORGE WILSON PIERSON, "The Obstinate Concept of New England: A Study in Denudation," *The New England Quarterly*, March 1955.

ALLEN TATE, "American Poetry Since 1920," *Bookman*, 1929.

35
For bioregionalism, see ABERLEY; and Kirkpatrick Sale, *Dwellers in the Land; The Bioregional Vision*, San Francisco: Sierra Club Books, 1985.

WENDELL BERRY, "The Regional Motive," in *A Continuous Harmony: Essays Cultural and Agricultural*, New York: Harcourt Brace Jovanovich, 1972.

Fairfield, Calif.: see PHILIP PREGILL, "Finding Fairfield," *Public Art Review*, Spring-Summer 1996.

EDGAR ALLEN BEEM, MT, July 25, 1996; Rooks, MT, Oct. 19, 1995.

37
BRASS VALLEY, see BRECHER, LOMBARDI, and STACKHOUSE.

JOHN K. WRIGHT, *Human Nature in Geography: Fourteen Papers, 1925-1965*, Cambridge: Harvard University Press, 1966. MT, Oct. 26, l995.

38
DAN HIGGINS, *The Incredible Onion Portraits*. Higgins is now working on a new version of the Onion Portraits, twenty years later: "Parts of Winooski I am exploring are no longer the neighborhood gathering spots (they have mostly disappeared) but [for] families—especially the many refugee families—Vietnamese, Bosnian, Iraqi, etc.—that have found themselves living here in the past few years. The project allows me into many homes, and the photographs record rich details about the organization of living rooms, the inclusion of images from the old country, and recent acquisitions from local garage sales." (Letter to the author, June 28,1996).

SUSAN MOGUL made *Everyday Echo Street*, a 1993 video diary of her Highland Park neighborhood, where she had lived for twelve years, a portrait of interaction. In 1994 performance artists MERRY CONWAY and NONI PRATT worked with the city of New Bedford, Massachusetts, to create a walk-through performance piece and "Memory Museum" that included the stories and mementos of local residents centered on the place itself (a bank slated to become an art museum) and father-daughter relationships.

39
LOUISE ERDRICH, "A Writer's Sense of Place," in MARTONE, ed.

40
WENDELL BERRY, *The Unsettling of America*. Americans move...: See J.H. KUNSTLER, *Geography of Nowhere*.

J. B. JACKSON, "The Movable Dwelling and How It Came to America," in *Discovering the Vernacular Landcape*.

NATHANIEL HAWTHORNE, quoted in ROCKLAND.

41
Sodbusters, quoted in BARRE TOLKEN, "Folklore and Reality in the American West," in ALLEN and SCHLERETH, eds.

HENRY DAVID THOREAU, in BROOKS ATKINSON, ed., *Walden and Other Writings*, New York, 1950.

42
"Like Maine, like New Mexico...": see two novels that have a great deal in common: CAROLYN CHUTE'S *Merry Men* (New York: Harcourt Brace, 1994) and JOHN NICHOLS' *Magic Journey* (New York: Ballantine Books, 1978)—both outraged tales of local displacement and chicanery.

DONA BROWN, "Purchasing the Past: Summer People and the Transformation of the Piscataqua Region in the Nineteenth Century," in SARAH L. GIFFEN and KEVIN D. MURPHY, eds., *A Noble and Dignified Stream*, York, Maine: York Historical Society, 1992.

43
GEORGE ELLA LYON, quoted in CARSON, see note for page 33.

WILLIAM DEAN HOWELLS, "Confessions of a Summer Tourist," *Literature and Life: Studies*, (1902), Port Washington, N.Y.: Kennikat Press, 1968.

F. HOLMAN DAY, "The Queer Folk of the Maine Coast," [1909] in *New England: A Collection from Harper's Magazine*, New York: W.H. Smith,1990.

45
CARLOS FUENTES: "The Mirror of the Other," *The Nation*, March 30, 1992.

Apache, quoted in KEITH H. BASSO, *Portraits of "The Whiteman,"* Cambridge: Cambridge University Press, 1979.

CHRISTOS DIKEAKOS and PATRICIA BERRINGER, in *Christos Dikeakos: Sites and Place Names*, Vancouver: Contemporary Art Gallery, 1992; See also *Christos Dikeakos: Sites and Place Names: Vancouver/ Saskatoon*, Saskatoon: Mendel Art Gallery, 1994 (with essays by DIKEAKOS and KEITH WALLACE), and "project" from *Sites and Place Names* in *Front*, May-June 1992.

46
Much of the information in pages 46-49 comes from GEORGE STEWART'S classic *Names on the Land*.

SARA JOSEPHA HALE, *Traits of American Life*, Philadelphia: E.L. Carey & A. Hart, 1835.

JAN ZITA GROVER, "Landscapes: Ordinary and Extrordinary," *Afterimage*, December 1983.

HAMMERBECK: See her artist's book, *Depositions*, San Francisco: Studebaker/ NFS Press, 1978.

47
Guadalupe: JACQUELINE DUNNINGTON, Letter to the Editor, *La Herencia del Norte* (Santa Fe), Spring 1995.

49
Street names are still changing and contested: In 1995, a controversy erupted when San Francisco Supervisor Susan Leal proposed that Army Street be renamed after Cesar Chavez. Opponents went so far as to put a proposition on the ballot, which was defeated 55 to 45 percent after a bruising battle against bigotry, in which one anonymous caller said, "How could you name the street after that wetback?"

Indian (or non-Indian) names are also contested: In 1996 Minnesota became the first state to ban the word "squaw" on geographic features (though not city names), at the instigation of Native American organizers; others are following suit.

296

50

LAFAYETTE BUNNELL and REBECCA SOLNIT, from SOLNIT, *Savage Dreams*.

Kwakiutl: KIM R. STAFFORD, "There Are No Names But Stories," in *Places and Stories*, Pittsburgh: Carnegie Mellon University Press, 1987.

SCARBERRY and GARCIA, *Artspace*, Spring 1988.

TERRY TEMPEST WILLIAMS, quoted in EDWARD LUEDERS, ed. *Writing Natural History: Dialogues with Authors*, Salt Lake City: University of Utah Press, 1989.

51

"Sense of place can outlast...," KENT RYDEN.

STAW AND SWANDER, in MARTONE, ed.

52

ELEANOR WACHS, *Crime-Victim Stories: New York's Urban Folklore*, Bloomington: University of Indiana Press, 1988.

JOHN PLOOF: see *Little City* (documentation of the 1994 Arts Residency Program at the Little City Foundation, Palatine, Illinois). Phippsburg policeman: TR, July 24, 1996.

53

No'theaster (or *No'theastah*) is the correct colloquialism despite the popularity of *Nor'easter*.

EDWARD D. IVES, *George Magoon and the Down East Game War: History, Folklore and the Law*, Urbana: University of Illinois Press, 1988.

migrating story: RYDEN.

54

HUNG LIU, in brochure for Anderson Ranch workshops, 1995.

CLEMENT GREENBERG, quoted in NATHAN LYONS.

55

ELLEN MANCHESTER, in GOIN, ed., *Arid Waters*.

"Between an exposed...": TRACHTENBERG. AMALIA MESA BAINS, *San Francisco Camerawork*, Spring 1992.

BELL HOOKS, *Art on My Mind*.

56

BARBARA ALLEN, "The Genealogical Landscape and the Southern Sense of Place," in ALLEN and SCHLERETH, eds.

INGSBY-WALLACE-THOMPSON and PARADA project: see JOYCE FERNANDES, "Digitizing the Extended Family," *High Performance*, Fall 1994.

On family histories, see MEL WATKIN, ed. She is an artist whose own installation work often deals critically with her own family and colonial history.

57

Rephotography: See KLETT and MANCHESTER; SUSAN GIBSON GARVEY (curator), *Rephotographing the Land*, Halifax: Dalhousie Art Gallery, 1992.

GROVER: see note for p.46.

58

SPENCE AND MARTIN: see JO SPENCE, *Putting Myself in the Picture*, London: Camden Press, 1987, and JAN ZITA GROVER, "Photo Therapy: Shame and the Minefields of Memory," *Afterimage*, February 1988.

KAREN ELLEN JOHNSON, press release for her "Approaching Mom" show at 494 Gallery, New York, 1995.

My essay appeared in NIEMEYER'S *Reframing* and in my *The Pink Glass Swan* (New York: The New Press, 1995).

LINDA CONNOR, in "the Esselin Arts Symposium 1982," *Aperture* no.93, 1983.

59

CHRISTINE BATTERSBY: "Gender and the Picturesque: Recording Ruins in the Landscape of Patriarchy," in BRATTLE and RICE, eds.

60

CARRIEMAE WEEMS, from interview with SUSAN CANNING, *Art Papers*, May-June 1993; see also interview with BELL HOOKS, *Art on My Mind*.

STEWART DOTY, "The Documentary Photograph in Maine's Past," in French, ed.

61

ILAN STAVANS, *The One-Handed Pianist and Other Stories*, Albuquerque: University of New Mexico Press, 1995.

HUGH ST. VICTOR, quoted in JAMES CLIFFORD, *The Prediament of Culture*, Cambridge: Harvard University Press, 1988. STEPHEN KERN, *The Culture of Time and Space*, Cambridge: Harvard University Press, 1983.

HOMI BHABHA: "What Does the Black Man Want?" *New Formations*, Spring, 1987.

"It was Americans...": DAVID SOPHER.

62

Anonymous Irish, quoted in RONALD TAKAKI, *A Different Mirror*, which was a rich source for this section. See also his *Strangers from a Different Shore: A History of Asian Americans* (New York: Penguin, 1989).

AMALIA MESA BAINS, quoted by SUZANNE LACY in a lecture in Portland, Maine, September 1995.

RICHARD RODRIGUEZ, in *Ethics of Change*, New Smyrna Beach, Florida: Atlantic Center for the Arts, 1992, and "On Borders and Belonging," an interview by VIRGINIA POSTREI and NICK GILLESPIE, *Utne Reader*, March-April 1995.

63

GUILLERMO GOMEZ-PEÑA, "Documented/Undocumented," in SIMONSON and WALKER, eds.

IRMA SALAZAR, quoted in PAULA MONAREZ DIAZ, "They're baaaak," *El Paso Times*, June 26, 1995. See also *Man on Fire: Luis Jimenez*, Albuquerque Museum of Art, 1994.

DAVIS: *Down East*, Feb. 1996.

64

JOHN M. COGGESHALL, "Carbon-Copy Towns? The Regionalization of Ethnic Folklife in Southern Illinois's Egypt," in ALLEN and SCHLERETH, eds.

Vietnamese immigrant, quoted in JAMES M. FREEMAN, *Hearts of Sorrow*, Palo Alto, Calif.: Stanford University Press, 1989.

SANDY LYON, *Chinese Gold: The Chinese in the Monterey Bay Region*, Capitola, Calif.: 1985.

Mama Blues: see KIM.

65

PATRICIA LIMERICK, "Disorientation...,"
a rare and excellent source of material on
Asian Americans and the landscape.
LILLIAN SCHISSEL made a similar obser-
vation in her study of women's diaries on
the early trails west; the wealthier and more
educated women, traveling with less travail
than their predecessors, enthused in their
journals about the overwhelming scenery,
whereas the poorer women tended to avoid
emotional experience and list repetitive
daily tasks as a way of hanging on to some
remnant of normal life.

MIN: see *Yong Soon Min DMZ XING*,
Hartford: Real Art Ways, 1994.

MALAGA: see John Mosier, *No Greater
Abomination: Ethnicity, Class and Power
Relations on Malaga Island, Maine, 1880-1912*
Master's thesis, University of Southern
Maine, 1991; also Abby Zimet in MST,
Jan.15, l995 and Day cited in note, p. 43.

66

VISHAKHA N. DESAI: "Whither Home?"
in *Asia/America.*

TSENG KWONG CHI: see *Asia/America*
and SITE Santa Fe.

JESSICA HAGEDORN, quoted in
MARGO MACHIDA, "Danger and Beauty,"
Asia/America.

67

JOHN HERSEY quoted in ARMOR
and WRIGHT.

MINÉ OKUBO: *Citizen 13660*, Seattle:
University of Washington Press, 1983.
TOKU SHIMOMURA, quoted by her
grandson, artist ROGER SHIMOMURA;
he made a series of paintings from her
diaries about life in the Minidoka camp
in Idaho. See *Roger Shimomura: Delayed
Reactions*, Lawrence: Spencer Museum
of Art, University of Kansas, 1996.

YOSHIKO UCHIDA: *Desert Exile*, Seattle:
University of Washington Press, 1982.

68

TOYO SUYEMOTO KAWAKAMI, quoted
in LIMERICK, "Disorientation....," See also
MARGE TANIWAKI, "Amache: An
American Concentration Camp," *Southwest*

Magazine, Autumn 1992; I am indebted
to Taniwaki, a Denver-based activist,
for first-hand information about the camp
experience.

ANSEL ADAMS, *Born Free and Equal:
Photographs of the Loyal Japanese-Americans
at Manzenar Relocation Center, Inyo County,
California*, New York: U.S. Camera, 1944.

JAN ZITA GROVER, "Historicism and
Ansel Adams's Manzenar Photographs:
The Winner Names the Age," *Afterimage*,
April 1989.

NOBUKO NAGASAWA: see ELI NIIJIMA,
"Secret Camera Out in the Open in Little
Tokyo," *The Rafu Shimpo*, July 19, 1993; and
Michael Several, "Photographic Memories,
Miyatakear Manzenar," *Public Art Review*,
Spring/Summer, 1996 (special issue on
"Rethinking Commemoration.")

LANGSTON HUGHES, "Afro-American
Fragment," in TAKAKI.

ARNA BONTEMPS, "The Exodus Train,"
in ADERO, ed.

MARITA GOLDEN, *Long Distance Life*,
New York: Doubleday, 1989.

69

ROBERT HAYDEN, quoted in DIXON.

JACQUELINE JOHNSON, "Rememory:
What There is For Us," in ADERO,ed.

SULAIMAN MAHDI, quoted in ROGER
CLENDENING, "Forty Acres and a Mule..."
in ALSTON, ed.

70

RUBY LERNER, at Alternate Roots
Conference, Fall 1987.

BEVERLY BUCHANAN: see REYNOLDS, ed.

71

JEFF KELLEY, "Crossing Places."

BUNNY MCBRIDE, *Molly Spotted Elk:
A Penobscot in Paris*, Norman: University
of Oklahoma Press, 1995.

72

PAUL "GONZALES" RAINBIRD: SITE
Santa Fe "The Place of Place" symposium,
September 1995.

DOROTHY EGGAN, "Hopi Dreams in
Cultural Perspective," in G. E.
GRUNEBAUM and ROGER CAILLOIS, eds.,
The Dream and Human Societies, Berkeley:
University of California Press, 1966; "one
envisions...": Judith Fryer.

JAMES LUNA, "I've Always Wanted to
be an American Indian"; the full piece is
published in *Strong Hearts: Native
American Visions and Voices*, New York:
Aperture, 1995.

My main sources for the history of Maine
Indians were EMERSON BAKER, *Trouble
to the Eastward: The Failure of Anglo Indian
Relations in Early Maine*, PhD. dissertation,
Department of History, College of William
and Mary, 1986; BRUCE BOURQUE and
EDWIN CHURCHILL in JUDD, CHURCHILL,
EASTMAN, eds.; and BAKER, CHURCHILL.
et al. eds.

73

JOE DALE TATE NEVAQUAYA, "Reso-
nances Are Observed," in *Will/Power*,
Columbus: Ohio State University, Wexner
Center for the Arts, 1992.

RUSSELL MEANS, *The Bloomsbury Review*,
September-October 1988.

DEADMAN, see LYNN A. HILL, *AlterNa-
tive: Contemporary Photo Compositions*,
Kleinburg, Ontario: McMichael Canadian
Art Collection, 1995.

Obamsawin: *The Wabanakis of Maine...*

"one of my friends..": Passamaquoddy
man, *The Wabanakis of Maine...*

74

"You should know...": "Medicine Man
of the Penobscots," Salt, March 1979;
"In the Passamamquoddy world...":
Passamaquoddy man from Indian
Township, *The Wabanakis of Maine...*

75

HERMAN MELVILLE, quoted in DIXON.

76

re GITSKAN AND WET'SUWET'EN, see
POOLE, ed., and MICHAEL MARCHAND
and RICHARD WINCHELL, "Tribal
Implementation of GIS," *Cultural Survival*,
Winter 1994.

298 Kennebec Proprietors: McLane.

77

JOHN K. WRIGHT, see note for p. 37.

DENIS WOOD'S *The Power of Maps* is a major source of information for this chapter.

78

J. B. HARLEY, "Victims of a Map: New England Cartography and the Native Americans," paper read at conference on "The Land of Norumbega," Portland, Maine, 1988.

DONALD WESTLAKE, *High Adventure*, New York: The Mysterious Press, 1985.

Goode's World Atlas (16th edition), Chicago: Rand McNally, 1982.

79

BERNARD NEITSCHMANN, in POOLE, ed. JOHN BROADHEAD, in HITT.

WILLIAM BUNGE, quoted in WOOD.

JOHN WIEBENSON, quoted in SARAH BOOTH CONROY, "Your Friendly Neighborhood Map," *Washington Post*, August 13, 1972.

80

MORITZ GAEDE on PETER DUIKHUIS, *World View: The G7 Suite*, Halifax: eyelevelgallery, 1995.

BROUWN, KAWARA, LONG, FULTON, and HUEBLER: see LIPPARD, *Six Years*.

WELCH: see *Roger Welch, Austin, Texas Children*, Brussels: Liverpool Gallery, 1991.

MARWYN MIKESELL, quoted in COSGROVE.

82

MARLENE CREATES, "fragile moment," in *The Physicality of Landscape*, Peterborough, Ontario: Artspace, 1985; see also *Marlene Creates: Landworks 1979-1991*, St. Johns: Art Gallery, Memorial University of Newfoundland; *Marlene Creates, The Distance Between Two Points is Measured in Memories, Laborador 1988*, Vancouver: Presentation House Gallery, 1990; *Marlene Creates: Language and Land Use, Alberta 1993*, Lethbridge: Southern Alberta Art Gallery, 1993.

83

GEORGE ORWELL: in *1984*.

84

The book that most enchanted me about antebellum Louisiana was HARNETT KANE'S *Plantation Parade*.

85

RAYMOND WILLIAMS, quoted in CHRISTINA KREPS, *Museums and Promoting Cross-Cultural Awareness*, paper presented at ICME conference in Leiden, Holland, 1987.

86

DONA BROWN, "Purchasing the Past: Summer People and the Transformation of the Piscataqua Region in the Nineteenth Century," in *A Noble and Dignified Stream*, York, Maine: Old York Historical Society, 1992.

HEAP OF BIRDS: See JIM BILLINGS, "Edgar Heap of Birds: Building Minnesota: A War Memorial," *Public Art Review*, Fall-Winter 1990 (Special Issue on Public Art and Multiculturalism).

DONA BROWN: See above, note p. 42. See also her book: *Inventing New England: Regional Tourism in the Nineteenth Century*, Washington, D.C.: Smithsonian Press, 1995. IAN MCCAY, "Twilight at Peggy's Cove," *Border/Lines*, no. 12, Summer 1988.

87

MEREDITH MONK: see JENNIFER DUNNING, "Meredith Monk Looks into Roosevelt Island's Past," *New York Times*, August 22, 1994.

88

MICHAEL WALLACE, quoted in NORKUNAS.

In Philadelphia, the only thing that remained after the restoration of the National Register Wanamaker House was its facade. In another development, objects removed from archaeological excavations in a historic district "were placed in an exhibit case in the lobby of the new commercial building erected on its ruins. The exhibit was then portrayed as a museum and used by the building's owners as the basis for claiming further tax exemptions as a non-profit organization serving the public" (THOMAS PATTERSON).

ALEXANDER WILSON writes acutely on these preserved villages.

BARBARA JO REVELLE: see KATHY MCCLURG, "Profiles in Tile," *Summit Magazine*, Winter 1991-92; LUCY R. LIPPARD, "Facing Up," *Z Magazine*, June 1991.

89

JONATHAN DANIELS, quoted in JAKLE.

Two long Island fishermen, described in T. H. BREEN.

See HELEN W. PEACOCK SNOWE KERNOUl, ed., *Georgetown, Maine Records 1697-1980* .

91

REBECCA SOLNIT, *Savage Dreams*.

92

Boston reachionary: STUART MAIS, quoted in JAKLE.

93

THOMAS SCHLERETH, "Above Ground Archaeology," in *Cultural Artifacts in the American Past*, Nashville: AASLH, 1980.

Old Fort: I hope my memory hasn't failed me in unwritten recollections of the two "museums" of Old Fort.

See BROWN, note p. 42; and PETER WOODRUFF, "The Bright White Anglo Summer," unpublished paper for University of Southern Maine New England Studies program, 1996.

94

MEL CHIN: see PATRICIA PHILLIPS, *Ghost: Mel Chin*, Hartford: Real Art Ways, 1991.

95

Plimoth plantation: KIRSHENBLATT-GIMBLETT.

96

Thanks to Mark Sloan of the College of Charleston for material on the Board of Architectural Review in Charleston, including an excellent history from 1931-1993 by DEBBI RHOAD and an equally informative article by STEPHEN NEAL DENNIS, Executive Director of the National Center for Preservation Law.

97

owners' acquisitive prowess: NORKUNAS.

Description of Chinatown History Project from museum's brochure. See also

CANDACE FLOYD, "Chinatown," *History News*, June 1984, and *Bu Gao Ban*, the journal of the museum.

JACK TCHEN, quoted by J. TEVERE MACFADYEN, "Exploring a past long locked in myth and mystery," *Smithsonian*, January 1983. Tchen et al. also experimented with radio docudramas based on the format of Hong Kong soap operas and with a street program using guided tours and kiosks.

TERRY BARLOW, quoted in MST, Oct. 13, 1996.

President Sagadahoc County Society: TR, Sept. 11, 1995.

98
ARDIS CAMERON, *Radicals of the Worst Sort: Laboring Women in Lawrence, Massachusetts, 1860-1912*, Urbana: University of Illinois Press, 1993.

LOWELL: See MARY C. BEAUDRY, "The Lowell Boott Mills Complex and Its Housing: Material Expressions of Corporate Ideology," *Journal of the Society for Historical Archaeology*, vol. 23, no. 1, 1989.

99
DEAN MACCANNELL "work displays" in, *The Tourist*, New York: Schocken Books, 1989.

DON MITCHELL: "Heritage, Landscape, and the Production of Community: Consensus History and its Alternatives in Johnstown, Pennsylvania," *Pennsylvania History*, July 1992.

100
DOLORES HAYDEN'S marvelous book *The Power of Place* has informed this section.

SHEILA DE BRETTEVILLE: See Michael W. Several, "Reclaiming a City's History: Biddy Mason's Place," *Public Art Review*, Fall-Winter, 1990.

101
In 1996 computer artist STEVE BRADLEY has his South West Baltimore (SOWEBO) students using photography and interviews; the final project was a "zine" uncovering the neighborhood's history.

102
ALLEN R. MYERSON, "For Defenders of the Alamo, the Assault Is Joined Anew," *New York Times*, March 29, 1994.

103
WILL INSLEY, quoted in KIRSHENBLATT-GIMBLETT.

NEIL HERRING, "The Passing Tribute of a Sigh," *Art Papers* March-April 1991.

DAVID CHARLES SLOANE, *The Last Great Necessity: Cemeteries in American History*, Baltimore: Johns Hopkins University Press, 1991.

105
YI-FU TUAN: " Geopiety: A Theme in Man's Attachment to Nature and to Place," *Geographies of the Mind*, DAVID LOWENTHAL and MARTYN BOWDEN, eds., New York: Oxford University Press, 1976;

"Afterlife...": *Portland Press Herald*, May 24, 1994.

106
CONWILL, DE PACE, MAJOZO: See *Stations of the Underground Railroad*, a booklet for the public produced by the Castellani Art Museum and the Niagara communities in which the works were situated. See also SUSAN KRANE, *Art at the Edge: Houston Conwill*, Atlanta: High Museum, 1989.

107
MAYA LIN: See TOM FINKELPEARL, "The Anti-Monumental Work of Maya Lin," *Public Art Review*, Fall/Winter, 1996; *Maya Lin Public/Private*, Columbus: Wexner Center for the Arts, Ohio State University, 1994.

108
Crazy Horse monument: The project was begun in 1947 by sculptor Korczak Ziolkowski who was asked by Lakota authorities, including Chief Henry Standing Bear, to create a work of art that would show "the white man the red man has great heroes too." The Boston-born Ziolkowski died in 1982, but work has been continued by his family. So far 8.4 million tons of rock have been removed (in comparison to Mount Rushmore's mere 450,000 tons). (DANIEL GIBSON,

"Crazy Horse Memorial: Tribute or Tourist Trap?", *Indian Artist*, Winter 1997.)

JAMES YOUNG, "Holocaust Memorials in America..." in *Survey of Jewish Affairs 1991*, WILLIAM FRANKEL., ed. Thanks to judy chicago for introducing me to James Young's scholarly and deeply moving work

109
"war memorials": see LIPPARD, "Within Memory," in *Athena Tacha: Massacre Memorials and Other Public Projects*, New York: Max Hutchinson Gallery, 1984.

On Conceptual monuments: See LIPPARD, *Six Years....*

CHARLES SMITH: see DAVID KARGL, DEBRA N. MANKOFF, THOMAS SKWERSKI, *Straight at the Heart: Charles Smith's African/American Heritage Museum*, Beloit, Wisconsin: Wright Museum of Art, Beloit College, 1995

110
JAMES YOUNG, "The Counter-Monument: Memory Against Itself in Germany Today," *Critical Inquiry*, Winter 1992. See also Young's "When a Day Remembers: A Performative History of *Yom ha-Shoah*, *History and Memory*", Winter 1990.

JOSIE BASSETT: see DIANA ALLEN KOURIS, *The Romantic and Notorious History of Brown's Park*, Greybull, Wyoming: Wolverine Gallery, 1988.

112
JOHN BUNKER, quoted in MST, Oct. 6, 1996.

113
PARSONS and GREENLUND: Quotations from letters to the author from SCOTT PARSONS.

EARLE SHETTLEWORTH, quoted in PPH, July 5, 1995.

114
"the real battle": As DAVID HARVEY has bluntly stated, "All history is, after all, the history of class struggle." ("Monument and Myth," *Annals of the Association of American Geographers*, September 1979.)

JEAN BAUDRILLARD, quoted by KYONG PARK in brochure for his lecture on

300

"Nuclear Heritage Park: Weapon-Based Entertainment," at the Cooper Hewitt Museum, New York, 1994.

MICHAEL EISNER, op-ed piece in *Portland Press Herald*, August 5, 1994.

115
EDMUND LADD, in symposium "Who Owns the Past?" at the Headlands Center for the Arts, October 10, 1992, *Headlands Journal*, 1992.

116
THOMAS PATTERSON'S book is the source of much of this information on the history of archaeology. He offers an intriguing cultural breakdown of European archaeological preoccupations by the end of the seventeenth century: Italian and French Catholics were particularly interested in Roman classicism; English, Dutch, and German Protestants were drawn to Greece (through trade with the Ottoman Empire); the Spaniards focused on the impressive Aztec and Inca civilizations of the New World.

"massive earthworks...": Thomas Jefferson conducted the world's first stratified excavation of an "Indian mound" in Virginia; immense sites like the Mississippian mound city of Cahokia, near today's St. Louis, made a great impression. It was the Smithsonian Institution that funded SQUIER and DAVIS'S 1848 volume on the ancient earthworks of the midwest.

117
PAMELA BEVERLY-GAGNER, "Nothing Is Sacred: A Proposal for Public Art Addressing Land Use at 325 Broadway," unpublished paper, University of Colorado at Boulder, 1994. Francis Brown became the president of the Medicine Wheel Coalition for Sacred Sites of North America. Despite ongoing discussions, ground was broken in October 1996 for the new National Oceanic and Atmospheric Administration building, with a Native American invocation as part of the ceremonies.

EMERSON BAKER in *Trouble...*, see note p. 72

119
Sabino Head: the 1995 excavation was led by Jeffrey Brain of the Peabody Essex Museum in Salem, Massachusetts.

120
See NEARA *Journal* and the ARARA newsletter, *La Pintura*.

121
PHIL YOUNG: see COOPER SCHRAUDENBACH, "Weaving Broken Threads: A Portrait of Artist Phil Young," (with interview), *Akwe:kon*, Fall 1993. Another artist who makes witty ersatz archaeological pieces is TYRONE GEORGIOU, working out of Buffalo.

CARRIE MAE WEEMS, quoted in ANDREA KIRSCH and SUSAN FISHER SPARLING, *Carrie Mae Weems*, Washington, D.C.: National Museum of Women in the Arts, 1993.

121
JOHN L. COTTER, DANIEL G. ROBERTS and MICHAEL PARRINGTON, *The Buried Past*, Philadelphia: University of Pennsylvania Press, 1992. An article in the *Portland Press Herald* (October 12, 1996) described the hundreds of thousands of colonial artifacts (a "mother lode of Boston history—ranging from a priceless 400-year-old jug to countless shards of common pottery") that were excavated during highway construction and are now languishing in a warehouse due to lack of interest.

African Burial Ground: *New York Times*, August 9, 1992, and *Archaeology*, March-April 1993.

121
EMERSON BAKER, unpublished report on excavations at Sagadahoc Island, 1995.

123
RAYMOND WILLIAMS, "Ideas of Nature," in *Problems of Materialism and Culture*, London: Verso, 1980.

126
WILLIAM JAMES, quoted in COSGROVE. EMERSON BAKER in *Trouble...* see note p. 72.

127
EDMUNDO O'GORMAN, quoted in OLIVER DEBROISE, "Heart Attacks: On a Culture of Missed Encounters and Misunderstandings," *El Corazon Sangrante/The Bleeding Heart*, Boston: ICA, 1991.

128
BIARD, MORTON and DWIGHT quoted in CRONON.

GORGES, quoted in BAKER.

"legal jargon," ROBERT GRUMET quoted in BAKER.

"no concept of legal ownership": CRONON. Puddlestone conference: *The Wabanakis of Maine...*

129
WENDELL BERRY, *The Unsettling of America*.

Greater Salmon Selway ecosystem: LESLIE HEMSTREET and JAKE KRELLICK, "Defending the Last Big Wild," *Z Magazine*, May 1995.

LUTHER STANDING BEAR, *My People, the Sioux*, Cambridge: Houghton Mifflin Co. and the Riverside Press, 1928.

130
JOHN MUIR: THURMAN WILKINS, *John Muir: Apostle of Nature*, Norman: University of Oklahoma Press, 1995. STEVE JOHNSON, quoted in SHARON APT RUSSELL.

PATRICIA LIMERICK, *Legacy*.

132
LIMERICK, "Disorientation..."

Passamaquoddy man: *The Wabanakis of Maine...*

bluefin: Conservationist Carl Safina to Edgar Allen Beem, MT, Aug. 24, 1995. There are curious pockets of cowboy culture in Maine, including local rodeos and fisherman who are country western singers.

133
PATRICIA NELSON LIMERICK, *Legacy...* Some random examples of commercial Western "wildness": a deranged cowboy called Mad Dog McCree, star of a successful arcade video game; Marlboro cigarettes (smarting under the recent death from lung cancer of their main fantasy man) distributes a catalogue of western "country store" gear that bears large Marlboro logos, including T-shirts that read "Cowboys Still Do Ride Horses, Only Today It's Not Just One at a Time. It's 454 Each One Alive Penned

in 8 Cylinders.... Eating Asphalt Kicking Dust Screaming Out Loud 'Don't You Dare Stop for Water.' RIDE HARD."

JOSIAH GREGG, *The Commerce of the Prairies,* Norman: University of Oklahoma Press, 1990.

MERIDEL RUBINSTEIN: Rubinstein's most complex work is *Critical Mass* (a large-scale installation, in collaboration with Steina and Woody Vasulka and Ellen Zweig) that originated at the Museum of Fine Arts, Museum of New Mexico, in 1994. (See "Meridel Rubinstein: Critical Mass," by REBECCA SOLNIT in *Artspace,* July-August 1992.

BARRINGER, quoted in LANSKY.

134
BLM biggest landowner: the biggest *private* landowner in the United States is Ted Turner.

R. E. BAIRD, "Western Grazing: Boon or Bane?" *Colorado Daily,* May 12, 1995.

Appalachian trail: BOB CUMMINGS, "Ban Clearcutting," *The Dissident,* Sept. 1996. Cummings is director of the Maine Association for Conservation Commissions.

135
TIMOTHY EGAN, *New York Times,* October 11, 1994.

SHARON APT RUSSELL'S *Kill the Cowboy* has been very useful for this section.

136
Forest Guardians: The group outbid another lessor by $50 and was granted a five-year lease for 555 acres along the Rio Puerco near Cuba, New Mexico, that were traditionally used for grazing; the group is exploring alternative uses.

Black cowboys: see DURHAM and JONES; KATZ.

LARRY WILSON: *Santa Fean,* January-February 1991, and *New Mexican,* January 14, 1996.

DON YOUNG, quoted in *Amicus Journal,* Summer 1995.

LEO ROBERGE quoted in DAVID DOBBS and RICHARD OBER, *The Northern Forest,* White River Junction, Vt.: Chelsea Green

Publishing Company, 1995. (Roberge lives over the New Hampshire border, but his experience is typical of Maine as well.)

137
RON ARNOLD, quoted in DAVID HELVARG, "Anti-Enviros Are Getting Uglier," *The Nation,* November 28, 1994; see also "The Anti-Enviro Connection," *The Nation,* May 22, 1995.

BILL AND BARBARA GRANNELL quoted by DAVID HELVARG in "Grassroots for Sale," *Amicus Journal,* Fall 1994.

BRUCE BABBITT, *Portland Press Herald,* September 7, 1995.

MEL AMES: MT, August 29, 1996.

138
DAVID HENDERSON of the Audubon Society quoted in STEPHEN KRESS, "Range Wars," *Crosswinds,* November 1995. The issue received national coverage for a while: see RICHARD LACAYO, "This Land Is Whose Land?" and "The West at War," *Newsweek,* July 17, 1995; ERIK LARSON, "Unrest in the West," *Time,* October 23, 1995.

Rensenbrink: TR, Sept. 6, 1996.

140
KEITH BASSO, *Western Apache Language and Culture,* Tucson: University of Arizona Press, 1991.

141
RUDOLFO ANAYA, "Mythical Dimensions/ Political Reality," in TEMPLE, ed.

Latino photography: Arizona photographer Annie Lopez, who has done some landscape photography, although she is better known for her work about Latina women's lives, says, "After years of being told landscape photography is not Chicano art, I stopped showing this work." (Letter to the author, 1993.) Mexican photographer Laura Cano has made some striking images of Mexican farm workers in the northeastern United States.

CHARLES BOWDEN, "Dead Minds from Live Places," in TEMPLE, ed.

LIZZY POOLE, "Letter to the Editor," *Working Waterfront,* July 1996.

142
DEVON PEÑA and JOSEPH GALLEGOS, "Nature and Chicanos in Southern Colorado," in BULLARD, ed.

Taylor Ranch: ALAN PRENDERGAST, "A Mountain of Trouble," *Westward,* July 6-12, 1994, including quotations from GENE MARTINEZ and RON SANDOVAL. In the fall of 1996, local *Hispanos,* farmers, and imported radical environmentalists joined forces to protest logging on the Taylor Ranch, which, after an eleven-year hiatus, had begun selling timber contracts again in 1995. Local activist GLORIA MONDRAGON-VALDEZ told the newcomers to the struggle, "You can't use the same approach in San Luis as you can in Oregon or Washington State. You need to do this case by case, get consent and local support." (*High Country News,* September 2, 1996.)

143
Tierra Amarilla land wars: see EBRIGHT, LUCY R. LIPPARD and CHRIS TAKAGI, "Land or Death in Tierra Amarilla," *The Guardian* (New York) August 17, 1988.

Ganados: LAURA PULIDO, "Sustainable Development at Ganados del Valle," in BULLARD, ed., including ANTONIO MANZANARES quote; see also ELIZA WELLS SMITH, "Ganados del Valle," *New Mexico Magazine,* June 1995. The issue is enmired in lawsuits, since the Sierra Club in turn sued Ray Graham, donor of the original gift that was not used until some twenty years after the fact, when land was both scarcer and far more expensive. Forest Guardians appears to be filing a lawsuit against all the public land permittees in Ganado's area. (Varela says that sheep grazing in wildlife areas improves wildlife forage.) In the mean-time, attempts are being made by independent groups to heal the rift between traditional users of the land and environmentalists—who should, indeed, be allies—and to reconceptualize the "inhabited wilderness." (Thanks to MARIA VARELA, phone conversation, summer 1996.)

LINDA HOGAN, "Walking," in ANDERSON, ed.

" An Indian is…": GERALD MCMASTER, Plains Cree artist and curator, quoting an anonymous friend in *Why Do You Call Us Indians?* Gettysburg: Gettysburg College Art Gallery, 1990

AMOS OWEN, the "spiritual Indian" from Minnesota, quoted in BUCKLAND.

"last creative option": MT, Dec. 14, 1995.

144
RINA SWENTZELL, at SITE Santa Fe's "The Place of Place" symposium, September 1995.

TITO NARANJO, quoted in RUSSELL.

"perpetual legal childhood": BURTON.

WINONA LADUKE, "White Earth," *Z Magazine*, October 1990.

JOHN RUNNING HORSE, quoted in CRITCHFIELD.

The history of Indian land claims is extensively documented in *The Abenakis of Maine…*

145
LUCI TAPAHONSO, "Come Into the Shade," in TEMPLE, ed.

See *Shooting Back.*

"the proposed settlement…": *Akwesasne Notes*, Spring 1980. Fifteen years later, Phyllis Austin writes that the Passamaquoddys "find wealth no match for inequality" (MT, May 19, 1995).

146
"education opened my mind…": Penobscot woman, quoted in "In Search of the 20th-Century Penobscot," *Salt*, Jan. 1983.

Georgia Pacific: Passamquoddy man, in *The Wabanakis of Maine..*

147
Navajo joke: from EICHSTAEDT.

Native Hawaiians (Kanaka Maoli) are discussing the possibilities of seceding from the United States or becoming a sovereign nation within the United States.

149
MARASCO: see *Ritual and Community: The Maine Grange, Photographs by Rose Marasco*, Rockland, Maine: Farnsworth

Museum, 1992 (texts by FRANK GOHLKE and ELSPETH BROWN).

WENDELL BERRY, *The Unsettling of America.*

150
Prairie Park: Catlin envisaged "a magnificent park" stretching from Mexico to Canada across the Great Plains—a kind of "Indians and buffalo park." This was said to be the world's first national park proposal; it came from an artist. In December, 1996, President Clinton created six new national parks, two in Kansas: the Tallgrass Prairie National Preserve of 11,000 acres of tall grass prairie, and the Nicodemus National Historic Site, the black community Ian Frazier visited (see p. 70).The Great Plains have been described as a place "where the whole world can see you, but no one is watching" (SAM HURST, *The Sun*, November 1995).

"debtor's cliffs": The most startling alternative to these problems is marijuana, the largest cash crop in the United States. The majority is grown in the midwestern "pot belt". Growing conditions are the same as for corn, but a bushel of corn sells for around $2.50, while a bushel of pot sells for around $70,000. Growers are predominantly white and male but fit none of the "doper" stereotypes. The DEA probably finds and destroys only 10 to 20 percent of the crop. (*Maine Sunday Telegram*, September 11, 1994).

WENDELL BERRY, *The Unsettling of America.*

Mennonites: DEBORAH TALL.

151
GILBERT C. FITE, *American Farmers: The New Minority*, Bloomington: University of Indiana Press, 1981.

LEON KOHLMEIER, quoted in "Making Sense of the Farm Bill," *American Farmland Trust*, Spring 1995.

Marfa: Since I wrote this text, the Chinati Foundation has published a highly informative bilingual bulletin (vol. 2, 1997) on the history of town and Fort Russell (by SUSANNE GRUBE), and on Don Judd's longstanding involvement with the town (by FLAVIN JUDD).

152
Alfalfa fields: see *New York Times*, May 1, 1994.

153
DAVID BUDBILL, quoted in WENDELL BERRY, *The Unsettling of America.*

154
J. B. JACKSON to J. H. KUNSTLER, in *Geography of Nowhere.*

155
SAMUEL BASS WARNER, *The Urban Wilderness*, New York: Harper & Row, 1972.

DAVID BACHMAN, quoted in CRITCHFIELD'S *Trees, Why Do You Wait?*, which was a major source for this chapter, as was KATHLEEN NORRIS'S *Dakota.*

155
Dairy farmer: Kevin Tilton, quoted by Andrew Weegar, MT, May

156
BOBBY ANN MASON, "The Chicken Tower," *The New Yorker*, October 16, 1995.

Land trusts work with donations, purchases and conservation easements to monitor properties and assure preservation as ownership changes. Easements permit the owner to retain title to the property but give away certain ownership rights, such as the right to develop or subdivide, in return for income, property and estate tax benefits. Deals with the owner are flexible and owners' wishes supercede changes in local land use law and the political climate.

157
current use: Douglas Rooks, MT, Aug. 18, 1996.

158
"farming isn't dead…": JEAN DEMETRACOPOULOS, quoted in FRENCH, ed.

"Our land is not for sale.." quoted in Northern Forest Forum, v.3, no.5 1995.

"Why should the farmer…", quoted in PPH, Nov. 14, 1994.

160
The chapter title is from a song by Woody Guthrie.

161

3.2 billion gallons: from the Washington-based group Population-Environment Balance.

TITO NARANJO, quoted in RUSSELL. His sister RINA SWENTZELL shows that the Pueblo world view is "a very *feminine* view of the world—*internal*, emphasizing everything that goes on around you and accepting the world as it is." But she also warns that "we must accept responsibility for our own actions—that is the biggest gift I can make to the world." (SITE Santa Fe symposium on "The Place of Place," September 1995.)

161

Newfoundland man: JOHN BOLAND, quoted in MT, Nov.4, 1994. Edie Lau's writings on the marine industries in PPH have been extremely useful to the sections on fishing.

162

MARC REISNER'S *Cadillac Desert* is an invaluable source on the water situation in the United States. Thanks to Bernice Ficek-Swenson for giving it to me.

Handsome Lake, in 1799, quoted by OREN LYONS.

"You'll have to drag me...": LENDELL ALEXANDER, quoted in PPH, April 30, 1995.

163

PAT PERCY, quoted in TR, August 2, 1996.

"we can't live with any of them": Maggie Raymond ,spokeswoman for Groundfish Group of Associated Fishermen of Maine, PPH, June 30, 1995

164

JERRY HONAWA and PEABODY SPOKES-MAN, *New York Times*, July 24, 1990.

Cottonwoods: see R. E. BAIRD, "Earth and Science," *Colorado Daily*, February 22, 1994.

165

The Albuquerque cottonwoods may not survive despite this boost because the annual flooding on which they depend has been cut off by dams on the Rio Grande.

JOHN NICHOL'S novel *The Milagro Beanfield War* (New York: Ballantine Books, 1974) became a movie in the mid-eighties; when the 1988 Tierra Amarilla struggle broke out in northern New Mexico, it seemed that life was imitating art, since many details were similar.

166

DANIEL J. LENIHAN, "Damming the Past," *Natural History*, November 1993.

RALPH NADER, introduction to DAVID ZWICK with MARCY BENSTOCK, *Water Wasteland*, New York: Bantam Books, 1971. ELLA FILIPPONE, in *Amicus Journal*, Fall 1995.

167

BILL DIEFFENBACH and ROBERT HAWK, quoted in DAVID TENENBAUM, "Rethinking the River," *Nature Conservancy*, July-August 1994.

RIVER KEEPERS and its ceremonial performances or ritual interactions with specific sites (River Soundings) is a project of the Delaware Riverkeeper Network, which is in turn "An American Littoral Society Project." American Rivers (801 Pennsylvania Avenue, Washington, D.C. 20003) keeps a list of the most currently endangered rivers.

See DOMINIQUE MAZEAUD, "Riveries: Paying Homage to Mother Earth," *Design Spirit*, Winter 1989. Among other artists working with water and conservation are Richard Hansen (Colorado), Basia Irland (New Mexico), Lorns Jordan (Washington), and Betsy Damon (Minnesota, and China). Joseph Bartcherer's artist's book *Pioneering Mattewa* (1992) is obliquely about irrigation.

Water in the West Project, see GOIN, ed.

169

The title of this chapter is borrowed from Carole Gallagher; see pp. 175-76.

CHERYL JOHNSON, *Resist Newsletter*, December 1993.

JOLENE RICKARD, see *Cracked Shell*, Syracuse: Robert B. Menschel Photography Gallery, Syracuse University, *Lightwork Bulletin* no. 36, 1994.

170

LOIS GIBBS, quoted in HELVARG, see note for p. 137.

TOXIC AVENGERS and ROSA RIVERA, in LINDA R. PROUT, "Toxic Avengers: Teenage Mutant Crusaders Against Pollution," in ALSTON, ed.

170

dioxins: ANDREW KEKACS, *Bangor Daily News*, Sept. 15, 1996.

171

ROBERT BULLARD, *Dumping in Dixie: Race, Class, and Enviornmental Quality*, Boulder: Westview Press, 1990.

JEANNE GAUNA and LINDA VELARDE, quoted in *Colorado Daily*, February 23, 1993. MARK GUTIERREZ cartoon in ALSTON, ed.

MARY DANN, quoted in REBECCA SOLNIT, *Savage Dreams;* see also JOE SANCHEZ, "Land, Sovereignty and Environment: The Western Shoshone: Following Mother Earth's Instruction," in ALSTON, ed.

motor boats: ANDRE MELE, *Polluting for Pleasure*, New York: W. W. Norton, 1993.

172

GRACE THORPE, in a lecture for Los Alamos Study Group, Santa Fe, Spring 1995. See also RONALD EAGLEYE JOHNNY, "Showing Respect for Tribal Law, Siting a Nuclear Waste MRS Facility," *Akwe:kon Journal*, Spring 1994.

Mescalero: Opposition to the reservation dump was led—virtually singlehandedly—by tribal member Rufina Laws. See interview with her by STEPHEN KRESS: "Nuclear showdown at Sierra Blanca," *Crosswinds*, March 1995.

In January, 1997, WIPP was the subject of a large series of public hearings in New Mexico. It is scheduled to open in November 1997, or perhaps 2002... The bypass around Santa Fe will not be completed soon, which means waste-bearing trucks will go right through the center of a tourist town in a state notorious for its accident rate. (The WIPP route south of town runs about two miles east of my village.) So many decisions remain to be made that it seems unthinkable that the plant will open soon. Aside from large groups of determined citizen protesters, the EPA and DOE are arguing about deadlines.

TRACEY BOWERS, quoted in VALERIE TALIMAN, "Nuking Native America," *Third Force*, March/April 1993.

SHUERHOLTZ: from recent statement and letter to the author, Summer 1996.

Androscoggin jewel: JOHN COLE in TR, July 28, 1995.

worm digger, quoted in PPH, June 11, 1994.

173
Diné Care, a strong Navajo environmental organization begun in the early 1990s as a result of one case of local uranium pollution, should be more effective on its own terrain than outside groups, given differences in cultural organizing. The issue is not dead; in April 1996, news came that permission was being sought for more uranium mining on the Navajo Reservation, with one projected mine only 1,900 feet from a Crownpoint municipal well.

Navajo yellow powder story: personal communication from ANNA RONDON, 1992, to EICHSTAEDT.

Maine Yankee... elephant: MIKE MCCONNELL, TR, June 16, 1995.

174
PERRY CHARLEY, MANUEL PINO, and DUNCAN HOLADAY, (below), quoted in EICHSTAEDT.

175
Hanford: "arguably the most polluted..." MICHAEL D'ANTONIO, *Atomic Harvest*, New York: Crown, 1993, and GAYLE GREEN, "In the Afterglow," *The Nation*, February 28, 1994. See also MARK RUWEDEL's artist's book on Hanford: *Columbia River: Hanford Stretch*, Montreal: Ruwedel, 1993, and his *The Italian Navigator Has Safely Landed in the New World*, Montreal: St. Mary's University Art Gallery, 1995.

Cleanup: In the early 1990s, Hanford, Rocky Flats (Colorado), Savannah River (South Carolina), and Fernald (Ohio) wore closed, but the future is hardly cheerful; the cost of truly cleaning up any one of these sites is enough to cut social services in the area forever. In 1994, it was reported that DOE had spent $23 billion to reclaim nuclear waste sites, but little actual cleanup

has resulted, and the eventual cost is expected to be some $300 billion over 30 years. Federal cleanup funds for my local mess—at Los Alamos—have just been cut in half, in favor of concentrating on places that are in even worse shape.

Armed Forces Magazine, quoted in GALLAGHER.

Los Alamos scientist—Norris Bradbury; in JAY M. GOULD, "A Tale of Two Bombs," *The Nation*, February 20, 1995.

STEWART UDALL, *The Myths of August*, New York: Pantheon, 1994.

FRED ANGIER, RAY SHADIS, quoted by KENNETH Z. CHUTCHIAN, MT, May 5, 1995.

177
LORRIE CATERILL, quoted in STEWART. Cancer Valley: MEREDITH GOAD, MST, Aug. 3, 1995.

178
DEBORAH BRIGHT, "Of Mother Nature..."; see also NANCY GONCHAR, *Deborah Bright: Textual Landscapes*, Binghamton, N.Y.: University Art Gallery, 1988.

179
DAVID BROWER and ROBERT GLENN KETCHUM, quoted by ADELHEID FISCHER, "Human Nature," *Hungry Mind Review*, Winter 1994.

180
WILLIS HARTSHORN, from interview by GUY CROSS, *The Magazine*, December 1995. Painting has lagged behind photography in dealing with specific environmental issues, although painter MARGARET GRIMES has stated that "environmental crisis has placed landscape painting in an entirely different context from the past" (undated press release, Blue Mountain Gallery, New York). There are of course striking exceptions, such as Janet Culbertson (Shelter Island, New York) whose devastating paintings of billboards recalling a past of sparkling rivers, shaded forests, and other "lost" scenes stand in the dark, vanquished lunar landscapes of a predicted future; Chuck Forsman (Boulder, Colorado), whose "Arrested Rivers" series depicts the great dams of the west; and Brad Yazzolino (Washington

state), who makes large mixed media photograph-paintings on western land uses.

The Laguna Canyon Project is as long standing and successful a project as environmental artists have come up with.

KLETT, quoted in FISCHER, see note for p. 179 and from *Revealing Territory*.

181
BUBIER: from FRENCH, ed.

Salt book is French, ed. See also the 1994 photography exhibition "To Make a Living: Franco-American Work Traditions in Lewiston and Auburn," reviewed in PPH June 1, 1994.

184
Herbert Bayer, a pioneer of landscaping art, proposed two dams to the King County Arts Commission; unlike the usual engineered structures, they were designed to conform to the surroundings and "look natural," to become integral parts of the new landscape. Mary Miss worked with a long strip of land bordering the Sea-Tac Airport, dotted with shrubbery and the remains of old railways and houses. She proposed a series of structures, complete and fragmented, based in the existing landscape, which provided for viewing the airport or turning one's back on it. Although it received more attention than most of the King County projects, Robert Morris's "reclamation" of Johnson Gravel Pit No. 30 dramatized the devastation ironically by uprooting all existing vegetation, planting eerie burnt trees and grading the hill so steeply that erosion was worsened, undermining nature's own restorative process.

Sculptor Harriet Feigenbaum was inspired to reclamation art in 1965 after visiting the Glen Alden anthracite mines in Wilkes-Barre, Pennsylvania. Successfully running the bureaucratic gauntlet, she completed the first phase of her work *Cycles* in 1983, when thousands of Austrian pines were planted on a strip mine site; she has continued to work in the area.

185
HARRISONS: see HELEN MAYER HARRISON and NEWTON HARRISON, "Conversational Drift" in BROOKNER, ed.

(This collection, and the MATILSKY cata-
logue are good sources for the "eco-art"
I have barely touched upon here.)

JEREMY SEABROOK, quoted in
Z Magazine, December 1991.

WILLIAM RATHJE, see RATHJE and
CULLEN MURPHY, "Poor Misunderstood
Garbage," New York Times, August 22, 1992.

Tatelbaum: MT, 4/28/95

reclamation: Among other Boston "recla-
mation artists" was TERYL SMITH, who in
1994 created an instant altar from a found
tire on the Charles River wasteland, North
Point, complete with candles, paper to
respond on with prayers for the place
(made from trash found there),and a circle
of chairs to suggest community.

KIM ABELES in Los Angeles has for years
been making work that informs local resi-
dents about the effects of smog; in 1986-87
she made a piece about the invisibility of
the Los Angeles landscape, documenting
a hike from her studio to the point where
she could finally see the mountains through
the smog—16 1/2 miles. Her 1992 "Smog
Collector" series featured glass plates
etched over time by the acids in the air.

186
KIRKPATRICK SALE, "The Trouble with
Earth Day," The Nation, April 30, 1990.
MILENKO MATANOVIC, whom I first knew
as a Yugoslavian conceptual artist in the
1960s, now directs the Pomegranate
Center in Issaquah, Washington, dedicated
to "integrating art into a community's
daily life."

In April 1996 MICHAEL BRAMWELL
performed Building Sweeps as part of his
work using manual labor to activate social
change and establish positive relationships
within communities, cleaning a Harlem
tenement building on a regular basis and
slowly involving the residents.

"Garbage Girls": Among then, longtime
artist/activist Christy Rupp has designed a
promenade accessible directly from the
street at the Coney Island Pollution
Control Plant (sewage, that is) because
people in the neighborhood had no access
to the waterfront. To point up national

water shortages, Rupp made a cracked,
caked pavement, "an image of the
absence of water without using water..."
And she has persuaded the DEP to
recreate wetlands along the long-degraded
Shellbank Creek. (ROBIN CEMBALEST,
Art News, September 1991). When Nancy
Holt was working on her fifty-seven-acre
Sky Mound, the transformation of a landfill
in the so-called "meadowlands" of New
Jersey into an astronomical observatory/
park, she wanted to make a cosmic
connection to the cycles of decay within
the mound. "I'm not pretending this isn't
a dump," she said. "I'm working with the
vernacular of landfill." (Although fully
funded, the project has been on hold for
several years now.)

187
MIERU UKELES: See PATRICIA PHILLIPS,
"Public Art: Waste Not," Art in America,
February 1989, and M. L. UKELES, "A Jour-
ney: Earth/City/Flow," in BROOKNER, ed.

HEIZER Effigy Mound: DOUGLAS MCGILL,
"Illinois Project to Turn Mined Land Into
Sculpture," New York Times, June 3, 1985
and DOSS.

My "garbage girls" list was augmented in
December 1996, when NANCY SUTOR, work-
ing with local teen artists, painted striking
mobile murals on four garbage trucks for
the city of Santa Fe—"The Refuse Vehicle
Mural Project."

188
RICHARD LONG: see LIPPARD, Overlay
and Six Years.

Earth Art: see BEARDSLEY, Earthworks...,
Lippard, Overlay, and two recent volumes:
GILLES A. TIBERGHIEN, Land Art, Prince-
ton: Princeton Architectural Press, 1996,
and BAILE OAKES, Sculpting with the Envi-
ronment—A Natural Dialogue, New York:
Van Nostrand Reinhold, 1995.

"Any place is diminished...": Some works,
such as Ross's Star Axis, Smithson's Spiral
Jetty, James Turrell's Roden Crater, and
Walter de Maria's Lightning Field, to some
extent avoid this problem by being literally
built into the earth, though this process
brings with it another set of problems.

"Excavating the Present," Aperture,
Spring 1985.

According to Phyllis Austin, Maine parks
and historic sites are in trouble "brought on
by two decades of insufficient investment
and capped by four years of state-level crisis
budgeting that has left park managers
scrambling for the duct tape and spare
change." (MT, June 21, 1995).

ERNEST JEWETT, quoted in PPH, Oct.1, 1996.
ERIC RAND, quoted in MST, June 23, 1995.

191
MEL CHIN Revival Field: see CHIN interview
with RUFUS L. CHANEY, collaborating
scientist on the project, in Inescapable
Histories: Mel Chin, Kansas City, Mo.:
Exhibits USA, 1997.

a rural public art: Some artists have appro-
priated farming techniques to make land art
or to comment on contemporary farming,
among them 1970s works by DENNIS
OPPENHEIM; a groundbreaking (so to
speak) "farm project" near Everett, Washing-
ton, in 1981; LAURA AUDREY'S enormous
architectural structure made from 3,000
bales of hay in South Dakota, in 1983; pro-
posals made for the Hirsch Farm Project in
southwestern Wisconsin(see MUD, The
Hirsch Farm Project, 1992); MELINDA HUNT'S
Circle of Hope in Madison Square Park, New
York City, which combined a corn field and
messages from children to from cross-
historical connections; JACKIE BROOKNER'S
Of Earth and Cotton, an evolving installation
organized by the McKissick Museum,
University of South Carolina, 1995-96, for
which she conducted interviews with those
who had worked the fields and old FSA
photographs with her sculptural field of dirt,
cotton, and cast feet; images and messages
cut into growing fields on New York state
farms(see STEVE DURLAND, "Dutchess
County 'Farm Again' Crop Art," High Perfor-
mance, winter, 1994), and KAREN MCCOY'S
Landscape Palimpsest, a collaboration with
the Land Institute in Salina, Kansas, 1996

192
STEVE SIPORIN, We Came to Where We
Were Supposed to Be, Idaho Commission
on the Arts, 1984.

306 NANCY PADDOCK and her husband JOE are coauthors of *Soil and Survival*, San Francisco: Sierra Club Books, 1986.

193
Dallas: *New York Times*, January 17, 1994.

195
YI-FU TUAN'S *Topophilia* was an invaluable source for this section.

196
The League of Women Voters estimates that 49 percent of eligible voters did vote in 1996, some 6 percent less than 1992, but other groups put the figure much lower; I read somewhere that only 39 percent voted in 1992.

198
GEORG SIMMEL, *The Stranger*. MARSHALL MCLUHAN, "The Media Fit the Battle of Jericho," *Explorations Six*, July 1956.

199
"stateliness": *Cosmopolitan*, 1875, quoted in GWENDOLYN WRIGHT.

DARREL CRILLEY, "Megastructures and Urban Change: Aesthetics, Ideology and Design," in KNOX, ed.

THOMAS JEFFERSON, from *Primary Documents*, no. 4, 1995.

POTTENGER: see J. A. LOBBIA, "Tunnel of Love," *Village Voice*, May 7, 1996.

PATRICIA RANZONI: MT, Oct. 26, 1995.

Bath Chamber of Commerce on tourism: TR, June 21, 1995.

201
HERBERT MUSCHAMP, "Questionnaire," *Zone*, 1985.

202
The section on housing is indebted to GWENDOLYN WRIGHT'S *Building the Dream*.

MICHAEL MERCHANT made his installation, *Abandoned Skyscraper*, 1995-96, after detailed study of a "forlorn modernist artifact," a handsome old Art Deco building in St.Louis that had been sealed shut for nearly two decades.

203
On the *Mill Hunk Herald*, see *Overtime: Worker Writer Anthology 1979-1989*, Pittsburgh and Albuquerque, Piece of the Hunk Publishers and West End Press, 1990.

COLEMAN YOUNG, quoted in R. TYSON, "Inward Rage," *Detroit Free Press*, July 19, 1987.

DAN HOFFMAN, "Erasing Detroit: A Work in Progress," *Art Papers*, September-October, 1992.

203
A convenient BIW chronology was published in PPH, Aug. 18, 1994.

204
PIACSECZNY: BLAISE TOBIA, "Making the Invisible Visible: Demolished by Neglect," and "Keith Piacseczny and Marilyn Zimmerman. Interviewed by William U. Eiland," *Art Papers*, November-December 1988.

205
Times Picayune cartoon, in GWENDOLYN WRIGHT.

206
DAVID MOBERG, "The Second City's 'Second Ghetto,'" *In These Times*, June 28, 1995.

KEVIN GILMORE AND JOE MCCOLE ("what's good for BIW..."): PPH, June 10, 1994.

207
PETER DREIER AND JOHN ATLAS, "Mansions on the Hill," *In These Times*, June 28, 1995; see also JEFF ELLIOTT'S horror story about the case of Sebastopol, California, his hometown, in "California Schemin'" in the same issue. See also PETER DREIER, "Metropolis Versus Suburbia," *Democratic Left*, March-April 1996.

CAMILO JOSÉ VERGARA, "Dee Dee Was Here Now She's Gone," *The Nation*, July 25, 1994.

many project residents: In the South Bronx, the slogan of the community development group Banana Kelly is "Don't Move, Improve."

208
RAFAEL PACHECO, quoted in Biddle.
SHEILA DEWAN, "Project Row Houses: Art in the House.", *High Performance*, Summer 1995.

AUTH cartoon from *Philadelphia Inquirer*, n.d., in *Overtime* (see note for p. 203.)

209
rumors: ERIC BLOM, PPH Aug. 8, 1995.

211
At Christmas 1996, GREG SHOLETTE made a window installation at the Lower East Side Tenement Museum called *Little Workers*, based on old photos by Jacob Riis and Lewis Hine protesting child labor, and connecting them to children working today to manufacture children's clothes in Indonesia and Haiti.

216
ED WALDEN, quoted in FRENCH, ed. French's excellent essay is a very good introduction to contemporary Maine.

217
low road economics: DAVID VAIL, MT, Oct. 12, 1995.

218
MAYERS AND SHAHN, quoted in *Casco Bay Weekly*, Jan. 11, 1990.

209
JOHN FEKNER, *Queensites*, Bjarred, Sweden: Wedgepress and Cheese, 1982.
CAMILO JOSÉ VERGARA, "A Guide to the Ghettos," *The Nation*, March 15, 1993. Folk art and Ruins Park: National Public Radio, Spring 1996.

On immigrant ghettos, see KAY J. ANDERSON'S intriguing history of Vancouver's Chinatown, which traces the social image from a "foreign" urban village (both a launching point for assimilation and a locus of segregation) to a "public nuisance" to a tourist attraction to a slum to an enclave of cultural identity.

RICHARD OF EAST 13TH STREET, "See You in the East River," (monologue recorded by TIM ROLLINS) in MOORE and MILLER, eds.

GANS, quoted in GWENDOLYN WRIGHT.

210

The Lower East Side Tenement Museum features a wonderful "doll house" that narrates details in the lives of twelve families of various ethnicities living at 97 Orchard Street in 1870 and 1915.

213

ELIZABETH HESS, "The Malling of SoHo," *The Village Voice*, March 14, 1995. In 1995, even SoHo began to look at its history with "Who Is SoHo? An Oral History Project," a monthly discussion series organized by the Puffin Room Artist Advisory Board. There are now two hotels in SoHo.

"Red-carpet culture" is a phrase I heard first from Arlene Goldbard.

"the medium through which..." PETER JACKSON, citing the work of the Centre for Contemporary Cultural Studies at the University of Birmingham, England.

215

MIGUEL ALGARIN, quoted in BIDDLE.

216

ROSLER book, see WALLIS.

JAMES LARDNER, "Our Local Correspondents: Shantytown," *The New Yorker*, July 1, 1991.

217

MIGUEL ALGARIN, quoted in BIDDLE.

Shooting Back (homeless): also includes quotations by KOZOL and FORCHÉ.

MALPEDE: see LIPPARD, "Sniper's Nest: Too Close to Home," *Z Magazine*, April 1992. LAPD puts out a newsletter (*The Real Deal*, 2124 Elsinore St., Los Angeles, CA. 90026).

KEA TAWANA: see also VERGARA.

218

Mad Housers: BAILEY POPE, "Essential Shelter: The Mad Houser Hut"; DAVID HEMMINGS, "Mad Housers Protesting Homelessness Productively"; and BARBARA RANDOPH, "Surviving the Streets," all in *Art Papers*, September-October 1992.

WODICZKO: see ROSALYN DEUTSCHE, "Architecture of the Evicted," in *New York City Tableaux: Tompkins Square: Krzysztof Wodiczko*, New York: Exit Art, 1989.

Other artists' projects with or on the homeless include Christopher True's Krugeresque sign project in Boston in 1990, imitating the style and format of legitimate traffic signage, but reading, for instance: "Your standard of living sometimes demands the exploitation of people and nature." In March 1992, Qiang Chen created a three-part public work called *Ghosts at the End of the Century*, which included the renaming of buildings and streets in SoHo, marked by photo portraits of homeless people on building walls and replica street signs, as well as a parade.

219

NEIL SMITH, "New City, New Frontier: The Lower East Side As Wild, Wild West," in SORKIN, ed. Smith also wrote a useful Tompkins Square timeline in the Exit Art WODICZKO catalogue cited above.

Fort Apache The Bronx: see LUCY R. LIPPARD and JERRY KEARNS, "Cashing in a Wolf Ticket: Activist Art and *Fort Apache*," *Artforum*, October 1981.

See MOORE and MILLER, eds., *ABC No Rio Dinero*, and PADD's *Upfront* magazine (PADD Archive, Museum of Modern Art, New York) for more detailed accounts of this lively period.

219

LAWLESS, quoted in TR July 17, 1994.

220

World War 3: see *World War 3 Illustrated*, New York: Fantagraphics Books, 1989 (introduction by LUCY R. LIPPARD).

GROUP MATERIAL is still going strong and working both locally and internationally, with Julie Ault and Doug Ashford of the early group still involved.

221

EVALENE CLAUDIO, DAVID GARCIA, HOWIE WHEELER, and RICHARD MORALES, all quoted in BIDDLE.

222

ALGARIN, quoted in BIDDLE.

223

TOBOCMAN, a founding editor of *World War 3*, remains on its staff and is still a committed activist in the Lower East Side struggle for fair housing practices.

worker: quoted in SMITH, see note for p.219.

224

Activist: phone conversation with the author, Summer 1996.

225

YI-FU TUAN, *Topophilia*.

REBECCA SOLNIT, in *Tracing Cultures*.

226

KUNSTLER's *Geography of Nowhere* and Gwendolyn Wright's *Building the Dream* were my basic sources for this chapter. See also Kunstler's new book, *Home from Nowhere*, New York: Simon & Schuster, 1996.

H. P. DOUGLAS, *The Suburban Trend*, New York: The Century Co., 1925.

Radburn: GWENDOLYN WRIGHT.

CHRISTINE FREDERICK, "Is Suburban Living a Delusion?" *Outlook*, Feb. 22, 1928. Her description is a prototype of Malvina Reynold's famous 1960s song about "little boxes, on the hillside, and they're all made out of ticky tacky...and they all look just the same."

226

"Elderly black woman," quoted in GWENDOLYN WRIGHT.

227

General Motors: KUNSTLER.

WILLIAM FAULKNER, quoted in *Amicus Journal*, Winter, 1995.

228

The parallel between pedestrian and second class is J. B. JACKSON'S.

Rural suburbs have been dubbed "Ruburbia," (see LEO MARX, "The Countryside, The Small Town, and Rural America," in GSD *News*, Fall 1996).

229

New Topographics was curated by William Jenkins, who believed that what the photograph does best is *describe*; his goal was to choose phtographers who "are content with observation," like Hilla and Bernd Becher, Ed Ruscha, Robert Adams, Lewis Baltz, and Joe Deal.

308

ROBERT ADAMS: see interview in FLATTEAU, GIBSON and LEWIS, in which he says "I'm not worried about the landscape. What worries me are the people who care so little for it."

230

RICHARD SENNETT, *Uses of Disorder*.

Addison, Illinois: *Maine Sunday Telegram*, August 6, 1995.

Munjoy Hill: PPH, July 15, 1996.

KUNSTLER lecture, quoted in MT, Sept. 12,1996.

231

WILLIAM M. DOBRINER, *Class in Suburbia*, Englewood Cliffs, N.J.: Prentice Hall, 1963. Levittown continues to be remodeled, and sometimes in very high style. The least altered building has recently been chosen as a landmark. KENNETH T. JACKSON, says "Home improvement is an expression of confidence in the community" (TED ANTHONY, "Seeking Levitt's Legacy," *The New Mexican*, January 12, 1997).

RON ROSENBAUM, "The Devil in Long Island," *New York Times Magazine*, August 22, 1993.

232

MICKI CLARK, quoted in *New York Times*, January 15, 1995.

Naming: African American painter Kerry Marshall, in his series "The Garden Project", calls attention to the incongruously idyllic names of inner city housing projects, marking off the territory of yet another Paradise Lost. (See *Art in America*, November 1995).

In northern Colorado, the innovative Larimer County Exchange Project used the arts to warn rural residents about the dangers of development in 1996. Collaborations among forty-eight participants included a farmer and a dancer, a doctor and a writer, a teacher and a photographer, and also involved The Colorado Young Farmers organization

233

Farming on the Edge survey: VALERIE BERTON, "Reurbanizing America," *American Farmland*, Winter 1995.

JOEL GARREAU, interviewed by RUTH DUSSEAULT in *Art Papers*, January-February 1996.

235

MACGOWAN, and CUSTOM HOUSE WHARF (Dana Neuts), quoted in FRENCH, ed.

WILLIAM GERENCER, and NICK ALFIERO ("would you rather.." quoted by ERIC BLOM in MST, July 14, 1996.

EDGAR ALLEN BEEM's book *Maine Art Now* was helpful on Maine public art.

236

CYNTHIA HAMILTON, *Inside the LA Riots: What Really Happened—and Why It Will Happen Again*, Los Angeles: Institute for Alternative Journalism, 1992.

Portland Metro plan: National Public Radio, 1995; see also CHRISTOPHER REYNOLDS, "The Other Portland: It's Great" (*Maine Sunday Telegram*, September 1, 1996), which explores the city's ninety neighborhoods, including the hard-to-find artists' lofts and galleries district called "The Pearl."

JOHN SMITH, in J. B. JACKSON, *A Sense of Place, A Sense of Time*.

237

RICHARD SENNETT, "Something in the City."

FELICITA CAMINERO, quoted in GEORGE PACKER, "Down in the Valley," *The Nation*, June 27, 1994.

Transcommunal: see JOHN BROWN CHILDS, "The Value of Transcommunal Politics," *Z Magazine*, July/August 1994.

238

GEORGE PACKER: see note for p.237.

JEFF GATES: He is also director of Art FBI (Art for a Better Image) which studies stereotypes of artists in the media and produces great bumperstickers ("Art is Not a Four Letter Word") and a newsletter for print, fax, and cyberspace—*Art FBI Art Fax*.

239

J. B. JACKSON, *Landscapes*.

ARTHUR AND MARILOUISE KROKER, *Panic Encyclopedia*, quoted in brochure

for Warren Padula's "Inferno" exhibition at Sage Junior College, Albany, 1995 (its theme was "Shopping Is Hell").

240

Villages created as islands: ALEXANDER WILSON.

ROBBINS and BECHER: "transportation of place, see M. Catherine de Zegher, ed., *Andrea Robbins and Max Becher*, Kortrijk (Belgium): Kanaal Art Foundation, 1994; and *Blind Spot*, 6, 1995." Their "Report Cards" call attention to historical ironies in the landscape on their own postcards.

EDWARD ROBBINS, in GSD *News*.

241

Southern artists: dialogue among KEN DUNN, CAROL HEALY, DAN PETERMAN in *Art Papers*, September-October 1992.

ALBERT NORMAN: *Boston Globe*, May 14, 1995.

243

HENRI LEFEBVRE, *The Production of Space*, Oxford: Basil Blackwell, 1991.

Places shift functions: this came up in a student dialogue in Don Mitchell's seminar, 1993.

J. B. JACKSON, *Landscapes*. Bath City Council: TR, Aug. 8, 1996.

244

JANE FLAX, "Postmodernism and Gender Relations in Feminist Theory," in L. J. NICHOLSON, *Feminism/Postmodernism*, New York: Routledge, 1990.

Bath Busines Association, quoted in TR, July 5, 1995.

245

BELL HOOKS, *Yearning*.

GILLIAN ROSE, *Feminism and Geography*, Minneapolis: University of Minnesota Press, 1993.

246

DAVID LEE, GSD *News*.

Great American Public Places: I have seen only the press release, which listed "Portsmouth, Maine"—presumably either Portland, Maine or Portsmouth, New Hampshire.

Bath Savings: TR, Oct. 25, 1995.

247
Urban Initiatives (run by GIANNI LONGO, also director of the Great American Public Places, and based in New York) was formerly the Institute for Environmental Action. It focuses on "community awareness, marketing, strategic planning and visioning." Its "Vision 2000" project began in Chatanooga in 1984. The rosy view of Chatanooga is from Diego Mulligan, "Beyond Hope," *The Sun*, November 1995.

ALEXANDER VON HOFFMAN's *Local Attachments* (Baltimore: Johns Hopkins Press, 1994) is a study of Jamaica Plain, Massachussetts.

WILCOX and yard spokeswoman JULIE PHILLIPS: TR, Oct. 29, 1996.

248
DENISE SCOTT BROWN, GSD *News*.

MARGO HUXLEY, quoted in ELIZABETH WILSON.

249
NATHANIEL, quoted in BALMORI and MORTON.

250
ROY ROSENZWEIG and ELIZABETH BLACKMUR, *The Park and The People*, Ithaca: Cornell University Press, 1992.

251
J. B. JACKSON, *Discovering the Vernacular Landscape*.

CINDI KATZ, at a symposium on landscape design at the Harvard Graduate School of Design, March 1995.

JEAN GARDNER, "Nature in New York City," in JEAN GARDNER and JOEL GREENBERG, *Urban Wilderness: Nature in New York City*, New York: Earth Environmental Group, 1988.

252
SUSANA TORRE, in phone conversation with the author, 1996.

253
Berkeley Blueprint: see BOOKCHIN.

Greening of Ruppert: WILLIAM HODGSON, quoted in *The New Yorker*, June 24, 1972.

GLENN LEWIS: see *Glenn Lewis: Utopiary, Metaphorest, Bewilderness*, Burnaby: Burnaby Art Gallery, 1993.

254
Dayton: SUSAN ZURCHER, *Community Garden Handbook*, Dayton: City Beautiful Council, 1977. See also the very useful *a little bit about lots*, New York: Parks Council, 1969-70.

255
KARNEAL THOMAS, see HATSY SHIELDS, "Hope Takes Root," *House Beautiful*, June 1994 and *Newsweek*, May 29, 1995 on urban gardens. Today, community gardens in New York City are being destroyed to make way for housing. greenthumb, the community garden network, expects to lose at least half of its 750 gardens in the next few years, despite the fact that some have become vital neighborhood centers of achievement and memory.

BONNIE SHERK: she has spent several years developing a complex public garden project—another interactive "life frame"—called *The Living Library*.

256
FRANCES COLPITT, "Art to Eat," *Art in America*, October 1993. Webster's contribution to the Public Art Fund's recent "Urban Paradise" project is concerned with understranding ground, garden, park, farm, and city and how they can interact.

BARTLETT: PATTI HAGAN, "Jennifer Bartlett's Walled Garden: 24 Rms, No Rv Vu," *Wall Street Journal*, October 26, 1989.

HAHA: see JACOB, *Culture in Action*, and PATTEN, ed.

ADAM PURPLE: see LUCY R. LIPPARD, "Mixed Messages from Public Artists," *The Village Voice*, October 2, 1984; reprinted in RAVEN, ed.

257
MEDINA and KATZ: MICHAEL LECCESE, "Visionaries," *Landscape Architecture*, December 1995, on the winners of *Landscape Architecture*'s "Visionary and Unbuilt Landscapes" competition.

moral landscape: AKIKO BUSCH, "The Moral Landscape of the American Garden," *Metropolis*, March 1995.

"unnatural creation...": SUZY VERRIER, *Maine Times*, November 11, 1994. See also F. HERBERT BORMANN, DIANA BALMORI, and GORDON GEBALLE, *Redesigning the American Lawn*, New Haven: Yale University Press, 1993. Some 50,000 square miles of the United States is covered by lawns—more than any agricultural crop—and to maintain this artificial carpet Americans spend some $30 billion. (WADE GRAHAM," The Grassman," *The New Yorker*, August 19, 1996).

SARAH STEIN, *Noah's Garden: Restoring the Ecology of Our Own Back Yards*, Boston: Houghton Mifflin, 1993.

organic gardening: JANET MARINELLI, "The Greening of the American Garden," *Amicus Journal*, Summer 1993.

258
RENEE RODIN, "We Are Cultivating Tolerance," *Front*, Summer 1992.

Beverly Hills: THIGPEN and VALDES.

MAGNOLIA MOSES, *New York Times*, August 8, 1993, and RICHARD WESTMACOTT, *African-American Gardens and Yards in the Rural South*, Knoxville: University of Tennessee Press, 1992.

259
JOHN BEARDSLEY, *Gardens*.

PHIL DAY: TR, Sept. 19, 1995.

260
BETTI-SUE HERTZ on *casitas*, "Bohio Manhattan, *Stroll* no.6-7, June 1988, and in *Art Papers*, Sept.-Oct., 1992.

261
RICHARD OF EAST 13TH STREET, in MOORE and MILLER, eds.

263
"Crazy melange..." PAUL FRIEDBERG, *Site*, vol. 1, no. 1, 1973.

264
JANE GREENGOLD: See also JANE GREENGOLD, *Excerpts from the Diaries of Agatha Muldoon*, another fictional memoir in conjunction with an installation for

310 Creative Time's annual "Anchorage" show under the Brooklyn Bridge. It is equally absorbing and historically accurate. My definition of public art; *Public Art Review*, Spring-Summer 1993.

265

Tilted Arc: See ROBERT STORR, "'Tilted Arc': Enemy of the People?" *Art in America*, September 1985; RICHARD SERRA, "'Tilted Arc' Destroyed," *Art in America*, May 1989.

JUDY BACA, at "Mapping the Terrain" conference, 1991.

mural: TR, May 23, 1994.

for decades now: An early percent-for-art participation by artists in unorthodox practical sites was at Seattle's Viewland-Hoffman power substation in 1979; the art was based around colorful windmills made from recycled materials by ninety-three-year-old self-taught artist EMIL GEHRKE, surrounded by complimentary work by contemporary artists ANDREW KEATING, SHERRY MARKOWITZ, and BUSTER SIMPSON.

266

CLAES OLDENBURG, "an art that 'takes its form...'" in *Environments, Situations, Spaces*, New York: Martha Jackson Gallery, May-June 1961.

CLAES OLDENBURG "an excuse for doing landscapes...," in *Claes Oldenburg*, New York: Museum of Modern Art, 1970.

N.E. THING CO: see NANCY SHAW and WILLIAM WOODS, eds., *Start Viewing*, Vancouver: University of British Columbia Fine Arts Gallery, 1993, and LIPPARD, *Six Years*.

267

Cultural workers: see LUCY R. LIPPARD *Get the Message?* New York, E.P. Dutton. 1984.

Under the "psuedonym" of "Anne Ominous" I wrote a semi-enthusiastic, semi-sceptical piece on COLAB'S Times Square Show ("Sex and Death and Shock and Schlock," *Artforum*, October 1980.) SISCO and HOCK, sometimes with DAVID AVALOS and other colleagues, have created a series of hard-hitting public works about San Diego's unadmitted dependence on

undocumented workers and its identity as a tourist mecca. A gentler piece geared to the local was HOCK and SISCO'S *Corral at Banff, 1991*, in conjunction with the "Between Views" show (see AUGAITIS and GILBERT, eds.), and its booklet *Banff Local Interpretations*, based on interviews with residents about their place.

SUZANNE LACY, "Thoughts on Public Art," manuscript, 1988.

269

The new California State University at Monterey offers a public art major—the first in the country.

OLIVIA GUDE, "Where We Come From... Where We're Going," *High Performance*, Winter 1992.

GARY DWYER, "Honest Contextualism," undated manuscript, Department of Landscape Architecture, California Polytechnic State University, San Luis Obispo.

UKELES, quoted in MST, Sept. 3, 1995; MT, Oct. 21, 1994; and phone conversation with the author, summer 1996.

270

LEICESTER'S Flying Pigs: see DOSS.

271

DARREL CRILLEY, see note for page 199. ROSALYN DEUTSCHE, "Art and Public Space."

SYLVIA GABRIEL, quoted in PPH, July 16, 1995.

SILLIBOY, quoted in Andrew Weegar, "Ash to Ashes," MT, March 3, 1995.

MARY GABRIEL, quoted in MST, July 16, 1995, and in conversation with CAROL SMITH-BRECKLING, Indian Artist, Fall 1995.

272

KRYSZTOF WODISCZKO, "Strategies of Public Address: Which Media, Which Public," in HAL FOSTER, ed., *Discussions in Contemporary Culture*, Seattle: Bay Press, 1987.

VITO ACCONCI, quoted by BROOKS ADAMS in "Public Address Systems, *Art in America*, October 1988.

273

MARY JANE JACOB, "An Unfashionaable Audience," in LACY, ed.

JUDY BACA, "Whose Monument Where? Public Art in a Many-Cultured Society," in LACY, ed.

PATRICIA PHILLIPS, "Public Constructions," in LACY, ed.

VIET NGO: see CHERYL MILLER, "Viet Ngo: Infrastructure as Art," *Public Art Review*, Spring-Summer 1990.

275

PATRICIA JOHANSON, "What Should Be the Future of Public Art?" manuscript. Johanson wrote a series of groundbreaking texts for *House and Garden* in the late 1960s in which she laid out the ideas that would inform her work for the rest of her life. See LUCY R. LIPPARD, "The Long View: Patricia Johanson's projects, 1969-1986," in *Patricia Johanson: Drawings and Models for Environmental Projects, 1969-1986*, Pittfield: The Berkshire Museum, 1987.

CLIFF GARTEN, *Saint Paul Cultural Garden*, St. Paul: Cliff Garten, 1996.

276

RALPH ELLISON, *The Invisible Man*.

277

About Place: see GRYNSZTEJN, ed.

ATHENA TACHA: CATHERINE HOWETT and JOHN HOWETT, *Athena Tacha: Public Works, 1970-1988*, Atlanta: High Museum of Art, 1989.

DONNA GOLD: MT, Aug. 4, 1995.

278

SUZANNE LACY, "Debated Territory," in LACY, ed.

279

JERRY WEST: WILLIAM CLARK, "Images of Past Stroll Capital Mural," *Albuquerque Journal*, March 12, 1989.

280

M. J. JACOB, *Places with a Past*. See also an astute critical review by BRADFORD COLLINS, "Report from Charleston: History Lessons," *Art in America*, November 1991.

ESTELLA CONWILL MAJOZO, in LACY, ed.

MARJERY IRVINE, quoted in MT, Nov. 20, 1995.

281
HAMMONS: see *David Hammons: Rousing the Rubble*, New York and Cambridge: PS1 and MIT Press, 1991 (with essays by STEVE CANNON, KELLIE JONES, and TOM FINKELPEARL).

282
Many of the artists mentioned here have worked with the important "American Festival" project across the country.

283
APPALSHOP, see *High Performance*, Winter 1993.

ROBBIE MCCAULEY, "Mississippi Freedom: South and North," *Theater*, v. 24, no.2, 1992. In 1990, McCauley used similar techniques in Buffalo (working with Hallwalls) to tell the obdurately hidden stories of the "riot" of 1967. She worked with Black and Polish residents to produce a "performance dialogue" of intimate, eye-witness accounts collected from residents in a very segregated city. *The Buffalo Project* was, from all accounts, an excruciating but also relaxed retelling of history. McCauley works regularly with the innovative American Festival Project, which does similar work with communities nationwide. (See C. CARR, "Talk Show," *Village Voice*, November 12, 1991.)

CHARLES FREDERICK, interviewed by LUCY R. LIPPARD, "This Is the Church and This Is the Steeple," *Z Magazine*, April 1989

284
Art Among Us, see JASPER and TURNER, eds.

HANS HAACKE, quoted in *The Village Voice*, March 25-31, 1981.

RALPH BISHOP, quoted in FRENCH, ed.

Hardy: Sandor M. Polster, "Whittler," MT, July 21, 1995.

Don Adams: The Mendocino People's Portrait Project was conceived in 1992 as several phases, including a play about forest issues, a Latino Youth Theatre Project, workshops, community arts training, and the exhibition, "Mendocino Black and White," and consisted of snapshot taken by residents in their communities in 1993. a framework within which the people of the county could use arts and media to stimulate dialogue on locally important issues.

285
ARLENE GOLDBARD, "What's Needed Now...".

287
WALTER BENJAMIN, *Illuminations*, New York: Harcourt Brace and World, 1968.

ESTELLA MAJOZO, in LACY, ed.

288
JAUNE QUICK-TO-SEE SMITH, "What Is This Thing Called Art?" 1996 manuscript of article commissioned by the Getty Center for Education in the Arts.

GLORIA BORNSTEIN, letter to the author, 1994.

289
PATRICIA PHILLIPS, in LACY, ed.

JOEL GARREAU, see note page 233.

RAHMANI: statement and letter to the author, 1996.

290
EVA HOFFMAN, *Lost In Translation: A Life in a New Language*, New York: Penguin Books, 1989.

LYNN SOWDER, at "Mapping the Terrain" conference, 1991.

MARGY BURNS KNIGHT, *Talking Walls: The Stories Continue*,

Gardiner: Tilbury House, 1996.

291
Haida Project: see DAVID LEVI STRAUSS,"The Haida Project," in *Capp Street Projects*, San Francisco, 1991.

A

DOUG ABERLEY, ed., *Boundaries of Home: Mapping for Local Empowerment*, Philadelphia: New Society, 1993.

DON ADAMS and ARLENE GOLDBARD, *Crossroads: Reflections on the Politics of Culture*, Talmage, CA.:DNA Press, 1990.

DON ADAMS and ARLENE GOLDBARD, "Grass Roots Vanguard," *Art in America*, April, 1982.

MALAIKA ADERO, ed., *Up South: Stories and Letters of This Century's African American Migrations*, New York: The New Press, 1993.

BARBARA ALLEN and THOMAS J. SCHLERETH, eds., *Sense of Place: American Regional Cultures*, Lexington: University Press of Kentucky, 1990.

PAULA GUNN ALLEN, *The Sacred Hoop*, Boston: Beacon Press, 1986.

DANA ALSTON, ed., *We Speak for Ourselves: Social Justice, Race and Environment*, Washington: The Panos Institute, December 1990.

KAY ANDERSON, "The Idea of Chinatown: the Power of Place and Institutional Practice in the Making of a Racial Category," *Annals of the Association of American Geography*, 77, 1987.

LORRAINE ANDERSON, ed., *Sisters of the Earth*, New York: Vintage, 1991.

GLORIA ANZALDUA, *Borderlands/La Frontera: The New Mestiza*, San Francisco: Spinster/Aunt Lute, 1987.

JOHN ARMOR and PETER WRIGHT, *Manzenar*, New York: Times Books, 1988. (Photographs by Ansel Adams; commentary by John Hersey.)

"Art and the Public," special issue of *Art Papers*, November-December 1993.

"Art in Public Places," special issue of *Circa Art Magazine*, May-June 1989.

Asia America: Identities in Contemporary Asian American Art, New York: Asia Society Galleries and The New Press, 1994. (Curated by Margo Machida, with texts by Machida, Vishakha N. Desai, and John Kuo Wei Tchen.)

DANA AUGAITIS and SYLVIE GILBERT, eds. *Between Views*, Banff: Walter Phillips Gallery, 1991.

B

GASTON BACHELARD, *The Poetics of Space*, Boston: Beacon Press, 1969.

EMERSON W. BAKER, *Trouble to the Eastward: The Failure of Anglo Indian Relations in Early Maine*, doctoral dissertation for Department of History, College of William and Mary, 1986.

EMERSON W. BAKER, EDWIN A. CHURCHILL, RICHARD S. D'ABATE, KRISTINE L. JONES, VICTOR A. KONRAD, AND HARALD E.L. PRINS, eds., *American Beginnings: Exploration, Culture and Cartography in the Land of Norumbega*, Lincoln: University of Nebraska Press, 1994.

WILLIAM AVERY BAKER, *A Maritime History of Bath, Maine and the Kennebec River Region* (2 volumes), Bath: Marine Research Society, 1973.

DIANA BALMORI and MARGARET MORTON, *Transitory Gardens, Uprooted Lives*, New Haven: Yale University Press, 1993.

REYNER BANHAM, *Scenes in America Deserta*, Salt Lake City: Peregrine Smith/Gibbs Smith, 1982.

JUDI BARI, *Timber Wars*, Monroe, Maine: Common Courage Press, 1994.

JOHN BASKIN, *New Burlington: The Life and Death of an American Village*, New York: New American Library, 1977.

RICK BASS, *Oil Notes*, London: Collins, 1989.

JOHN BEARDSLEY, *Earthworks and Beyond*, New York: Abbeville Press, 1984.

JOHN BEARDSLEY, *Gardens of Revelation: Environments by Visionary Artists*, New York: Abbeville Press, 1995.

EDGAR ALLEN BEEM, *Maine Art Now*, Gardiner: Dog Ear Press, 1990.

ROBERT BELLAH, et al., *Habits of the Heart*, New York: Harper & Row, 1985.

EMILY BENEDEK, *The Wind Won't Know Me: A History of the Navajo-Hopi Land Dispute*, New York: Vintage Books, 1992.

WENDELL BERRY, *Home Economics*, San Francisco: North Point Press, 1987.

WENDELL BERRY, *The Unsettling of America: Culture and Agriculture*, San Francisco: Sierra Club Books, 1977.

WENDELL BERRY, *What Are People For?*, New York: North Point Press, 1990.

HOMI K. BHABHA, *The Location of Culture*, New York: Routledge, 1994.

GEOFFREY BIDDLE, *Alphabet City*, Berkeley: University of California Press, 1992.

DAVID P. BILLINGTON, "The Engineering of Symbols: The Statue of Liberty and Other Nineteenth Century Towers and Monuments," in WIlton D. Dillon and Neil G. Kettler, eds., *The Statue of Liberty Revisited: The Making of a Universal Symbol*, Washington: Smithsonian Institution Press, 1994.

JON BIRD, BARRY CURTIS, TIM PUTNAM, GEORGE ROBERTSON, and LISA TICKNER, eds., *Mapping the Futures: Local Cultures, Global Change*, New York: Routledge, 1993.

LIZ BONDI, "Gender Symbols and Urban Landscapes," *Progress in Human Geography*, vol. 16, no.2, 1992.

MURRAY BOOKCHIN, *The Limits of the City*, New York: Harper, 1974.

JOAN BORSA, ed., *Maskunow: A Trail, A Path*, St. John's: Memorial University of Newfoundland, 1989. (Texts by Joan Borsa and David Reason.)

SU BRADEN, *Artists and People*, London: Routledge and Kegan Paul, 1978.

JANE BRATTLE and SALLY RICE, eds., *Public Bodies—Private States*, Manchester University Press, 1988.

JEREMY BRECHER, JERRY LOMBARDI, and JAN STACKHOUSE, *Brass Valley: The Story of Working People's Lives and Struggles in an American Industrial Region*, Philadelphia: Temple University Press, 1982.

T. H. BREEN, *Imagining the Past*, Reading, Mass.: Addison Wesley Publishing Co., 1989. (Photographs by Tony Kelly.)

DAVID BRETT, "From the Local to the Global" *Circa Art Magazine*, July-August 1986, special issue on "The Place of Place in Art."

GUY BRETT, *Through Own Own Eyes: Popular Art and Modern History*, Philadelphia: New Society, 1987.

BETTY BRIGHT, ed. *Completing the Circle: Artists' Books on the Environment*, Minneapolis: Minnesota Center for Book Arts, 1991.

DEBORAH BRIGHT, "The Machine in the Garden Revisited: American Environmentalism and Photographic Aesthetics," *Art Journal*, Summer 1992.

DEBORAH BRIGHT, "Of Mother Nature and Marlboro Men: An Inquiry Into the Cultural Meanings of Landscape Photography," *Exposure*, Winter 1985.

HUGH BRODY, *Maps and Dreams*, New York: Pantheon, 1982.

JACKIE BROOKNER, ed., "Art and Ecology," special issue of *Art Journal*, Summer 1992.

DREX BROOKS, *Sweet Medicine: Sites of Indian Massacres, Battlefields, and Treaties*, Albuquerque: University of New Mexico Press, 1995. (Essays by Patricia Nelson Limerick and James Welch.)

DAVID BUCKLAND, *The Agri-Economy*, Minneapolis: First Bank System, 1989.

MICHAEL BUNCE, *The Countryside Ideal: Anglo-American Images of Land-scape*, New York: Routledge, 1994.

ROBERT D. BULLARD, ed., *Confronting Environmental Racism: Voices from the Grassroots*, Boston: South End Press, 1993.

"Burning Fires: Nuclear Technology and Communities of Color," special issue of *Race, Poverty & the Environment*, Spring-Summer 1995.

LLOYD BURTON, *American Indian Water Rights and the Limits of Law*, Lawrence: University Press of Kansas, 1991.

C

DAVID CANTER, *The Psychology of Place*, New York: St. Martin's Press, 1977.

EDMUND CARPENTER, *"Oh, What a Blow That Phantom Gave Me!"*, New York: Holt Rinehart & Winston, 1972.

EDWARD S. CASEY, *Getting Back Into Place*, Bloomington: Indiana University Press, 1993.

ANA CASTILLO, *Massacre of the Dreamers: Essays on Xicanismo*, New York: Plume, 1994.

ANN CHAMBERLAIN, ed. with JENNIFER DOWLEY, *Headlands Journal 1986-1989*, San Francisco, 1991.

IAIAN CHAMBERS, *Migrancy, Culture, Identity*, New York: Routledge, 1994.

KOU CHANG and SHEILA PINKEL, *Kou Chang's Story: The Journey of a Laotian Hmong Refugee Family*, Rochester: Visual Studies Workshop Press, 1993.

JOHN R. CHAVEZ, *The Lost Land: The Chicano Image of the Southwest*, Albuquerque: University of New Mexico Press, 1984.

PATRICIO CHAVEZ and MADELINE GRYNSZTEJN, *La Frontera/The Border: Art About the Mexico/United States Border Experience*, San Diego: Centro Cultural de la Raza/Museum of Contemporary Art, 1993.

BENJAMIN CHAVIS JR., ed., *Toxic Wastes and Race in the United States*, New York: Commission for Racial Justice/United Church of Christ, 1987.

SERGE CHERMAYEFF and CHRISTOPHER ALEXANDER, *Community and Privacy*, Garden City, NY: Doubleday, 1963.

MARIAN CHERTOW, ed., "Garbage Out Front," special issue of *The Livable City*, November 1990.

WARD CHURCHILL, *Struggle for the Land: Indigenous Resistance to Genocide and Expropriation in Contemporary North America*, Monroe, Maine: Common Courage Press, 1993. (Preface by Winona LaDuke.)

"Cities Don't Suck," special issue of *The Utne Reader*, September-October 1994.

KATHRYN CLARK, *Homeland*, Santa Barbara: Contemporary Arts Forum, 1993. (Essay by Rebecca Solnit.)

GRADY CLAY, *Close-Up: How to Read the American City*, New York: Praeger, 1973.

EVA SPERLING COCKCROFT and HOLLY BARNET-SANCHEZ, *Signs from the Heart: California Chicano Murals*, Venice, Calif.: SPARC, 1990.

EVA COCKCROFT, JOHN WEBER, JAMES COCKCROFT, *Towards a People's Art: The Contemporary Mural Movement*, New York: EP Dutton, 1977.

ROBERT P. TRISTRAM COFFIN, *Kennebec: Cradle of Americans*, Camden, Maine: Down East Enterprise Inc., 1965.

DENIS E. COSGROVE, *Social Formation and Symbolic Landscape*, Totowa, N.J.: Barnes and Noble, 1984.

JULIE COURTNEY and TODD GILENS, eds., *Prison Sentences: The Prision as Site/The Prisons Subject*, Philadelphia: Moore College of Art and Design, 1995.

MARGARET CRAWFORD, "The World in a Shopping Mall," in Sorkin, ed.

STANLEY CRAWFORD, *Mayordomo: Chronicle of an Acequia in Northern New Mexico*, Albuquerque: University of New Mexico Press, 1988.

RICHARD CRITCHFIELD, *Trees, Why Do You Wait?: America's Changing Rural Culture*, Washington/Covelo, Calif.: Island Press, 1991.

WILLIAM CRONON, *Changes in the Land: Indians, Colonists, and the Ecology of New England*, New York: Hill & Wang, 1983.

FLORENCE ISHAM CROSS, a series of unpublished papers on the old houses of Kennebec Point, Maine (Patten Free Library, Bath, Maine).

CAROLE L. CRUMSEY, ed., *Historical Ecology: Cultural Knowledge and Changing Landscapes*, Santa Fe: School of American Research Press, 1993.

314

D

ROBERTO MARIA DAINOTTO, "All the Regions Do Smilingly Revolt: The Literature of Place and Region," *Critical Inquiry*, Spring 1996.

MIKE DAVIS, *City of Quartz: Excavating the Future in Los Angeles*, New York: Verso, 1990.

TIMOTHY DAVIS, "Beyond the Sacred and the Profane: Cultural Landscape Photography in America, 1930-1990," in Franklin and Steiner, eds.

WILLIAM DEBUYS, *Enchantment and Exploitation: The Life and Hard Times of a New Mexico Mountain Range*, Albuquerque: University of New Mexico Press, 1985.

JAMES DEETZ, *In Small Things Forgotten: The Archaeology of Early American Life*, New York: Anchor Books, 1977.

VINE DELORIA, "Out of Chaos," in Dooling and Jordan-Smith, eds.

ROSALYN DEUTSCHE, "Art and Public Space: Questions of Democracy," *Social Text*, Winter 1992.

ROSALYN DEUTSCHE, "Krzysztof Wodiczko's Homeless Projection and the site of Urban 'Revitalization,'" *October*, Fall 1986.

ELLEN DISSANAYAKE, *What Is Art For?* Seattle: University of Washington Press, 1988.

MONA DOMOSH, "Urban Imagery," *Urban Geography*, vol. 13, no. 5, 1992.

D. M. DOOLING and PAUL JORDAN-SMITH, eds., *I Become Part of It: Sacred Dimensions in Native American Life*, New York: Parabola, 1989.

ERIKA DOSS, *Spirit Poles and Flying Pigs: Public Art and Cultural Democracy in American Communities*, Washington: Smithsonian Institution Press, 1995.

JENNIFER DOWLEY, ed., *Headlands Journal*, 1992 (devoted to "the Native American perspective").

RICHARD DRINNON, *Facing West: The Metaphysics of Indian Hating and Empire Building*, New York: Schocken Books, 1990.

GAIL LEE DUBROW, "Claiming Public Space for Women's History in Boston: A Proposal for Preservation, Public Art, and Public Historical Interpretation," *Frontiers*, vol. 13, no. 1, 1992.

JAMES DUNCAN, *The City As Text: The Politics of Landscape Interpretation in the Kandyan Kingdom*, Cambridge: Cambridge University Press, 1990.

JAMES DUNCAN and DAVID LEY, eds., *Place/Culture/Representation*, New York: Routledge, 1993.

JIMMIE DURHAM, *A Certain Lack of Coherence*, London: Kala Press, 1993.

PHILIP DURHAM and EVERETT L. JONES, *The Negro Cowboys*, New York: Dodd, Mead, 1965.

E

MALCOLM EBRIGHT, *Land Grants and Lawsuits in Northern New Mexico*, Albuquerque, University of New Mexico Press, 1994.

FANNIE HARDY ECKSTORM, *Indian Place Names of the Penobscot Valley and the Maine Coast*, Orono: University of Maine Press, 1978.

JULIA EINSPRUCH, ELIZABETH FINCH, JAMES MARCOVITZ, HELEN MOLESWORTH, and LYDIA YEE, *The (Un)Making of Nature*, New York: Whitney Museum of American Art Downtown, 1990.

PETER H. EICHSTAEDT, *If You Poison Us: Uranium and Native Americans*, Santa Fe: Red Crane Books, 1994.

LEONARD ENGEL, ed., *The Big Empty: Essays on the Land as Narrative*, Albuquerque: University of New Mexico Press, 1994.

JON D. ERICKSON and DUANE CHAPMAN, "Sovereignty for Sale: Nuclear Waste in Indian Country," *Akwe:kon*, Fall 1993.

F

ALBERT FEIN, *Landscape into Cityscape: Frederick Law Olmsted's Plans for a Greater New York City*, Ithaca: Cornell University Press, 1967.

ALBERT FEIN, *Frederick Law Olmsted and the American Environmental Tradition*, New York: George Braziller, 1972.

WILLIAM FERRIS, *Local Color: A Sense of Place in Folk Art*, New York: McGraw Hill, 1982.

ROBERT FINCH, *The Primal Place*, New York: W. W. Norton, 1983.

MARGARET FITZSIMMONS, "The Matter of Nature," *Antipode*, 21:2, 1989.

JOHN FLATTAU, RALPH GIBSON, ARNE LEWIS, *Landscape: Theory*, New York: Lustrum Press, 1980.

CHUCK FORSMAN, *Arrested Rivers*, Niwot: University Press of Colorado, 1994. (Paintings by Forsman, texts by Helen Mayer Harrison and Newton Harrison, Patricia Nelson Limerick, Roger C. Echo-Hawk, Gary Holthaus, and Charles Wilkinson.)

MICHEL FOUCAULT, "Of Other Spaces," *diacritics*, Spring 1986.

WAYNE FRANKLIN and MICHAEL STEINER, eds., *Mapping American Culture*, Iowa City: University of Iowa Press, 1992.

IAN FRAZIER, *Great Plains*, New York: Farrar/Straus/Giroux, 1989.

CHARLES FREDERICK, *Everything I say here is dedicated to my friend, Louis, who died from AIDS, Eastertime 1990: An Essay About Community Performances*, New York: Ad Hoc Artists/ Cultural Correspondence, 1990.

HUGH T. FRENCH, ed., *Maine: A Peopled Landscape, Salt Documentary Photography 1978-1995*, Hanover, New Hampshire: University Press of New England, 1995. (Essays by French, C. Stewart Doty, James C. Curtis, and R. Todd Hoffman.)

JUDITH FRYER, *Felicitous Space: The Imaginative Structures of Edith Wharton and Willa Cather*.

COCO FUSCO, *English Is Broken Here: Notes on Cultural Fusion in the Americas*, New York: The New Press, 1995.

G

SUZI GABLIK, *The Reenchantment of Art*, New York: Thames and Hudson, 1991.

CAROLE GALLAGHER, *American Ground Zero: The Secret Nuclear War*, Cambridge: MIT Press, 1993.

HERBERT GANS, *The Levittowners*, New York: Vintage, 1969.

JOEL GARREAU, *Edge City: Life on the New Frontier*, New York: Doubleday, 1991.

MARIE GEE, "Building A World: The Political Nature of Public Art," doctoral dissertation, Department of Psychology, City University of New York, 1996.

KAMNI J. GILL, *Earthwork: A Garden of Reversals*, Calgary, 1994. (Artist's book submitted for Master of Environmental Design at the University of Calgary.)

FRANK GOHLKE, et al., *The Sudbury River: A Celebration*, Lincoln, Mass.: De Cordova Museum, 1993.

PETER GOIN, *Humanature*, Austin: University of Texas Press, 1996.

PETER GOIN, *Nuclear Landscapes*, Baltimore: Johns Hopkins Press, 1991.

PETER GOIN, ed., *Arid Waters: Photographs from the Water in the West Project*, Reno: University of Nevada Press, 1992. (Text by Ellen Manchester.)

ARLENE GOLDBARD, "Postscript to the Past: Notes Toward a History of Community Arts," *High Performance*, Winter 1994.

ARLENE GOLDBARD, "What's Needed Now: A Call for Courage, Intelligence, Art, Judgment and Guile," *High Performance*, Summer 1995.

RICHARD GOLDSTEIN, MICHAEL VENTURA, and MARILYN A. ZEITLIN, *South Bronx Hall of Fame: John Ahearn/Rigoberto Torres*, Houston: Contemporary Arts Museum.

RODOLFO "CORKY" GONZALES, *I Am Joaquin*, c. 1968 (epic poem published in booklet form).

BERYL GRAHAM, ed., "Maximum Exposure: Photography as Public Art," special issue of *Camerawork*, Fall-Winter, 1993.

GAY M. GRANT, *Along the Kennebec: The Herman Bryant Collection*, Dover, New Hampshire: Arcadia, 1995.

DEREK GREGORY, *Geographical Imaginations*, Cambridge: Blackwell, 1994.

SUSAN GRIFFIN, *Woman and Nature: The Roaring Inside Her*, New York: Harper & Row, 1978.

MADELEINE GRYNSZTEJN, ed., *About Place*, Chicago: Art Institute of Chicago, 1995. (Essay by Dave Hickey.)

GSD News (Harvard Graduate School of Design, "Featuring: Public Space," Winter-Spring 1995.

GEORGE GUMERMAN, *A View from Black Mesa: The Changing Face of Archaeology*, Tucson: University of Arizona Press, 1992.

FRANCES "BABE" GUNNELL, *A Nice Life Back Then: Georgetown Island— 1900-1920*, Georgetown, Maine: Georgetown Historical Society, 1996 (edited by Margaret M. Mates).

PETE A. Y. GUNTER and BOBETTE HIGGINS, eds., *Present, Tense. Future, Perfect: A symposium on widening choices for the visual environmental resource*, Dallas: The Landmark Program for the People, 1984.

H

MICHAEL D. HALL and EUGENE W. METCALF, eds., *The Artist Outsider: Creativity and the Boundaries of Culture*, Washington: Smithsonian Institution Press, 1994.

DONNA HARAWAY, "Cyborgs at Large: Interview with Donna Haraway," in Constance Penley and Andrew Ross, *Technoculture*, Minneapolis: University of Minnesota Press, 1991.

DOLORES HAYDEN, *The Power of Place: Urban Landscapes as Public History*, Cambridge: MIT Press, 1995.

ELEANOR HEARTNEY, "The Dematerialization of Public Art," *Sculpture*, March-April 1993, pp. 45-49.

KENNETH HELPHAND and ELLEN MANCHESTER, *Colorado: Visions of an American Landscape*, Boulder: Rinehart, 1991.

ANTHONY HERNANDEZ, *Landscapes for the Homeless*, Hannover: DG Bank/Sprengel Museum, 1995.

High Country News (P.O. Box 1090, Paonia, Colorado 81428). Virtually every issue of this newspaper has relevant material on land use in the West.

High Performance (available by membership from API, P.O. Box 68, Saxapahaw, North Carollina 27340). All issues are relevant to local art. See special issues: "Local Life Aware of Itself," Winter 1993; "Sharing the Future: The Arts and Community Development," Winter 1994.

DAWN HILL, "The Land Is Everything: An Interview with Lubicon Chief Bernard Ominayak," *Native Americas*, Winter 1995. (Most of this issue is on indigenous land rights in Canada).

JACK HITT, "Atlas Shrugged: The New Face of Maps," *Lingua Franca*, August 1995, pp. 24-32.

DERYCK W. HOLDSWORTH, "I'm a Lumberjack and I'm OK: The Built Environment and Varied Masculinities in the Industrial Age," Department of Geography, Pennsylvania State University, July 1992.

BELL HOOKS, *Art on My Mind: Visual Politics*, New York: The New Press, 1995.

BELL HOOKS, *Yearning: Race, Gender, and Cultural Politics*, Boston: South End Press, 1990.

BARBARA HOOPER, "'Split at the Roots': A Critique of the Philosophical and Political Sources of the Modern Planning Doctrine," *Frontiers*, vol. 13, no. 1, 1992.

SUSAN HOPMANS, *The Great Murals of Farmer John Brand, Clougherty Meat Packing Co., in Vernon, California*, New York: Colorcraft Lithographers, Inc., 1971. (Photographs by Peter Kenner.)

PAUL HORGAN, *Great River: The Rio Grande River in North American History*, Hanover, N.H.: Wesleyan University Press and University Press of New England, 1984.

EBENEZER HOWARD, *Garden Cities of Tomorrow*, Cambridge: MIT Press, 1965.

I

IVAN ILLICH, H_2O and the Waters of Forgetfulness, Berkeley: Heyday Books, 1985.

J

J. B. JACKSON, *Discovering the Vernacular Landcape*, New Haven: Yale University Press, 1984.

J. B. JACKSON, *The Essential Landscape: The New Mexico Photographic Survey*, Albuquerque: University of New Mexico Press, 1985.

J. B. JACKSON, *Landscapes: Selected Writings of J. B. Jackson*, Amherst: University of Massachusetts Press, 1970.

316

J. B. JACKSON, *The Necessity for Ruins and Other Topics*, Amherst: University of Massachusetts Press, 1980.

J. B. JACKSON, *A Sense of Place, a Sense of Time*, New Haven: Yale University Press, 1994.

KENNETH T. JACKSON, *The Crabgrass Frontier: The Suburbanization of the United States*, New York: Oxford University Press, 1985.

PETER JACKSON, *Maps of Meaning*, London: Unwin Hyman, 1989.

WES JACKSON, *Altars of Unhewn Stone: Science and the Earth*, San Francisco: North Point Press, 1987.

MARY JANE JACOB/Sculpture Chicago, *Culture in Action*, Seattle: Bay Press, 1995. (Essays by Jacob, Michael Brenson, and Eva M. Olson.)

MARY JANE JACOB, *Places with a Past: New Site-Specific Art at Charleston's Spoleto Festival*, New York: Rizzoli, 1991.

JANE JACOBS, *The Death and Life of Great American Cities*, New York: Vintage, 1961.

LYNN JACOBS, *Waste of the West: Public Lands Ranching*, Tucson: Lynn Jacobs, 1991.

ELAINE JAHNER, "The Spiritual Landscape," in Dooling and Jordan-Smith, eds.

ANNETTE JAIMES, ed., *The State of Native America: Genocide, Colonization, and Resistance*, Boston: South End Press, 1992.

JOHN A. JAKLE, *The Visual Elements of Landscape*, Amherst: University of Massachusetts Press, 1987.

John A. Jakle and Keith A. Sculle, *The Gas Station in America*, Baltimore: Johns Hopkins Press, 1994.

PAT JASPER and KAY TURNER, *Art Among Us/Arte Entre Nosotros*, San Antonio: San Antonio Museum of Art, 1986.

WILLIAM JENKINS, "Introduction," *New Topographics*, Rochester, N.Y.: International Museum of Photography/George Eastman House, 1975.

FRANCIS JENNINGS, *The Invasion of America: Indians, Colonialism, and the Cant of Conquest*, New York: W. W. Norton, 1976.

ROBERT JENSEN, ed., *Devastation/Resurrection: The South Bronx*, New York: Bronx Museum of the Arts, 1980.

STEPHEN JOHNSON, Gerald Haslam, and Robert Dawson, *The Great Central Valley: California's Heartland*, Berkeley: University of California Press, 1993.

WILLIAM GRAY JOHNSON and COLLEEN M. BECK, "Proving Ground of the Nuclear Age," *Archaeology*, May-June 1995.

DAVID ALLEN JONES, *Earthworks: Land Reclamation As Sculpture*, Seattle: King County Arts Commission, 1981.

MALDWYN A. JONES, *Destination America*, London: Fontana/Collins, 1977.

RICHARD W. JUDD, EDWIN A. CHURCHILL, and JOEL W. EASTMAN, eds., *Maine: The Pine Tree State from Prehistory to the Present*, Orono: University of Maine Press, 1995.

ESTELLE JUSSIM and ELIZABETH LINDQUIST-COCK, *Landscape As Photograph*, New Haven, Yale University Press, 1988.

K

IVAN KARP and STEVEN D. LAVINE, eds., *Exhibiting Cultures*, Washington: Smithsonian Institition Press, 1991.

WILLIAM LOREN KATZ, *The Black West*, Seattle: Open Hand, 1987.

MICHAEL KEITH and STEVE PILE, eds., *Place and the Politics of Identity*, New York: Routledge, 1993.

JEFF KELLEY, "Art in Place," *Headlands Journal 1986-89*, San Francisco, 1991.

JEFF KELLEY, "An Art of Places, the Places of Art," revised version published as "Common Work," in Lacy, ed.

JEFF KELLEY, "Crossing Places," versions published in *Border Arts Workshop*, (BAWTAF), San Diego: BAW, 1989, and in *Artforum*, March 1990.

KLARA BONSACK KELLEY and HARRIS FRANCIS, *Navajo Sacred Places*, Bloomington: University of Indiana Press, 1994.

DANIEL KEMMIS, *Community and the Politics of Place*, Norman: University of Oklahoma Press, 1990.

ELAINE H. KIM, "A Different Dream: Eleven Korean North American Artists," in Jane Farver, ed., *Across the Pacific: Contemporary Korean and Korean American Art*, New York: The Queens Museum of Art in cooperation with SEORO Korean Cultural Network, 1993.

YNESTRA KING, "The Ecology of Feminism and the Feminism of Ecology," in Judith Plant, ed., *Healing the Wounds*, Philadelphia: New Society, 1989.

KATHLEEN M. KIRBY, "Thinking Through the Boundary: The Politics of Location, Subjects, and Space," *Boundary 2*, Summer 1993.

BARBARA KIRSHENBLATT-GIMBLETT, "Objects of Ethnography," in Karp and Lavine, eds.

WILLIAM KITTREDGE, *Hole in the Sky: A Memoir*, New York: Vintage Books, 1992.

MARK KLETT, *Revealing Territory: Photographs of the Southwest*, Albuquerque: University of New Mexico Press, 1992. (Essays by Patricia Limerick and Thomas Southall).

MARK KLETT and ELLEN MANCHESTER, *Second View: The Rephotographic Survey Project*, Albuquerque: University of New Mexico Press, 1984.

CAROL KLIGER, *A Public Art Primer for Artists of the Boulder-Denver Area*, Boulder: Kliger, 1993.

MARCIA KLOTZ, *A Citizen's Guide to Rocky Flats*, Boulder, Colo.: Rocky Mountain Peace Center, 1988. (Updated, expanded, and republished under the same title by LeRoy Moore, et al., 1992.)

PAUL KNOX, ed., *The Restless Urban Landscape*, Englewood Cliffs, N.J.: Prentice Hall, 1993.

MAX KOZLOFF, "Ghastly News from Epic Landscapes," *American Art*, Winter-Spring 1991.

KARL KROEBER, *Retelling/Rereading: The Fate of Storytelling in Modern Times*, New Brunswick: Rutgers University Press, 1990.

JAMES HOWARD KUNSTLER, *The Geography of Nowhere: The Rise and Decline of America's Man-Made Landscape*, New York: Simon and Schuster, 1993.

STEPHEN A. KURTZ, *Wasteland: Building the American Dream*, New York: Praeger, 1973. (Photographs by Laurence Fink.)

L

SUZANNE LACY, ed., *Mapping the Terrain: New Genre Public Art*, Seattle: Bay Press, 1995.

WINONA LADUKE, "Native Environmentalism," *Cultural Survival Quarterly*, Winter 1994, pp. 46-48.

MITCH LANSKY, *Beyond the Beauty Strip: Saving What's Left of our Forests*, Gardiner, Maine: Tilbury House, 1992.

WILLIAM LEAST HEAT-MOON, *PrairyErth (a deep map)*, Boston: Houghton Mifflin, 1991.

ALDO LEOPOLD, *A Sand County Almanac*, New York: Ballantine Books, 1966.

PATRICIA NELSON LIMERICK, *The Legacy of Conquest: The Unbroken Past of the American West*, New York: W. W. Norton, 1987.

PATRICIA NELSON LIMERICK, "Disorientation and Reorientation: The American Landscape Discovered from the West," *The Journal of American History*, December 1992.

PATRICIA NELSON LIMERICK, CLYDE A. MILNER II, and CHARLES E. RANKIN, eds., *Trails: Toward a New Western History*, Lawrence; University Press of Kansas, 1991.

LUCY R. LIPPARD, *Mixed Blessings: New Art in a Multicultural America*, New York: Pantheon, 1990 (especially the "Landing" chapter).

LUCY R. LIPPARD, *Overlay: Contemporary Art and the Art of Prehistory*, New York: Pantheon, 1983 (reprinted by The New Press, 1995).

LUCY R. LIPPARD, ed., *Partial Recall: Photographs of Native North Americans*, New York: The New Press, 1992.

LUCY R. LIPPARD, *Six Years: The Dematerialization of the Art Object...*, New York: Praeger, 1973 (reprinted by the University of California Press, 1997).

BARRY LOPEZ, *Crossing Open Grounds*, New York: Vintage Books, 1989.

KEVIN LYNCH, *The Image of the City*, Cambridge, MIT Press, 1960.

KEVIN LYNCH, *What Time Is This Place?* Cambridge: MIT Press, 1972.

NATHAN LYONS, "...the outline of its mountains will be made familiar to us," in E. Manchester, S. Hume, G.Metz, eds.,*The Great West, Real/Ideal*, Boulder: University of Colorado Art Department, 1977.

OREN LYONS, "Water Is a Sacred Trust," *New Observations*, June 1988.

M

DEAN MACCANNELL, *Empty Meeting Grounds: The Tourist Papers*, New York: Routledge, 1992.

Make Yourself at Home: Race, Ethnicity and the American Family, Atlanta: Atlanta College of Art Gallery, 1995.

JERRY MANDER, *The Absence of the Sacred: The Failure of Technology and the Survival of the Indian Nations*, San Francisco: Sierra Club Books, 1991.

RIC MANN, *A Bridge Between Territories: A Study of Community Cultural Development*, Aukland: Media Studies Trust, 1994.

Marks in Place: Contemporary Responses to Rock Art, Albuquerque: University of New Mexico Press, 1988. (Essays by Polly Schaafsma, Keith Davis, and Lucy R. Lippard.)

KARAL ANN MARLING, *The Colossus of Roads: Myth and Symbol Along the American Highway*, Minneapolis, University of Minnesota Press, 1984.

PETER MARRIS, *Loss and Change*, Garden City, N.J.: Anchor/Doubleday, 1975.

MICHAEL MARTONE, ed., *A Place of Sense: Essays in Search of the Midwest*, Iowa City: University of Iowa Press, 1988. (Photographs by David Plowden.)

LEO MARX, *The Machine in the Garden: Technology and the Pastoral Ideal in America*, New York: Oxford University Press, 1964.

VICTOR MASAYESVA and ERIN YOUNGER, *Hopi Photographers Hopi Images*, Tucson: Sun Tracks/ University of Arizona Press, 1983.

BARBARA C. MATILSKY, *Fragile Ecologies:Contemporary Artists' Interpretations and Solutions*, New York: Rizzoli/Queens Museum of Art, 1992.

SKEET MCAULEY, *Sign Language: Contemporary Southwest Native America*, New York: Aperture, 1989. (Introduction by N. Scott Momaday.)

WILLIAM S. MCFEELEY, *Sapelo's People*, New York: W. W. Norton, 1994.

RANDALL H. MCGUIRE and ROBERT PAYNTER, eds., *The Archaeology of Inequality*, Oxford: Blackwell, 1991.

CHARLES B. MCLANE, *Islands of the Mid-Maine Coast: Pemaquid Point to the Kennebec River*, Rockland, Maine: The Island Institute, 1994.

JOHN MCPHEE, *Control of Nature*, New York: Noonday Press, 1989.

D. W. MEINIG, ed., *The Interpretation of Ordinary Landscapes*, New York: Oxford University Press, 1979.

CAROLYN MERCHANT, *The Death of Nature: Women, Ecology and the Scientific Revolution*, New York: Harper and Row, 1983.

EUGENE METCALF, "Public Art, Folk Art, and the Social Consequences of Aesthetics," paper delivered at a conference sponsored by the Durham Arts Council, Durham, North Carolina, June 1989.

ELIZABETH MEYER, "Terrible Beauty: The Sublime in Bloedel Reserve and Gasworks Park," *GSD News*, Fall 1996, pp. 26-29. (On Richard Haag's landscape architecture.)

RICHARD MISRACH, *Violent Legacies: Three Cantos*, New York: Aperture, 1991. (Text by Susan Sontag.)

RICHARD MISRACH with MYRIAM WEISANG MISRACH, *Bravo 20: The Bombing of the American West*, Baltimore: Johns Hopkins Press, 1990.

DON MITCHELL, *The Lie of the Land: Migrant Workers and the California Landscape,*, Minneapolis: University of Minnesota Press, 1996.

JOHN G. MITCHELL with CONSTANCE L. STALLINGS, *Ecotactics: The Sierra Club Handbook for Environmental Activists*, New York: Pocket Books, 1970.

JOHN HANSON MITCHELL, *Ceremonial Time: Fifteen Thousand Years on One Square Mile*, Boston: Houghton Mifflin, 1984.

MARK MONMONIER, *How to Lie with Maps*, Chicago: University of Chicago Press, 1991.

ALAN MOORE and MARC MILLER, eds., *ABC No Rio Dinero: The Story of a Lower East Side Art Gallery*, New York: ABC No Rio, 1985.

318

JOANNA MORLAND, *New Milestones: Sculpture, Community, and the Land*, London: Common Ground, 1988.

MARGARET MORTON, *The Tunnel: The Architecture of Despair*, New Haven: Yale University Press, 1995.

MUMFORD, LEWIS, *Sticks and Stones*, New York: Dover Publications, 1955 (originally published 1924).

KATHLEEN MUNDELL and HILARY ANNE FROST-KRUMPF, *Sensing Place: A Guide to Community Culture*, Augusta: Maine Arts Commission, 1996.

JOAN MYERS (photographs) and GARY Y. OKIHIRO (text), *Whispered Silences: Japanese Americans and World War II*, Seattle: University of Washington Press, 1996.

N

GARY PAUL NABHANARD and STEPHEN TRIMBLE, *The Geography of Chilhood: Why Children Need Wild Places*, Boston: Beacon Press, 1994.

PATRICK NAGATANI, *Nuclear Enchantment*, Albuquerque: University of New Mexico Press, 1991. (Essay by Eugenia Parry Janis.)

GERALD D. NASH, *Creating the West: Historical Interpretations 1890-1990*, Albuquerque: University of New Mexico Press, 1991.

A Nation of Strangers, San Diego: Museum of Photographic Arts, 1995 (with essays by Vicky Goldberg and Arthur Ollman).

WARREN NEIDICH, *American History Reinvented*, New York: Aperture, 1989.

DIANE NEUMAIER, ed., *Reframings: New American Feminist Photographies*, Philadelphia: Temple University Press, 1995.

DIANE NEUMAIER and DOUG KAHN, eds., *Cultures in Contention*, Seattle: Real Comet Press, 1985.

ANNE NEWMARCH AND KATHY MUIR, *Recollections of Prospect*, Prospect Australia: 1982.

MARTHA K. NORKUNAS, *The Politics of Memory: Tourism, History and Ethnicity in Monterey, California*, Albany: State University of New York Press, 1993.

KATHLEEN NORRIS, *Dakota: A Spiritual Geography*, New York: Tickner and Fields, 1993.

VERA NORWOOD and JANICE MONK, eds., *The Desert Is No Lady: Southwestern Landscapes in Women's Writing and Art*, New Haven: Yale University Press, 1987.

BARBARA NOVAK, *Nature and Culture: American Landscape and Painting 1825-1875*, New York: Oxford University Press, 1980.

O

MARK O'BRIEN and CRAIG LITTLE, eds., *Reimaging America: The Arts of Social Change*, Philadelphia: New Society, 1990.

CLAES OLDENBURG, *Proposals for Monuments and Buildings 1965-69*, New York: Museum of Modern Art, 1969.

DENISE OLEKSIJCZUK, *Lost Illusions: Recent Landscape Art*, Vancouver: Vancouver Art Gallery, 1991.

"On Maps and Mapping," special issue of *Arts Canada*, Spring 1974.

An Open Land: Photographs of the Midwest, 1852-1982, Chicago: Art Institute of Chicago, 1983.

P

MARY PATTEN, ed., "Local Options," special issue of *Whitewalls*, no. 36, 1995.

THOMAS C. PATTERSON, *Toward a Social History of Archaeology in the United States*, Fort Worth: Harcourt Brace College Publishers, 1995.

NEAL PEIRCE, "Land Use and the Poor: A Bishop Speaks Out," *Liberal Opinion Week*, May 22, 1995.

PATRICIA C. PHILLIPS, "Out of Order: The Public Art Machine," *Artforum*, December 1988.

OLIVE PIERCE, *Upriver:The Story of a Maine Fishing Community*, Hanover, N.H.: University Press of New England, 1996. (With "word pictures" by Carolyn Chute.)

PETER POOLE, ed., "Geomatics: Who Needs It?" special issue of *Cultural Survival Quarterly*, Winter 1995.

EDWARD T. PRICE, *Dividing the Land: Early American Beginnnings of Our Private Property Mosaic*, Chicago: University of Chicago Press, 1995.

Public Art Review (c/o Forecast, 2324 University Avenue West, St. Paul, Minnesota 55114). Every issue is relevant to Part V of this book.

JUDY PURDOM, "Mapping Difference," *Third Text*, Autumn 1995.

R

TOM RANKIN, ed., *'Deaf Maggie Lee Sayre': Photographs of a River Life*, Jackson: University Press of Mississippi, 1995.

ARLENE RAVEN, ed., *Art in the Public Interest*, Ann Arbor: University of Michigan Press, 1989.

MARC REISNER, *Cadillac Desert: The American West and Its Disappearing Water*, New York: Penguin Books, 1993.

EDWARD RELPH, *Place and Placelessness*, London: Pion, 1976.

REPOHISTORY, *The Lower Manhattan Sign Project*, New York: REPOhistory, 1994.

JOCK REYNOLDS, ed., *House and Home: Spirits of the South, Max Belcher, Beverly Buchanan, and William Christenberry*, Andover: Addison Gallery of American Art, 1994.

MICHAEL AARON ROCKLAND, *Homes on Wheels*, New Brunswick, N.J.: Rutgers University Press, 1980. (Photographs by Amy Stromsten.)

JANICE ROGOVIN, *A Sense of Place/ Tu Barrio: Jamaica Plain People and Where They Live/La Gente de Jamaica Plain y Donde Ellos Viven*, Jamaica Plain, Mass.: Janice Rogovin, 1981.

GILLIAN ROSE, *Feminism and Geography*, Minneapolis: University of Minnesota Press, 1993.

MEL ROSENTHAL, *The South Bronx of America*, New York: Curbstone Press, 1997.

ANDREW ROSS, *The Chicago Gangster Theory of Life: Nature's Debt to Society*, New York: Verso, 1994.

SHARMAN APT RUSSELL, *Kill the Cowboy: A Battle of Mythology in the New West*, New York: Addison-Wesley, 1993.

WITOLD RYBCZYNSKI, *Home: A Short History of an Idea*, New York: Viking, 1986.

KENT RYDEN, *Mapping the Invisible Landscape: Folklore, Writing, and the Sense of Place*, Iowa City: University of Iowa Press, 1993.

S

HEATHER SALAMINI and MARY KAY VAUGHN, eds., *Women of the Mexican Countryside, 1850-1990*, Tucson: University of Arizona Press, 1994.

KIRKPATRICK SALE, "Ecofeminism— A New Perspective," *The Nation*, September 26, 1987.

SIMON SCHAMA, *Landscape and Memory*, New York: Vintage Books, 1995.

MAT SCHWARZMAN, "Drawing the Line at Place: The Environmental Justice Project," *High Performance*, Summer 1996.

RICHARD SENNETT, et al., "Architectural Theory: Its Uses and Abuses," *GSD News*, Summer 1995. (Article responded to by Leo Marx, Edward Robbins, Linda Pollak, Henry N. Cobb, George Baird and K. Michael Hays.)

RICHARD SENNETT, "The Dialectics of Scale," *GSD News*, Summer 1996, p. 45.

RICHARD SENNETT, "Something in the City," *Times Literary Supplement*, September 22, 1995, pp. 13-15.

RICHARD SENNETT, *The Uses of Disorder: Personal Identity and City Life*, London: Penguin, 1970.

PAUL SHEPARD, *Man in the Landscape*, New York: Ballantine Books, 1967.

GREGORY SHOLETTE, "Transformations in the Concept of Site-Specificity" (Unpublished manuscript, 1996).

Shooting Back: Photography By and About the Homeless, Washington DC: Washington Project for the Arts, 1990. (Essays by Philip Brookman, Carolyn Forché, E. Ethelbert Miller).

Shooting Back from the Reservation: A Photographic View of Native American Youth, New York: The New Press, 1994. (Selected by Jim Hubbard, foreword by Dennis Banks.)

RICK SIMONSON and SCOTT WALKER, eds., *The Graywolf Annual Five: Multicultural Literacy*, St. Paul: Graywolf Press, 1988.

CHARLES R. SIMPSON, *SoHo: The Artist in the City*, Chicago: University of Chicago Press, 1981.

SITE Santa Fe, *Longing and Belonging: From the Faraway Nearby*, Santa Fe: SITE Santa Fe, 1996. (Documents 1995 exhibition; essays by Dick Hebdige, Lucy R. Lippard, Reesa Greenberg, Bruce Ferguson and Vincent Varga; edited by David Abel; symposium excerpts edited by Lon Dubinsky.)

RICHARD SLOTKIN, *Gunfighter Nation: The Myth of the Frontier in Twentieth-Century America*, New York: Harper Perennial, 1993.

HENRY NASH SMITH, *Virgin Land: The American West and Symbol and Myth*, Cambridge: Vintage Books, 1950.

SMITH, JAUNE QUICK-TO-SEE, and NANCY LIDDLER, eds., *Our Land/Ourselves*, Albany: University Art gallery, 1990.

NEIL SMITH, *Uneven Development: Nature, Capital and the Production of Space*, Cambridge: Basil Blackwell, 1984.

ROBERT SMITHSON, *Robert Smithson: The Collected Writings*, Berkeley: University of California Press, 1996 (edited by Jack Flam).

Robert Smithson: The Collected Writings, Berkeley: University of California Press, l996 (edited by Jack FLam).

GARY SNYDER, "Not Here Yet," *Shambhala Sun*, March 1994.

ROBERT SOBIESZEK, *Robert Smithson: Photoworks*, Albuquerque: LA County Museum, University of New Mexico Press, 1993.

EDWARD SOJA, *Postmodern Geographies: the reassertion of space in critical social theory*, New York: Verso, 1989.

REBECCA SOLNIT, "Elements of a New Landscape."in *Visions of America: Landscape as Metaphor at the End of the 20th Century*, Denver: Denver Art Museum, 1994.

REBECCA SOLNIT, "Five Miles," *in Walking and Thinking and Walking*, one of 4 exhibitions presented as *NowHere*, Humlebaeck (Denmark): Louisiana Museum, 1996

REBECCA SOLNIT, *Savage Dreams: A Journey Into the Hidden Wars of the American West*, San Francisco: Sierra Club Books, 1994.

REBECCA SOLNIT, "Five Miles," in Walking and Thinking and Walking, one of four exhibitions presented as NowHere, Humlebaeck (Denmark): Louisiana Museum, 1996.

DAVID E. SOPHER, "The Landscape of Home: Myth, Experience, Social Meaning," in Meinig, ed.

REBECCA SOLNIT, "Unsettling the West, Contemporary American Landscape Photography," *Creative Camera*, December-January 1993.

MICHAEL SORKIN, ed., *Variations on a Theme Park: The New American City and the End of Public Space*, New York: Noonday Press, 1992.

DAPHNE SPAIN, *Gendered Spaces*, Chapel Hill: University of North Carolina Press, 1992.

MARY SPARLING, ed., *Africville: A Spirit That Lives On*, Halifax: Art Gallery of Mount Saint Vincent University/The Black Cultural Centre for Nova Scotia/The Africville Genealogical Society/The National Film Board, 1989.

ANNE W. SPIRN, *The Granite Garden: Urban Nature and Human Design*, New York, Basic Books, 1984.

CAROL STACK, *Call to Home: African Americans Reclaim the Rural South*, New York: Basic Books, 1995.

WALLACE STEGNER, *Where the Bluebird Sings to the Lemonade Springs: Living and Writing in the West*, New York: Penguin Books, 1992.

MICHAEL C. STEINER, "Regionalism in the Great Depression," *Geography Review*, 1983.

GEORGE R. STEWART, *Names on the Land: A Historical Account of Place-Naming in the United States*, Boston: Houghton Mifflin, 1967.

SHARON STEWART, *A Toxic Tour of Texas*, Houston: Sharon Stewart, 1992.

JOHN STILGOE, *Alongshore*, New Haven: Yale University Press, 1994.

JOHN R. STILGOE, *Common Landscape of America: 1580-1845*, New Haven: Yale University Press, 1982.

CATHERINE STIMSON, ELSA DIXLER, MARTHA J. NELSON and KATHRYN B. YATRAKIS, eds., Women and the American city, Chicago: University of Chicago Press, 1980.

320 IMRE SUTTON, ed., *Irredeemable America: The Indians' Estate and Land Claims*, Albuquerque: University of New Mexico Press, 1985.

T

RONALD TAKAKI, *A Different Mirror: A History of Multicultural America*, Boston: Little Brown and Company, 1993.

DEBORAH TALL, *From Where I Stand: Recovering a Sense of Place*, New York: Alfred A. Knopf, 1993.

JUDY NOLTE TEMPLE, ed., *Open Spaces, City Places*, Tucson: University of Arizona Press, 1994.

ANN MARIE THIGPEN and KAREN VALDES, *The Great American Lawnscape: Yard Art*, Gainesville: University Gallery, University of Florida, 1992.

ROBERT FARRIS THOMPSON, "The Song That Named the Land," in *Black Art: Ancestral Legacy*, Dallas: Dallas Museum of Art, 1989.

HENRY DAVID THOREAU, *Walking*, New York: Penguin Books, 1995.

TZVETAN TODOROW, *The Conquest of America: The Question of the Other*, New York: Harper & Row, 1984.

ALAN TRACHTENBERG, *Reading American Photographs*. New York: Noonday Press, 1989.

BRUCE G. TRIGGER, ed., Handbook, North American Indians: vol. 15 Northeast, DC.: Smithsonian, 1978.

Tracing Cultures, San Francisco: Friends of Photography, 1995. (Essays by Andy Grundberg, Rebecca Solnit, and Ronald Takaki.)

WILLIAM H. TRUETTNER, ed., *The West as America: Reinterpreting Images of the Frontier, 1820-1920*, Washington: Smithsonian Institution Press, 1991.

YI-FU TUAN, *Passing Strange and Wonderful: Aesthetics, Nature and Culture*, Washington/Covelo, Calif.: Island Press/ Shearwater Books, 1993.

YI-FU TUAN, *Space and Place: The Perspective of Experience*, Minneapolis: University of Minnesota Press, 1977.

YI-FU TUAN, *Topophlia: A Study of Environmental Perception, Attitudes and Values*, Englewood Cliffs, N.J.: Prentice Hall, 1974.

ANNE WILKES TUCKER, *Crimes and Splendors: The Desert Cantos of Richard Misrach*, Boston: Bulfinch Press; Little Brown and Company; Museum of Fine Arts, Houston, 1996. (With an essay by Robecca Solnit.)

FREDERICK JACKSON TURNER, *History, Frontier, and Section*, Albuquerque: University of New Mexico Press, 1993.

U

DON J. USNER, *Sabino's Map: Life in Chimayo's Old Plaza*, Santa Fe: Museum of New Mexico Press, 1995.

V

MICHAEL VAN VALKENBURGH, *Design with the Land: Landscape Architecture of Michael Van Valkenburgh*, Princeton: Princeton Architectural Press and Harvard Graduate School of Design, 1994. (With essays by Peter G. Rowe, Will Miller, James Corner, Paula Deitz, John Beardsley, and Mildred Friedman.)

CAMILO JOSÉ VERGARA, *The New American Ghetto*, New Brunswick, N.J.: Rutgers University Press, 1995.

The Voice of Citizenry: Artists and Communities in Collaboration, San Francisco: San Francisco Art Institute, Walter McBean Gallery, 1993.

Voices of Henry Street: Portrait of a Community, New York: Henry Street Settlement, 1993. (Photographs by Harvey Wang.)

W

The Wabanakis of Maine and the Maritimes: A Resource Book about Penobscot, Passamaquoddy, Maliseet, Micmac and Abenaki Indians, Bath, Maine: Maine Indian Program of the Regional Office of the American Friends Service Committee, 1989.

BRIAN WALLIS, ed., *If You Lived Here: The City in Art, Theory and Social Activism, a Project by Martha Rosler*, Seattle: Bay Press, 1991.

E. V. WALTER, *Placeways: A Theory of the Human Environment*, Chapel Hill: University of North Carolina Press, 1988.

COLIN WARD, "Future Communities," *Future Communities*, London: ICA, 1981.

MEL WATKIN, *History 101: The Re-Search for Family*, St. Louis: Forum for Contemporary Art, 1994. (Essay by Lucy R. Lippard.)

WALTER PRESCOTT WEBB, *The Great Plains*, New York: Grosset and Dunlap, 1931.

CHARLES F. WILKINSON, *The Eagle Bird: Mapping a New West*, New York: Pantheon, 1992.

RAYMOND WILLIAMS, *The Country and the City*, New York: Oxford University Press, 1973.

LYNNE WILLIAMSON, "As We Tell Our Stories: Living Traditions of the Algonkian Peoples of Indian New England-A New Exhibit," Northeast Indian Quarterly, Winter, 1990.

DEBORAH WILLIS, ed., *Picturing Us: African American Identity in Photography*, New York: The New Press, 1994.

ALEXANDER WILSON, *The Culture of Nature: North American Landscape from Disney to the Exxon Valdez*, Cambridge: Blackwell, 1992.

ELIZABETH WILSON, *The Sphinx in the City*, Berkeley, University of California Press, 1991.

DENIS WOOD with JOHN FELS, *The Power of Maps*, New York: The Guilford Press, 1992.

SOL WORTH and JOHN ADAIR, *Through Navajo Eyes*, Bloomington: Indiana University Press, 1974.

DONALD WORSTER, *Under Western Skies: Nature and History in the American West*, New York: Oxford University Press, 1992.

GWENDOLYN WRIGHT, *Building the Dream: A Social History of Housing in America*, New York: Pantheon Books, 1981.

Z

WILBUR ZELINSKY, *Exploring the Beloved Country*, Iowa City: University of Iowa Press, 1994.

HOWARD ZINN, *A People's History of the United States*, New York: Harper and Row, 1980.

SHARON ZUKIN, *Landscapes of Power: From Detroit to Disney World*, Berkeley: University of California Press, 1991.

DAVID ZWICK with MARCY BENSTOCK, *Water Wasteland*, New York: Bantam Books, 1971. (Ralph Nader's Study Group Report on Water Pollution.)